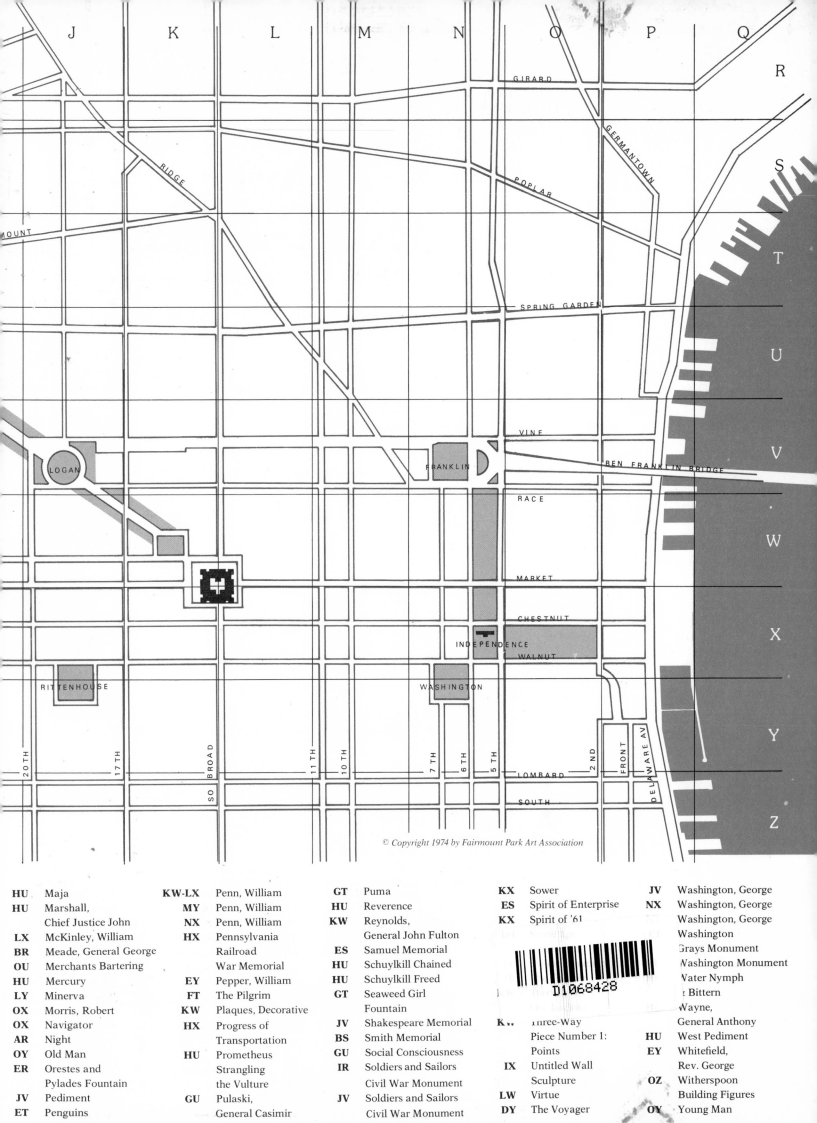

© Copyright 1974 by Fairmount Park Art Association

Sculpture of a City:

Philadelphia's Treasures in Bronze and Stone

Fairmount Park
Art Association

Published by
Walker Publishing Co., Inc.
720 Fifth Avenue, New York, N.Y. 10019

First published in the United States of America
in 1974 by the Walker Publishing Company, Inc.

Published simultaneously in Canada by
Fitzhenry & Whiteside, Limited, Toronto.

ISBN: 0-8027-0459-x

Library of Congress Catalog Card Number: 74-79214

Printed in the United States of America
by Rapoport Printing Corp.

Preface

This book is a proud record of the remarkable achievements of an American city in the use of sculpture in public places. Beginning with the first entry on William Rush, dated 1787, to the latest at the time of publication, on Louise Nevelson, dated 1970, the story is told in authoritative text and is illustrated by the skill and artistry of members of the nationally known "Philadelphia School" of photography. The goal has been an appreciation of the creative abilities of those native and foreign sculptors whose works adorn the Philadelphia scene.

Those responsible for the enrichment through sculpture of many of our buildings and parks include numerous private individuals, local organizations, the Federal Government and the City of Philadelphia which, to its credit, in 1959 adopted a unique ordinance which requires that one per cent of the cost of all new public buildings be expended on aesthetic ornamentation. Foremost in the movement to acquire sculpture has been the Fairmount Park Art Association, the sponsor of this volume.

The Association is a nonprofit corporation chartered by the Commonwealth of Pennsylvania in 1872 "To promote and foster the beautiful in the City of Philadelphia, in its architecture, improvements and general plan." Through the years, in pursuance of this aim, it has commissioned and purchased an imposing amount of sculpture, and established it in appropriate settings throughout the city. In 1907 the Association also engaged the noted French city planner Jacques Greber to assist in the design of the Benjamin Franklin Parkway, which leads from the Fountain Society's Swann Fountain in Logan Circle not far from City Hall out to the Philadelphia Museum of Art at Fairmount.

Some fifteen years ago a catalogue of the Association's acquisitions was proposed. At first a modest guide book was contemplated, but it was soon found that the quantity and importance of the sculpture warranted a more significant presentation, particularly as it was decided to include sculpture acquired by agencies other than the Fairmount Park Art Association. While thus enlarging the scope of the book, its focus has been narrowed to emphasize sculpture which is situated out of doors, although there are some exceptions to this rule. In general, sculpture recorded as being in Philadelphia museums, or in private collections to which access is limited, has been excluded.

As research on the book progressed, appreciation of the quality and the number of outstanding pieces of Philadelphia sculpture grew correspondingly. Some are of great beauty, some are interesting primarily from an historical point of view, but all reflect the intellectual and aesthetic attitudes which characterize various periods of the past. All told, they represent a record of achievement and taste in the world of the sculptor during the past two centuries.

This book is presented in the hope that it will be of interest to laymen as well as of value to student, sculptor, and scholar.

C. Clark Zantzinger, Jr.
President, Fairmount Park
Art Association

Acknowledgements

When the Fairmount Park Art Association decided to compile this record, the responsibility for the task was given to its Publications Committee composed of J. Welles Henderson, Chairman, and Joseph T. Fraser, Jr., Frederick H. Levis, H. Radclyffe Roberts and Evan H. Turner, with C. Clark Zantzinger, ex officio. Subsequently, Mr. Henderson was called away from Philadelphia and was replaced as Chairman by Dr. Roberts who presided over the project in its final editorial and publication phase. Special recognition is due to the members of the Committee, in particular to Dr. Turner, Director of the Philadelphia Museum of Art, who evolved the form the book was to follow and who gave a great deal of his time to it before other commitments caused him to withdraw. Mr. Fraser, former Director of the Pennsylvania Academy of the Fine Arts also played a prominent role, devoting his unrivaled familiarity with Philadelphia's artistic heritage to the selection of materials.

After the text of the book had been assembled, Nicholas B. Wainwright, Director and Editor of the Historical Society of Pennsylvania, reduced some parts of it so that the volume would conform in length to the Committee's original intention, and he also edited the single-page presentations and appendixes in addition to performing other editorial tasks. Prior to his undertaking this work, preliminary editing had been performed by Mrs. Joanne Greenspun.

As Archivist, Miss Caroline Pitts combed the Association's voluminous files for long-forgotten information about the city's sculpture. With her assistants, Mrs. Rae Rondeau Weeks and Miss Ann Marie Cioschi, she collated this data for the essayists, gave directions to the photographers, and prepared the captions for the single-page presentations. Mrs. Eileen Wilson, the Association's Secretary, served as coordinator.

During the organizational period, Weld Coxe evolved procedures to insure orderly progress and budget control. From the start, Samuel Maitin was actively and enthusiastically concerned; it is he who designed the book. Samuel Walker, as publisher, added refinements to the presentation.

Finally, although the book owes much to many people, it was the ability and interest of essayists and photographers alike which made possible the accomplishment of the Association's goal.

Introduction

In order to permit a chronological sense of development, this history of public sculpture in Philadelphia is divided into six periods. The earliest one stems from the Revolution, encompassing the wood carving of William Rush, the nation's earliest native-born sculptor of distinction, and ends with Rush's death in 1833. Aside from Rush's carvings, nearly all Philadelphia's sculpture emanating from this early time was done by foreigners, but this was soon to change. From 1833 to 1875 sculpture of native origins becomes more prominent. Here the Italian influence may be observed, since most American sculptors were then receiving their training in Italy. German influences were strong from the Centennial of 1876 to 1893. Centennial sculpture was much affected by Teutonic styles and it was in these years that Rudolf Siemering was commissioned to design the Washington Monument that was to bring baroque grandeur to the Parkway. It was also in this period that Alexander Milne Calder, the decorator of City Hall, established a dynasty of Calder sculptors. From the astonishing sculptural displays at the Columbian Exposition of 1893 to World War I, the Beaux-Arts tradition held sway, bringing to Philadelphia one of its most successful periods of sculptural accessions. Many of the country's outstanding artists, most of them trained in Paris, received commissions. Then followed the years 1914 to 1960 when the academically correct taste of the past gave way to increasingly abstract forms. It was during this time that Fairmount Park gained the Samuel Memorial in which the change to the nonrepresentative may be traced. Finally, from 1960 on the "1% for art" has stimulated commissions and brought in much that reflects the aesthetic taste of today.

Within each of the six periods sculptures of particular significance are described at essay length and are illustrated in close detail. The provenance of other pieces are held to a single illustrated page. To complete the record, all of the remaining sculptures are briefly listed in their respective periods and are accompanied by an identifying picture.

Nicholas B. Wainwright
Editor

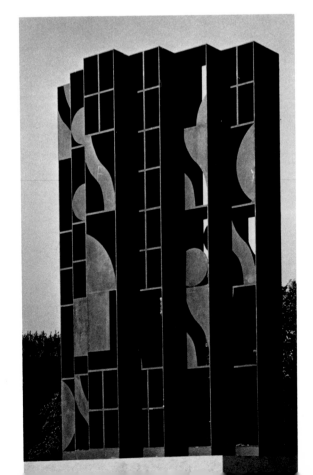

Table of Contents

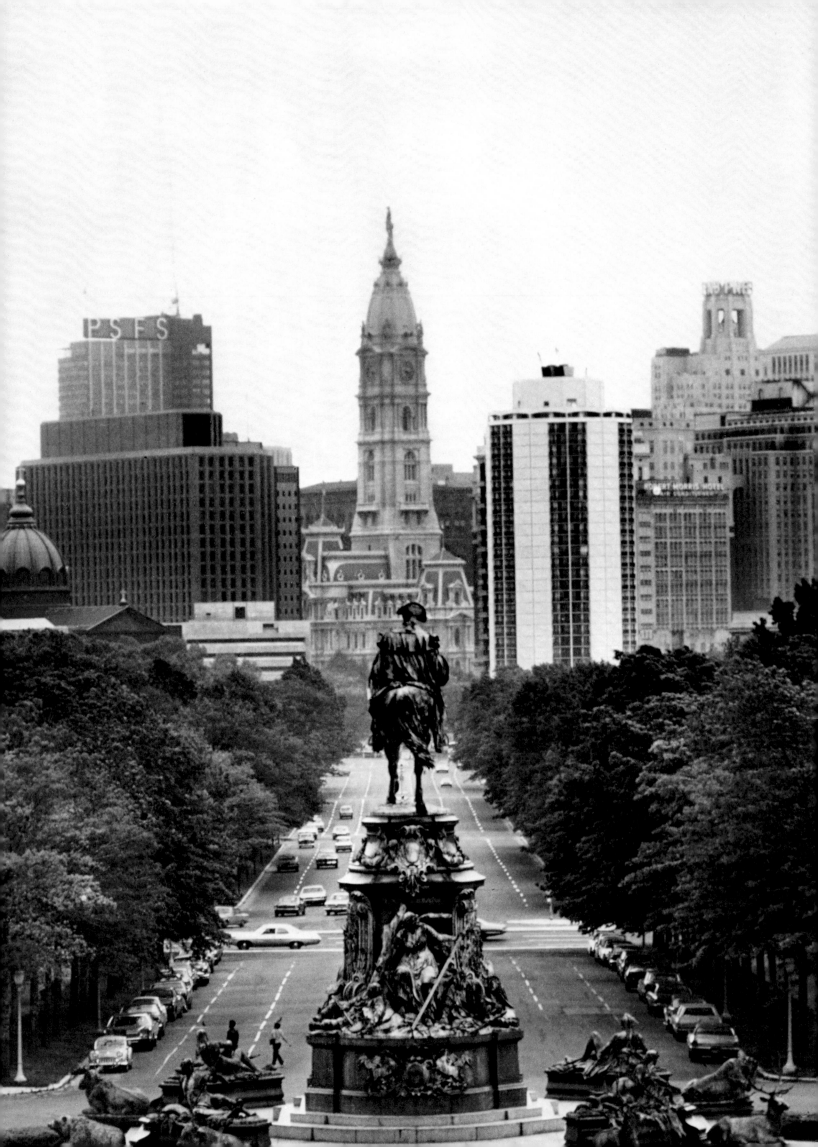

Section I 1776–1833

photograph by Bernie Cleff

William Rush
at Fairmount

by Charles Coleman Sellers

*photographs by
Murray Weiss*

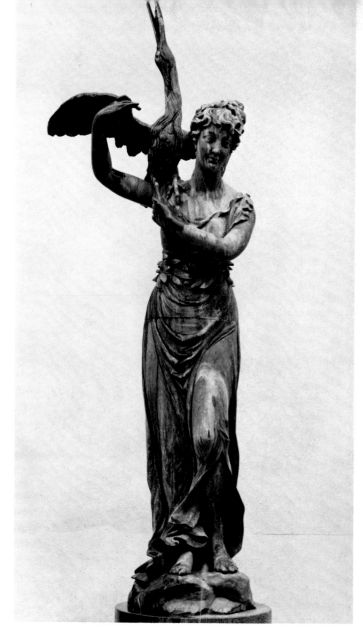

Nymph and Bittern

Philadelphia's park and sculpture, that slowly accomplished interweaving of storied and romantic artifice with the natural beauty of river and wild hills, holds a heritage not only of art but of Revolutionary fervor. From a distance of two hundred years, the emotions that followed our long and bloody war for independence may not be clearly felt or, even, shared. But they are there for all that, in wood and bronze and stone. Successful revolutionaries look with a bright eye upon public works. Things of "general utility," a favorite phrase with our fathers, must be combined with beauty to show the world that out of the struggle and tragedy a new and nobler society has been born.

Philadelphia, impelled by the notorious impurity of its wells and alarmed by the terrible yellow fever epidemics, launched its first great civic improvement in 1799, a public water system. Bitterly argumentative opposition was overcome by the genius of a great engineer, Benjamin Henry Latrobe. That round marble edifice of his design rose on Centre Square, pumping fresh, untainted Schuylkill water into a tank overhead.

The smoke from its steam engine rose through its core, flowing out above the little structure like holy vapor from some Olympian altar fire.[1] Water, responsive, gushed from pipes and hydrants near and far. Walks were laid out around the building and trees planted, the newly imported Lombardy poplars, straight and tall, like sylvan guardians of the shrine. After practical success, beauty was sought, and a regular sum was appropriated for the purpose. In the summer of 1809 came the fountain, a playful nymph, seven and one-half-feet tall, holding a large bird captive in her hands; jets of bright water flew high from the bird's beak and rose all about her feet.[2] With this central attraction, benches were added along the walks,[3] and then Adam Traquair, the marble cutter, was brought in to give the little temple its final polishing.[4]

Water Nymph and Bittern, by William Rush, is said to have been America's first decorative fountain built with public funds.[5] Originally of wood, now recast in bronze, it remains as a unique passage in the history of American art and as a convincing affirmation of the claim of his biographer, Henri Marceau, that William Rush was not

only the first native sculptor but, in his lifetime, "was the whole of American sculpture."[6] Carvers of wood and stone had come before, and in wax the unique genius of Patience Wright, but there had been no other with his versatile, disciplined mastery of the art.

His bill for the work, dated August 11, 1809, is preserved in the Philadelphia City Archives:

The Corporation City Philada. Dr.
Wm. Rush
to carving figure for fountain at Centre Square
to Collecting stone for Ditto and
Superintending the Erection thereof
and painting figure $200[7]

As simple as that. The statue's pedestal was no more than a heap of native rocks, selected by the artist, and the arrangement of lead pipes protruding from them an easy matter.

His bill is a statement perfectly fitting the man as his fellow citizens had known him through the years, short and sturdy, a pleasant, intelligent face, respected everywhere as a practical man of affairs.[8] Some thirty

years before, just out of his apprenticeship as a wood carver to the shipwrights, he had been elected an officer in the city militia and had campaigned with Washington in its defense. With the peace, he had become pre-eminent in his craft, his figureheads admired throughout the world, and, as new designs were required for the rising American navy, he had conceived symbolic figures reflecting a full measure of patriotism and pride. By 1809 he had studied modeling in clay and would acquire a mastery of that medium also.[9] It was a career firmly grounded in American life and affairs, subject from the first to all the anxieties and compulsions of commission and deadline—similar in this regard to those of Frederic Remington and others of a century later who had emerged from illustrated journal and newspaper, tempered and disciplined, as original artists.

Already, also, William Rush was an elected member of city councils, in which he would remain an influential figure for many years, forward and outspoken, active and occasionally an official on its important "Watering Committee." The pretty daughter of James Vanuxem,

chairman of the committee, had posed for the head of his *Nymph*.[10] Tradition has it that she posed for the lightly clad figure as well. Here Henri Marceau ventures a logical suggestion of the *Venus de Medici* as a "probable source."[11]

Rush and his friend Charles Willson Peale had been the only practicing artists elected to the first Board of Directors of the Pennsylvania Academy of the Fine Arts in 1805, and Rush was undoubtedly instrumental in making the Academy's first acquisition a collection of casts of the great examples of classical sculpture and was undoubtedly influenced by them as well.[12] *Poulson's American Daily Advertiser* for August 28, 1809, acclaimed the design of Philadelphia's new fountain:

COMMUNICATION

The ingenious RUSH, *whose superior excellence in the sculpture of wood, has done equal honor to himself and his country, within a few days past compleated a design in the highest degree ornamental to our City. In the eastern avenue to the rotunda on Centre Square, a mass of rocks have been placed (as nearly resembling nature as circumstances would admit) amongst which are distributed small leaden pipes, and through them flows the Schuylkill water in an irregular manner. On the top of the rocks, in graceful attitude and attire, stands a female figure, on whose right shoulder a large water fowl is seen endeavouring to escape from the hands of the Nymph. From this bird's beak issues a column of water about eight feet above the figure, at the base of which also ascend streams of unequal height, the whole forming an elegant fountain (figure 1).*

Common Council minutes of September 14 record with satisfaction that all this had come within the budget annually approved for the maintenance and improvement of the square. Improvement continued. Rush was a participant and contributor to the plans for a greater waterworks, far more efficient, more beautiful, and begun ten years later, right on the bank of the Schuylkill, at Fairmount. On Fairmount's summit, towering over the city's tallest building, a huge reservoir would hold water enough to supply the whole, and for years to come. A dam would be built, water wheels installed to work the pumps, and thus this wide stream of pure water flowing down from the countryside would itself fill the reservoirs—a marvel of utility and economy sure to be visited and admired by citizen and stranger, worthy of every adornment. It was an intricate, ambitious transformation, slowly advancing, but fairly achieved by 1822.[13]

An event of two years later brought a sudden, exultant revival of Revolutionary fervor, all the ardors and ideals of the conflict heartfelt once more. Lafayette returned from France to travel among us as our "National Guest." He landed in August, 1824, was at Philadelphia in September for a tremendous ovation, his cortege sweeping up to Independence Hall through a triumphal arch surmounted by the statues of *Wisdom* and *Justice* which Rush, a member of the Reception Committee, had carved for the occasion, and which the city still

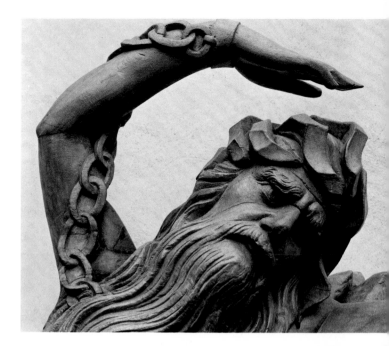

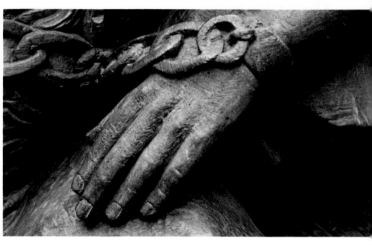

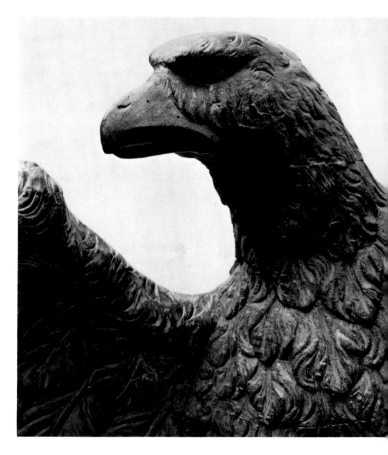

preserves.[14] The general moved on to his far-flung tour of the South and West, but as early as April, 1825, plans were in the making for a second visit in the summer. The Philadelphia newspapers followed his progress along the distant roads and rivers and reported great things to occur on his return. Unhappily, the Washington Monument, of which he was to lay the cornerstone, faded out for lack of funds,[15] but there can be no doubt that the beautification of the new facility on the Schuylkill was stimulated by an expectation that the genial old soldier would see it and count it among the blessings for which he had fought and bled (figure 2).

Here a small park of thirty acres lay between the river on one side and the rocky walls of Fairmount on the other, a hundred feet high. On the plateau above was a complex of reservoirs and filtering beds. One could survey them from the encircling gravel walk, looking down on the river below, or out across the city on the other side. A stairway path led down to the riverside, with a columned gazebo as a halfway resting place. At its foot, among lawns and gardens, was the main building of the waterworks, then the long row of wheelhouses carrying a paved promenade across to the edge of the dam, where conversation would be hushed by the steady rush of falling water.[16] The architecture had classic inspiration— machinery surmounted by Greek pediment and portico, linking the jaunty spirit of young America to an ancient splendor, reawakened. Fairmount had become a wonder of the modern world and, as one charmed stranger wrote at the time, "a paradise, where the lover of nature could almost delight to dwell."[17]

On the walk between forebay and river, two lofty entrances led down to the wheels and pumps, splashing and churning below, and these were now capped by William Rush's recumbent symbolic figures, *Schuylkill Chained* and *Schuylkill Freed*.[18] The sculptor's bill of March, 1825, has its own classic quality, terse and precise:

Corporation City Philada. Dr.
Wm. Rush & Son.
to carving two figures for water work fair Mount
One male figure Emblematic river schuylkill in its
improved state
One female Ditto Emblematic of the water works
$450[19]

Here we see that the master, now aged sixty-nine, had been joined in the work by his eldest son, John, who for some years had maintained a separate wood-carving shop on Front Street. It is also to be noted that the bill is endorsed by "Samuel W. Rush, Register," a younger son who would continue for many years as register and secretary of the Watering Committee.

William Rush had students and assistants to help him, but the two figures, *Schuylkill Chained* and *Schuylkill Freed*, are in concept entirely his own. He was relating nature to man in his own way and as all the Fairmount architecture sought to do, and adding an ancient instinctive grace to the unfolding mechanized patterns of contemporary living. Henri Marceau has pointed out the probability that *Schuylkill Chained* had been suggested by the symbolic figure of the *Nile* in the Vatican Museum, illustrated in *The Artist's Repository, or Encyclopedia of the Fine Arts*, which is known to have been in Rush's

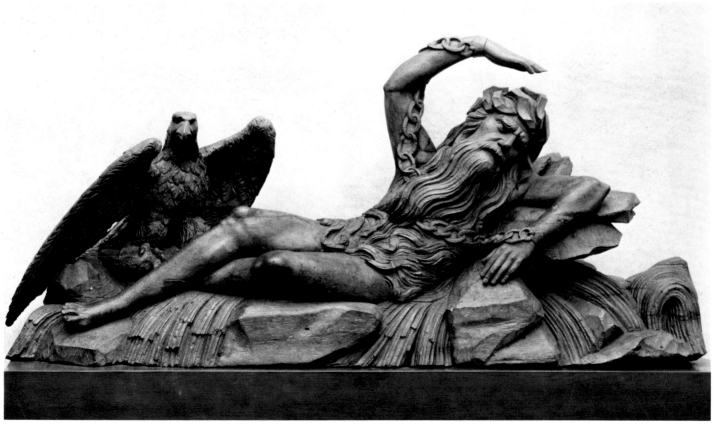

Schuylkill Chained

11

library.[20] It is even closer to the *Marforio*, another male figure representing some unknown river, an engraving of which could have been available to the sculptor.[21] But Rush was too original an artist to adopt more than the basic concept of masculine strength stretched out upon a bed of flowing water. His waters gush with a fierce vigor that the others lack, conjured by that raised chained hand. Beard and garment echo the water's flow, and at his figure's feet the American eagle spreads protective wings and darts its warning glance. The chains offer no restraint. It is all a representation of flowing power.

If Rush had been in any way influenced in his companion piece by the Vatican's *Cleopatra*, where the dying queen appears with the Nile's currents pouring from beneath her shoulders and feet, he had carried it to an even further transformation. Here the light drapery also rhymes the flow of water, but the lady sits upright upon a throne of bolted steel, alert to her task, one hand gracefully poised above the water wheel, while behind her the water leaps from the pump's mouth and overflows a symbolic reservoir.

From their opening in 1825, the "Fair Mount Gardens" became a showplace of the city, constantly boasted of, cherished, improved. "The first thing a visitor is recommended to do by way of recreation," as we read in *The Lions of Philadelphia* (1837), "is to ride out to see the waterworks. Until he has seen them he has seen nothing."[22] An omnibus would be waiting for him at the Merchants' Exchange, and the trip could be made in half an hour.

Improvements to the park were usually installed in late winter or early spring, with an official annual inspection by the mayor and the corporation in April. It was on February 3, 1829, that William Rush and Son billed the Watering Committee $60.00 for "Carving a figure of Mercury for fair mount."[23] Half life size, upright on an iron rod, this small deity was to stand on the arbor-type roof of the gazebo halfway up the Mount. Poised on that height, feet free in the air, it would seem to be borne upward by the wings on its hat and sandals, and appears so in some of the old prints of this favorite view (figure 3).

Mercury, most happily, lives still in the collections of the museum which now stands where the reservoir once spread its sheets of water to the sun. His sandal's wings have vanished, his feet have suffered some damage, and only the stump of his caduceus remains, but the outstretched right hand still clutches the little packet of good news from the Messenger of the Gods. His cloak, where it falls back on the shoulder, has lost a part which once floated behind him in the wind. The whole pose is that of onward movement. It is the "walking" pose characteristic of William Rush's full-length figureheads.[24] Mercury, with his attribute of speed and his patronage of commerce, has had many seagoing namesakes and often, of course, his effigy under their prows. Here is a figure typical of Rush's prime as a ship carver. Its attitude of forward movement was not truly appropriate to the pinnacle of that pavilion roof. One is reminded of *General Reynolds* on the Smith Memorial, stepping off from his dizzy height. *Mercury* is a design of headway and

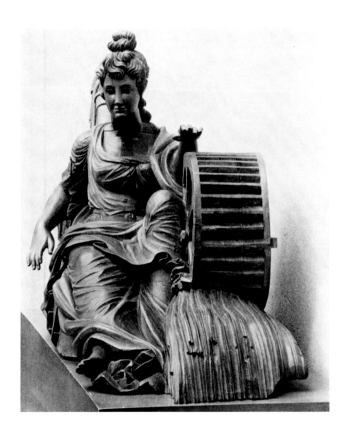

swiftness, not to be fixed upright and static on a pole, but inclined forward over the cutwater's lift and surge. It is marked by that sense of advance which Rush could impart so well. "There is a motion in his figures that is inconceivable," Latrobe had said in his oration of 1811 before the Society of Artists. "They seem rather to draw the ship after them than to be impelled by the vessel. Many are of exquisite beauty. I have not seen one on which there is not the stamp of genius."[25]

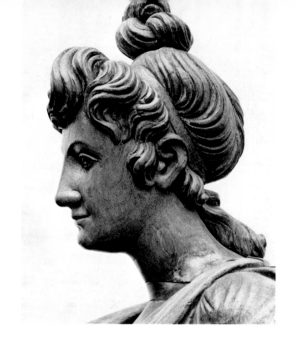

Given that *Mercury* is an earlier design applied to this new purpose, it need not be inferred that the master had come to a sterile old age. The *Philadelphia Gazette* of July 31, 1830, informed its readers that "our ancient and respectable fellow townsman, William Rush, is very desirous of employment in the way of his profession. He is the father of American sculpture and it would be very agreeable to his feelings if he could leave behind him in his native city a few more specimens of his art"—and suggested empty niches in buildings here and there which might be filled. These were not forthcoming, but on October 27 the *United States Gazette* reported an exhibition of newly completed portrait busts "at his shop in Front Street . . . well deserving the attention of lovers of art," *Jefferson, Madison, Washington,* and *Lafayette* among them. At his death on January 17, 1833, at the age of seventy-seven, the city would mourn an artist long to be held in honor through cherished "testimonials not only of his skill but of his patriotism." And more than in any other place his memory would live on at Fairmount, as it does today.[26]

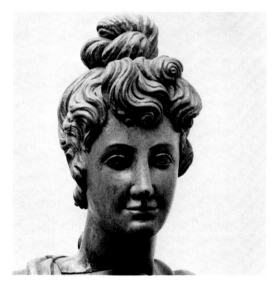

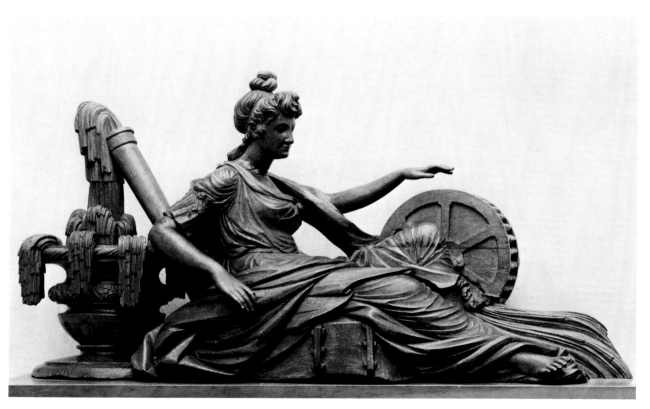

Schuylkill Freed

In 1835, another columned circular pavilion was built at the edge of the falls, another spot for meditation and repose, and John Rush supplied a carved eagle for its summit. The *Wisdom* and *Justice* of the Lafayette triumphal arch were enshrined in the main hall of the engine house, and the *Water Nymph and Bittern* fountain brought out from Centre Square to stand on the bank of the forebay, splashing water high in the air, adding coolness and delight to the scene. There the *Nymph* remained, recast in bronze in 1854, and in 1940 brought up to the summit of the Mount, an apotheosis of her own in the American galleries of the Philadelphia Museum of Art.

Fairmount Park has spread its boundaries far beyond those original thirty acres, up the river and into the Wissahickon's wild gorge. Laurel Hill joined the complex in that early day when cemeteries had become another favored form of public improvement, combining utility with beauty, greenery and cool shade for the wayfarer, art in a mood of melancholy reflection. Back, under the Mount, the utility is gone, the machinery silent, but the river and the city are still one. Classic grandeur crowns the height more nobly than before and that echo of a Revolutionary fervor, rational, romantic, striving for a greater and more beautiful land, can still be felt.

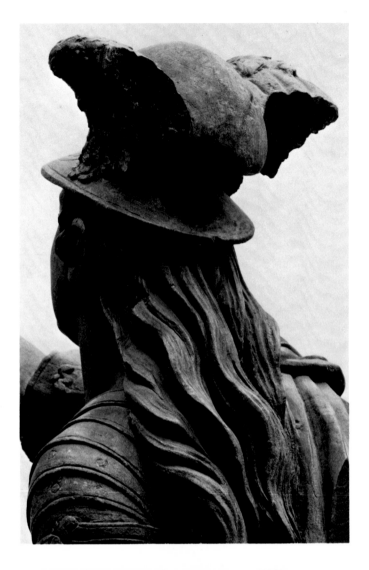

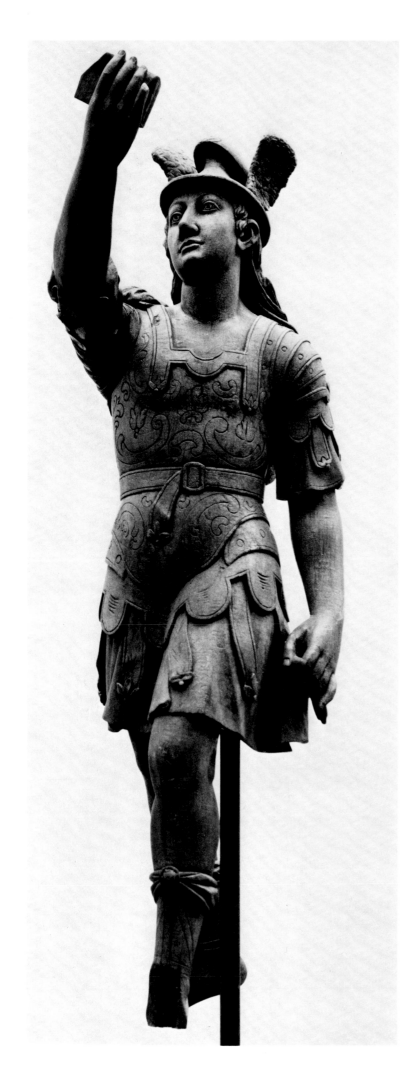

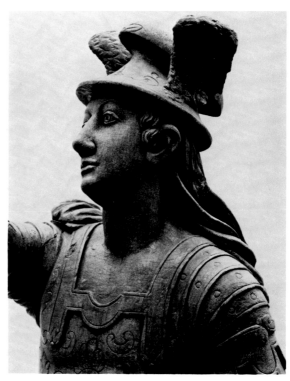

Jean Antoine Houdon (1741–1828)
Thomas Jefferson. *c.* 1787
American Philosophical Society
Plaster, height 29″

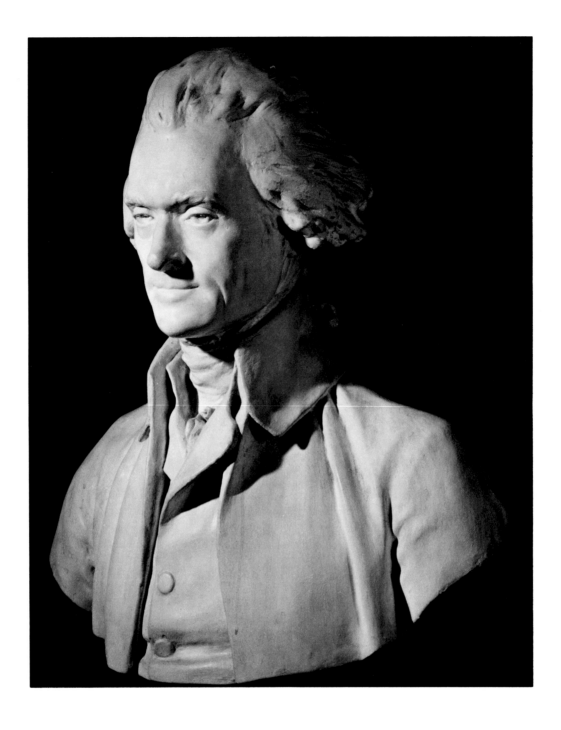

In 1785, Jefferson succeeded Franklin as Minister to France, where he remained until late in 1789. An admirer of Houdon—"he is disinterested, generous, candid & panting after glory"—he was responsible for the commission Virginia granted the sculptor to carve a statue of Washington. Despite Jefferson's wishes, Washington insisted that he be portrayed in contemporary garb. This statue became the principal ornament of the state capitol in Richmond, which Jefferson himself designed after the Maison Carré, a beautifully preserved Roman temple at Nimes.

About 1787, while working on the Washington

figure, Houdon made his bust of Jefferson, which was exhibited at the French Salon of 1789 under the mistaken appellation "M. Sesseron, envoyé des Etats de la Virginie." Jefferson owned a number of casts of his bust, and evidently gave several to his friends. Only two well-preserved ones remain. Of these, one, which has been heavily overpainted, is at the New-York Historical Society, and the other is the one shown here. It was given to the American Philosophical Society by the daughter of Jefferson's friend, and predecessor as president of the Society, David Rittenhouse.

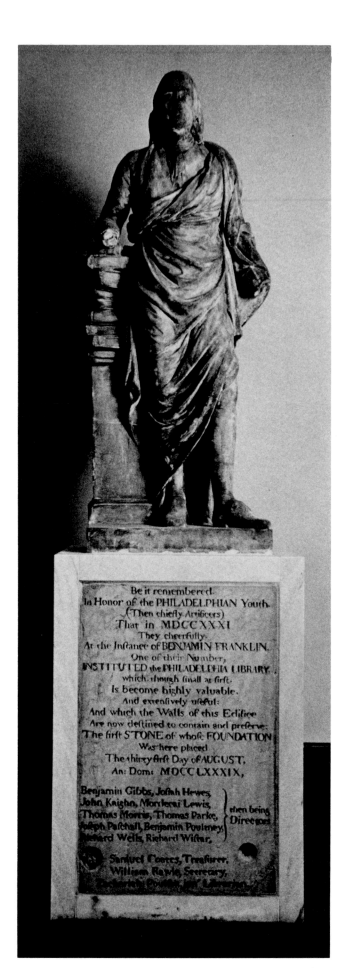

William Bingham (1752–1804), perhaps Philadelphia's wealthiest citizen, in 1789 commissioned Lazzarini to carve this statue of Carrara marble for a fee of more than 500 guineas. In April, 1792, it was placed in a niche over the main entrance of the Library Company of Philadelphia's building at Fifth and Library streets, an institution founded by Franklin in 1731. Exposed to the elements for many generations, the statue became much defaced, but is now preserved inside the Library Company's new building at 1314 Locust Street.

The Library Company's minutes record that its directors in 1792 "flatter themselves that, from the accuracy of its resemblance and the excellence of its execution, it will be considered not only as the first Ornament of their building, but as the most finished specimen of Sculpture America can exhibit...." On its base they had carved "This Statue of Dr. Benjamin Franklin was presented by William Bingham, Esq. MDCCXCII." Franklin's learning is suggested by the stack of books upon which he leans, and his dislike of monarchies was evident in his holding a scepter, now missing, downward.

Giuseppe Ceracchi (1751–1802)
Minerva as the Patroness of American Liberty. 1792
Library Company of Philadelphia
Terra cotta, bronze patina, height 66″

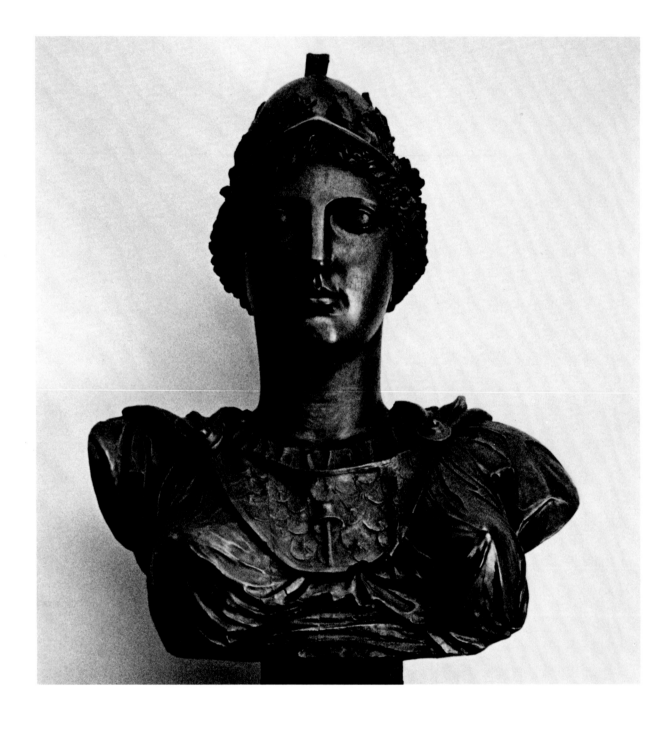

Ceracchi had executed commissions in Amsterdam and elsewhere before coming to Philadelphia during the winter of 1790–91, bearing a letter of recommendation to Thomas Jefferson. It is likely that he had heard of Congress' intention to commission an equestrian statue of George Washington, a prospect that had already attracted Houdon. He executed a large-scale model for a Washington in 1791, and, since this was to be done on a colossal scale, it is thought that Minerva, as the patroness of American liberty, was modeled as a tour de force to demonstrate his skill. This large head so impressed Congress that it was placed behind the speaker's chair in Congress Hall. In 1890 George M. Abbot of the Library Company noted: "In regard to the bust of Minerva, I can find no reference to it in the Minutes, but I have always understood that it was made to stand behind the Speaker's chair in the first Congress that sat in Philadelphia and upon removal of Congress to Washington, it was presented to the Library."

Clodius F. Legrand and Sons
Eagle. 1797
First Bank of the United States,
Third Street between Chestnut and Walnut
Mahogany, height 96″

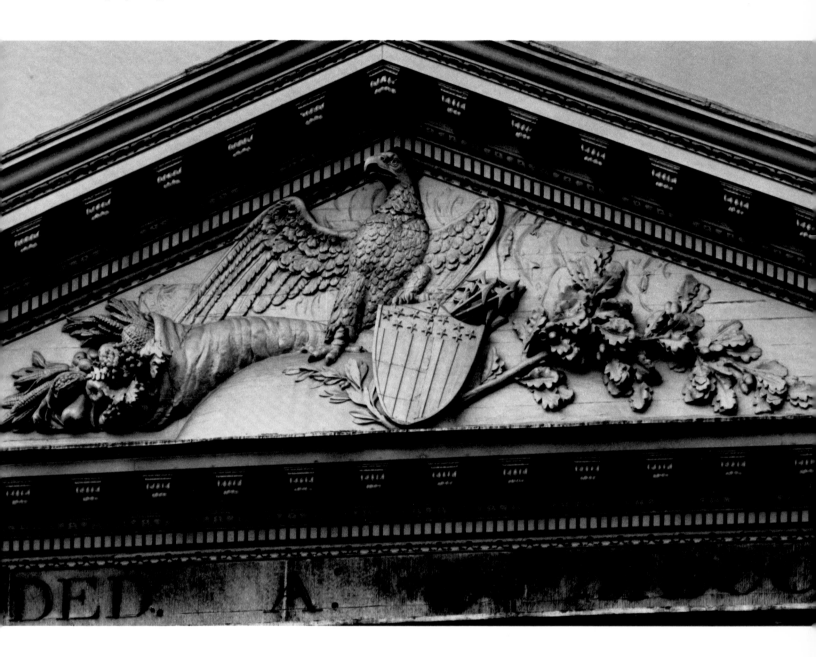

Incorporated in 1791, the Bank of the United States moved into its Third Street headquarters in 1797, a structure destined to become the oldest bank building in the United States. On behalf of his firm, the sculptor Legrand, a French craftsman known to have worked in Philadelphia between 1795 and 1801, advertised in the *Aurora* on December 14, 1797, "That having just finished the marble collonade, sculpture, carving, etc of the portico of the new building of the Bank of the United States, they...are ready to contract for any works of their respective professions, from the plainest to the most extensive job of stone cutting; likewise all sorts of sculpture and carving executed in the marble, wood, plaster of Paris or terra cotta." It is on this basis that the ma-

hogany eagle in the Bank's pediment is believed to be his work.

The Department of the Interior, which administers the building, has described the carving as follows: "In the center the fierce-eyed eagle with open beak and partly spread wings holds a firm stance on the upper portion of the globe. In his raised left claw he grasps the shield of thirteen stripes and thirteen stars, beyond which is a cluster of arrows. An olive spray is placed across the globe. To the left of the eagle is a cornucopia from which tumble all kinds of good things—wheat, corn, pears, apples, pomegranate, grapes and melon. To the right is an oak branch well furnished with leaves and acorns."

19

John Bacon, the elder (1740–1799)
William Penn. 1774
Pennsylvania Hospital Yard, Pine Street side
Lead, painted black, height 72″ (marble base 42″)

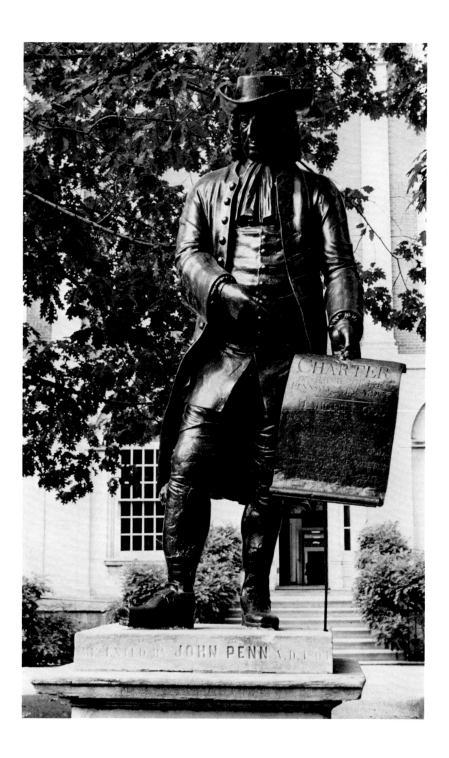

In 1775 Benjamin Franklin wrote: "A friend of mine, Lord Le Despencer, has lately erected at Wycombe, his fine Country Seat, a noble Statue of William Penn, our Founder, holding in his hand a scroll...I think such a Statue would well become a Niche in some part of the Statehouse next the Garden." At some time after 1788 the statue came into the possession of John Penn, grandson of the Founder, and stood for a time in his house at Stoke Poges before his presentation of it to the Pennsylvania Hospital. The minutes of the Hospital's managers record its arrival in Philadelphia in September, 1804. Its attribution to John Bacon the elder rests on a statement by the antiquarian John Fanning Watson; it is known that Bacon did a bust of Lord Le Despencer, the original owner.

The statue was designed to be placed on the top of a house, which explains the position of the figure with its head looking down. Doubtless, Alexander Milne Calder was influenced by this representation of Penn while planning his colossal figure for City Hall.

William Rush (1756–1833)
Comedy and **Tragedy.** 1808
Pennsylvania Academy of the Fine Arts
Pine: *Comedy*, height 90½″ (base 13½″);
Tragedy, height 90″ (base 11½″)

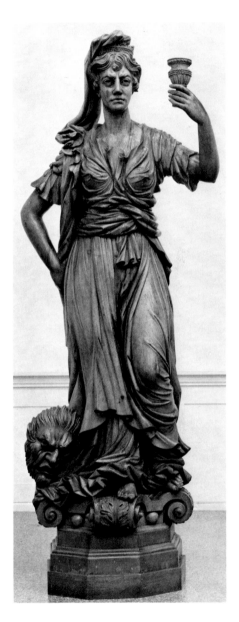

On April 2, 1808, a Philadelphia newspaper noted that "William Rush, Esq., of this city, has recently completed two elegant figures for the proprietors of the Philadelphia Theatre, to be placed in niches in front of that building on Chestnut Street. In the execution of this work the genius of the artist is truly portrayed; he has done himself honor and added to that of his country."

Some years later, the Chestnut Street Theatre was destroyed by fire, but the statues, Rush's first architectural carvings, were saved and were remounted on the second Chestnut Street Theatre designed by William Strickland. There they remained until the 1850s. Later they were acquired by Philadelphia's pre-eminent actor, Edwin Forrest. For a time they were exhibited at the Philadelphia Museum of Art, but since 1954 they have been at the Pennsylvania Academy of the Fine Arts, on loan from the Edwin Forrest Home for Aged Actors.

William Rush (1756–1833)
Eagle. *c.* 1810
Philadelphia Museum of Art
Painted pine, wing spread 29¾″;
height to top of wings, 24¾″

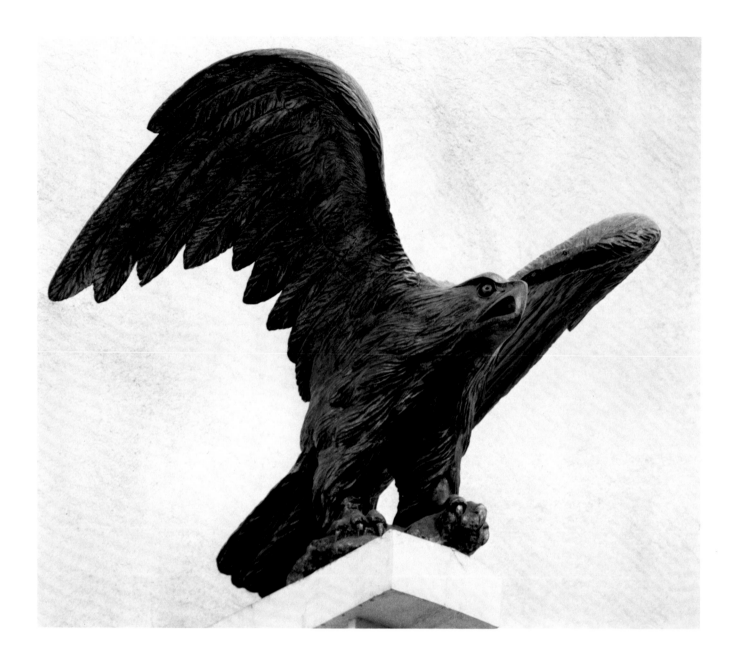

Rush was well known as a carver of eagles for ships, trade signs, and fire houses. They were popular symbols of the young nation, and their ferocity and attractive patternization of feathers appealed to master carvers.

This example is believed to have been carved about 1810 for the Hibernia Engine House, which was burned during the riots of 1844. The symbol of the Hibernia Engine Company was an eagle rising in flight from a shield bearing the stars and stripes.

Frederick Graff, who, as the son of the builder of the Fairmount Water Works, was familiar with Rush's work, acquired the carving and made possible its presentation in 1889 to the Pennsylvania Museum of Art. The work represents at its finest a long tradition of popular images which added spirit to Philadelphia's streets.

William Rush (1756–1833)
Virtue. c. 1811
Grand Lodge of Free and
Accepted Masons of Pennsylvania,
1 North Broad Street
Painted Pine, height 70½″ (base 25″)

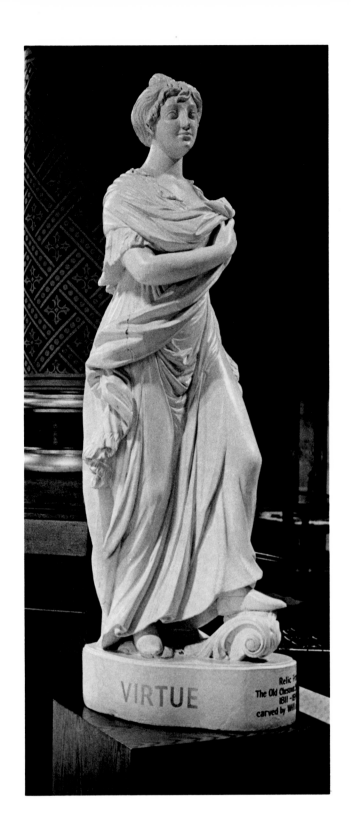

Because of the pose of the foot placed on an acanthus scroll and the billowing drapery, this life-size figure of a woman is thought to have been created initially to be a ship's figurehead. Since Rush first emerges as a carver of figureheads, it seems reasonable that this might be an early (before 1811) work redesigned for use by the Masons. The more contained style of the carving supports the possibility of its early date. *Virtue* is in mint condition.

William Rush (1756–1833)
Faith, Hope, Charity. *c.* 1811
Grand Lodge of Free and
Accepted Masons of Pennsylvania,
1 North Broad Street
Painted pine: *Faith,* height 26½″, length 58½″;
Hope, height 26½″, length 60½″;
Charity, height 36½″, length 69½″

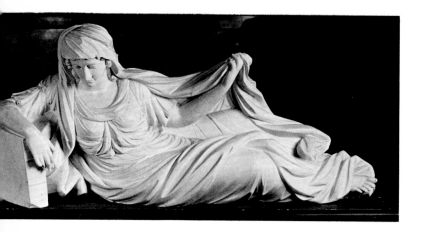

The three women can be identified by the attributes of Masonry: *Charity* with three cherubs; *Faith* reclining on her book; and *Hope* clinging to her symbolic anchor. Carved before 1811, these figures ornamented the first Masonic Hall, which stood on the north side of Chestnut Street, between Seventh and Eighth. Designed in the Gothic style by William Strickland, the building was dedicated in 1811 and suffered a disastrous fire in 1819. Just when the three reclining carvings were placed in its interior is not known. They are magnificent examples of the carver's skill.

William Rush (1756–1833)
George Washington. 1814
Independence National Historical Park
Painted pine, height 73″ (base 9″)

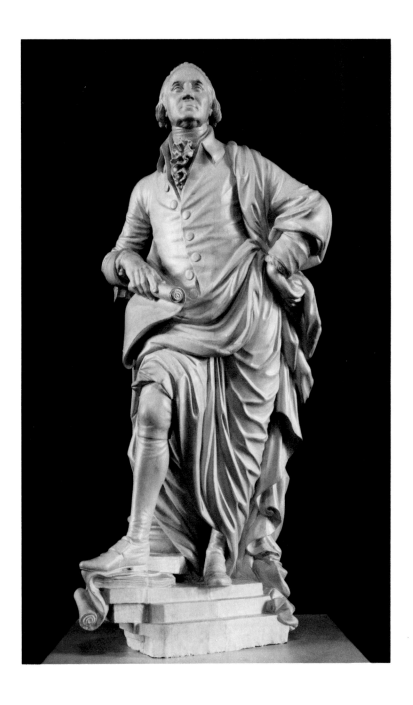

Rush carved this statue in 1814, taking about four months to complete it. Evidently, he hoped to sell casts of it to subscribers. "The figure," he wrote, "is executed in wood well seasoned, the interior is all hollow, so that air circulates through the inside, and leaves nothing to ferment and rot, nor yet to rent, for it is not more than three inches on an average in thickness, is perfectly seasoned and saturated with oil...."

The statue was exhibited at the Pennsylvania Academy of the Fine Arts in 1815, and in 1824 was placed in Independence Hall. In 1831, when the sculptor sold the piece to the City of Philadelphia for $500, he wrote: "I wish it in a perpetual place in the Hall that it may be said that a prophet may obtain some honor in his native place. I think that you need not have any doubts as to its being a good likeness. I have modelled General Washington in his lifetime frequently in miniature and as large as life. Judge Washington pronounced the figure here alluded to, immediately on sight, a better likeness than Stuart's."

William Rush (1756–1833)
Justice and *Wisdom. c.* 1824
Pennsylvania Academy of the Fine Arts
Painted pine, height 96″

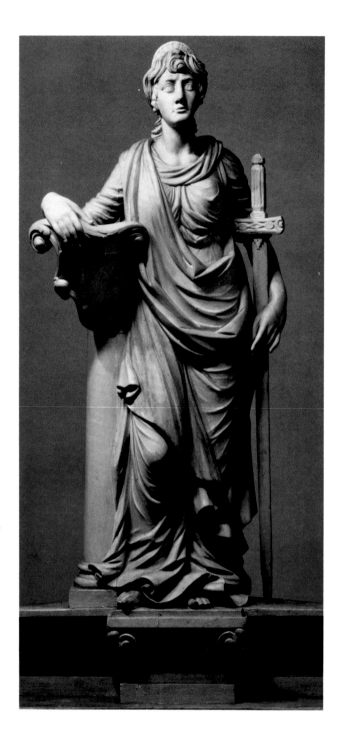 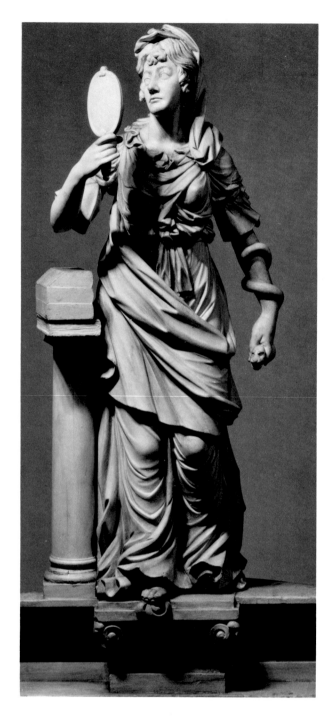

In 1824 Rush provided these figures for a great Roman arch which spanned Chestnut Street in front of Independence Hall. Designed by William Strickland, the arch was of wood covered with canvas painted to simulate marble. It was "forty-five feet front, twelve feet in depth and...24 feet above the pavement of the street." Rush's two large figures were placed on either side of the coat of arms of Philadelphia at the top of the arch.

The occasion for this extravaganza was La-fayette's triumphal return to America as the Nation's Guest. Met by a huge parade outside the city, the hero was escorted to Independence Hall with its magnificent arch crowned by Rush's work. Later, the two sculptures were placed in a room above the water wheel machinery at the Fairmount Water Works. They are now on loan from the Commissioners of Fairmount Park to the Pennsylvania Academy of the Fine Arts.

Appendix
Section I

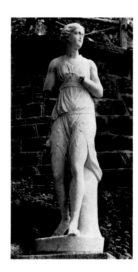

Unknown Artist
Diana.
Fairmount Dam, adjacent to the
old Water Works
Marble on granite base, height
70″ (base 31″)
Commissioned by the Water
Commission. Instated *c.* 1830–31.

Giuseppe Ceracchi (1751–1802)
David Rittenhouse. 1794
American Philosophical Society.
Gift of the sculptor in 1795.
Marble, height 19¾″

John Dixey (*c.* 1765–1820)
Alexander Hamilton.
c. 1789–1800
Pennsylvania Academy of the
Fine Arts
Marble, height 24″
Provenance unknown. Replica
after Giuseppe Ceracchi's
marble.

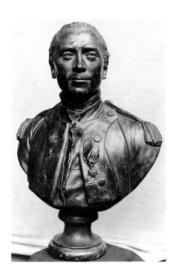

Jean Antoine Houdon
(1741–1828)
John Paul Jones. 1780
Pennsylvania Academy of the
Fine Arts
Plaster, height 27¾″
Provenance unknown. Bronze
cast made in 1905.

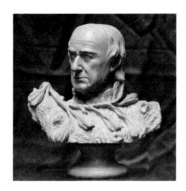

William Rush (1756–1833)
Self-Portrait (Pine Knot). *c.* 1822
Pennsylvania Academy of the
Fine Arts
Bronze, height 19½″
Provenance unknown. Bronze
cast made from the original terra
cotta in 1905.

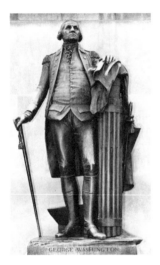

Jean Antoine Houdon
(1741–1828)
George Washington
(Revolutionary War Memorial)
Washington Square
Bronze on granite base, height
79½″
Given in memory of John
McIlhenny to the Philadelphia
Museum of Art in 1922 by his son
John D. McIlhenny. Moved from
the Museum to Washington
Square in March, 1954. Original
marble was done *c.* 1790 and is
located in the Virginia State
House, Richmond.

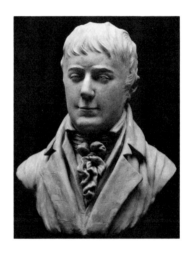

William Rush (1756–1833)
Silence. *c.* 1811
Grand Lodge of Free and
Accepted Masons of
Pennsylvania
Painted wood, height 65½″ (base
15″)
Commissioned as interior
ornament for old Masonic Hall
on Chestnut Street between
Seventh and Eighth streets,
which was erected in 1811 and
destroyed by fire in 1819.

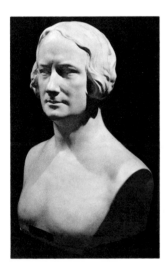

Attributed to Luigi Persico
(1791–1860)
Nicholas Biddle
American Philosophical Society
Plaster, height 21⅜″
Provenance unknown

William Rush (1756–1833)
Joseph Wright. *c.* 1811
Pennsylvania Academy of the
Fine Arts
Terra cotta, height 19½″
Provenance unknown

Section II 1833–1875

Lion Crushing a Serpent

by Glenn F. Benge

photographs by
Tana Hoban

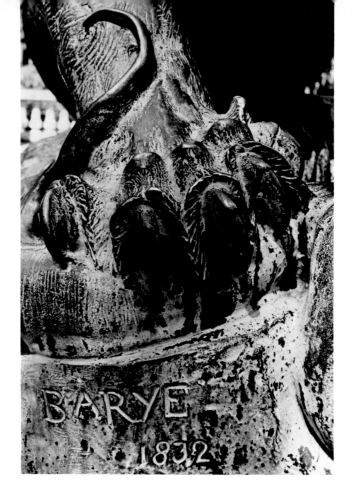

The Paris of Victor Hugo and Hector Berlioz was the setting for the great French sculpture Antoine-Louis Barye (1796–1875).[1] It was the Paris of the aftermath of the Romantic Revolution of 1830 and of the ascendancy of Louis Philippe. Barye's *Lion Crushing a Serpent* (1832; Louvre, Paris)[2] probably embodies the widespread hope of the late 1820s and the early 1830s "that a truly liberal monarchy would be responsive to the opinions of enlightened citizens."[3] It gives image to one of the forces that led to the Revolution of 1830 and to the establishment of the July Monarchy. At the political level, Barye's *Lion* probably would represent the Orleanist monarchy of Louis Philippe, crushing the traditional serpent of evil. Philadelphians take pride in an excellent cast of Barye's *Lion Crushing a Serpent*, placed in the center of Rittenhouse Square in 1892 by the Fairmount Park Art Association.

What is the relation of Barye's novel sculpture to certain major works of its era? François Rude's colossal relief, *The Departure of the Volunteers of 1792*, on a pier of Napoleon's mighty Arc de Triomphe de l'Étoile (1835–36) and Eugène Delacroix's *Liberty at the Barricades (July 28, 1830)* (1830; Louvre, Paris) are well-known works of the period that directly refer to the glory and sacrifice of the July Days, as do Barye's *Lion Crushing a Serpent* and his monumental relief, the *Striding Lion*, on the base of the commemorative July Column in the Place de la Bastille (1836–40).[4] Barye's bronze *Lion and Serpent* embodies an intriguing complexity of position, fully as rich as those of the contemporary works of Rude and Delacroix.

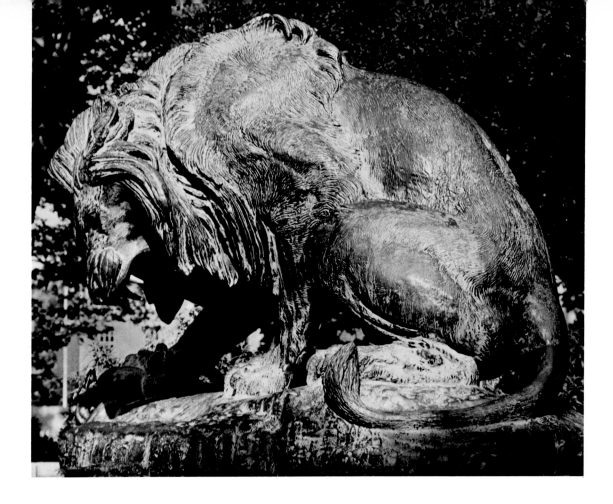

Barye's *Lion Crushing a Serpent* was definitely radical, in its romantic preferences for animal protagonists as symbols of human feeling, and in its use of richly modeled bronze rather than the smooth marble of neoclassical sculpture. It was also conservative, both in its academic correctness of anatomy and in its traditional, almost heraldic, use of a monarchical lion versus a serpent of evil. In its positive attitude toward the July Monarchy, Barye's bronze was pointedly the opposite of Honoré Daumier's satirical caricature of *Louis Philippe as Gargantua* (1832), for which Daumier was briefly imprisoned.

Barye's slightly earlier, major bronze, the *Tiger Devouring a Gavial Crocodile of the Ganges,* was a sensation of the Salon of 1831 (figure 1).[5] In this work, Barye apparently was not yet concerned with specifically political symbolism, but rather with fascinating zoological particularities. Science greatly abetted the romanticism of the exotic, for Barye actually consulted recent scholarly treatises on the anatomy and habits of the Gavial.[6] In Barye's day, Paris was a thriving world center of zoological study. The sculptor was able to examine closely the living specimens in the menagerie of the Jardin des Plantes and the wealth of plaster casts, preserved specimens, and dissection displays in the Museums of Comparative Anatomy and Natural History. Nature, studied in this scientific frame of reference, was one of the major sources of his art, a realm of forms of which Barye became a consummate master. Late in his career, in 1854, Barye was appointed professor of zoological

drawing in the Museum of Natural History.[7] There the sculptor Auguste Rodin would study animal anatomy with him in 1863.[8] Yet for all his prodigious scientific knowledge, Barye would indulge artistic license and would take liberties with the forms of nature when they might aid the expressive or dramatic interest of his art.[9]

The critic Etienne Delécluze, a classically trained student of the painter Jacques-Louis David, voiced the typical academic rejection of Barye's animal protagonists in his review of the Salon of 1831.[10] For Delécluze, Barye's *Tiger and Gavial* existed in a "less elevated mode" than the imagery of the human figure. His view was simply the traditional, hierarchical notion of the relative value of various subjects in art, according to which animals rank at the bottom of the scale, along with still-life painting, as, supposedly, the least challenging to an artist. Interestingly enough, the power and vigor of Barye's *Tiger and Gavial* also moved Delécluze to judge it the "strongest and most significant work of sculpture of the entire Salon"! The sheer excellence of the sculpture led Delécluze momentarily to set aside that traditional academic scale of values in order to pay the work a just and impressive tribute.

Barye left no body of writing on his art whatever—no letters, no diaries, no journals—and he was described by those who knew him as a man of few words, who was a very good listener. Thus it becomes necessary to deduce Barye's probable attitudes largely by means of parallels in the thought of his leading contemporaries. Seen from an early nineteenth-century, romantic point of view, Barye's

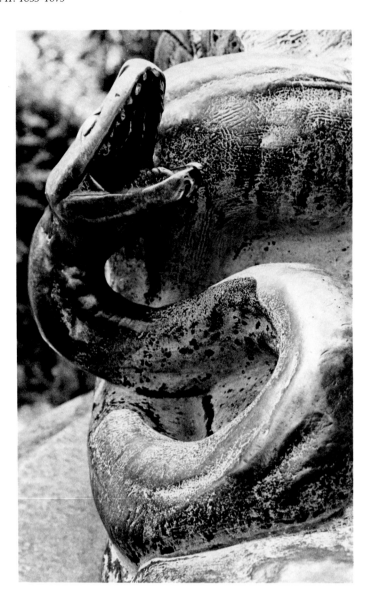

Tiger and Gavial explores a realm of intriguingly exotic imagery. On a visit to the Museum of Natural History one day in 1847, the painter Delacroix noted that the mere *sight* of exotic animals could release very powerful feelings and could engender a sense of emotional transport.[11]

One of Barye's most fundamental artistic concerns, however, is distinctly unlike the transcendental romanticism suggested by Delacroix. That is, his positivistic delight in an empirical study of nature itself. Auguste Comte (1798–1857) is generally regarded as the source of the fundamental notions of positivism.[12] His famous *Cours de philosophie positive* (1830–42) was published during one of the most vigorous periods of Barye's artistic development. Central to the positivist attitude is a regard for the close scrutiny of empirical data as the only valid basis for the derivation of larger truths or laws. Thus positivism, in part, seems to be an earthbound reaction against transcendental romanticism. In 1857 Théophile Silvestre evinced a positivist's enthusiasm, albeit one shaded with a romantic concern for the feelings, when he said, "Barye does not fail to accent the details of his animals with great verism: the most delicate of muscular insertions, the folds of the skin, the movements of the fur, the palpitations of the flanks or the trembling of a nostril. Without excess and without pettiness, he allows us to feel in turn the majesty, the strength, the elegance, the guile, the audacity, the cruelty, the intelligence, the gentleness, and the melancholy of the animals."

There is a *moral* level of interpretation that was also basic to a romantic view of such a sculpture as Barye's *Tiger and Gavial*, one beyond the purely zoological level of meaning and beyond the romanticisms of the exotic and the transcendental. Barye's *Tiger and Gavial* is a hideous image of the terrible animal violence possible in nature. It offers a parallel with Bernadin de Saint-Pierre's morally instructive notion that carnivorous beasts commit a *sin* against their own nature, as they devour their prey *alive*.[13] Victor Hugo's notion of the grotesque offers another parallel with Barye's *Tiger and Gavial*.[14] A grotesque image in Hugo's sense exploits the compelling fascination and the infinite variety inherent in ugliness and evil. It avoids the monotony of the good and the beautiful.

The mood of Barye's *Lion Crushing a Serpent* indicates that the artist did *not* express merely unbridled violence or the wildest extremes of fury.[15] Barye's bronze captures a tensely charged moment of challenge—an instant of nearly human analysis and reflection. It is a moment rendered dramatic by its very contrast with the irrational rush and frenzy of the struggle one imagines will follow. The energy and tension of the coiled serpent echoes in the folds and swirls of the lion's pelt. The rippling, rhythmical surface of the bronze is alive with excitement. Even the detail of the extended claws of the lion has a stark force.[16] A romantic intensity and a subtly engaging richness are vividly apparent in Barye's *Lion and Serpent*, a masterful work of the artist's finest period.

For the brilliance of his art, and through the patronage of the royal house of Orléans, Antoine-Louis Barye was made Knight of the Legion of Honor on May 1, 1833.[17] And Barye's major aristocratic commission of the 1830s, an elaborate table decoration ensemble of nine sculptural groups, was begun at this moment for the Duc d'Orléans, one of the five sons of Louis Philippe.

These and other gestures of support[18] suggest that the very concept of the *Lion Crushing a Serpent* was probably dictated to Barye by the *Orléaniste* circle, and that it was conceived from the outset as a flattery of the July Monarchy. The most concrete link of Barye's bronze with the Revolutionary Days of the 27th, 28th and 29th of July 1830, and thus with Louis Philippe's accession to the throne of France, is found in the imagery of the astrological Houses of the Zodiac, and in the related star maps used for celestial navigation.[19] The star charts traditionally show the adjacent constellations of Leo and Hydra in the forms of a lion and a serpent! Leo and Hydra were the constellations that ruled the heavens, in the astrological sense, during the Revolutionary Days of late July, 1830. In this frame of reference, Barye's *Lion Crushing a Serpent* was a symbol of the celestial impetus given the triumphant struggle of the July Revolution, and, hence, of the accession of Louis Philippe. The dynastic, *Orléaniste* reference was easily understood; for a French audience of this era it was implicit in the very idea of the July Days. Barye's artful handling of the image of two adjacent constellations, as they appear in the star charts, was its transformation into a romantically stirring combat of wild animals.

Barye's plaster original for the *Lion and Serpent* was purchased by the Minister of State from the Salon exhibition of 1833. By his order it was cast in bronze by the lost-wax process by the eminent founder, Honoré Gonon. The splendid bronze was shown in the Salon of 1836 and was then placed in the garden of the Tuileries Palace. The original bronze is now in the Salle de Barye of the Louvre. It is signed and dated, just below the right forepaw that pins the serpent: BARYE 1832. At the back,

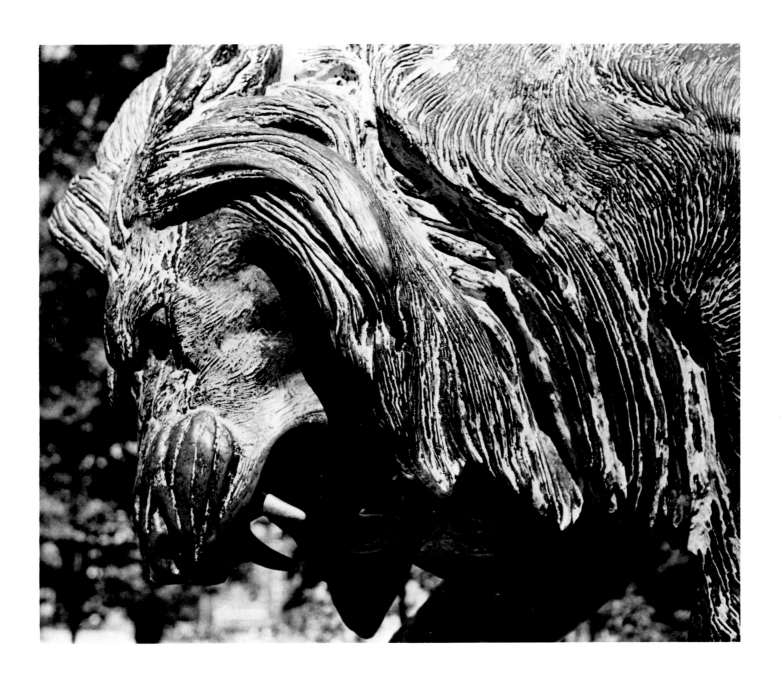

below the tail, it is inscribed: FONDU PAR HONORE GONON ET SES DEUX FILS 1835. The bronze in Philadelphia's Rittenhouse Square is signed and dated, just below the right forepaw: BARYE 1832 (inscr. h. 1¼"); it is inscribed along the front bottom edge of the cast, below the coil of the serpent: F. BARBEDIENNE, *Fondeur. Paris* (inscr. h. 7/16"); it is also inscribed, at the left of the founder's inscription: CH. G. (inscr. h. 7/16"), possibly the initials of the principal artisan for the casting of the bronze. The length of the *Lion and Serpent* is seventy inches.

The purchase by the state, the casting, and conspicuous placement of Barye's *Lion and Serpent* were fateful events in the career of the artist, for they apparently symbolized an official acceptance of animal sculpture as a major artistic mode. This form of approval flew in the face of the established academic notions of the proper hierarchy of subject matter in art and triggered violent criticism along those lines. Indeed, Barye's notoriety in the Parisian art world was established by the vicious criticism leveled at his *Lion and Serpent*.

The special bitterness of this criticism is worthy of notice. Gustave Planche sarcastically asked, "How is it possible that the Tuileries has been transformed into a zoo?" An anonymous writer said, "Imagine using the Gardens for a menagerie!—Only the cage is missing!" Victor Schoelcher noted a distinct "odor of the menagerie." A safely anonymous writer leveled the most vicious and mindless thrust of all and exclaimed that "Barye's type of sculpture had developed because it was so easy and so popular."

It is most reassuring to read the enthusiastic response to Barye's *Lion and Serpent* written by the poet Alfred de Musset in his "Salon de 1836" for the *Revue des Deux Mondes*. Of Barye's exotic sculpture, he observed: "The bronze lion of Barye is as terrifying as nature's own beast. What vigor and verism! The lion roars, the serpent hisses. What rage is in that snarling mask, in that sideward gaze, in the bristling fur of its back! What delicacy in that paw set upon the prey! And what a thirst for combat in that terrible monster, in that greedy and gaping jaw! Where could Barye pose such models? Is his studio a desert of Africa or a forest of Hindustan?"

With a positive effect of another kind, the critic Charles Lenormant objected to an "overworked impression" in the *Lion and Serpent* and said that while he admired the artist's laborious attention to "all the details of the hide and fur," he nonetheless found himself "continually distracted by minutiae." Similarly, Gustave Planche wrote of Barye's *Tiger and Gavial* of 1831, "I reproach Barye for smothering the liveliness of these animals beneath a multitude of minutely reproduced details." Barye evidently accepted these judgments of Lenormant and Planche, for, as his artistic development progressed, his larger designs took on an ever greater boldness and a more powerful simplification. Barye's large *Jaguar Devouring a Hare* (figure 2), shown in the Salon of 1850, is a culmination of this important trend in his art.[20] The boldly knotted muscular masses of this jaguar—so dramatically heightened in effect by the fine detail of the hare's pelt—led Théophile Gautier to assert in memorable phrases that "Barye does not treat animals from a solely zoological point of view. He exaggerates, he simplifies, he idealizes the animals and their style; he has a fiery manner, energetic and bold, in fact, like a Michelangelo of the menagerie."

Barye was a characteristically nineteenth-century artist in his desire to appeal to the newly established middle class for the principal patronage of his art of the small bronze. Barye's mentors, the French royal goldsmiths, normally created only single miniature sculptures, in precious metals, for individual aristocratic patrons.[21] Barye, however, chose to make multiple casts of his models in bronze. Thus he could sell his works in quantity and at prices the bourgeoisie might afford. One related contribution of Barye's sculpture was a freeing of miniature animal imagery from its traditional subsidiary roles as a decorative finial on a useful object, or as the attribute of a deity or a personification figure. Barye developed variations upon his famous *Lion Crushing a Serpent* in several different sizes,[22] suited to typical middle-class interiors: business offices, parlors or salons, and sleeping rooms—as he termed the chief alternatives in one of his own sales catalogs of bronzes (figure 3).[23]

Two related drawings by Barye show distinctly different aspects of his study of animals and offer a glimpse at his technical method.[24] One is quickly drawn after the living animal seen in motion, and the other records the appearance of a dissected specimen. In addition, the drawings confirm the vital connection of several of Barye's sculptures in both monumental and miniature scale, and they attest to the elaborate investigation which underlay his command of animal anatomy.

Numerous letters and original documents preserved in the archives of the Fairmount Park Art Association record the full sequence of events related to the fund campaign and to the inspection, purchase, shipping, exhibition, and final installation of Barye's *Lion Crushing a Serpent* in Rittenhouse Square.[25] They disclose how the Parisian art-bronze founder, F. Barbedienne, in 1885 interested Thomas Hockley, chairman of the Committee of Works of Art of the Association, in Barye's work. Five years later, Hockley decided to order "Barye's lion from Barbedienne," and circulated subscription books to raise funds. In 1891, Barbedienne was sent 10,200 francs. The *Lion and Serpent* arrived later in the year, and was installed by October 27, 1892. On March 2, 1893, the bronze was formally presented to the city at its site on Rittenhouse Square.

Original documents preserved in the Archives Nationales de France[26] record that casts were to be made of two of Barye's major sculptures in Parisian public settings for display in a retrospective exhibition at the Universal Exposition of 1889—the very World's Fair for which the famous Eiffel Tower was constructed. Barye's *Lion Crushing a Serpent* and his *Striding Lion* relief (1836–40), on the base of the July Column in the Place de la Bastille, were chosen to be reproduced.

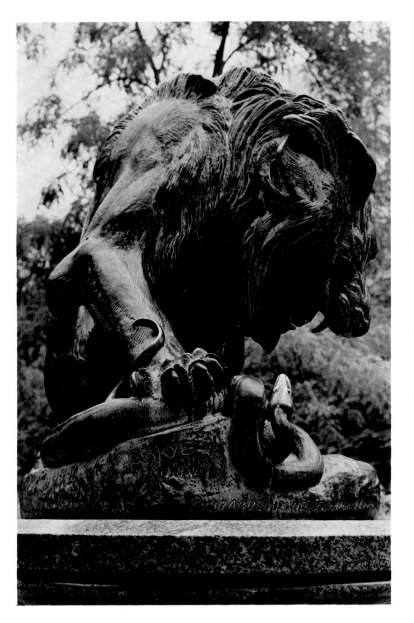
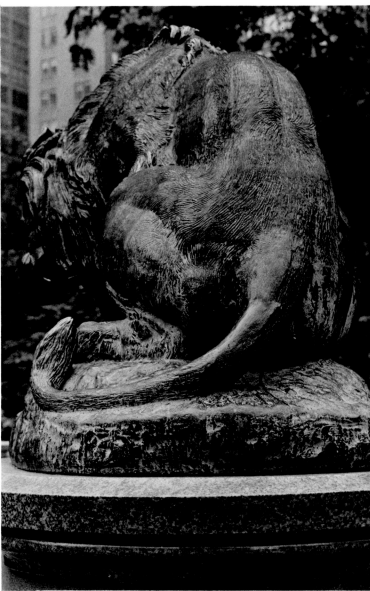

Philadelphia's bronze, documented as cast sometime in the period 1889–91, may be the very bronze shown in the Universal Exposition of 1889; or it may have been produced at this time in order to take advantage of the official French interest in reproducing the work, thus possibly to reduce the cost of the casting of the bronze; or, simply as a reflection of the rising American enthusiasm for the art of Barye.

That is, the date of this purchase of a Barye strongly suggests that the patrons of the Fairmount Park Art Association were active in the American Barye Monument Association of that period.[27] A group of eminent American collectors of Barye, led by William T. Walters of Baltimore, had set out to erect a commemorative monument to the artist in Paris, the city they felt had unjustly neglected him. Leading figures of the American cultural scene promoted the project, including Samuel P. Avery, William Corcoran, John Taylor Johnston, Frank Frick, and Cyrus J. Lawrence. The campaign was begun sometime in 1888 and culminated in 1894 with the unveiling of a monument designed by the architect

Stanislas Bernier (b. 1845).[28] In form, the monument to Barye is essentially a stone pedestal that creates a setting for several of Barye's larger bronzes: the *Lion Crushing a Serpent*—a striking inclusion in view of the reproduction effort of 1889—the *Theseus Slaying a Centaur* (1846)[29] and two of Barye's four personification groups for the Louvre (1854–57). The activity of the American Barye Monument Association of 1888–94 represents an impressive enthusiasm for the art of this great French sculptor, as does the Fairmount Park Art Association purchase for Philadelphia of his *Lion Crushing a Serpent*.

Antoine Louis Barye (1796–1875)
Lion Crushing a Serpent. 1832
Rittenhouse Square
Bronze, height 54″ (granite base 38″)

The Statue in the Garden

by George Thomas

photographs by
George Krause

A discussion of funereal monuments in a book which seeks to bring attention to the wealth of public statuary in the city of Philadelphia may seem somewhat macabre, even distasteful to some readers. There are, however, good reasons for the inclusion of this subject, for it can be shown that the garden cemetery was one of the forerunners of Fairmount Park, and that the monuments displayed in cemeteries of that type form part of the tradition continued to the present day in the collection of monuments honored in this volume, more than a few of which are themselves commemorative. Most of the pieces discussed here will be from Laurel Hill Cemetery at Ridge Avenue, overlooking the Schuylkill River, because Laurel Hill was the first and largest of the garden cemeteries of this city, and its collection of monuments is the most varied and generally of a higher level of quality than elsewhere.

Laurel Hill was laid out in 1836 in a then distant suburb, three miles from the limits of Philadelphia. (The city only reached its present size with the 1854 Act of Incorporation.) The owners selected John Notman (1810–1865) to plan the grounds and to design the various structures needed for the proper operation of the cemetery—a large, appropriately severe Roman Doric entrance gate, a cottage for the superintendent, a chapel in the Gothic style, and several minor structures such as the "gothicky" baldachino protecting the sculpted figural group of Old Mortality and Sir Walter Scott, executed by the Scottish sculptor James Thom (1802–1850), whose work earned him the accolade of "the Burns of sculpture" by his contemporaries (figure 1).

The chapel was pulled down some time ago, and the entrance gate has been considerably altered by the addition of a story, and by the removal of a great urn which had been placed over the arched portal (Plate 1). Windows have been opened where there was once a solid wall. However, the landscaped site remains much as Notman planned it—a curious fusion of the formal, geometric garden with vast areas which retain an informal, even natural, appearance so prized at that time by the proponents of the picturesque school of landscape architecture. Paths follow the twists and turns of the land's contours, and only a few of the less expensive plots are laid out on the grid system, which characterizes so much of the planning of the city for the living. This necropolis is one of the earliest American examples of the type of planning which would be followed in so many of the suburban communities of the later nineteenth century and, as well, in the natural landscaping of other garden cemeteries and, eventually, of Fairmount Park. It is a local model of great importance.

The cemetery was erected for a variety of reasons, not the least of which were practical—financial remuneration to the owners, and for popularly conceived reasons of health, it having become common knowledge of "the evils caused by the exhalations of these receptacles of the dead"[1] being placed in the midst of the city of the living. Reasons of sentiment played a role, too,

for more than a few cemeteries in the path of the city's growth had been deconsecrated and the bodies removed to other places. It was felt that the suburban site, far from the city, might avoid a repetition of that problem, and that some such permanent solution was needed. "The citizens felt the want of a *Rural Cemetery*, where family affection could be gratified in the assurance that the remains of father and child, husband and wife, could repose side by side, undisturbed by the changing interests of man; where the smitten heart might pour out its grief over the grave of the cherished one."[2]

In addition to these practical advantages, the garden cemetery was considered to be one of the important urban amenities, and the presence of Laurel Hill enabled Philadelphia to keep pace with other cities in this country and Europe, providing a parklike space for its citizens. As Alexander Jackson Downing commented: "It is remarkable that these cemeteries are the first really elegant public gardens or promenades formed in this country."[3] Because the cemetery was considered a public garden in addition to its utilitarian function, it became natural to embellish the place with sculptured figures which commemorated the dead and were decorative and artistic as well. The owners of Laurel Hill believed that "The salutary effects of ornate and well-preserved cemeteries, on the moral taste and general sentiments of all classes, is a most valuable result, and seems to have been appreciated in all ages, by all civilized nations."[4]

Thus the cemetery and its monuments should not be viewed with the morbidity expected in more recent times. Instead it can be seen as a place for meditation, education, and the cultivation of taste. It is a place charged with aesthetic dimensions, one which would acquire sufficient popularity in the middle of the last century to cause the owners to issue tickets of admission to control the size of the crowds. One of the major reasons for that popularity was the opportunity for the visitor to view works of art, for that was one of the intended levels of comprehension of the monuments (figure 2).

To encourage that attitude, the owners of Laurel Hill acquired the figures carved by James Thom, which depict the encounter of Sir Walter Scott and an aged peasant, known in Scott's story as "Old Mortality."[5] The latter had become well known for having undertaken the task of recutting the names of the long-since deceased on the tombstones of churchyard cemeteries and is shown engaged in that very task. By performing that pious act, Old Mortality, although himself aged and subject to the effects of time, combats some of its ravages and affirms the virtue of the commemoration of the dead, an idea peculiarly appropriate to this place. The placement of the group at the entrance serves not only to keynote the concept of the cemetery as a memorial garden, but also as a repository for specimens of the sculptural and architectural arts, and, by extension, prepares the viewer to perceive the monuments as more than simple grave markers. Instead, they are intended as quasi-public works

in a place set aside for that purpose. As such they must be considered part of the mainstream of monumental productions of the nineteenth century.

If the Thom group is indicative of the didactic, memorial, and aesthetic levels of meaning intended in the funereal monuments of the nineteenth century as represented by those in Laurel Hill, the variety of styles, materials, forms, and types of monuments should serve to recall the rapidly increasing complexity and vitality of the last century. The industrial age had been entered; the old social unity had broken down and was made visible in an increased range of life and death styles. The types of markers alone should illustrate that change, with simple headstones, sculptural groups, and architectural compositions separated into "neighborhoods" depending on the cost of the lot. That variety was augmented by a stylistic vocabulary which spanned the entire history of architecture and enabled the designer of the monuments to bring new and appropriate contents to his designs, although changes in the scale of the edifices reduce them from that of a building to little more than a piece of decorative carving, not unlike the architectural conceits of the eighteenth-century English landscaped gardens.

Egyptian obelisks, mausoleums, and tombstones abound, characterized by such motifs as lotus columns, battered bases, and the Horus figure, all carved with varying degrees of archaeological accuracy. Some, such as the Ball mausoleum, on a terrace overlooking the river,

were large enough to be regarded as legitimate architectural commissions and important enough to interest such architects as Thomas Ustick Walter, who designed Girard College and later the United States Capitol.[6] Gothic tombs were popular as well. John Notman designed several handsome markers in marble, including the small Gothic enclosure which shelters a sleeping lamb for Sarah Harrison's tomb. The delicate detailing and various motifs, such as the interlocking arches, are characteristic of Notman's more important ecclesiastical commissions, which include St. Mark's Protestant Episcopal Church on Locust Street and Holy Trinity at Rittenhouse Square. Also, in South Laurel Hill was the long-since-demolished Samuel Townsend monument, which was executed and probably designed by the firm of Robert Wood in the then new architectural material of cast iron (figure 3). That firm was noted for its metalwork, the most visible example being the splendid lamps in front of the Pennsylvania Academy of the Fine Arts: its work at Laurel Hill reinforces the connection between these monuments and the contemporary architectural profession. After the Civil War, Renaissance, Roman, and Greek monuments became increasingly common, reflecting changes in taste and architectural fashion.

The profusion of styles in architectural markers has another meaning, other than personal taste and nineteenth-century exoticism, for a symbolic language using the various styles of architecture can be readily

discerned. The Middle Eastern Moorish and Egyptian styles were thought appropriate for Jewish patrons, although the Egyptian styles, because of their popular association with death, were used by all groups. After the English architect Augustus Charles Pugin demonstrated that Christian nations ought to utilize the vocabulary of the Gothic or "pointed" styles because they were developed to serve the Christian Church, unlike the classical styles which were designed for and by pagans, it became increasingly common to see Gothic spires dotting the landscaped grounds. The William Fotterall plot, with a large, central, crocketed spire, is one example of the Gothic type, while the numerous smaller head- and footstones grouped around the larger stone visually describe the popular conception of the nineteenth-century family structure.

The logical use of revived styles to express specific contents became less common in the last quarter of the nineteenth century, as contemporary fashion began to dictate design choices. Richardsonian Romanesque was briefly fashionable, and later, after the Columbian Exposition, classicizing styles predominated. The decision in the late 1870s to complete the Washington Monument in the originally conceived form of a giant obelisk was largely responsible for the sudden appearance of seemingly endless groves of obelisks, with each year's "crop" outdoing that of the year before. In some cases, such as the Dallas Monument in nearby Mount Peace

Cemetery, all of the popular styles were fused into one memorial. In that particular example a rough stone base supports a marble pedestal decorated with a Gothic tabernacle and cusping, over which towers an obelisklike shaft, which was in turn capped with a draped Greek urn. It can safely be said that the language of style had become less meaningful.

To the variety and content of architectural monuments the sculpted pieces brought the possibility of other levels of meaning, with the addition of subjects and themes which might be biographical, allegorical, biblical, or simply decorative. In some instances architectural motifs were used in combination with figural groups. This can be seen, for example, in the shafts capped with angels instead of urns used for the William Clothier and Thomas Kirkpatrick monuments, the latter from the marble yards of Thomas Delehunty and Sons, conveniently located across the street from the entrance to the cemetery. In other monuments, architectural elements, removed from their usual context, were treated as sculptural and symbolic forms, complete in themselves and without any specific reference to a stylistic era for their meaning. Such a case is the common sign of the broken column, signifying a life cut short, which reaches a high point in the triple-shafted monument for the Knight family. Similarly, specific connotations were given to figures as well; the lamb, in addition to its Christological overtones, had a meaning not unlike the broken shaft and was

Old Mortality

Ball Masoleum

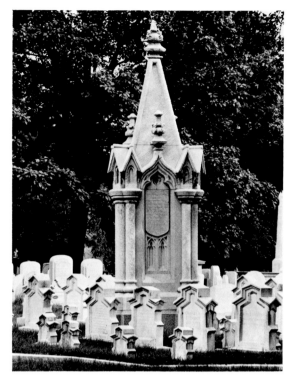

Fotterall Plot

usually reserved for small children and young women, as seen, for example, in the previously cited tomb of Sarah Harrison.

Other figures acquired definable meanings as well, and are usually readily identifiable as types, for they are frequently familiar as figures which were placed in secondary positions on enormous public monuments, and were thus sufficiently well known to require no explanation. The weeping woman thus refers to the concept of grief and perhaps familial piety, instead of to a particular surviving member of the family. Where there were pretensions to public grief, the figure might be a chastely draped nude. One of the more impressive examples of this type is the General Francis E. Patterson monument, designed and sculpted by the important Philadelphia sculptor, Joseph A. Bailly (1825–1883). A handsome, and for the artist, full, even sensuous figure of a nude woman is seated, holding an urn with her right arm, presumably containing the ashes of the hero. Samuel Sloan's *Architectural Review and American Builder's Journal* for 1868 shows an engraving of the statue and gives a description of the supposed emotional state of the figure with a precision characteristic of nineteenth-century writing. There "is seated a female figure, emblematic of GRIEF.... The whole attitude is replete with the dignified expression of profound, but not hopeless melancholy."[7]

Military figures as a group usually received a similarly indirect treatment. The Isaac Hull monument, designed by the architect William Strickland (1788–1854) and executed by the firm of John Struthers, takes as its point of departure a classical couch of a type associated with the tomb of Scipio and is surmounted by an American eagle clasping the colors in one talon. The parallels

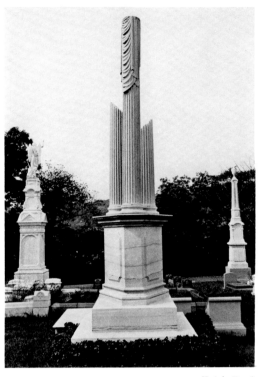

Knight Tomb

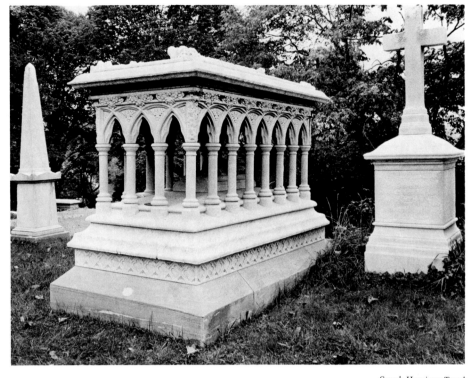

Sarah Harrison Tomb

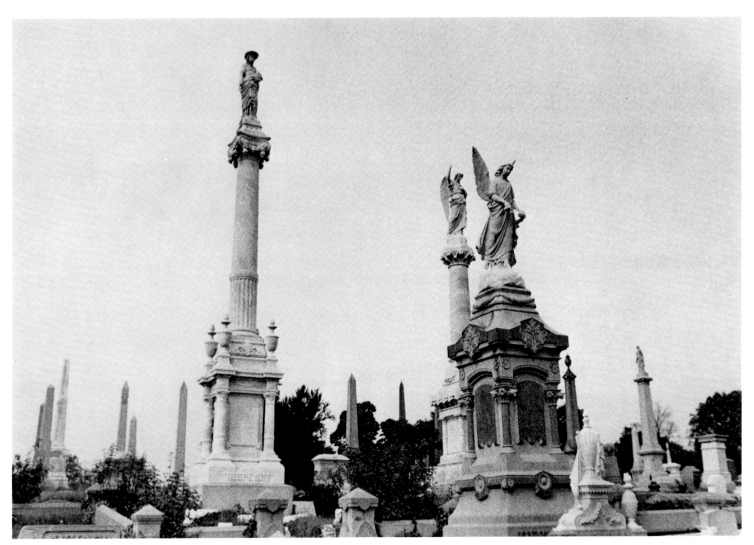

Clothier, Kirkpatrick and Winpenny Tombs

between the ancient, victorious Roman republican general and the modern, victorious, American republican sea captain are too obvious to need detailing. That approach to subject was one which Strickland had used in the Bank of the United States and the Merchants' Exchange, in which the architectural forms of Greece and republican Rome were revived to allude to the democratic ideals hopefully being established here. It is thus one of the better examples of American democratic neoclassicism, and is far richer than other memorial works which followed the same pattern as, for example, Horatio Greenough's by now infamous figure of George Washington.

A similarly elliptical treatment of a tomb is that of the marker for Major Levi Twiggs and his son Lieutenant John Twiggs, designed by Richard Graff, son of Frederick Graff, the designer of the Fairmount Water Works. It was exhibited in 1847 and then placed in Laurel Hill in commemoration of the two men, who had both died in the Mexican War. The imagery is of considerable interest, for a single large stone is carved to look as if many stones had been piled up, apparently in imitation of the ancient cairn or rock altar to mark a holy place. A marble anchor embedded in the rock pile forms a common enough symbol of fidelity; Roman fasces marking the perimeter are the one overtly military sign (figure 4).

In a similar vein, although more overtly martial, is the General Robert Patterson monument, near the Frances Patterson tomb. A great lion rests on a granite plinth with one paw draped rather casually over the tools of the general's profession, a sword and a cannon, and the flag which the general defended. Unlike the rather sophisticated monument for Francis Patterson, this sculptor's conception evidently exceeded his abilities, for the lion, although vaguely leonine, is gaunt to the point of emaciation, with a facial expression which belies any ferocity; indeed, it resembles nothing so much as the Cowardly Lion of the *Wizard of Oz*. Its sculptor, J. Lacmer, does not seem to have carved out a career of any real distinction with this work, one of only three known to be by him.

Biographical monuments achieved a considerable success in the second half of the nineteenth century. In some cases, such as the Robert Stewart marker, metaphorical touches were added to relatively common marker types, in this instance the already noted cairn, to give a specifically biographical touch. Long tendrils of ivy and a broken urn were carved from the single stone block, with the smashed urn apparently referring to the violent end to Stewart's life. He was murdered by his servant, but at such an age that the broken column would not have been appropriate.

Generally, the biographical monuments are more direct, with one of the common types being the portrait statue. Some are little more than a standardized bust, placed in an architectural frame, while the best are full-scale portraits of the deceased. Two of the most impressive examples of the type are bronze portraits by

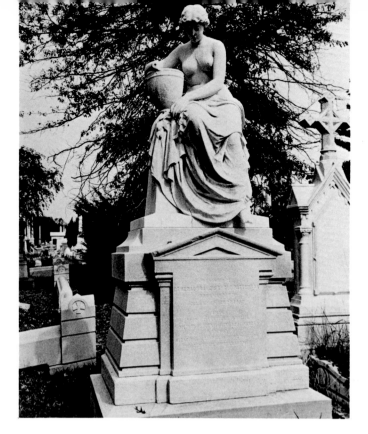

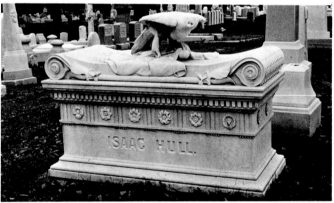

Isaac Hull Tomb

Twiggs Tomb

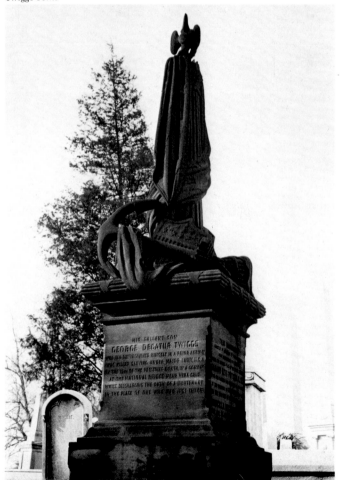

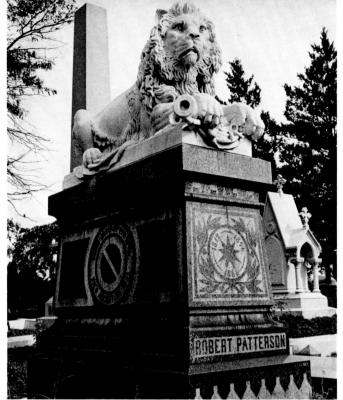

Robert Patterson Tomb

W.F. Hughes Tomb *Robert Stewart Tomb*

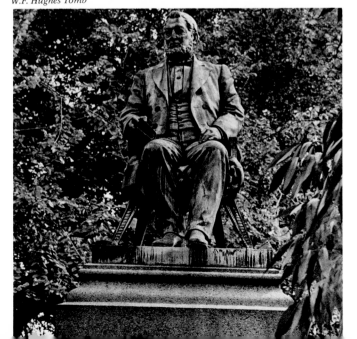

Joseph A. Bailly, whose work reiterates the already noted connection between funereal and public monuments. Bailly achieved a modicum of notoriety for his marble figure of Aurora, exhibited at the Centennial Exposition and recognized by all as a sculptural tour de force,[8] while his figure of George Washington (located in front of Independence Hall) was at the time well received.[9] It is now criticized, somewhat rightly, for being dry, even dull, in its rather dispassionate and thus antimonumental presentation of Washington's physiognomical peculiarities. Those same qualities, however, may be seen as virtues in the homey portraits of W. F. Hughes, and more especially in the exceptionally fine seated figure of William Emlen Cresson, patron of the arts and founder of the Pennsylvania Academy of the Fine Arts' fellowship fund which bears his name. If the *Washington* appears unimaginative because of the literal quality of the piece, the *Cresson,* by contrast, appears to anticipate a later cool objectivity in this casual, almost diffident, and curiously passive figure, which gazes out across the Schuylkill River Valley. It is extraordinarily advanced for 1869, the year in which it was executed.

Quality aside, there are no biographical monuments in Laurel Hill, or in any other local cemetery which in any way rival the spectacular monument to William Mullen, guardian of the poor and known as "the prisoner's friend." This work in South Laurel Hill was apparently carved by a local artist, who signed the piece "E. Kornbau," evidently from designs by Mullen, who exhibited parts of the monument in a tableau of his life at the Centennial Exposition, in an effort, according to contemporary sources, to "rescue his name from possible oblivion." The group shows Mullen standing to the right of the gate-tower of a building, recognizable as T. U. Walter's recently demolished Moyamensing prison. Over the gate stands an angel with a long horn, therefore presumably the Angel Gabriel, gesturing toward Mullen, while in the foreground a newly freed woman prisoner sits, shielding her eyes from the unaccustomed light of day. The meaning is, however, more complex than the simple recording of a typical good deed in the life of Mr. Mullen. Over the door of the prison is placed a relief of the head of Christ, and the door of the prison is ajar, an image not unlike that of the tomb from which Christ was resurrected. The prisoner may be seen as an image of the newly delivered soul of Mullen, freed from the body which had been its earthly prison. The monument is then a witness both to the character of the man and to his anticipated rebirth.

The custom of erecting public funereal monuments in a garden setting, of which these are but a select few, can be readily understood in the context of the local tradition of public statuary of the highest quality. It largely ended with the passing of the nineteenth century. The new taste of the post-Chicago-Fair era gradually developed a preference for an antimonumental type of marker which might be mistaken for a bit of garden architecture—a pergola, or an exedra, or it might even be so simple a form

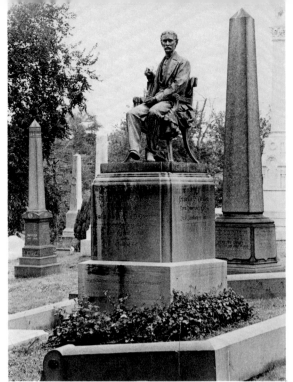

William Cresson Tomb

Lea Tomb

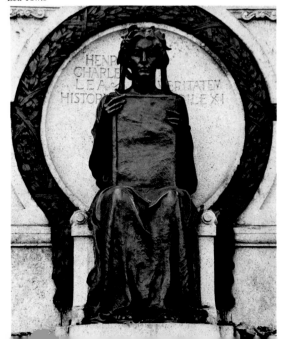

Mullen Tomb

as a boulder with a bronze plaque affixed to it. The cemetery managers of that era encouraged a flat stone marker embedded in the ground with its face even with the ground's surface, a type which would not interfere with the view or with the newly mechanized grounds-keeping functions.

A few pieces, however, did continue Philadelphia's great tradition into this century, none with more distinction than the monument to Henry Charles Lea. A classicizing architectural frame by the firm of Zantzinger and Borie (later, with Horace Trumbauer, architects of the Philadelphia Museum of Art) formed an appropriately severe setting for the handsome bronze seated figure of Cleo, the muse of history, which was sculpted by Alexander Stirling Calder in 1911. This piece might even be considered as a summa of Philadelphia's funereal monuments, combining a significant architectural composition with an important piece of sculpture commissioned for this purpose. Like the best local monuments, it is personalized, biographical, and readily understandable. Ultimately, because of its setting and quality, it is, like those already mentioned, considerably more than a simple marker. Like the other monuments, it is the private gift of a modern Maecenas to a hopefully appreciative public.

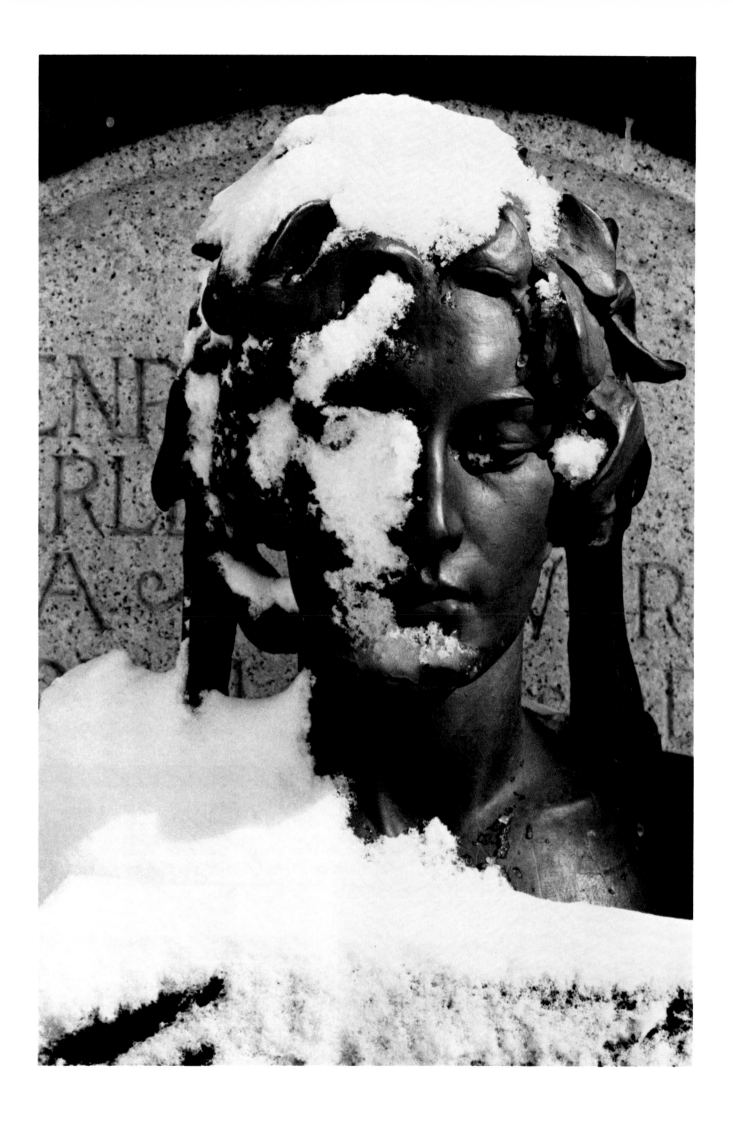

Abraham Lincoln

by Wayne Craven

photographs by
Bernie Cleff

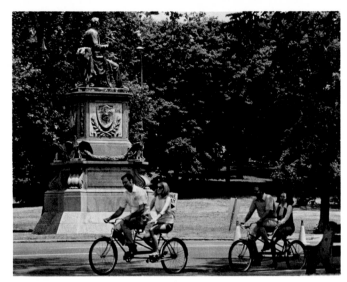

Following Abraham Lincoln's assassination on April 14, 1865, the nation experienced a deep mourning such as it had never before known. Several cities soon organized committees to erect memorials to their beloved leader, and Philadelphia was among the first to do so. On May 22 of that year a group of men under the chairmanship of Mayor Alexander Henry met to form the Lincoln Monument Association, and commenced raising money for the projected memorial. By late 1866, when its fund totaled $22,000,[1] a Committee on Design was appointed with Charles Janeway Stillé as chairman.[2] Stillé had previously been chairman of the Sanitary Fair held in Philadelphia's Logan Square in 1864, the purpose of which was to raise money for the benefit of soldiers wounded in the Civil War. He was an ardent admirer of Lincoln and in 1862 wrote a widely acclaimed pamphlet titled *How a Free People Conduct a Long War*, which brought him the following message from President Lincoln himself: "The pamphlet is by far the best production upon the subject it treats which I have ever seen; the reading and rereading of it have offered me great pleasure, and, I believe, some profit."[3]

Stillé played an important role in the progress of the Lincoln Monument Association's activities, for he was the chief correspondent with the several artists who were invited to contribute designs and models. In mid-December he wrote to Hiram Powers (1805–1873) and Thomas Ball (1819–1911) in Florence, to William H. Rinehart (1825–1874) and Randolph Rogers (1825–1892) in Rome, and to John Rogers (1829–1904) in New York, asking them if they would care to enter the competition for Philadelphia's memorial to Lincoln. Three of these

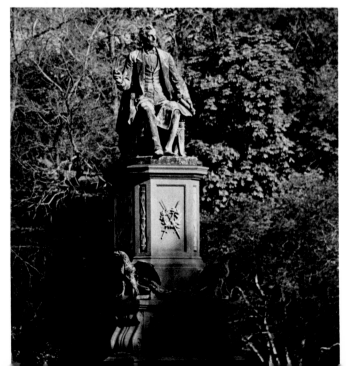

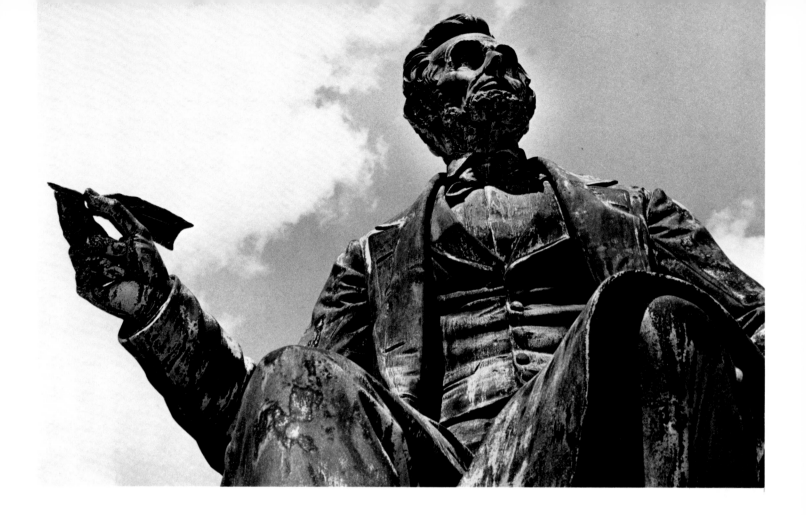

sculptors declined. John Rogers, creator of the famous and popular "Rogers groups,"[4] replied, "As I devote myself entirely to my groups, I could not undertake any work connected with the Lincoln Monument—and I hardly think the design I might make would be considered sufficiently statuesque to suit the common ideas of what such things ought to be."[5] He therefore declined Stillé's invitation, although he later did attempt the heroic scale in the bronze equestrian statue of *General John Reynolds* (1884), which was placed outside Philadelphia's City Hall, and in his *Lincoln* (1892) for Manchester, New Hampshire.

William Rinehart[6] and Hiram Powers also declined, Powers declaring that "a rule adopted by me many years ago and from which I never intend to swerve—prevents me from complying with your kind suggestion—That rule is, never to enter my name as a competitor for any commission."[7] Powers, long famous for his celebrated *Greek Slave* of 1843, continued, "It requires considerable time and labor to prepare designs for important works. Young artists can better afford to bestow this time and labor than I can—without the certainty of an order." Powers then went on to recommend his "young friend" and neighbor in Florence, Thomas Ball, who "has already produced a fine group of Lincoln liberating the slave. I have got a photograph of it . . . and you will find it enclosed. I told Mr. Ball that I thought he might venture to send it himself, but he declined, stating that he had not been invited." In truth, Ball was one of the sculptors that Stillé had written to regarding the competition, but due to an error in the address the letter reached him sometime later than the other sculptors.

When Ball finally received the invitation he replied immediately. "My model representing Mr. Lincoln emancipating the slave, of which you have seen a photograph,[8] I carefully studied and modeled just after Mr. Lincoln's death, when he was first in the minds of us all, partly as a duty I felt I owed to the memory of so great and good a man and partly from the conviction that it would be required for some city in our union. . . . In making this model, I endeavored, not only to represent the form and features of Mr. Lincoln, but as an ardent admirer of his character, to embody it as far as possible in the expression of his face"[9] (figure 1). Ball's entry showed Lincoln standing with one hand resting on a column, which held the scroll of the Emancipation Proclamation, with the other hand he gestured for the kneeling Negro at his feet to rise.

In the meantime, Randolph Rogers had written expressing his gratitude to the committee for its invitation, and stating that, "I am now engaged upon the work and hope to be able in the course of four or five weeks to send you my designs."[10] The committee had allowed the artists considerable latitude, but evidently one requirement was that the figure of Lincoln be standing; there was also some discussion about a secondary figure representing a freed slave. This was, of course, the form Thomas Ball's design had already taken, and, interestingly enough, John Rogers, although declining to submit a design, had written to Stillé as follows in his letter of December 18, 1866: "The design that strikes me without having had time to think of it much, would be to represent him as just risen from writing, and as receiving with one hand a petition from a crouching negro, whom he is

raising with the other."[11] In fact, this is generally the same motif employed in Randolph Rogers' original design, which survives in the Michigan Historical Collections at the University of Michigan (figure 2). It is to this or a similar model that an entry of late March or early April, 1867, in Rogers' unpublished journal refers: "Lincoln Monument Association of Phila. Group with Mr. Lincoln and Negress, etc."[12]

But for both Thomas Ball and Randolph Rogers, their models underwent almost continual modification during the early months of 1867, Ball making minor alterations on his one design, Rogers experimenting with as many as four different types, all, however, represented Lincoln standing. On March 21, Rogers wrote Stillé from Rome that he had completed two designs but could not resist making a third, and added he would send a photograph of it within a few days.[13] Meanwhile, in Florence, Ball was surprised to learn that the committee had not already awarded the commission to Rogers and that the latter had asked permission to submit a new design: "Mr. [Nathaniel B.] Brown said if I also felt inclined to modify my own design or estimate, he thought it was not too late for the Committee to consider it."[14] Accordingly, he did modify it slightly and sent photographs to Stillé. Rogers wrote to Stillé again on March 25, giving a brief description of his three models and the estimated costs of each.[15]

From this letter and the model preserved at the University of Michigan we may obtain an idea of what Rogers' original conception of the design was. There apparently followed, however, several months of indecisiveness on the part of both Ball and Rogers with regard to the design. As late as November 30, 1867, Rogers wrote to Stillé to inform him that his "fourth design for the Lincoln Monument is now finished, and I am keeping the model in clay until the arrival of Mr. [Nathaniel B.] Brown.... I have treated the subject in an entirely new way, and believe it to be by far better than any of my former designs and without the objectionable points to which you alluded in my former designs."[16] And still later, on January 3, 1868, he wrote to Stillé that he was modifying his design for the base.[17]

This fourth design represented a radical departure from his first three, for it had Lincoln seated, a solitary figure, without any accompanying figures. The sculptor informed Stillé: "You will see that I have represented Mr. Lincoln in a sitting posture, holding in one hand the Emancipation Proclamation, and a pen in the other, his eyes are turned toward heaven, asking the Almighty his approval for the act. That was the great event of his life."[18] This was ultimately the design that was selected at a meeting of the committee held sometime in February of 1868, the choice lying between the designs submitted by

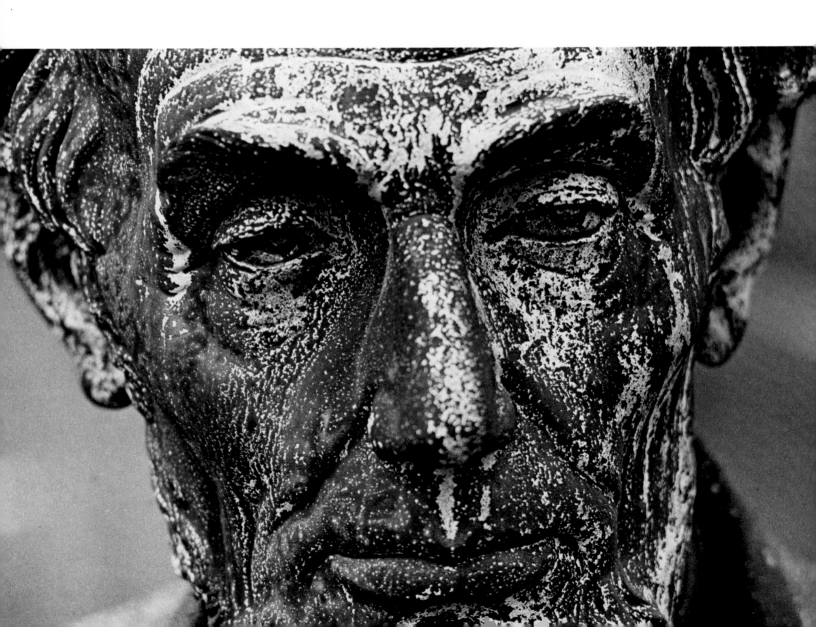

Randolph Rogers and Thomas Ball.[19] An engraving of Rogers' design, showing Lincoln seated, holding a scroll in his left hand, appeared in a Philadelphia newspaper on February 29, 1868,[20] in which it was explained that "After several attempts to procure a satisfactory standing figure, it was found impossible to combine anything like artistic grace with a truthful representation of the gaunt form and homely garb of Mr. Lincoln."

Stillé sent Rogers a detailed statement confirming the commission on March 2, 1868.[21] It specified that the statue be nine feet in height, that it be cast in good quality bronze at the Royal Foundry in Munich, and that the price for the *Lincoln* would be $13,000, while the cost of the four eagles, the plaque of the coat of arms of the city of Philadelphia, and the garlands (all in bronze) would be $6,300, making a total of $19,300. Rogers was to receive half of this amount when all parts were modeled, cast in plaster, and ready to be sent to Munich, and the other half when the finished pieces arrived in New York. Rogers replied from Rome on May 15: "Your letter dated March 2nd announcing that my design for the Lincoln Monument had been chosen came duly to hand. I am now about finishing the colossal statue for the Soldiers' Monument for the State of Rhode Island.[22] When completed I shall put up in its place the statue of Lincoln, and by October next shall have the model ready

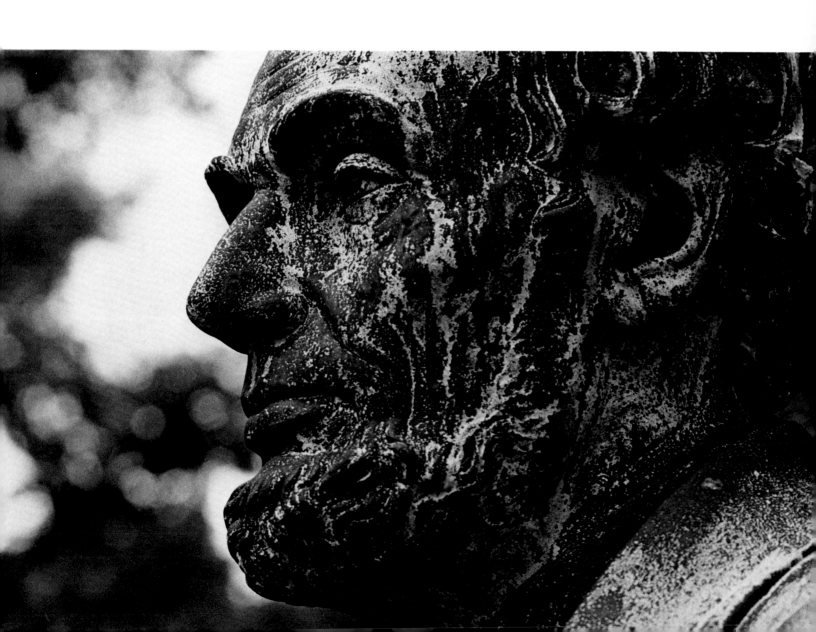

for the bronze founder."[23]

Rogers had never modeled a portrait of Lincoln from life, but photographs of Lincoln existed in abundance and nineteenth-century sculptors and painters had long since learned to make use of the daguerreotype and the photographic image when making portraits. In sculpture, probably the earliest source available to Rogers was the life mask made in 1860 in Springfield, Illinois, by Leonard Volk (1828–1895). This shows a beardless Lincoln at the time he received word that he was his party's nominee for the presidency. Volk made several copies of not only the life mask but also the hands, which were offered for sale in plaster or bronze, and he also developed the mask into a portrait bust.[24] The Fairmount Park Art Association at one time owned bronze replicas of both the mask and the hands,[25] but it is known from an inscription[26] on the life mask that this copy was made only in 1886 and therefore this specific copy could not have been placed at Rogers' disposal for use in connection with the Lincoln statue. However, the sculptor might easily have obtained them from another source.

Although Volk's life mask and his portrait bust probably served as the model for more portraits of Lincoln than any other likeness of the man, there were other images upon which Rogers could draw. Thomas Dow Jones (1811–1891) made a portrait bust of Lincoln (not from life) in 1861 and produced many copies for sale;[27] William E. Marshall (1837–1906) painted the portrait of the Emancipator in 1864; and Francis B. Carpenter (1830–1900) painted his portrait in the White House in the same year.[28] An engraving was made of Marshall's portrait and would therefore have been accessible to Rogers. In 1866 Rogers himself modeled a bust of Lincoln, which was produced in marble and soon afterwards given to the Pennsylvania Academy of the Fine Arts by Richard D. Wood (figure 3). This bust possesses similarities with the portraits by Jones, Marshall, and Carpenter, and he very likely drew upon several such sources; in his finished portrait for the statue, however, he surpassed all of these in character study. The detail of the face illustrated here reveals the character of the man and the gravity of his mood at the moment being represented, probably to better advantage than the viewer may be able to obtain from the original monument, since the head is approximately thirty-two feet above the level of the ground.

Rogers also labored carefully on details of the figure, the fabric of the garments, and the chair, as may be seen in other details illustrated here. In style, Rogers was following the tradition of naturalism that prevailed in almost every portrait statue of the mid-nineteenth century. In naturalism Americans found a truthfulness they could admire and it then formed the basis of the aesthetics of portraiture.

As early as April 28, 1868, Joseph William Miller, a Philadelphian traveling abroad, wrote to Mayor Morton McMichael from Munich regarding the statue's progress: "I visited Rogers' studio in Rome & saw the model of his Lincoln monument. It is very good & he had done as

much with the figure probably as the case admits of. It will be an ornament to our city when finished."[29] There then followed a lengthy discussion about the taste and appropriateness of the inscriptions and the coat of arms; accordingly, certain modifications were later made.[30] The letter points out an interesting fact about American expatriate artists who lived abroad for long periods, away from immediate contact with current life in their native land, even when so important a figure as Lincoln was involved; Miller wrote, "Rogers has lived...so long away from home that he is not quite well enough informed as he himself says as to contemporary history as to be able to make the most judicious selections [for the appropriate inscriptions]."[31] A notice, titled "American Artists in Rome," dated December, 1868, in a popular periodical, stated that, "Randolph Rogers, our distinguished American sculptor, has his studio so crowded with the various national monuments he is completing that he has been forced to take another studio for the statue of Abraham Lincoln, which statue is to be sent to Philadelphia when finished. This new studio, by the way, is the actual one formerly used by Canova."[32]

With the project progressing well, the committee entered into negotiations with the firm of Struthers and Son, Marble and Sand Stone Work, of 1022 Market Street, for the purpose of erecting a granite pedestal according to Rogers' design.[33] Meanwhile, Rogers wrote, "I am happy to inform you that the colossal Statue of Lincoln is completed in clay, and is now being transfered to plaster....I will say that the statue has made a sensation, and there seems to be but one opinion in regard to it. My own opinion is that I have come as near realizing my original conception as I have any right to expect."[34] A few days earlier, George W. Childs of Philadelphia had seen the statue and informed Stillé: "I am glad to report to you that Mr. Rogers has made a most successful statue of Mr. Lincoln.... The likeness is admirable, and the position striking and effective. It will do all concerned great credit, and will be an ornament to Philadelphia."[35] But as the months passed without further apparent progress on the statue, Stillé wrote to the sculptor to ask for a report on the state of the project, to which Rogers replied, with some irritation: "I finished the model in clay...23d of January 1869. Transfering it to plaster occupied about six weeks. To make a second model over it in order to preserve a duplicate in my studio took about six weeks more, and about the same time to dry before it could be boxed. The statue left my studio for Munich May 20th. I saw the model in the foundry last August. The last letter received from Herr [Ferdinand] von Müller the bronze founder was dated Oct. 25th; I enclose you that portion of the letter relating to the statue. He...says, 'The Statue of Lincoln goes on more slowly, as the model is a difficult one to cast.' I wrote him again today urging him to press on with the work....I cannot count with any certainty upon [von Müller] who is always overrun with work. My belief is that the bronze will not be completed before July or August [of 1870]."[36]

At last, on August 3, 1870, Rogers wrote to Stillé to

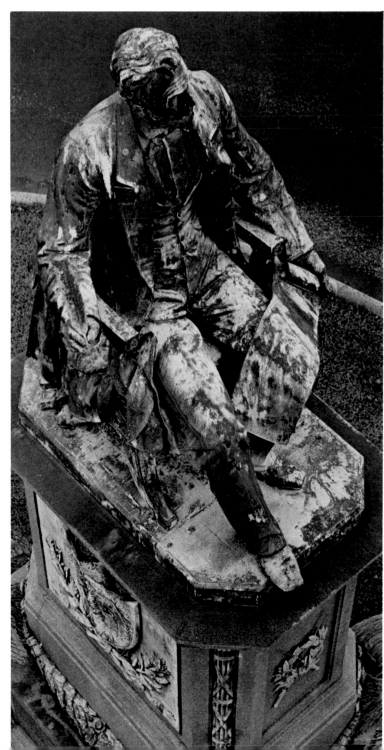

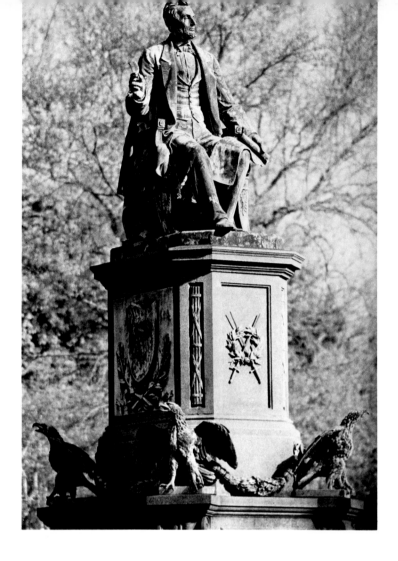

report: "I am happy to inform you that I this day received a letter from von Müller…informing me that the 'Lincoln' is cast and is now in the hands of the chissellers [i.e., chasers]. All will be finished by the 1st of October. The foundation should be put down at once.…I shall leave for Munich in the course of ten days, and from there will give you full account of the conditions of the work."[37] The chasing was a lengthy process on such a large statue, and it was still not finished when Rogers again wrote to Stillé on November 1, 1870: "Last accounts from Munich inform me that the Lincoln is nearly finished. I have no doubt they will be ready to be sent forward as soon as the [Franco-Prussian] war is over, and the steamers resume their regular trips…."[38]

Meanwhile, work progressed on the granite pedestal; by November of 1870 the committee had decided on a site in Fairmount Park, near Lemon Hill, instead, as originally planned, at Broad and Girard streets. Finally the bronze statue arrived in New York and then in Philadelphia, and the newspapers began carrying notices of the forthcoming unveiling, creating an air of excitement among the citizenry, who were promised a festive occasion. At last, on September 22, the statue was unveiled amidst impressive ceremonies witnessed by a throng of 50,000, to whom the sculptor was introduced.

In the five years that had preceded that triumphant moment, Randolph Rogers had created an image of the beloved martyr that did indeed move the hearts of his countrymen. He himself was so pleased with the solution for the design that he used almost the identical

composition in his bronze seated figure of William Seward, which was unveiled in New York City in 1876.[39] Rogers' *Lincoln* for Philadelphia was not the first bronze memorial to the Great Emancipator to be erected in the United States, for Henry Kirke Brown's statue in Prospect Park, Brooklyn, was unveiled in 1869, and another *Lincoln*[40] by Brown was dedicated in New York in 1870. Rogers' seems to have been the third such memorial, predating Larkin Mead's elaborate monument in Springfield by a few years. The *Lincoln* is the only bronze portrait statue by Rogers in Philadelphia, but copies of his famous marble figures of *Nydia, The Blind Flower Girl of Pompeii*, and *The Lost Pleiad* are owned by the Pennsylvania Academy and the Philadelphia Museum of Art respectively.

Randolph Rogers (1825–1892)
Abraham Lincoln. 1871
East River and Lemon Hill Drives
Bronze, height 114″ (granite base 270″)

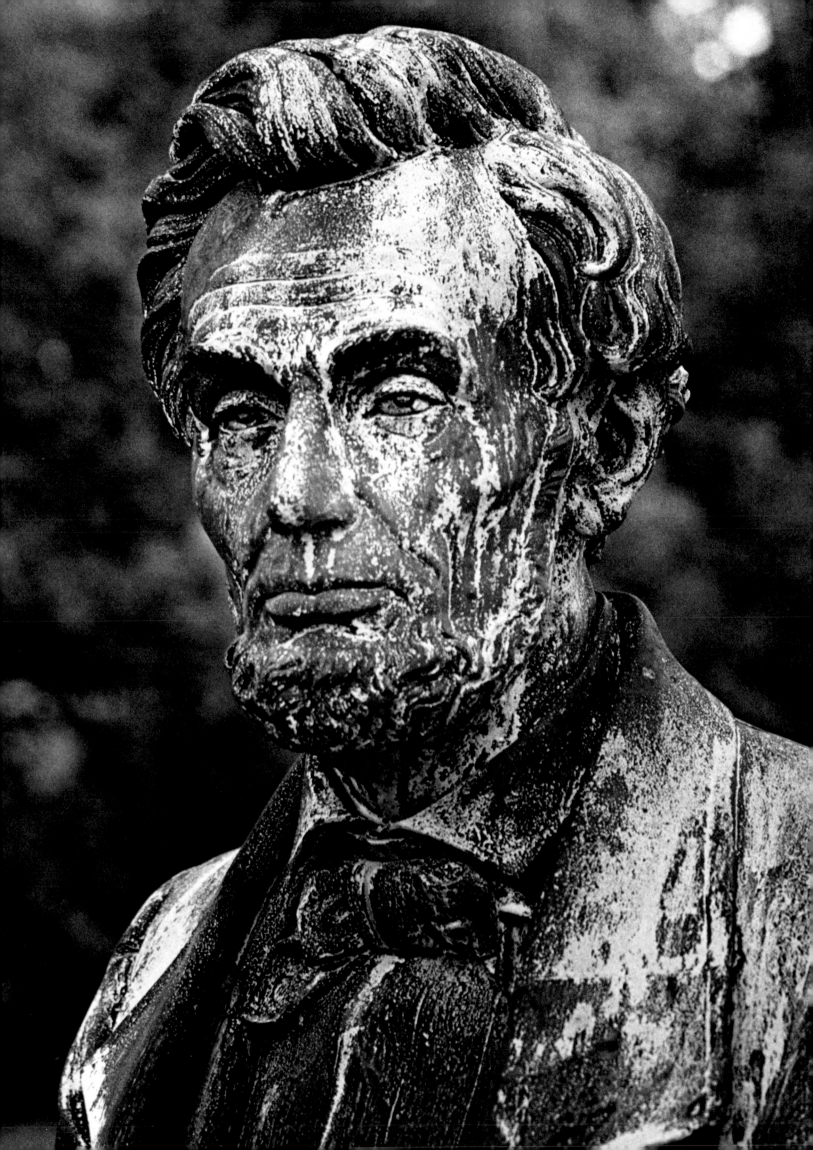

Hudson Bay Wolves

by Michael Richman

*photographs by
Murray Weiss*

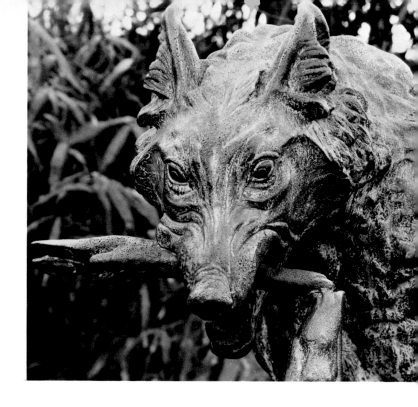

By the middle of the nineteenth century, American sculpture had undergone vital changes. Marble statues that were enjoyed by well-to-do clients in luxurious parlors, or displayed for profit in exhibition halls, could now be seen by a greater number of people in bronze in municipal squares and public parks. The impetus to preserve open areas in the cities and to create urban parks assisted the development of monumental outdoor sculpture. In 1855, Philadelphia began to protect its public lands, and by 1867 this effort culminated in the formation of the Fairmount Park Commission. With the creation of the Fairmount Park Art Association in June, 1871, and its subsequent incorporation on February 2, 1872, Philadelphia became the first city in America to form a private society "who propose to collect a sufficient sum of money, and apply the same in embellishing that beautiful spot with Statues, Busts, Fountains, and similar ornament; such as good taste shall dictate."[1] For its first official act of sculptural embellishment, the Art Association purchased from Edward Kemeys his statue of *Hudson Bay Wolves Quarreling Over the Carcass of a Deer.*[2]

Kemeys was born in Savannah, Georgia, on January 31, 1843. With the death of his mother in 1847, the young boy returned to Scarborough, New York, to live with his grandfather, Judge Edward Kemeys. At the age of twelve, he moved to New York City to be with his father. The next year, and for several years thereafter, he traveled to Dwight, Illinois, to spend summers with relatives. This exposure to the frontier was important, for it helped to instill in Kemeys a lifelong attachment to the West.[3]

What Kemeys did in the years before the Civil War is

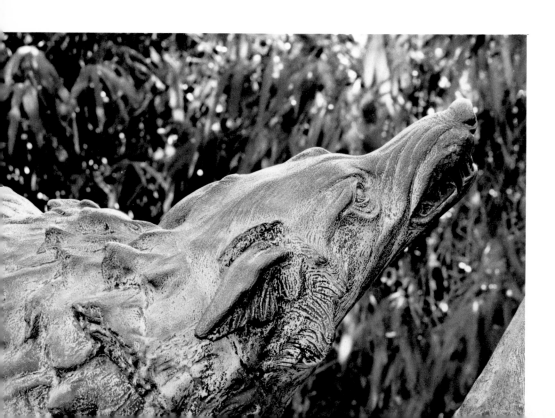

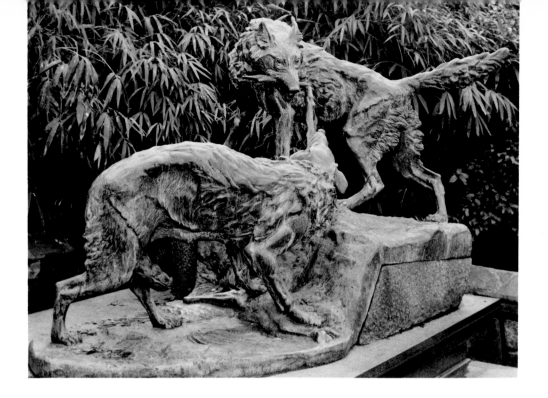

not known. Lorado Taft indicated that on finishing high school, he went to work in an iron business.[4] Another biographer, writing with the approval of the sculptor's widow, claimed that Kemeys attended both high school and college.[5] It is known that he joined the army as a second lieutenant on March 31, 1862. At the time of discharge on February 21, 1866, he returned to Dwight.[6] Kemeys recalled:

At the time of Muster-out in '66 I found myself in no mood to take up life in New York City and naturally gravitated to the scene of my earlier experiences which had lost nothing of their charm and fascination. … While from a business point of view this move might have been regarded as a mistake, it just suited my needs…and in the meantime gave me a most fortunate opportunity to store my memory with a

knowledge of the forms and creatures destined to become my lifework.[7]

Two years passed before Kemeys left for New York where he worked as a laborer for an engineering company engaged in laying out Central Park. One day, probably during the summer of 1869, Kemeys met an old sculptor who was modeling the head of a wolf. Hamlin Garland reported how Kemeys started his sculptural career:

Quick as lightning came the thought to him, 'I can do that! I felt it for an absolute certainty. The old man laughed at me, but it made no impression on me. My fingers itched to get hold of that wax.' He then related, with wealth of detail, the wonderful night he had. He carried his bunch of wax to his room, too excited to eat or sleep, and there modeled his wolf's head with

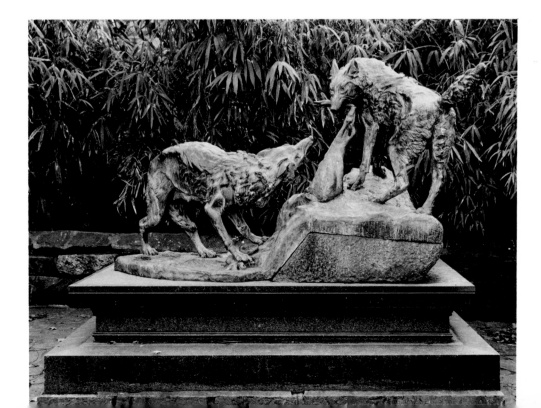

the jaws open.[8]

From his youth, Kemeys had been intrigued by the wolf: "I had but to go out on the prairie on a moonlight night to listen to the wolves howling to feel…that strange uncanny inexplicable sensation stirring my blood; a creeping thrill at the roots of my hair."[9] It seems only natural that his first group would portray these familiar animals, but inspiration must be combined with practical knowledge. How the novice Kemeys was able to execute a large statue is puzzling. Certainly his claim that he "never had an hour's instruction from any teacher"[10] can be accepted, but it is extremely difficult to believe that he received no training in the mechanical aspects of sculptural production—making an armature, modeling in clay and plaster, working with molds, or learning about the complicated process of bronze casting. The identity of the man who helped Kemeys remains a mystery.

With no apparent exceptions, the literature on Edward Kemeys also supports the thesis, which the sculptor himself actively promoted, that nothing happened between the time he modeled the wolf's head and began *Hudson Bay Wolves.*[11] Fortunately the discovery of two bronzes helps to clarify Kemey's early career. Each piece is authentically inscribed: "E Kemeys / 1870."[12] For the moment it cannot be determined why these 1870 statues, *Wolf at Bay* and *Wounded Wolf* were created, but it can be assumed that they are not directly related to the 1872 group. A comparison of the *Wounded Wolf* (figure 1) with the Philadelphia monument reveals some superficial similarities in the body postures and the rather pronounced treatment of the heads. The rendering of the fur and muscles appears, in the 1870 work, to be somewhat inexperienced.

While there is uncertainty about Kemeys' first years as a sculptor, material has survived to document the execution of the *Hudson Bay Wolves.* In the Minute Book of the Fairmount Park Art Association, dated April 16, 1872, it was stated that, "A communication was presented by the Secretary concerning Kemeys' group of American Wolves Quarrelling over the Carcase [*sic*] of a Deer, and proposing to sell the group…."[13] Kemeys sent the proposal to the Association's Committee on Works of Art, whose ten members included Chapman Biddle, who was appointed chairman, James L. Claghorn, and Charles H. Rogers. Action was taken promptly for on June 8 it was recorded that Biddle and Theodore P. Cuyler of the Commissioners of Fairmount Park "visited New York for the purpose of seeing Kemey's [*sic*] group of American Gray Wolves Quarrelling over the Carcass of a Deer."[14] While no record of Biddle's reaction exists, Mr. Cuyler was "very much pleased with the group."[15] Five days later, the chairman of the Committee on Works of Art was "authorized to enter into contract…for the purchase of his group…and that an arrangement be entered into with Mr. Kemeys for the supervision of his group in Philadelphia."[16]

Edward Kemeys signed a contract with the Fairmount Park Art Association on June 25, agreeing to accept a fee of $1,800—$800 when his model was delivered to the Robert Wood Foundry in Philadelphia and the remainder when the group was erected. An additional sum of $1,000 was provided for Kemeys' services in supervising the casting, finishing the bronze, and overseeing the placement of the group.[17]

Kemeys remained in Philadelphia until July 2, for on that date he sent a note confirming the receipt of the first payment to James L. Claghorn, treasurer of the Association.[18] No record exists to confirm when the model reached the foundry, but by September 1, work was in progress there.[19]

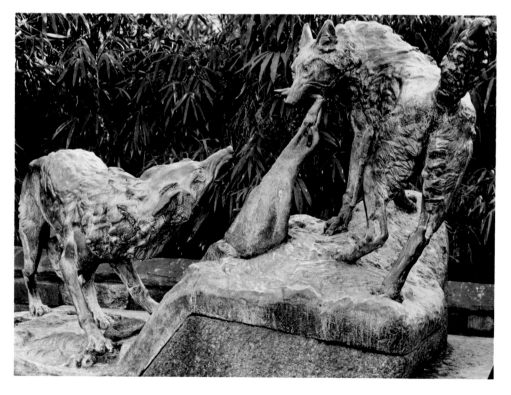

On October 11, the secretary wrote to Cuyler, stating that the Kemeys group was in the hands of the chasers and asked the Fairmount Park Commission for its formal approval. In this letter Cox mentioned that Kemeys had been to the Park in early September and had selected two possible sites in the West Park: one at the Lansdowne entrance, and the other near the northernmost group of old pine trees at the Lansdowne Concourse.[20] At the meeting on the following day, the commissioners officially accepted the group. The *Hudson Bay Wolves* could now be erected, but regarding the choice of a site, Mr. Cuyler moved that this decision be entrusted to the Committee of Plans and Improvements of the Commission.[21]

In the Association's minutes of October 15, 1872, the progress on the statue was summarized by A. J. Drexel, the president, who concluded: "It is hoped to have this remarkably fine and unique group set in place in the Park before the First of November.... This group is to be mounted upon a rugged rock base, six feet high, the material for which has been contributed by the Conshohocken Stone-Quarry Company."[22] No sooner had a tentative date been suggested than further delays were announced. On October 25, Chapman Biddle visited the Wood Foundry and reported that "the Kemeys group had been cast, parts had already been chased and finished, and the whole might be expected in three weeks,"[23] but, unexplainably, the Fairmount Park Commissioners had not approved a site.

Kemeys' frustration at the delay was justified, for by the terms of his contract he could not receive final payment until the statue was in place. Prompted by Kemeys, the secretary of the Association wrote to the commissioners on October 31 that a site on the south side of Lansdowne Valley near the Ferndale Pool had been tentatively selected with the advice of the assistant engineer, Herman Schwarzmann. This site was approved on November 9.[24] Five days later, Cox informed Kemeys of the decision and by December 18 the work on the foundation and the building of the pedestal were completed.[25] On December 23, the Committee on Works of Art notified the Association that Kemeys should receive the money due him. The report also mentioned that Messrs. Rogers, Biddle, and Joseph Patterson had on December 21 visited the site and "hereby express their entire satisfaction with the manner in which the founders have performed their work and also with which the group has been mounted on its base in the Park."[26] Four days after the report was made, Kemeys acknowledged that he had received his fee of $2,000.[27] On February 20, 1873, Mr. Schwarzmann was paid $306 for overseeing the construction and an additional sum of $50 for his pedestal design.[28]

With all the extant documents that are relevant to the history of the Fairmount Park Art Association's first venture in public sculpture, it is perplexing not to be able to determine how or why Kemeys was selected. He did not have a sponsor in Philadelphia nor a supporter within the Association. In an address delivered at the twenty-fifth annual meeting in 1897, Kemeys implied that he had not received special assistance in securing this commission.[29] Kemeys must have initiated the contact and secured a favorable reaction from the members by emphasizing the novelty of bringing a specimen of wild fauna, albeit in bronze, into the urban park.

Not only is this the first monumental animal sculpture to be executed by an American, but, as the first accomplishment of a novice sculptor, it is a triumph. In conceiving the group, Kemeys has created a composition of novelty. He has chosen the moment when the wolves, having collaborated to chase and kill their prey, begin to

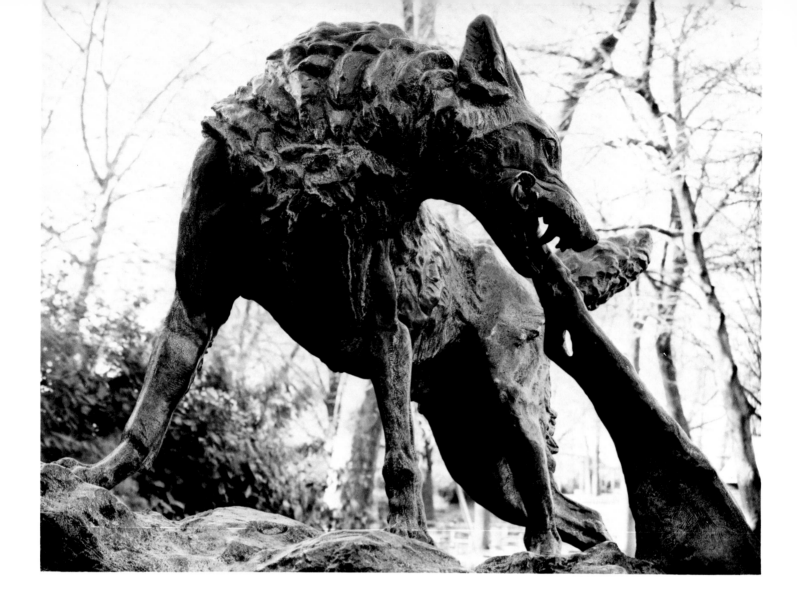

quarrel. It would seem that Kemeys has arbitrarily isolated the two animals; but in so doing he achieved a controlled spatial unity. The wolves, juxtaposed on different levels of the ledge, are brought closer by the carcass, which each wolf has claimed. For the moment one has the initiative as he holds the deer's leg in his mouth, but his adversary, whose front leg is stationed on the body, refuses to yield. The incipient combat is accentuated by the sculptor in his contrasting treatment of the challenging and furtive glances, the erect and flattened ears, and the clenched and snarling mouths. The placement of the wolves on divergent diagonals enhances the action and unifies the composition. On the upper plateau the wolf is in an open stance, with front legs erect and tail jutting out sharply, while below, the other shrinks, his body in a closed position with his tail tucked snugly between his legs.

Kemeys returned to the subject of the wolf several times. The most successful treatment appears in a pair of related bronzes: *Before the Feast* and *After the Feast*, modeled in 1878 but probably not cast until the early 1890s.[30] In the former the wolf snarls as he protects his kill, while *After the Feast* (figure 2) portrays the wolf savoring his feast. As shown in this work, Kemeys was at his best sculpting single animals in stationary positions or uncomplicated postures. The soft modeling of surfaces in the small bronze has replaced the more active rendering visible in the Philadelphia group.

Kemeys' involvement with the Fairmount Park Art Association did not end with the erection of *Hudson Bay Wolves*. Aware that the members were pleased with his first effort, Kemeys wrote to Cox on May 12, 1873:

Having ascertained that the Art Assn. are looking about again for new works of art I take the liberty of calling your attention to my plaster model of Panther and Buck Deer Fighting, *which was exhibited with my large bronze group at Baileys last December.... The group ... has been pronounced upon by all the art critics of N. Y. and is by them considered one of the finest works of Art ever produced in this country, and I myself* know *it to be far ahead of the Wolves in all respects, and doubt if I ever shall be able to make a happier conception.*[31]

The Association did not act on this proposal and, when he reintroduced the plan in 1897, it was again rejected.[32] In *Fighting Panther and Deer* (figure 3), as the piece came to be known, Kemeys records the violence of the struggle, but falters in translating this action into a cohesive sculptural ensemble.

The sculptor also contacted the Association in 1885

when a collection of his models of Indians and wild animals was exhibited at the Pennsylvania Academy. Thomas Hockley, the chairman of the Committee on Works of Art wrote that: "The Fairmount Park Art Association have agreed to subscribe Three Hundred and fifty dollars towards a large reproduction in bronze of 'The Deer Stalker' by Kemeys, on condition that the whole amount ($3,500.00) be raised...."[33] The necessary funds were not collected and *The Deer Stalker* (figure 4)—a tense study of an American panther—was not enlarged.

Kemeys' life-long desire was to record the native American wild life; but his efforts to obtain sculptural commissions were all too often unsuccessful. He executed only three other major monuments—*The Still Hunt* (1883–1884) in New York City, *Lions* (1892–1894) in Chicago, and *The Johnson Fountain* (1898–1899) in Champaign, Illinois.[34] Throughout, Kemeys struggled to work in the mainstream of late nineteenth-century American sculpture. Philadelphia and the Fairmount Park Art Association are indeed fortunate to have Edward Kemeys' first masterwork, *Hudson Bay Wolves Quarreling Over the Carcass of a Deer.*

Edward Kemeys (1843–1907)
Hudson Bay Wolves. 1872
Philadelphia Zoological Gardens,
adjacent to Wolf Woods
Bronze, height 50″ (granite base 30″)

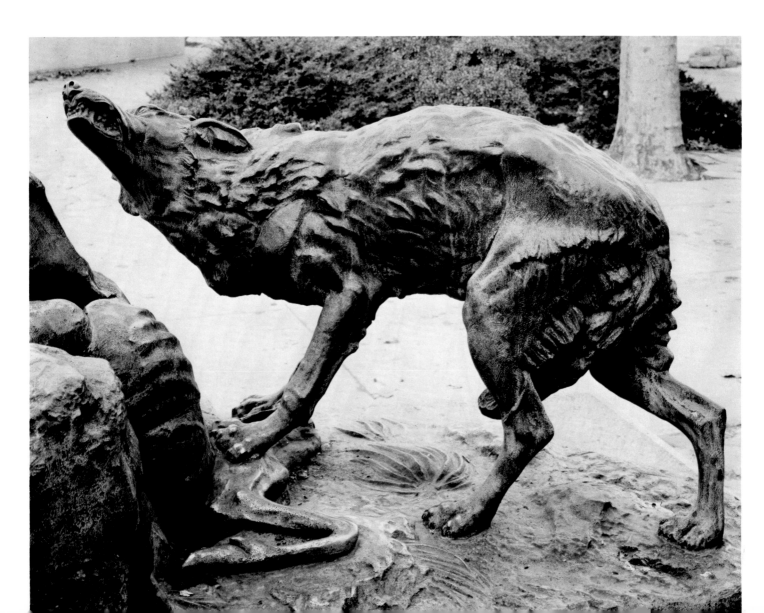

Henry Fiorelli and Battin
Lions. 1838
Merchants' Exchange, Walnut, Third, and Dock Streets
Marble: south side lion, height 42″; north side lion, height 42″

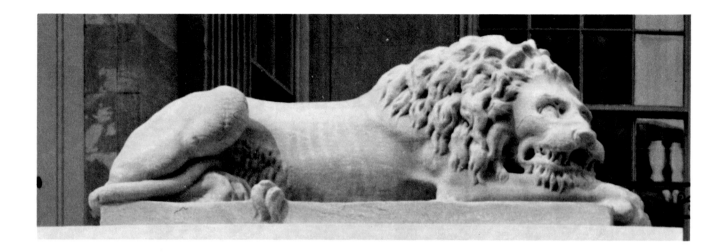

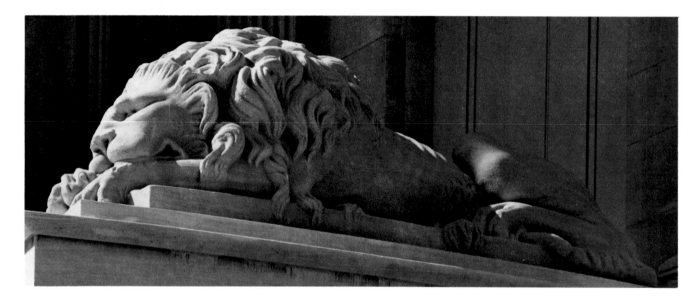

Designed by William Strickland, the Merchants' Exchange was built between 1832 and 1834 in the Greek Revival style of which Strickland was a master. When the capstone was placed in 1833, the event was celebrated at a dinner at which the architect was toasted: "He found us living in a city of brick, and he will leave us in a city of marble." The stonemason of the building was John Struthers, who frequently worked with Strickland. Pietro and Filippo Bardi carved the elaborate capitals. In addition to the Philadelphia Exchange, the building housed the post office and various offices including Strickland's.

Among its principal decorations were a pair of lions at the head of the steps on the east facade. For many years it was believed that they were imported

from Italy by John Moss, a wealthy Philadelphian, but it is now known that they were carved in Philadelphia. According to the *United States Gazette* of March 21, 1838, there was "a pair of lions being sculptored by Messrs. Fiorelli and Battin, 3 Dock St., to be placed in front of the Merchants' Exchange." On April 5, 1838, the *Gazette* announced that "one of the marble lions sculptored by Signor Fiorelli, assisted by Mr. Battin, has been put in place."

The deterioration of the Exchange and the purposes it served caused the removal of the lions in 1922 to the Philadelphia Museum of Art. With the recent restoration of the Exchange by the Independence National Historical Park, the lions were returned to their original place on the steps.

August Kiss (1802–1865)
The Amazon. 1843
Philadelphia Museum of Art, East Entrance
Bronze, height 135″ (limestone base, 204″)

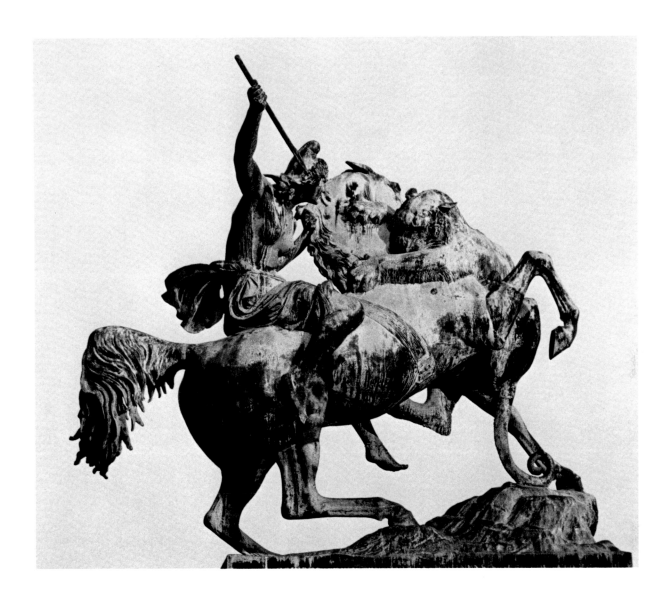

The people of Berlin were justly proud of their great Museum designed by K. F. von Schinkel between 1824 and 1828. The grandeur of its facade, a long classical colonnade, was heightened by the deliberate placement of several spirited sculptures. The most famous group, starred as worthy of particular note by the writer of guide books, Karl Baedeker, was this work created by a young student of Christian Rauch. It was modeled in 1837 and instated before the Museum in 1843. For eighteen years it stood alone until a pendant composition was created by yet another Rauch student.

In 1889 the Fairmount Park Art Association announced with pride that it had been able to acquire the original plaster casts of this work, and its pendant, Professor Albert Wolff's *Lion Fighter.* However, the acquisition of the Kiss presented practical problems; by 1893, it was agreed that the disintegra-

tion of the original plaster was such that the Association should accept the German government's offer to provide a new plaster made from the bronze. At about this time a newspaper wit observed: "An Amazon by Kiss, may be a good thing, but if its all the same to you I'll take a kiss by an Amazon."

The plaster of the *Amazon* was exhibited at the Pennsylvania Museum until, in 1909, after the Association decided that it would commission American art only, it was presented to Harvard's new Germanic Museum. However, in 1928 the Association, then deeply involved in the finishing of the Benjamin Franklin Parkway and the building of the new Museum, arranged that a bronze version should be cast so that, in a new setting, the pair might be instated once again at a great art museum, and this was accomplished in 1929.

Henry D. Headman
William Penn. 1851
Penn Mutual Life Insurance Building,
Sixth and Walnut Streets
Cast iron, height 75″

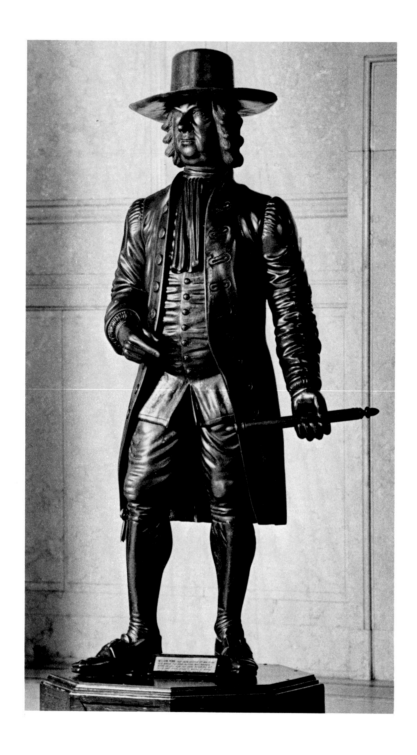

In 1850 the Penn Mutual Life Insurance Company commissioned architect J. B. Cummings to construct an office building in the Italianate style at Third and Dock Streets, at that time the central business district. Thought to be fireproof this was Philadelphia's first cast-iron structure. The contract for its fabrication and construction was given to Joseph Singerly for six and one-quarter cents a pound.

Over its doorway stood the 600-pound statue of *William Penn*, its gaze directed at Strickland's Merchants' Exchange and the First Bank of the United States. *William Penn* remained for years as both a landmark and an advertisement for a successful insurance venture. In time the Penn Mutual moved on to larger quarters, but *William Penn* remained in place until 1946, when, shortly before the demolition of the building, it was removed and placed in the Penn Mutual's lobby.

Joseph A. Bailly (1825–1883)
Beauty, Faith, Hope, Wisdom,
Strength, Charity. 1855
Grand Lodge of Free and
Accepted Masons
of Pennsylvania,
1 North Broad Street
Wood painted White:
Beauty, height 75″;
Faith, height 72″;
Hope, height 72″;
Wisdom, height 72″;
Strength, height 72″;
lead painted white,
Charity, height 72″.
(All heights include
3¾″ bases.)

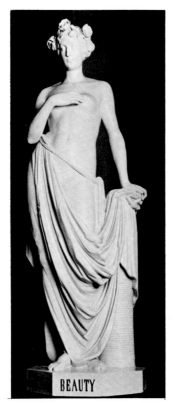

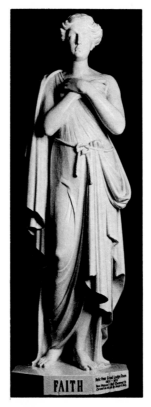

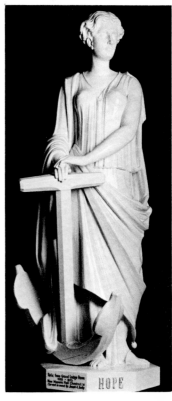

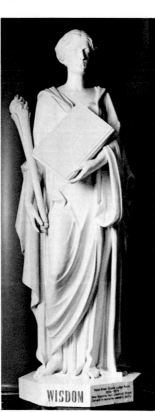

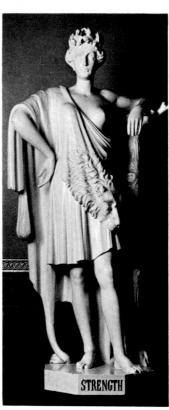

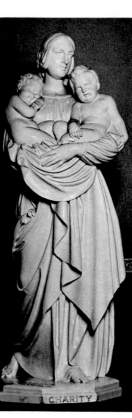

Joseph A. Bailly was a prolific and facile artist. Among his works are the sophisticated bronze portrait for the tomb of William Emlen Cresson at Laurel Hill (1869) and the nearby seated effigy of William F. Hughes (1870). In 1876 the Centennial Exposition gave him an opportunity to exhibit *Aurora* (now lost), and a colossal equestrian statue of President Guzman Blanco of Venezuela. His *John Witherspoon* (1876) still stands on the Horticultural Hall site in West Fairmount Park. His *The Expulsion* and *The First Prayer* may be seen at the Pennsylvania Academy of the Fine Arts where Bailly taught in the 1870s.

His standing female attributes of Masonry are early works and rather formal. The minute books at Masonic Hall disclose that Bailly and his partner Buschor were commissioned to create the six figures at $300 a statue. They were also employed to carve the Grand Chair and other work for the Masonic Temple's Gothic Hall.

63

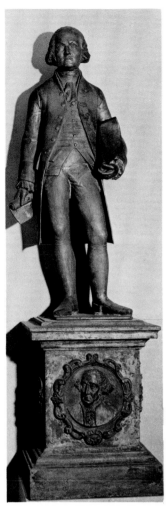
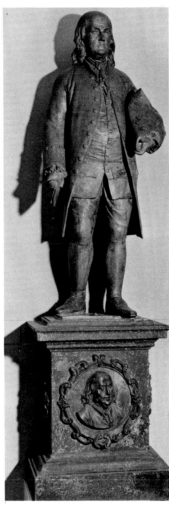

Unknown Artist
Washington, Franklin,
Gutenberg, Fust. *c.* 1857
Rare Book Department,
Free Library of Philadelphia
Lead: *Washington*, height 49¼″;
Franklin, height 50¼″;
Gutenberg, height 49⅞″;
Fust, height 49½″.
(Each with a lead base of 27½″.)

About 1857 the *Public Ledger* erected a building with the then fashionable cast-iron front. Its facade was elaborately ornamented and featured on its fifth story eight statues, which, running from left to right, represented Franklin, Gutenberg, Gutenberg's patron Johann Fust, Washington, Franklin, Fust, Gutenberg, and Franklin. Franklin was thus favored with three statues, perhaps in error, Washington being represented only once, for the pattern should have been two statues apiece for the four subjects. At another level of the building appeared basreliefs of Washington and Franklin alternately. These have been reapplied to the base of the four surviving statues.

A reporter in the *Sunday Dispatch* observed of these figures in 1859: "they were placed there by the *Ledger* people, we presume, as evidences of their sterling patriotism, their fondness for philosophy, and their admiration for the inventors of the art by which they have managed to acquire a very snug property."

It is possible that Joseph A. Bailly may have made them. His shop at 47 South Eighth Street was covered with a wealth of ornamental detail including six life-size figures and three large eagles, advertisements for his trade. The four figures which have been preserved from the Ledger Building were given to the Free Library in two gifts—*Franklin* and *Washington* by William L. Elkins (1947), and *Gutenberg* and *Fust* by Arthur Sussel (1955).

Albert Wolff (1814–1892)
The Lion Fighter. 1858
Philadelphia Museum of Art,
East Entrance
Bronze, height approximately 168″
(limestone base 204″)

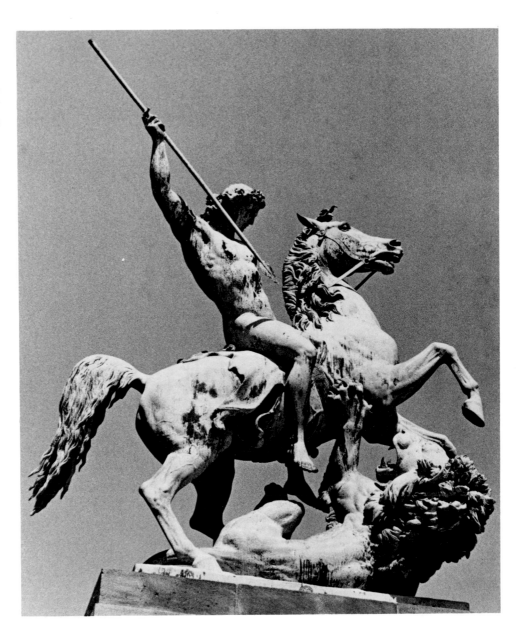

Albert Wolff was born in Mecklenburg. He did garden sculpture for Sans Souci in Potsdam and then settled in Berlin where he became a professor at the Royal Academy in 1866. The original plaster cast of *The Lion Fighter* was obtained by the Fairmount Park Art Association along with the one of *The Amazon* to be used as companion works. In 1892 *The Lion Fighter* was cast in bronze by Bureau Brothers for display at the 1893 Columbian Exposition, and was later placed in front of the Post Office at Ninth and Chestnut Streets. It was moved to the East River Drive in 1897, at which time the Association received a lengthy letter of praise from Mayor Charles Warwick: "Every true Philadelphian must appreciate with a sense of gratitude the efforts you have made for the adornment of our city."

Opposing Mayor Warwick's sentiments, an editor of the *Evening Telegram* attacked Wolff's statue. "The so-called 'Lion Hunter' is no more a companion for the immortal 'Amazon' than a stove casting figure is a companion for the Venus of Milo…the

group is a poor, cheap piece of clap-trap at best…." Leslie Miller replied to this attack on behalf of the Fairmount Park Art Association: "The originals of these two groups stand together as companion pieces on the steps of the National Museum in Berlin. There is no claim, or pretence, or allegation about it. There the two statues stand, and have stood for years, companions, in nearly as strict a sense, as far as architectural effect is concerned, as the two Pegasi which flank the entrance to Memorial Hall. …The question arises then, is art to be served, and its interests in a community promoted most efficiently by encouraging, or by denouncing, the setting up in public places of such works as this? Frankly, it seems to me that what we want to do is to quicken and strengthen the habit of doing just such work as the Fairmount Park Art Association has done in erecting this group."

Today *The Lion Fighter* rests as originally intended on a plinth opposite *The Amazon* at the head of the Parkway.

H. S. Tarr
Hirst Tomb. *c.* 1858
Cathedral Cemetery,
49th Street and Lancaster Avenue
Marble, height 156″

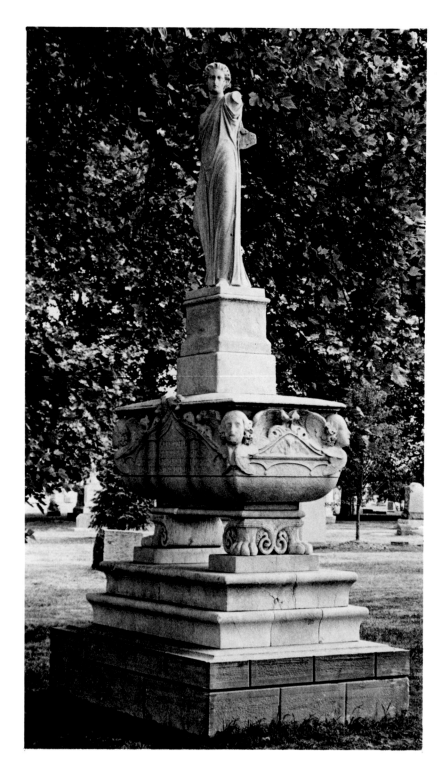

This monumental sarcophagus, surmounted by a winged Nikelike figure, may well be the finest First Empire tomb in the United States. It commemorates Mrs. William Lucas Hirst (Mary Adele Cochran, 1825–1858): "She was well born, the daughter of Captain Stephen Cochran, Commander of the U.S. Naval fleet at Tripoli and granddaughter of Dr. Antommarchi, Napoleon's physician on St. Helena."

Mrs. Hirst's husband was admitted to the Philadelphia bar in 1827. Becoming a convert to Catholicism, he was for decades legal advisor to the Roman Catholic diocese (later arch-diocese) of Philadelphia. Hirst was an early summer resident of Chestnut Hill and owned two "Old Master" paintings exhibited in 1848 at the Pennsylvania Academy of the Fine Arts.

Guillaume Geefs (1805–1883)
Gardel Monument. c. 1862
Mount Vernon Cemetery, Ridge and Lehigh Avenues
Marble, height 278″

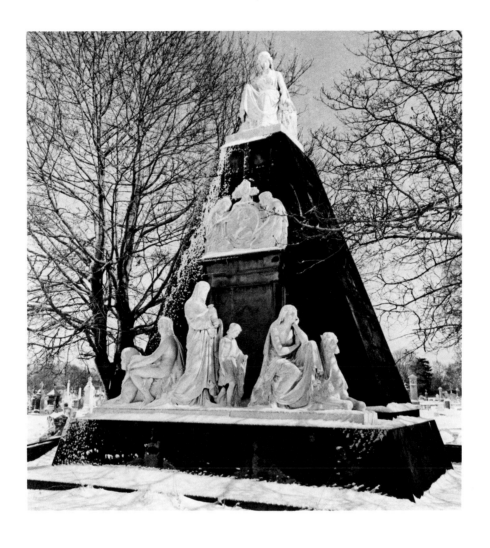

A wealthy Philadelphian, Bertrand Gardel, commissioned the architectural firm of Napoleon LeBrun, of which Edwin Greble was a member, to erect an impressive tomb to the memory of his wife. Guillaume Geefs, sculptor to the King of the Belgiums, was employed to carve it and used as his source the procession on the tomb of Countess Maria Christiana in the vaults of the Augustine Church in Vienna. This famous tomb was carved by Antonio Canova in 1805, using the theme of "The Landing of Agrippina at Brundisium with the Ashes of Germanicus."

Gardel has left a description of the tomb in a letter of November 12, 1862: "First, the four life size female figures represent Europe, Asia, Africa, and America. Natives from these four great divisions of the globe having been present at the Burial of Mrs. Gardel, come to pay their benefactress their tribute of gratitude and respect. Second, the three front or central groups represent a funeral procession consisting of Europe proceeded by Genius with torch and key come to deposit the cinerary urn in the pyramid; Asia on the left and Africa on the right. Third, in the Bas Relief over the door contains the bust of Mrs. Gardel enclosed in a medallion supported in the hands of Hope and Faith, emblems of the religious character of the deceased. The two emblematic figures are in the act of raising the medallion to the crown above it. Fourth, America, uppermost figure, is surrounded by the emblems of the physical sciences cut out on both sides of her socle and one arm resting on the Bible; deposits with the other, on the head of the deceased, the crown of Immortelles awarded to her long and earnest labors in the moral and mental education of American youth."

Joseph A. Bailly (1825–1883)
George Washington. 1869
City Hall
Marble, height 102″ (base 35″)

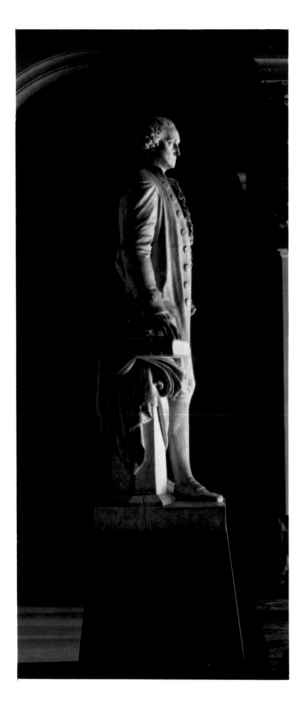

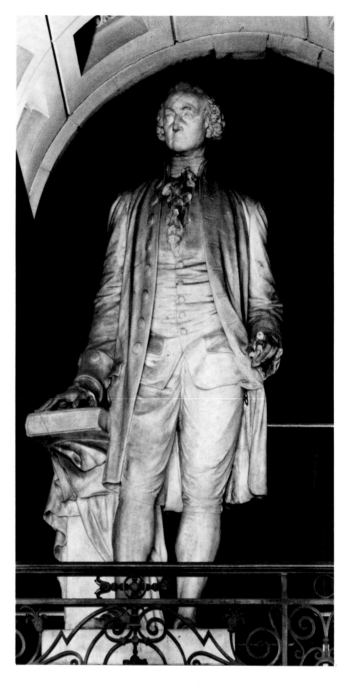

Joseph Alexis Bailly, the son of a cabinetmaker, was born in Paris and had received some atelier training before escaping the 1848 uprising. He went to New Orleans and devoted himself to making medallions and busts. His reputation increasing, he traveled to Buenos Aires and to New York before finally settling in Philadelphia. On August 1, 1850, he married Louisa David, the daughter of a tavern keeper in Dock Street. Bailly established himself in "Marble Alley" where John Struthers and his son William, the city's outstanding marble contractors, worked.

George Washington stood in front of Independence Hall from 1869 until the 1880s, when to protect it the statue was moved to City Hall and placed on a balcony above the north vestibule. A bronze replica replaces the original on Chestnut Street, in front of Independence Hall.

J. Wilson
Washington Grays Monument
Lemon Hill Drive, East Fairmount Park
Bronze, height 87″ (height of granite base 114″)

This militia unit was organized in 1822 in Philadelphia as a company of light infantry and was soon one of the city's most popular military outfits. Subsequently it became the Artillery Corps, Washington Grays. It served with distinction in the Civil War and continued in service until 1879, when it was consolidated into the First Regiment, National Guard of Pennsylvania.

In 1871, Edwin N. Benson donated $2,000 "to defray the expenses of erecting a granite monument, in a proper place, to the memory of the gallant comrades who fell in the war for the Union." This was unveiled on April 19, 1872, at the intersection of Broad Street and Girard Avenue. In 1898 it was moved to the center of Washington Square, and in 1906, a committee of the Old Guard was appointed to procure a bronze figure of a Washington Gray to place on the top of the monument. Cast by Bureau Brothers, the statue was dedicated on April 18, 1908. In 1954, the monument was moved to its present site in Fairmount Park. The plaques on its base refer to the Grays' Civil War record, and are inscribed: "To our fallen comrades, 1861–1865."

Edward Stauch (1830– ?)
Night. 1872
George's Hill, West Fairmount Park
Bronze, height 68″ (granite base 60″)

The minute books of the Fairmount Park Association indicate that the donor of its first gift of sculpture wished to remain anonymous, but notations reveal that one of the founding board members, Edwin N. Benson, gave the funds to purchase a "bronze allegorical statue." The total sum paid, which did not cover the cost of the pedestal, was $1,000. In June, 1872, the Commissioners of Fairmount Park accepted the work. Of Stauch little is known. The only other examples attributed to him in Philadelphia are a bust of George Bacon Wood at the American Philosophical Society and a bust of Friedrich Schiller (1859) in the hallway of the German Society at 611 Spring Garden Street.

Wilhelm Franz Alexander Friedrich Wolff (1816–1887)
The Dying Lioness. 1873
Philadelphia Zoological Gardens, entrance
Bronze, height 69″ (granite base 48″)

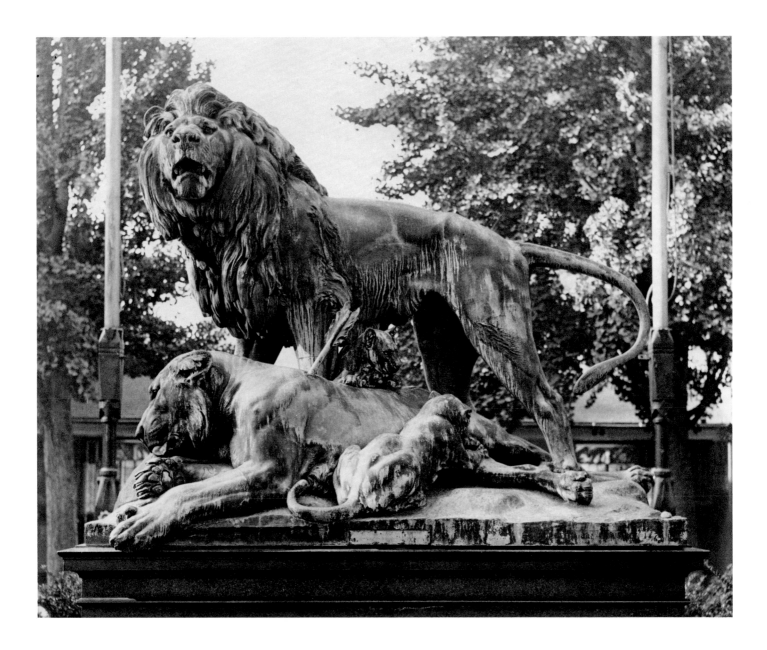

Wilhelm Wolff was the younger brother of Albert, the sculptor of *The Lion Fighter,* and was often called "the animal Wolff." The first cast of *The Dying Lioness* was instated in Berlin in 1874 as part of the German Emperor's collection. The model had won a first prize at the Vienna International Exhibition of 1873.

The Philadelphia cast of the *Lioness* is inscribed "F. V. Miller fudit Munchen 1875." It was first exhibited in Philadelphia at Earle's Galleries, where admissions were charged to view it. Subsequently, it formed an important part of the outdoor sculpture exhibition at the 1876 Centennial. The 1876 *Annual Report* of the Fairmount Park Art Association describes its acquisition: "The work consists of a lion, lioness and two whelps. A dart of the hunter has transfixed the dam, and 'stretched upon the plain,' her long sinewy body is relaxing in death. The face of the beast is a study in itself, depicting, with that half-human reality so often seen in the works of Landseer, the mute agony of mortal pain; the maternal instinct, stronger than death, has caused the dying lioness to give her latest strength to the nourishment of her young; over the mother and the whelps stands the lion, the prominent figure of the group, who, with head erect and tail outstretched, roars defiance, grief and rage; his whole attitude is a study of nature and nature's servant, Art."

Samuel H. Sailor (dates unknown)
Navigator. *c.* 1875
Philadelphia Maritime Museum
Painted wood, height 66¾″

The port cities of the American colonies and of the early Republic required the skill of ship carvers. William Rush, one of America's first distinguished carvers, began his career as a craftsman carving figureheads, taff rails, and other ornaments for vessels built in Philadelphia's extensive shipyards.

Ship carvers were also called upon for carvings that advertised shop wares. The familiar cigar-store Indian, emblem of the tobacconist, is a case in point.

Sailor's advertising figure depicts a naval officer sighting through a sextant. His *Navigator* long maintained its position over the Riggs Brothers store on Market Street, which sold nautical instruments and charts. A similar figure by Sailor is at the Mercer Museum in nearby Doylestown. After more than a hundred years on guard at Riggs's, the *Navigator* was recently acquired by the Philadelphia Maritime Museum.

Appendix
Section II

Unknown Artist
Frederick Graff Memorial
Fairmount Dam, adjacent to the old Water Works
Marble on granite base with Gothic trim, height 26″ (base 162″)
Commissioned by the city of Philadelphia in 1844. Instated June 1, 1848.

Joseph A. Bailly (1825–1883)
The Expulsion
Pennsylvania Academy of the Fine Arts. Bequest of Henry C. Gibson in 1892.
Marble, height 60½″

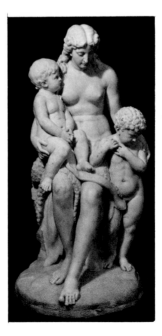

Joseph A. Bailly (1825–1883)
The First Prayer
Pennsylvania Academy of the Fine Arts. Bequest of Henry C. Gibson in 1892.
Marble, height 58″

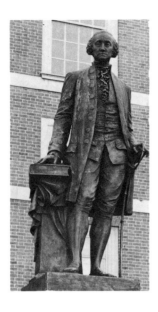

Joseph A. Bailly (1825–1883)
George Washington. 1869
Independence Hall, facing
Chestnut Street
Bronze on marble and granite
base, height 102″ (base 80″)
Replica made in 1908 of original
which stood on this site and is
now placed in the north vestibule
of City Hall.

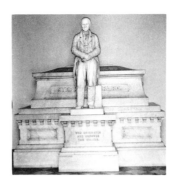

François Victor Gevelot
(1791–after 1846)
Stephen Girard
South vestibule of Main
Building, Girard College
Marble on marble base, height
66″ (base 42″)
Commissioned by the city of
Philadelphia and the Building
Committee of Girard College in
1833. Instated in 1846.

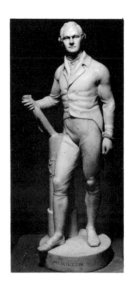

Robert Ball Hughes (1806–1868)
Alexander Hamilton
Pennsylvania Academy of the
Fine Arts. Gift of Mrs. John K.
Mitchell in 1917.
Marble, height 27″

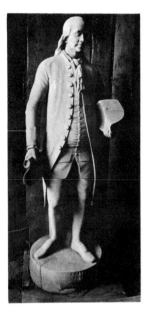

John T. Battin, Jr. (*c.* 1803–1863)
Benjamin Franklin
University of Pennsylvania
Marble, height 72″ (base 6″)
Placed in the Odd Fellows
Cemetery about 1852 by the
Benjamin Franklin Lodge of
Odd Fellows. Given to the
University in 1951 by the
Cemetery, and now undergoing
conservation.

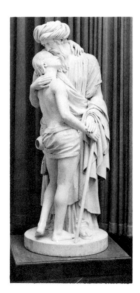

Joseph Mozier (1812–1870)
The Prodigal Son
Pennsylvania Academy of the
Fine Arts. Gift of J. Gillingham
Fell in 1869.
Marble, height 75″

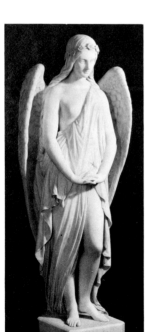

Thomas G. Crawford (1813–1857)
The Peri. 1856
Pennsylvania Academy of the
Fine Arts. Bequest of Clarissa A.
Burt in 1917.
Marble, height 70″

Erastus Dow Palmer (1817–1904)
Spring
Pennsylvania Academy of the
Fine Arts. Purchased in 1857.
Marble, height 23¼″

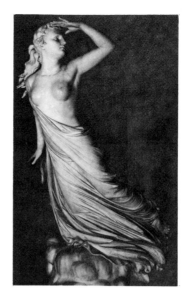

Randolph Rogers (1825–1892)
The Lost Pleiad. 1874–75
Philadelphia Museum of Art.
Gift of Lydia Thompson Morris
in 1929.
Marble, height 68½″

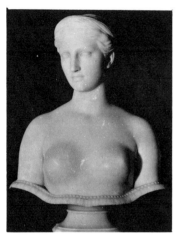

Hiram Powers (1805–1873)
Persephone
Pennsylvania Academy of the
Fine Arts. Gift of John Livezey.
Marble, height 20¾″

Edward Stauch (b. 1830)
George Bacon Wood. c. 1857
American Philosophical Society.
Bequest of Walter Wood in 1935.
Marble, height 27″

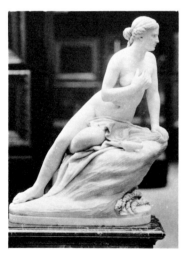

William Henry Rinehart
(1825–1874)
Hero. 1869
Pennsylvania Academy of the
Fine Arts. Bequest of Henry C.
Gibson in 1892.
Marble, height 35¾″

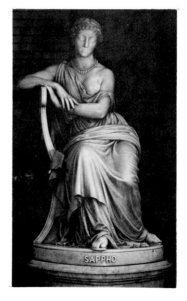

William Wetmore Story
(1819–1895)
Sappho. 1866
Main Building, Drexel University
Marble on marble base, height
58″ (base 32½″)
Given to Drexel Institute of
Technology by Mrs. Charles J.
Peterson in 1892.

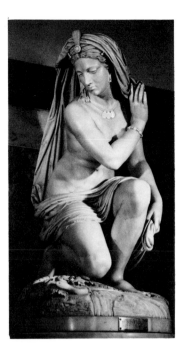

Scipione Tadolini (1822–1892)
***Georgian Surprised at the
Bath.*** 1866
Main Building, Drexel University
Marble on marble base, height
38″ (base 40″)
Given to Drexel Institute of
Technology by Seth B. Stitt in
memory of his wife in 1904.

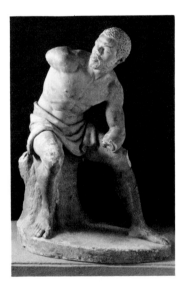

John Quincy Adams Ward
(1830–1910)
The Freedman
Pennsylvania Academy of the
Fine Arts. Gift of the artist
in 1866.
Plaster, height *c.* 25″

Section III 1876–1893

The Centennial

by David Sellin

*photographs by
Bernie Cleff*

Memorial Hall

When Philadelphia was the Nation's capital, a group of
artists congregated there to create an association to
promote the arts. Sculptors among them made up for
their small number in richness of experience. William
Rush was a native American; Johann Eckstein had been
historical sculptor in the court of Frederick the Great, and
his son Frederick was trained in Berlin;[1] Rome-trained
Giuseppe Ceracchi was a fierce advocate of egalitarian
principles, which would lead him back to Paris and to the
guillotine. All wanted to celebrate the Republic in suitable
monuments, but for want of patronage Ceracchi's
hundred-foot pile surmounted by Liberty in a quadriga
was never erected, nor was the Eckstein equestrian
Washington in Roman republican guise. By 1876 the
United States, having survived a bloody paroxysm, a
presidential assassination, and the catharsis of
emancipation was now prepared to celebrate its
Centennial with monuments aspired to in earlier days.
From the *Columbus Water Cooler* and the Gorham
Century Vase to Memorial Hall, elaborate patriotic
iconography was worked out. Only explicit partisan
reference to the late war was barred by Centennial rules.

From the cupola of Memorial Hall *Columbia* presided
"the hand presenting no sword, but the peaceful bays; the
bowed head of salutation and welcome; the crown of
savage feathers, adorning the forehead of a Cybele of the
wilderness, whose diadem has not yet crystalized into
towers."[2] At her feet, personifications of the quarters of
the globe, in galvanized zinc, were accompanied by
Industry and Commerce on the south, and Agriculture
and Mining on the north. On the south front stone figures
represented Science and Art. The largest terra cotta ever

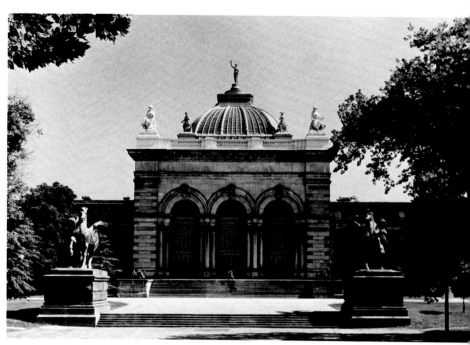

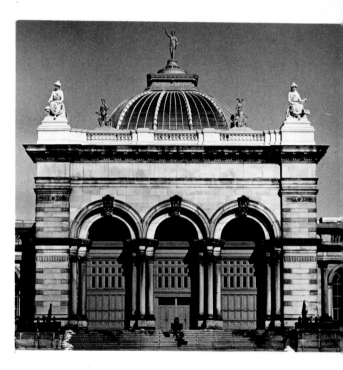

seen in this country, cast from the group of *America* by John Bell on a corner of London's Albert Memorial, struck a warm chord in the white surroundings of the rotunda inside (figure 1).

"The Teuton is not very flexible," wrote Earl Shinn, "but whatever he learns to do becomes a fixed fact...in America he has come to stay."[3] The Germanic character of the Philadelphia Centennial was assured by the selection of Bavarian Herman Schwarzmann as designer of the fair. The architectural vocabulary for his Memorial Hall is from his professor Gottfried Semper, and he bolstered his efforts with work by other Germanic artists:

> German talent—in the person of Mr. Schwarzmann— has adorned the Centennial Park with buildings, arbors and bridges.... A German artist, Mr. Pilz, was the author of the two statues of Pegasus, in bronze, which restively perch, with clipped wings, in front of the Art Building.... A German artist, Mr. Müller, prepared for the dome of the same hall the colossal figure of "Columbia," in persistent metal, to welcome the nations to the feast of Industry and Commerce—the international peacemakers.... As we pause, before entering, in the shadow of the shielding wing of the monumental Pegasus, we behold... [that] Memorial Hall... is just such a patient restoration of Roman architecture as Von Klenze might have drawn upon cardboard to show to his patron, Ludwig of Munich; and, crowning every pedestal and pinnacle with art of the same national parentage, we see the shadows of the Industries, of America, and of the gigantic mountain eagle, throwing themselves from the parapets above to the sward beneath.[4]

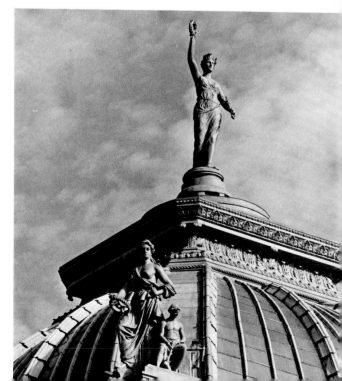

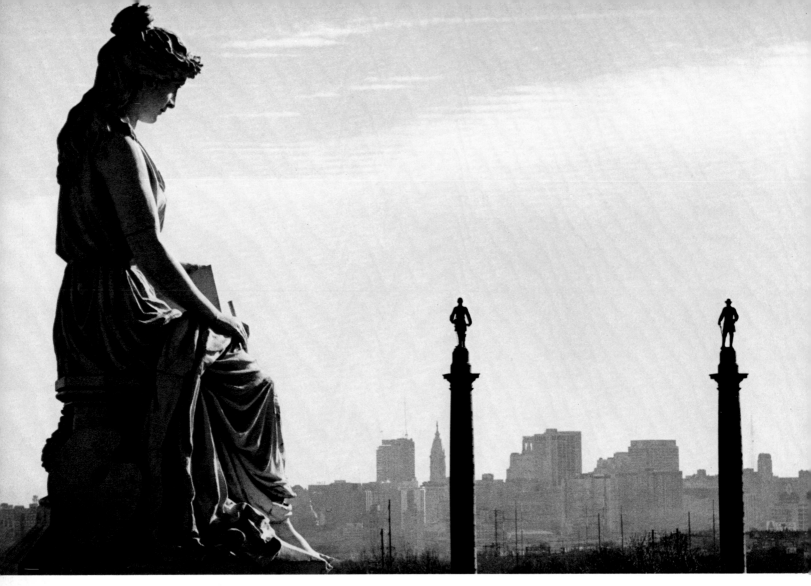

Images of Memorial Hall in contemporary illustrations and commemorative medals show variations in the figure of *Columbia,* explained by its history:

> *The figure was modeled in clay by Mr. A. J. M. Müller, a German artist, resident in Philadelphia, and was cast in metal by a firm in the same city. After the figure was placed in its present elevated position, it was subjected to several changes; at first it stood with outstretched arms; next these were put down, the left hand resting on the end of a cornucopia, and the right hand gracefully holding forth the olive branch—this latter change rendered the whole more graceful than before; but a storm arose, and next morning found the lady minus the forearm of the right member. A course of patching was then instituted, ending in making a bad case worse.*[5]

Eventually the original was replaced. Müller also did the corner groups and some of the inside decoration of Memorial Hall and remained in Philadelphia to compete for other commissions.[6]

Vincenz Pilz's *Pegasus* groups before the entrance were created for the Vienna Opera House. Condemned for being out of scale, removed and returned to the foundry for melting by order of the Austrian government, they were acquired instead by Robert H. Gratz of Philadelphia, who offered them to the city while Memorial Hall was still on the drawing boards; they were planned into that complex.[7]

Schwarzmann had recently landscaped the Philadelphia Zoo and was familiar with the zeal with which the Fairmount Park Art Association had cast Kemeys' *Hudson Bay Wolves,* so when he saw Wilhelm Wolff's *Dying Lioness* in Vienna in 1873, he thought it a proper acquisition for the Park. Photographs he brought back convinced the board to buy it, and "to place it during the Exposition next year in Memorial Hall." Schwarzmann installed it outside, however, at the southeast corner.

A gargantuan *American Soldier* in front of Memorial Hall, an industrial exhibit of the New England Granite Company, further enhanced the German character (figure 2). "What sempster . . . has draped him in those folds of adamant, that hang ten feet or farther from his inflexible loins?" asked Shinn, who had reservations about the artistic delicacy of the image, but nothing but admiration for the achievement.[8] A visitor from Hartford, Connecticut, claimed that it "was generally regarded as one of the finest colossal figures of ancient or modern times."[9] A more cautious observer remarked, "if not absolutely satisfactory as a specimen of skillful modelling,

it at least compared favorably with the colossal bronze 'Bismark' [by H. Manger] which was the most important piece of sculpture in the German section."[10] Could Carl Conrads ask for any higher compliment? A Bavarian stonecutter who emigrated to New York City in 1860, he joined the Union Army, and at the war's end settled in Hartford. He worked with no pretense to "high art," returning to Munich in 1871 to further his sculpture studies before commencing to fashion the sixty-ton block of Westerly granite into a common soldier as imposing as Bismark. "Of the tens of thousands of soldiers visiting the Exhibition, all stopped to admire and many to cheer the grand emblematic monument."[11]

Another German monument on the grounds was Herman Kirn's fountain, intended "to make forever memorable the Catholic Total Abstinence Union of America, and the Irish race in America."[12] Sculptor Kirn, born in Baden,[13] came to America as a child. After attending art schools, he returned to Germany for study with Carl Steinhäuser. Back again in the Tyrol after a stay in America, and assisted by Steinhäuser, he cut the figures for the fountain—*Moses, Commodore John Barry, Charles* and *John Carroll,* and *Father Theobald Mathew,* the apostle of temperance.[14] Resembling the *Moses* of the Acqua Felice in Rome, whose artist is supposed to have died of chagrin on hearing public reaction, Kirn's sixteen-ton *Moses* points upward to the source of the miracle which slaked the thirst of many a visitor that sweltering summer—also the source of the lightning bolt that was to demolish *Father Mathew.*[15]

The German aspect of the Philadelphia exhibition was so pronounced that it seems appropriate that Richard Wagner composed the Centennial March. However, if the appearance of the fair was Teutonic, it had a Gallic accent. Auguste Bartholdi came to Philadelphia in 1871 with plans for a series of fountains and a monumental gate to Fairmount Park, "a combination of Revolutionary history and municipal development,"[16] to be erected at the foot of Green Street, and outlined his idea for a Centennial lighthouse for the Atlantic gateway to America—a female figure with a tiara of lights which would be visible for fifty miles—The Statue of Liberty. John W. Forney, publisher of the *Press,* saw his drawings and models. Later, as Centennial commissioner in Europe, he called at Bartholdi's Paris studio in 1875 and saw a work intended for the coming exhibition:

> *a fountain, to be cast in iron, and placed, as a specimen of his work, I trust, in one of the spaces in the American division. It embodies Light and Water, the twin goddesses of a great city. Three colossal nymphs of exquisite form upbear a wide circular shield into which the water falls from other figures, while ten lamps held up by as many beautiful arms shed light at night from their gas-globes, . . . but the water is to flow forever. This rich and delicate group would cover some twenty feet, and rise about forty. All he asks is that our authorities should supply the water and the light. It is the joint production of M. Bartholdi and a Paris moulder of distinction [M. Durenne][17]*

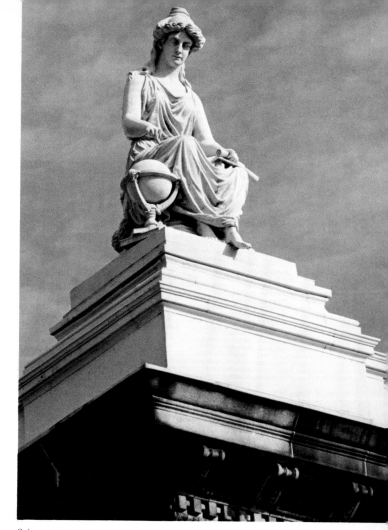

Science

Pegasus

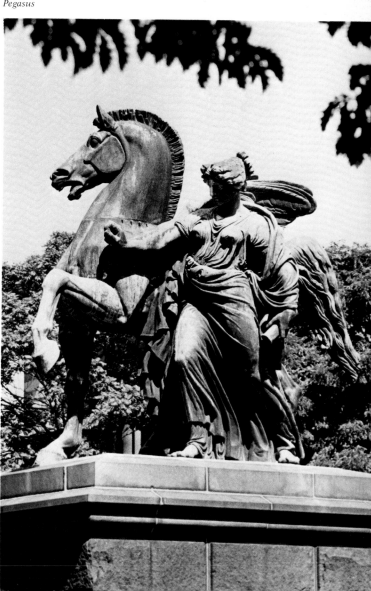

Commissioner Forney hoped that it would serve as a model for all our cities, "especially for such places as Reading, Lancaster, Easton, Erie, and other towns."[18] Two months before the opening Bartholdi wrote a nervous committee chairman, "if the foundation is ready, you will see that the building up will be made in a very short time."[19] The site at the main entrance commanded the most conspicuous view on the grounds (figure 3). In September Forney had also reported on the progress of the Bartholdi colossus: "One part of this colossal figure, the arm alone, has been modelled for display at the Philadelphia Exposition. The size of the complete statue may be conjectured when I tell you that this single limb looks like the mast of a ship."[20] Size thwarted the intention of French commissioners to place it in the French section. Also, as Bartholdi explained, it had to be close to the power source:

> We should like to have it placed not far from the square which is between the Machinery Building and the Main Building, because we shall light by electricity the fanal which is held in the hand. It will be done by M. Fontaine whose apparatuses are located in the point F, and consequently it is necessary to not be too far of that place.... I am to go with the work myself to Philadelphia at the end of May to see it constructed and ready for the fourth of July.[21]

Forty-two feet long, twelve feet deep, with a forefinger nearly eight feet and a torch capable of holding twelve people aloft, the arm of the Statue of Liberty was placed by the lake front, its "tremendous fingernails ...reflected in the shuddering waters of the Lake" (figure 4).[22] Meanwhile, "unable to do justice to the alarming versatility of this inexhaustible producer, who formed an Exposition within an Exposition by the variety of his contributions at Philadelphia," Earl Shinn settled with relief on a Bartholdi piece in more intimate scale:

> His "Young Vine-Grower," a bronze design for a fountain was exhibited in the middle of the principal French room in Memorial Hall.... The strapping young vintner...drinks from a keg of new wine, which he lifts with a free action in his hands. In the fountain when complete, a stream would run from the bung-hole of the keg directly into the open mouth of the figure: this was represented in the specimen on exhibition by a slender thread of glass. It is a graceful thought gracefully expressed.[23]

France's display was generally undistinguished, although Rodin made his American debut with decorative pieces exhibited among the Belgians with whom he was then working, and Joseph A. Bailly also contributed. Bailly was a revolutionary who fled France in 1848 after shooting his commander, and ultimately settled in Philadelphia in 1850, where he married, and at the Academy of the Fine Arts instructed the younger generation of sculptors such as Blanche Nevin, Albert E. Harnisch, and Howard Roberts. After the closing of the old Academy, he executed portraits of President Guzmán Blanco in Venezuela. One of these, an equestrian, was shown in the great central hall of the Art Building. His

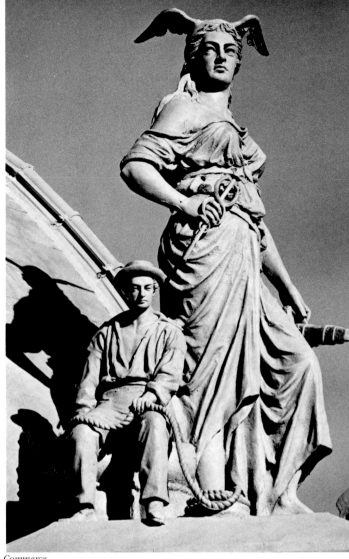

Commerce

Industry

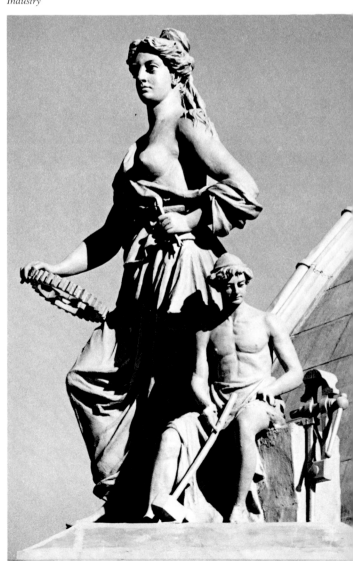

delicate marble *Aurora* was in the United States gallery, and his bronze *Witherspoon* was planted firmly on the block of Scottish granite donated by Presbyterian women of America as a permanent Protestant monument for the park (figure 4). In 1876 Bailly was one of the most respected American sculptors.

Never before in the United States had the needs of sculpture been so well anticipated as in Memorial Hall, which had been designed especially to accommodate sculpture. Even by European standards it was a noble building. Lithographs of it impressed both the exiled Empress Eugenie and repatriated Garibaldi, and throngs admired them on display in Paris shop windows. Philadelphian Thomas Evans owned the *American Register,* which he used to promote the fair in Paris. A thorough progress report from Philadelphia was published in the London *Times* on July 24, 1875, and in translation in the German press, and it dawned on Europeans that it would be the greatest trade fair ever held. Americans in Europe had been hard at work for some time. "I have yet to hear of an American, from whatever State, who is not doing his best for the Centennial abroad," said Forney. "The Philadelphians are, of course, foremost in their appeals."[24]

Some years earlier, in 1866, three Pennsylvania Academy students enrolled at the École des Beaux-Arts— Earl Shinn, Thomas Eakins, and Howard Roberts. Roberts worked there with Dumont and Gumery for three years. He returned to Paris in 1873 with a piece completed in the plaster in Philadelphia *(Hypatia),* intending to work it up for the Centennial, but he abandoned the literary subject in favor of an academic nude. "The French distinguish works of this character from historical subjects or traits of character, by the term *'académie,'* or an academical study; that is to say, a conscientious reproduction of some living figure, where faithful adherence to nature is more the object sought than pathos or humor or dignity."[25] By April, 1874, Roberts' success was apparent to an American visitor to his Paris studio: "In its center stands a female figure in clay that would seem to require less than an act of the gods to bring her to life. It will do much to raise high the reputation of Philadelphia for having produced a number of the best modern sculptors."[26]

"The teaching of French professors is above all technical in its nature," Earl Shinn wrote. "The teaching of Italy is only an 'influence in the air.' "[27]

The American artist in Rome scarcely ever hears severe, healthy criticism. Unlike the American artist in Munich, who sees the measure of his success as in a mirror in the publicity of art-comradeship, in the enthusiastic appreciation of his Bavarian fellow-artists, and in the discriminating encouragement of his professor—unlike the American artist at Paris, for whom the harsh grunts of the maître *and the merciless irony of the "school" quickly distinguish every fault and weakness—the Yankee at Rome is a little king, a great diner-out, a frequenter of "At Homes" and "Thursdays," one of the sights of the city, and a power*

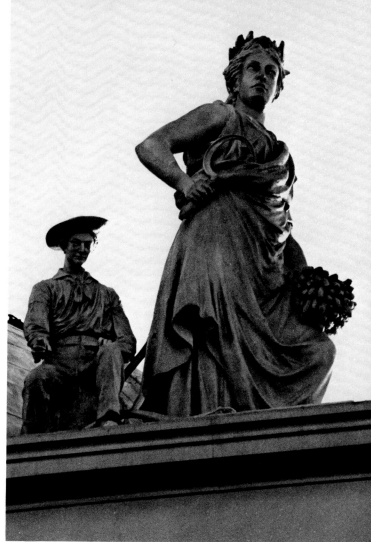

Agriculture

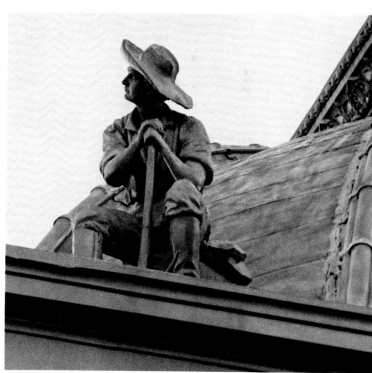

Mining

that may be cultivated or neglected, but never weighed.[28]

The uncontested dean of American sculptors in Rome was William Wetmore Story, known through his writings and those of James and Hawthorne. Forney visited him in his splendid apartments in the Palazzo Barberini to discuss the progress of the Rome Committee on Selection, headed by Story, and paused in the palazzo gardens at a modest studio. "Mr. St. Gaudens was absent in America," he reported, "but his janitor informed me that he contemplated an appropriate contribution to our Exposition." Fresh from Paris, he too was working up an *académie*: "In Mr. St. Gaudens' studio there is a colossal 'Hiawatha,' of much merit."[29]

The unlaureled leader of the American sculptors in Rome was Randolph Rogers. "He is so essentially a Philadelphian...that it would be idle to speak of his deep interest in the Centennial."[30] The work which made his fame and fortune was *Nydia, the Blind Flower Girl of Pompeii* (figure 5), which tugged at the same heart strings that vibrated to Little Eva crossing the ice and was known in every Victorian drawing room. A hundred-odd replicas were produced; "I once went to his studio and saw seven Nydias, all in a row, all listening, all groping, and seven marble-cutters at work, cutting them out," recalled a visitor. "It was a gruesome sight."[31] "Even at this day," the Philadelphia critic William Clark said in 1877, "[it is] one of the most popular statues that has ever been executed by an American artist."[32]

No German romantic could aspire to surpass the surroundings the American Moses Ezekiel found in Rome, his apartment in a tower in the city walls, or the vast studio in the ruins of the Baths of Diocletian. In the B'nai B'rith monument to Religious Liberty, his first monumental commission since completing studies in Berlin, there is a satisfying combination of ideal German convention and virtuoso Italian finish, integrated with an iconography complex enough to command attention:

It represents Republican Freedom, in the figure of a woman eight feet high holding in her left hand the laws of equality and humanity, and symbols of victory; in her right, the genius of Faith raising the burning torch of religion. Liberty is a female of majestic and dignified mien, strikingly grand in the simplicity of her Greek attire. She is clothed in armor, but the mantle of peace held by an Agraffe, so that her right breast and arm are exposed, descends in long broad folds from the left shoulder to the right foot.

The genius of Faith, holding the flaming torch, is a handsome youth, naked, symmetrical in all his forms. The crown of laurel, the instrument of the American Constitution, the colossal eagle crushing the serpent (the symbol of tyranny), typify the glory and power of the country of Washington.[33]

The American women of Rome were hard at work for the art exhibit, except Harriet Hosmer. "I don't think I should trouble myself to send anything to the *general* exhibition," she wrote to Mrs. Gillespie of the Centennial

Young Vine Grower

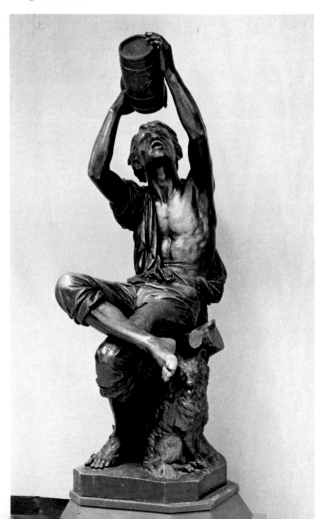

The Reverend John Witherspoon

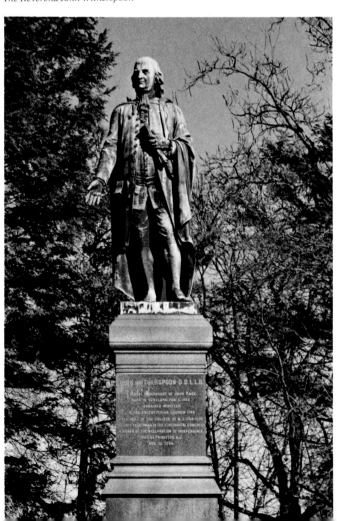

Women's Committee, "whereas for the women I shall send everything I can rake and scrape together.... I have a truly American subject in hand now, and I shall certainly send that; I must try and find a good woman subject."[34] Free transportation for American works cleared by the regional selection committees was offered by the United States Government, and early in 1876 the sculptors of Rome were preparing to meet the boat:

> Many works are already at Civita Vecchia, awaiting the arrival of the United States ship by which they are to be transported. Among these are seventeen pieces by the sculptor Mr. T. H. Haseltine.... Mr. Handley sends seven or eight works of sculpture, Milmore, his "Boston Monument"; Mrs. Freeman her bronze vase; Miss Foley,... her graceful design for a fountain.... A young artist from Cincinnati, C. L. Fettweis, Jr., has finished a statue for the Centennial,... called "The Castaway".... It would be well if this statue could be in the possession of some steamship director, warning him, with its silent but eloquent discourse, to look earnestly to the safety of those confided to him.[35]

In 1875 William G. Turner, Larkin Mead, Pierce Francis Connelly, Thomas Gould, H. R. Park, and Preston Powers were in Florence, preparing pieces for the Centennial.[36] "The studio of Mr. P. F. Connelly contained many exquisite pieces," Forney reported. "This promising artist is but thirty-three, and has not seen his native country for many years, yet has a most vivid recollection of his friends in Philadelphia."[37] Born in Louisiana, brought up in England, Connelly was known at the Philadelphia Sketch Club as Father Connelly because his clergyman father had become a priest and, as Mother Cornelia, his mother founded the Order of the Holy Child Jesus.[38] Connelly studied at the École des Beaux-Arts in Paris, and in 1863 he submitted to the Pennsylvania Academy's Annual from Rome, where Tuckerman said he had "gained rapidly in public estimation by his well-executed portrait-busts, and a few ideal works exhibiting both force and feeling."[39] Regarded by fellow American sculptors as an eccentric, Connelly was well connected in Italian society and had many English commissions. In the decade prior to the Centennial he worked in Florence on "ideal" works such as Thetis, St. Martin Dividing His Cloak, Diana Transforming Acteon, and Honor Arresting the Triumph of Death, all exhibited at the Centennial. Honor and Death occupied him for three years (1866-69) and created a sensation: "One scarcely knows which to admire more, the audacity of the scheme or the skill with which it has been handled," said Lorado Taft.[40] Death rides roughshod over Courage, Perseverance, and Strength, only to be pulled up short by Honor. "If not all a nice aesthetic taste would require in its treatment," Jarves remarked in Art Thoughts, "[it] is a profound idea, harmoniously put into plastic form, and calculated to incite the ambition of other of our young sculptors."[41]

Memorial Hall had no Chief until John Sartain accepted the post in September, 1875, almost too late to pull the chestnuts out of the fire. Not until then was it discovered that space in the building was inadequate, and a brick annex was commenced. "The honey-comb of ...the Annex is filled with consignments of paintings and statues, yet unpacked, from all lands under the sun, [and] in one of the cells of this labyrinthine construction, Mr. Sartain, the Superintendent of the Art Bureau, has established his office," the New York Tribune advised its readers on April 24. In expectation of a large American turnout, Sartain convinced France, Great Britain, and Germany to relinquish assigned space.

The assignment of space must have been dictated by accident. There was much public pressure on Martin Milmore and Larkin Mead to use American labor on American monuments, so Mead's Navy group for Springfield's Lincoln Monument (figure 6) had been sent from Florence to be cast at Chicopee, Massachusetts, and was then put in place flanking The Dying Lioness. Bailly's Aurora was made in Philadelphia. The Première Pose had arrived in the city from Gotha early in the year for Roberts' finishing touches. Connelly's Honor and Death was cast in 1869, and like his marble Ophelia must have been in Philadelphia before the late arrival of the ship Supply, which had been delayed at Gibraltar.[42] On May 2 the Press held forth hope that the Supply was "daily expected in port" with American art works from abroad. "The Art Department of the Exhibition is the one department that will not put its house in order," the New York Tribune complained well after the opening of the fair, with "statues in boxes seen through slats like animals in a menagerie."[43] Through some mishap at the docks in

Religious Liberty

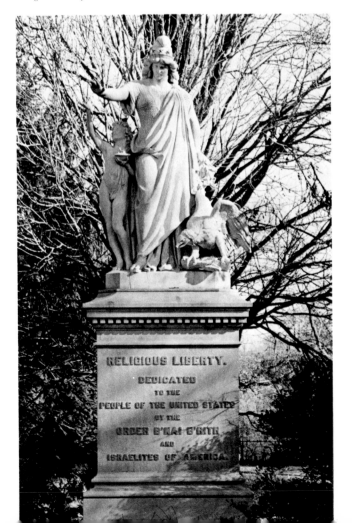

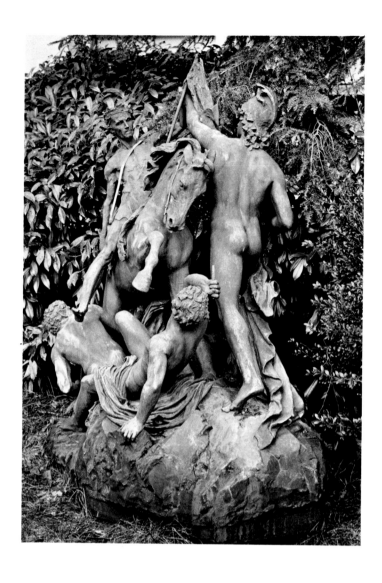

Livorno, Ezekiel's *Religious Liberty* arrived in Philadelphia after the close of the fair and a similar misadventure in Antwerp befell most of the figures for Kirn's fountain.

John F. Weir's complaint that there was no attempt to illustrate the progress and present condition of American sculpture seems harsh.[44] The gamut ran from the ideal classicism of Story's *Medea* through a homespun Apollo Belvedere, *The Minute Man*, by young Daniel Chester French. More than a score of John Rogers "groups" represented the popular anecdotal genre, and the *Ruth*, *Nydia*, and *Atala* of Randolph Rogers illustrated the slightly more sophisticated literary genre. The bric-à-brac in the Main Building reflected the same narrative tendency, such as the *Bryant Vase* encrusted with waterfowl and other motifs from the poet's oeuvre. Our statesmen and heroes were present in effigies by William Rush (Washington), Erastus Palmer (Livingston), and the young Saint-Gaudens (Evarts).

Power's *Greek Slave* had been hailed by the English at the Crystal Palace as the bud of New World genius, and in 1862 they saw in Story the bloom. According to Clark, "It was during the progress of the Centennial Exhibition of 1876, in Philadelphia, that the American public was first afforded a reasonably good opportunity of forming an estimate of this artist's merits."[45] His *Jerusalem*, just donated to his alma mater and then on view in the new Pennsylvania Academy, impressed him less than the *Medea* shown in the rotunda of Memorial Hall, and even this raised doubts: "the question involuntarily arises, why...did he not adhere to tradition in representing the Colchian sorceress as other than a Greek? For a Greek this beautiful woman with the beetling brows and the dagger in her hand assuredly is."[46]

When Story burst upon the American public in Philadelphia even Italian sculptors "declined to 'do Greek' any longer, betaking themselves to those romantic, picturesque, and *genre* subjects and methods which have held sway ever since."[47] Progressive Americans had turned from Rome to Paris for their training and philosophy, and foremost among these in 1876 was Howard Roberts. "In the United States Department there was no piece of sculpture which was marked by such high technical qualities as the *Première Pose* of Howard Roberts—a work which was almost as much a product of the schools of Paris as the admirable performances exhibited in the French Department," Clark said of his Sketch Club colleague (figure 7).[48] Taft acknowledged that "compared with the knowledge and control of the body shown in this work, many of the earlier statues look almost like

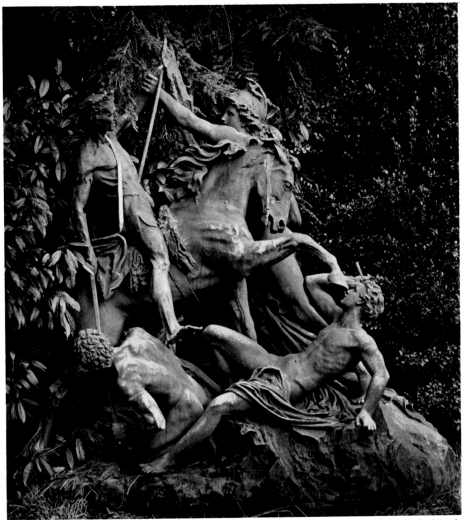

Honor Arresting the Triumph of Death

examples of poor taxidermy.... Henceforth the sculptor must know his theme."[49] Roberts' position in art was transitional, for he was already being overtaken by Saint-Gaudens. "The change in American sculpture which the Centennial period ushered in was not one of name alone, but of spirit," said Taft in retrospect, giving credit to Roberts for his role. "Broadly speaking, it was the substitution of the art of Saint-Gaudens for that of Hiram Powers."[50]

The most ambitious work by a woman sculptor, the fountain by Margaret Foley, was originally conceived as a bronze for a Chicago park. After the Chicago fire she released subscribers from obligation and translated it into marble for the Centennial.[51] She was dismayed that it was not erected in Memorial Hall, but a visitor to Horticultural Hall thought "Miss Foley's beautiful fountain in the centre adds very much to the *tout ensemble*":[52]

> *In the centre of the conservatory is a beautiful fountain, executed by Foley. Its basin is encircled with a verdant rim of foreign ferns, interspersed with rich-leaved bergonians [sic] and beautiful tree-plants, such as ornament the gardens of Japan. They bow gracefully to receive the perpetual sprinkle of the fountain's spray, and seem to enjoy watching the gold-fish sporting among the lily-pads in the water below (figure 8).[53]*

Among the women artists, Edmonia Lewis was a revelation. She declined to follow Story's example and give her *Cleopatra* Nubian features, although herself of mixed African and Indian descent, following documented likenesses instead. She was otherwise true to the subject—too true for some: "The effects of death are represented with such skill as to be absolutely repellant."[54] The *Spirit of Carnival* by Vinnie Ream was shown in Memorial Hall, and was better than comparable figure work by male compatriots in Rome, for instance, the *West Wind* by Thomas R. Gould.[55]

In the Women's Pavilion, Blanche Nevin's plaster of *Cinderella* posed "as if the Dying Gladiator had shrunk back into infancy and femininity."[56] A special alcove was draped in red to receive "Miss Hosmer's Gates," listed in the early editions of the official catalogue as *Lord Brownlow's Gates,* and her *African Sibyl,* but these were never sent for fear of damage in transit.[57] She "scraped up," instead, a gilded *Triton* and something unquestionably a suitable "woman subject," a relief portrait of the dauntless Mrs. Gillespie.

Had this been executed in mozzarella it would have competed with the "Butter Lady," beside which the mustard pyramid, the tobacco eagle and liberty bell, and all the citrus and pomological architecture at the

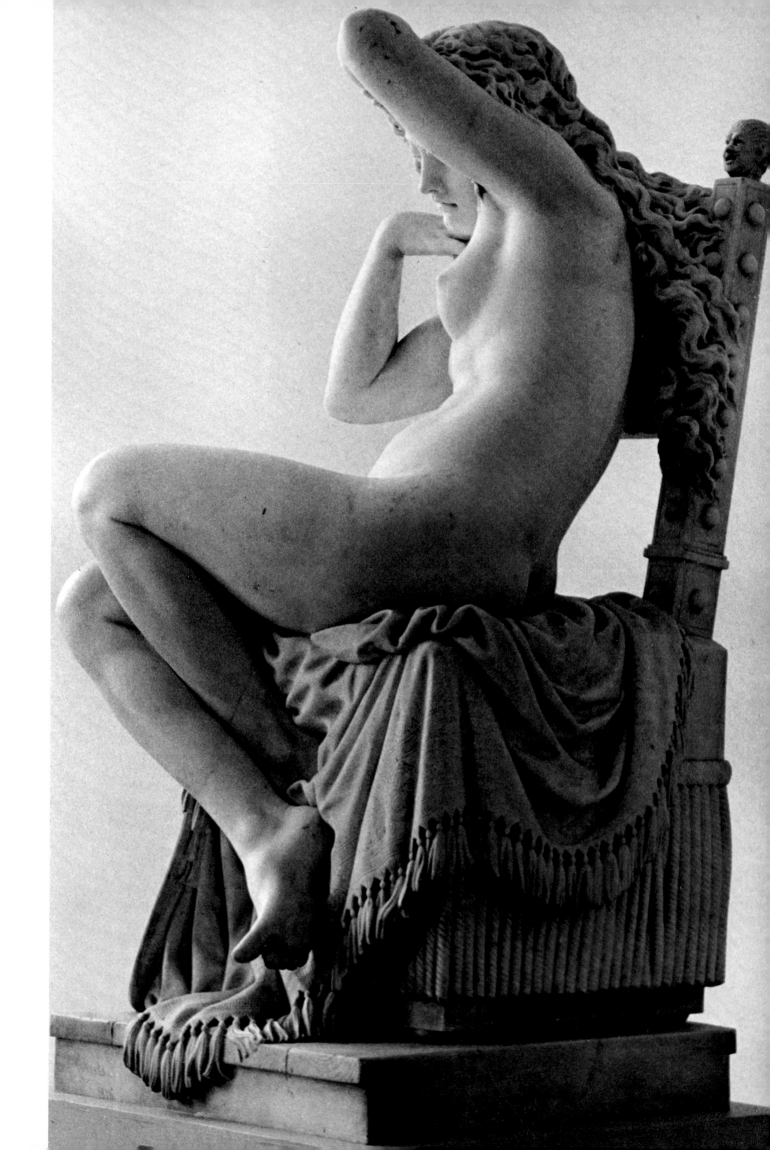

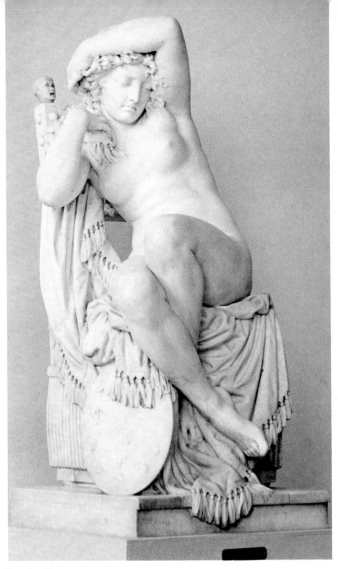

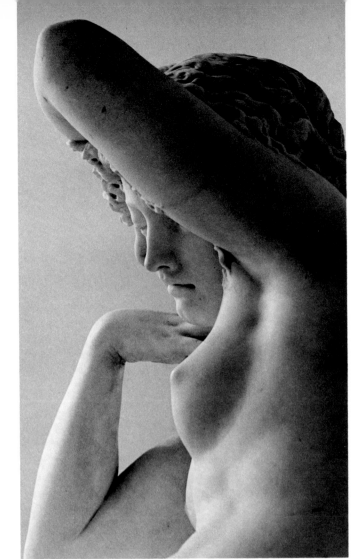

Première Pose

Exhibition paled. Packed in ice, it had been sat upon in transit by a "burly son of Africa" and had to be reshaped. "So great was the crowd in the Women's Building, that the Butter Lady was removed to the upper floor of Memorial Hall, [where] the multitudes had to be regulated by the Centennial guards."[58] "That the Art Committee should have allowed that head modelled in butter to have been exposed as it was, shows that they considered art as a kind of a boyish trick," Alden Weir complained from Paris.[59] Yarns about the lard eagle flying back to Cincinnati and of the ice cream racehorse that only ran at certain temperatures were rampant. But to many a visitor it was a grand achievement, as it was to Josiah Allen's wife:

> I had thought in my proud spirited hautiness of soul that I could make as handsome butter balls, and flower 'em off as nobby as any other woman of the age. But as I looked at that beautiful roll of butter all flattened out into such a lovely face, I said to myself in firm accent, though mild: "Samantha, you have boasted your last boast over butter balls."[60]

In a command performance on October 14 before Centennial Commissioners, members of the Women's Committee, and gentlemen of the press, Miss Caroline S. Brooks of Arkansas repeated her feat, and in an hour and a quarter, with a pair of spatulas and a dozen pounds of butter, produced another golden *Iolanthe*[61] (figure 9).

Italian residents of Philadelphia had been raising funds for years for the erection of a monument to Columbus. Ground was dedicated on the Fourth of July, 1875, at a location suggested by Schwarzmann, "a point west of Belmont Avenue on a new walk open from the conservatory to the rear of Machinery Hall," and sketches were submitted in August:

> The statue and accessories will be as they appear in the design with the legend Italy to America and In Commemoration of the First Centenary of American Independence on the pedestal. The whole will, when completed, present a high finish and grand character. It will be executed in Italy by an Italian sculptor of eminence and of a durable Italian marble.[62]

Of all the permanent installations this is the only one whose artist defies identification beyond "court sculptor." Surrounded by symbols of his accomplishments, Columbus stands atop a pedestal decorated with reliefs depicting the sighting of the coast, the first landing, and the seals of Italy and the United States.

In 1875 it appeared to one reporter that "almost the only one of the Florentine sculptors who was devoting himself assiduously to the preparation of works to be sent to the Philadelphia Exhibition is [Emanuele] Caroni."[63] Early in 1876, another wrote, "On account of the material risk incurred by transportation, as well as the expense, which, in spite of the amount assumed by their government, is still considerable to the artists themselves, many of the best Italian artists have decided not to send their works to the Philadelphia exhibition."[64] But these fears were unrealized. Of the 675 sculptures exhibited in the art department, 325 were Italian.

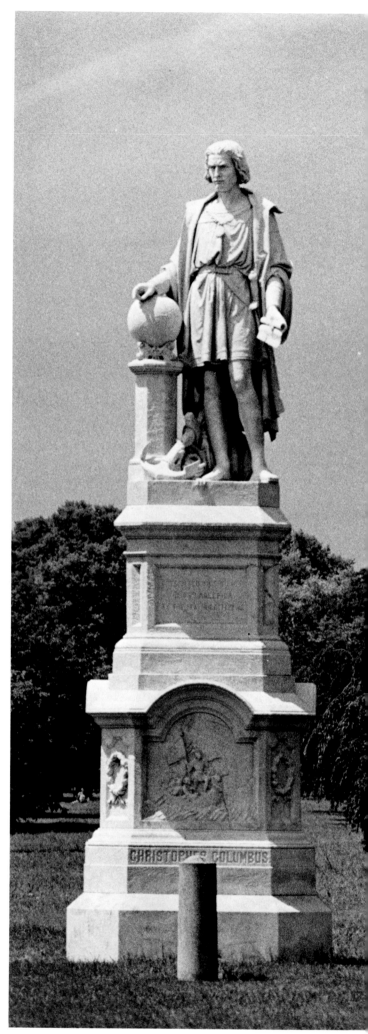

Columbus Monument

"Almost immediately after the Centennial the Italianate group became negligible as a force, and the Parisian-trained sculptors rose into a prominence which, in a short time, became domination," wrote Taft.[65] But in 1876 Italians carried the field. The Italian consul in Philadelphia, Signor Alonzo Viti, had "always, like his father before him, felt for Italian sculpture the interest of a connoisseur and a patron."[66] He had worked hard. Also, many of the pieces were already on this continent for a Latin American exhibition immediately preceding the Centennial. "Nothing in the whole Exhibition attracted so much attention as the Italian statuary," observed John Sartain: "The Art Galleries were at all times the most crowded part of the fair, and the rooms containing these statues were the most crowded portions of the galleries."[67]

Despite this enthusiasm, many professionals, such as John F. Weir, were negatively impressed: "The display of remarkable subtlety in the manipulation of material, in the dexterous undercutting and intricate chiseling, which rendered many of the sculptures curiosities rather than works of art, gave evidence of great skill in workmanship; but there was little that was essentially and vitally sculpturesque."[68] But Earl Shinn pointed out that the statuary had a "rich, pictorial, and...colored quality of their own, which justifies the theory on which they are carved": "If the success in representing texture were attained by an uncommon and worthless degree of mere *finish*, it would not be commendable; but...it is not the difficulty or the patience, but the live flesh and expressiveness of the touch that gives the effect."[69] And Sartain responded to critics with customary vigor: "Their execution is wonderful, and whatever the critics may say, the popular instinct recognizes and approves the truthfulness to nature manifested in these works."[70]

Emmanuele Caroni had worked as a cutter for Randolph Rogers and knew the value of American appreciation. His preparations were not misplaced. From Philadelphia his *Africana* (figure 10) and *Telegram of Love* went to the San Francisco collection of A. E. Head, as did the *Forced Prayer* by Pietro Guarnerio, one of the most popular sculptures at the Centennial. Another edition of this work was acquired by the Corcoran Gallery, along with Caroni's *Youth as a Butterfly*.[71] Pasquale Romanelli's *Benjamin Franklin and His Whistle* and *Washington and His Hatchet* were mass produced and found their way to the collections of the Union League and the University of Pennsylvania.[72]

Of the "Centennial nudities" which sent thrills of revulsion down some American spines, one of the best was the *Bather* by Antonio Tantardini of Milan, acquired by A. T. Stewart for his Fifth Avenue mansion, where it shared a gallery with Story's *Zenobia* and yet another *Nydia*. The Tantardini is less objective, more generalized, and at the same time more daring in undercutting than the *Première Pose*, which it otherwise resembles. Pietro Bernasconi's *Adultress* joined Story's *Cleopatra* in the New York collection of Mrs. Paran Stevens. At least two editions of Francesco Barzaghi's *Finding of Moses* stayed in America, the one in the Centennial being acquired for

$3,500 and given to the Pennsylvania Academy.[73]

The proscription against walking sticks and umbrellas in the galleries was totally ignored, but there was surprisingly little damage suffered by Centennial sculpture while on exhibit. Souvenir hunters took the knife of Story's *Medea* and the book held by Tantardini's *Reader*, but the culprit who broke off two middle fingers from Andrea Malfatti's *After the Bath* apparently had other motives: "the remaining fingers, extended, accordingly represented a superstitious and vulgar gesture in use among the lower Italians. The outrage was probably therefore committed by an enemy and a native of Italy."[74]

At the close of the fair, Mead's *Navy* went to Springfield, Illinois, the *American Soldier* to Antietam, the *Columbus Water Cooler* to Upjohn's new capitol at Hartford, the *Hiawatha Vase* to the White House. Bailly's *Blanco* returned to Caracas, to be overthrown in 1878 along with the regime of the subject, and the terra-cotta cast from Bell's *America* went to Washington, and on to Chicago, where it eventually met the same end. Bartholdi's *Young Vintner* was acquired by Anthony J. Drexel, and his *Fountain of Light and Water* was reassembled in Washington's Botanical Gardens. Works unclaimed became the property of the Fairmount Park Commission, which thereby obtained the Portland brownstone portal, admired as "one of the finest finished works that was ever made of this stone," now on East River Drive. The Foley fountain, purchased for Philadelphia for $8,000 from the artist by George Whitney, whose death delayed the intended donation, was never installed in a permanent basin and fell into disrepair; the present whereabouts of its components are unknown to me, although replicas of the individual figures are in public and private collections.[75]

Immediately after the close of the fair, Gibson's small *Venus*, Roberts' *Première Pose* and *Hypatia*, Connelly's *Honor Arresting the Triumph of Death*, Barzaghi's *Finding of Moses*, Story's *Jerusalem*, and sculpture by Lombardi, Mozier, Bailly, and others were assembled in the Pennsylvania Academy, in what was, at the time, the finest public collection of contemporary sculpture in this country. Style is fickle, and by the middle of this century most of the Centennial deposits and gifts had been withdrawn, declined, given away, or destroyed.[76]

The stuffed tableaux in the United States Government exhibition and the *tableaux vivants* staged by Mrs. Gillespie might qualify as sculpture today. The pre-Columbian pottery, the carved and painted totem poles and canoes of the Pacific northwest tribes, and the Yoruba helmet masks certainly would (figure 11), but in 1876 they were regarded as curios, like the Japanese architecture. No one was looking for them, as they would at fairs in America and Paris in the following quarter century. Then there was the whole ensemble, the environment: the overlapping sounds of the Wagner overture and the passing military bands, with the clattering of machinery set in motion when President Grant and the Emperor of Brazil activated the giant

Franklin and his Whistle

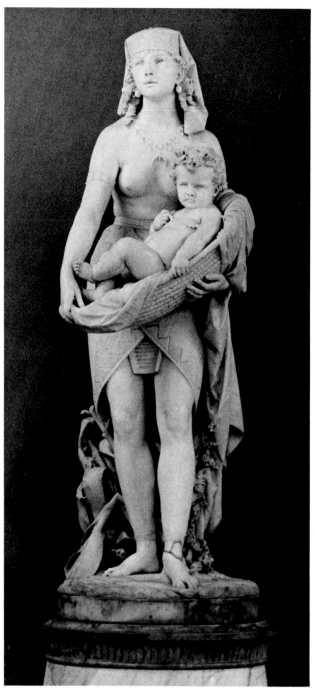

Finding of Moses

Corliss Engine; the roar of the everchanging hydraulic jets and cascades of the pressure pump exhibit, with its rush of cool air; the glitter of the crystal fountain; the great glass buildings themselves.

One evening the architect of the Main Building took the narrow-gauge scenic railway and was enchanted beyond expectation:

> As we turn and look back towards the Main Building, we are treated to one of the most beautiful sights it has ever been our fortune to witness. We are on a slightly rising slope, and the whole extent of the Main Building and Machinery Hall... comes into view. The Main Building is one blaze of light, of flaming fire, from end to end, owing to the reflections on the glass of the rays from the departing sun. It is a grand illumination. In the foreground the fountain has ceased to play, and the now quiet lake, a bright gem in its green setting, reflects every line and flash. The dome of Memorial Hall looks up over the trees.... Restless, happy crowds are flitting from point to point, and the whole looks like fairy-land, an incantation scene, something that we wish would never pass away.[77]

Lot's Wife

The Sculpture of City Hall

by George Gurney

*photographs by
Seymour Mednick*

The creative magnitude and design of the sculpture of
Philadelphia City Hall, or the "New Public Buildings" as it
was first called, may seem superfluous when compared to
contemporary public buildings which favor purity of line
and simplified ornamentation.[1] Begun in the early 1870s,
City Hall was to be in the French Second Empire style
exemplified by the new Louvre (1852–57). This style
demanded unification of sculptural and architectural
ornamentation not unlike the Gothic cathedrals of the
thirteenth century. The combined arts were meant to be
instructive as well as aesthetically pleasing. But the
iconography of City Hall attempts to encompass such a
wide scope of subjects that its instructional value is
unappreciated or only vaguely apparent today. City Hall is
also medieval in that its construction took over thirty
years, during which time its sculptural designs changed
and developed as the building progressed. The three men
most responsible worked so closely together that the final
sculptural program cannot be attributed to any one
individual. These men were: Samuel C. Perkins
(1828–1903), president of the Commissioners for the
Erection of the Public Buildings for twenty-eight years,
John McArthur, Jr. (1823–1890), the architect, and
Alexander Milne Calder (1846–1923), the sculptor.

When the State Legislature of Pennsylvania approved
the act creating the "Commissioners for the Erection of
the Public Buildings" on August 15, 1870, Samuel Perkins
was one of the appointed members, and on April 17, 1872,
he became the permanent president, remaining so until its
dissolution in 1901. This autonomous body, which
superseded a city-appointed committee that had been
working on plans during most of 1869, had full power to
arrange and approve all functions that were needed for
the erection of the new buildings and to appoint a
"competent" architect. John McArthur, Jr. was appointed
September 15, 1870. As early as 1871 Perkins was made
chairman of the subcommittee on plans, and, therefore,
from the beginning he worked closely with the architect.[2]

The relationship of these two men can be illustrated

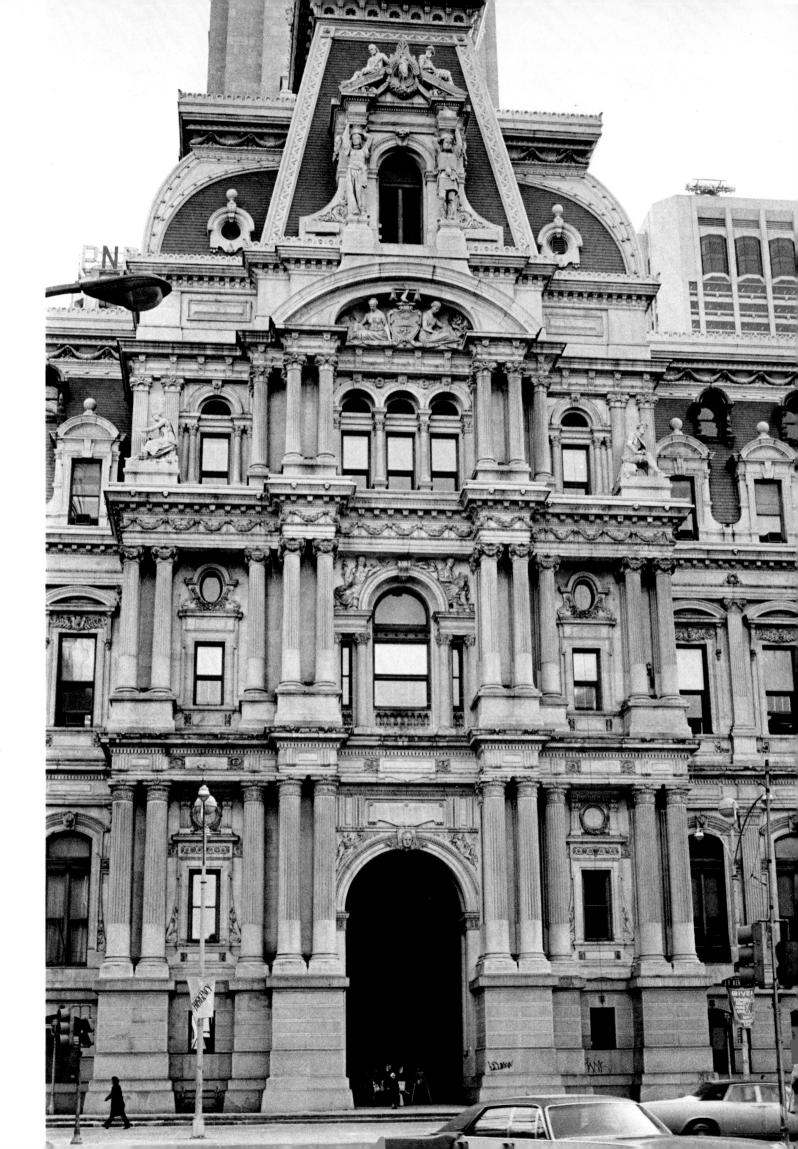

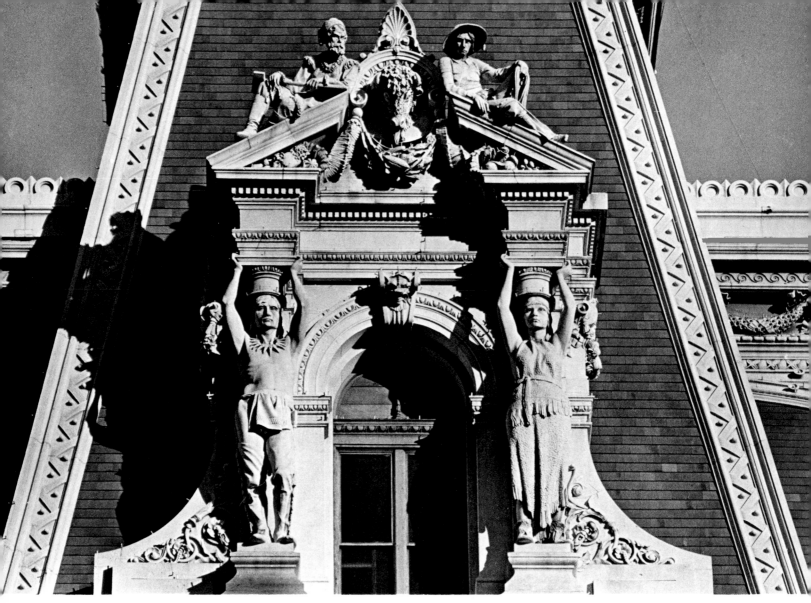

Dormer Caryatids

by an incidental detail. On September 29, 1874, the commissioners approved the addition of eight sculptured panels of a cat pursuing a mouse for the south entrance vestibule. Perkins loved cats, and the inclusion of the panels appears to have been an early personal concession on the part of McArthur to Perkins, as no other explanation for their appearance is apparent.[3]

The Second Empire style as employed by Louis Visconti and H.-M. Lefuel in the new Louvre had become "the taste of the age," and sculpture was one of the Louvre's prominent decorative features. Even before the commissioners took control, there was little doubt that City Hall was going to be in this style. In McArthur's prize-winning design of September, 1869, the plan was French-inspired in the use of mansard roofs and pavilions, but sculpture was largely ignored. However, the committee asked McArthur to make some modifications and the resulting perspective of December, 1869, featured sculpture on the domed clock tower. Single standing figures had been placed at the four corners of the first story of the tower, and, above these, seated figures dominated the corners of the second story. It is believed that the crowning figure of the dome represented justice.[4]

The photozincograph of City Hall by F. A. Wenderoth, which was issued in 1872 by the Commissioners for the Erection of the Public Buildings, and I believe is the one illustrated here, gives evidence of further changes in the sculptural program and a suggestion that ideas for the iconography were beginning to develop (figure 1). In this perspective view of the north front, the arms of Pennsylvania are found on the central pavilion in the top segmental pediment.[5] Below, around the second-floor window arch, some spandrel reliefs seem to be indicated. The tower figures and their positions remained generally the same except for three important alterations. A standing figure of William Penn replaced Justice. An eagle appeared over the clock on each side. Below the first floor of the 1869 tower elevation, another story was also inserted, and four standing figures with symbolic attributes flanked the east and west sides respectively. Two of the figures can be identified: a female figure with a cornucopia presumably representing Plenty and a male form with a large gear at his feet emblematic of Mechanics.[6]

By 1876 the sculptural decoration definitely was beginning to have grandiose pretensions, but the detailed

conceptions were still far from settled. A perspective drawing in the *American Architect and Building News* of July 1, 1876, showed that the tower elevation had been modified and that the lower emblematic figures on the 1872 view had been eliminated. Ironically, on the wall below the north stairway of the east entrance vestibule, this 1876 transitional tower design is now depicted in the background of a relief panel that symbolizes Architecture. On the lower body of the building, the 1876 perspective also pictured some figurative keystones, spandrel reliefs, seated three-dimensional figures on the central pavilions, dormer caryatids, and crowning figures on top of the dormers. Therefore, the iconography must have been worked out to a large degree, and the representation of the four continents' theme on the central dormers had been settled upon. Except possibly for the tower, the final ideas for the sculpture must have been decided sometime before June 7, 1882, when William Struthers and Sons, the marble contractors for the exterior, notified the commissioners that the last stone had been put in place on the southern facade. The shape of the other facades, therefore, was established, as they followed the same general design. This documentation proves that City Hall started without any sculptural program and ended with the most ambitious sculptural decoration of any public building in the United States up to its time.

A report on the final payment to the marble contractors in the minutes of the commissioners of November 7, 1887, noted the situation: "changes in treatment of the original design of the building have from time to time been made, as artistic developments of the first conception, such for instance as the adoption of human figures as the *motif* of decoration, instead of conventional foliage, arabesque or geometric figures, thus permitting a high and more beautiful style of ornamentation. The New Public Buildings or City Hall, today contains 94 sculptured figures as against 20 contemplated in 1873."

Incidentally, Struthers and Sons was able to do this at no extra cost![7] Although the marble cutters produced ninety-four figures for the exterior, this number reflects only a portion of the total sculpture. The number of figurative works on the exterior and interior of the building adds up to more than 250.

Truly City Hall was McArthur's monument, for he controlled the integration of the architecture and the sculpture.[8] With the aid of Samuel Perkins, the architect had the strong backing of the commissioners. McArthur also had the somewhat rare experience of hiring and working with only one sculptor, Alexander Milne Calder, to supervise all the modeling of the architectural and sculptural decoration.

Calder had started working in stone as a youth in Scotland under John Rhind, R.S.A., who was the father of John Massey Rhind, sculptor of the figure of John Wanamaker at the base of the east side of City Hall.[9] For three years, he worked in Edinburgh at the Royal Academy, where he probably learned the techniques of

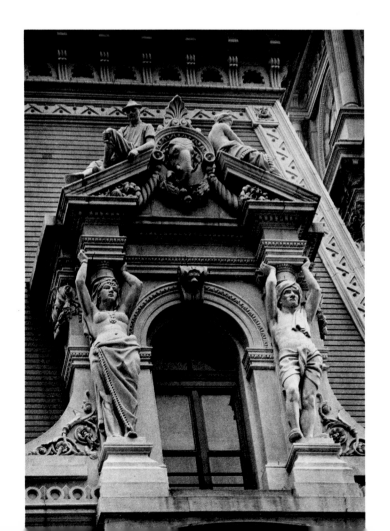

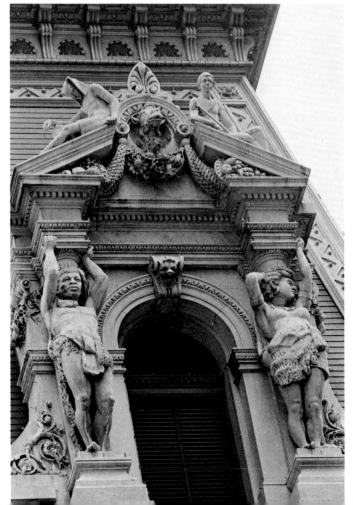

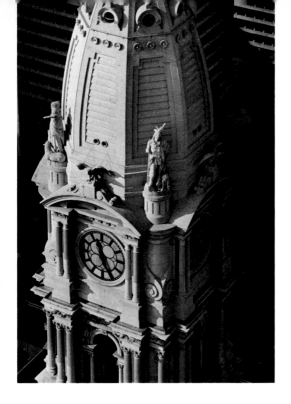

modeling. In 1867 he visited Paris briefly, perhaps to study, but he must also have been attracted by the International Exposition and certainly by the new Louvre. Returning to London, he was engaged in work on the Albert Memorial, designed by Sir George Gilbert Scott, but in what capacity it is not known.[10] This was the extent of Calder's training in Europe, which must have included a firm grounding in the neobaroque manner of the Beaux-Arts style that prevailed in European academies.

In 1868 Calder immigrated to Philadelphia with an introduction to the most noted sculptor in the city, Joseph A. Bailly, a Frenchman by origin, and William Struthers, of Scottish ancestry, whose family had been identified with the manufacture of stone monuments and statuary in Philadelphia since 1816. From Struthers he seems to have gained immediate work, probably as a modeler or stonecutter, and established himself as an architectural decorator at an early date.[11] He was really following the trend of foreign sculptors who came to America to decorate public buildings because few native sculptors possessed the artisan training that was necessary to model both architectural and sculptural detail with equal facility. Also, most American sculptors probably felt that ornamental sculpture was not worthy of their efforts.

Why Calder was hired by McArthur in May, 1873, is an interesting question. However, Calder was not commissioned to do the sculpture. The records of his first authorized payment on August 15, 1873, and his last on April 7, 1893, show that he was paid to make "plaster models," and at a meeting of the commissioners on December 28, 1892, it was resolved "That after the first day of February next, the services of Mr. Alexander Calder, the Plaster Modeler, be dispensed with." There is no mention of his abilities as a sculptor. Yet Calder had completed the models for the largest sculptural program of any building in the United States.

What seems more surprising is that very little interest in the sculpture on City Hall was shown by other sculptors. The minutes of the commissioners record several artists who were interested in modeling the statue of William Penn for the tower, but none applied for commissions for any of the many other figures and groups.[12]

Alexander Calder must have had a great capacity for work. The creation of the designs, if he did them, and the clay models for two hundred and fifty figurative works is equivalent to the lifetime production of many sculptors. He did have a number of studio assistants, who helped to transfer the clay models into plaster, which then became the life-size models that were turned into stone or cast in bronze. James G. C. Hamilton was often given official credit as Calder's "assistant," and John Cassani, an Italian immigrant and artisan, seems to have been hired to transfer the clay models into plaster, which was an arduous job and in which Cassani appears to have made a specialty.[13] Two other Calder assistants are known and are of particular interest. Stirling Calder, Milne's son and father of the mobile artist Sandy Calder, was reported in the *Press* on November 10, 1886, as having modeled an arm of an Indian boy about his mother's waist in the colossal group to be placed on the northwest corner of the clock tower. The *Ledger and Transcript* on October 1, 1891, related that the figure of Penn and the four groups on the tower had "occupied Mr. Calder and his assistants, among whom are his sons, A. S. Calder, now a student in Paris, and Charles Calder, five years." Over the twenty years between 1873 and 1893 that he worked on City Hall, Calder was paid $82,475.66 or about $4,124 a year. But from this amount it would appear that he had to pay his assistants, as they are not mentioned in the cash accounts.

Alexander Calder would probably have chosen his figure of William Penn on top of the tower as his greatest

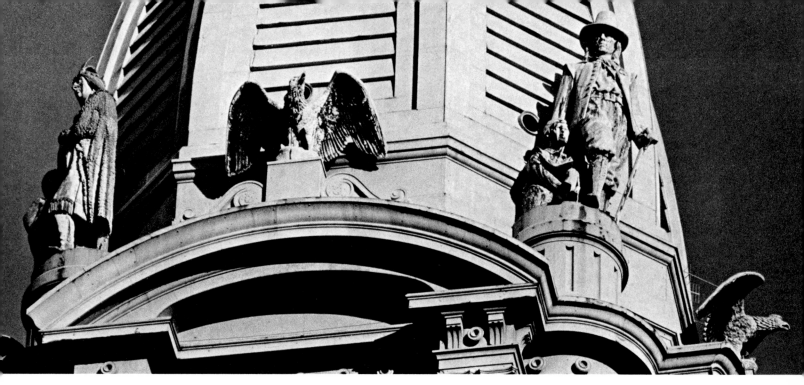

Tower

achievement, even though it is possibly not his best work. The story of its history is given in the following essay in this volume. Calder followed the veristic naturalism that was the style of American sculptors of the period in order to give historical accuracy to Penn's features and costume and to interpret Penn as he was thought to be. The style of the rest of the sculpture on City Hall reveals the intermingling of this naturalistic trend with the neobaroque elements of the Beaux-Arts tradition that favored classically inspired forms. The naturalistic aspect of the sculpture would seem to be what was best suited to Calder's temperament. He must have taken great delight in giving an accurate and yet decorative depiction of native foliage and animals, as shown in the panels to either side of the east entrance archway that represent herons, a beaver, and an owl in their appropriate habitats. The faces of the four races on the capitals in the crypt of the tower were given a studied ethnological portrayal. Some of the sculptured figures and faces appear to lack character, but a summary treatment of surfaces was often necessary for the ease of the stonecutters and for a strong impact in bright sunlight. However, the bronze portrait medallion of Chief Justice George Sharswood in the Supreme Court, modeled in 1890, or the bust of John McArthur in the south stairwell, show that Calder could perceptively capture the character of a man.

In the spirit of the times the Beaux-Arts style appears mostly in the emblematic works, and the nude or draped classical figures were meant to lend dignity to the instructional and aesthetic function of the sculpture. Old photographs of Calder's studio reveal not only plaster casts of hands and feet but of antique statues, both Greek and Roman; the Venus de Milo actually appears in a panel in the east entrance vestibule. Calder probably used these classic models as aids in facilitating the rapid output of the sculptural ornamentation. Although he carefully varied the poses and details of his figures, there is a uniformity in the gentleness and grace which is somewhat repetitious. This is possibly one of the limitations of entrusting such a large program to a single sculptor. Calder did not excel at representing forceful action. Perhaps this is the reason why many persons today are not struck by the ornamentation of City Hall. Yet if City Hall is McArthur's monument, it also is in no small way Calder's.

The simple answer to the problem of the authorship of the sculptural designs would be to assign them all to Calder, with McArthur and Perkins directing the location of the works and advising upon the subject matter. But this might be unfair to McArthur and his assistants. In the *American Architect and Building News* of May 20, 1876, there appears a note that "an exhibition of all the models for the stone cutting for the new Public Buildings has just been opened at Philadelphia. These models have been made by Mr. Alexander Calder of Philadelphia, from the drawings of the architect, Mr. McArthur." In a letter to the *Press* on August 20, 1878, McArthur stated that "every piece of ornamentation for the new Public Building, since the beginning of the work, has been designed in the architect's office, and modeled in plaster for the use of the workmen, by Mr. Alexander Calder." The phrases "models for the stone cutting" and "every piece of ornamentation" could relate specifically to the architectural ornament, such as capitals, friezes, and window surrounds. Undoubtedly McArthur or his assistants did drawings for these, and Calder transferred them into plastic form as a guide for the stonecutters. The question of whether McArthur actually designed some of the sculpture may never be completely resolved, but in many ways he had a definite impact on the sculptural program.

For City Hall to be visually unified, McArthur inevitably considered the relationship of the sculpture to

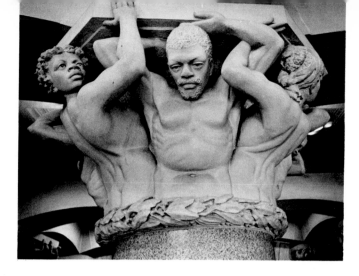

the architecture. The sculpture is often part of the structural fabric, as in the keystones of the windows or archways or in the dormer caryatids. In the case of the latter figures he had to calculate the scale of the forms in order that they would be readable from the ground and in proportion to the dormer itself. The height of the reliefs and the projection of the three-dimensional figures add a coloristic contrast in light and shade to the plainer masonry areas and had to blend with the main architectural contours. At some points the sculpture relieves the severity of the structural lines. On the fourth floor of the central pavilions, three-dimensional seated figures, such as Law, guide the eye inward toward the segmental pediment in the center, and thereby the sculpture and architecture work as complementary factors in the total unity of the central pavilion.

To say that McArthur was always successful in placing the sculpture might be questioned. It is true that some of the sculpture in the interiors of the central entrances do not have enough light to be seen well. Critics have also commented that the exterior work is placed too high for the subjects to be easily discernible from the ground. This is a valid argument in the case of the emblematic impost reliefs on the third story of the corner pavilions, where the details are too small. Yet most people can see what is generally depicted. What must disturb many persons today is that they do not understand the symbolism of the sculpture and its purpose, since identifying inscriptions are not included.

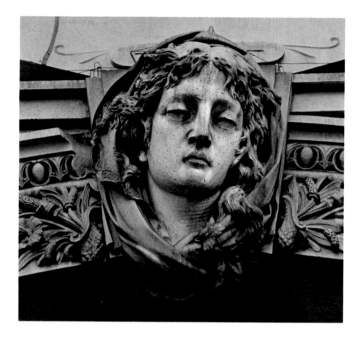

A full treatment of the identification of the sculpture of City Hall is too large a subject to be presented here, but certain observations can be made. If there was a coherent plan for the iconography that tied the subjects of all the sculpture together, it is not apparent now. Modifications in the plans as the building was being constructed may have precluded this. In some cases the depiction of foliage, animals, and fantastic creatures seems to serve a purely decorative purpose. Because a large number of emblematic illustrations were necessary, one idea, such as Mechanics, was repeated in several different positions but in slightly different forms. This reinforced different themes. The creation of an intelligible iconography on a public building with as many functions as City Hall definitely presented problems. The decoration was meant to give visual meaning to the municipal building and to express the pride of the citizens of Philadelphia in their past and present history in the development of America.

The sculpture on the facades and entries of the central pavilions generally relates to the function associated with that entrance. The south entrance leads to the law courts; hence, Law, its benefits and history, is symbolically implied in the keystone head of Moses, the seated figures of Law and Liberty, and the spandrel figures of Executive Power checked by Judicial Power. Because the Supreme Court of Pennsylvania was also lodged here, the arms of Pennsylvania appear on the fourth-floor pediment, whereas the other facades bear the arms of Philadelphia. On the west side the prison vans originally entered City Hall under a keystone with the face

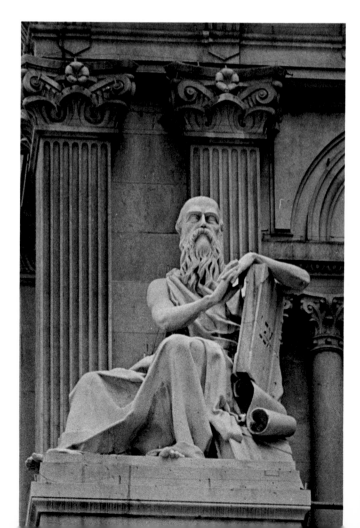

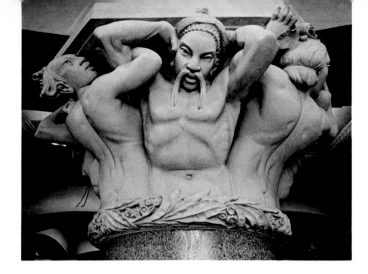

of Sympathy. Some of the sculpture instructed the prisoner in those acts which would be most beneficial to his rehabilitation; for example, on the fourth floor there are the seated figures of Prayer and Meditation and in one of the spandrels Repentance is depicted by a portrayal of the prodigal-son image. Approaching the entrance to the mayor's office on the east, the face of Benjamin Franklin on the keystone brings to mind Philadelphia's history. On this facade, the seated figures of Industry and Peace emphasize those virtues of the citizens of the Quaker city which had produced its prosperity. Similarly, the spandrel reliefs that picture Art and Science denote the creative nature of Philadelphians. To a greater or lesser extent, the interiors of all these entries reinforce the prevailing symbolism on their exteriors.

The northern facade with the clock tower is properly the main entrance, and a more detailed account of its iconography will reveal many of the themes that are found elsewhere on the building. The entry formerly led to the chambers of the legislative bodies of the Select and Common Councils, which controlled the welfare of the city. On the facade, William Penn's face on the keystone of the entrance arch appropriately suggests the early government of the city. In the spandrels to the left and right of Penn, a pioneer with an axe in his hand faces an apprehensive Indian, who sees the coming progress of civilization. Liberty and History in the third-floor spandrels and the seated forms of Fame and Victory to either side of the arms of Philadelphia emphasize the achievements of wise legislative action.

In the interior, these ideas are expanded. On entering the foyer, the viewer sees the high relief spandrels of the second-floor level with their images of Suffrage and Education, the foundation on which a good government must depend. In the side spandrels at the same level and in the capitals of the columns and pilasters appear emblems of the principal pursuits of the citizenry of the Commonwealth, such as Navigation, Commerce, Mechanics, Architecture, Horticulture, and Poetry, which must be encouraged and protected by a government. Further images of these fundamental activities of a creative community are also prominently illustrated on the corner pavilions of the exterior of the building.

Progressing from the north vestibule into the crypt under the tower, one can see the capitals of four huge marble columns that portray the straining half-figures of four different races of man representing the four continents of Europe, Asia, Africa and America. The children of these races are found around the sides of the crypt on the capitals and pilasters. The heads of a bull, tiger, elephant, and bear on the keystones are the animals native to the four continents respectively. The theme of the four continents is repeated on the exterior in the colossal male and female caryatids which support the dormers of the central pavilions of each facade and appropriately face toward the geographical region of the globe in which each race may be found.

The iconography is remarkable for its variety of symbolism. Biblical allusions appear in the head of Moses

at the south entrance and in the prodigal son on the west facade. Surprisingly, mythological figures are notably scarce, but in the corridor leading from the eastern entrance to the inner courtyard a supporting bracket in the form of a half-figure portrays Hercules as Fortitude. History is brought in with the figure of William Penn on top of the tower. Below him on the northern side of the tower, an Indian brave with his dog and a squaw with her child symbolize the native inhabitants of the land. On the south side two groups represent a Swedish family as the first European settlers of the region of Philadelphia before Penn arrived. Also, seasons are personified in the keystones in the Council caucus room by a child's head for Spring and an aged man for Winter. Allegorically, Prayer and Meditation on the west front are meant to

imply the manner by which delinquent members of the community may find salvation.

Most of the sculptural ornament is emblematic. Male and female figures, either nude or draped, are usually modeled in a classical style and carry symbolic attributes. In some cases, an emblematic object alone appears. For instance, the north face of the northwest corner pavilion symbolizes Industry: a beehive caps the dormer. The spandrels around the third-floor window show, on the left, a woman with weaving implements and, on the right, a man with a lathe. Below, two impost panels picture products of industries related to iron, leather, cloth, and wood. On the keystone of the second-story arch, Mercury symbolizes his aid in facilitating transportation of these goods. As shown here and in the preceding paragraphs,

the iconography of the whole building in the broadest sense attempted "to express American ideas and developing American genius," as one critic of the period wrote.[14]

The City Hall sculpture that was modeled by Alexander Calder must be admired for its sympathetic aggrandizement of the architectural style. Calder was a gifted architectural decorator whose facility enabled him to produce rapidly the hundreds of figurative and ornamental details. While his authorship of some of the designs of the sculpture cannot be proved, there is little doubt that he was responsible for the creation of the figurative groups on the tower and the statue of William Penn on top.

William Penn

by George Gurney

*photographs by
Bernie Cleff*

The story of the creation of *William Penn* on top of the clock tower of Philadelphia's City Hall is practically as involved as the construction of the building itself.[1] In December, 1869, the original wood model of John McArthur's building design was topped by a figure of Justice. The first indication that *William Penn* was to assume the focal position became fixed in the plans that were submitted by McArthur in early April, 1872, as shown in a photozincograph by F. A. Wenderoth.[2] Just who decided that Penn should replace Justice in the intervening period is not known. Subsequently, the idea of winning a commission for the statue created more interest among sculptors than all the rest of the 250 figurative works on City Hall. The records of the Commissioners for the Erection of the Public Buildings, who oversaw the construction of the building, prove that the commissioners were the controlling agent in the production of the figure and that Alexander Milne Calder, as the official "Plaster Modeler,"[3] held a silent but favored position for sculpting the piece. Still, the thirty-six-foot-four-inch figure did not mount its perch until some twenty-two years had passed in 1894.

As the Centennial celebration approached, a gentleman wrote to the commissioners in January, 1875, to suggest that Penn should be finished in time for exhibition at the World's Fair of 1876. The ever-interested press reported the idea. Within a short time, perhaps inspired by the newspapers, several sculptors submitted models for the statue, although the commissioners had not invited such action. Little is known about either the models that were prepared by George F. Gordon or Professor Fr. Meynen, or the sculptors themselves. Joseph A. Bailly, one of the most prominent sculptors in Philadelphia, and briefly Calder's instructor at the Pennsylvania Academy, submitted, by April 6, 1875, a figure of Penn that is surprisingly similar in pose, gesture, and support to Calder's final design. Whatever happened to Bailly's sketch model is unknown, but an engraving of it was published in Frank Leslie's *Illustrated Newspaper* on October 30 of that year (figure 1). Leslie stated that "we have accurately engraved the Penn statue, by Mr. Bailley [*sic*], of Philadelphia. It will be of bronze, and thirty feet in height. The figure stands as if in the act of explaining the original plan of the city, which rests upon the stump of a tree. When cast, it will be placed in the Park, and remain there until the completion of the public buildings on Broad and Market Streets, when it will be set as a finial upon the dome." However, Leslie seems to have been confused, for the commission had not decided on Bailly's model. On the contrary, the commissioners appear not to have taken the idea of the Penn statue seriously until after Leslie's publication.

On November 1, 1875, Samuel Perkins, on behalf of the commissioners, asked the Historical Society of Pennsylvania if it would appoint a committee to investigate the proper costume and appearance of Penn. The Historical Society acted quickly, and by November 4 Perkins instructed William C. McPherson, superintendent of the Public Buildings, to allow Messrs. James S. Earle &

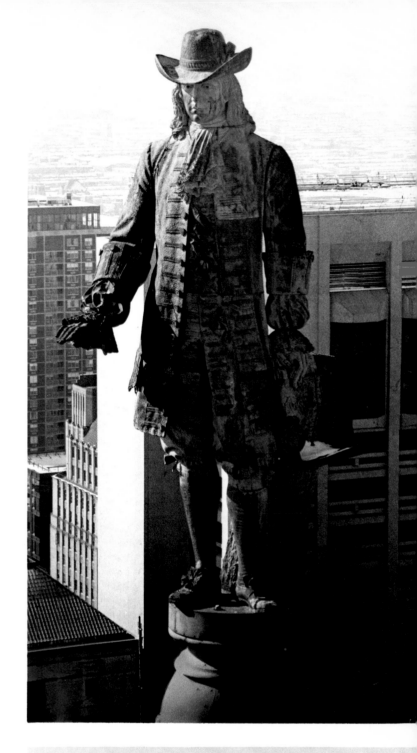

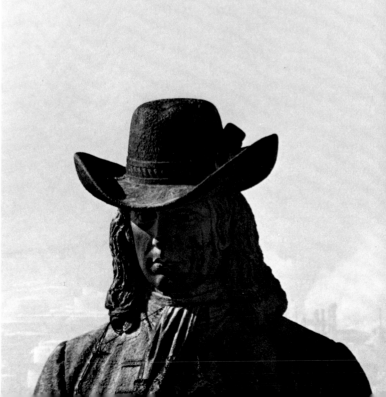

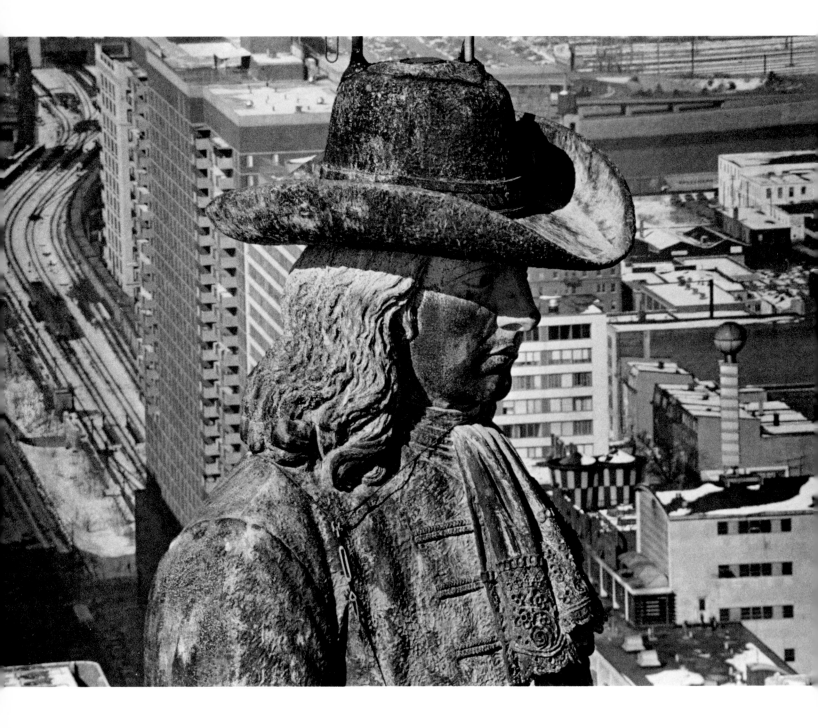

Sons to remove to their gallery the model of Penn that the society had sent the commissioners. On November 15, the *Times* of Philadelphia reported that a "Model for a statue of William Penn's clothes has been prepared under the direction of the Historical Society, and we are informed, has been 'accepted by the Commissioners of the Public Buildings.' " The *Times* hoped that the commissioners would now employ "a sculptor to put the man inside." However, the commissioners may then have realized that it was a bit premature to worry about the creation of the crowning feature for their building. The tower itself might still undergo changes in design that could alter the size of the figure. Indeed, Perkins may have asked his official modeler, Alexander Milne Calder, how long it would take to execute the finished colossus. He certainly would have indicated that much more time was needed to model and cast the figure than remained before the Centennial. For the moment, plans for the statue were dropped.

The next mention of Penn in the records of the commissioners appeared in 1882. In that year Perkins seems to have fully realized the nature of the undertaking when he answered an inquiry by William B. Smith of the Philadelphia Bi-centennial Association. In his letter, Perkins stated that "the Sketch Model of the Statue of William Penn intended for the tower of the Public Buildings has not even been commenced. This model would be one-tenth of the intended full size, and would take careful study and some time for its preparation. It will be impossible to have any model of the intended statue completed in time for use in the contemplated celebration of the Bi-centennial of the City."

By 1885, Calder had presumably completed most of the necessary plaster models for the interior and exterior architectural detail and the sculptural adornments of City Hall. The sculptor next faced the lengthy task of modeling the large figures for the tower. These included not only Penn, but also four twenty-four-foot-high figurative groups which constituted an Indian and Swedish family, a female Indian with child, an Indian brave with his dog, a Swedish settler with his son, and a Swedish matron with a child and lamb. Calder also needed to make the model for the eagle with a fourteen-foot wing span that would be duplicated on each of the four sides of the tower between the figurative groups. For the next eight years, until his final payment in April, 1893, Calder's primary effort was to complete these clay figures and to supervise their casting in plaster before they were shipped to the foundry. Two and one-half years of this time was spent creating the Penn.

Beginning in the early part of 1886, after completing the Indian squaw group, Calder suspended all other work to concentrate on the Penn statue. It was a prolonged process. First, Calder had to make a maquette at about one-tenth the size of the final figure. Then this had to be approved by the commissioners. As Calder related on June 20, 1920, to a reporter for the *North American*, he made three versions of the Penn before the "revised" model was finally settled upon. The little three-foot sketch was then transferred to a more permanent plaster model by John Cassani and his assistants, who specialized in casting the plaster models for Calder in his studio. It is fitting that the Historical Society of Pennsylvania today possesses an aluminum bronze cast of this maquette (figure 2).[4]

On September 15, 1886, the *Inquirer* reported that Calder had finished the quarter-size clay model of nine feet but that he was still undecided about the final figure. He wanted to represent Penn in the prime of life and felt that "what we want is William Penn as he is known to Philadelphians; not a theoretical one or a fine English gentleman. The picture by West of the treaty represents Penn according to our ideas, and as the painter was a hundred years nearer to Penn's time than we are I think his idea can be allowed to influence us more than any fancy one." Nonetheless, Calder sculpted a "revised" Penn; the figure bears little of the portliness of Benjamin West's image and the costume reflects more accurately the time of Charles II.

The slow process of enlarging the statue continued. By December 20, 1886, the nine-foot clay model had been converted into the duplicate plaster. From this Calder and his assistants began the final clay model, over thirty-six-feet tall, by the crude "pointing" system that was used by sculptors in such enlargements. The difficulties in accomplishing this task are interesting, and an account by Calder as related to the *Press* on February 5, 1888 is edifying:

> We started off on the work of constructing the big model about a year and a half ago by placing a hoop of iron just above the crown of the hat upon the figure known as the sketch. From this hoop hung many small strings at different places where we wished to get plumb lines, and along these lines we also had made small marks to guide us in heights, widths and other points of comparison. Then upon that big round table over there we built up the wooden and iron framework or skeleton upon which we modeled the legs in clay, of course keeping them in each detail enlarged the proper amount upon the size of those in the sketch (figure 3).
>
> The whole figure was built up in this way in clay, but of course in sections, as that material is tremendously heavy and hard to handle in this weather, one of the trials of a sculptor in a cold climate being that if he allows his workroom where he is modelling to remain cold his clay will freeze while he is working it. If he heats the room the heat "bakes" it and requires him to be eternally sprinkling it with cold water to keep it in the right consistency.

When the clay sections were finished, John Cassani and his assistants again had to go through the elaborate task of producing the huge plaster model. The "great model" was completed in Calder's studio in City Hall on August 21, 1888, when all the plaster sections had been hoisted into place. The figure was so tall that it had been necessary to leave a hole in the ceiling in order that Penn's head could be lowered from above onto the completed figure (figure 4).

The plaster Penn stood idly in City Hall for another

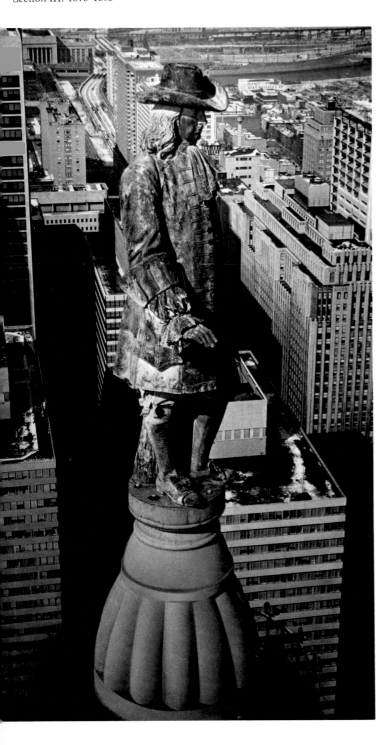

year and a half. At the time, there was no foundry in the United States capable of casting the figure. In fact, it would be the largest statue cast in bronze in the world and also the heaviest, weighing some twenty-seven tons. A foundry needed to be built to cast it. On September 4, 1889, the newly founded Tacony Iron and Metal Works of Philadelphia was awarded the contract for the entire metal work required for the completion of the clock tower, including the sculptural figures. On January 30, 1890, Calder must have uttered a sigh of relief when he watched four large horse-drawn trucks with the plaster sections of the great statue travel up Broad Street to the fireproof buildings at the Tacony Works. Finally his Penn and his other figurative groups were to take permanent form. However, this was not the last of Calder's worries in this matter.

On November 6, 1892, Penn was standing once again at City Hall. This time it took a place of honor in the interior of the courtyard after all of "his" fourteen sections in bronze had been put together. Philadelphians felt proud of their founding father and came to have a close look. One observer was Charles Henry Hart, a director of the Pennsylvania Academy of the Fine Arts and chairman of the Committee on Retrospective Art for the World's Fair in Chicago. He was not pleased. In a letter to the *Evening Telegraph* on December 17, 1892, he noted that the seal on the charter of Pennsylvania granted by Charles II, which Penn held in his left hand, was not that of Charles II but "the Royal arms of her Majesty Queen Victoria, known as the arms of the United Kingdom." Although he commented that this would not matter too much when the figure was in place on top of the tower, Hart pleaded that the statue not be sent to the World's Columbian Exposition in Chicago to prevent its being an embarrassment to Philadelphians. (And it was not sent.)

This, incidentally, was not the last time that Calder was to be brought to task, although it did not concern the Penn. In November, 1895, the *Press* headline read, "City Hall Eagles Are Not American" because the Mexican eagle, as depicted on coins, faces right and the American left. Calder should not have been disturbed by this criticism, for he had simply tried to give majestic form to the magnificent bird and had succeeded.

On November 28, 1894, at 10 A.M., Penn's head was lifted to its final resting place. No official ceremony was held since the commissioners did not want to incur an expense. The statue faced northeast, as it does today. Shortly thereafter, in a letter to the commissioners and later in the *North American* of June 20, 1920, Calder protested that it should not be facing northward where it would be "condemned to eternal silhouette." Instead it should face south, where the sun would reveal the details of the face and figure throughout most of the day.[5] Calder stated that the "bed and anchoring of the statue had been prepared for its facing south," but that W. Bleddyn Powell, the supervising architect at the time and a "political appointee," had placed it wrongly out of spite.

Unfortunately this claim by Calder cannot be verified. However, the intention that the statue should face northeast was clearly indicated in every official illustration of City Hall from the first one in 1872.

Calder was correct that a southern exposure would do artistic justice to the form and detail of his masterpiece, but as a group the tower figures possess more historical continuity with its northeast orientation. In that position, with the Charter of Pennsylvania in his left hand, the dignified and youthful Proprietor of Pennsylvania makes a gesture of peace and friendship toward Penn Treaty Park, where he had met the Leni Lenape Indians. The suggestion of this meeting is repeated by placing the Indian family underneath on the northern corners of the tower. On Penn's arrival, the principal Swedish settlements were to the south of Philadelphia, and so the Swedish family rightly belongs on the southern corners. Thus, the specific placement of the tower figures symbolizes the actual founding of Pennsylvania and Philadelphia by William Penn.

Alexander Milne Calder (1846–1923)
William Penn. 1894
Top of City Hall Tower
Bronze, height 436″

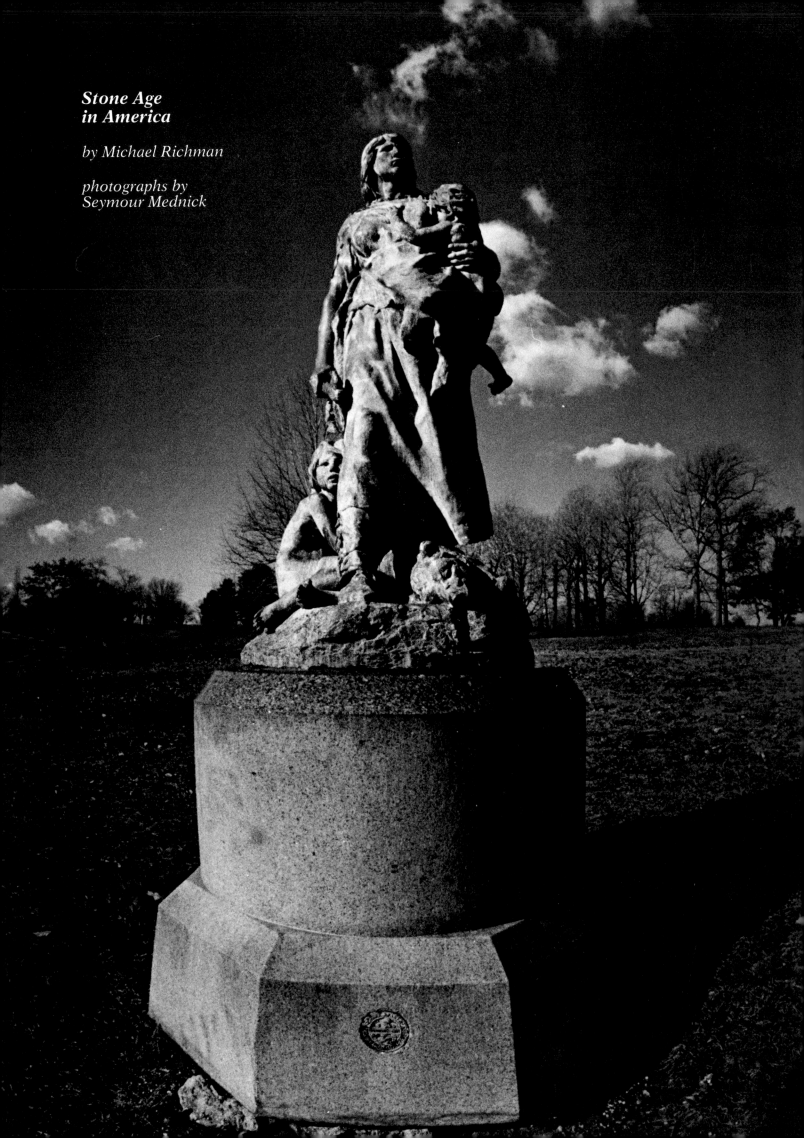

Stone Age in America

by Michael Richman

*photographs by
Seymour Mednick*

An often overlooked but important aspect of nineteenth-century American sculpture is the relationship of patron and artist. Before the Civil War, a client might order a statue that he saw in a sculptor's studio to be put into marble. As the public monument became an increasingly important art form, private citizens, veterans organizations, and civic groups with large sums of money to spend began to commission sculptors. Artists were now required to sign contracts and to have their work judged at various stages of development. If the sculptor were well known, he might not be bothered by a patron's inquisitive interruptions. More often, the sculptor accepted his patron's intrusion, and the patron respected the sculptor's integrity. The Fairmount Park Art Association and John J. Boyle (1851–1917) disagreed about an element in the design of *Stone Age in America*. When the conflict was over it was the sculptor who had acquiesced.

It seems appropriate to begin a discussion of one of the city's splendid monuments by examining Boyle's early associations with Philadelphia. Born in New York City on January 12, 1851, Boyle came to live in Philadelphia in 1857. He started his career in sculpture as a stone carver,[1] and in 1872 enrolled in a drawing class at the Franklin Institute.[2] Next he studied anatomy with Thomas Eakins at the Philadelphia Sketch Club.[3] In the fall of 1876 Boyle was admitted to the Pennsylvania Academy of the Fine Arts. "One of the first four that ever dissected inside its walls,"[4] Boyle continued his instruction with Eakins and worked with the now forgotten Joseph Alexis Bailly.[5] After a year, the aspiring sculptor departed for Paris, where he enrolled in the École des Beaux Arts. He seems to have succeeded quite well, for in 1880 he exhibited a bronze bust of a Doctor Warren at the Salon.[6]

With his three-year training completed, Boyle returned to Philadelphia in the fall of 1880 and opened a studio at 2217½ Chestnut Street. His arrival was triumphal, because in Paris he had received a commission to execute a monumental bronze—*An Indian Family* (figure 1). This statue to commemorate the Ottawa Indians was ordered not by a Philadelphian but by the Chicago lumber tycoon Martin Ryerson.[7] To make final arrangements about the design of the pedestal, on which he was to place four relief panels, Boyle went to Chicago.

Next, he spent "two months with the Indians who were to be represented."[8] It seems unlikely that Boyle visited the Ottawas, for this tribe which once lived in the Lake Michigan region could now be found only in scattered groups in Missouri or in Oklahoma. Instead, Boyle probably visited a Sioux reservation in North Dakota.[9] When this trip was taken cannot be documented.

By the summer of 1881 the sculptor was back in Philadelphia, eager to begin the full-scale model. When the clay was completed to his satisfaction, it was photographed and prints sent to Chicago. Boyle's effort did not entirely please Ryerson. A comparison of the first model with the final bronze is possible because a print of the former has survived at the Chicago Historical Society. Boyle was asked to improve the composition by eliminating the awkward diagonal created by the juxtaposition of the woman's left arm and the man's right leg. The Indian's countenance was rendered more intensely in the bronze, and the bland treatment of the squaw's face has been strengthened. A peaceful mood suggested by the placement of the bow and sheath of arrows on the ground is enhanced by the addition of the young child. Undoubtedly, these changes were proposed by the patron and amicably incorporated by the sculptor.

When Boyle finished working is not known, but probably by the spring of 1883 the clay models of the group as well as the four reliefs were put into plaster. The panels—*The Hunt, The Peace Pipe, The Corn Dance* and *Forestry*—illustrate events in the life of the Ottawas. An examination of one plaque, *The Corn Dance* (figure 2) which, incidentally, was displayed at the annual exhibition of the Pennsylvania Academy of the Fine Arts in 1883, attests to the sculptor's competency in high relief. Boyle has captured the enthusiasm of the dancing men and chanting women with a rhythmic modeling technique.

Certainly by early April, 1884, the Philadelphia firm of Bureau Brothers had completed casting the group and reliefs and had sent the bronzes to Chicago. There, *An Indian Family*, which came to be known as *The Alarm*, was dedicated in Lincoln Park on May 17.[10] Fortunately for Boyle, this monument had been well received in Philadelphia, where "it impressed many, and a feeling

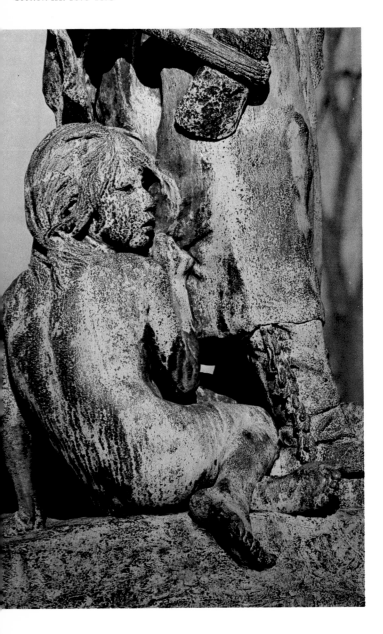

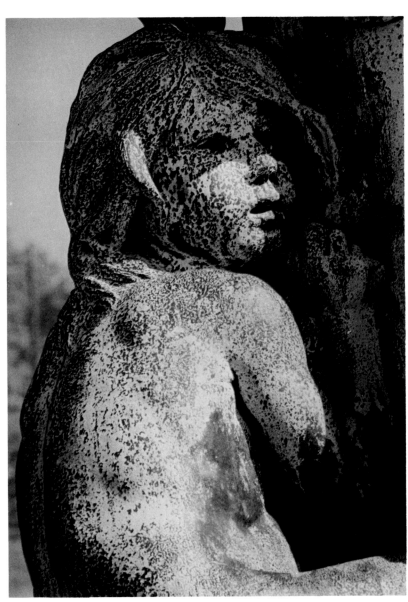

prevailed that the Fairmount Park Art Association would do well to have me carry out a group of a like kind."[11] Quite plausibly, Boyle contended that members of the Art Association visited his studio as the Chicago group took shape, and, pleased with his effort, decided to encourage the promising local sculptor.

On November 21, 1883, the Committee on Works of Art acting "upon the motion of Mr. Claghorn...resolved that a commission be given to Mr. John J. Boyle for his Indian group in bronze, according to his proposition on November 19...."[12] By December 19, 1883, Boyle had his first commission from his native city, as recorded in the minutes of the Fairmount Park Art Association:

> *Resolved: That the Board contract with John J. Boyle to produce within two years from date of contract, a bronze group of heroic size (7½ ft. high) of an Indian mother defending her two children from an attack by an eagle, to be finished in standard bronze and set in position on a pedestal to be provided by this Association, for the total price (exclusive of pedestal) of ten thousand dollars; whereof $1000. shall be paid at the execution on the contract and the balance, as may be therein stipulated.*[13]

From the little documentation that has survived, it may be suggested that Boyle did not make a maquette for *Stone Age in America* before December 19. There is also no way to prove if a small model was executed in the first months of 1884. Boyle probably stayed in Philadelphia to oversee the casting of his first bronze statue, but exactly when he left for his seconl visit to France is not known. On arriving in Paris he took a studio at 255 Boulevard d'Enfer and began the statue. By the spring of 1885, the sculptor, having nearly finished the clay model, decided to send a photograph of the group to Philadelphia. To his amazement, Boyle learned that members of the Art Association were displeased that an Indian was portrayed strangling a national symbol—an eagle. Obviously the sculptor felt that he was being unfairly criticized. From the outset Boyle had explained what he intended to do; no objections were raised about his choice of subject when the contract was signed. Now, one and one-half years later, the large model almost completed, the sculptor was asked to change the design radically.

The photograph of Boyle's first conception has regrettably not survived, and one must rely on the description given by Lorado Taft, who championed the

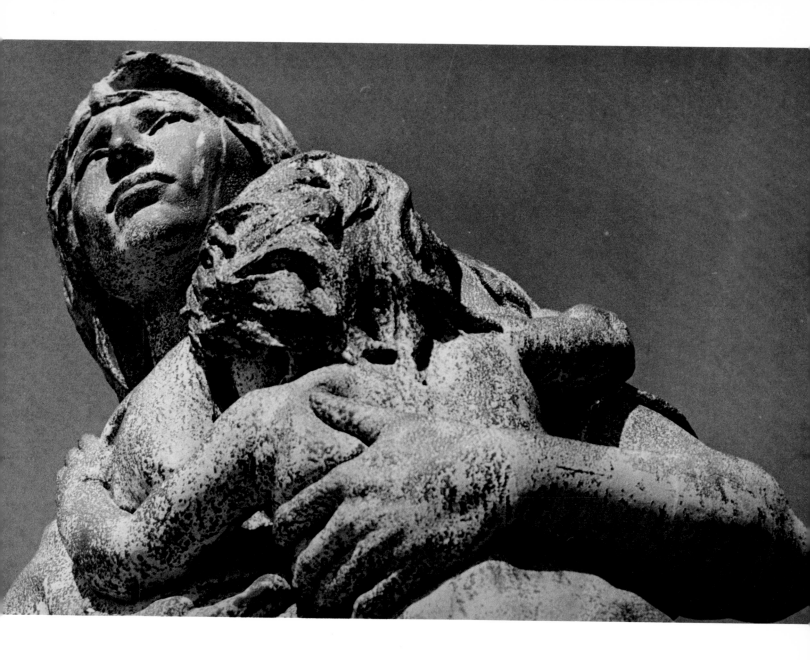

sculptor's right to resist the interference of a patron.

As to the group itself, however, the artist used to complain bitterly that he had not been left free. He had sketched a fine thing, an Indian woman of mighty physique defending her children from a powerful eagle—a western Rizpah, as it were. The children were living ones, however, and clung to their mother's skirts, as far as possible from the vanquished bird, which lay upon its back clawing the air and apparently shrieking defiance in impotent rage. The great outspread wings offered beautiful lines, and their shadowy concaves set off the figures most effectively. The sculptor was pleased with his work, and when he had the full-sized model well advanced he called in a photographer, that the committee at home might note his progress.

The answer came, and all too soon, for it urged with sufficient emphasis that it would never do to treat the national bird so ignominiously, and would the sculptor not kindly substitute some other creature? He did so. It is perhaps as well that there is no record of his half-murmured observations as he cut off those magnificent wings and painfully converted the Bird of Freedom into a bear cub![14]

Realizing that he would lose the commission if he failed to comply with the mandate of the Art Association, Boyle wrote on May 12, 1885, to Thomas Hockley, Chairman of the Committee on Works of Art.

After several weeks of hard work and thinking, of the deluge of good, bad and indifferent advice and evolving from my own inner consciousness, I have arrived at a conclusion, that I trust will be satisfactory to all. I have taken out the eagle and after a number of trials with different animals with as many different actions, I have decided on a dead couger [sic] the head of which falls over the base and the hind feet still sticking in the drapery of the woman.

This gives me a chance to raise up the head of the woman looking forward for new prey or danger. Everything else is near the same excepting the boy's right arm.

I shall go on now and finish unless I am inspired with a happier thought....[15]

Boyle also reworked the small Indian youth, possibly at the suggestion of Charles E. Dana, a Philadelphian who was living in Paris. On June 13, 1885, Dana informed

Hockley: "I have not seen Boyle of late, he lives so very far off that it is impossible for me to look him up. My views remain the same, I like the group very much, including the eagle, excepting the boy, a figure that I do not think very happy in any way."[16] Boyle next wrote to Hockley on October 25 to ask for an advance as well as report his latest alteration:

> *You will see the aspect of the group is changed, also the title, it is now a mother protecting her children, but more properly do I call it the "Age of Stone"[sic].The object to the left at her feet is a small bear with the four feet tied together Indian fashion. I believe I can say it is the one thing I am not yet satisfied with—in pose.*[17]

Boyle and the Fairmount Park Art Association had resolved their differences, and the sculptor received $500.[18]

By the spring of 1886 all changes were made so that a plaster cast could be taken from the clay. This operation was completed in time for Boyle to exhibit the statue in the annual Salon. The sculptor claimed that the group— *L'age de pierre dans l'Amerique du Nord*—was awarded an honorable mention; however, an official catalogue did not list him as a recipient of a prize.[19] Nevertheless, Boyle and, by extension, the Fairmount Park Art Association, could feel proud, for only three other American sculptors were invited to participate in the Salon of 1886.[20]

By July the plaster was ready for casting in bronze, an operation which was performed in Paris by the Thiébaut

Foundry. *Stone Age in America* was completed by the spring of 1887 in time to be exhibited again in the Salon.[21] Following its arrival in the United States, the statue was displayed at the exhibition of the American Art Association in New York City, which opened on December 1. A reviewer in the *Magazine of Art* suggested that *Stone Age in America* was the best example of sculpture in the show, but qualified his praise by saying the statue was only of average merit.[22] In the first months of 1888 the Fairmount Park Art Association allowed Messrs. Haseltine and Company to exhibit the bronze in Philadelphia. Next, with the consent of the custodian of the United States Post Office, the statue was erected temporarily on the sidewalk near the corner of Ninth and Chestnut streets.[23] These two displays were evidently permitted because no decision had been reached on an appropriate site. Ultimately, however, by the late summer or early autumn of 1888, *Stone Age in America* was erected in the West Park. Inexplicably, no dedication was held, but in the Art Association's sixteenth annual report, Anthony J. Drexel acknowledged its arrival: "The group has awakened deep interest in those who care to perpetuate in bronze, types of American Indians. In the near future there will be few living representatives of that once powerful race. We may now preserve in enduring form characteristic pictures of their life and lineaments, which will enhance in value and rarity as time advances."[24]

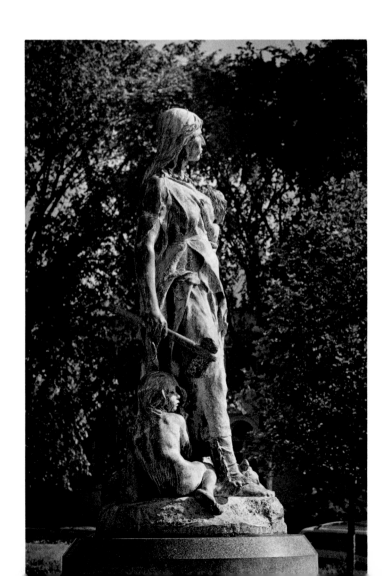

The history of this monument does not end with its placement in the park. In 1892, Boyle, working in Chicago on sculptural decorations for Louis Sullivan's Transportation Building, wrote to the Association and asked that the group be removed from its base so that it might be displayed in the Art Palace at the World's Columbian Exposition. Skeptical at first, the Association nevertheless acceded to the request, recognizing that its appearance at the fair of 1893 would be a compliment to both the sculptor and the Association.[25]

Stone Age in America was the third monument ordered by the Fairmount Park Art Association. The commission and the execution of Kemeys' *Hudson Bay Wolves* and Calder's *George Gordon Meade* proceeded without incident. Perhaps the Association acted harshly toward Boyle in rejecting a statue which the sculptor thought had been approved, but Boyle's contract, like all others written in the nineteenth century, called for payments to be made when work was completed. Boyle prudently avoided dismissal and a financial loss. It is fortunate that his irate mutterings alluded to by Lorado Taft were not heard, for the outburst might have been damaging. In fact, in the late 1890s, when writing an autobiographical sketch for one of the Association's publications, Boyle indicated that the commission had been given in "the most liberal manner," and "the results," he felt, "were most satisfactory."[26] The Association was undoubtedly pleased, for *Stone Age in America* received considerable national attention.

In 1903, Lorado Taft, in *The History of American Sculpture*, included a full-page illustration of the statue and lauded Boyle's effort:

> *His most valuable contribution to our national art is undoubtedly in his favorite field of aboriginal subjects.... Some of the younger men may excel him in "finesse," in subtlety of modelling and charm of line; but for the expression of power, for monumental simplicity and integrity of conception, his groups, "The Alarm," in Lincoln Park, Chicago, and "The Stone Age"... have not been surpassed. In their very deficiencies they err on the right side, and one may even question if a certain harshness, a crudity of handling here and there noticeable, does not positively contribute to the impression of force. At any rate, it removes them far from the class of exquisitely finished and exquisitely foolish Indians of the jewelry stores, with which not a few public works have a close relationship.*[27]

Enthusiastic criticism was provided by Charles Caffin:

> *In Philadelphia, however, is an Indian group representing "The Stone Age."... It is by John J. Boyle, one of his few ideal subjects, a work of powerful imagination.... For in this group we pass from interest in the episode to a realisation of the rude grandeur of the primitive nature, the physical grandeur of untrammelled development and the natural instinct of*

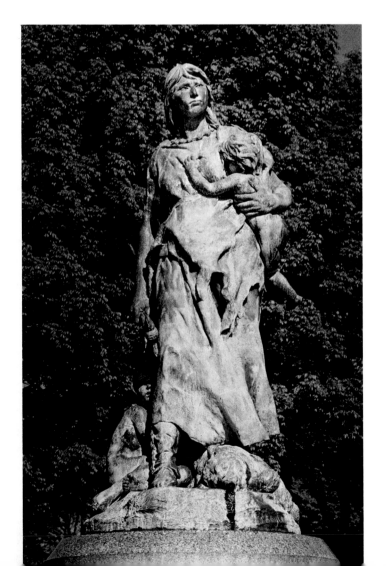

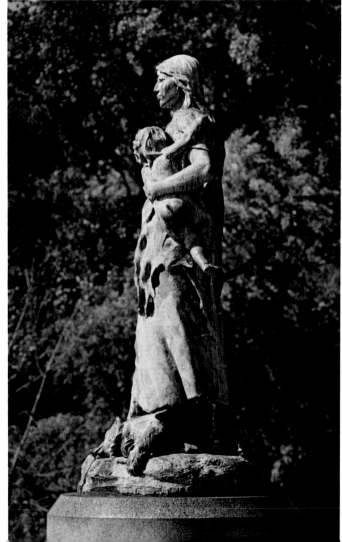

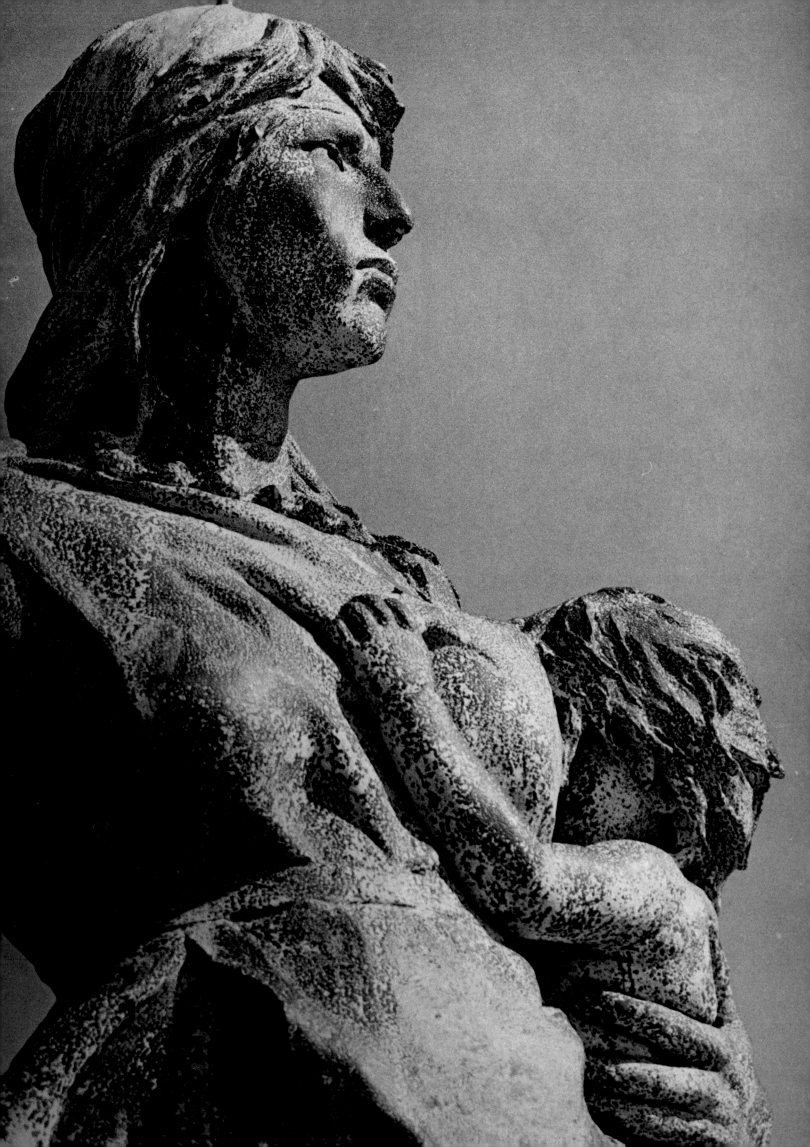

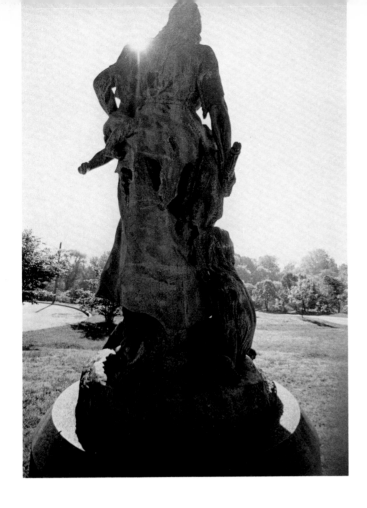

the mother animal.[28]

It is important to assess Boyle's place among sculptors who portrayed the American Indian in the nineteenth century. Before Boyle's *Indian Family* and *Stone Age in America,* sculptures depicting the red man were infrequently produced by expatriate neoclassicists and native sculptors. Horatio Greenough's *Rescue Group* epitomizes the former. This marble anomaly, made for the entrance plinth of the United States Capitol, presents a naked savage being subdued by a rugged settler who protects his wife and child from a brutal death. For Greenough and his neoclassical compatriots, the portrayal of the Indian often became nothing more than a convenient vehicle for sculpting a nude male or female. These expatriates, it seems, were never interested in making detailed studies of Indians. On the other hand, John Quincy Adams Ward (1830–1910) approached the problem differently. Beginning the small model of *The Indian Hunter* (figure 3), in 1857, Ward journeyed to the Dakotas before completing the bronze group erected in New York City's Central Park in 1868.[29] In seeking to develop what he felt was a valid national artistic style, Ward not only selected a subject native to America, but also emphasized the importance of faithful observation and realistic execution.

It is difficult to explain why Boyle did not exploit Indian themes in his later sculptures, for he had demonstrated his considerable talent in the monuments for Chicago and Philadelphia. In basing the Chicago group on first-hand observation, Boyle was following

Ward's example. But, with the Philadelphia commission secured, he returned to France where he could learn more, he felt, about his craft. It would remain for the next generation—Hermon A. MacNeil (1866–1947), Solon H. Borglum (1868–1922), Cyrus E. Dallin (1861–1944), and A. Phimister Proctor (1862–1950)—to concentrate on sculpting the red men. These artists grew up in the West, spending considerable time with the Indians, and in their sculptures created at the turn of the century they demonstrated a deep and abiding compassion for the first Americans.[30]

Boyle lacked this commitment and so his decision to go to Paris was easily made. Benefitting from this renewed contact, he produced in *Stone Age in America* a statue superior to *An Indian Family.* The composition is noticeably simplified. The attendant figures—a young boy kneeling by his mother's side and a small frightened child who buries his head—do not compete for attention as they did in Boyle's previous work. The placement of the secondary elements strengthen the pyramidal structure and form an articulate silhouette. By making the group only slightly larger than life-size and by erecting the statue on a low unobtrusive pedestal, Boyle has effectively captured the spectator's attention.

Stone Age in America must be considered Boyle's masterwork. It is conceived without exaggeration. The Indian mother is staunchly poised, intent on protecting her children from the anticipated charge of the bear. Her right arm is tense, her hand firmly clutching the hatchet. Her penetrating stare, tightened lips, and firmly set jaw convey a mood of determination. Surfaces are modeled with facility. In rendering the woman's animal hide costume, the sculptor varied the patterns and folds with a marvelous looseness. Boyle's statue certainly deserves the critical recognition it has received and merits the fitting tribute which appeared in the Fairmount Park Art Association's fiftieth anniversary publication: "The group is among the most masterly works which have been added to the works in the Park, and Mr. Boyle is undoubtedly the first sculptor who has adequately presented the Indian's case in American art."[31]

John J. Boyle (1851–1917)
Stone Age in America. 1887
West Fairmount Park
near Sweetbriar Mansion
Bronze, height 90″
(granite base 50″)

General Meade

by Victoria Donohoe

photographs by
Seymour Mednick

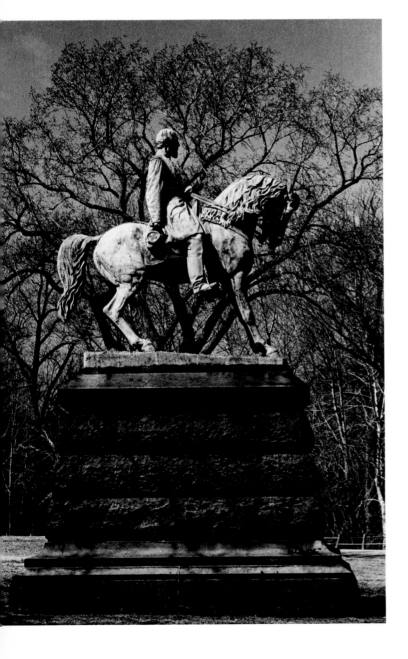

The equestrian statue of *General Meade* by Alexander Milne Calder (1846–1923) occupies a position in American sculpture comparable to that of an important footnote that was omitted from a book.[1] Founder of the Calder dynasty of sculptors which includes his son Stirling and grandson Sandy, who invented mobiles, stone carver Calder arrived in this country from Scotland in 1868 at the age of twenty-one and settled in Philadelphia. The coachman's son from Aberdeen almost immediately set to work here on his major achievement, the sculptures for City Hall. That early commitment on such a grand scale has tended to overshadow Calder's other accomplishments completely, including his *Meade*—the sculptor's first large-scale bronze, a unique work of his because its open ground-level location provides full visibility.

Overlook the *Meade* and you overlook a cluster of life and memory and art. A friendship[2] of Calder's early years is commemorated in the equestrian sculpture he made of the general. Also, Calder's statue can be viewed as the only monumental equestrian bronze in Philadelphia that Eakins' legacy has, in some measure, produced, since this *Meade* perpetuated the general discipline of certain methods Eakins taught. Furthermore, the unraveling of the story of this statue broadens the picture of the Hero of Gettysburg to the surprising extent that Meade, the public servant, emerges as an early champion of the conservation of Philadelphia's threatened natural environment at a crucial period.

In his most familiar role, Major General George Gordon Meade (1815–1872) commanded at the greatest, most hotly contested, battle of the Civil War—the Battle of Gettysburg, July 1-3, 1863. Meade, *the* soldier of Philadelphia, won his battle on local soil in the same spirit in which Philadelphia fought its share of the war—both

were equal to the occasion. Instead of noisy enthusiasm, Meade and his fellow townsmen expressed a grim, unflagging determination and an unwavering confidence. Even as Meade strenuously did his duty at Gettysburg after the Confederate invasion of Pennsylvania had begun, so Philadelphia's quota was always full. When General Meade died at the age of fifty-seven on November 6, 1872, Philadelphians sought a fitting tribute to the precious memory of the man whose able conduct of the Gettysburg battle had ensured the safety of the city by turning back the Confederate high tide.

On November 9 the year-old Fairmount Park Art Association embarked upon its first undertaking of magnitude—the formation of a committee to erect a statue of the Gettysburg victor. The Meade Memorial Fund was started, its management sponsored by the Association at the request of a large and influential committee of citizens. The Association, with Anthony J. Drexel as its president, agreed to contribute $5,000 toward the fund and began canvassing every ward in the city. Apparently from the start, local sentiment favored an equestrian monument that would perpetuate, as far as possible, the memory of Meade's personal appearance.

Sent reeling by Jay Cooke's September panic of 1873, the project gathered less than $1,000 the first year. Encouraged by a donation by Congress of twenty bronze cannon in 1874, valued at $7,000, the committee asked Joseph A. Bailly about current equestrian prices and then blanketed sculptors, Thomas A. Carew and Howard Roberts included, with requests for their proposals. Nearly a decade later they would consult Thomas Ball about costs. But collections in the wards of the city fell behind, and the project languished as Philadelphia's Centennial approached with demands of its own to be met. That "distraction" over, the committee renewed its

efforts, sometimes with outside help.

One such benefit, the Meade Memorial Matinees, tendered in the spirit of enterprise and patriotism by the manager of the Walnut Street Theatre, faltered when other theatres muscled in. Competition of another sort saw a large Memorial Day service for General Meade in 1880 conducted at Philadelphia's Academy of Music, with President Hayes attending, to raise money for a Meade Monument in Washington completed by Charles Grafly in 1927.

By all accounts, what saved the day for Philadelphia's project was the dramatic intervention of 119 spirited ladies, called upon for their assistance when funds were low, who formed themselves into the Meade Memorial Women's Auxiliary Committee. Led by Miss Mary McHenry, Meade's backer in his favorite charity, Lincoln Institute, a home for soldiers' orphans, they threw themselves into the fray. In short order these determined ladies, by an 1880 Act of Congress, obtained thirty more cannon, which were turned into cash like the earlier donation, and other money, making up nearly the full $30,000 needed for the statue and pedestal. Having supplied the funds, the women claimed the right to a voice in choosing the sculptor. After a hard fight the men gave in.

Circulars launching the design competition went out to thirty-four American sculptors, among them fourteen expatriates including Moses Ezekiel. There is no record of Calder's having been contacted directly at this time; he must have entered the competition on his own. Eventually, fifteen sketch models and three photographs of another model were submitted. Among the competitors was the obscure, young, New York-born sculptor Arthur Louis Lansing, who was active here in the fairly new field of terra-cotta work, as were two other probable

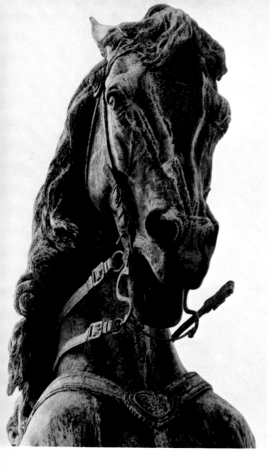

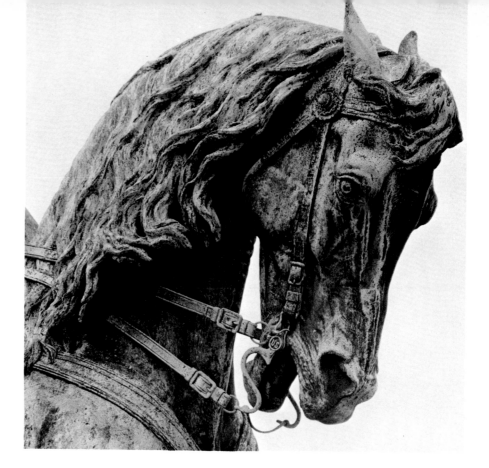

competitors, Henry Jackson Ellicott and Pennsylvania Academy student Frank Stephens. Washington's Theo A. Mills competed. Louis T. Rebisso, George E. Bissell, Charles Conrads, Henry Manger and assorted amateurs also probably followed through on their registrations. Ninety-one persons paid twenty-five cents each to view the nine-day Meade sketch model exhibition at 1001 Chestnut Street, while fifty-eight artists and eight journalists were among 160 admitted free. On October 19, 1881, the Memorial Committee and three women awarded Alexander Calder the $1,000 first prize on the first ballot. Joseph Alexis Bailly placed second, Arthur Lansing third. Perhaps the 1881 *Art Journal* came close to the truth in its cryptic comment: "The award was the result of a not very successful competition." Be that as it may, the Art Association shelved its project "for further consideration."

Bailly's defeat by a student in the Academy school where Bailly recently taught modeling from plaster casts— and would be teaching still, had students like Calder not insisted upon live models—added insult to injury for this local lion. Bailly had done equestrian statuettes of Generals McClellan, Meade, and Grant (figure 1)—the latter presented to the Union League in 1871 by Edwin N. Benson, honorary member of the Fairmount Park Art Association—and an Academy-owned bust of Meade. Moreover, the Art Association had consulted him about equestrian costs in a letter that said "assuming the order be given to you." Responding to that early overture, Bailly was not to be outdone in the flamboyance of his bid for the Meade equestrian project. For one thing he had exhibited a Meade equestrian statuette at the annual exhibit of the Academy in 1876. For another, he

conspicuously exhibited at Philadelphia's Centennial that year his model for one of the western hemisphere's most controversial equestrian statues—the monument that vain, despotic Venezuelan president Antonio Guzmán Blanco had erected of himself in front of the Caracas capitol in 1875 at public expense.[3]

Calder found his method of creating the equestrian statue when he studied with Thomas Eakins at the Pennsylvania Academy of the Fine Arts. He had fallen in with Eakins as a teacher prior to their formal classroom meetings at the Academy. In January, 1876, the sculptor petitioned that Eakins be allowed to conduct an evening life class there. By autumn, both were at the Academy— Eakins as a teaching assistant in the evenings and Calder enrolled there for a long term of study that naturally meant attending Eakins' classes. In addition to modeling the human figure from life, advanced students were encouraged to model and dissect horses through arrangements Eakins made for them elsewhere. Then, in January, 1881, for the first time in the classroom they began to model a live horse over a six-week period. This once-a-season revolutionary practice continued throughout Calder's remaining period at the Academy. The timing was right. Very likely, Calder, the Meade project at a standstill in 1881, plunged right back into the study of equine and human anatomy for two more years under Eakins' watchful eye. What better way to convince the Art Association of his readiness for another try at Meade's monument?

By December, 1883, the Art Association was ready. It contracted with Calder for a completely new $500 plaster sketch model to be delivered May 1, 1884. A favorable

outcome gave Calder the $25,000 job. As security he put up his $4,500 Bainbridge Street home, a Latona Street property valued at $1,000, and various insurance policies. By summer, work had begun. A first payment of $1,600 followed, the Association's year-end report noting "Calder is busily engaged upon the full-sized model of the Meade Memorial statue which is, according to the contract to be finished and placed in position in the Park in spring or early summer 1887."

The pose shows the influence of the French painter Henri Regnault's majestic portrait of General Juan Prim, the Spanish revolutionist, statesman, and former governor of Puerto Rico, which was the sensation of the Paris Salon of 1869.[4] Above all, the position of the bronze horse is taken from the painted, black, Andalusian steed, both shown at a dramatic turn of battle. In Calder's original sketch, the horse was "almost a copy" of Regnault, noted a mid-1886 *Magazine of Art* progress report,[5] but "the spirit of the Frenchman's conception has been softened away in making the statue, until very little is left. In the case of the rider the original idea has been abandoned entirely, and the action is so quiet that a want of harmony between his figure and that of the horse is the most obvious criticism." It added, however, that "As a portrait of General Meade the statue is regarded as very successful."

Besides the close connection with the Prim portrait and the study of anatomy in relation to form, Calder relied upon memory and photographs for guidance. Calder's recollections may have included seeing General Meade on horseback—perhaps riding battle-scarred "Baldy," which the general constantly used as a saddle

horse in Philadelphia until the faithful animal was farmed out to suburban Jenkintown. Though that famous Gettysburg war horse was crotchety by 1881, Calder could have sketched him that year.

Making a fresh start, Calder this time used as his live model a horse called "Duke," belonging to John McPherson of Bridgeton, New Jersey. Calder aspired to treat this beast as a heroic animal recognizable as such by its expression and energy of action and motion implied by the compressed pose as it pulls back on its haunches on the slope of a hill, the agitation of the steed contrasting with the calmness and dignity of the rider. Calder's conception of monumental art, calling for hero worship combined with a record of events, finds him giving much attention to accessories—eyeglasses tucked in the coat, riding gear, the veins of the horse, and a now missing sword.[6]

As for photos, the hatless profile of George Gordon Meade by F. Gutekunst, about 1863 (figure 2), guided Calder in establishing his statue's strongest angle of vision. Thus Calder gives the general his noble head, but does not do the same for Baldy. Nothing distracts from the right side of the general's strong-featured face—to assure this, the sculptor lowered the arm and tightly reined in the horse's muzzle, lowering his head. The general, by his deliberate attitude, either acknowledges a salute, cap in hand, or is receiving important information, his straight arm accentuating his upright posture.[7]

A satisfactory progress report on the *Meade* prompted a committee of nine men and one woman to inspect the full-size working model (figure 3) in Calder's studio on June 10, 1886. That test passed and predicting

an arrival date in the park of May 1 next, Calder armed himself with a $1,000 advance. By mid-December the statue was being cast in bronze under his supervision by the flourishing new Henry Bonnard Company in New York. Probably completed by May 1, the one-and-one-half life-size bronze weighed three-and-one-half tons.

In accord with the wishes of the general's family and friends, a place in Fairmount Park was selected for the monument, a broad grassy slope just north of Memorial Hall facing the Schuylkill River.[8] Many people thought the proper spot for the Meade equestrian would be in front of the north portal of City Hall, there to have light, room, and effect amid dignified surroundings opposite John Rogers' recently installed statue of Meade's friend and Gettysburg comrade General Reynolds. But the earlier plan won out.[9]

The highly unusual park location salutes Meade's peacetime activity as a practical man with a strong civic sense. The location emphasizes less a soldier's conquest than an engineer's victory over nature—especially his knowledge of the anatomy of the landscape. Since it is still possible to see the influence of George Gordon Meade on the shape of the landscape of Fairmount Park, his presence there is further intensified by the high degree of accuracy his equestrian likeness has. The statue tries to perpetuate an honest vision of Meade as he really was.

An aloof and somewhat forbidding figure, seated with monumental aplomb on his favorite charger, the general was a man of stiff pride, stern justice, and formidable wrath (he once had a vexing *Philadelphia Inquirer* reporter mounted backwards on a mule and ridden from camp amid jeering troops). Courageous but not dashing, Meade was a thorough soldier and a cultured gentleman with gracious, almost courtly, manners. During the last few years of his life, the working out of the design of Fairmount Park became a primary means of expression for him, and his involvement in the task was passionate and urgent. A commissioner of Fairmount Park from its origin until the day he died, and its vice-president most of that time, Meade was the one man most responsible for the arrangement of park drives, walks, and bridle paths and for unifying the disjointed park lands. Almost daily, at any hour, in all weather, General Meade was a familiar sight on foot or horseback making his rounds of Fairmount Park, often accompanied by his daughter Henrietta.

"Very straight, with his stirrups low, it's just the way father used to sit on his horse," Henrietta said in 1927, commenting on the accuracy of a small bronze equestrian model of Meade then in her possession. Her description fits Calder's statue exactly, not Henry K. Bush-Brown's. Calder's renewed interest in the Meade subject that resulted in an 1892 bronze bust of the general commissioned by the Union League (figure 4) seems connected with the imminent choice of a sculptor for the Gettysburg *Meade* equestrian statue, a task Bush-Brown completed in 1896. The pose of Calder's palm-decorated *Meade* bust is closely derived from his equestrian, in

which the profile view, more than the frontal, caught Meade's psychological overtones.

Preparations for unveiling the statue were extensive. Railroads advertised three-day excursion rates. Precautions were taken to stop the parade music so marchers could step lightly crossing Girard Avenue Bridge to prevent its collapse. Flags fluttered from nearly every window along the parade route on cloudy, mild, Tuesday, October 18, 1887. Two small grandsons of the general unveiled the flag-draped statue before 30,000 persons in the flickering sunshine as the Sixth Regiment Band of New Jersey rendered "Sheridan's March," composed for the occasion, amid tumultuous applause. Festivities were followed by a Union League reception for 1,500. Everywhere in the city that day the talk was of Meade.

Conspicuously posted on the speakers' stand during the unveiling ceremonies were two placards containing extracts from General Meade's farewell address to the Pennsylvania Reserves: "To the services of the Reserves I here acknowledge my indebtedness for whatever of reputation I may have acquired," and "The commanding general will never cease to be proud that he belonged to the Reserve Corps." The Art Association read into its next annual report extreme satisfaction with the monument—their fifteen-year task complete but for one small item. The word "Meade" still remained to be cut in raised letters on the front of the pedestal. Some thought it should say: "Equal to the occasion."

Alexander Milne Calder (1846–1923)
Major General George Gordon Meade. 1887
West Fairmount Park,
Lansdowne Drive north of Memorial Hall
Bronze, height 138″ (granite base 144″)

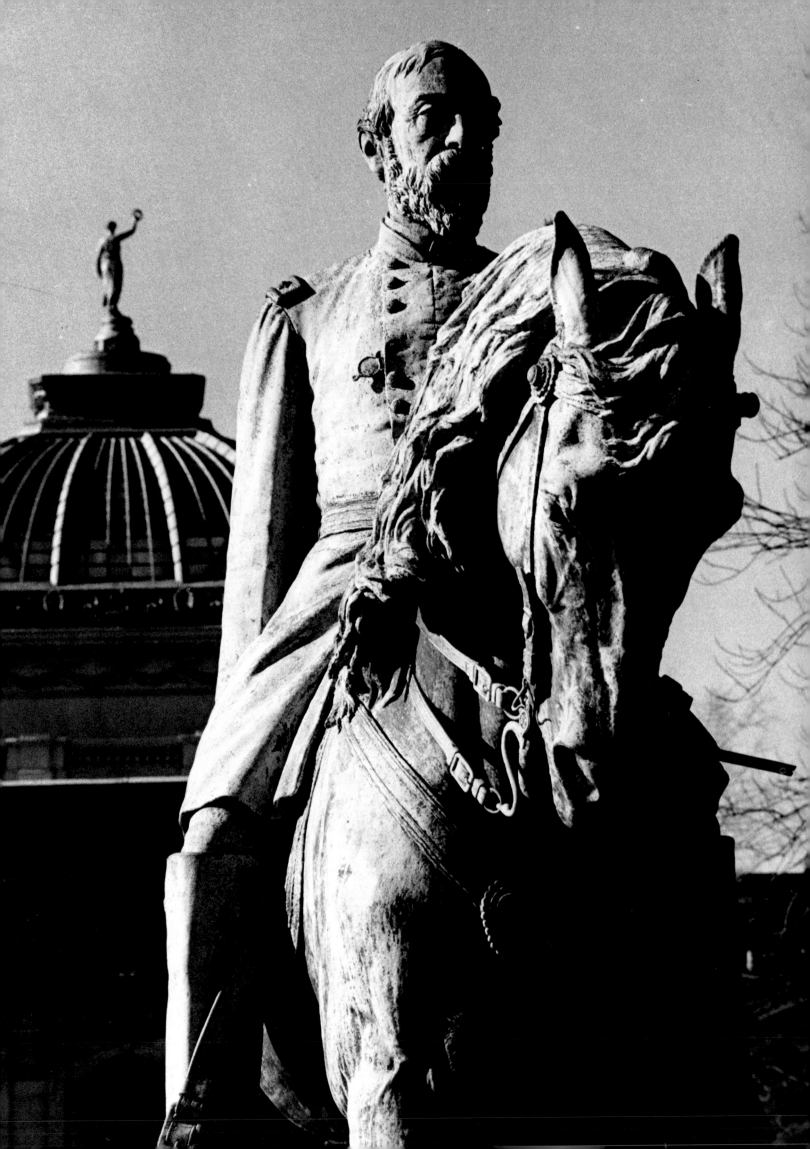

Joan of Arc

by David Sellin

*photographs by
Bernie Cleff*

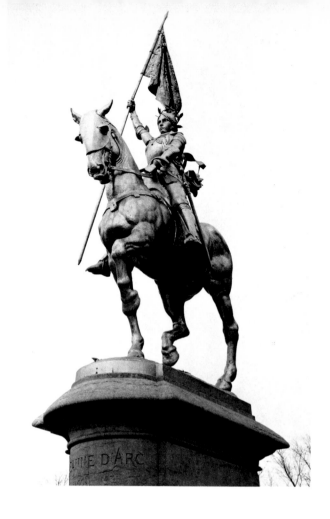

The education of Emmanuel Frémiet (1824–1910) began under the direction of an uncle in the service of the Museum of Natural History.[1] He then followed art courses in the rue de l'École-de-Médecin preparing for admission into the atelier of another uncle, the celebrated sculptor Rude, where Carpeaux was his fellow student. Carpeaux went on to the École des Beaux-Arts, the Prix de Rome, and almost immediate fame, but Frémiet stayed with Rude. Intense study gave him a control of his medium and a command of anatomy which eventually put him in closer harmony with the philosophy of the École des Beaux-Arts in the closing years of the Second Empire than if he had followed Carpeaux's example.

It is natural to compare Frémiet with the great *animalier* Barye. The latter eventually renounced anthropomorphic representation, while Frémiet progressed from animal images to groups combining human and animal motifs. Barye studied individual animals in order to synthesize an accurate representative of the species, but Frémiet analyzed the specific in pursuit of the character of the thing under examination. His realism was of an intellectual order, with few concessions to popular taste and no social messages. Domestic animals were the staple of his early career, among them a *Draft Horse* (1855) and a *Montfaucon Horse* (1853), a wretched beast ready for the abattoir. Fidelity to fact led to an imperial commission for a series of figurines illustrating branches of the military service, including several equestrian studies, which he executed between 1855 and 1859. Figurines of a Roman and a Gallic

horseman drew attention at the Salon and Exposition of 1867, along with an equestrian bronze of Napoleon I commissioned for the city of Grenoble. His election to the Legion of Honor pleased Frémiet, but what gave him particular satisfaction was to succeed Barye as professor at the Museum of Natural History, where he had begun his hard course of studies.

Finally, after more than twenty-five years of almost continuous Salon representation, Frémiet achieved full artistic maturity in the twilight of the Second Empire with his *Louis d'Orléans,* for the Château of Pierrefonds, the first of a series of monumental equestrian works to which the *Joan of Arc* in Fairmount Park belongs.[2] Frémiet did a number of variations on the theme of the *Maid of Orleans:* in peasant dress and in armor, kneeling, standing, on horseback. The appeal of the subject in the wake of the Franco-Prussian War is self-evident—"A nation which has given birth to Joan of Arc may sustain passing reverses; it cannot disappear from the surface of the world," the French consul would say in Philadelphia.[3] In the face of a staggering indemnity, the government commissioned Frémiet in 1872 to do a monument to the national heroine for the Place des Pyramides, hard by the fire-gutted ruins of the Tuileries (figure 1), which he erected on Thursday morning, February 20, 1874, in the presence of its founder Monsieur Thiébaut fils, and about fifty spectators[4] (figure 2). There was no ceremony to call attention to the paradox of a monument to an ancient victory in the midst of rubble from recent overwhelming defeat and consequent turmoil.

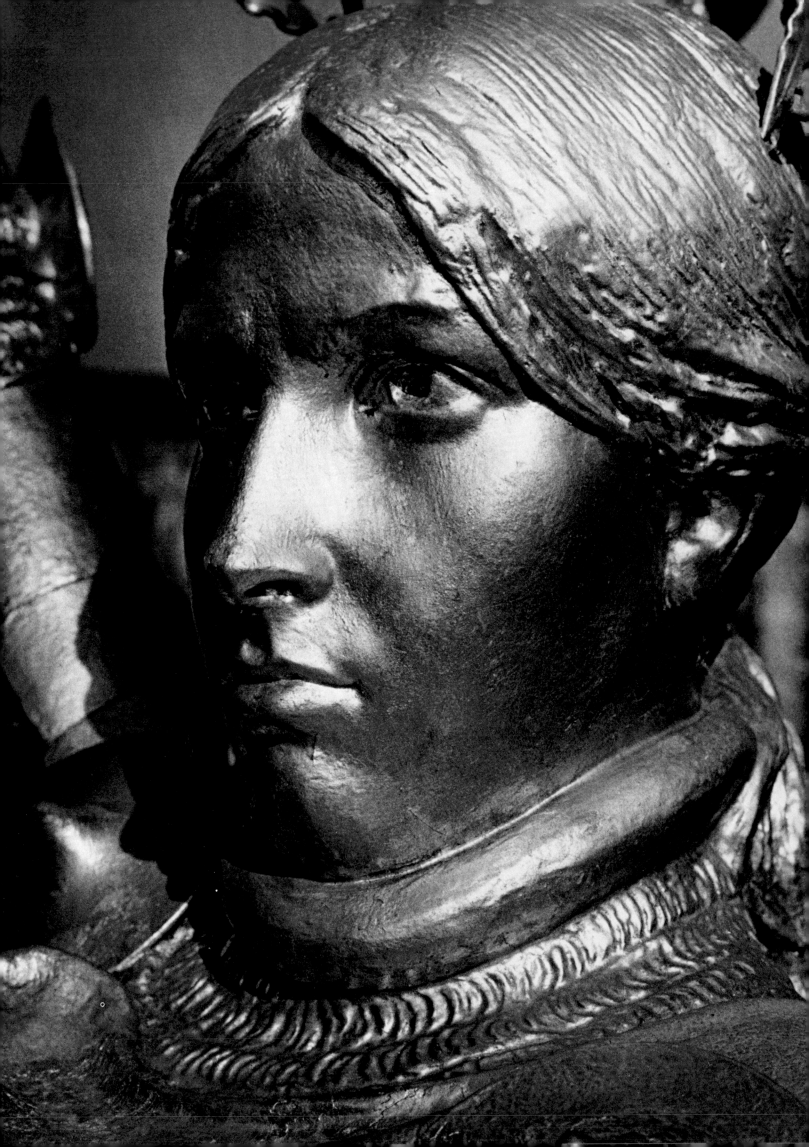

The Pre-Raphaelite Brotherhood was only one of many movements then seeking their sources in nature, and turning attention to the age which had first explored it in modern Europe. Dante and Petrarch had long inspired literati, but Giotto was too "primitive" a model for nineteenth-century artists, and it was the experimental artists of the fifteenth century that many of the "realists" admired. Frémiet, the naturalist, was also a student of history, who looked to fifteenth-century sculpture and tapestries for details of armor, and conventions of posture and dressage; little wonder that he should emulate Donatello and Verrocchio; "I used the Orleans tapestry, a German tapestry which dates from sixty years after the death of Joan of Arc at Rouen," Frémiet said of another source.[5] "If . . . M. Frémiet does not have a feeling for monumental art," commented a contemporary biographer, "it is because realists, by their very concept of things, never see larger than nature."[6] Frémiet the realist knew the small stature of most grown men of the fifteenth century and the size of the war horses which carried them into battle. He would seat Isabeau of Bavaria sidesaddle on a stately palfrey, but he put the Maid of Orleans, in armor fitted to her small stature, astride a man's battle horse.

Public criticism mounted. How could a monumental feat be credited to a girl so small? Even Frémiet found it unsuccessful *in situ* because of his failure to scale it to the buildings surrounding the site. "I was desolate, truly, to have had the honor of such a beautiful emplacement, and to be mistaken in proportion," Frémiet confessed, and finally could not bring himself to look at it. He determined to do a replacement in secret at his own expense.[7]

Some years later in Philadelphia, a meeting was held on June 18, 1889, at the house of Thomas Hockley of the Fairmount Park Art Association's Art Committee, with Charles H. Howell and Charles Cohen present, and old John Sartain there by invitation.[8] With less than a month to Bastille Day, the French community was eager to commemorate its Centennial:

> In view of the statements made of the desire of the French Colony in Philadelphia to secure the statue of Joan of Arc for Philadelphia, and of their certainty that the fund necessary would be subscribed to by, not only the French in the city but by many others, the following resolution was offered by Mr. Cohen.
>
> Resolved—that the treasurer be authorized to contract with M. Frémiet of Paris for the statue of Joan of Arc as described in his letter of May 25, 1889, for the price fcs 17,500. Carried.[9]

Howell circulated a notice to the board membership on July 31 asking for instructions, but Hockley was already in Paris. On August third he saw the *Bear Tamer* by Paul W. Bartlett, and wrote: "I have the photograph hanging up in my office. The model is being exhibited at the Exposition & attracts a good deal of attention. It is by Mr. Bartlett, an American. This latter circumstance makes me all the more wish that we could secure it . . . if we had the money."[10] Hockley's chief order of business, however, was not with Bartlett, but with his professor, Frémiet, and he brought capable advisers with him:

> By appointment with Mr. Frémiet this P.M. I went to see the model of the new Joan of Arc. I was surprised to find that the new model is in all respects the same as the statue now in the rue des Pyramides with the exception of the figure which is heightened about 4 or 5 inches. The figure itself is, except by this small addition, exactly the same, as it was re-produced by the mathematical process of Barbedienne.
>
> In view of all this & after a talk with Mr. [John J.] Boyle, who went with me, and also with Mr. Stewart who is a capital art critic & an American, living here, I could see no possible reason why I should not be carrying out my original authority & agree to take the statue. . . . It will take six months to cast the statue in bronze. We shall not therefore get it until next winter.[11]

The contract was signed on August 5, with Frémiet agreeing to furnish Philadelphia "an equestrian statue of Joan of Arc in bronze, and similar to that of the Place des Pyramides," for 17,500 francs payable on delivery, with the further stipulation that: "There will be only three editions of this statue, that of the place des Pyramides, that of Philadelphia and one in Nancy."[12]

On March 17, 1890, Hockley circulated a request to the Committee on Works of Art to consider a location for the equestrian statue,[13] but characteristically continued on his independent course:

> Mr. [Leslie W.] Miller & I are heartily in favor of the Eastern approach to Girard Avenue Bridge as the site for the Joan of Arc, & I think we ought to settle on that. Mr. [George Thompson] Hobbs, the artist, entirely agrees with us, & he is very familiar with Park grounds. Will you then kindly take the necessary steps towards getting permission for this site.[14]

That was the site settled upon. By June 6 the excavations were about to commence and the statue and pedestal were on the way. The pedestal had been executed from Frémiet's design by a Paris firm for "about $200 less than it would have cost if ordered in this city."[15]

More care was given in Philadelphia to scale than for the original site in Paris: "As to the size of the statue it is full life size & the position assigned it (back 30 feet) is on that account. It will be on a platform of grass, so to speak, with approaches—practically a little garden in itself. . . . Had it been nearer the road without the accessories, it would have looked smaller."[16]

On the twentieth of the month the Customs House Brokers informed the Association that "the S.S. Switzerland having on board the statue 'Joan of Arc' arrived from Antwerp today, and we will thank you to call at this office in order to make affirmation of this."[17] About a month later the Park Commissioners were told by Atkinson & Myhlertz, Marble and Sand Stone Works: "we hauled from the steamship, out to Fairmount Park the Six boxes containing the Statue and Pedestal of Jeanne d'Arc: Mr. Hockley is very anxious for us to put in the foundations, and put up the granite pedestal; Will you please let us know . . . when you will be ready for us. . . ."[18] By October 3 the foundation of Conshohocken stone was laid, the granite base set up, and the statue hoisted into place. "They are pushing us very much and the Park

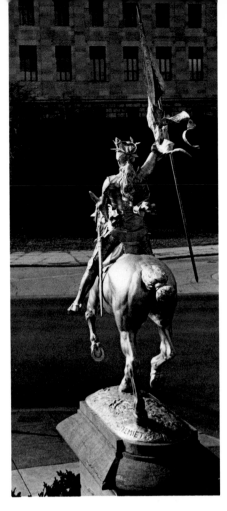

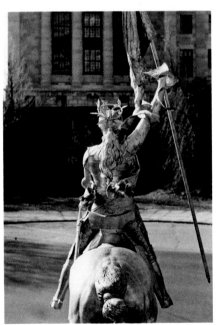

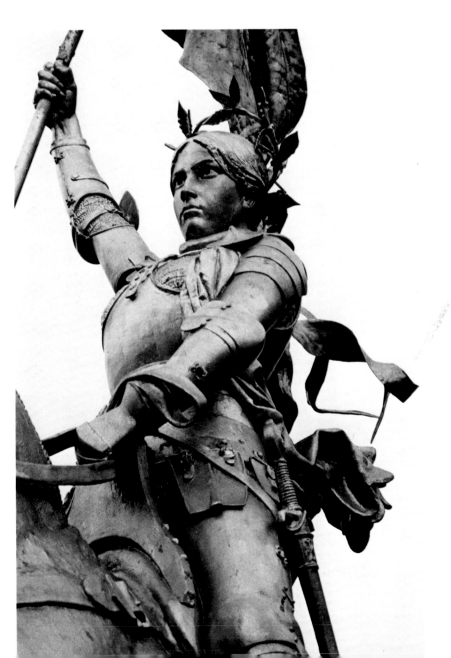

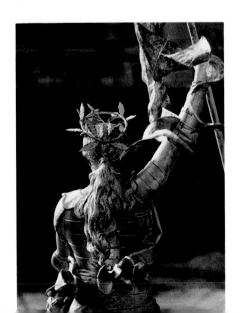

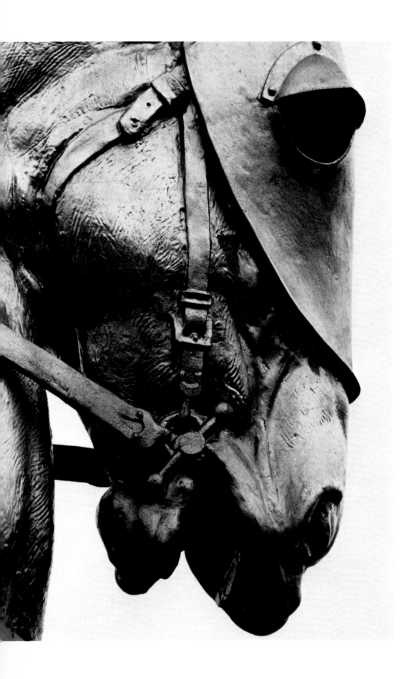

Coms. are hauling dirt and filling up all around the base for sodding we suppose," the contractor complained. "They did not give us any time, but were right on top of us."[19] Finally the derricks were pulled away, and on October 6, 1890, the park engineer wrote jubilantly: "The 'Joan of Arc Memorial' is in position ready for unveiling & I take pleasure in saying that I think it is by far the finest and most beautiful work of art yet placed in the Park."[20]

Unveiling had been postponed once and the moment for an autumn ceremony was rapidly passing, but was finally set for Saturday, November 15, at 3:00 o'clock. French and American flags were lent by John Wanamaker's Store. Traffic was halted on the thoroughfare as the invocation was delivered by the Rev. Dr. C. Miel of the French Colony, followed by remarks by Samuel C. Perkins and the official presentation to the Park Commissioners by the venerable Charles J. Stillé. Leslie Miller and John Sartain were also on the platform. Gentlemen removed their hats as Lucille Rigueur pulled away the bunting and the Girard College Band struck up the *Marseillaise,* a moment frozen for posterity by the photographer (figure 3). Samuel Gustine Thompson then said some appropriate words:

> *Most of the works of art placed in public parks are made to represent destruction in some form or other. In such works we see the lion, the king of the forest, with his prey in his grasp ready to destroy it; we see the tiger about to spring on his unconscious victim; we see fierce wolves in a death struggle for food; we see the savage seeking to drive off the wild beast intent upon destruction; we see the gladiators in mad contortion striving to crush out life.... Far better it would be that these works in public places should represent subjects that will tend to advance and elevate the public mind.*

Professor Victor Rigueur delivered a ponderous oration in French, and French Consul Louis Vossion expressed an appreciation in the name of Frémiet and of the French Colony:

> *When, in future years, the ships of our navy will visit your friendly shores, and drop their anchors in the blue waters of the Delaware; when our tourists, travelers, artists, merchants and writers will come ...all, without exception, will be delighted to salute, with a throb of their hearts, Joan, the virgin of Domremy, on her pedestal of marble, holding in her hand the lance and the oriflamme.*
>
> *The genius of Bartholdi created the beautiful statue of "Liberty Enlightening the World," which adorns so splendidly the entrance to New York harbor. But it is an emblem, a figure that may well belong to all the civilized nations, and symbolize the progress of the human race. Frémiet, in his Joan of Arc, which will now forever decorate your beautiful Fairmount Park, has created something exclusively illustrative of France; and it can well be said that in no place in the world, outside of France, could that noble statue be better placed than in Philadelphia, the Mecca of American liberties.*[21]

Frémiet, swelled with patriotic feelings, was flattered. "I,

more than anyone, appreciated the language, so moving and elevated, to which the unexpected good fortune of seeing our heroine glorified in the great country of America inspired you—a good fortune which gives me constant satisfaction, of which I never tire of thinking."[22]

Not everyone on the art committee agreed that the original *Joan of Arc* had been improved. Charles M. Burns, on seeing photographs of the new version sent on from Paris by Hockley, averred that "compared with the splendid movement of the earlier work the later horse has hardly the nervous action of a fat cow." His remarks confirm that the intention had been to buy the actual original *Joan of Arc* from the Place des Pyramides:

> In the earlier work the horse has all the elements of go, push forward, hard muscles, arched neck, pointed ears, the woman draws a tight rein and even her grip of the lance and the angle at which it stands, like all the rest suggests tension of enthusiasm.... the second production... is by no means a facsimile. The horse is pudgy; he has no nervous action, no go. Perhaps it may be retorted that this like the change in the shape and movement of the tail, the addition of the head piece and the omission of the breeching straps is more historically correct, a horse of the breed she might have mounted having very little nervous action the sculptor may have thought his earlier rendering showed too much. I might ask did we start out to buy archaeology or art. I...desire to go on record with a protest against having a second rate object placed in the park, when we have bargained for a first rate one. The city of Paris or the French Government knew what it was about when it declined to carry out the scheme proposed at first.

The prevailing attitude, however, was one of admiration and delight. William C. Brownell, artist and art critic, regarded it at the time of installation as one of the masterpieces of a great artist:

> The horse is fine, as always with M. Frémiet; the action of both horse and rider is noble, and the homogeneity of the two, so to speak, is admirably achieved. But the character of the Maid is not perfectly satisfactory to à priori *critics, to critics who have more or less hard and fast notions about the immiscibility of the heroic and the familiar. The* "Jeanne d'Arc" *is of course a heroic statue, illustrating one of the most puissant of profane legends; and it is unquestionably familiar and, if one chooses, defiantly unpretentious. Perhaps the Maid as M. Frémiet represents her could never have accomplished legend-producing deeds. Certainly she is the Maid neither of Chapu, nor of Bastien-Lepage, nor of the current convention. She is, rather, pretty, sympathetically childlike,* mignonne; *but M. Frémiet's conception is an original and a gracious one, and even the critic addicted to formulae has only to forget its title to become thoroughly in love with it beside this merit* à priori *shortcomings count very little.*[23]

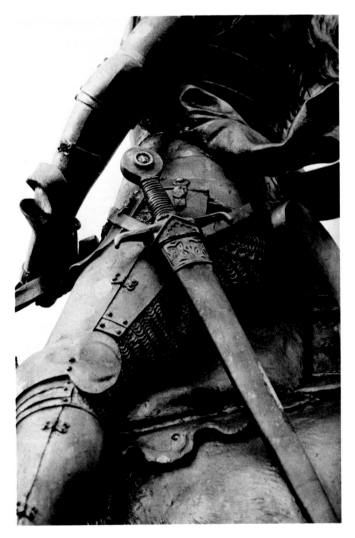

"There will be only *three* editions of this statue, that of the Place des Pyramides, that of Philadelphia and one in Nancy," according to the contract. A duplicate cast was

erected in the Place Lafayette in Nancy, and Frémiet retained a plaster in his studio against the day when he could fulfill his vow to replace the one in the Place des Pyramides. When the Art Institute of Chicago appealed to the French Commissioners of Exhibitions for Fine Arts to obtain the *Joan of Arc* for the Columbian Exposition, Frémiet, "moved by feelings of great delicacy," was not willing to give authority for the removal of the cast from his studio without the Association's permission.[24] Finally Frémiet's long awaited opportunity came:

> *An American from Chicago, very rich bien entendu, elegant in appearance, very Yankee, with very round shoes and very curt speech, came to Europe with the idea of buying he didn't know exactly what, but lots of things. In London he tried to acquire all the bus lines. That fell through. He descended on Paris. His itinerary and his checkbook led him to me.*[25]

He bought two major sculptures to embellish the grand staircase of his alma mater, in the environs of Chicago, giving Frémiet enough money to cast another *Joan of Arc* just when the prefect of police informed him that the base in the Place des Pyramides was sinking. The artist gave instructions to have the original hauled to the Barbedienne Foundry near Porte St. Denis during the five or six days needed to repair the base. At six in the morning of May 16, 1899, Frémiet installed a new cast of the one acquired a decade earlier by Fairmount Park, gilded to pick it out boldly against the surrounding buildings. Frémiet no longer needed to pass with eyes averted: "Aujourd'hui je suis content." The original cast by Thiébaut fils was consigned to the crucibles in the presence of 200 workmen in the Barbedienne Foundry, and only the laurel crown was preserved by the artist as a souvenir.[26]

In 1905 the National Gallery of Victoria, Australia, commissioned a replica of the Paris *Joan of Arc* directly from the sculptor, and to keep to the letter of the contract he introduced minor variations.[27] A fifth is in the Place Gambetta of Mirecourt, Vosges, so, including the one destroyed, there were six monumental *Joans* in three variants. An important role was played in the development of the concept by a small fourth variant, a figurine cast and gilt by Barbedienne in 1877. Preserving details of the 1872 commission, it has the proportions of the one in Fairmount Park and is by the same founder, so can be considered a maquette for the replacement Frémiet had in mind, a resemblance enhanced by the gold, since all of the other monumental variants remained in the natural bronze. This brings into question the wisdom of the recent removal and gilding of the Philadelphia edition[28] (figure 4). It now stands near the spot on which Bartholdi had hoped to erect a monumental allegorical gateway to the park. Brownell commented that, "It is only M. Frémiet's ... fondness for exercising his lighter fancy in comparatively trivial *objets de vertu*, that obscure in any degree his fine talent of illustrating the grand style with natural ease and large simplicity." This grand simplicity has to a certain extent been obscured by the Association's disregard for the landscaping of a site of dubious compatibility to begin with. The gold exaggerates in the open space the illusion of smallness noted by contemporary critics, shrinking the Maid of Orleans almost to the *objet de vertu*. As Brownell said, however, "If it may be called a monumental clock-top, it is nevertheless monumental."

Emmanuel Frémiet (1824–1910)
Joan of Arc. 1890
East River Drive at the
Philadelphia Museum of Art
Bronze, gilded, height 180″
(granite base 100″)

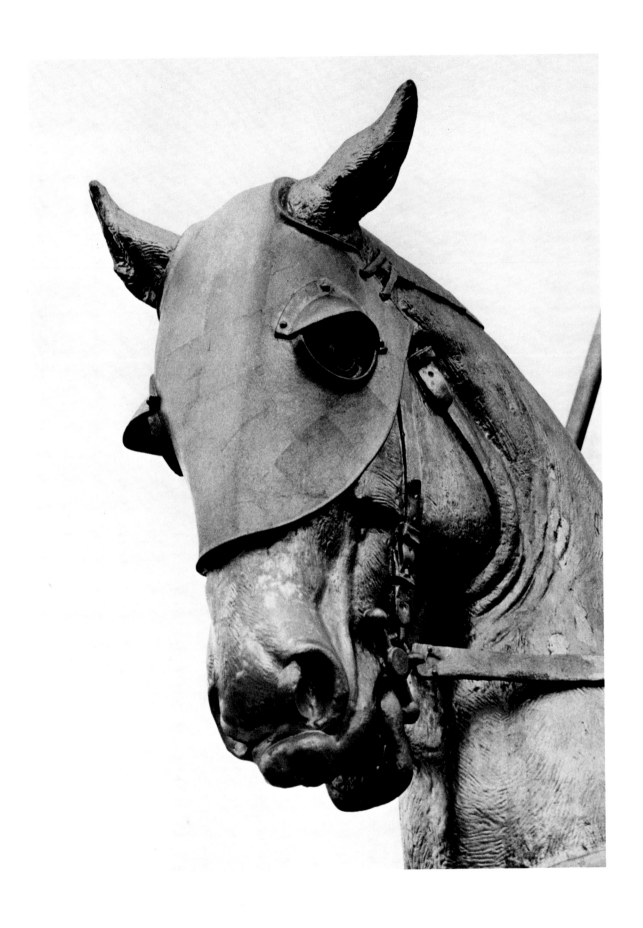

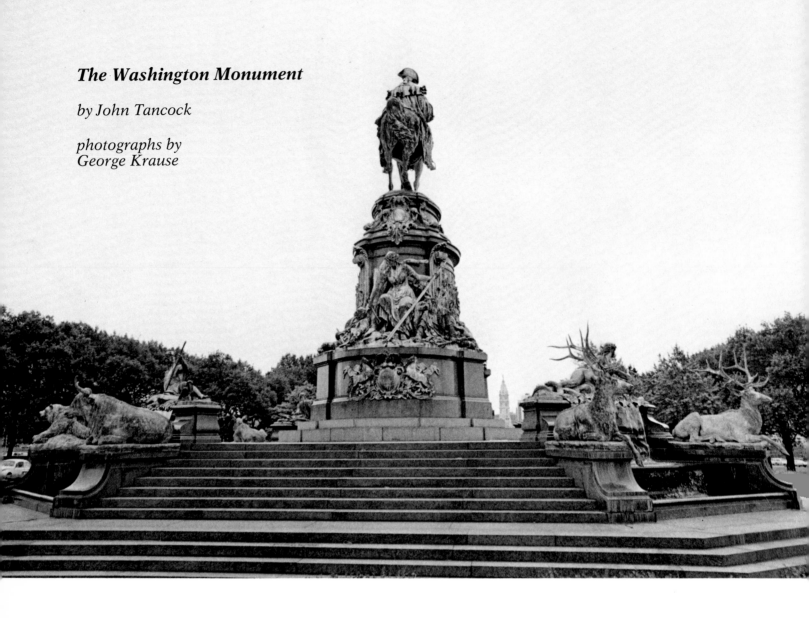

The Washington Monument

by John Tancock

*photographs by
George Krause*

The monuments of the past are relics that continue to engage attention only in so far as they provide aesthetic interest. Few kings, queens, heroes, or politicians of former times are more than mere names to the general, even the educated, public of today, with the result that statues and monuments erected to them long ago cannot be expected to satisfy on the emotional and intellectual level that they once did. Most of the monuments erected in the great age of monument building, the nineteenth century, have today become mere landmarks and probably obstacles to traffic.

In the middle of the twentieth century one is accustomed to monuments arriving "ready-made" in public locations. Contemporary monuments, conceived in the artist's studio, in isolation, are expected to be continuations, on a larger scale, of the artist's previous train of thought. Yet, in the nineteenth century, it was by no means uncommon for the preparations prior to the erection of a monument to last for decades. The dedication ceremonies attending the unveiling of the Washington Monument were in fact the culmination of a campaign that had lasted for well over eighty years and might justifiably be traced back to the founding of the

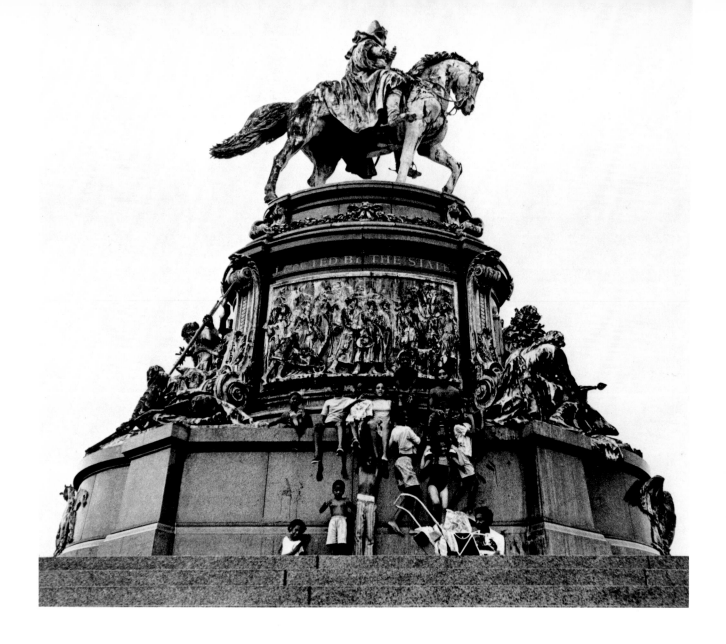

Society of the Cincinnati on May 13, 1783. The role of the sculptor, Professor Rudolf Siemering of Berlin, in the endeavor consisted in giving three-dimensional form to themes that were elaborated for him by the members of the Society and were in fact inseparable from its history.

The Society of the Cincinnati, composed of officers of the Continental Army, was founded at their cantonment on the Hudson River. Its purpose was "to perpetuate—as well the remembrance of this vast event (the separation of the colonies of North America from the domination of Great Britain) as the mutual friendships which have been formed under the pressure of common danger, and in many instances cemented by the blood of the parties."[1] The name of the Society was derived from their "high Veneration for the Character of that illustrious Roman, Lucius Quintius [*sic*] Cincinnatus, and being resolved to follow his Example by returning to their Citizenship, they think they may with Propriety denominate themselves *The Society of the Cincinnati.*"[2] There are fourteen constituent societies of the Cincinnati, one being the State Society of the Cincinnati of Pennsylvania, which erected the monument. Each of the thirteen original states has one of these organizations and there is one in France. The

Pennsylvania Society was organized at the City Tavern in Philadelphia on October 4, 1783. These fourteen societies meet every three years under the style of the Society of the Cincinnati. General Washington was the president of this organization from its conception until his death in 1799.

From the beginning, the Society was more than just a patriotic or fraternal organization. Each of the original members deposited one month's salary as the basis of a fund for giving financial assistance to such of the surviving officers and their families and descendants as needed it. Besides the philanthropic side of their activities, one project above all began to occupy the attention of the members, namely the creation of an enduring monument to their first president. On July 4, 1810, the Pennsylvania Society met in the State House in Philadelphia and resolved: "To establish a permanent memorial of their respect for the memory of the late father of his country, General GEORGE WASHINGTON, by the erection of a monument in the City of Philadelphia...."[3]

A committee was formed, but money raised by subscription to erect the monument accumulated very slowly. On October 1, 1824, at a time when the Cincinnati

Fund was still extremely modest, a meeting of citizens of Philadelphia was convened in the Merchants' Coffee House, the result of which was the establishment of a second Washington Monument Fund.[4] The site chosen for the monument was Washington Square and it was hoped that General Lafayette could be persuaded to lay the foundation stone before his departure from the city. It was also proposed that the Society of the Cincinnati should be approached to see whether or not it would be willing to cooperate with the newly established fund. This fund, too, progressed slowly, although by 1871, when the trusteeship was handed over to the Pennsylvania Company for Insurances on Lives and Granting Annuities, it amounted to $30,466.

Meanwhile, through careful investment, no less than $87,633 was available to the Society of the Cincinnati in 1871, a considerable sum but not sufficient for the kind of monument the Society had in mind. In 1877 and 1878 the Trustees of the Monument Fund began to correspond with and interview a number of artists,[5] among those approached being William Wetmore Story.[6]

One sculptor above all soon began to outshine the other contenders by virtue of the ambitiousness of his plans. On July 29, 1879, Professor Rudolf Siemering sent drawings and a lengthy description of a monument which to all intents and purposes corresponds with the monument as it was finally erected. Siemering was born in Königsberg in 1835 and studied at the academy of that

city before going to Berlin in 1858, where he became a pupil of Gustav Bläser (1813–1874). From 1834 to 1841 Bläser had worked in the studio of the outstanding German sculptor of the first part of the nineteenth century, Christian Rauch (1777–1857), whose monument to Frederick the Great (1839–52) remained, in its expansive treatment of its theme, a source of inspiration to many of the monumental sculptors of the latter part of the nineteenth century (figures 1 & 2). In 1862, Siemering entered a competition for a monument to Schiller to be erected in Berlin, and, although he did not win first prize, he was able, with some prize money, to make his first journey to Italy. Exposure there to the great public monuments and equestrian figures served only to confirm him in his monumental aspirations in spite of the fact that his own propensity was toward a style of the most extreme naturalism. His first great success came in 1871 when he supplied the frieze on the theme of the Rising of the German People for the pedestal of Albert Wolff's Germania Monument. In view of the patriotic theme and the sentimental naturalism of Siemering's relief, it is not surprising that he soon became one of the most popular sculptors in Berlin, one of his more ambitious projects being the Leipzig War Monument.[7]

Work was already far advanced on the latter when negotiations started with the Society of the Cincinnati of Pennsylvania with regard to the monument to General Washington they proposed to erect. A model was shipped

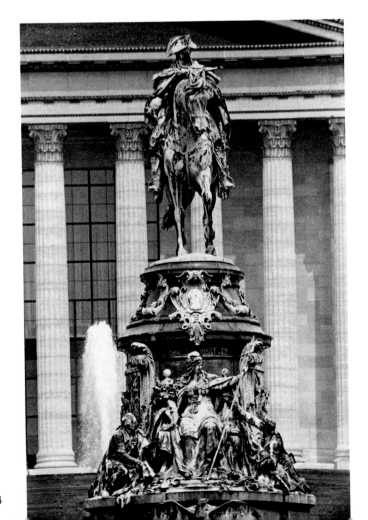

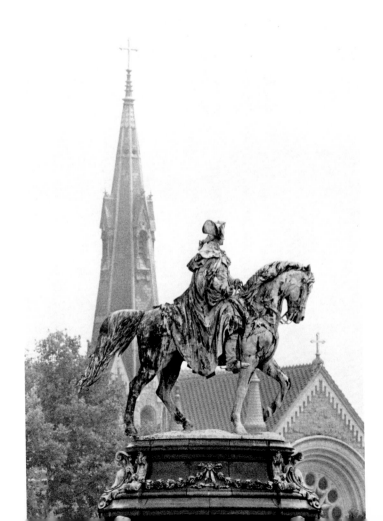

to Philadelphia on July 15, 1879, and a detailed description followed two weeks later of a monument which closely approximates the final result.[8]

Siemering promised "a monument so grand, as there has never been one executed to my knowledge" and that he had deliberately not considered the costs but had composed freely.[9] As sponsors of the undertaking, the Society of the Cincinnati could not afford to be so cavalier in their handling of the finances and it was fortunate for their purposes that on June 19, 1880, the trusteeship of the Washington Monument Fund was handed over to them from the Pennsylvania Company. Thus a further sum of $55,676 was put at their disposal, enabling them to authorize Professor Siemering to proceed with his ambitious schemes.[10]

From the very beginning, Siemering was anxious to make the monument as realistic and as accurate in all its details as possible. "If I should get the contract," he wrote on June 3, 1880, "I would request you to send me some more auxiliary means for the head of Washington. A bust of Washington would do the best."[11] The Society was even more anxious that the monument should not contain historical inaccuracies or anachronisms. On July 8, 1880, for example, it stated that "We will not enter into a criticism of the work but there may perhaps be some things that might be somewhat modified. For instance, do you consider the horse too heavy, and would it be better if more animated? Again, the face of Washington represents

him as being older than he was at the period of the revolution, say from 45 to 50 years of age. But all these things can be attended to later. We have much faith in your knowledge and skill. We, of course, wish the monument to be as *American* in appearance as possible."[12] In the same letter, but pertaining to the symbolic aspect of the monument, the Society inquired if it "would…do to add one step, thus making thirteen, the original number of the states of our Union?"

In November of the same year, the Society sent Siemering a photograph of Houdon's bust of Washington and a cast of the same,[13] and the following January "the copy of a mask of Washington which was taken *from life.*"[14] But it was not only the figure of Washington that was cause for anxiety. The Society sent engravings of Indians to Siemering, but in his quest for strict verisimilitude, "warts and all," these did not suffice. "I thank you for the Indians," he wrote on March 4, 1881, "but I request you to send me, if possible, 'Photographs taken from life'—of each head the front and the profile."

The contract was finally signed on October 19, 1881, Siemering agreeing to finish the work within eight to ten years and "as much sooner as possible."[15] Henceforth work progressed smoothly and according to the schedule outlined in the contract, although never as fast as the Society would have wished. In June, 1882, Siemering made urgent requests for photographs of prints of all the Revolutionary heroes that were to be represented. At this

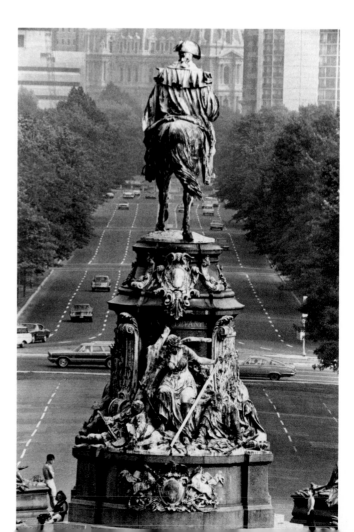

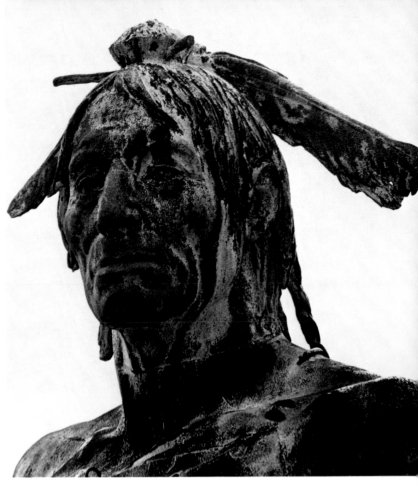

stage the Society accepted the suggestion that it would be appropriate to include the portraits of two Germans associated with the Revolutionary War, namely Peter Muhlenberg and Baron von Steuben, since this would be greatly appreciated by the large number of Germans and people of German ancestry.[16]

Further to enhance the realism of the monument, the sculptor requested "photographs of as many characteristic heads of women and men, as you can. For the women, sitting on the front and the back of the Postament, I must have beauties; but for the Reliefs, characteristic figures and heads. I desire to make the monument a typical American one, and request you to take the photographs, and to select if possible, for each figure a person to serve as a type.... The photographs must not be retouched but show nature with all 'incidentals.' "[17] In 1886 it was even proposed by John Sartain that a live Indian should be sent to Berlin[18] and, in fact, Siemering later worked from several Indians who belonged to a visiting troop.

The monument did not see the light of day until 1897, a delay that is hardly surprising in view of the complex debates that had already attended it at every stage of its development. In 1887, for example, Siemering expressed the desire to have his monument gilded in the manner that had just been used for the Leipzig War Memorial, where the gilding had been applied only in the indentations of the figures, the folds of the drapery, and not all over. In the opinion of one viewer, this kind of partial gilding "brings out the outlines of details most

beautifully, and produces a great contrast with the dull dark-greyish appearance any statue in its natural color shows for many years, until age and the slow oxidation of the metal begin to produce that greenish bright surface which is so much admired in old statues."[19] On the other hand, Dr. Alonzo Sylvester, the Society's representative in Berlin, was very much opposed to this scheme, giving as an example of the harmful effects of gilding Friedrich Drake's *Siegessäule* in Berlin "which is gilded and very objectionable indeed, also much laughed at,"[20] and it seems that he was able to persuade the committee of the justice of his observations.

The debate as to the location of the monument was even more protracted. It was originally intended to place the monument in Fairmount Park, a location which was entirely pleasing to Siemering. At a special meeting of the Standing Committee of the Society in February, 1891, however, it was decided to abandon both proposed sites in the park in preference for Washington Square. In 1891 the issue was debated in a lively press campaign. Finally, late in 1895, the Commissioners of Fairmount Park approved the Green Street entrance to the park as the permanent site of the monument and work soon began on the foundations. Still further delays were caused by the arrival in a damaged condition of part of the granite base, the attempt to decide who was finally responsible for damages giving rise to such hard feeling that Siemering announced that he would not go to the unveiling even if invited.

The long-awaited event finally took place on May 15,

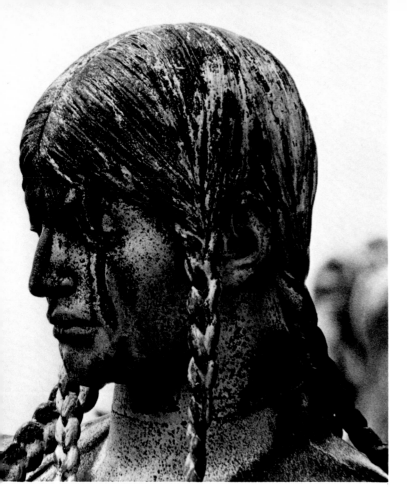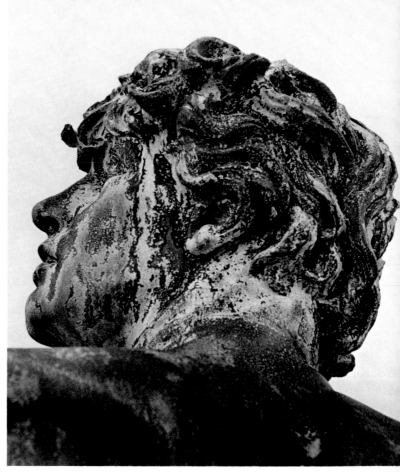

1897, the actual unveiling being undertaken by President William McKinley. The day was declared a public holiday and celebrations of all kinds took place. The unveiling was thus a national event, the culmination of a hundred years of preparation, and the recognition on a national scale of the single-mindedness of the Society of the Cincinnati of Pennsylvania in pursuing its goal. In the wave of patriotic fervor that attended the unveiling, however, Professor Siemering's role was largely overlooked. The speeches and toasts at the opening ceremonies concentrated exclusively on the subject of the monument, on Washington's role, and that of the Society of the Cincinnati in American history, sidestepping the artist completely.

Siemering had made every attempt to embody the ideals of the Society as faithfully as possible, yet he was very far from being a mere lackey. In view of the fanatical attention to detail that characterized his work on the project, it is surprising that he had any time at all for composition and the grouping of masses, for purely plastic concerns. Yet he did, incontestably. The scale of the undertaking and the amount of space at his disposal enabled him to isolate the various elements and stagger them at different levels.

At whichever corner the spectator stands, his eye is led inexorably to the imposing figure of Washington. Standing between the two stags, the viewer has a line of vision which extends along the spear of the reclining Indian, through the spear of the figure of the liberated Union, and up to the figure of Washington. On the other

side, too, her spear provides the link with the equestrian figure, the points of visual contact being the noble head of the reclining Indian and the kneeling figure of the youth gathering the flags. Nor is there any decrease in the formal inventiveness of the rear of the monument which, with the horns of the stags and the linear relationships between the upper and lower portions of the monument, attains a degree of elegance that recalls, amazingly, Fontainebleau. To have combined the scrupulous observation of surfaces, "with all incidentals," to use Siemering's phrase, with the harmonious organization of masses that characterizes the monument, was a considerable accomplishment. In part, this was simply a question of space, but more important, perhaps, was the fact that the theme of the work was foreign to him.

With as much discipline as his contemporary, Taine, who traced greatness in a writer to three main causes—his race, his environment, and his historical circumstances—Siemering divided his monument into three zones, the hero, his time (on the middle level), and his country (on the lowest level). Seen from the bottom of the steps the sculptured forms seem to cascade off the monument, an impression only heightened by the downward flowing water in the fountains to which Siemering attached such importance. In its profusion of intricate forms the effect is almost overwhelming. Yet, at the same time, the logical framework and formal organization of the whole monument hold this luxuriance in check. Siemering never forgot that he was creating a monument to George Washington.

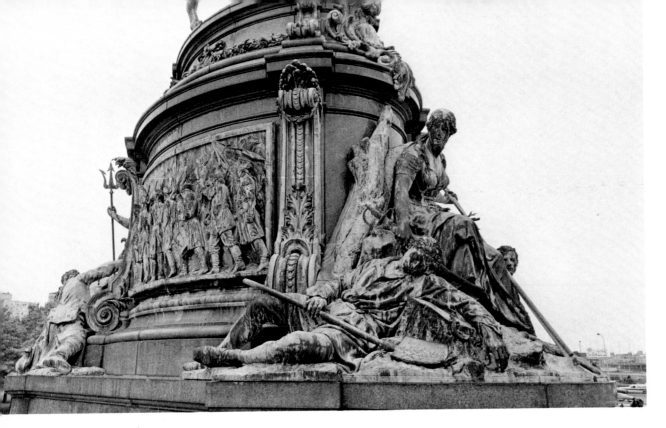

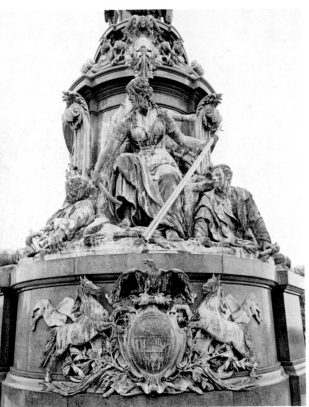

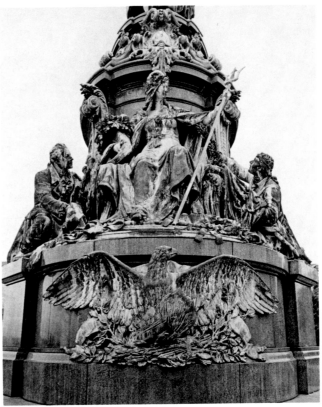

In 1928, when the Benjamin Franklin Parkway had become a reality, it was decided to move the Washington Monument from its rather remote site in the Park to the very prominent one it now occupies in front of the Philadelphia Museum. Two other works by German sculptors—*The Lion Fighter* by Albert Wolff and *The Amazon* by August Kiss—were placed on pedestals on the outer sides of the cascades on the Museum steps. By initiating the fund in 1810 which finally resulted in the Washington Monument, the Society of the Cincinnati of Pennsylvania provided Philadelphia with one of its major sculptural adornments and one of the world's more spectacular equestrian monuments.

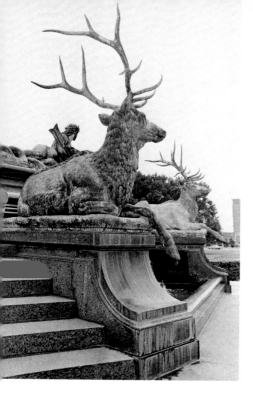

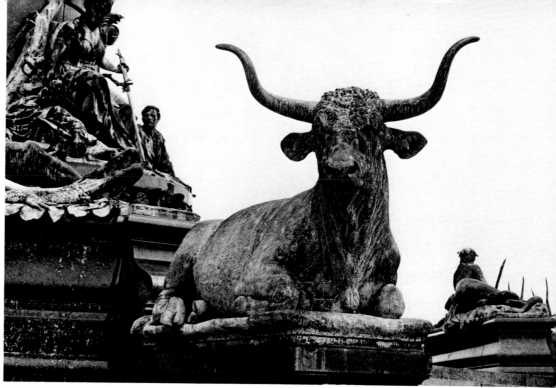

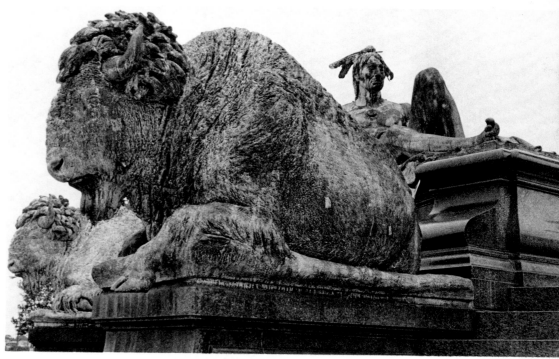

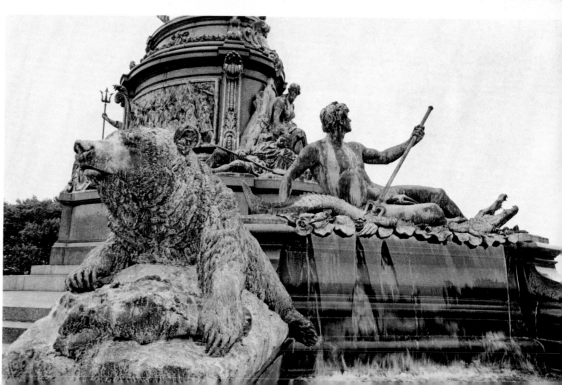

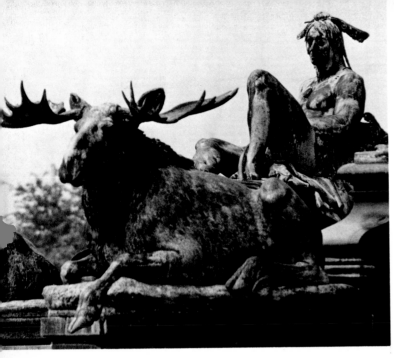

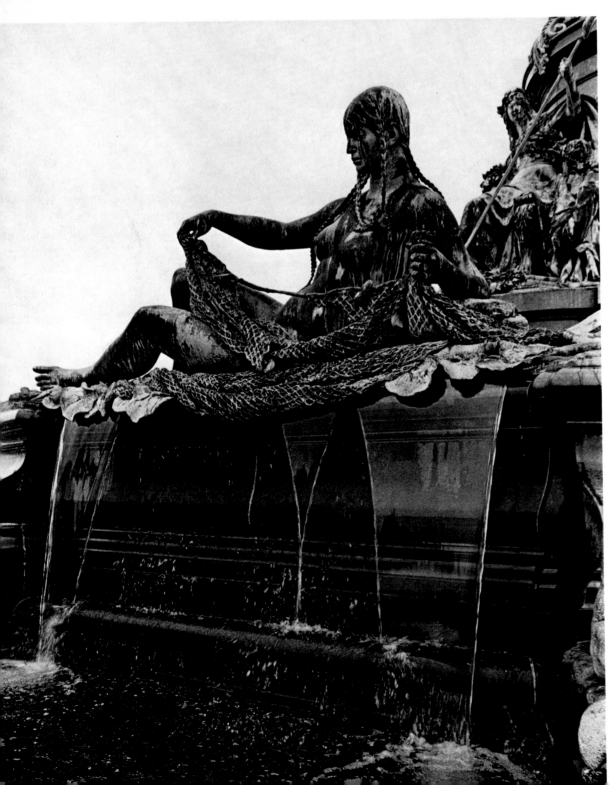

Rudolph Siemering
(1835–1905)
Washington Monument. 1897
Bronze and granite,
total height 528″

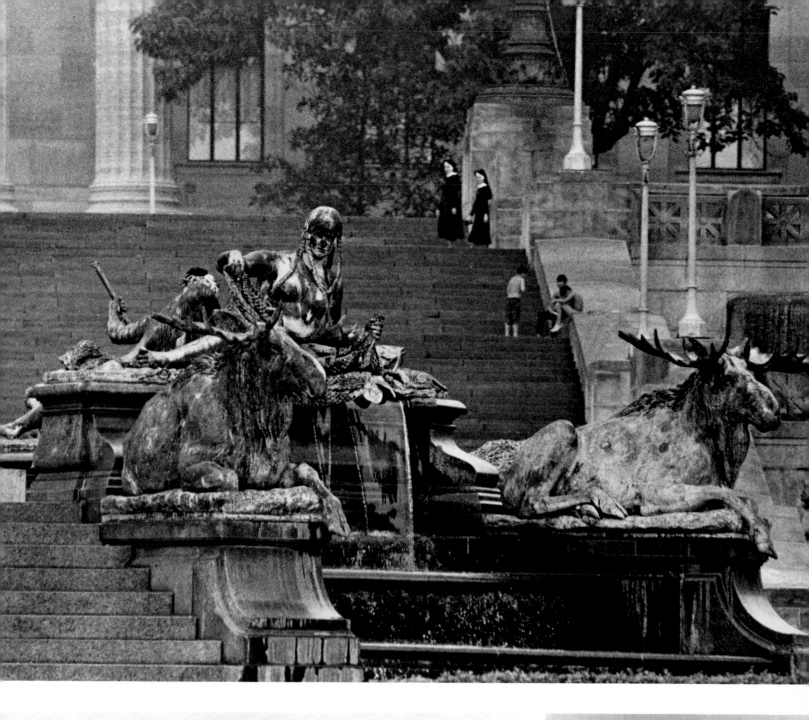

Frederick Drake (1805–1882)
Alexander von Humboldt. 1871
Girard Avenue at 53rd Street
Bronze, height 108" (granite base 144")

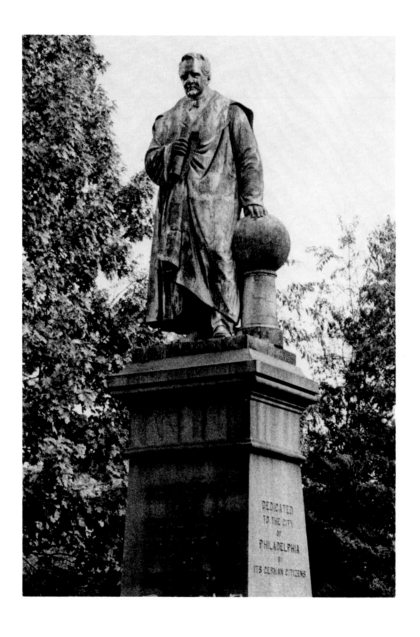

J. Henry Horstmann was one of the most active of the early board members of the Fairmount Park Art Association. While serving as consul in Munich, he was instrumental in securing Wolff's *Lion Fighter* and Kiss's *Amazon* for the Association. In a letter of 1875, he mentions being appointed by the Humboldt Monument Committee to seek out "some of the first sculptors of Germany. Professor Drake of Berlin received the commission to make the statue."

Humboldt (1769–1859)—naturalist, astronomer, explorer, geographer, politician and diplomat—was an important symbol of Germanic culture. His statue was given to the City of Philadelphia by its German citizens. Although its foundations were laid in 1869, it took several years more to raise the money necessary for the purchase. At last, on July 4, 1876, the statue was unveiled as part of the Centennial celebration. A spokeman for the German community had earlier explained "we select him of German origin as the intellectual representative of our works, and our working for the founding and preservation of this great Republic. German pioneers especially were the ones who cultivated Pennsylvania over two hundred years ago, not with the sword but with labor of peace."

Attributed to Frank Furness (1839–1912)
Brownstone Gate to a Footpath. 1876
East River Drive, below Laurel Hill
Brown sandstone, height 150″

Originally located on the 1876 Centennial grounds between the Connecticut and Massachusetts pavillions, this gate was a sample of the skill of the Portland, Connecticut, Brownstone Quarrys Company. It displayed not only the quality of their stone but their ability at finished detailed carving. A contemporary account, *Souvenir of the Centennial Exhibition,* describes it as "the grand portal or gateway of Portland stone…one of the finest finished works that was ever made of this stone." It illustrated the many excellent qualities of the material which had made it a favorite with builders because of its texture, color, and durability. After 1878, the gate was removed from the fair grounds.

The rich carving bears a remarkable likeness to the floral ornament used by architect Frank Furness. The calla lillies below the projecting face of the arch are almost identical to those that decorated Furness' fireplace at 711 Locust Street and other fireplace carvings he used in the 1870s and 1880s. Furness' architectural whimsy is clear in the combination of natural forms and geometric patterns on the leaves just below the springing of the arch—a motif very close to the leaves on the tympanum over the windows on the Pennsylvania Academy of the Fine Arts.

Herman Kirn (? —after 1911)
Catholic Total Abstinence Union Fountain
West Fairmount Park
Marble, 40' diameter (granite base)

After the Civil War there was a general movement in America toward temperance, and among the organizations formed was the Catholic Total Abstinence Union of America, half of whose membership were Pennsylvanians. Its Philadelphia members enthusiastically endorsed a resolution for the erection of a fountain to mark the Union's participation in the Centennial of 1876.

Costing $50,000, the fountain consists of a granite platform in the form of a Maltese Cross, approached by steps that extend entirely around it. The fountain rises from a mass of rockwork in the center of the basin. Moses points toward heaven as the source of water, while at the end of each arm of the cross are drinking fountains surmounted by statues nine feet high. These represent Commodore John Barry, Father of the American Navy; Archbishop John Carroll, patriot priest of the Revolution; Charles Carroll of Carrollton, Catholic Signer of the Declaration of Independence; and Father Theobold Mathew, Catholic Apostle of Temperance who personally administered the Pledge to 600,000 Americans before his death in 1856.

At points around the circular wall are medallion decorations. Represented are George Meade, a Revolutionary Philadelphian; Colonel Stephen Moylan, a Revolutionary soldier; Count Casimir Pulaski; Marquis de Lafayette; Comte de Grasse; Chief Orono, Penobscot Indian; and the badge of the Temperance Union.

Alexander Kemp
Decorative Plaque (Architects). *c.* 1877
Pennsylvania Academy of the Fine Arts
Terra cotta, 60″ by 58½″

Alexander Kemp, about whom little is known, was one of Alexander Milne Calder's assistants on the sculpture program for City Hall. When architect Frank Furness (1839–1912) began work in 1872 on the Pennsylvania Academy of the Fine Arts two blocks away from City Hall, he had every opportunity to meet Kemp and evaluate his skill. Furness, now recognized as one of America's most creative architects, did not always enjoy critical acclaim. In 1925, a critic condemned the Academy unsparingly: "In 1876, the year of the Centennial, the new home of the Pennsylvania Academy of the Fine Arts was formally opened. This building, constructed in a most unfortunate period of American architecture, was designed, so to speak, by Messrs. Furness and Hewitt. It is in the parti-colored, heavy style of abor-tive Gothic so admired by our grandparents and so despised today."

There are six plaques on the building, each representing great artists from the Middle Ages and the Renaissance. The theme, although Kemp and Furness simplified it, was taken from Paul Delaroche's Hemicycle in the École des Beaux Arts in Paris. Furness' master, Richard Morris Hunt, had been one of the first American architects to study there. The panels show painters, architects, and sculptors. This example is the third one from the North on the facade and shows, right to left, Bramante, Lescot in profile, Arnolfo di Lapa, Brunelleschi seated, Palladio and Robert of Luzarches turning away. The other five plaques are described in the appendix.

Daniel Chester French (1850–1931)
Law, Prosperity, and Power. 1880
George's Hill, West Fairmount Park
Marble, height 192″ (concrete base, 30″)

John McArthur, Jr., the architect of City Hall, was also the supervising architect for the United States Post Office and Federal Building, which was erected according to plans furnished by Alfred B. Mullet, architect for the Treasury Department. The building, located at Ninth and Chestnut Streets, was begun in 1873 and was completed in 1884 in the style of one of the Louvre pavillions with a high mansard roof. Built of granite, it cost more than $7,000,000. Federal structures of such pretensions were embellished by the best-known sculptors of the day. Daniel Chester French received three such "allegorical" commissions which were intended to describe the interior functions of federal buildings: the St. Louis Post Office in 1877; Philadelphia in 1883; and the Boston Post Office in 1882–83. His Philadelphia group represents *Law* in the center flanked by *Power* and *Prosperity*.

When McArthur's building was demolished in 1937, the joint efforts of a few dedicated men saved French's work from destruction. Louis A. Simon, federal architect, and Henri Marceau of the Fairmount Park Art Association arranged for *Law, Prosperity, and Power* to be given to the City of Philadelphia and Paul Cret was commissioned to devise a site plan and pedestal on George's Hill where a bandstand had been located. Difficulty with the demolition contractor over the granite base was solved by a $1,000 donation from the Association, and in 1938 *Law, Prosperity, and Power* was placed in the West Park.

William Wetmore Story (1819–1895)
Chief Justice John Marshall. 1883
Philadelphia Museum of Art, West Entrance
Bronze, height 80″ (granite base 66″)

The original seated figure of John Marshall, the great Chief Justice of the United States, was done late in the career of William Wetmore Story, the cultivated and elegant expatriate American sculptor who was himself the son of an Associate Justice of the Supreme Court, Joseph Story. Unveiled on May 10, 1884, this statue, one of Story's most distinguished works, ornaments the grounds of the United States Capitol.

In the early 1920s, James M. Beck, Vice-President of the Fairmount Park Art Association and a member of the United States Congress, commissioned a plaster replica from which a bronze cast could be made. Louis Milione, a well-known Philadelphia sculptor, was employed to evaluate the quality of the plaster cast and to oversee the casting of the bronze by the Baltimore founders Limerick Company. The granite base was given by the Association and the work was placed on its present site in 1931.

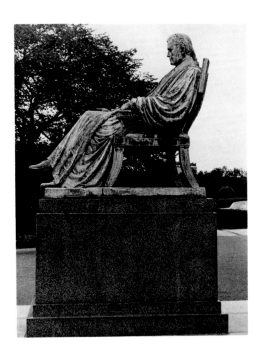

Carl Johann Steinhauser (1813–1879)
Orestes and Pylades Fountain. 1884
Columbia Avenue at 33rd Street, East
Fairmount Park
Bronze, height 96″ (granite base 72″)

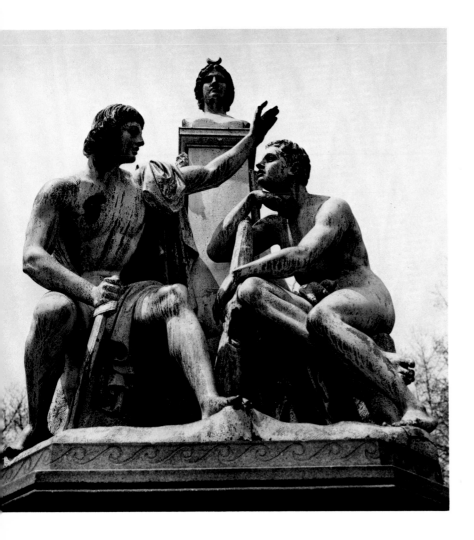

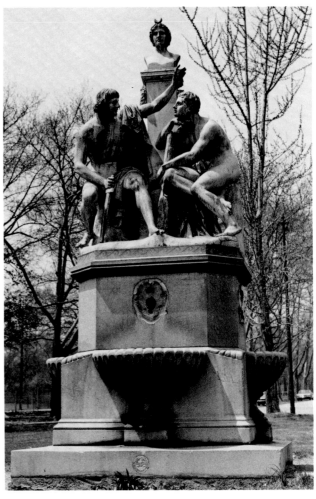

The fountain shows the two seated figures of Orestes and Pylades with a bust of Diana on a plinth behind them. Pylades was the son of the King of Phocis and grew up with Orestes who had been exiled to that court to protect him from the vengence of Clytemnestra and Aegisthus. The friendship between the two young men was as proverbial as that of David and Jonathan. Pylades later became the husband of Orestes' sister, Electra.

The sculptor, Steinhauser, studied in Berlin with Christian Rauch and was later a professor of art in Karlsruhe. One of his students was Herman Kirn, the sculptor of the Moses Fountain in the West Park (1876). Kirn had in his possession a sketch in plaster of his master's Orestes and Pylades Fountain that was originally placed in the palace park in Karlsruhe. The Fairmount Park Art Association in 1883 purchased the plaster for $250 and had it cast in bronze by Bureau Brothers for $2,550. Instated in 1884, the fountain has been vandalized and no longer works. In supplying the granite base for it, Kirn suffered an accident in which he lost his right arm. Nevertheless, he continued for years to serve Fairmount Park as the restorer of sculpture.

The fountain is a characteristic example of German fondness for placing monuments in public places to serve as daily reminders of virtues and ideals. That it honors friendship may well be the reason for Kirn's owning a cast of this particular work by the man who had so influenced him.

John Rogers (1829–1904)
General John Fulton Reynolds. 1884
North City Hall Plaza
Bronze, height 144″ (granite base 120″)

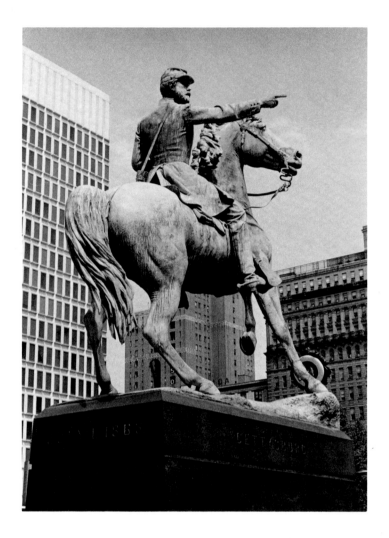 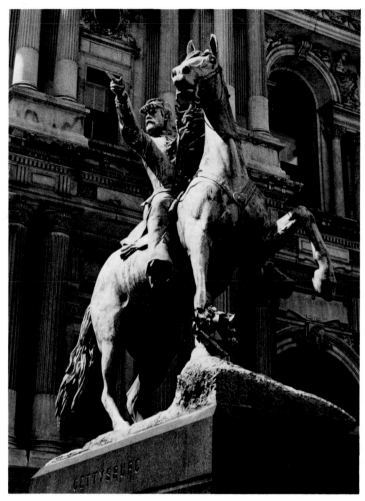

John Rogers' "conversation groups" attained enormous popularity in the Victorian Era, and it was no doubt the reputation he gained through them that brought him to the attention of Joseph E. Temple of Philadelphia. Temple had offered $25,000 toward a memorial to General Reynolds, who lost his life at Gettysburg. On July 1, 1881, the Reynolds Monument Association was organized. Former Governor Curtin pledged $5,000 for the pedestal as well as cannon for the bronze figure, and Temple secured John Rogers for the commission, although Rogers, a master of small parlor-size groups, had misgivings about creating a large-scale equestrian. According to a newspaper, "Mr. Rogers was loath to undertake a work of such magnitude, and had it not been pressed upon him in the most complimentary and emphatic manner, would modestly have refused the undertaking."

On October 24, 1884, the sculptor wrote to the Association: "The intention of the design was to rep-

resent General Reynolds in the front of the battlefield, as he was the first day of Gettysburg. The horse is startled and shying from the noise and danger in the direction he is looking, while the general is pointing to the same spot and giving direction to his aides at his side." Rogers dedicated himself to studying the anatomy of horses and also studied photographs of General Reynolds. The plaster was built one and a half size on rods and in 1883 was sawed into thirty pieces and shipped from the artist's studio in Connecticut to Bureau Brothers in Philadelphia for casting. Three and one-half tons of bronze went into the cast, for which Rogers paid $15,000.

The unveiling took place on September 18, 1884, Grand Army Day, celebrated by a general holiday, a parade of 10,000, and elaborate ceremonies—fitting tribute to Philadelphia's first equestrian statue and its first public monument to a Civil War soldier.

Auguste Cain (1822–1894)
Lioness Carrying to her Young a Wild Boar. 1886
Philadelphia Zoological Gardens
Bronze, height 90″ (granite base 36″)

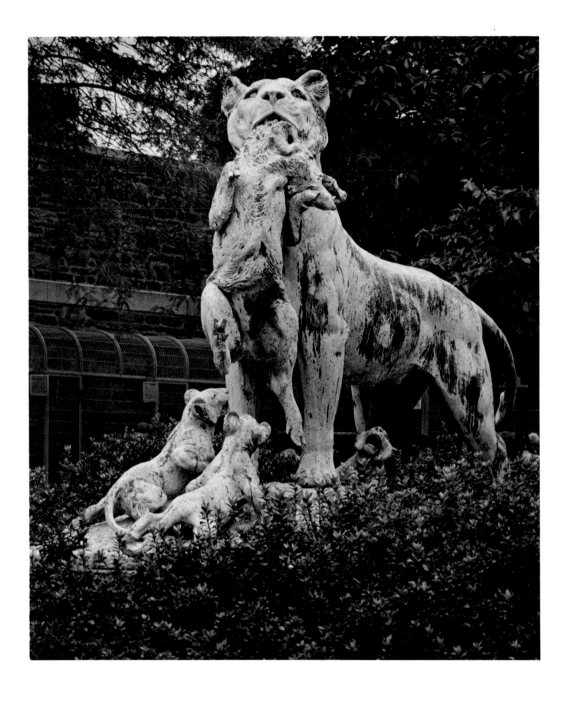

This work, shown in the French Salon of 1886, was acquired by the Fairmount Park Art Association. The complimented sculptor, writing to the Association, spoke in praise of the "beautiful and artistic city of Philadelphia," and went on to add: "It means all the more to me to be represented in your admirable park." Born in Paris, Cain was one of the generation of animaliers that followed Barye, and was celebrated enough to be given commissions on the refurbishing of the Louvre and the Tuileries. The other well-known sculpture by him in the United States is a *Tigress* in New York's Central Park.

Before the *Lioness* was placed at the Zoo, it was instated near the Lincoln statue at the foot of Lemon Hill. Prior to that it had been on the River Drive, but, according to a contemporary newspaper account, "the realistic pose of the Lioness so terrified many horses, that in other respects were fearless, that it was removed. There could be no greater compliment to the artist and to his life like production than the uncontrollable fear manifested by horses as they approached this spirited group."

Alexander Milne Calder (1846–1923)
William Warner Tomb. 1889
Laurel Hill Cemetery
Granite, height 92″, length 90″, width 64″ (granite base)

In the 1840s urban America began to awaken to the problems of overcrowding that plagued growing cities. The developing science of urban planning called for public cemeteries that were well-tended and that provided open space. Laurel Hill was soon to boast that in 1846 some 30,000 visitors had come to enjoy its beauties and its woods and birds. The new space in the Victorian cemetery, compared to the crowded eighteenth-century churchyard, gave sculptors an opportunity to create "sepulchral" tombs; the wealthier the deceased, the more impos-

ing the tomb or obelisk commissioned.

The Warner Tomb at Laurel Hill was placed on a lot deeded in 1879. This half-open sarcophagus with the soul escaping in a stone cloud is the marker of William Warner, a coal merchant, who referred to himself as a "gentleman" in his will, in which he left a fortune of $59,000 to church-related charities and institutions. He was a Victorian citizen who contributed a fascinating monument to the vast sculpture garden above the East River Drive.

Frank Edwin Elwell (1858–1922)
Dickens and Little Nell. 1890
Clark Park, 43rd and Chester Avenues.
Bronze, *Little Nell,* height 64″;
Dickens, height 80½″
(granite base approximately 65″)

Nearly every American reader became involved in the fate of Little Nell as each successive installment of *The Old Curiosity Shop* was read during 1841. That Charles Dickens had his beloved heroine die was a source of grief to many. Given the popularity of the tale and the sentimentality of the subject, it understandably inspired numerous nineteenth-century artists. In the later 1840s, shortly after Robert Ball Hughes left Philadelphia in disappointment, he created in Boston his little-known figure of Nell. Dickens' narrative with its many specific details was ideal material for one of John Rogers' most popular groups, created in the 1850s. But perhaps the most famous statue of Little Nell was that created by Frank Elwell; the figure won a Gold Medal at the Philadelphia Art Club when it was shown there in 1891, and then two years later the complete group earned a Prize of the First Rank at the Columbian Exposition.

Elwell was an ideal artist to have created this subject. He grew up in Concord during its great literary period. Louisa May Alcott was a major force in his young life and her sister Abigail May taught him the rudiments of sculpture. He created this piece, hoping that it might be instated in London; the work was refused because of the author's firm wish, at the time of his death in 1870, to have no monument other than his life's writings. The Fairmount Park Art Association began to negotiate the purchase of this piece in 1896; but, because of the lack of funds and certain disagreements over the price, the acquisition was not finally made until 1900.

Augustus Saint-Gaudens (1848–1907)
Diana. 1892
East Foyer, Philadelphia Museum of Art
Copper sheeting, height 184½″ (copper ball base 18″)

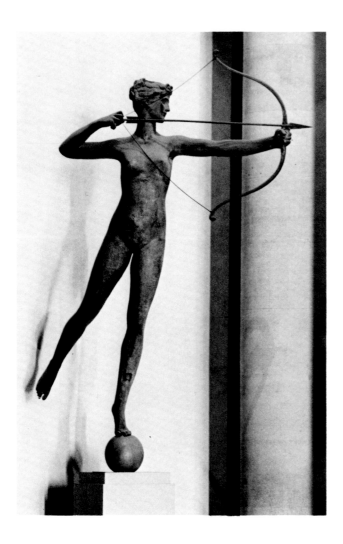

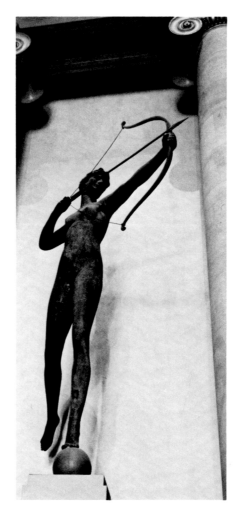

The old Madison Square Garden (1892–1925) in New York was designed by McKim, Mead and White. Saint-Gaudens created *Diana* as a tribute to his friendship with Stanford White of that firm. This was Saint-Gaudens' first large-scale nude, his first ideal figure, and the thirteen-foot maiden became the perfect finial for the Garden's famous old tower. As protectress of the various exhibitions and shows, she spun above the convention group to nominate William Jennings Bryan for President, and, ironically, was a near witness to the shooting of Stanford White by Harry Thaw in 1906 in the rooftop cafe under her feet. She brought a special quality to New York and was immortalized as a landmark in O. Henry's story "The Lady Higher Up," when the author had Bartholdi's *Liberty* say to Saint-Gaudens' *Diana* "Ye have the best job for a statue in the whole town."

On May 5, 1925, *Diana* was removed and placed in storage while the Garden gave way to a skyscraper built by the New York Life Insurance Company. Finally, through the efforts of Fiske Kimball, director of the Philadelphia Museum of Art, and funds provided by the Fairmount Park Art Association, she was brought to Philadelphia in 1932, after repairs at the Roman Bronze Works on Long Island. Since then New York has made attempts to recover *Diana*. She was requested to attend the *World's Fair* in 1939, but declined. In 1967, when another Madison Square Garden was being built, the mayor of New York wrote Mayor James Tate of Philadelphia requesting her return. Mayor Tate replied: "Would you really want me to believe that you would give Manhattan back to the Indians if they returned the $24 you paid for it? When no one wanted this poor little orphan girl, Philadelphia took her in, gave her a palatial home and created a beautiful image for her with a world-wide reputation."

Appendix
Section III

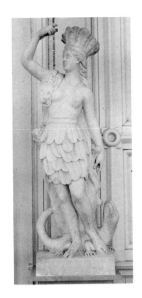

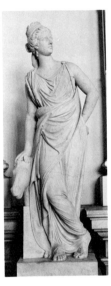

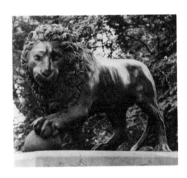

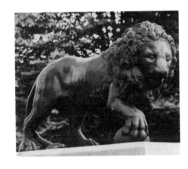

Unknown Artist
Florentine Lions. 1849
Originally the pair flanked the
Welsh Memorial, West Park. One
is now in storage.
Bronze, height 46″ (concrete
base 62″)
Gift of Mrs. A.M. Eastwick to the
Fairmount Park Art Association.
Instated April, 1887. The cast was
made in 1849 from the pair at
the Imperial Head Mechanical
Works in Alexandroffsky,
Russia.

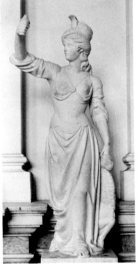

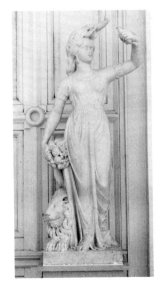

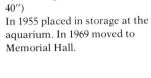

Unknown Artist
The Four Continents
Memorial Hall, center hall
Marble: *Europe,* height 64″
(marble base 40″); *Asia,* height
61″ (marble base 40″); *America,*
height 66″ (marble base 40″);
Africa, height 62″ (marble base
40″)
In 1955 placed in storage at the
aquarium. In 1969 moved to
Memorial Hall.

Unknown Artist
Silenus and the Infant Bacchus
East River Drive above
Fairmount Avenue
Bronze, height 73″ (granite base
51″)
Fairmount Park Art Association.
Purchased and instated in
November, 1885. Cast from the
original by Praxiteles in the
Louvre.

Henry Baerer (1837–1908)
Franz Schubert
Horticultural Hall site, West
Fairmount Park
Bronze, height 51″ (limestone
and granite base 128″)
Gift of the United German
Singers of Philadelphia to the
City. Instated October 6, 1891.

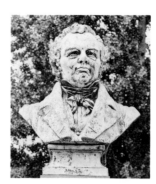

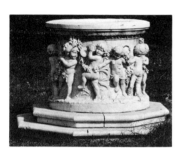

Unknown Artist
Stone Basin (well head)
East River Drive, just east of
the Samuel Memorial,
Fairmount Park
Marble, height 32″, diameter 40″
(marble hexagonal base)
Unrecorded purchase by or gift
to the Fairmount Park Art
Association.

Auguste Bartholdi (1834–1904)
Statue of Liberty (model)
Drexel University, main building
Terra cotta, height to top of
headpiece 37″
One of fifty such models which
were sold in 1876 by the Franco-
American Committee in order to
raise funds for the Statue of
Liberty.

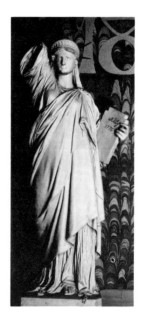

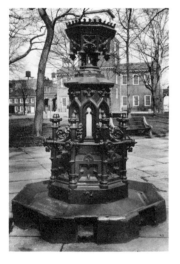

Unknown Artist
Temperance Drinking Fountain.
1876
City Hall storage, disassembled
Cast iron
Commissioned by the Sons of
Temperance of the State of
Pennsylvania for the Centennial
Exhibition, where it was
placed at Belmont and Fountain
Avenues. Moved to
Independence Park until 1969
and then placed in storage.

Alexander Kemp
Decorative Plaque (Painters)
Pennsylvania Academy of the
Fine Arts
Terra-cotta basrelief, 60″ by
58½″
Installed *c.* 1877, this is the first
panel from the left. It depicts,
right to left, Poussin, Giotto,
Masaccio (standing),
Michelangelo (seated), Raphael
and Fra Bartolommeo.

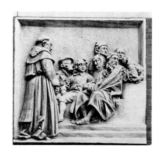

Alexander Kemp
Decorative Plaque (Painters)
Pennsylvania Academy of the
Fine Arts
Terra-cotta basrelief, 60″ by 58½″
Installed *c.* 1877, this is the
second panel from the left. It
depicts, right to left, Domenico
Zampieri, Leonardo da Vinci,
Albrecht Durer, Orcanga, Le
Sueur, Holbein and Fra Angelico.

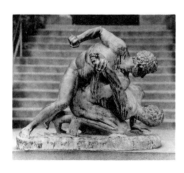

Unknown Artist
The Wrestlers
Memorial Hall, South Entrance.
Bronze, height 38″ (granite base
27″)
Gift of Anthony J. Drexel to the
Fairmount Park Art Association
in 1885. Originally located on
West River Drive at the foot of
Lemon Hill. Cast from original in
the Royal Gallery of Florence.

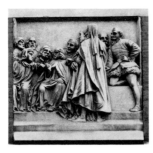

Alexander Kemp
Decorative Plaque (Sculptors)
Pennsylvania Academy of the
Fine Arts
Terra-cotta basrelief, 60" by 58½"
Installed *c.* 1877, this is the
fourth panel from the left. It
depicts, right to left, Jean
Gougon, Bernard Palissy,
Lorenzo Ghiberti, Donatello
(profile), Bandinelli, Giovanni
Pisano, Benedetto da Maiano,
Luca Della Robbia, Pierre
Bontemps and Peter Fischer.

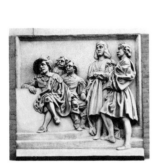

Alexander Kemp
Decorative Plaque (Painters)
Pennsylvania Academy of the
Fine Arts
Terra-cotta basrelief, 60" by 58½"
Installed *c.* 1877, this is the fifth
panel from the left. It depicts,
right to left, Giorgione, Giovanni
Bellini, Anthony Van Dyck,
Velasquez and Peter Paul Rubens.

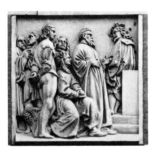

Alexander Kemp
Decorative Plaque (Painters)
Pennsylvania Academy of the
Fine Arts
Terra-cotta basrelief, 60" by 58½"
Installed *c.* 1877, this is the sixth
panel from the left. It depicts,
right to left, Rembrandt van
Rijn, Titian, Jan Van Eyck
(seated), Murillo (back),
Antonello da Messina, Paolo
Veronese and Correggio.

Herman Kirn (–after 1911)
Toleration (William Penn). 1883
East bank of Wissahickon Creek
near Walnut Lane
Marble, height 116"
(marble base 51")
Provenance unknown

John Lacmér
Civil War Soldiers' Monument
Market Square, Germantown
Granite, height 114"
(granite base 420")
Commissioned by a committee
of Grand Army veterans and
private citizens. Funds provided
by public subscription. Instated
July 4, 1883. Base designed by
James Windrim.

John H. Mahoney
Morton McMichael. 1881
Lemon Hill Drive, East
Fairmount Park
Bronze, height 79"
(granite base 82")
Funds provided through public
subscription. Instated October
23, 1882.

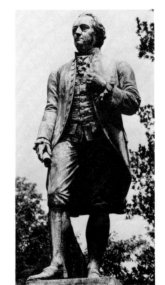

Heinrich Carl Johan Manger
(1833–after 1891)
Goethe
Horticultural Hall site, West
Fairmount Park
Bronze, height 102"
(granite base 132")
Commissioned by the Canstatter
Volksfest-Verein, a German-
American organization, in 1889.
Instated May 30, 1891.

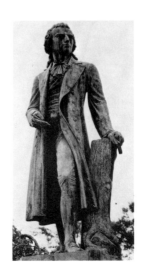

Heinrich Carl Johan Manger
(1833–after 1891)
Schiller
Horticultural Hall Site, West
Fairmount Park
Bronze, height 108"
(granite base 132")
Commissioned by the
Cannstatter Volksfest-Verein in
1885. Instated October 25, 1886.
Schiller was selected for the
honor as many members of this
organization came from
Marbach, Schiller's birthplace.

Section IV 1893–1914

The Gates of Hell

by John Tancock

*photographs by
Bernie Cleff*

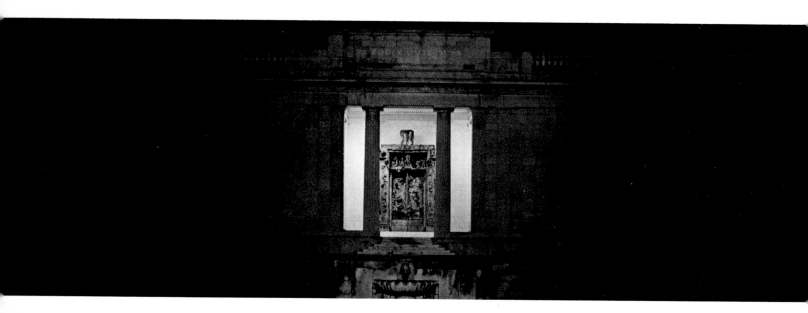

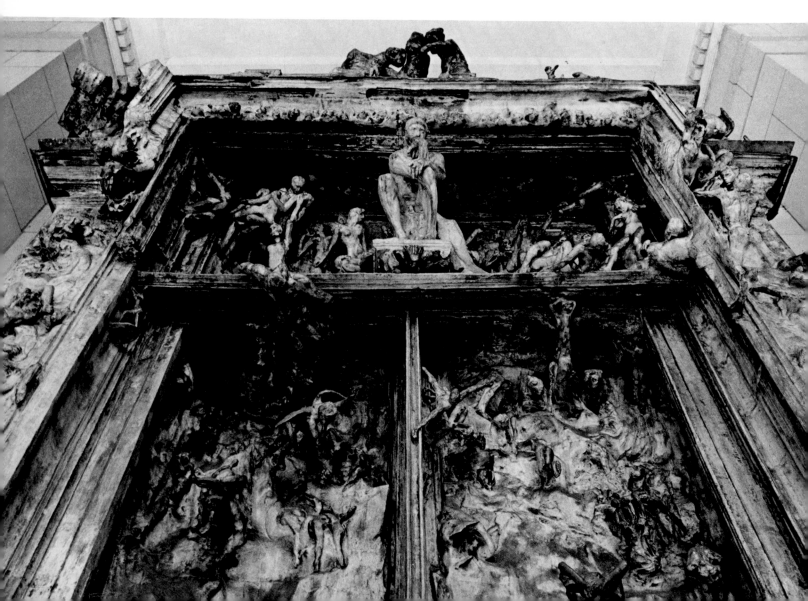

Standing at the entrance to the Rodin Museum at Benjamin Franklin Parkway and 22nd Street in Philadelphia is the first bronze cast of Auguste Rodin's *The Gates of Hell*. Commissioned at a turning point in his career, this work dominated Rodin's thoughts from 1880 to 1890 and remained a source of fascination and anxiety for the remaining twenty-seven years of his life. Like Marcel Duchamp's *Large Glass*, left "definitively unfinished" in 1923, it may be regarded as a résumé of a lifetime's interests and preoccupations—the art and architecture of the Italian Renaissance, the architecture of Gothic France, the poetry of Dante and Baudelaire, and, above all, Rodin's own overwhelming response to the beauty and expressive power of the human body. Rodin's ruminations on the tragic destiny of mankind were to a large extent conceived within the framework of *The Gates*, but the power of many of the single figures and groups led to their detachment and display as individual sculptures, a diaspora, as it were, of variously suffering figures from the realm of the damned. Many of Rodin's best-known works were originally part of *The Gates—The Thinker, The Three Shades, The Prodigal Son, The Fallen Caryatid Carrying Her Stone, The Crouching Woman*, and *The Martyr*, to name but a few. Just as many were conceived within its aura—*The Kiss, The Old Courtesan, Adam*, and *Eve*. The crucial role *The Gates* were to play in Rodin's career and development as an artist could never have been anticipated, however, from the terms of the original commission.

By 1880 he had already gained a considerable degree of notoriety. The realism of his nude figure *The Age of Bronze*, shown at the Salon of 1877, had given rise to accusations that he had made liberal use of life casts in his work. So unprepared for the astonishing veracity and power of his sculpture were the academic sculptors and critics of the time that these charges were not easily dispelled. Three years later a committee sent to inspect the same work to determine its quality prior to its purchase by the State concluded that casting from life played such a "preponderant role" in its creation that it could not really be regarded as a work of art in the strict sense of the term.[1] By way of recompense, after a group of friends and admirers testified on his behalf, Rodin, on August 16, 1880, received the commission for a set of portals for a new Museum of Decorative Arts in Paris to be erected on the site of the former Cour des Comptes, destroyed by fire in 1871. By the terms of the contract Rodin was to design a set of "bas-reliefs representing the Divine Comedy,"[2] the choice of subject surely having been suggested by Rodin himself, as he was already an avid reader of Dante and, as early as 1876, had executed a group entitled *Ugolino and His Sons*.

An interest in Florentine art was not at all unusual in France in the third quarter of the nineteenth century. A group of sculptors, notably Paul Dubois, whose *Florentine Singer* was one of the most popular works at the Salon of 1865,[3] Antonin Mercié, and Jean-Alexandre-Joseph Falguière derived much of their inspiration from Florence. To Rodin, however, Florence meant

Michelangelo and, to a considerably lesser extent, Donatello, and not the milder strains of the *quattrocento*. Michelangelo dominated his visit to Florence late in 1875 and remained a potent influence throughout the next decade, notably in the strongly muscular, anguished figures connected with *The Gates—The Thinker, The Three Shades, Adam*, and *Eve*. But not surprisingly it was to Ghiberti that he turned in the first studies for the portal. In the four published architectural sketches of varying degrees of elaboration, the surface of the door is divided into a number of small panels.[4] With the exception of the first, there are rapid notations of figural compositions in each of these, indicating that at this point he intended illustrating certain major incidents from Dante's poem. A drawing in the Rodin Museum entitled *Le repas d'Ugolin* in which the figures are arranged in groups parallel to the picture plane, is related stylistically to the second architectural sketch (figure 1) and gives a clear idea of the kind of scheme envisaged by Rodin.

A more rapid development is evident in the three surviving models. In the second of these[5] the architectural framework has been abandoned entirely, while in the third, a terra-cotta version of which is in the Rodin Museum (figure 2), the gradual recession of the architectural elements before the demands of the struggling figures is vividly apparent. The panels are no longer sturdy enough to contain the dramas enacted within their confines. The figures clamber over the edge and certain groups, notably those of *Paolo and Francesca*

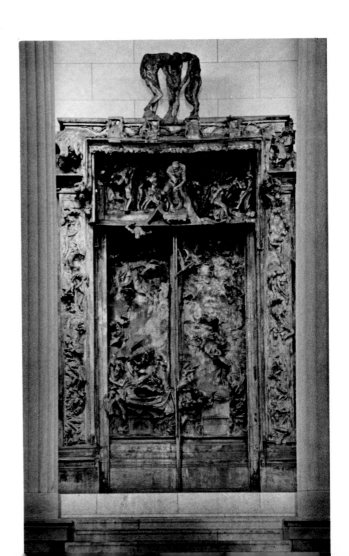

on the left panel, *Ugolino and His Sons* on the right panel, and the figure in the tympanum, later to be known as *The Thinker,* are almost entirely in the round. On the pilasters on either side are figures of male nudes, strongly recalling Michelangelo's Boboli *Slaves* and his *St. Matthew.*

It was at this stage in its development that the full-scale frame of *The Gates* was erected, although the earliest surviving documents that throw light on its appearance date from as late as 1883. In January of that year, Roger Ballu, an inspector in the Fine Arts Administration, visited Rodin in his studio to estimate how much might be paid as a second installment. Rodin showed Ballu "only isolated groups from which wet protective cloths were successively removed"[6] as they were shown to him. He stated that he was obliged to reserve his judgment on the whole as he had not seen all the groups in place but that he was greatly struck by what he referred to as Rodin's "really astonishing originality and power of expression."[7]

The impossibility of keeping the exceedingly complex reliefs of *The Gates* damp while he worked on them forced Rodin to progress in a tentative, experimental manner that was to have an important effect on his entire oeuvre. As each group was completed it was cut off in sections and pieces and cast in plaster. The fine critic Gustave Geffroy described the doors and the studio as he saw them in 1889. "It is standing and it is scattered. The figures at the top, certain groups on the panels, the doorposts, the bas-reliefs are in position. But everywhere in the vast room, on the benches, on the shelves, on the sofa, on the chairs, on the ground, statuettes of all dimensions are scattered, faces raised, arms twisted, legs contracted, in absolute disorder, giving the impression of a living cemetery."[8]

Removed from its context in *The Gates* a group might acquire an entirely new meaning that could not have been deduced from its original function. An experimental or chance juxtaposition with another group, the exchange of elements from one group to another, a different orientation (Paolo in *Fugit Amor* becoming *The Prodigal Son* when placed on his knees were just some of the ways in which Rodin attempted to realize the diverse possibilities embodied in his sculptures. The appearance of *The Gates* thus changed incessantly throughout the 1880s, growing in an unplanned, organic manner, and casting aside a stream of works that document various stages in its development.

Rodin soon abandoned the idea of illustrating particular incidents from Dante's poem, although certain figures—*Ugolino and His Sons* on the left panel, *Paolo and Francesca* on the right, and *The Three Shades* crowning the tympanum—were to remain. In his conversations with the American critic Truman H. Bartlett about 1887–88, Rodin avowed that his sole idea was "simply one of color and effect. There is no intention of classification or method of subject, no scheme of illustration or intended moral purpose. I followed my imagination, my own sense of arrangement, movement, and composition. It has been

from the beginning, and will be to the end, simply and solely a matter of personal pleasure."[9] Certainly the prevailing mood of *The Gates* reflects more of Rodin's own spiritual preoccupations, especially those he shared with Baudelaire, than the theological ordering of Dante. Rodin's own highly developed sense of eroticism found much to identify with in the poetry of Baudelaire, a set of illustrations for whose poetry he provided for the publisher Gallimard in 1888. The influence of Baudelaire in shaping and giving a certain edge to Rodin's understanding of human personality at the point where the sensual merges with the spiritual certainly came, if not to rival, at least to enrich that of Dante in the latter part of the 1880s. The extraordinary group at the top of the right hand pilaster, which represents a strongly muscled man sweeping a crouching and passive female figure off the ground in the excess of his passion, was developed as a free-standing sculpture which bears on its base a quotation from Baudelaire's poem "La Beauté," from *Les Fleurs du Mal* (figure 3).

In July, 1885, Rodin informed the Ministry of Fine Arts that the plaster model of *The Gates* would be finished in "about six months." As a result he received a grant of a further 35,000 francs for the bronze casting. However, he never lived to see this take place. He underestimated the time required to bring this immensely complicated work to a satisfactory degree of equilibrium at the same time as he accepted commissions that required extraordinary amounts of research and concentration. Rodin was not the kind of artist who completed one project before moving on to the next. Such a progression from one degree of completion to the next seemed to him to be the worst kind of academicism. Instead, he worked simultaneously on a number of major works, his experience in these widely differing enterprises serving only to enrich and diversify his approach to the work that happened to be in hand. Thus in 1884, at the height of his involvement in the swirling sea of figures of *The Gates*, he accepted a commission for a monumental group on a heroic theme, *The Burghers of Calais*. In 1889, the year of his successful one-man exhibition with Claude Monet at the Galerie Georges Petit, he undertook to produce a monument to Victor Hugo to be erected in the Panthéon, and two years after this he came to an agreement with the Société des Gens de Lettres whereby he promised to furnish them with a monument to Honoré de Balzac within a period of eighteen months. In all cases, while failing to keep his commitments and enduring protracted and frequently highly disagreeable negotiations with the commissioning bodies, he continued to produce an overwhelming body of independent works, monuments of a less taxing nature (for example, those to Jules Bastien-Lepage, Claude Lorrain, and President Sarmiento), portraits of friends and celebrities (Jules Dalou, Alphonse Legros, Victor Hugo, and Jean-Paul Laurens) and, of course, fragments of and studies for his major works.

A number of individual figures and groups from *The Gates*, as well as the six separate figures of the burghers

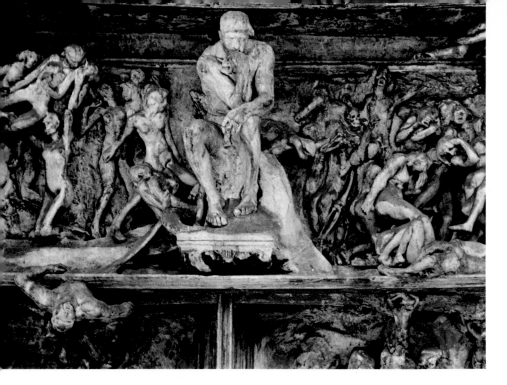

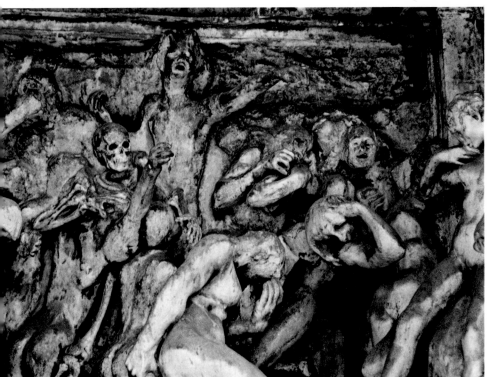

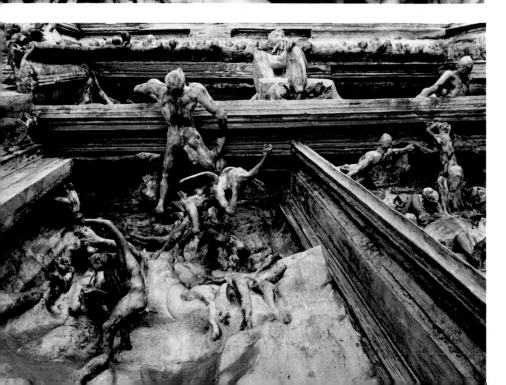

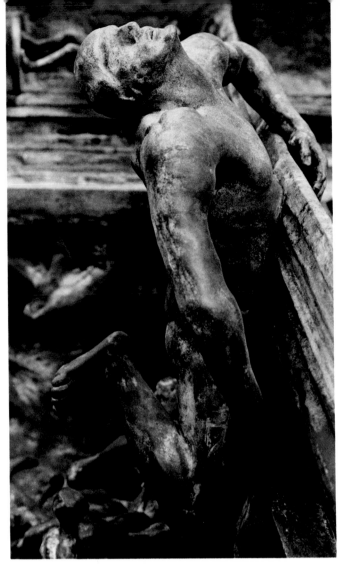

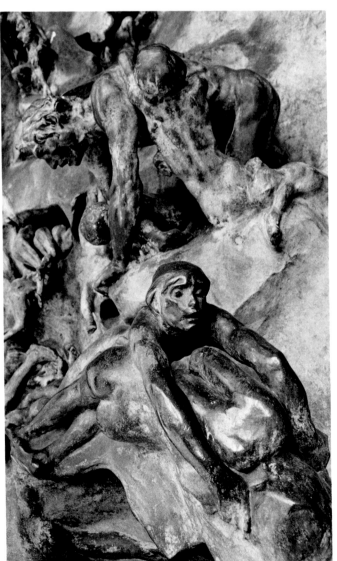

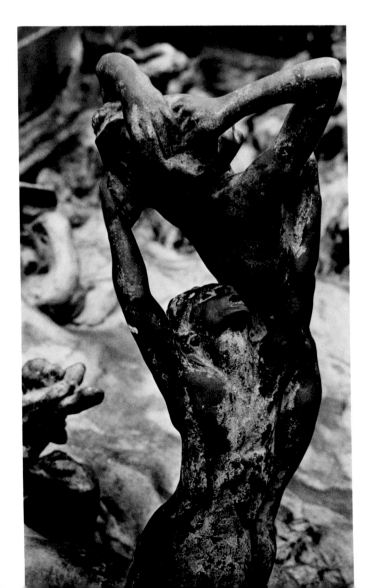

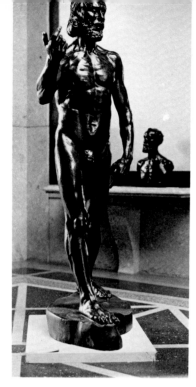
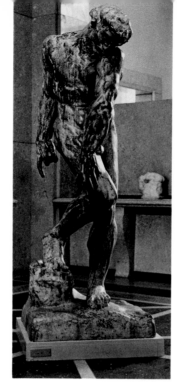
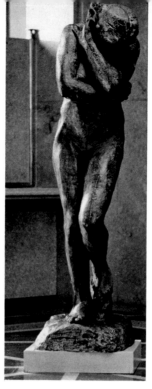
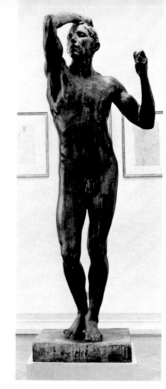

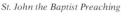

St. John the Baptist Preaching Adam Eve Age of Bronze

were shown at the Galerie Georges Petit in 1889. *The Gates* as an architectural entity were far from being finished, but already certain figures connected with them, such as the marble reductions of *Eve,* had been widely circulated and their reputation as one of the outstanding works of the century was well established. "All those who have been able to admire in the artist's studio the finished studies and those in course of execution agree in saying that this door will be the greatest work of this century," wrote Octave Mirbeau in 1885. "One must go back to Michelangelo to form an idea of an art so noble, so beautiful, so sublime."[10] Gustave Geffroy was equally impressed by its comprehensiveness and its powerful statement of eternal themes. "The Gates of Hell," he wrote, "is the gathering, in eventful motion, of the instincts, the fatality, the desires, the despair, of everything that cries out and groans in man. The poem of the Ghibelline has not retained any local color, it has lost its narrowly Florentine meaning; it has been, as it were, stripped and expressed synthetically like an anthology of the unchanging aspects of the humanity of all countries and all times."[11]

Such praise on the part of critics as astute as Geffroy and Mirbeau constituted more an act of faith than a just assessment of the facts on their part, since at no point in their development can *The Gates* ever have been seen in their entirety. The rare photographs of the portal that survive from the decade of the 1880s have more the aspect of the ruins of a once-completed work than of one nearing completion. A photograph of the tympanum published in 1888[12] showed that many of the most prominent components, such as the flying figure above *The Kneeling Fauness* and one based on the *Torso of Adèle* in the upper left-hand corner of the tympanum, are missing. The architecture was still in a rudimentary stage of development, the row of masks above the tympanum

was not in place, and, with the exception of two fragmentary figures clinging to the outer brackets, the numerous small figures beneath *The Three Shades* were missing. The basis of what later became thorn branches— plaster-covered rope—is also visible.

The fate of the two bas-reliefs in the general scheme of the work epitomizes the manner in which the doors developed. It was originally Rodin's intention to place two bas-reliefs in the lower section of each leaf of the door. At the center of each of these reliefs, which have since been cast separately, is the contorted head of a crying girl, while on either side are scenes of rape and violence, probably based on Ovid's account of the wedding feast of Pirithoüs and Hippodame.[13] As time went by, however, Rodin clearly came to feel that the geometrical form and the symmetry of these reliefs belonged to an earlier period of his thinking, when Ghiberti was still at the back of his mind. Consequently they were gradually submerged beneath lava-like flowing forms until all that could be seen was a grieving head peering through the overlay. The curious manner in which these reliefs were physically incorporated in *The Gates* and not simply removed is typical of Rodin's working method. Although dealing with an architectural form, that of a monumental portal, he did not work from a plan or with any preconceived idea in mind. Once the framework of *The Gates* had been set up, they may be said to have grown organically, hence the considerable number of elements—for example, the baby balancing precariously near the bottom of the left-hand pilaster, the figure of a dancing fauness on a small shelf at the top left-hand corner of the left-hand leaf, and the *Head of St. John the Baptist on a Platter* around the corner from the top of the right-hand pilaster—that have no rational or architectural justification, but nonetheless contribute immeasurably to the variety and interest of the doors.

It is no exaggeration to say that by the decade of the 1890s Rodin was one of the most knowledgeable men in France on the subject of medieval architecture, although as an artist and connoisseur rather than as an architectural historian. He traveled widely, familiarizing himself not only with the great cathedrals but also with the most obscure village churches, making endless notations that would later be incorporated in his great book, *The Cathedrals of France*, published in 1914.[14] As is the case in the cathedrals, where exquisite carvings seem often to have been deliberately hidden, many elements in *The Gates* cannot be seen at all or only with great difficulty. Increasingly, however, Rodin came to distrust the proliferation of forms that encrusted the surface of the doors. In 1893 the young sculptor Antoine Bourdelle began to work for Rodin. Before long a very close friendship had developed and Rodin came to realize that the younger man's observations concerning the lack of architectonic qualities of *The Gates* and its ambiguous status, neither a wall nor a door, seemed to be only too well founded. "The Gate is too full of holes," he wrote in one of his notes,[15] and just at the point when his friends thought that the work was nearing completion, he proceeded to cut off all the projecting elements, either wholly or in part. These were then numbered, as were the corresponding parts on the door, making possible their reassembly if Rodin so desired. It was in this denuded state that *The Gates* were exhibited in Rodin's one-man

exhibition in the Pavillon d'Alma in 1900.

Henceforth *The Gates* existed in a kind of limbo, and it is hardly surprising that in 1904, twenty-four years after the original commission, the Ministry of Fine Arts made enquiries as to the degree of their completion and of the other works still pending, namely the two monuments to Victor Hugo. The inspector who visited Rodin reported that the work was far advanced but that the sculptor intended to make various modifications which in all likelihood would not be completed for another three or four years. As a result the sum of 35,000 francs granted for the casting in bronze was withdrawn, although the ministry still agreed in principle to pay the costs at a later date. Although no major changes in the disposition of the various groups were made at this late stage, Rodin was still struggling with the architectural framework. In 1904 when René Cheruy, Rodin's newly appointed secretary, asked him why he considered his *Gates of Hell* still unfinished, Rodin replied that he was not satisfied with its architecture. He wanted a molding that would be "precise enough to act as a frame to the composition, but which would also be soft enough in tone to connect it with the surrounding atmosphere and his mind was not firmly set on the result of his last experiment."[16] The many drawings of moldings in the sketchbook in the Rodin Museum that once belonged to the critic Roger Marx reveal his extreme sensitivity to moldings, and it must be because of this that he never succeeded in finding the miraculous molding

Burghers of Calais

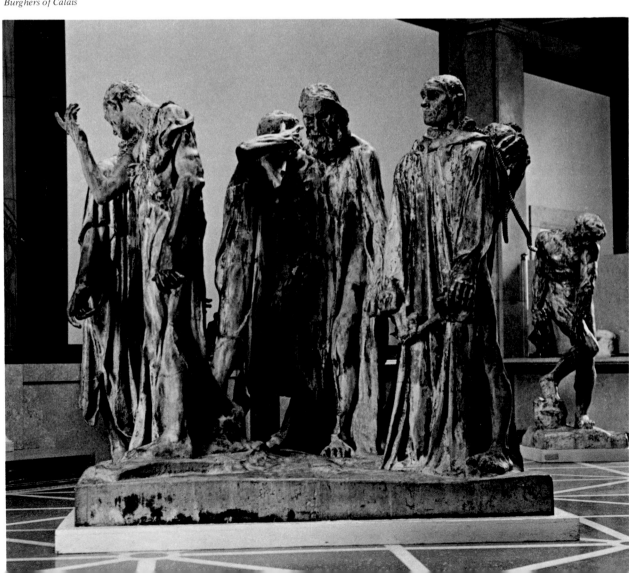

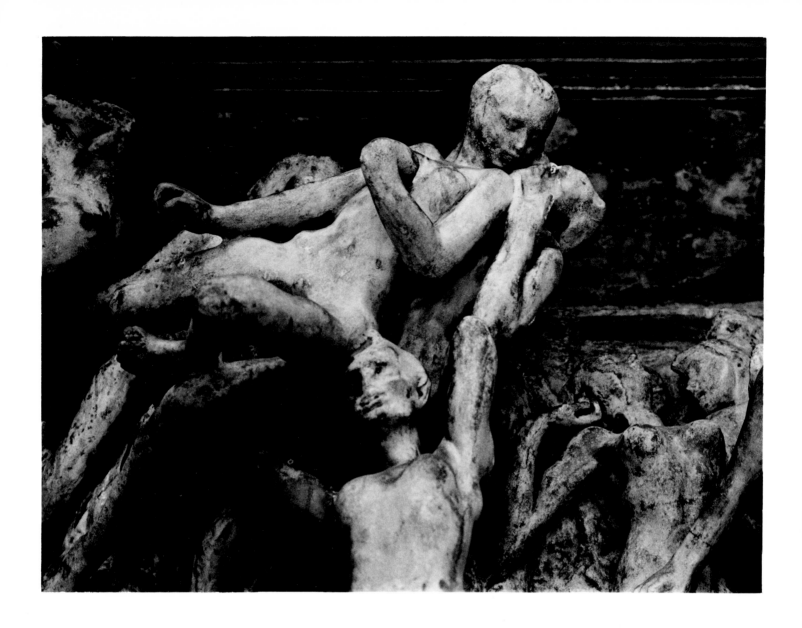

that would have achieved the unifying effect he was striving for. As it is, the Gothic molding framing the leaves of the door is cut off abruptly on the inside of the two posts.

After the debacle of the Balzac affair, Rodin seems to have lost interest in the creation of monumental works. Enthusiasm for *The Gates* revived, however, when Léonce Bénédite, Rodin's friend and first director of the Musée Rodin, which opened in 1919, suggested that the work should no longer be regarded simply as a door that would not open, but as a kind of iconostasis to be erected in the choir of the chapel of the Séminaire Saint-Sulpice, which had been handed over to the Ministry of Fine Arts in 1905 to be used as a Museum of Contemporary Art.[17] Thus between 1908 and 1910 *The Gates* were reconstructed with the aid of sketches supplied by Rodin himself.[18] The doorposts were to have been carved in marble while the leaves of the door and *The Three Shades* were to have been cast in bronze, which might conceivably have been gilded like Ghiberti's Baptistery Doors. Due to the rapid decline in Rodin's health, however, and the outbreak of war, these plans were never carried out. *The Gates* were not cast in bronze during Rodin's lifetime.

Seven years after his death they still had not been cast in bronze. This situation might have continued had Mr. Jules Mastbaum, newly fired with enthusiasm for the art of Rodin, not decided to establish a museum in Philadelphia devoted to the work of the great sculptor. Shortly before his death, late in 1926, Mr. Mastbaum ordered two bronze casts of *The Gates*, one for his own museum in Philadelphia and the second for the Musée Rodin in Paris. The Philadelphia cast was incorporated in the architecture of the building by the architects Paul P. Cret and Jacques Gréber and was in position at the opening of the museum on November 29, 1929.

Auguste Rodin (1840–1917)
Gates of Hell. 1880–1917
Bronze, height 250¾″
Rodin Museum, 21st Street
and Benjamin Franklin Parkway

Auguste Rodin (1840–1917)
The Thinker. 1880 (enlarged 1902–04)
Rodin Museum
Bronze, height 79″
(limestone base)
Gift of Jules Mastbaum
to the City in 1929

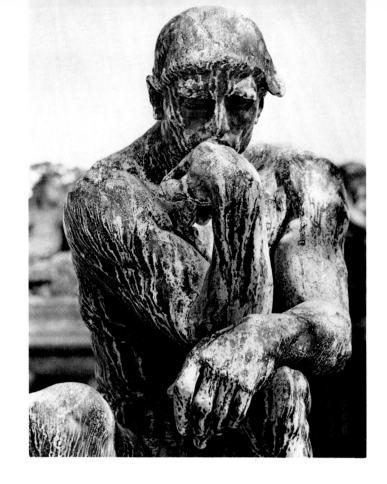

by Carolyn Pitts,
Saint Joseph's College,
Philadelphia.

photographs by Bernie Cleff

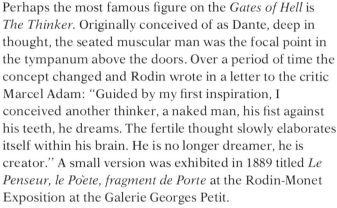

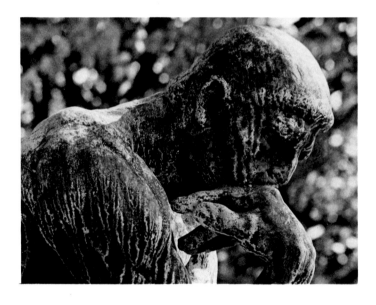

Perhaps the most famous figure on the *Gates of Hell* is *The Thinker.* Originally conceived of as Dante, deep in thought, the seated muscular man was the focal point in the tympanum above the doors. Over a period of time the concept changed and Rodin wrote in a letter to the critic Marcel Adam: "Guided by my first inspiration, I conceived another thinker, a naked man, his fist against his teeth, he dreams. The fertile thought slowly elaborates itself within his brain. He is no longer dreamer, he is creator." A small version was exhibited in 1889 titled *Le Penseur, le Poète, fragment de Porte* at the Rodin-Monet Exposition at the Galerie Georges Petit.

Rodin admired the works of Michelangelo and that influence is particularly strong in this case. The seated man recalls both *Il Penseroso* on the Lorenzo de Medici tomb in Florence and the prophet Jeremiah on the ceiling of the Sistine Chapel in Rome. The French sculptor Carpeaux had also done a similar figure of Ugolino with crossed arms of which Rodin owned a bronze cast.

The evolution of *The Thinker* in Rodin's scheme for the *Gates* was described by Rodin himself: "What makes my Thinker think is that he thinks not only with his brain, with his knotted brow, his distended nostrils, compressed lips, but with every muscle of his arms, back and legs, with his clenched fist and gripping toes."

The Thinker outside Philadelphia's Rodin Museum today is a cast of an enlarged version begun late in 1902 (bronze, 79″ high, 51¼″ wide, 55¼″ deep, signed right side of the base, A. Rodin). The larger version was exhibited in Paris in 1904 and its reception was so successful that a public subscription was begun to acquire the work for the city—there was no great Rodin displayed publicly up to that time. The funds were in hand by December of 1904.

Rodin's choice of a site was the square in front of the Panthéon and *The Thinker* was unveiled on April 21, 1906.

From the original idea of Dante brooding over Hell to the fully realized embodiment of a universal man there is a great conceptual change; the social and political climate of France at the end of the nineteenth century made the notion of a "common man" acceptable. Rodin, although acclaimed at the end of the century, had been at the center of a number of artistic and political controversies, particularly regarding his monument to Balzac. Rodin lived to see his *Thinker* become the symbol of the artist and his creative force. Since that time *The Thinker* has become one of the most admired and popular works with an even broader symbolism—an affirmation of mankind's positive potential.

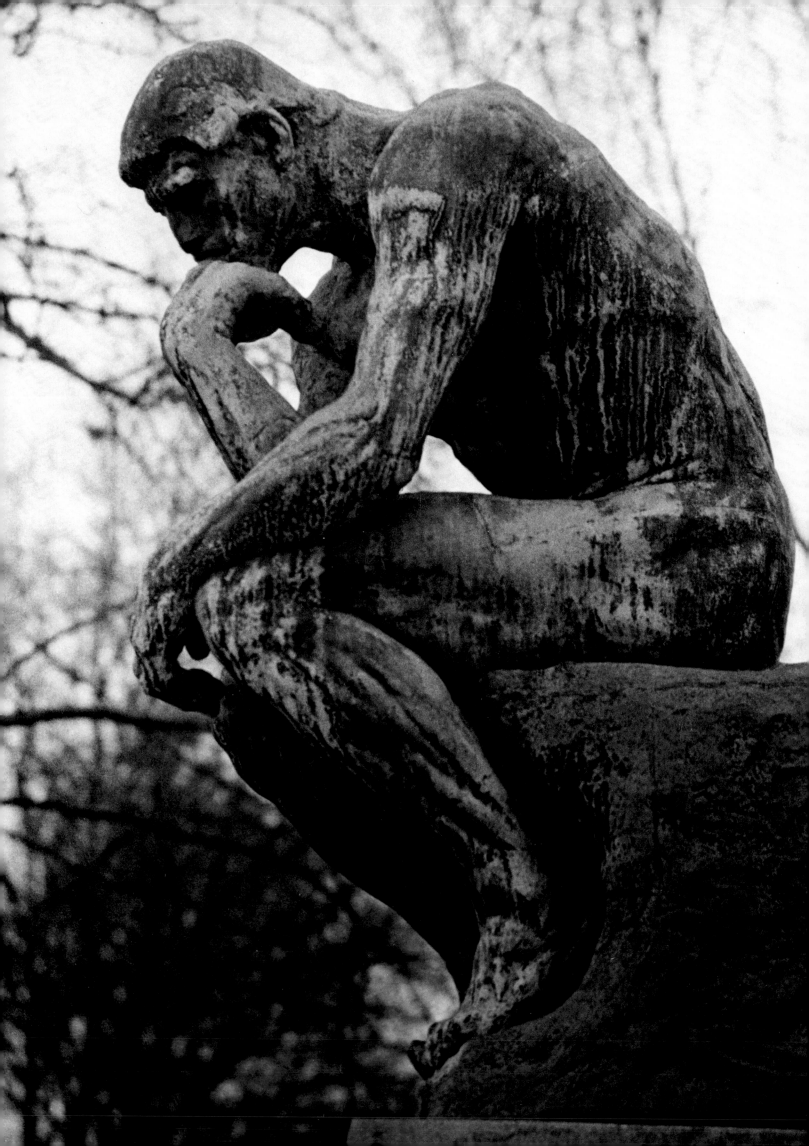

The Smith Memorial

by Lewis Sharp

*photographs by
Edward Gallob*

The era between the Philadelphia Centennial of 1876 and the outbreak of World War I was one of the most productive periods in American sculpture. Neoclassical sculpture was replaced by the vigorous realism of the Parisian-trained sculptors, and the Gilded Age witnessed a proliferation of public monuments and the incorporation of sculpture into architecture. Among the more spectacular manifestations of this period were the great neobaroque decorative schemes designed for the Columbian Exposition at Chicago (1893), the Pan-American Exposition at Buffalo (1901), the Louisiana Purchase Exposition at St. Louis (1904), and the Panama-Pacific Exposition at San Francisco (1915). Unfortunately, a large number of the decorative projects produced at the time were executed in staff (a composition of plaster of Paris and hemp fiber) and have long since either decayed or been destroyed.

The Smith Memorial, the gateway to West Fairmount Park in Philadelphia, was one of the most ambitious permanent sculpture projects undertaken. This semicircular structure contains fifteen individual pieces of sculpture executed by some of the most eminent

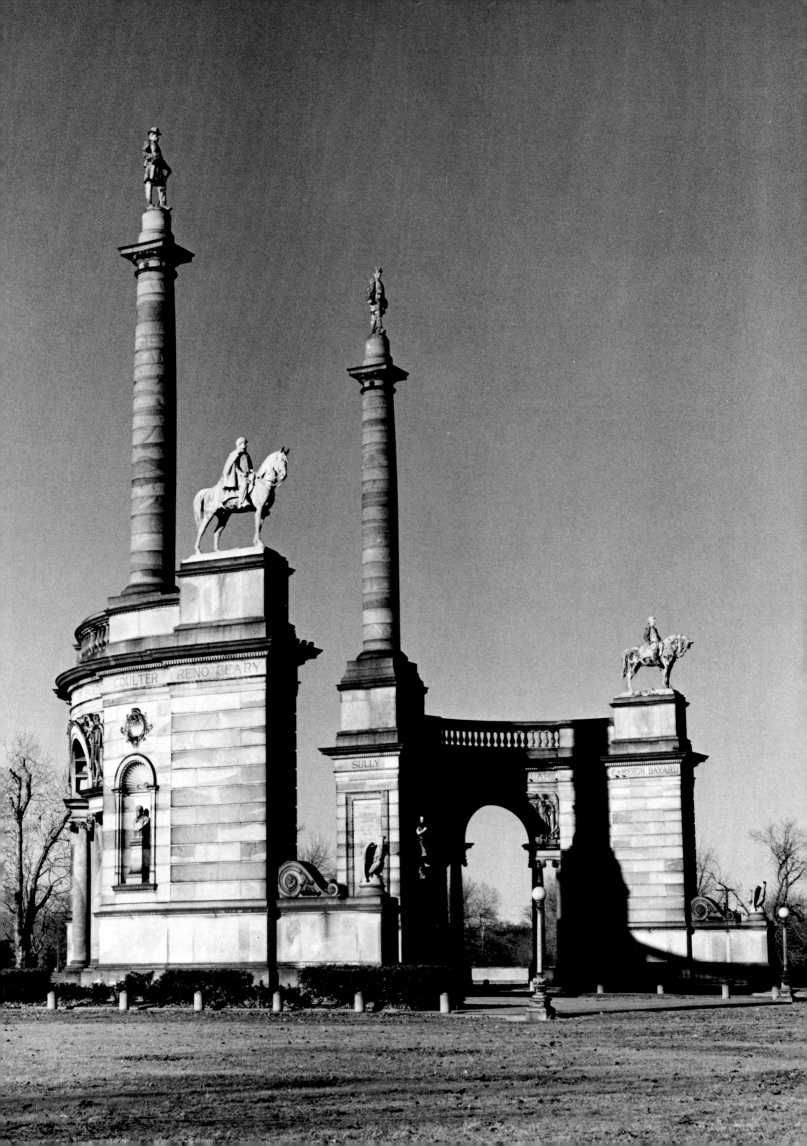

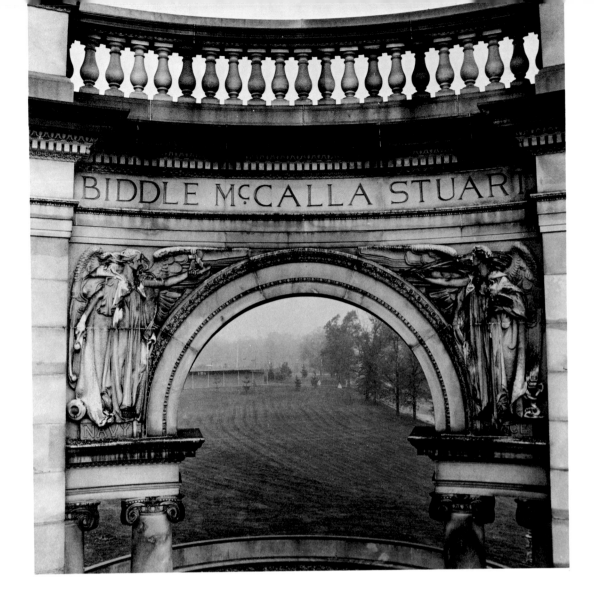

American artists of the day. The action and dramatic movement of the Memorial, in contrast to the sculptural projects of the first decade of the twentieth century, are restricted by the design of the arch—the statues are individually conceived and confined to the architectural stations allotted them. Yet, this neobaroque Memorial, with its towering columns and sweeping, semicircular arch, possesses an overwhelming picturesque quality that makes it one of the most visually striking public monuments erected at the turn of the twentieth century.

The Memorial was commissioned by Richard Smith (1821–1894), a wealthy Philadelphia electroplate and type founder. Provisions for the $500,000 monument to Pennsylvania's military and naval heroes of the Civil War were explicitly outlined in Smith's will, drawn up in 1891, the year that an approved model and designs for the arch were deposited at the Fidelity Insurance Trust and Safe Deposit Company. In his will, Smith left the financial responsibility of his estate to John B. Gest, president of the Fidelity Insurance Trust, the architectural design and construction to the Philadelphia architect James H. Windrim, and the selection and supervision of sculptors for the specified statues to the Fairmount Park Art Association. With the death of Smith's wife in 1895, the terms relating to the Memorial became operative,

however it was not until 1897 that the Fairmount Park Art Association's Committee on the Smith Memorial met at the Art Club to begin the task of selecting the sculptors for the statuary of the arch. During the next fifteen years, the committee met regularly to oversee the responsibilities entrusted to them. Its voluminous correspondence and minutes offer a comprehensive record of the commissioning and supervision of a public monument.

The committee's first responsibility was to prepare a circular, dated December 23, 1897, to be sent to seventy-three sculptors, notifying them of the desired statuary, and requesting photographs of their work and proposed estimates for specific works listed.[1] Within two months, fifty-nine sculptors had responded. The bids submitted were printed and presented for consideration to the full committee on February 22, 1898. During the next three months, the committee reviewed the bids of the artists and their portfolios, and, in addition, traveled to Washington and to New York to inspect existing monuments by the sculptors.

Since the committee was disappointed that John Quincy Adams Ward and Daniel Chester French, two of the country's foremost sculptors, had not responded, a member of the committee, Edward A. Coates, visited them in their New York studios. Following these

interviews, both artists consented to participate in the project, and on May 6, 1898, the Subcommittee on fine arts unanimously recommended that the following commissions be awarded:

John Quincy Adams Ward	Equestrian statue, Major General Winfield Scott Hancock
Paul Wayland Bartlett	Equestrian statue, Major General George B. McClellan
Daniel Chester French	Colossal figure, Major General George Gordon Meade
William Ordway Partridge	Colossal figure, Major General John Fulton Reynolds
Herbert Adams	Colossal figure, Richard Smith
Charles Grafly	Bust of Admiral David Dixon Porter
A. Stirling Calder	Bust of Major General John Frederick Hartranft
George E. Bissell	Bust of Admiral John A. B. Dahlgren
Samuel Murray	Bust of James H. Windrim, Esq.
Bessie O. Potter [Vonnoh]	Bust of Major General S. W. Crawford
Moses Ezekiel	Bust of Governor Andrew Gregg Curtin
Katherine M. Cohen	Bust of General James A. Beaver
John J. Boyle	Bust of John B. Gest, Esq.
Paul Wayland Bartlett	Two eagles and globes

With the artists selected, the committee anticipated that the Memorial would be completed within two years; however, from the outset the project was beset with problems. In an effort to compensate the artists fairly for modeling the busts, the committee offered each $1,800— an average of the estimates submitted by the sculptors involved. This amount was acceptable to all but John J. Boyle, who had requested $2,400 for the portrait of John B. Gest. Incensed at the reduction and admonishing the committee for lack of communication between the Association and himself, he declined the commission. After reviewing the list of available sculptors, the committee, in February, 1899, awarded Boyle's bust of Gest to Charles Grafly—thus giving the sculptor his second commission on the arch. Of the seven artists accepting a commission of a bust, it is interesting to note that two were women, Katherine M. Cohen and Bessie O. Potter [Vonnoh]; that four were Philadelphians, Charles Grafly, A. Stirling Calder, Samuel Murray, and Katherine M. Cohen; and that all were Parisian-trained artists, with the exception of Samuel Murray, a pupil of Thomas Eakins, whose studio he had shared for a number of years, and Sir Moses Ezekiel, who had studied in Germany and worked in Rome.

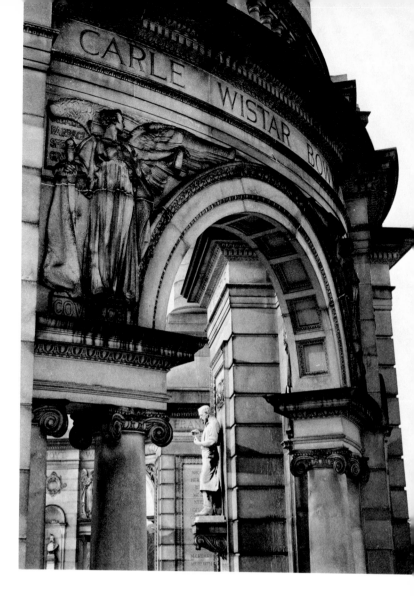

As might be expected, the sculptors modeling the busts progressed more rapidly than those working on colossal figures. With the exception of Grafly's portrait of Gest, all of the sketch models for the busts were completed within a year. After inspecting these busts, the committee decided a uniform base was needed and selected the lower part of A. Stirling Calder's bust of Major General Hartranft as a standard. In November, 1899, enlarged staff models of the bust of Admiral Porter by Grafly, Major General Hartranft by Calder, and Admiral Dahlgren by Bissell were placed on a staff mock-up of the arch that was erected in Fairmount Park to better determine the "height and measurement" of the sculpture. Satisfied with the scale of the statuary, the artists proceeded with their work and by June, 1901, all of the busts were cast in bronze, except Sir Moses Ezekiel's portrait of Governor Curtin. At first the bust of the popular wartime governor of Pennsylvania had progressed smoothly, the sketch model being approved without criticism in June, 1899. However, when the finished model was submitted in March, 1901, the committee criticized it severely and recommended its rejection. Although distraught by the committee's action and uneasy about reworking the bust from another photograph of the governor, Ezekiel attempted to comply

with the criticism. He reworked the model and repeatedly sent photographs of his improvements to Philadelphia for approval. However, the committee wisely refused to pass judgment on the piece on the basis of photographs. Finally in September, 1902, a model was sent to the Association, and it was accepted on the condition that its scale be adjusted to conform with the existing busts on the Memorial. Approximately a year later, in December, 1903, Ezekiel's work was completed in bronze, and the last bust for the Smith Memorial was put in place.

Reviewing the busts on the arch, one is immediately struck by the disharmony between Ezekiel's and the other seven portraits. Though a highly regarded sculptor who had been knighted by three European monarchs, Ezekiel has a dry Italianate style, which lacks the intense realism, the dramatic spontaneity, and the richly textured surfaces of the Beaux-Arts-trained sculptors. The head and facial features of Governor Curtin are coarsely modeled and there is little psychological penetration of his character. The two other civilians represented, John B. Gest by Grafly and James H. Windrim by Murray, are among the most sensitive portraits on the arch. The scale and proportions of their busts, in contrast to Ezekiel's portrait, are more compatible with the architectural niches of the Memorial. The highly realistic portraits of the executor of Smith's estate and the architect of the Memorial are fluently modeled and possess a vitality of human life stated simply and powerfully. As naturalistically conceived but more vigorously modeled is George Bissell's bust of Admiral Dahlgren. Though Dahlgren is ornately dressed in military garb, his uniform does not overwhelm the countenance of the officer and inventor of naval ordinance—it is a spirited portrait of a proud, self-assured military leader.

The work on the standing colossal figures of Major General Meade by Daniel Chester French, Major General Reynolds by William Ordway Partridge, and Richard Smith by Herbert Adams paralleled that of the busts. These three distinguished sculptors had studied in Paris and their work represents some of the finest achievements of American Beaux-Arts sculpture. However, as with the busts, there were contractual problems. The Association was bewildered by the discrepancy between the time and cost for the columnar figures—Partridge estimated six months at $8,000, while French estimated three years at $21,000. After consultation, Partridge confessed he had not fully realized the scope of the project and revised his estimate to eight months at $10,000, and French adjusted his time to two years at $18,000.

With these technicalities resolved, the sculptors turned to the task at hand. By November, 1898, only six months after notification of the commission, Partridge's sketch model of Major General Reynolds was ready for inspection. French and Adams, also working at a rapid pace, had completed their models by February and May, 1899, respectively. Following the enthusiastic acceptance of the three models, the sculptors enlarged the figures. By

November, 1899, the enlarged figures were completed and set in place on the staff mock-up of the arch erected in Fairmount Park. French's figure of Meade was deemed a great success by everyone, and Adams' figure of Smith was favorably received on condition that the scale of the figure be slightly altered. However, Partridge's figure of Reynolds came under particularly severe criticism, and in February, 1900 the committee recommended its rejection on the grounds that:

> The figure is lacking in dignity of pose.
> The head is too small and is badly set on the shoulders.
> The position of the left hand on the sword has not been satisfactorily altered in accordance with the criticism made at Mr. Partridge's studio.
> There is an absence of repose in the way the right hand is resting in the breast of the coat, and the position of this hand is meaningless and the action exaggerated. Finally, the body is not well set on the legs.
> Many of the suggestions made at the studio have not been carried out, and the defects in the small sketch study have been greatly exaggerated in the large model submitted for approval.[2]

While French and Adams prepared their final models for casting, Partridge returned to New York to work on a new full-size plaster of Reynolds. It was completed in October and the Association was invited to inspect the new model, which it again rejected, noting among other things that the composition "as a whole lacks unity." Aware that the commission was in danger, not certain of its responsibility to the artist, and definitely opposed to selecting a new sculptor, the Association appointed a special committee of three to review the work with Partridge and to make suggestions to the sculptor "which might help him make the work acceptable." Obviously frustrated, Partridge unfortunately spurned the committee's invitation. His new sketch model was completed in January, 1901, was submitted to the Association, and was rejected. While dissension grew among the members of the Association regarding the commission, Partridge, pressed by other obligations and probably sensing that an unbridgeable gap had developed between himself and the Association, retired from the project in February, 1901.[3]

Following his withdrawal, the committee hurriedly set to work to select a new sculptor. After much debate, John J. Boyle was chosen. However, the trustees, still seemingly offended by Boyle's earlier refusal to execute the bust of John B. Gest, passed over Boyle contending "that the candidate named is not available." On April 11, 1901, the commission was awarded to Charles Grafly. This represented Grafly's third piece of sculpture for the arch.

At the time Grafly was selected for the Reynolds statue, French's figure of Meade was already completed, having been cast in bronze by December, 1900; Adams' figure of Smith was nearing completion and was to be cast in the fall of 1901. Within five months of receiving the Reynolds commission, Grafly, assisted on the project by Carl A. Heber and the well-known animal sculptor Albert

Admiral Porter

Governor Curtin

John Gest

General Weaver

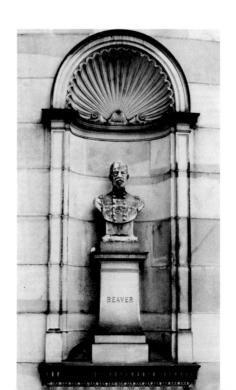

Laessle, submitted a sketch model to the Association. The quarter-size plaster was well received and Grafly enlarged the figure, which was ready for the committee's inspection in January, 1902. This figure was judged acceptable subject to a few minor alterations. After Grafly reworked the plaster, the committee unanimously approved the figure, and the statue, the last of three colossal figures to be placed on the Memorial, was cast in bronze in September, 1902.

The three colossal statues are all credible pieces of sculpture, but it is unfortunate that the architectural scheme placed the statues of Meade and Reynolds at such distant heights. Although so removed from the viewer as to make appreciation of details and modeling impossible, the two military figures, viewed against the sky, offer richly variegated silhouettes. The third figure, Adams' statue of the donor Richard Smith, is possibly the finest piece of sculpture on the Memorial. At the outset, Adams had questioned the rationale of juxtaposing on the pedestal stages of the columns a free-standing statue with an inscription. Instead, Adams and Ward had suggested a portrait in relief or a free-standing figure recessed into the arch. However, these suggestions were dismissed; the will clearly stipulated a free-standing statue and Windrim also felt it was not good architecture to cut into the base of the columns of the arch. Overruled, Adams turned his attention to his figure of Smith, and, although it may not harmoniously balance with the inscription, it is an outstanding statue, one of the finest in his oeuvre. Of monumental proportions, Smith is depicted in the informal dress of a type founder at work at his craft. The massive figure has subtle contrapposto and the surface has a richly modeled texture that gives the statue a lively, vibrant quality. It is a fresh and unpretentious representation of a self-made man.

The equestrian statues of Major Generals Hancock and McClellan, the principal statuary on the arch, prolonged its completion until 1912—a full twelve years after the projected date. John Quincy Adams Ward and Paul Wayland Bartlett, the sculptors commissioned to model the figures, were two of the country's most eminent artists, and were to be paid $32,000 and $35,000 respectively. Although Ward had rejected European training, in the 1870s he became aware of the new impressionistic, invigorated naturalism of Parisian sculpture and incorporated it into his own art.

Unfortunately, he was in his late sixties when he accepted the Hancock commission and was plagued by poor health; thus the project was repeatedly delayed. Bartlett, a close friend and associate of Ward, was an urbane artist who was taken to Paris at the age of nine to study sculpture. His precocious talent in modeling made him a leading Beaux-Arts sculptor by his early twenties. However, Bartlett was a notoriously slow worker, and, to make matters worse, at the time that he accepted the McClellan commission he began work on an equestrian statue of Lafayette, a reciprocal gift from the United States to the French nation for the Statue of Liberty. Absorbed in the statue of Lafayette, Bartlett spent almost all his time in his Paris studio and to a great extent ignored his Philadelphia commission.

At first Bartlett's work on the Memorial progressed well. By May, 1899, he had finished a preparatory sketch and six months later had completed an enlarged figure to be placed on the staff mock-up of the arch erected in the Park. Satisfied with the enlargement, the committee paid him the $7,000 the contract stipulated he would receive upon completion of the staff figure. During the next two years, there was almost no contact between the Association and the two artists, until October, 1901, when the Association passed a resolution to ascertain their progress. Three months later, representatives of the committee met with the sculptors in Ward's studio. Upon inspecting Ward's model of Hancock, the representatives wrote: "It had progressed very much further than we had anticipated, and met with our enthusiastic approval, the whole design being serious, dignified, and most interesting."[4] In their conversation with Bartlett, the committee was assured that his full-size model was nearing completion and could soon be brought from Paris to be cast in bronze. Bartlett also explained how he and Ward had worked closely together on their statues in order to make them harmonize.[5]

The committee, favorably impressed and aware that the selection of new sculptors would only further delay the project, decided to retain Ward and Bartlett. In March, 1902, the two sculptors signed new contracts calling for their figures of Hancock and McClellan to be finished and in place within fifteen months. At this same time, Bartlett, who was also modeling a pair of eagles and globes for the arch, relinquished that commission. Hurriedly the Association cast about for a sculptor to execute these works, and two months later, in May, 1902, awarded the eagles and globes to J. Massey Rhind. Rhind had already been employed by the architect to execute the architectural reliefs on the arch. Within four months, he had completed his sketch models of the eagles and globes, and, after reworking the design several times, had the committee approve the full-size model in May, 1903. By December, a year and a half after the commission had been awarded, the eagles and globes were cast in bronze and ready for placement on the arch.

Unfortunately, Ward and Bartlett were not as punctual as Rhind, and by the contracted date, July, 1903, neither sculptor had presented anything new to the

General Meade

General Reynolds

committee. The Association repeatedly debated whether to solicit new artists to execute the equestrian figures, but delayed a final decision in hopes that the statuary would soon be completed. After more delay, the committee finally met in New York in January, 1906, to inspect Bartlett's full-size plaster model. Whether frustrated by Bartlett's tardiness, his absence because of work on the Lafayette in Paris, or simply dissatisfied with the model, the committee criticized his work, contending that important details had been neglected and the entire figure was insufficiently completed. Mystified by the report, Bartlett wrote the committee:

> *I am sorry you had a bad impression of the statue—you saw it under the worst possible circumstances, bad light, too near, and you probably climbed up to the loft and looked at it from above. I hoped you would make allowances. This statue is made to be seen at a distance and from below, and there are many rough places which at a distance scintillate and give it more life than pretty polished pleats. I do not deny there is still something to do to it, but it is very little in comparison to its qualities—you cannot deny that there is power there and that the horse has a fine poise and a great deal of nobility in its simple pose...[6]*

The disappointment with Bartlett's model prompted the Association to take action. In May, 1906, Ward and Bartlett were notified that their contracts were nullified and a court suit was initiated against Bartlett to recover the $7,000 he had received for his staff model. Although the contracts were terminated, the sculptors continued to work on the statues, and the Association itself seemed to hold out some hope that the works would be completed, since no moves were made to select new artists to execute the equestrian figures. However, after two years, Bartlett had still not come forward with a new model, and Ward, because of poor health, had even given up his studio. Finally in December, 1908, the Association made the inevitable decision to recommission the statues and to try to bring the project to an end.

Daniel Chester French, who as a youth had studied briefly with Ward, was sympathetic both to Ward's position and to his model. In a compassionate but logical vein French wrote John M. Gest, the son of the executor who had assumed his father's duties: "Mr. Ward had completed a model which, in the eyes of his fellow artists, is a work of unusual merit, admirably suited to the place, dignified and impressive, so that the success of the finished statue is practically assured. It is possible to finish the statue and erect it in bronze so that it can be put in place by June 1st, 1910."[7]

The committee wanted nothing more to do with Ward, but they agreed to let French handle the commission in any manner he wished. On June 4, 1909, French signed a contract calling for the equestrian Hancock to be completed and in place by October, 1910. French was assisted in the enlargement of the figure by Edward C. Potter and Carl A. Heber, and the statue was finished and on the Memorial by the contracted date. The

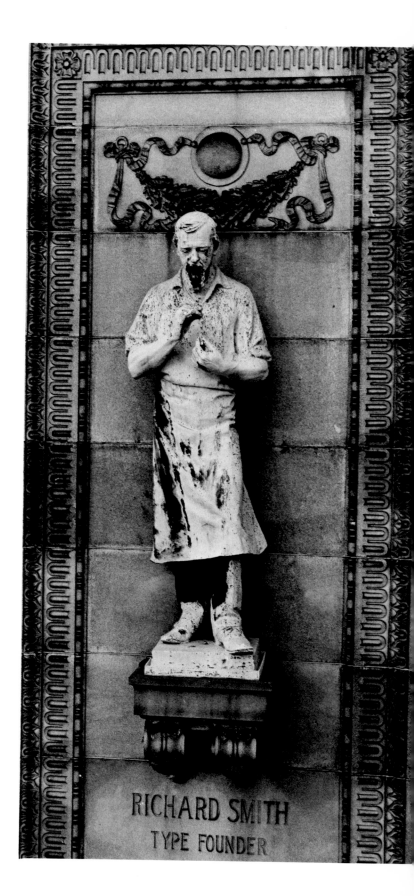

RICHARD SMITH
TYPE FOUNDER

Hancock is not only a powerful statue in its own right, but with it, Ward succeeded in coordinating the figure to the curve of the architecture—the head of Hancock's horse is arched and turned, thus directing the viewer's eye back into and around the arch of the Memorial.

Bartlett's equestrian statue of McClellan was unfortunately not as successfully carried out. On French's recommendation, the commission was granted to Potter. Signed in September, 1909, the new contract called for the work to be completed within a year and a half, and, according to his schedule, Potter's figure was finished and

in place by June, 1912. Although it was professionally modeled and executed, the McClellan, perhaps because of the time limitation, shows no coordination with Ward's figure or with the architecture of the Memorial. It lacks Ward's and Bartlett's vision of the statues as the climactic figures—balancing in size and spirit while corresponding to the movement of the baroque arch—and it makes one even more conscious of the loss of Bartlett's balancing equestrian.

By the time Potter's statue was in place in 1912, the enthusiasm and fanfare one normally would expect for a

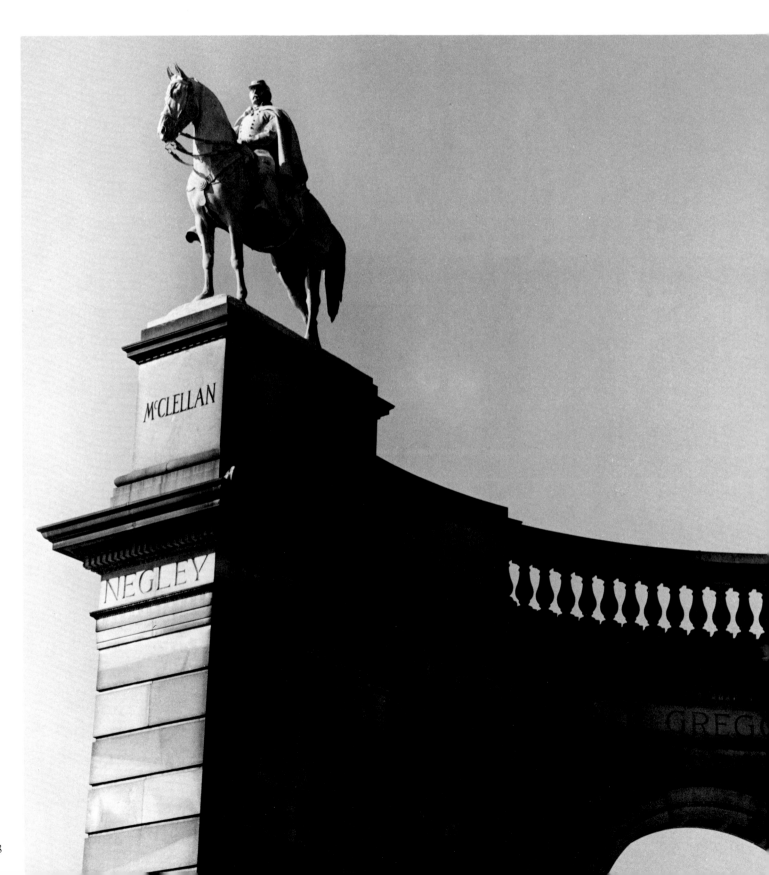

public monument of its size and cost was missing. Drawn
out over fifteen years, everyone's patience and interest in
the project had been dampened. The once rather bold
design now appeared retardataire, and the enthusiasm for
Civil War memorials had waned. Yet the Smith Memorial,
with its curving, neobaroque arch and soaring columns
populated by fifteen pieces of sculpture, is visually
striking and remains one of the most ambitious public
monuments erected in Victorian America.

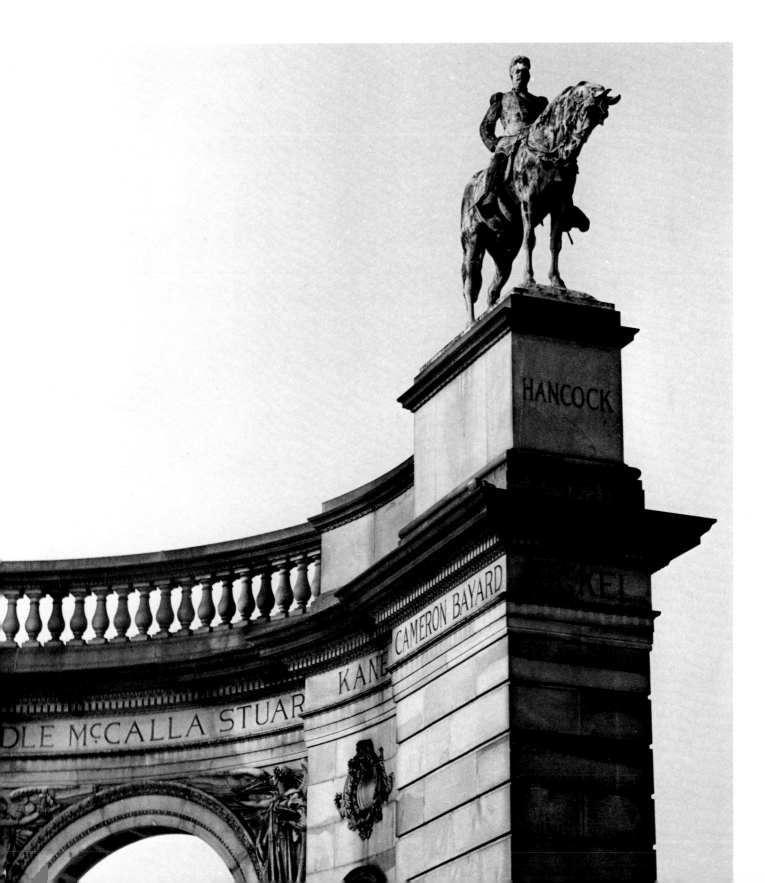

Garfield Monument

by John Dryfhout

photographs by
George Krause

The monument to James A. Garfield, the twentieth President of the United States, who died as a result of assassination, is one of the least-known works of the American sculptor Augustus Saint-Gaudens (1848–1907). The sculpture was the second commemorative monument in a long list of commissions awarded by the Fairmount Park Art Association to a living American artist.[1] The fund for the monument, begun in October, 1881, immediately after the President's death, had grown to more than $15,000 in 1885 when a special five-member committee from the Association recommended Saint-Gaudens be given the commission.[2] The sculptor agreed to the project, but it was not until February, 1889, that a formal contract was signed.[3]

The year 1885 was a high point in the sculptor's career. He had a number of commissions in hand,[4] having received national acclaim with the completion of the Farragut Monument in New York in 1881. Saint-Gaudens was not one to hurry with a commission, and his "infernal delays," as Henry Adams called them, must have been a source of consternation to a number of committees. Philadelphia was no exception. In 1889, Saint-Gaudens began preparing various pencil sketches, which were all that developed in the ensuing four years. These early sketches indicate that the committee wanted a standing figure on a pedestal. Saint-Gaudens' innovative use of pedestals, as a bench in the Farragut Monument, a low circular dais for the *Puritan* (Springfield, Massachusetts, 1887), and a stone footstool with seat in the Adams Memorial (Washington, D.C., 1891) are reflected in the

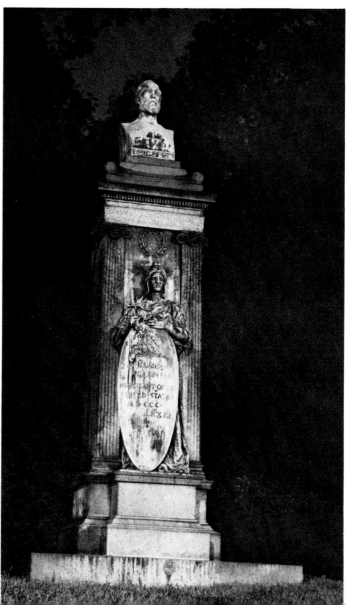

sketches for the *Garfield*, with a low, broad-stepped platform. Actually the studies indicate a more progressive and modern arrangement than is found in the final execution of the monument. One of the important developments in late-nineteenth-century sculpture was the gradual elimination of the pedestal, bringing the sculpture down to the observer and its natural environment. Yet other sketches show the use of architectural details, such as freestanding columns with standing or seated figures on a block with shields at the four corners representing the attributes of the subject's life: statesman, American, president, and so forth. There were precedents for most of these plans, primarily deriving from Saint-Gaudens' own academic training as a sculptor—the same influence found in the work of his colleagues and their monuments to Garfield: John Quincy Adams Ward, Charles Niehaus, and Alexander Doyle.

Ward was one of the foremost sculptors of the day and his bronze freestanding figure of Garfield in the nation's capital, unveiled in 1887, is set on a rounded pedestal with three recumbent figures at its base representing the life of the assassinated president: soldier, statesman, and teacher. The origin of Ward's composition could have been Michelangelo or some contemporary French sculptor such as Paul Dubois and his tomb of General Lamoricière at Nantes (1876–78), with its attendant figures of Military Courage, Faith, Science, and Charity. (One of the only published drawings by Saint-Gaudens is of Dubois' figure of Faith; Saint-Gaudens rated him as one of the top ten sculptors in western art.) Charles Niehaus completed his nine-and-one-half-foot marble figure for Cincinnati in 1889, while the national memorial to Garfield in Cleveland's Lakeview Cemetery has an uninspired freestanding figure of the president by Alexander Doyle finished in 1884.

By June, 1893, the Philadelphia committee received word that Saint-Gaudens wished to do something entirely different from his original intention and asked for a change in the agreement signed four years earlier. He also sought an extension of two years for its completion. In August a water color sketch was sent by the architectural firm of McKim, Mead, and White (Stanford White, had been associated with all of Saint-Gaudens' monumental work since their great success with the *Farragut)*. This and other sketches showed the change in the artist's thinking from the conventional full-standing figure.

However, one of the committee members, John T. Morris, was not very pleased with Saint-Gaudens' actions, as he wrote in October, 1893, to the secretary of the Association, Charles Howell: "I think Mr. St. Gaudens is treating us miserably and I fear we will have trouble in getting any satisfactory work from him."[5] However, the board of the Art Association went along with Saint-Gaudens' wishes and by December, 1893, a new contract was drawn up reflecting these changes, calling for a bust on a pedestal as well as an allegorical figure, both to be in bronze. The new contract was witnessed by the sculptor's assistant, Charles Keck, and Saint-Gaudens' model-

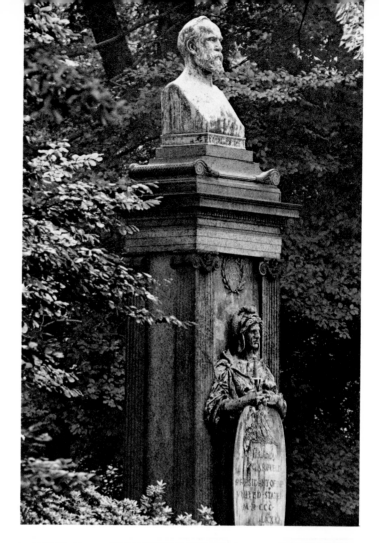

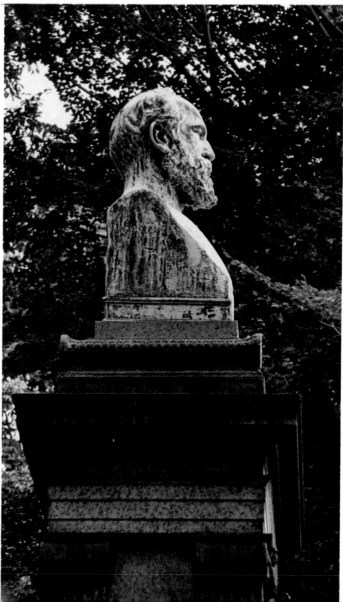

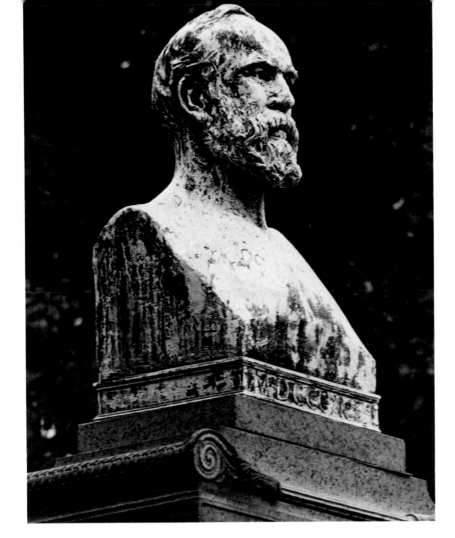

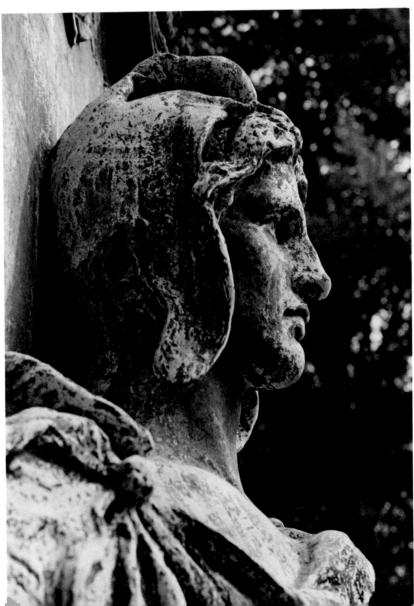

mistress, Davida Clark, who no doubt posed for some of the work on the "Republic" figure, as she had been the model for several of his other ideal works including the *Amor Caritas*. The contract specified that the bust be not less than life-size nor more than four feet and that the allegorical figure not exceed eight feet in height. In addition, the commission was increased from the previous $15,000 to that of $20,000.[6]

In March, 1894, Saint-Gaudens sent his architect friend Stanford White a note concerning their collaborative work on the monument:

I am dealing with a committee now with whom I am not on very pleasant terms. Some of them understand art but they are Philadelphians and it would take me a week of Sundays to explain to them that the monument will be finer than the watercolor. I am sure that the pencil outline drawing as originally proposed will please them better. Louis [Saint-Gaudens] will draw in the figure as before.[7]

The drawings, completed in August, 1894, show a rather well-defined figure of the Republic or History with a wreath of oak leaves in her hair and a spray or branch of oak in the background. She also holds a shield, a wreath, and a sword (symbols of soldier, statesman, etc.) in her right arm. Surmounting the pedestal is a stark heroic bust of the President.[8]

By November of that year, the site had been chosen by the architect and sculptor, at Rond Point on Girard Avenue and the Schuylkill River (East River Drive). In May, 1895, Saint-Gaudens wrote the secretary of the Association that the monument was finished in the clay and would be ready to send to the foundry. The committee was asked to visit the studio on West 20th Street in New York on June 8, 1895, and inspect the work for final approval.

Like other artists in the nineteenth century, Saint-Gaudens borrowed the symbolism of the Renaissance and classical Greece to endow his idealistic work. However, he continually worked toward a balance of the real and the ideal, particularly in monumental pieces. The symbolism, as in this case, was not especially inherent in the subject. The introduction of the allegorical figure was therefore necessary. Garfield had not been a very colorful personality and his career was not overly remarkable as a soldier, congressman, and teacher. Nor did his short term in the office of President provide any basis for conjecture on that facet of his life. The biographies that appeared immediately after his death tended to be patronizing and appealed to the Horatio Alger success story—the frontier youth, canal boy, achieving the presidency through hard work and study.

Saint-Gaudens' development of this commission was perhaps more directly derived from French sources than from anything specifically Italian or Greek. He made special note in his drawing book of one French master, David d'Angers, and his pediment group in relief on the Panthéon in Paris (Ste. Geneviève). Here the allegorical central figures represent France in classic attire, holding out bunches of wreaths, accompanied by seated female figures, one of Liberty wearing a Phrygian cap and the other of History. He may also have been influenced by the French sculptor Jules Dalou, whose *Triumph of the Republic* (1889) he no doubt saw at the Salon in Paris that year. The use of the plinth-pedestal, with its attendant figures and decorated bust, was not unusual in French contemporary sculpture. As the typical memorialization of artists and statesmen, it was used by such masters as Chapu, Falguière, and Rodin.

In the United States, Daniel Chester French created a sixty-foot figure of the Republic, which was the focal point of the Chicago World's Columbian Exposition of 1893, an exposition having a profound effect on art and architecture in this country. It was Saint-Gaudens who acted as the supervisor of all the sculpture for the fair and recommended the setting for this particular piece with its fountains, lagoon, and columned peristyle. Bartholdi's *Liberty Enlightening the World* in New York Harbor, unveiled in 1886, is equally expressive of the same concept. However, Saint-Gaudens had been evolving a quite personal style for the female ideal figure. Beginning in 1873, while he was in Rome, he modeled a marble statue of Silence for a New York patron, which found fulfillment in a later and much more mature poetic abstraction—the Adams Memorial (Rock Creek Church Cemetery, Washington, D.C., figure 1). The figures in relief on the Farragut Monument base are truly novel representations of the female form in sculpture: "Loyalty" and "Courage," symbols of the admiral's life, represent perhaps the first use of the Art-Nouveau style in the United States, if not in Europe (figure 2). The *Amor Caritas* funereal monument was an evolvement of a series of angelic figures begun in Paris in 1875, later destroyed by fire, and again appearing in the caryatids *(Amor Pax)* in Cornelius Vanderbilt II's mansion in New York in 1882. All of these ideal figures have distinctive features in common: a Greek face with broad, flat nose, heavy eyelids, deep-set eyes, high forehead, wide cheekbones, and down-turned lips. Their necks are unusually long and large and the rest of their features are somewhat Amazonian. They recall the paintings of the Pre-Raphaelites, of Burne-Jones and Rossetti—what Thomas Beer in the *Mauve Decade* labeled the "Titaness," and what Charles Dana Gibson would later refine in his drawings as "the Gibson girl." But there is a solemnity to Saint-Gaudens' ideal females which finds its ultimate embodiment in the striding "Victory" who proceeds the General Sherman equestrian (New York, 1903) and is emblazoned on the obverse of the twenty-dollar gold piece of 1907, done just before his death.

The Garfield "Republic" is strong in front of her nichelike plinth, having the same bearing, facing forward—with sword, shield, and stance—as Donatello's *St. George* in Florence (a copy of which we know to have been in the sculptor's studio). This is also reflected in Stanford White's architectural frame—a pedestal with ogee cornice and dentils, well-proportioned architrave

and frieze, supported by four fluted and engaged columns with Ionic capitals. The heroic bronze bust of Garfield was no doubt modeled from the actual death mask, thus gaining the precise realism to balance the composition—a Greek Hermes, without any of the ridiculous bravura inevitably found in the French contemporary sculptors' handiwork.[9]

The only real problem in the composition arose from the use of an inscription. Lettering was an important element in Saint-Gaudens' sculpture, as it was for the Pre-Raphaelite painters. It became a part of the composition as well as a decorative feature. The shield which the "Republic" holds is very large, since it was to serve as the standard for a longer inscription. But the committee did not agree with the sculptor's choice of words and therefore it remains, to this day, in an abbreviated form. Their action in this matter irritated Saint-Gaudens so much that he almost did not sign the finished work. The shield bears the beautiful rendition of the standing eagle, holding in its claws the fasces and the olive branch, and in the background the inscription: "E Pluribus Unum." In addition, there are the lines: "James Abram/ Garfield/ President of the/ United States/ MDCCC/ LXXXI."

Originally Saint-Gaudens wanted to use the following lines: "Who'er amidst the sons of Reason, Valour, Liberty and Virtue, display distinguished merit, is a Noble of nature's own creating."[10] Somewhat later this evolved to

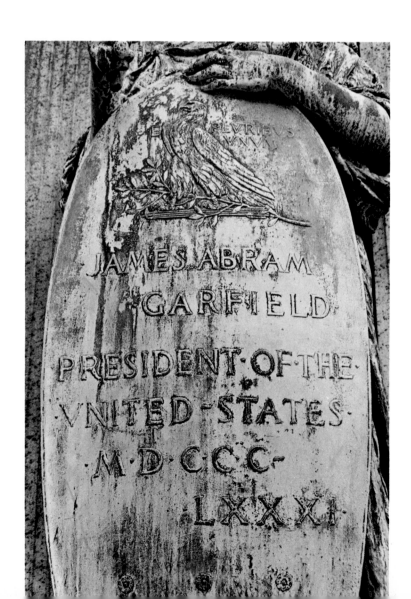

the descriptives: citizen, scholar, soldier, statesman, man, besides some lines from Wordsworth: "There's not a breathing of the common wind / That will forget thee." However, one of the members of the committee declared that "man" was going a little bit too far (not realizing its source in Shakespeare's *Julius Caesar:* "This was a man!"). Yet another gentleman thought that instead of "man," they should substitute "Christian!"

Meanwhile Saint-Gaudens was becoming more anxious about finishing the piece and having it sent to the foundry. The committee, having waited ten years for him, did not seem to understand his apparent haste. On September 3, 1895, Charles Cohen, one of the members of the Garfield Committee, visited Saint-Gaudens, saw the work, and evidently arrived at a compromise. The figure was cast by the Henry Bonnard Bronze Foundry in New York and was set in place in Fairmount Park in the fall of 1895. The landscaping, planned by both Stanford White and Saint-Gaudens, called for the most simple arrangement, capitalizing on the natural amphitheater surrounded by rocks and trees and a gentle mound, half-circled by a boxwood hedge.

The unveiling ceremony took place the following May 30, 1896, when all of Philadelphia, it would seem, took part in the celebration. The festivities included a parade, flotilla or river fête, and an illuminated pageant—a first for Philadelphia. The spring night was made as brilliant as

day for the unveiling, with electric and calcium lights.[11] Saint-Gaudens, however, remained somewhat uneasy about the piece and it evidently stayed with him, since in 1905, after the completion of the *Pilgrim* for City Hall Square in Philadelphia, he proposed to the Association that he be allowed to gild the Garfield bust and the allegorical figure (no doubt as a result of his success in this with the *Sherman*, and his constant fear that over the years his sculpture that was outdoors would darken or "look like stovepipes"). He also asked to be allowed to remodel the shield, to make it smaller, but these requests were turned down by the Association.

The Fairmount Park Art Association had waited ten years for the "prince of sculptors" to finish his work, and they were apparently not in the mood to start over again. For Saint-Gaudens, whose life's work was mostly portraiture, this opportunity to do ideal sculpture, which he loved as much as the work in bas-relief, time had no particular significance, and in many cases these larger commissions brought him little net income. He is often quoted as paraphrasing Buffon: "It is not what you do, but how you do it, that is important." The "infernal delays" were often due to the details which he desired, to make a better composition, giving color without detracting from the whole. The *Garfield* had all of the qualities of good monumental sculpture, what Lorado Taft described as "simplicity, serenity, and dignity."[12]

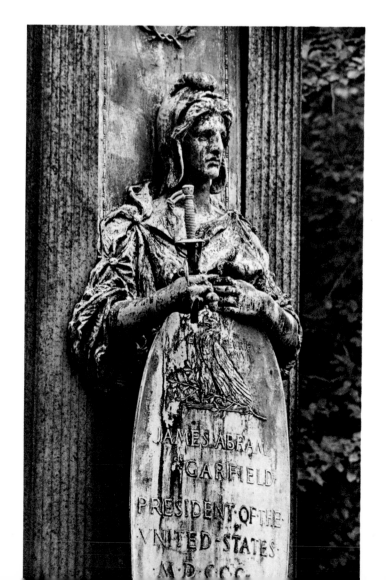

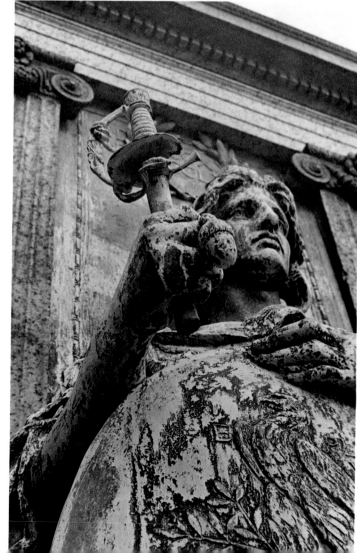

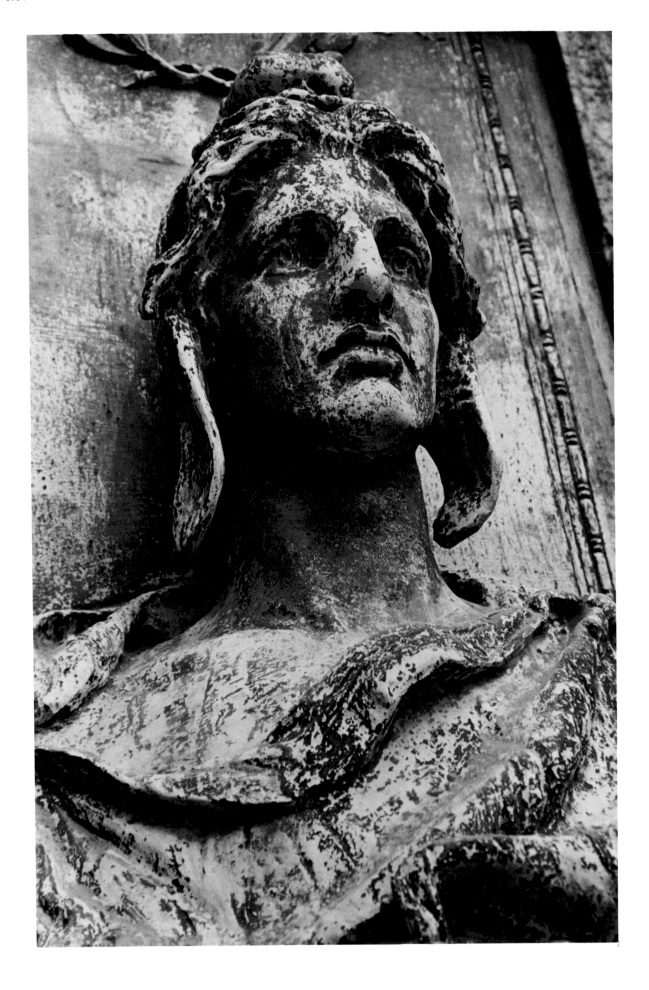

The monument also embodies his attitudes of "beauty" as something beyond the cold, accurate rendering of nature, but rather something enobling and uplifting. Saint-Gaudens' own statement in this was "that art seemed to be the concentration of the *experience* and *sensations* of life...which accounts for the desire in artists to have realism." But that realism was not always enough: "The imagination must be able to bring up the scenes, incidents, that impress us in life, condense them....The imagination may condemn that which has impressed us beautifully as well as the strong or characteristic or ugly."[13]

The use of the allegorical—ideal figure in monumental compositions was not always as successful as in the *Garfield.* The commemoration to Phillips Brooks outside Trinity Church, Boston was underway in Saint-Gaudens' studio at the same time. Here the sculptor introduced a figure of Christ in the background of the freestanding Bishop Brooks. The result is imbalance and ridicule. The strong character of the clergyman, with his arm on the Bible and his hand raised to his flock, is negated by the shadowy figure in the background tapping on his shoulder. The architectural canopy, also designed by Stanford White, is heavy in conception and overshadows and reduces the significance of the sculpture, as did White's canopy for the Peter Cooper Monument in New York, completed in 1897. This was not the case with the *Garfield,* where the elements seem to be much better arranged and balanced: the real with the ideal, the stone with the bronze, the architecture with the sculpture. The "Republic" expresses in no uncertain terms an abstraction—the spirit of the age, history—guarding not only the virtues but also the memory of her slain son, whose image on the one hand dominates, yet is subordinate to the total composition. The gilding which the sculptor proposed in 1905 would have been an additional enhancement to the composition, giving not only some necessary color, but also, more importantly, movement, which is almost nonexistent in its present wooded setting. The location of the work also lends to its anonymity. In the busy, abrupt spot on a fast-paced drive, there is little chance to catch the subtleties of the sculpture, to savor the whole. Saint-Gaudens resolved the conflict between the presentation of a moral statement required by the patron, society, and the necessity of a realistic representation of the subject. He has successfully rendered a refined and dignified form—the Hermes bust with the allegorical figure—devoid of overt romanticism and drama, yet having all the style and design which evolved in other of his great works.

Augustus Saint Gaudens
(1848–1907)
James A. Garfield. 1895
East River Drive below
Girard Avenue Bridge
Bronze, height of bust 42½"
(granite base 12",
granite pedestal 180")
(height of figure
on pedestal 94")

Ulysses S. Grant

by Michael Richman

*photographs by
Bernie Cleff*

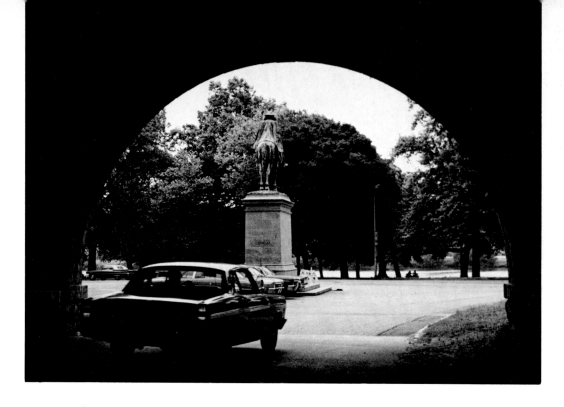

With the end of the Civil War, the production of monumental sculpture in America exploded, in large part sponsored by civic groups, patriotic organizations, and private citizens eager to commemorate wartime heroes. Small towns with modest funds purchased inexpensive, hastily manufactured bronze or granite soldiers. The larger urban centers either constructed granite ensembles of soaring columns with garlanded maidens personifying such worthy attributes as War, Victory, Valor and Peace, or memorialized valiant officers in minutely detailed bronze statues. But the most lavish projects honored the great war leaders, and Philadelphia, like other major cities, erected monuments to these nationally prominent figures. With the death of Ulysses S. Grant on July 23, 1885, only four days passed before the Fairmount Park Art Association called a special meeting to plan for a suitable memorial. It was promptly decided to form a standing committee, whose members were Anthony J. Drexel, Joel J. Baily, Charles J. Cohen, Lincoln Godfrey, Charles J. Harrah, Thomas Hockley, and Charles H. Howell. At this initial session on July 27, a resolution offered by Mr. Harrah was adopted.

> *Whereas: The people of Philadelphia desire to perpetuate the memory of the late General Ulysses Simpson Grant, his honorable life, noble example and great achievements; therefore, Resolved: that the Fairmount Park Art Association shall create a fund to be called the Grant Memorial Fund, for the erection in Fairmount Park of a suitable memorial statue . . . and that Fairmount Park Art Association shall contribute whatever may be needed to complete the Fund, not exceeding $10,000.*[1]

The Association's concern was the collection of money and by January 28, 1886, contributions in the amount of $12,963.50 were received. Almost two years elapsed before, on December 6, 1888, the Committee on the Grant Memorial and the Committee on Works of Art held their first official meeting. At this session it was reported that both Chicago and Saint Louis had erected statues to honor Grant while New York City's memorial project was underway.[2] Those present agreed that Philadelphia should act and the Association was urged to

> *choose three prominent artists and . . . invite them to prepare sketch models, to be completed and delivered to the Association within one year, for an equestrian statue . . . one and one-half life size. . . . For the said sketch models each of the said artists shall be paid the sum of one thousand dollars: the said models to become the property of the Fairmount Park Art Association. Estimates for the statue (exclusive of the pedestal) shall accompany each model and shall not exceed the sum of $25,000.*[3]

Despite this declaration, it was not until April 29, 1892, that invitations, written by Charles H. Howell, the Association's secretary, were extended to seven (rather than three) sculptors.[4] One of those invited, Daniel Chester French (1850–1931), had previously expressed interest:

> *I am told that you can give information in regard to the proposed equestrian statue of General Grant for the city of Philadelphia. Will you kindly write me whether the commission for the statue has yet been given out and what steps have been taken in the matter. As a sculptor I am naturally interested in the project and shall be much indebted if you will enlighten me in regard to it.*[5]

Several months passed before French again wrote to the Fairmount Park Art Association: "It is gratifying to hear that the Sub Committee considered me favorably as a candidate for the Grant Equestrian Statue. I will send some photographs soon that may help to decide the question of my ability to furnish a satisfactory horse."[6]

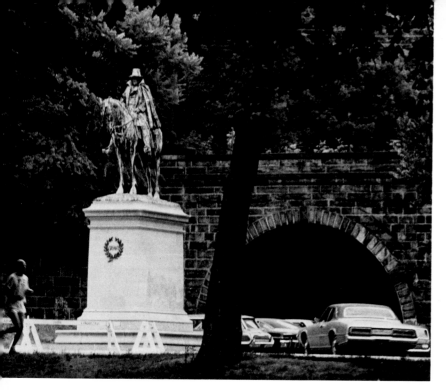

Committee members were impressed with French, a sculptor whose talents were recognized both at home and abroad. For the World's Columbian Exposition at Chicago, French was asked in 1891 to make the monumental statue of *Republic* that was to be the principal decoration in the Court of Honor. With the assistance of Edward Clark Potter (1857–1923), his former pupil, French also produced four massive animal and figure groups prominently positioned near the entrances of Charles F. McKim's Architectural Palace, and a quadriga atop the Peristyle designed by Charles B. Atwood (figure 1). At the Paris Salon of 1892, French's exquisite relief, *Death Staying the Hand of the Sculptor* (figure 2) was awarded a bronze medal, the first such prize ever given to an American sculptor.

In November, 1892 the Committees on Works of Art and the Grant Memorial invited the sculptor to come to Philadelphia. It was probably at this meeting that French first indicated that he would execute the monument with Potter's help. Early in December, after seven years had elapsed, the subcommittees made their recommendation. With understandable enthusiasm, French wrote to his brother, William Merchant Richardson French:

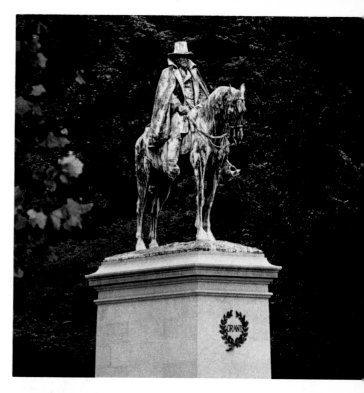

> *I wonder if you have heard through the papers of Potter's and my good fortune. The Grant equestrian … has just been awarded to us. I think I am more jubilant on Potter's account than on my own. He is radiant, and he says his May [Potter's wife] is daft over it. It will be a good chance for us both and we intend to make the most of it. I called at Philadelphia on my way north with Mamie [French's wife] and saw the Committee, and apparently sufficiently impressed them with Potter's and my importance. There was no competition or even preliminary model.*[7]

The commission was officially awarded by the Association's president Anthony J. Drexel on

December 27, 1892.[8]

Work on the first model began immediately and on February 24, 1893, French wrote to Howell that "we have settled on a motif and I am feeling rather happy about it."[9] On May 4, Howell learned that the sketch was almost finished. During the summer Potter began the one-third scale model of the horse, and on September 10 French wrote:

I cannot report much tangible progress on the Grant. Mr. Potter has been studying the horse all summer and within a few days is going to join me here [Windsor, Vermont]. If satisfactory to us, I will send you a photograph of it.[10]

French returned to his studio-home in New York City and by the time he next wrote to the Association, on December 19, he confirmed that the one-third scale model for the horse was almost finished.

In the annual report of 1894, the new president, John H. Converse, summarized the progress of the previous year.

At the suggestion of Daniel Chester French...the proportions will be larger than one and one half life-size as originally intended.... [They] are very enthusiastic over their work, and hope to produce a memorial...that will make Philadelphia famous in the possession of another Art Treasure of national importance, which every patriot will desire to see. The site selected by the artist is on the East River Drive.[11]

The design of the equestrian had been approved by the two committees and the formal contract drawn on January 23, 1894. Some members questioned Potter's design of the horse, but by March 14 French acknowledged that everything was in order: "We are anxious to get the large model set up...and get it as nearly completed as may be before the winter weather sets in. I do not remember if I told you that we intend to arrange things so that we can roll our statue out-of-doors and work upon it under the same conditions as the bronze will have."[12]

The enlargement of the statue in clay was undertaken at Potter's studio in Enfield, Massachusetts, where it was finished and put in plaster by December, 1895. French happily reported: "I have just returned from a trip to Philadelphia whither Potter and I went on Friday [December 20] to inspect the model of the Grant, which had arrived a day or two before at the foundry. We found it in good condition, needing only a little mending to put it in order for casting."[13] The Philadelphia foundry, Bureau Brothers, began the casting early in 1896, and completed the statue at their shop at 21st Street and Allegheny Avenue by the end of April, 1897 (figure 3). The large bronze was at its designated site in early May.

Sixteen months is a longer period of time than would normally be required to cast a statue like the *Grant*, but the foundry prolonged the operation because the pedestal was not ready. In fact, construction had not even started.

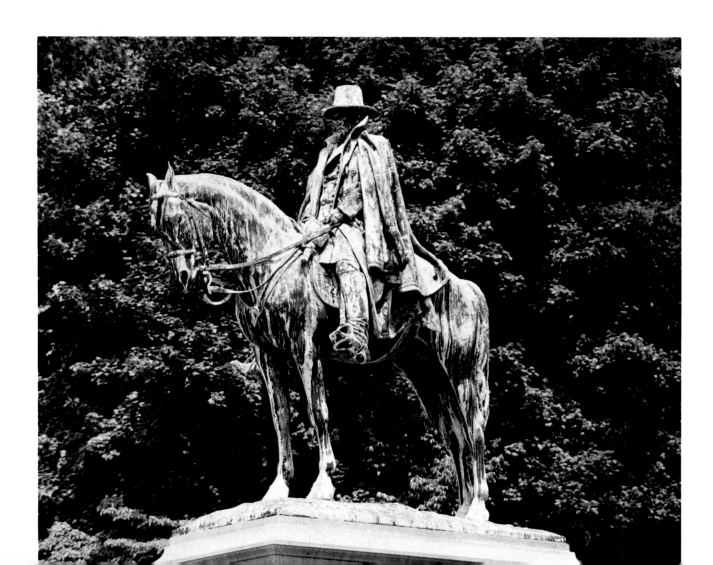

French was concerned early in the project about the delay and wrote to Howell on April 6, 1896, that "I want to see you about this pedestal mess."[14] The sculptor was faced with the prospect that the third installment of his fee would be withheld. French's contract called for payments to be made in four allotments: $4,000 when the first model was approved and the contract signed; $6,000 when the full-size plaster was finished; $11,000 when the bronze was cast and delivered to the site; and $1,000 when the statue was set in place.[15] Four months passed and French again wrote to the secretary:

This complication about the pedestal has, as you know, delayed the finishing of the statue and consequently the payment of certain monies that Mr. Potter and I had confidently expected to receive before this.... Do you think that the committee would be willing to advance us two or more thousand dollars at this stage? You will understand why I want the money when I tell you I am contemplating the purchase of a country-place, a farm in Stockbridge, Massachusetts....[16]

The Association granted an advance of $3,000 which enabled French to buy the property where he built a summer home, Chesterwood.

Delays in building the pedestal were not the fault of the architect Frank Miles Day. He must have submitted his plans to the Association soon after he conferred with the sculptor about the selection of a site. Earlier in that same year, 1893, the Fairmount Park Art Association sought a $5,000 contribution from the state of Pennsylvania to help defer the cost of the base. The legislature did not act on the proposal, which forced the Association to ask the City of Philadelphia for the necessary funds.[17] It was not until December 22, 1896, that the Committee on Plans and Improvements of the Commissioners of Fairmount Park resolved: "That the contract for the pedestal and adjunct for the statue of General Grant, be awarded to Allen B. Rorke, in accordance with bids submitted for Jonesboro granite, provided the cost to the City shall not exceed $5,000. The balance to be paid by the Fairmount Park Art Association."[18]

Work on the granite base did not actually begin until July, 1897, but even then there was little progress as French learned from the architect.[19] When exactly the pedestal was completed can not be determined, but the statue was in place by May 17, 1898. On that day, Charles J. Cohen of the Grant Memorial Committee authorized Howell to pay French $1,000. This last installment, as well as $4,000 that remained from the third payment, were unexplainably not sent to the sculptor until after September 27, 1898.[20]

Next the dedication was delayed. Congress had declared war on Spain on April 25, 1898, and on May 4 Cohen informed the sculptor:

Owing to the war conditions it has been decided that the unveiling of the statue of General Grant in

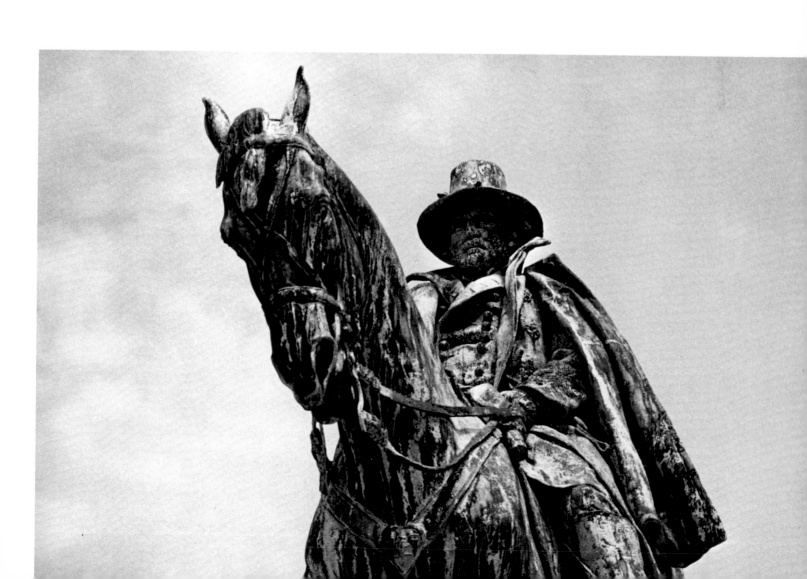

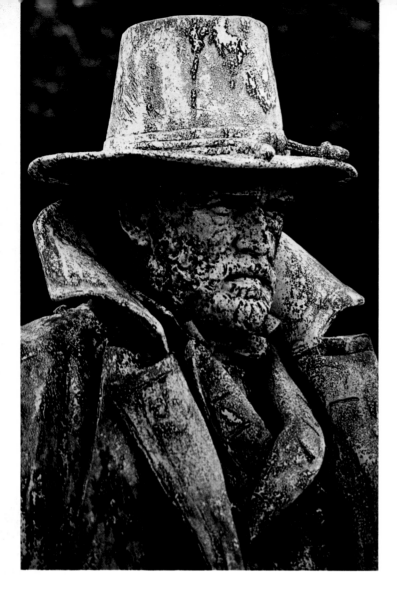

The Association was contemplating an impressive ceremony that would re-enact Philadelphia's role in the Civil War with appropriate military embellishment. With the end of the Spanish-American War on August 12, 1898, it seemed appropriate to have a victory celebration coincide with the unveiling, and April 27, 1899—the seventy-seventh anniversary of Grant's birth— was selected.

The exercises took place as scheduled with the arrival of the cruiser *Raleigh* enhancing the festive atmosphere. The Philadelphia *North American* reported the activities under the banner headline "The Gallant Cruiser Raleigh Heartily Welcomed by the City." The story continued:

In her fighting garb of gray, the same she wore when she crept into Manilla Bay, the cruiser Raleigh came proudly up the Delaware River.... Though she does not bear a single scar of the battle, the glory of that day's victory belongs to her as to the other ships that Commodore George Dewey led....[22]

French and Potter's sculptural achievement was almost forgotten in the excitement but its symbolic importance was summarized by John J. Converse as he presented the statue to the city.

It is our privilege on the present occasion to celebrate the completion of the most impressive and inspiring work which the genius of sculpture has thus far conceived and executed under our auspices. Art is fulfilling its highest office when it immortalizes heroism; when it perpetuates the memory of those whose fame men will not willingly let die; when it preserves in the hearts of a grateful people reverence and affection for those who have rendered services to humanity and saved the nation from destruction.[23]

French was pleased with the Grant Memorial and when asked for a formal description of the statue he observed:

We chose for our motif a moment when Grant was surveying a battle field from an eminence and he is supposed to be intent upon the observation of the forces before him. The horse is...obedient to the will of his rider. We endeavored in the figure of Grant to give something of the latent force of the man, manifesting itself through perfect passivity.... If the statue impresses the beholder by its force as having character and stillness, it will have fulfilled its mission.[24]

The success of the Philadelphia statue assured the sculptors that other equestrian commissions would be forthcoming, and they were. From 1897 to 1906 French and Potter worked together on three projects—*George Washington* for Paris, *Joseph Hooker* for Boston, and *Charles Devens* for Worchester, Massachusetts. Their partnership proved to be both mutually beneficial and

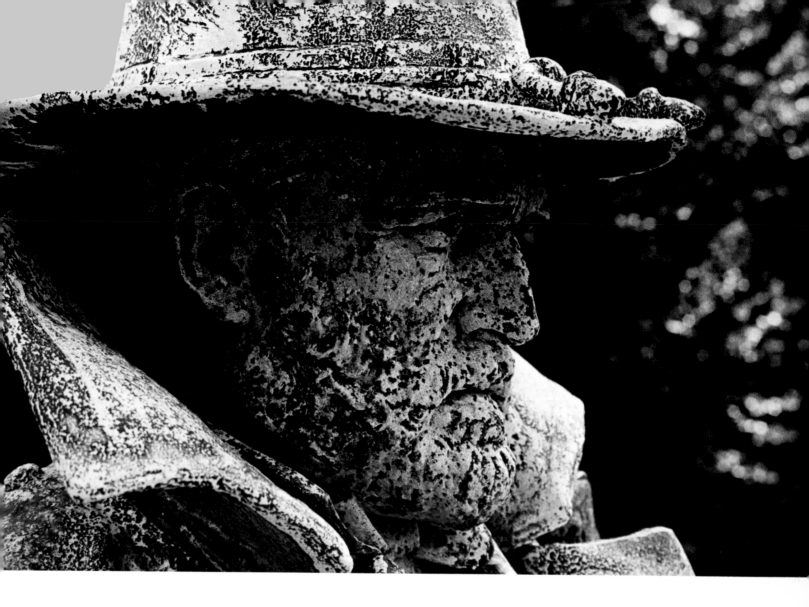

lucrative. The *Washington* first stood in plaster at the entrance to the United States Pavillion at the Paris Exposition of 1900 before being formally erected in bronze in the Place d'Iéna. Its motif is somewhat contrived. The general glances upwards, his right arm extended, appealing for help as he takes command of the American forces. In the statue honoring *Hooker* for Boston, French selected an animated arrangement of horse and rider. In their final collaboration, a commission offered by the citizens of Worcester in 1902, the sculptors returned to the contained composition (figure 4). Completed in 1906, the equestrian statue of *General Charles Devens* is reminiscent of the *Grant* without being imitative. By accenting the pronounced arch of the horse's neck and the sweeping movement of the tail, the sculptors effectively balanced the horse and the rigidly upright rider. A feeling of repose is created by the relaxed manner in which the general, his hat removed, holds the reins.

In all cases, French secured the commissions and sought Potter's participation. French first knew of the young man in 1879. Four years later Potter came to his studio for instruction, and assisted with the enlargement of the clay model for the *John Harvard* during the winter of 1883–1884.[25] The two remained in contact as evidenced by a letter of March 23, 1886, in which French mentioned: "Potter has been working with me for a month or two doing some good things—heads in clay of Irish children. He is slower than a snail, but has talent."[26] However, it was not until 1891, at the beginning of the decoration of the Chicago World's Fair, that French and Potter first collaborated. For these projects and for the equestrians that would follow, French created the maquettes. Preliminary designs of the *Hooker* and the *Devens* have survived and they demonstrate that French was capable of modeling a horse. In the small model for the Boston monument which was made in 1897 (figure 5), the sculptor has placed the rider erect in the saddle and rendered the spirited horse in such a way that the tense excitement that preceded the explosive action of the battle permeates the composition.

By delegating the execution of the working or third-scale model of the horse as well as the time-consuming task of making the full-size clay to Potter, French was able to concentrate on the figure. Since French felt that the younger sculptor could make a contribution, he willingly acknowledged his involvement, a magnanimous gesture on French's part. In the history of American sculpture, the

only precedent for such professional generosity was Henry Kirke Brown's recognition of the contribution made by his assistant, John Quincy Adams Ward, in the execution of the now famous equestrian of *George Washington* in New York City's Union Square. French desired to produce a strong monument but not at the expense of his friend. The *Grant* was their most successful venture.

In modeling the figure, French was confronted with two problems: making a successful portrait and correctly rendering the uniform. In the latter task he was aided by Colonel Frederick Dent Grant, "the authority for the long cape to the overcoat...that his father wore...several inches longer than usual."[27] To create the face, French had to rely on photographs, paintings, and busts. The sculptor of the posthumous portrait is like the historian in that he must carefully study the available documents before formulating his conclusions. With the aid of photographic close-ups, French's marvelous sculptural interpretation of

Grant's rugged countenance can be clearly seen.

French has skillfully rendered the stern expression of the commander as he intently surveys the battlefield. Grant sits motionless in the saddle, legs locked, while the horse stands quietly, its head bent from the slight tension of the reins. The sculptors have chosen to emphasize the momentary inactivity of the group. The horse and rider have become an integrated unit, and their posture heightens the mood of uneasy calm. However, the underlying potential for dramatic and sudden action is subtly accented. To convey the power of the general in such a confining situation was difficult, but the task was deftly handled. The achievement of French and Potter in their *Grant* overwhelms the equestrians that were executed by Alexander Milne Calder (1846–1923), John Rogers (1829–1904), and Henry Jackson Ellicott (1847–1901). In their *Meade, Reynolds,* and *McClellan,* respectively, each sculptor attempted to portray decisive action, but succeeded only in placing horse and rider in

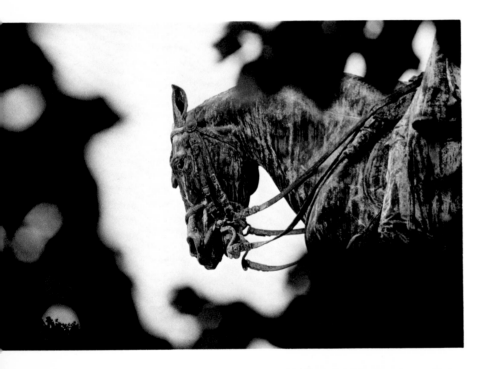

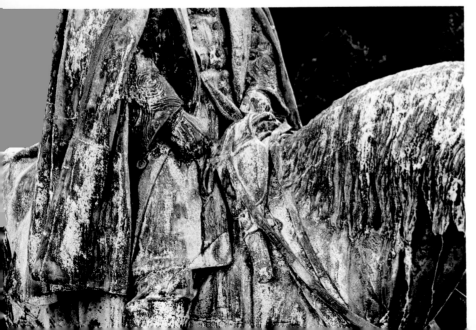

awkward, often confusing positions.

 The *Grant* is a splendid monument and
unquestionably the finest equestrian in Philadelphia.
French, with Potter's assistance, created in this memorial
a statue befitting the praise of the critic Adeline Adams
who wrote: "All sculptors who succeed in their equestrian
statues are heroic; even if they are not heroes when they
begin such enterprises they achieve heroism before
they finish them."[28]

Daniel Chester French (1850–1931)
Edward C. Potter (1857–1923)
General Ulysses S. Grant. 1897
East River Drive and Fountain Green Drive
Bronze, height 174" (granite base 196")

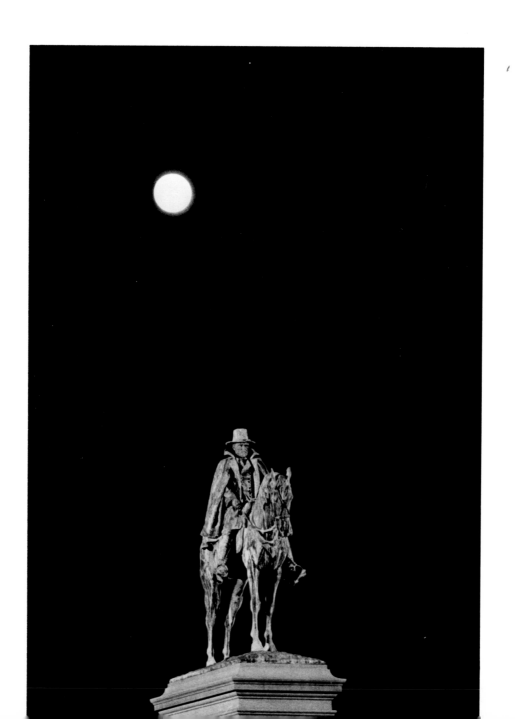

Cowboy

by David Sellin

*photographs by
George Krause*

The popular legacy of several generations of illustrators, beginning with Winslow Homer and ending with the Philadelphia contingent of the "Ash Can School," is a vivid picture of America in the second half of the nineteenth century. Success depended upon quick perception, rapid execution, understanding of the subject, and a good knowledge of the technical means for mass production. Cheap photogravure put an end to the heyday of American wood engraving, but far from killing off the illustrator the new process created fresh demands on the artist who could provide exciting halftone and color work for reproduction in the slick magazines. Frederic Remington (1861–1909) spans the transition, and from his first efforts for *Harper's Weekly* through his reportage for *Century Magazine* to the spreads and covers for *Collier's,* Remington was the source of adventure for millions of Americans. It is no surprise to find that Teddy Roosevelt, Kipling, and Buffalo Bill were his friends, for the life he recorded with such intimacy had something of all of them in it. If life was an adventure to Remington, art was a business. He produced a popular commodity with enviable regularity, an accomplishment which sometimes obscures his real achievements as an artist. Long after he had mastered pictorial representation he brought to what he called the "mud business" the same qualities for which he was and is recognized in painting. The spectator finds

himself in the middle of an action, of a space, a time; in this sense classic rules of unity are violated sometimes. Only occasionally does his work depend on anecdote or narrative to the extent that it intrudes upon plastic virtue, but it always satisfied the public that had treasured the *Nydias* of one Rogers and the "groups" of another, but which had been abandoned by the generation of sculptors emerging at the Centennial of 1876.

In a burst of enthusiasm over a bronze seen in Tiffany's window, the art director of *Century Magazine,* Alexander W. Drake, wrote Remington in 1899 to tell him he thought it a "stunner":

> *I shall not die happy until I see in a public square in New York, and I hope in many other cities in America, a large bronze group or single figure or something of yours. What could be more appropriate for an American city? The fast disappearing Indian and western cowboy should be put in enduring bronze, a record for the coming generations of what once was in America, and this should be done by the only man in America who can do it.*[1]

Richard W. Gilder, the magazine's pioneer editor, echoed that enthusiasm. "I went the other day to see those ripping bronzes of yours," he wrote the artist. "They are all thoroly alive and thoroly original....They have the beauty of *life.*"[2] George Wharton Edwards, art editor for

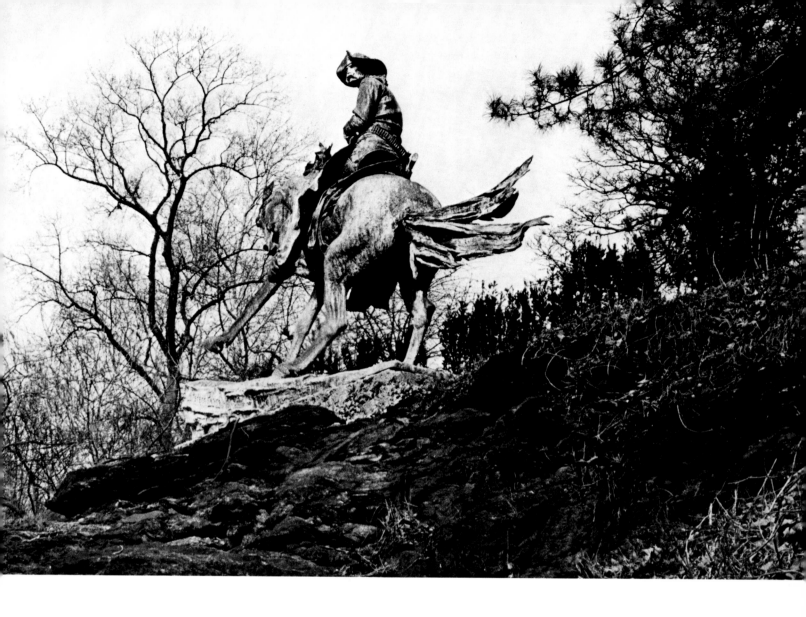

Collier's Weekly, found the solid ring of bronze even in Remington's verbal representation of a plainsman, and after reading one of his manuscripts told him: "You have hewn him in the bold strokes that remind me irresistibly of Rodin.... Your men walk upright—the sun shines—I hear the rattle of camp life—and then at once I feel the hot waste of the plains."[3]

Collier's put out a "Remington number" in the spring of 1905,[4] and within a month he sold five bronzes to the Corcoran Gallery, "thus giving me a brevet before death."[5] Remington was riding high. The Fairmount Park Art Association had recently dedicated Cyrus Dallin's *Medicine Man* (see page 210), and its president suggested at the March, 1905, meeting that a statue of a cowboy be erected in the park, a suggestion referred to the art committee, which seems to have found deliberation unnecessary. As the March 18 Remington issue of *Collier's* hit the newsstands the artist wrote Leslie W. Miller: "I should be delighted to make a horsed cowboy for the Park. It would be necessary to see the place where it would go and to consult with you generally before I can say more."[6]

Remington and his bronze man, Riccardo Bertelli, drove around the Park with Miller on the eleventh of April—a pleasant season on the carriage drives along the fresh green banks of the Schuylkill. "He selected as the

best site for such a statue as he had in mind a rocky [point] on the East River Drive just beyond the tunnel north of Girard Avenue Bridge," Miller reported back to the Association. "It is Mr. Remington's own choice, and was not selected until after he got a horseman to pose for him in that exact place."[7] Remington wrote Miller the next day that he would be happy to undertake the commission, and that he was sending a photo of one of his sculptures to "give an idea of the plinth which will cap the rocky bluff selected."[8] His conception of the *Cowboy* in relation to the site was already developing, and he suggested a horse and rider ten feet high and gave an estimated cost of $20,000. "If it weren't for the considerable added cost of nearly 50 per cent," he added, "I think the addition of a packhorse would be desirable." The art committee proposed that Remington be paid forthwith $500 for a sketch model, without further obligation to the Association, which met with approval.[9]

Writing Miller concerning contractual matters, the Association's counsel endorsed the Remington project warmly: "I think his work is most interesting and that a fine statue, such as he suggests, would not only be an interesting departure from the conventional statue, but would encourage the development of a typically American art. I think we want more statues in our Park such as the Medicine Man and that suggested by Mr.

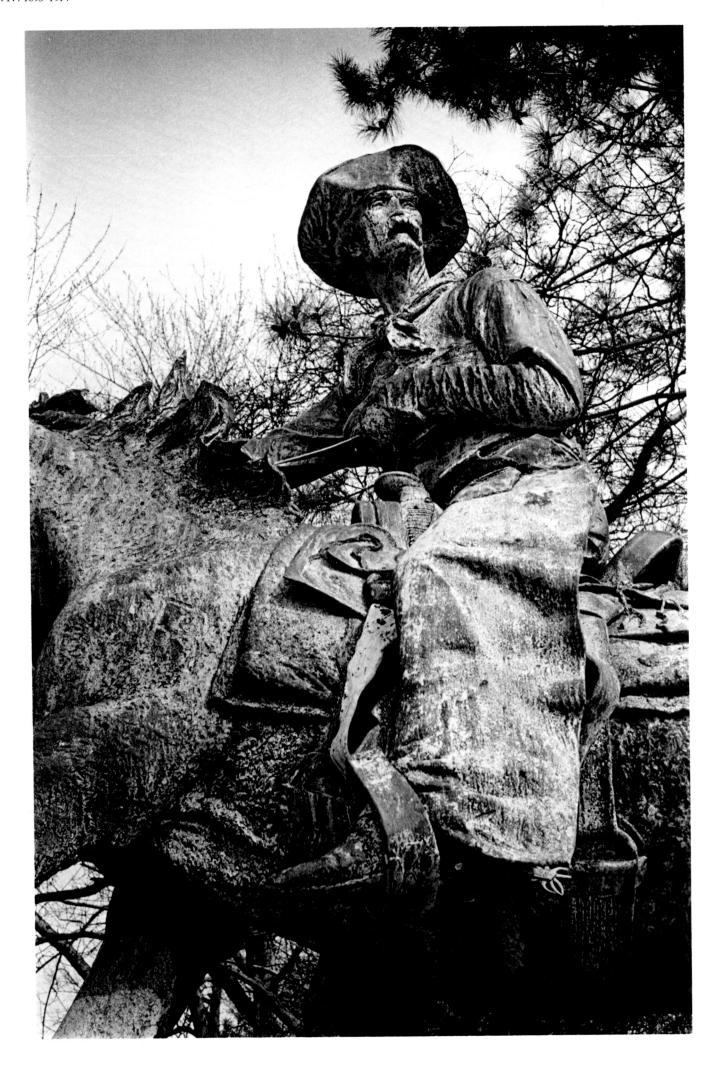

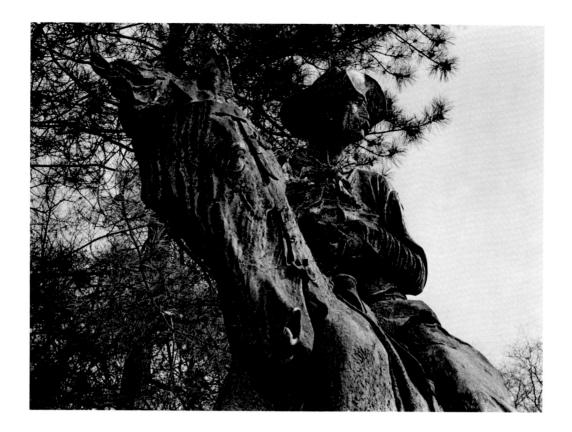

Remington."[10] Ambitions did not embrace an additional $10,000, however. On the seventeenth Remington again wrote Miller: "I shall make as many miniature models as I please—then one statuette size for your consideration in which form it is so easily altered. Then when I throw it to 'quarter life' you can have another look in."[11] That summer he worked on sketches, using Italian plasteline, which he preferred for both artistic and practical reasons. While more stable than traditional clay, it was more ephemeral than the plaster cast, however, and he objected to the decision that the finished model be sent down to Philadelphia for the inspection of the committee, proposing instead the sensible alternative:

> *The model horse is of plasteline—carried pretty far, and there are many flying things about a cow-boy which can never be got into plaster cast. I want to carry it into the quarter-life and to put it into plaster will ruin my model. New Rochelle is not much of an adventure—so please try and have a committee come over here and look at it.*[12]

The committee accepted the challenge on December 19. Weeks afterward Remington wrote his wife: "I don't hear from Philadelphia but it is early. I am going to start a new small model anyway."[13] The committee, however, had been impressed, as one member later wrote the artist: "I came to New Rochelle to see the sketch model. I was convinced then what the finished work would be."[14] On January 12, 1906, a formal contract was prepared.[15]

The working of the sketch model up to one-quarter life-size took a year. In January, 1907, the sculptor wrote Miller:

> *I am out of the woods with my working model of the Cow-boy. I had a lot of hard going but have finally made the horse and rider do what I expected of them and am now finishing, and if the horse don't buck I'll be ready for your committee in a month or so.*[16]

Before the month was out Miller got good news; "The working model of the Fairmount *Cow-puncher* is done and ready for the inspection of your committee. When may I expect them? I am anxious to get it in plaster."[17]

The committee visited Remington on February 11, and approved the sculpture, with one dissenting opinion by John T. Morris, who had strong reservations about the interpretation of the horse, objections that were overruled by the artist:

> *I am of course highly delighted to have your committee's approval and sorry for the dissenting opinion. That...foreleg is imperative however and cannot be compromised. I have run the plinth out to it however and think it improves the group. My final bronze will be so much better than this working model that you won't know it.... The model goes in plaster next week and I hope next fall to have a place ready to set up the big model.*[18]

Remington had experience in business and investment, but compared to the Association he was a greenhorn. The money was to be paid him over four years so that accrued interest might contribute to the total sum, but as the installments were paid he was required to post bond to indemnify the Association in the case of default. Now he needed money, but found that New York banks didn't understand Philadelphia ways and required

collateral. Remington finally threw it back in the lap of the Association, and the original contract was amended on April 26, 1907, to permit him to draw from the account against expenses. Meanwhile, he informed Miller that "The model was cast in plaster and safely transported to Roman Bronze Works."[19]

Remington's plan and initial progress is traced in letters to Miller. The full-scale figure would be done in plasteline:

> It is my intention to have the work thrown up late in the summer and to try and finish it next winter. If nothing goes wrong I ought to have it ready for the plaster man by spring & then it wouldn't be long going through the wax and casting etc. and ought to be ready by that autumn, and right then I would need some money.... As you know a "lost wax" casting bill is a good stiff institution and not to be passed over lightly.[20]

> The Cow-boy goes ahead all right and I expect I shall want you to look at it about the first of the year. I built a studio on my place here (New Rochelle) with a track to run it out on and I find the track of the greatest advantage. I think without it I could never have done the work. The hard lights of in-doors are so different from the diffused light of out-doors that it looks like two statues. It is a car and on a turn table and this turn table is so small that I dare not take it out of doors when there is any wind for fear of its overturning. Of course I want your committee to see it out doors but how we are to regulate the wind when you come here I do not know.... Your committee is so immobile and the wind so persistent at this time of year that I despair of ever making the combination....

> It would give you no proper idea at all to see it in the studio—it is 12 feet & 2½ ft. up on car and studio is only 17 ft. by 25 ft. We work on ladders and only work from impressions as we remember them after seeing it out-doors.

> I am trying to give you a Remington bronze and am not following the well known receipt of sculptors for making a horse. I intended to do this from the first and believe I am succeeding.[21]

"I am anxious to get the thing through the plastic stage and into the final wax where the real finish comes. It's a dandy Professor and I am just a bit afraid of your old committee."[22] In another letter he amplified on his methods and reported on progress: "I had the bronze & plaster men up today figuring on my job. This is modeled in Italian plasteline because it is soft but Italian plasteline also shrinks rapidly and I don't want to keep it from the plaster men any longer than I have to. Can you set a date when you can come over and see it?"[23]

John T. Morris could not make the committee's third adventure to New Rochelle, but he told Miller, "I trust the committee will find the leg of the horse much improved for I feel strongly that we should not have a statue with such an inartistic pose as was shown in the sketch model. A good artist selects the best pose, not the disagreeable one, accurate though it be."[24] But this was no ordinary rider, destined for a conventional site. Those on the carriage drives and promenades would come upon it unexpectedly, seeing it in passing from below, or from across the water. And would a plainsman coming suddenly onto as sweet a sight as the waters of the Schuylkill behave like the military dignitaries on parade review that dotted public squares throughout America? The day after Christmas in 1907 Remington trundled the *Cowboy* out into the open light and the committee liked what it saw. Philadelphia would get its ripping Remington bronco rider after all.[25]

Now, however, the foundry needed payment as work progressed. Charles E. Dana regarded Remington's request for an advance toward expenses with extreme caution. "If R. takes a notion to play any of the Bartlett antics I most sincerely trust that I shall not be around to sign the check," he wrote Miller.[26] But the Association underestimated their man, which it later was to acknowledge. "The promptness with which this work was completed by Mr. Remington has been a source of much gratification," President Converse would report to the membership, "especially in view of the interminable delays to which the Association has sometimes been subjected in the case of other commissions."[27] Meanwhile Remington needed money. "I have financed the thing up to now but will need money about February," he wrote Miller in January, 1908.

One month later, the *Cowboy* was ready for casting: "The vans took the cow-boy away this morning and I hear by telephone it has been safely delivered at the Roman Bronze Works at Greenpoint—a good plaster job without a crack or mar, and I am truly thankful. If it doesn't blow up in the casting I guess the worst is over."[28] On March 6 he met Miller at the site and they worked out problems of installation. Remington wrote Miller after a few more weeks, "As soon as I can see Mr. Bertelli I will get him to be as definite as possible as to when the Cowboy will be in place, but I am almost sure he intends to have it up before the 1st of June."[29]

The model for the rider had been Remington's old friend from Montana days, Charlie Trego (1856–1925). Born in Pennsylvania, he went West in the eighties and found work on the Cody ranch, eventually becoming the manager of Buffalo Bill's Wild West Show.[30] According to his hometown paper Remington's likeness was good: "The statue in the Park in Philadelphia has been visited by many Chester Countians who knew Charlie Trego 'in the flesh' and they declare it was a true likeness of the cowboy who was born in Honey Brook Township."[31] Remington portrayed him as he was when they both first went West, a man with the bark on, "a good type of the old Texas cow-boy, who came up over the trails with cattle in the early eighties on a small Spanish horse," according to Charles Cohen. "The saddle, hat and other accouterments are of that day and must not be confused with later things. These were the Plainsmen who traveled by the stars."[32] Owen Wister wrote Remington, "I am glad we are going to have a cowboy from you in Fairmount Park."[33] It was set in place, and the *Philadelphia Daily News* described it on June 18, 1908: "The horse has been

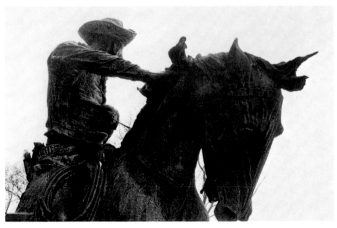

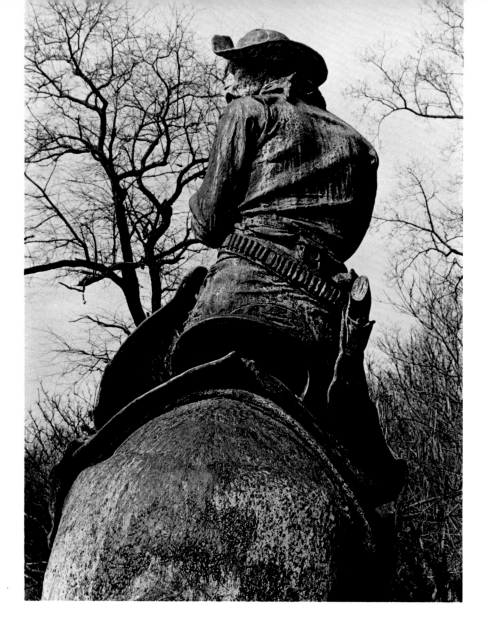

running at full speed and has almost reached the brink of a precipice before his rider has seen it; he has stopped his steed just at the edge. The study of the anatomy of the man and horse is a remarkable one, mad action brought almost to a dead rest."

Morris proposed a simple ceremony of presentation and unveiling,[34] and Remington would not have objected for he was away at Chippewa Bay, New York; "no one pays much attention to the sculptor,"[35] he wrote Miller, and may have been right in this instance.

Fearless, even nonchalant, sitting in the saddle, on the pony which he himself has broken in and trained until the two are one—this is "The Mounted Cowboy," moulded by Frederic Remington, cast in bronze and yesterday unveiled with picturesque ceremony high up on the rocky banks of the Schuylkill River, in Fairmount Park, a little way above Girard Avenue Bridge, on the east side.

Probably no other unveiling just like this one ever took place. Grouped about the foot of the statue, which

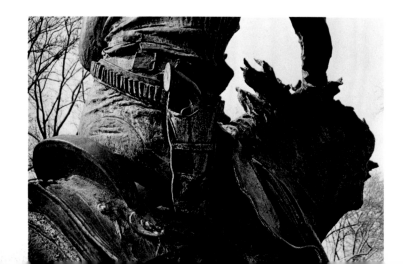

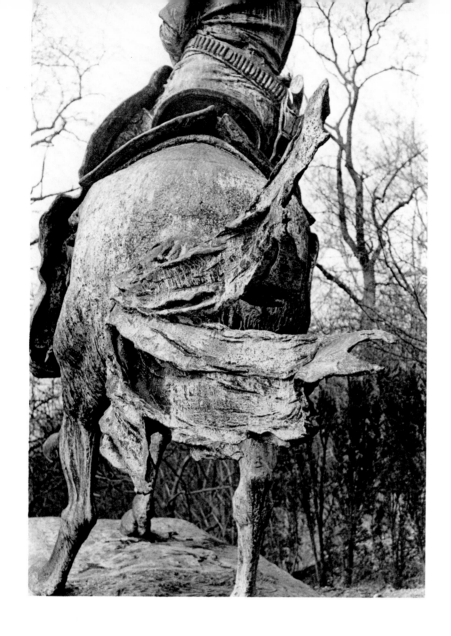

perpetuates a type of American manhood fast disappearing from the western plains, were representatives of the remnant that remains of the civilization which the bronze figure has crystallized for coming generations. Drawn up on the river drive at the base of the rocky slope into which the pedestal of the statue is cut was a cordon of real cowboys, led by Wyoming Jack, a famous scout.... To the thousands of spectators who lined the drive and blackened the hills all about the statue they gave the living stamp of truth

to the conception of the artist. And there was a small army of Indians, in full warpaint and accompanied by squaws and papooses [which] formed a striking bank of color against the green foliage, with their war-paint and gay headdress.... With a whoop and a yell, the halyards were...loosed by He-Dog, an Indian medicine man, and Wyoming Jack, [and] a cheer burst from the great crowd on grandstand and drive.[36]

"No statue has been unveiled with more appropriate ceremonies," A. G. Hetherington wrote Remington. "He-

Dog the Chief who pulled the rope has been ever since the proudest Indian possible." Hetherington had seen the first sketch model, and now found the promise more than fulfilled. "You have done a great thing in our *Mounted Cowboy.* I hope you may long be here to give by your genius to other cities great works. I took one of the greatest surgeons in the country to see it—he says it is the greatest anatomical work in the world."[37] "Now that the work is in position, I feel more strongly than ever that it is a magnificent thing," Miller wrote Remington, enclosing about $8,000 then due.[38] A few days later Theodore Roosevelt wrote him: "By George that is a corking bronze."[39] As for Remington, in looking back upon the year's accomplishments he made the following account:

> *This year I: Unveiled a monument to the cowboy in Fairmount Park. I painted a lot of pictures which made a great hit at Knoedler's. I started building a house in Ridgefield, Connecticut. And my gross receipts in money were $36,614.87 and money from Knoedler's $6,800. And I kept on the water wagon.*[40]

The hopes that the art director of *Century Magazine* had voiced in 1899 that New York might have a monumental Remington bronze, and those recently expressed by Hetherington for long life and other great productions for other cities, went unfulfilled. The Mounted *Cowboy* in Philadelphia was the first bronze of a large size by the artist, and it proved to be his last. Not long after it was dedicated on East River Drive by the vanishing breed it represented, Remington died. Sooner than anyone at the time could imagine, even the carriages and horses that daily carried Philadelphians through the tunnel and into view of the bronze horseman of the plains were just as certainly a thing of the past.

Frederic Remington (1861–1909)
Cowboy. 1908
East River Drive
Bronze, height 144"
(natural stone base)

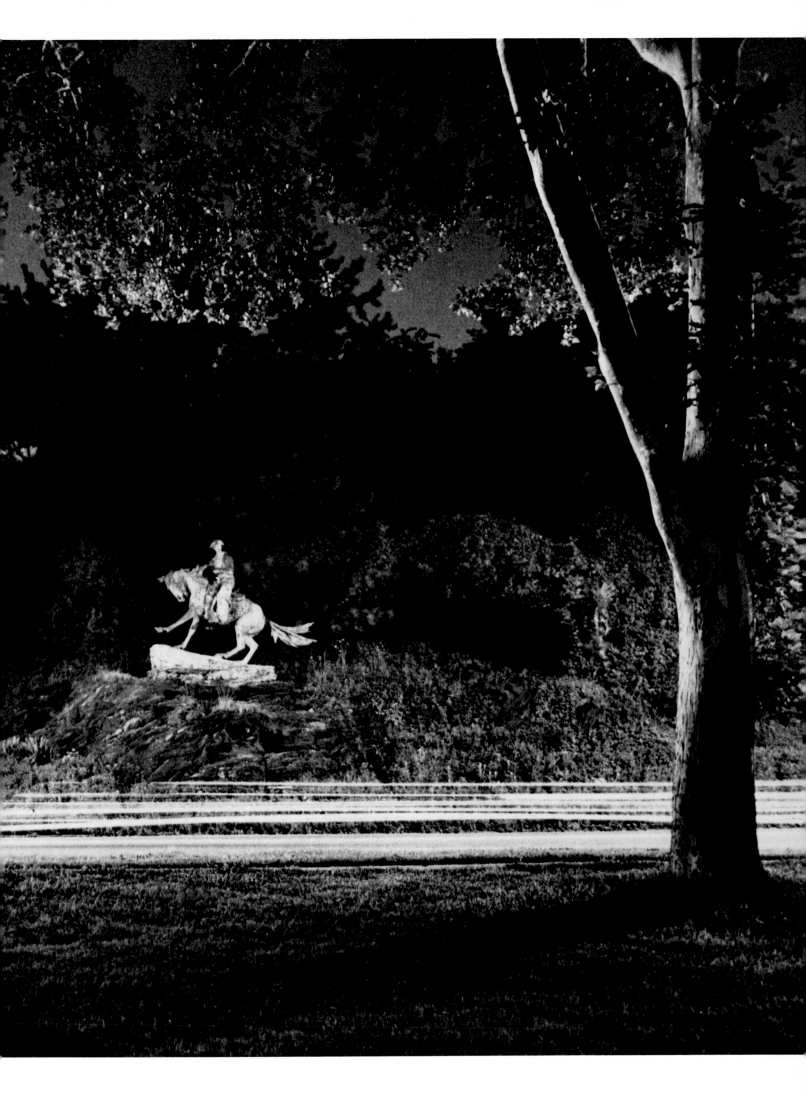

Karl Bitter (1867–1915)
William Pepper. 1895
University Museum, 33rd Street side
Bronze, height 65" (granite base 64")

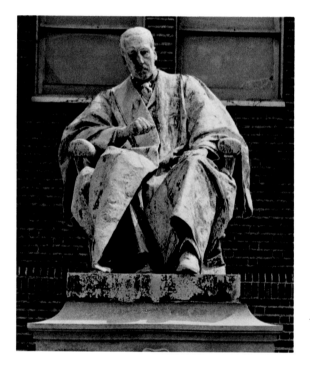

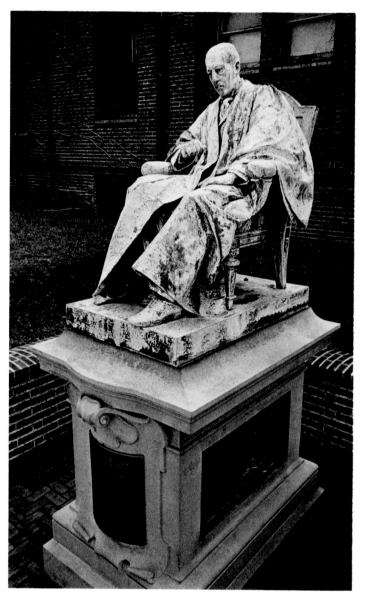

Probably no one else in Philadelphia was as widely respected as Dr. William Pepper (1843–1898) during the last years of the nineteenth century. A distinguished scholar and brilliant diagnostician, he was from 1881 to 1894 Provost of the University of Pennsylvania during some of its greatest years of growth.

At the time of his retirement he was honored by this sculpture, which was completed in 1895 but which was not unveiled until December 19, 1899, when the new University Museum, which owed so much to Dr. Pepper's energy, was opened. Admired as an excellent likeness, he is shown seated, his head tilted, his legs and arms restless implying controlled energy.

Enthroned figures such as this are usually meant to be seen from the front and are placed in a niche or against a wall, so that the details of the back are minimized. However, the statue was first placed in a small garden where it was seen in the round. To compensate for this, Bitter designed a pedestal with bronze relief panels on all four sides. Subsequently, the work was reset against the wall of the Museum. A second version of this figure was cast for the Free Library of Philadelphia in 1926.

Karl Bitter (1867–1915)
Progress of Transportation. 1895
30th Street Station, Penn Central Transportation Company
Cast plaster, wall plaque, height 144″, length 360″

The flamboyance and ingenuity with which the Viennese-born Karl Bitter organized impressive programs of sculptural decoration is clearly evident in this relief, the only part remaining of his extensive work for the Pennsylvania Railroad's Broad Street Station. Bitter had been discovered by Richard Morris Hunt, who had recognized the decorative competence that was to be characterized in Bitter's short-lived career. So it was that when Hunt's student, Frank Furness, received the commission in 1892 to design additions to the station Furness employed Bitter to provide large reliefs for the exterior of the building. These were destroyed when the station was demolished in 1952.

Prior to that time, his relief on the west wall of the waiting room, above the information desk, had been moved in the early 1930s to the new 30th Street Station, and mounted in a corner of the ticket sales area. Here may be seen the Spirit of the Genius of Transportation, a female seated beneath a dome. The parts of the world joined by Transportation are shown as Orientals with parasols, a Mid-Eastern patriarch, and a couple dressed in seventeenth-century costume representing the western world. The section on the left depicts the discovery of America—Indians, settlers, oxen and sheep, Columbus and his ship. Most interesting of all is the group of boys at the right with models of a locomotive, a steamboat, and of even an airplane—executed eight years before the Wright Brothers' famous flight at Kitty Hawk!

Alexander Stirling Calder (1870–1945)
Dr. Samuel D. Gross. 1897
Thomas Jefferson University, 11th and Walnut Streets
Bronze, height 111″ (granite base 120″)

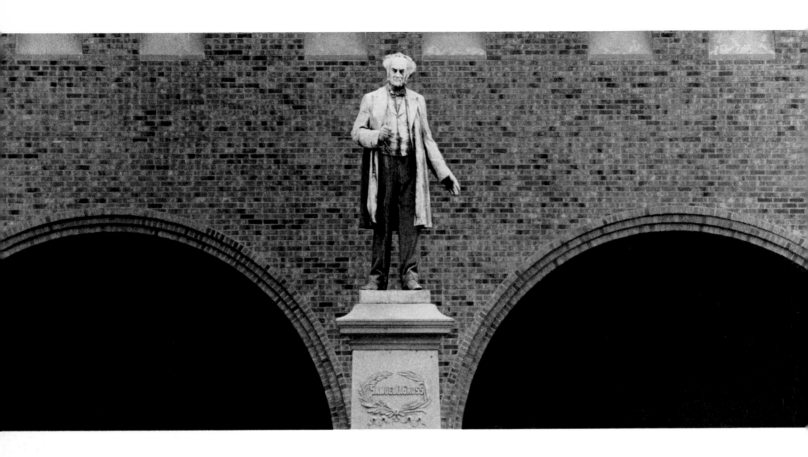

Philadelphia's famous surgeon, Dr. Samuel D. Gross (1805–1884), was immortalized by Thomas Eakins in his celebrated if controversial painting "The Gross Clinic," which was rejected by the Centennial's Art Committee. A few years after Dr. Gross's death Calder won out over Charles Grafly, his fellow student at the Pennsylvania Academy of the Fine Arts and in Paris, for a statue of the doctor financed jointly by the American Medical Association, the Jefferson Alumni Association, and the United States Congress at a cost of $11,000.

Assisted by photographs of the august medical figure loaned by Eakins, Calder followed Eakins' pose of Dr. Gross with a scalpel in his hand as in "The Gross Clinic," and it may be said that the statue is entirely based on that great painting. In 1897 it was placed outside the National Library of Medicine in Washington. When the library was moved, the Alumni Association of Jefferson, the institution with which Dr. Gross's teaching career had been associated, obtained the statue from Washington and reinstated it in Philadelphia in April, 1970, on the occasion of the Alumni Association's centennial.

Alexander Stirling Calder (1870–1945)
Witherspoon Building Figures. 1898–1899
Presbyterian Historical Society, 425 Lombard Street
Cast stone, heights 108″

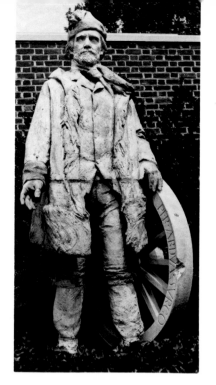 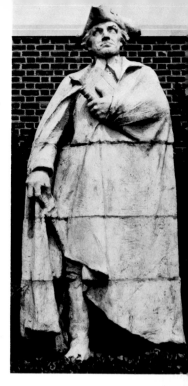

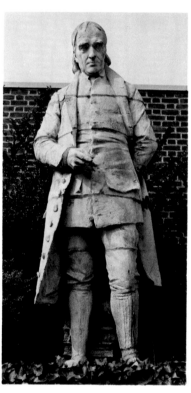

The Witherspoon Building at the corner of Walnut and Juniper Streets was designed by Joseph M. Huston in 1896. Huston was also the architect of the State Capitol in Harrisburg. His Philadelphia commission was enhanced by an elaborate sculptural program, some of it the work of Samuel Murray (1870–1941) and some possibly by Thomas Eakins (1844–1916). The figures of the twelve Presbyterian Divines which ornamented the Walnut Street facade at the seventh story were done by young Alexander Stirling Calder, whose father had recently completed the vast task of decorating City Hall.

From 1898 until 1967 the building housed the Presbyterian Historical Society, which in the latter year moved to its new headquarters in Lombard Street. By then Calder's giant figures were considered a threat to the safety of pedestrians on the sidewalk far below, and were removed from the Witherspoon Building. Under the city's 1% fine arts program, six of them were relocated at the Presbyterian Historical Society: *Francis Makemie (c. 1658–1708), John Witherspoon (1723–1794), John McMillan (1752–1833), Samuel Davies (1723–1761), James Caldwell (1734–1781),* and *Marcus Whitman (1802–1847). Makemie, McMillan,* and the trial piece of *Whitman* were exhibited at the Pennsylvania Academy of the Fine Arts's 67th annual exhibition, *Samuel Davies* at the 68th.

Cyrus E. Dallin (1861–1944)
The Medicine Man. 1899
East Fairmount Park, Dauphin Street Entrance
Bronze, height 96″ (granite base 102″)

Born in Utah, Dallin spent his early years among pioneers and Indians. After training in sculpture under Truman Bartlett in Boston, he went to Paris for further academic training. Inspired by Buffalo Bill's Wild West Show, which was the rage of Paris in 1889, Dallin turned to Indian subjects, seeking to portray the dignity and integrity of the red man. His *Signal of Peace*, the first of his four great equestrian monuments won a prize at the Chicago Columbian Exposition of 1893.

In 1898, while working on *The Medicine Man*, Dallin wrote to the Fairmount Park Art Association: "In regard to being represented in your collection, I feel that as this Indian promises to be my best work (thus far) and being a subject that I enjoy and know thoroughly, I should like to have it represent me in your collection." The statue won praise in the 1899

Salon and a silver medal at the Paris Exposition of 1900. The bronze figure was purchased by the Association for $6,000. Dallin himself selected the Dauphin Street site, where it was placed on a base obtained from the Smith Granite Company in Westerly, Rhode Island.

At the dedication on December 10, 1903, a distinguished Indian, Francis La Flesche, described the ritual and symbolism of this tribal holy man: "The representation of the Medicine Man as a nude figure is not a mere fancy of the artist, for in many of the religious rites the priest appeared in such manner. This nudity is not without its significance, it typifies the utter helplessness of man, when his strength is contrasted with the power of the Great Spirit, whose power is symbolized by the horns upon the head of the priest."

John J. Boyle (1851–1917)
Benjamin Franklin. 1899
University of Pennsylvania, College Hall
Bronze, height 81″ (granite base 132″)

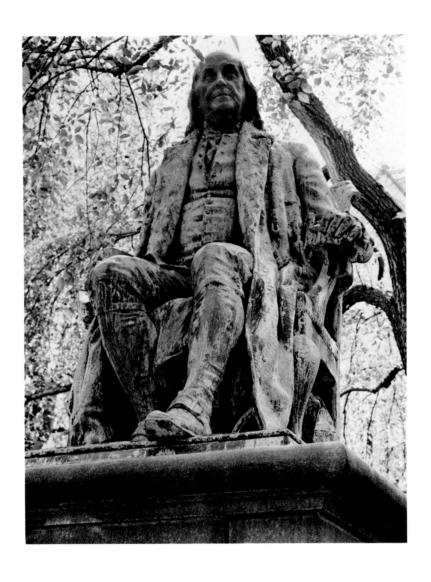

This work was a gift to the city from Justus C. Strawbridge, who selected Boyle for the task. One of the city's leading sculptors, Boyle had given clear evidences of his abilities as a portraitist. He based his remarkable likeness on Houdon's bust. Although he made Franklin a younger man, he retained the pinched muscles on one side of the face. The clothing was derived from the Duplessis portrait, showing the heavy fur-trimmed surtout covering the plain clothes of the period.

The statue was placed on a pedestal designed by Frank Miles Day in collaboration with Boyle, and was originally located in front of the United States Post Office building at Ninth and Chestnut Streets, an appropriate site for the colonial postmaster. Subsequently, a replica was obtained by the New England Society and was sent to Passy, France, where Franklin had lived during the Revolution.

When the Post Office was razed in 1938, the City of Philadelphia donated *Franklin* as a permanent loan to the University of Pennsylvania, an institution of which Franklin had been a founder. The statue was rededicated on Founders' Day, January 21, 1939.

John Massey Rhind (1860–1936)
Henry Howard Houston. 1900
Lincoln Drive and Harvey Street
Bronze, height 114″ (granite base 86½″)

Henry H. Houston (1820–1895) started his career by working at the future President James Buchanan's Lucinda Furnace Company in Wrightsville, Pennsylvania. Later he organized the freight operations of the Pennsylvania Railroad and went on to acquire a large fortune, with interests in railroads, oil, and western gold mines. He was instrumental in developing Chestnut Hill, where he owned large tracts of land and where he built a church and a hotel.

Among his benefactions was Wissahickon Heights, which he gave to Fairmount Park and where his statue now stands on a site selected by the commissioners in 1895. They instructed the Park Superintendent to "report a plan and cost of a pedestal to sustain a bronze monument similar in style to that erected to the memory of Morton McMichael." In May, 1900, the payment of $11,000 for the monument was made to the sculptor.

John Massey Rhind (1860–1936)
Tedyuscung. 1902
Indian Rock, Wissahickon Valley at Rex Avenue
Limestone, height 144″ (natural rock base)

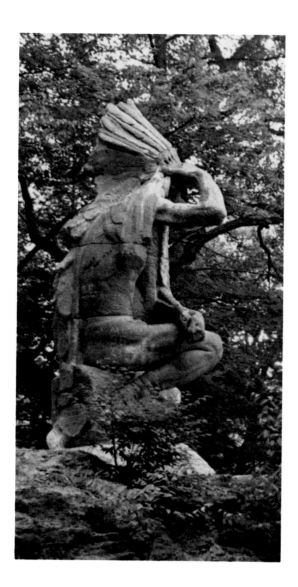 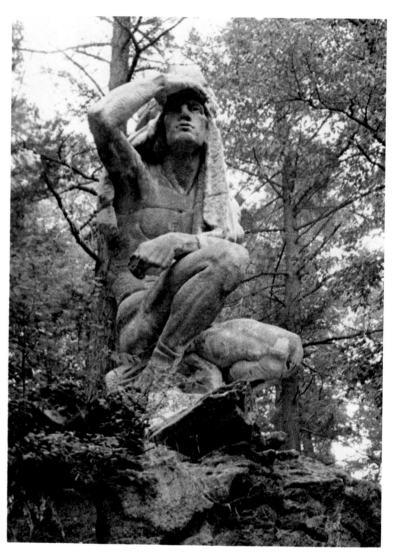

Tedyuscung (*c.* 1700–1763), a Delaware Indian chief, represented the grievances of his people at conferences with the white authorities during the 1750s and 1760s. It was widely believed that Quaker leaders, anxious to embarrass the Proprietors of Pennsylvania, the Penn family, largely controlled Tedyuscung in his charges of land frauds levelled at the Penns. But Tedyuscung was difficult to manage as he was so frequently drunk.

A wooden statue "dear to the heart of every Germantown boy" crowned a height in the Wissahickon. When it began to decay (it is now preserved in the Germantown Historical Society), Mr. and Mrs. Charles W. Henry commissioned Rhind to replace it, and his majestic Indian has long been a noted Wissahickon landmark. In 1907 the architect Albert Kelsey claimed that it was "merely a duplicate of one of four figures which adorn a public fountain in Hartford, Connecticut, and might just as well stand for a cigar store Indian as for the legendary chief."

Augustus Saint-Gaudens (1848–1907)
The Pilgrim. 1904
East River Drive, Boat House Row
Bronze, height 109″ (fieldstone base 19″)

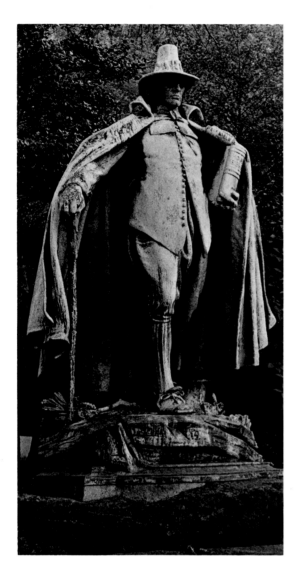 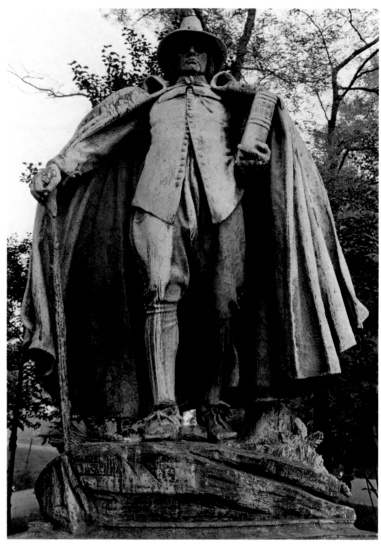

A gift of the New England Society of Pennsylvania to the City of Philadelphia, the statue was originally placed on the South Plaza of City Hall, where it was dedicated on April 29, 1905. With the advice of the Fairmount Park Art Association, it was moved to its present site in 1920. There the stern figure views the passing scene with a stolidity and mystery strongly in contrast to the daily rush.

This work is often confused with the sculptor's earlier *Deacon Samuel Chapin* at Springfield, Massachusetts, which won the Grand Prix at the Paris Exposition in 1900. Saint-Gaudens, however, was eager to improve on the theme, and so was delighted to receive the Philadelphia commission. As he explained in his reminiscences, published in 1908: "The statue, as I have said, was to represent Deacon Sam-

uel Chapin, but I developed it into an embodiment such as it is, of the 'Puritan.' And so it came about that, in 1903, the New England Society of Pennsylvania commissioned me to make a replica of it. This I did as far as the general figure and arrangement went, though I made several changes in details. For the head in the original statue, I used as a model the head of Mr. Chapin himself, assuming that there would be some family resemblance with the Deacon, who was his direct ancestor. But Mr. Chapin's face is round and Gaelic in character, so in the Philadelphia work I changed the features completely, giving them the long, New England type, beside altering the folds of the cloak in many respects, the legs, the left hand, and the Bible."

Sir Moses Jacob Ezekiel (1844–1917)
Anthony J. Drexel. 1904
Drexel University, 33rd and Market Streets
Bronze, height 100″ (marble base 116″)

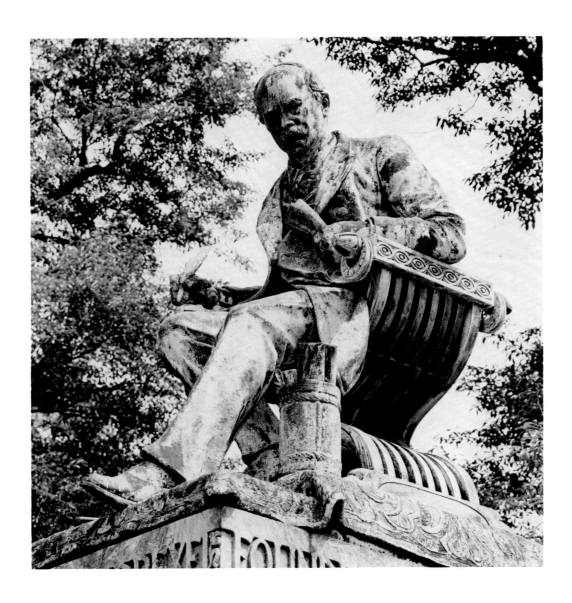

Born in Richmond, Virginia, the sculptor studied under Albert Wolff in Berlin and spent most of his years, after winning the Prix de Rome, in Rome, where he maintained a studio in the Baths of Diocletian. It was in that romantic setting that he completed his first large work, *Religious Liberty,* shown at the 1876 Centennial in Philadelphia. One of the most famous sculptors of his day, Sir Moses was knighted by three monarchs.

He made several portrait busts of Anthony J. Drexel (now at Drexel University) in 1903 so that the large seated bronze could be executed easily. Drexel (1826–1893), the city's most powerful financial figure, was president of the Fairmount Park Art Association during its first twenty-one years. The present work was commissioned by the banker's partner, John H. Harjes of Paris and given by him to the City in negotiations in which the Fairmount Park Art Association represented the donor.

The bronze was cast in Germany while Ezekiel sculpted the base in Rome. Unveiled on June 17, 1905, at Belmont and Lansdowne Avenues, this memorial to Drexel was fittingly moved in December, 1966, to a site near the library of the University he endowed.

August Gaul (1869–1921)
Eagle. 1904
John Wanamaker's, 13th and Chestnut Streets
Bronze, height 78″; length 118″; width 39″

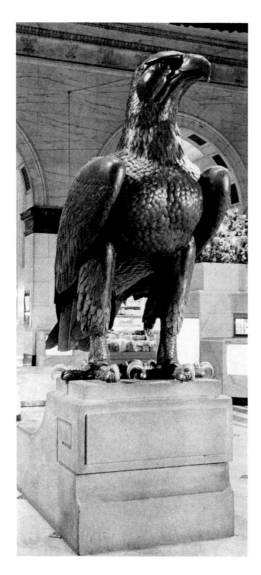 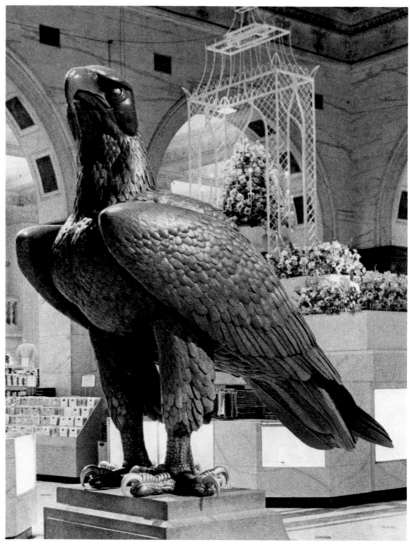

Germany's contribution to the Louisiana Purchase Exposition of 1904 in St. Louis was a Court of Honor in the Palace of Varied Industries. The court was "modern" and had an Egyptian influence characteristic of German decorative art at that time. Dominating it was August Gaul's colossal *Eagle.* The technical process used to forge the bird was developed by the firm of Armbrüster Brothers in Frankfurt am Main, which had gained fame for casting iron gates for the Chicago Fair in 1893 and an eagle for the Paris Exposition in 1900. The metal chosen was "Durana" bronze that had a warm goldlike lustre and was made by the Dueren Metal Works in the Rhineland.

Assembling the parts of the heroic bird was done by hand. Each individual feather was also wrought and attached by hand, 5,000 in all, 1,600 for the head alone. It took skilled workmen five months to assemble the piece which weighed 2,500 pounds. Upon the conclusion of the Fair, Wanamaker's store purchased Gaul's *Eagle* and it has since become a familiar Philadelphia symbol.

Alexander Stirling Calder (1870–1945)
Sundial. 1903
Horticultural Hall site, West Fairmount Park
Marble, height 49″ (marble base 6″)

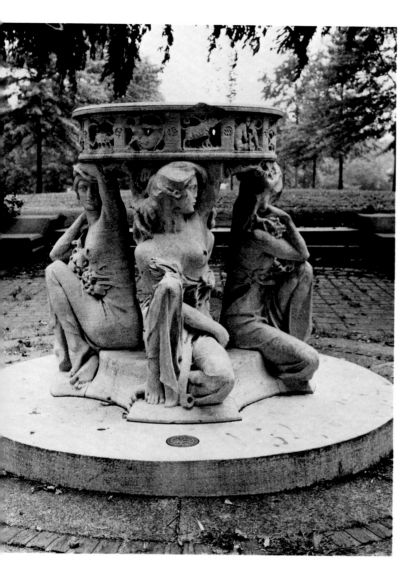

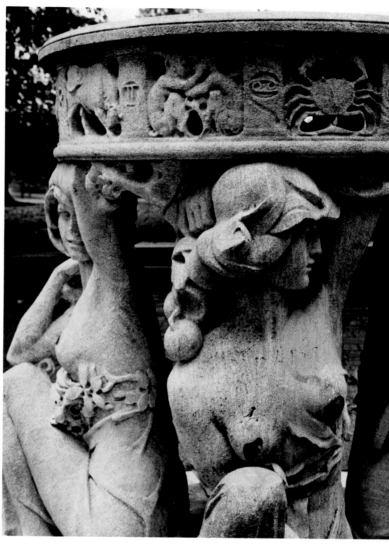

In 1903 the Fairmount Park Art Association offered the Fairmount Park Commission a sundial valued at $2,000 as the gift of an anonymous donor. The donor's identity is disclosed in the Association's minutes as Mrs. Charles P. Turner. The site selected for the piece was the "Sunken Gardens" near Horticultural Hall.

Before being placed there it was exhibited at the Pennsylvania Academy of the Fine Arts's Centenary Exhibition and was described in the *Public Ledger* of January 29, 1905: "The dial, which is on a sort of circular level table, is supported by four figures of young women grouped around its edge, who represent the four seasons. Spring holds a rose; Summer is carrying poppies; Autumn wears grapes in her hair, while a branch of pine lies across the figure of Winter. Each figure holds an apple bough aloft. By this is suggested the opulence of the year, which each season foresees in turning her head expectantly toward the season before her, whose place she is eventually to usurp. Conforming to this idea, the table which the figures support is circular, and the signs of the zodiac around the outer edge suggest the interminable succession of the universe."

Today the sundial is badly weathered, but the inscription on the base can be read: "Copyright 1906 by Alex Stirling Calder. Watch therefore for ye know not what hour your hour doth come."

Samuel Murray (1870–1941)
Commodore John Barry. 1907
Independence Square
Bronze, height 114″ (granite base 138″)

Samuel Murray studied under and later assisted Thomas Eakins at the Pennsylvania Academy of the Fine Arts. He exhibited at the Paris Exposition of 1900 and at the St. Louis and Buffalo Expositions. He was also responsible for the Pennsylvania State Battlefield Monument at Gettysburg and his career embraced fifty years of teaching anatomy and drawing at Moore College of Art (the old Philadelphia School of Design for Women). In addition, he was a member of the Society of the Friendly Sons of St. Patrick of Philadelphia.

It was perhaps this latter connection which led to his being commissioned by the society to create a monument honoring Irish-born John Barry, known as "The Father of the United States Navy," as a gift to Philadelphia. In accepting the statue, the city set apart a fifteen-foot-square plot in Independence Square as its site.

The dedication was held on St. Patrick's Day, March 16, 1907, with 15,000 in attendance, including numerous civic and naval personages.

John J. Boyle (1851–1917)
Rebecca at the Well. 1908
Horticultural Hall site, West Fairmount Park
Bronze, 80″ by 73″ (granite base 150″)

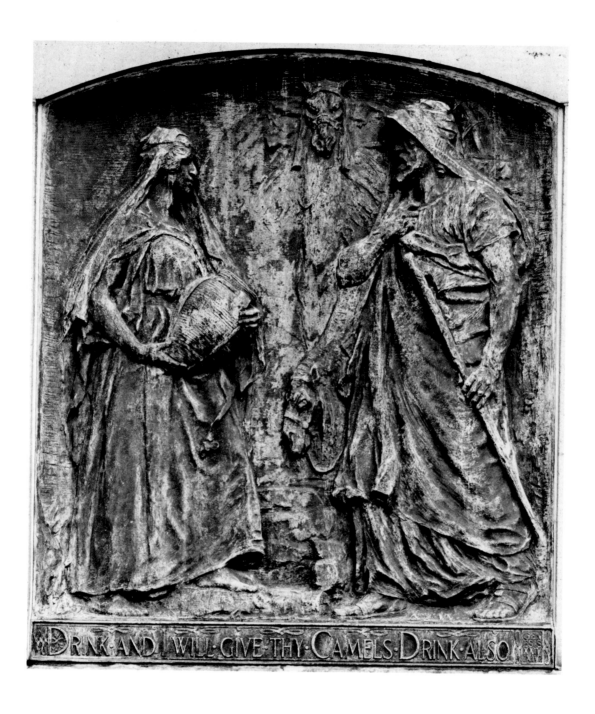

The Fountain Society considered various distinguished artists to carry out Rebecca Darby Smith's desire that her 1888 bequest of $5,000 be spent for a fountain that would, according to the inscription now on it, "ornament the city that William Penn founded...refresh the weary and thirsty both man and beast and...commemorate a fact of Sacred History." The commission for the brass relief went to John J. Boyle, who chose as an appropriate subject, Rebecca offering water to a stranger and his camels (*Genesis*, XXIV, 19).

The relief was placed above a water fountain and bench while, on the ground before it, there was a horse trough. The architectural design was by Eyre, Cope, and Edgar V. Seeler. Not until 1908 was the fountain completed and placed on the medial garden strip that divided Spring Garden Street at Twelfth. By 1912 the Smith Memorial had begun to deteriorate and in 1922 it was taken up by the Bureau of Highways when the medial strip was removed in the interest of greater traffic efficiency. After much negotiation it was finally reconstructed in 1934 at its present site, where it remains a tribute to a generous donor.

Charles Albert Lopez (1869–1906)
and Isidore Konti (1862–1938)
William McKinley. 1908
City Hall, South Plaza
Bronze, height 114″ (granite base 174″)

Following the assasination of President McKinley on September 14, 1901, the *Philadelphia Inquirer* initiated a public subscription so that a fitting monument could be raised to his memory. McKinley himself was associated with the city's monuments having dedicated the Washington and Grant memorials.

At the request of Mayor Samuel Ashbridge, the Fairmount Park Art Association coordinated the funding and organized a design competition. By February, 1902, thirty-eight models had been submitted, five of which were selected to be judged by a distinguished jury of awards presided over by J. Q. A. Ward. The sculptor Charles Albert Lopez emerged the winner.

His work on the statue was slowed because those in charge insisted upon changes in the original design. Then, in 1906, Lopez died, leaving the work uncompleted. Isidore Konti was named by Lopez' executors and the Committee on Design to carry out the final details.

McKinley is shown in a characteristic pose, delivering an oration. Below him sits a symbolic figure of Wisdom instructing Youth. Contemporary attitudes toward sculpture such as this are evident in the official publication memorializing the dedication of the piece, which observed that this allegorical group "Takes away the stiffness of the single figure, adds womanly beauty and childish innocence and results in a composition which is singularly pleasing to the untutored as well as to the learned student of art."

Adolph Alexander Weinman (1870–1952)
Eagles
Market Street Bridge over the Schuylkill River
Granite, height 60″, width 72″ (granite bases)

The Pennsylvania Station in New York was built in 1903. Its architects, McKim, Mead and White, patterned the magnificent neoclassic structure after the Roman Baths of Caracalla and called on Weinman for sculpture. He had trained under Phillip Martiny, Daniel Chester French, and Augustus Saint-Gaudens. In 1904 he won his first silver medal at the St. Louis Exposition. His best-known works, all in Washington, include the facade sculpture on the Post Office Building and the National Archives Building, as well as a monumental frieze for the Supreme Court. For the Pennsylvania Station he carved a number of 5,500 pound *Eagles* which ornamented the roof.

Four of these were given by the Railroad to the Fairmount Park Art Association after the station was demolished in 1963. Hauled by truck to Philadelphia, they were placed on the bridge in 1967, impressive fragments of a once grandiose building.

Paul Manship (1885–1966)
Duck Girl. 1911
Rittenhouse Square, Children's Pool
Bronze, height 61″ (limestone base 32″)

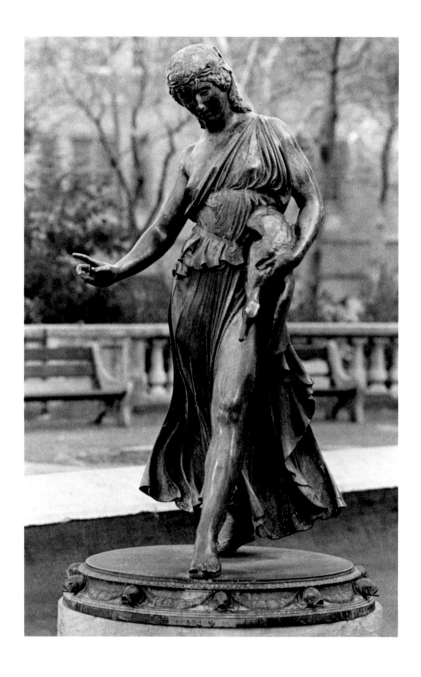

This charming young girl in Greek costume was exhibited in 1914 at the Pennsylvania Academy of the Fine Arts, where it won the Widener Gold Medal. The Committee on the Works of Art of the Fairmount Park Art Association decided to purchase the *Duck Girl* fountain from the exhibition, but discovered that it was made of galvanized base metal, rather than bronze, and could not withstand the elements. After lengthy negotiations, Manship had two casts made by the Roman Bronze Works in Brooklyn and the purchase was finally effected in 1917. The architects of the base were Edgar V. Seeler, and Hatfield, Martin and White.

Originally placed in Cloverly Park at Wissa-

hickon and School Lane, the *Duck Girl* was damaged and removed to storage at Belmont Stables in 1956. From there she was rescued by the Rittenhouse Square Improvement Association.

The sculptor Manship was a precocious student in the Art Institute in St. Paul, studied under Solon Borglum and Isidore Konti in New York, and then became a student of Charles Grafly at the Pennsylvania Academy. In 1909 he won the coveted Prix de Rome which brought him into contact with Greek and Roman sculpture. The *Duck Girl* is one of his early works reflecting a strong archaic Greek influence, so different from his mature style.

Henry Kirke Bush-Brown (1857–1935)
Spirit of '61. 1911
Union League of Philadelphia,
140 South Broad Street
Bronze, height 106″, to bayonet tip 120″
(polished granite base 72″)

Henry K. Bush-Brown was the nephew of Henry Kirke Brown, one of the White Marmorean Flock working in Italy in the first half of the nineteenth century. Bush-Brown grew up in Newburgh, New York, traveled abroad, and settled in Washington, D. C. There are but few examples of his work in the Philadelphia area. The Fairmount Park Art Association archives contain letters from him offering *The Buffalo Hunt* for sale, and also *Comanche Breaking a Wild Horse* (1905), neither of which it purchased. His Generals *Meade* and *Reynolds* at Gettysburg and *Anthony Wayne* at Valley Forge are among his best-known works.

To celebrate its fiftieth anniversary, the First Regiment, Infantry, an outgrowth of the Gray Reserves, commissioned Bush-Brown's bronze soldier, commemorating the regiment's response to Lincoln's call to arms on April 17, 1861, and it was unveiled at the League on April 19, 1911. It was intended that the statue be moved to Fairmount Park, but it still stands where it was originally placed, and in 1962 was formally deeded to the Union League by the First Regiment.

J. Otto Schweizer (1863–1955)
James Bartram Nicholson Tomb. 1913
Mount Peace Cemetery,
31st Street and Lehigh Avenue
Bronze, height 102″ (granite base 100″)

James Bartram Nicholson was the grandson of John Nicholson, a Scotsman who arrived in Philadelphia in 1755 and later became an innovative manufacturer of firearms for the Continental Army. Born in 1820, James was apprenticed to a bookbinder and in 1848 formed a partnership with James Pawson. Between them they conducted one of the finest bookbinderies in the country, a business which was carried on by Nicholson's sons until 1911. Nicholson was widely known for his book, *A Manual of the Art of Bookbinding* (1856).

In 1845, Nicholson joined the Independent Order of Odd Fellows and was elected Grand Sire of the Sovereign Grand Lodge in 1862. His efforts toward keeping this fraternity intact throughout the Civil War, the only order of its kind which was not divided, brought him wide acclaim. Twelve years after his death in 1901 the Pennsylvania Grand Lodge of the Odd Fellows paid him tribute with this bronze memorial, one of Schweizer's finest statues. The sculptor's biographer has termed the portrait head "Lincolnesque."

John Massey Rhind (1860–1936)
Soldiers and Sailors
Civil War Monument. 1914
Girard College
Bronze, height 108″
(granite base 108″)

The memorial that originally stood on this site was erected in 1869. Designed by Joseph A. Bailly, it was cut from marble by William Struthers and Sons. By 1913 the single marble figure and its canopy had deteriorated so badly that the Board of City Trusts governing Girard College voted to replace it with a new monument to be placed on the same site. The commission was awarded to John Massey Rhind.

Memories of Girard College by Ernest Cunningham recalls that: "The monument was designed and erected, consisting of a huge granite block as a base, surmounted by bronze figures of a soldier and a sailor standing in defense of the flag of the Union. This durable and impressive memorial was unveiled with appropriate ceremonies on May 20, 1914, the address being delivered by Major Moses Veale, a veteran of the Civil War, and long a popular chapel speaker at Girard College. One feature of the monument of 1914 was the preservation on bronze tablets of the names of all the former students of the college known to have served in the Civil War."

Appendix
Section IV

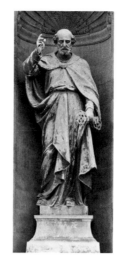

Unknown Artist
Sacred figures. *c.* 1915
Cathedral of St. Peter and St.
Paul, 18th Street and
the Parkway
Bronze: ***St. Peter,*** height 107″
(base 29″); ***St. Paul,*** height 107″
(base 29″); ***Christ*** and ***Mary***
slightly smaller than the above.
These statues were the gift of
James Givens in memory of
his family.

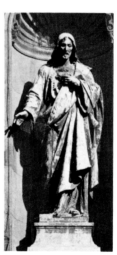

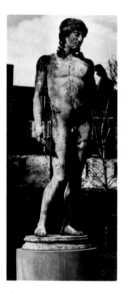

Unknown Artist
Apollo
Hill-Physick-Keith House, 321
South 4th Street
Bronze, height 60″ (marble
base 36″)
Gift of John Wanamaker to the
University Museum, *c.* 1905.
Cast in Naples *c.* 1870 from
original found at Pompeii and
now in the National Museum in
Naples. On loan to the Hill-
Physick-Keith House.

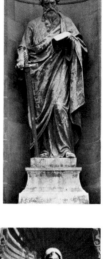

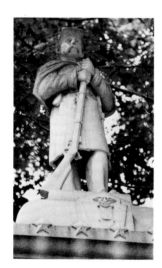

Unknown Artist
***Civil War Soldiers and Sailors
Monument***
Belmont Avenue and George's
Hill Drive, West Fairmount Park
Granite, height 87″ (limestone
base 225″)
Gift of the Grand Army of the
Republic to the City. Instated
May 8, 1909.

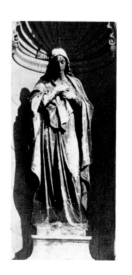

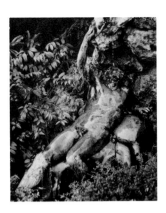

Unknown Artist
Drunken Satyr
Hill-Physick-Keith House, 321
South 4th Street
Bronze, length 66″
Gift of John Wanamaker to the
University Museum, *c.* 1905. Cast
from an original found at
Pompeii and now in the National
Museum in Naples. On loan to
the Hill-Physick-Keith House.

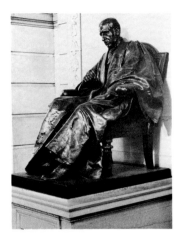

Karl Bitter (1867–1915)
William Pepper. 1895
Free Library of Philadelphia,
19th and Vine Streets
Bronze, height 65″ (marble
base 37″)
Commissioned by the Free
Library. This is the second
casting. The original is at the
University of Pennsylvania.
Instated in 1926.

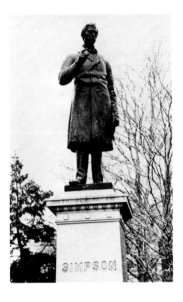

Unknown Artist
Bishop Matthew Simpson.
c. 1896
Methodist Home for the Aged,
Belmont Avenue and
Edgeley Road
Bronze, height 114″
(granite base 114″)
Provenance unknown

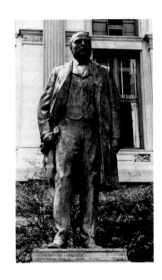

John J. Boyle (1851–1917)
John Christian Bullitt. 1907
City Hall, North Plaza
Bronze, height 118″ (granite
base 61″)
Commissioned and funded by
private citizens.

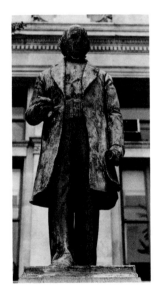

Herbert Adams (1858–1945)
Matthias William Baldwin. 1905
City Hall, North Plaza
Bronze, height 96″ (granite
base 128″)
Gift of Burnham, Williams &
Company of the Baldwin
Locomotive Works to the City
through the Fairmount Park Art
Association. Originally at Broad
and Spring Garden Streets.
Moved to present site in 1921.

John J. Boyle (1851–1917)
Charles Lennig. 1900
University of Pennsylvania,
south side of College Hall
Bronze, height 35″ (granite
base 74″)
Gift of Nicholas Lennig in
memory of his father.

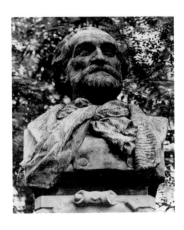

G. B. Bashanellifusi
Guiseppe Verdi
Horticultural Hall site, West
Fairmount Park
Bronze, height 44″ (granite and
limestone base 102″)
Gift of the Italian Colony of
Philadelphia to the City in 1907.

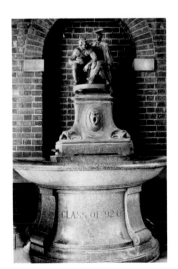

Alexander Stirling Calder
(1870–1945)
***The Scholar and the
Football Player***
University of Pennsylvania,
Quadrangle
Bronze, height 21″
(granite basin 66″)
Gift of the Class of 1892. Instated
in April, 1900.

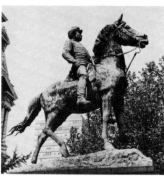

Henry Jackson Ellicott
(1847–1901)
General George McClellan
City Hall, North Plaza
Bronze, height 174″ (granite
base 120″)
Gift of the Grand Army of the
Republic to the City. Instated
in 1894.

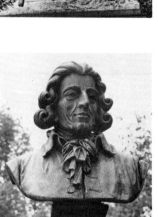

Idusch and Son
Joseph Haydn
Horticultural Hall Site, West
Fairmount Park
Bronze, height 47″ (granite
base 97″)
Gift of the United German
Singers of Philadelphia to the
City in 1906.

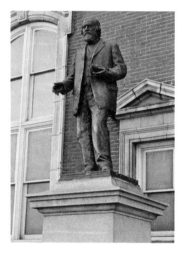

Samuel Murray (1870–1941)
Joseph Leidy
Academy of Natural Sciences
Bronze, height 102″ (granite
base 120″)
Gift of the Leidy Memorial
Committee to the City in 1907.
Originally located at City Hall.
Moved to present site in 1929.

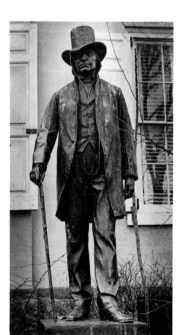

Raffaelo Romanelli (1856–1928)
John Wister. 1903
Vernon Park, 5700 Germantown
Avenue
Bronze, height 90″ (granite
base 42″)
Commissioned by Jones Wister,
grandson of the subject. Instated
in 1904.

Augustus Saint-Gaudens
(1848–1907)
Angel of Purity. 1902
St. Stephen's Church, 19 South
Tenth Street
Marble, height 96″
Commissioned by Dr. and Mrs.
S. Weir Mitchell as a memorial
to their daughter, Maria
Gouverneur Mitchell.

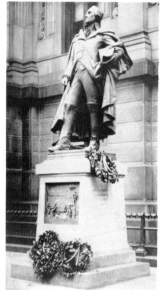

J. Otto Schweizer (1863–1955)
General Peter Muhlenberg
Philadelphia Museum of Art
(in storage)
Bronze, height 108″ (granite
base)
Commissioned by the German
Society of Pennsylvania.
Instated October 6, 1910, at City
Hall, South Plaza. Moved to
Reyburn Plaza in 1920 and to
storage in 1961 in connection
with construction of Municipal
Service Building.

Section V 1914–1960

Swann Fountain

by Victoria Donohoe

*photographs by
Seymour Mednick*

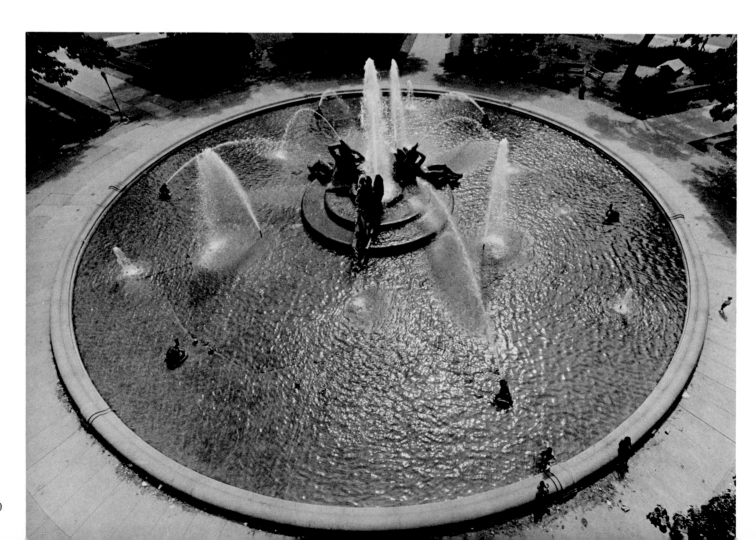

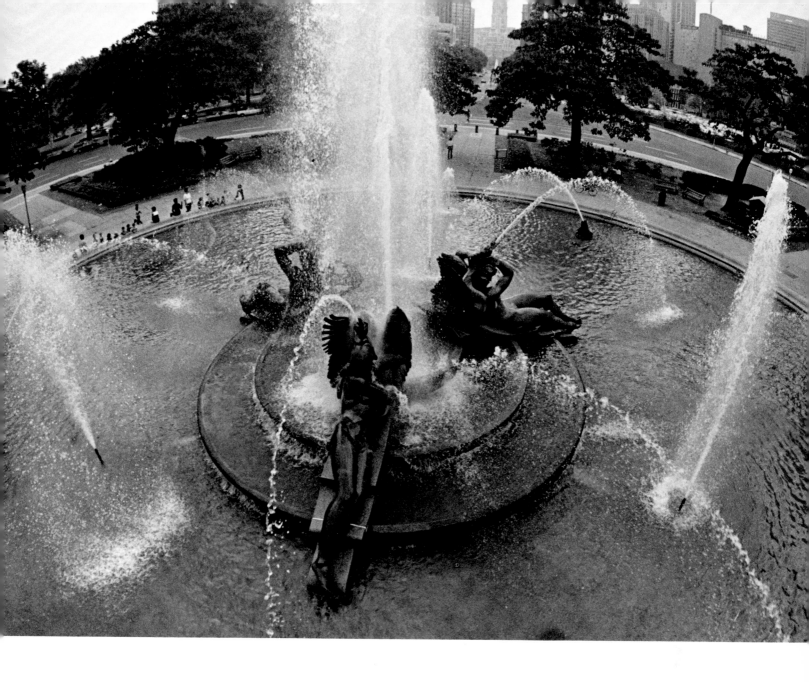

The *Fountain of the Rivers* calls attention to the meridian point in the unfaltering career of American sculptor Alexander Stirling Calder (1870–1945). Calder was a Bainbridge Street schoolboy when Maria Elizabeth Swann (1814–1891) wrote her will in 1878, declaring:

> I give the sum of fifty thousand dollars to the Philadelphia Fountain Society in trust to erect in some suitable locality a large and handsome fountain in memory of my beloved husband [the late Wilson Cary Swann, M.D.], they reserving out of this sum a sufficient amount to be invested, and the income applied to pay the annual expenses of cleaning the fountain and keeping it in perfect order and repair and defraying any extra expense requisite for a constant supply of water.[1]

Some forty-three years later, Stirling Calder, by then a prominent sculptor, sought authorization to start the Swann Fountain sculpture: "I have received statements and inquiries from several quarters including the press, assuming that this work was under way. I am enthusiastic about the chance to create a fine thing for my native City,

and eager to begin before I grow much older."[2] By 1924, Calder's task was complete. This project was the Fountain Society's swan song, but by no means a final undertaking by Calder.

The Swann Fountain is an interesting monument to a minor figure. It is also a fitting memorial to Dr. Wilson Cary Swann (1806–1876), a bland, courteous, compliant Virginia gentleman devoted to benevolent causes. Bent upon easing the burdens of man and beast, he early abolished slavery from his household, was a lifelong accommodator, and a very generous man but not endearingly human. Born in Alexandria, the son of a prominent federal lawyer, Wilson Swann attended the University of Virginia and acquired a medical degree from the University of Pennsylvania in 1830. In October, 1847, he married Maria Bell and then settled in Philadelphia. There he served on the original board of managers of Episcopal Hospital from 1851–76, was one of the first members of the Union League of Philadelphia, and the first president of the Pennsylvania Society for the Prevention of Cruelty to Animals. In his own day, Dr.

Swann, an art collector, was best known as the founder-president of the Philadelphia Fountain Society, begun during an era of horse power and incorporated by an Act of Assembly of the Commonwealth of Pennsylvania on April 21, 1869.

The Fountain Society's aim of furnishing drinking water to man and beast had the twofold purpose of enabling people to slake their thirst "from nature's bountiful provider without an entrance to the Public House or Saloon" and refreshing "dumb animals …during the hours of their toil," especially in hot weather.[3] By the turn of the century more than fifty fountains, nearly all Philadelphia's ornamental drinking fountains, were Society property and in its care. Obsolescence came quickly though, as horses vanished from the streets and health restrictions were placed on public drinking fountains.

If Wilson Swann was "unobtrusive,"[4] his invalid wife, a chronic rheumatism sufferer, was splashy. Although ill-health made her an unseen presence for decades, Maria was still there, practicing liberality, generous to a fault, and capable of astonishing people.[5] Mrs. Swann's will, when admitted to probate, "caused considerable surprise," noted the *Press*, "as it was generally believed she was worth several millions, whereas her estate is appraised at $60,000" and the bequests "amount to nearly $500,000." That she inherited her father's estate, a fraction at a time, was reportedly the reason for the excess of bequests over the amount of her estate. At all events, the Fountain Society fared well from her will. Soon awarded $51,500 from two legacies, it had to wait longer for a third bequest of $12,000 that was subject to the life interest of a dog named Dot and many old family servants, probably including slaves freed by Dr. Swann.

No sooner had a search for a site for the memorial begun than the Fountain Society realized a properly endowed memorial was impossible with available funds. So it invested and reinvested the income, while discussing locations and considering architectural contests, which it ultimately rejected, expecting thereby to keep tighter control. Finally, in 1917, the board took a swift turn, unanimously choosing the architect Wilson Eyre, Jr. (1858–1944) to submit preliminary fountain sketches.[6]

As for the location, Mayor Thomas B. Smith had suggested a conspicuous parkway site close to City Hall. Meanwhile Jacques Gréber's parkway revision plan, announced in January, 1918, proposed an enlarged Logan Square, his sweeping circular treatment of its center, Logan Circle, suggesting the Champs Élysées at Paris' Arc de Triomphe, with the central spot to be used for some important ornamental feature. Gréber's plans called for bringing spacious green areas of Fairmount Park more than a half-mile into the heart of the city's business district, as a vista in the center of Logan Square. Because of the vista, foliage in the center of the circle was to be kept low, affording an unbroken view of the parkway's full length, from City Hall to the Philadelphia Museum of Art. Wilson Eyre preferred this more secluded site over Mayor Smith's preference because of its landscape setting and its strategic position in relation to Fairmount Park, it being necessary to face the square both coming from and going to the Park.[7] Sensing the time was right, the Fountain Society offered to locate the Swann Fountain at Logan Circle. The park commission allotted them the site on March 12, 1919.

To help him determine the design of the Swann Memorial in this setting, Eyre conducted "an exhaustive study" of fountains here and abroad. He discussed with Gréber and park commission president Eli Kirk Price the height and design of a "central column," probably like one in the Place de la Concorde in Paris, as Gréber already had proposed a pair of public buildings nearby giving Logan Circle the effect of that great plaza. By April 21, 1920, the column had evolved into "bronze figures" for which, Eyre said, drawings were being completed by a sculptor. This artist was Calder, whose drawings were done evidently on speculation at Eyre's behest and were soon viewed by the Fountain Society. Still it postponed authorizing Calder to start work, even though it was receptive to Eyre's choice of sculptor, to the idea of figures, and apparently found nothing objectionable in the sketches themselves.

The pool for the fountain, consisting of a 124-foot basin, low-curbed and unadorned, and rimmed with Milford pink granite, was finished on November 11, 1920. In a statement of January 25, 1921, Eyre expressed the feeling that this fountain "should comprehend a very extensive use of water, with a moderate amount of sculpture, rather than a massive architectural effect which might interrupt the vista up the Parkway to the Art Museum."[8]

The Fountain Society, however, remained hesitant about the expense of the sculpture and deemed the times unpropitious for the liquidation of its securities. Finally, Price intervened. Calling for updated Calder sketches, he proposed that the park commission would pay for the sculpture if the Fountain Society handed over the balance of the Swann fund.[9] This proved to be the solution, and, after the contract between the commission, the architect, and Calder was signed on November 10, 1921,[10] the Swann Fountain trusteeship was granted to the Girard Trust Company. Since then the park commission has received income for the fountain's maintenance.

Of several decisive and lifelong friendships, that with Wilson Eyre was particularly congenial to Calder. It resulted in collaborations and the first major article on Calder's art.[11] Both men believed in expressive handling of materials, craftsmanship, and in the teamwork that could produce a fountain as the culminating motif in this ensemble. "A threepoint scheme naturally suggested itself" because "the Parkway cuts the city street system at such an angle," making this a subordination of many parts.[12] In view of the programmatic need for a low-lying fountain with water action paramount, river figures were a very natural choice. Eyre's particular contribution was an expression of horizontal continuity by means of uninterrupted vistas (his interlacing of curved jets and sprays "center with the vistas by which the fountain can

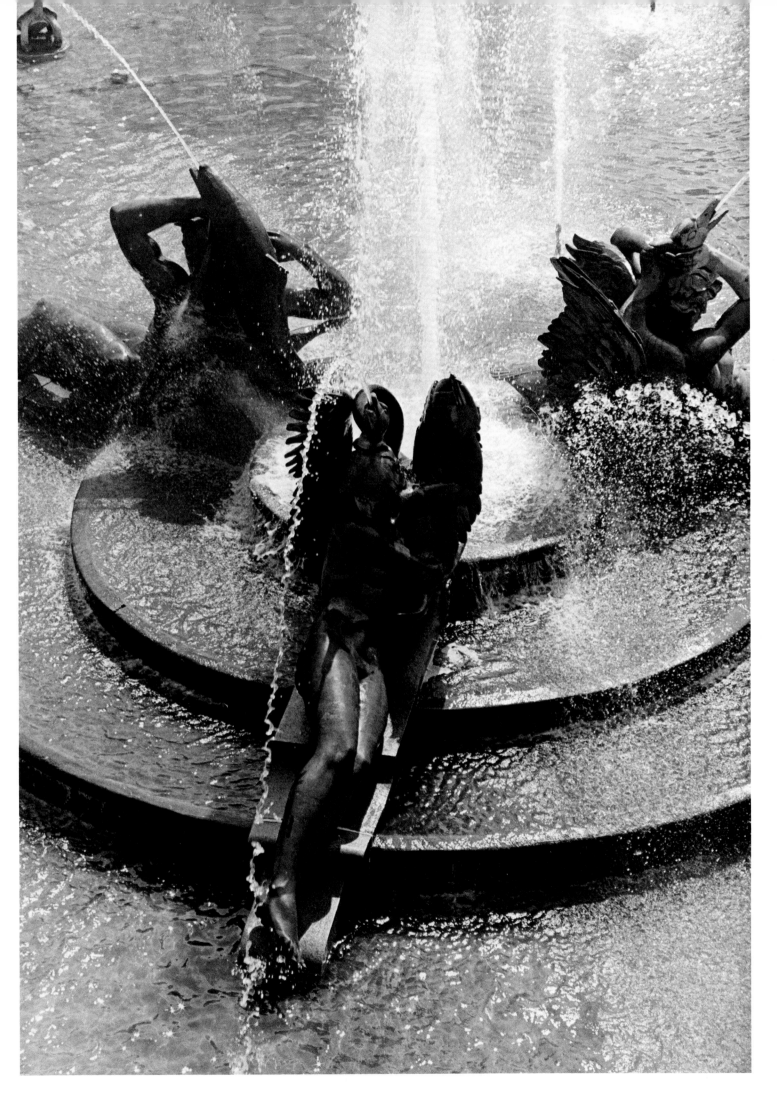

be seen from different directions"),[13] and by a gentle rise of stepped basins framed by swan-necked cornices with Calder's figures on them.

Of these figures, Stirling Calder said, "When I make a statue for Philadelphia I want it to be as big and comprehensive as possible. I called the group in Logan Square 'The Fountain of Three Rivers.' "[14] He explained, "It was my fancy to imagine the three great decorative bronze figures as the rivers enclosing the City of Philadelphia. The Delaware represented by the male Indian, the Schuylkill (or gentle river) south of this, and the Wissahickon (or hidden creek) to the west."[15] Calder gave his composition three distinct profiles, each to be viewed like a pediment. The southeasterly side offers City Hall the view "along the wedded rivers"[16] between which Penn located his city, attracted by this river junction. The figures feed and protect the fountain, dominate the basin, and are of colossal size with rather conventionalized features because they were made to conform to an architectural idea. Reclining postures typify the rivers' fluid character.

The Swann sculpture is a mixture of ancient and Italian, French, and local ideas. Although Stirling Calder chose a Philadelphia subject, he made use of a classical motif, a venerable, emblem-bearing, recumbent river god.

Moreover, his work reflects Michelangelo's Florentine "Medici Tomb" figures (figure 1), which recline back-to-back on scrolled ornaments similar to consoles. Preparing sculpture axial with the templelike art museum, Calder surely thought, too, about figures from the Parthenon pediment, especially *Theseus.*

Calder's sculptures are more up-in-arms than their prototypes. This enables his work to be congruent with the water action and reinforces the vertical movement of the central jet.[17] Philadelphia is again that "young city, round whose virgin zone/ The rivers like two mighty arms were thrown."[18] Calder felt an affinity between the intense motion of swans and fish, and the rush of waters. Animal movement is the only dramatic action uniting the decorative group, the calm figures providing a welcome transition between excited swans and landscaped surroundings. The sculptor's new stylized look, gaining a foothold, is but a beginning that will see further development. Bronze frogs and turtles, the inner basins, and the location on a strong axial plan recall Versailles' Latona Fountain (figure 2). To Calder, "There's no psychology about a frog, and of course little mystery concerning a turtle. They're simply part of the general decorative scheme."[19]

Of the three major figures, that of the *Wissahickon*

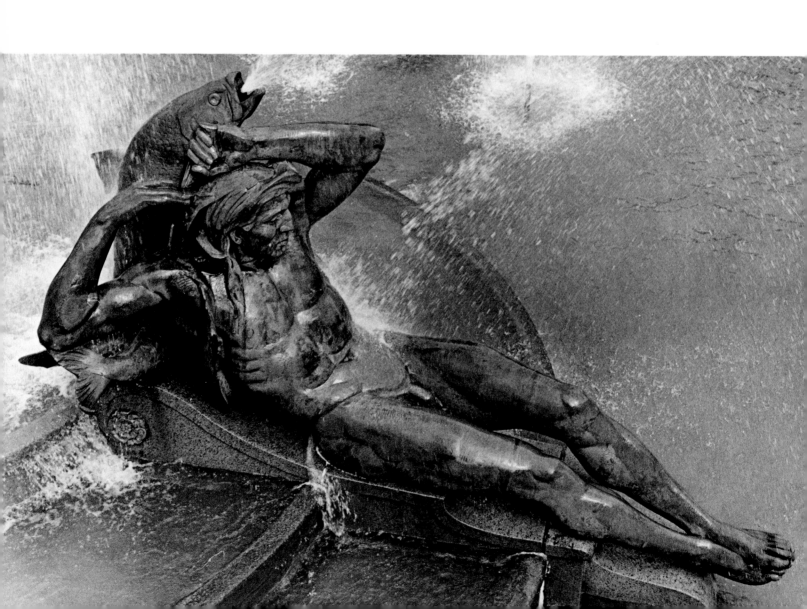

was completed first. The art jury met in November, 1922, in Calder's studio with representatives of the Fountain Society and the park commission to inspect the first full-size model. It was accepted and completed in wax on March 14, 1923, and in bronze on May 9. Calder's affectionate regard for the female nude is not lost in the figure of the *Wissahickon*. He threw this young human form into curving, calligraphic, reptilian lines suggested by the creek's hidden Fairmount Park setting,[20] capturing the image "Deep in the woods, where the small river slid/ Snake-like in shade."[21] *Wissahickon*, Calder's Leda, does her sliding against the back of a water-spouting swan,[22] the agitation of whose wings is a foil for cascading water. Her calm pose becomes easy and momentary, the torsion making it satisfactory from every angle. The head has expressiveness and her sinuously curved figure an unselfconsciousness and essential modesty, the hands curving delicately. As the ideal, both feminine and passive, it echoes the spirit of the twenties and is perhaps the Swann figuse with which Calder felt most satisfaction. *Arts and Decoration* published an illustration of this figure to preview her January, 1924, New York exhibition debut, and she enjoyed other attention. The pose of her torso recalls Calder's Atlantic Ocean figure (part of the "Fountain of Energy," shown at the 1915 San Francisco exposition) and certain Viscaya Bay *Island* work.

The *Delaware* was cast in wax on June 13 and in bronze on September 12. Benign and majestic, shown in the full strength of manhood, attended by leaping fish and holding his bow, the Indian figure is very much like an ancient river god, although nude and beardless. The *Delaware* shows that a great river is powerful, calm, and gives food.[23] As the Lenape confederacy of the Algonquian were called Delawares from their river, the portrayal would seem to be obviously that of a Delaware Indian. However, an intriguing interpretation could identify the statue with the celebrated Iroquois and Cayuga chief Logan, so called after Logan Square's James Logan (1674–1751), William Penn's learned secretary and peace-promoting Indian affairs expert who hosted Indian sojourns at Stenton, his country home. It is an appealing thought that Chief Logan is thus immortalized, accepting the hospitality of his namesake. Stirling Calder had lived with Indians in the southwest and sculpted them from life. The lowered pose of the head is reminiscent of Calder's *Son of the Eagle (c.* 1913), but *Delaware* has a more relaxed facial expression.

Calder's third figure, the model of which was approved in June, 1923, reflects aboriginal and poetic Schuylkill images. Called by the Indians "mother" and

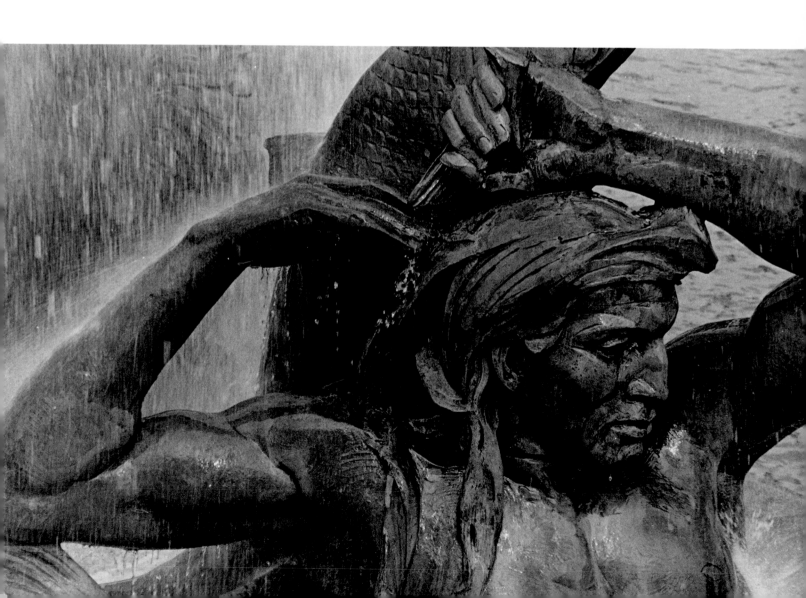

"noisy water," and represented here as a mature woman, this river recalls Whittier's poetry, "Through the deep/ Hush of the woods a murmur seemed to creep,/ The Schuylkill whispering in a voice of sleep." To show water gives drink, she grasps the neck of the harassed larger swan, which ruffles its neck feathers and is thrown off balance as it spouts water, the power of its wings tossing water, swanlike, into the air.[26] Save for her reclining pose, *Schuylkill* has little in common with William Rush's earlier Schuylkill allegories, which Calder surely knew well, and none at all with Calder's own early river figure, *Missouri.* Nevertheless, preliminary to his Swann work, besides studying swans firsthand, Stirling Calder did a bronze that pays homage to Rush's *Water Nymph and Bittern*, then known as *Allegorical Figure of the Schuylkill.* He called this oft-exhibited sculpture *The Little Dear with the Tiny Black Swan.* In both his and Rush's standing fountain figures, the right arm reaches gracefully toward

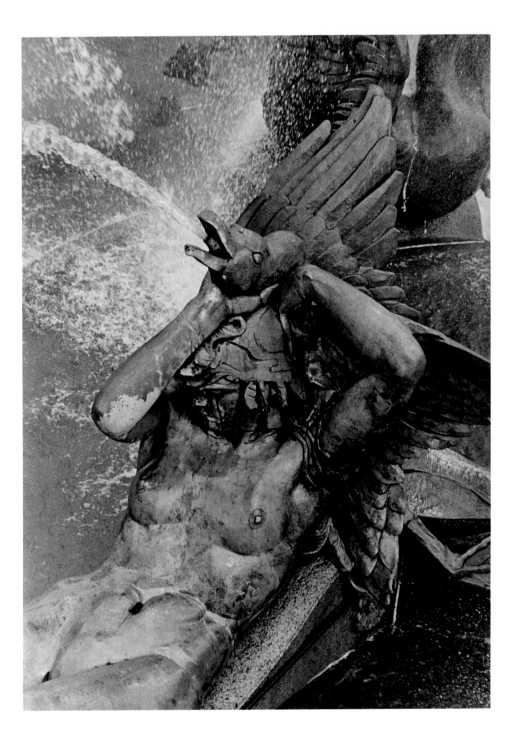

a shoulder-perching aquatic bird, about to take flight. Other Calder bronze nudes of this period, *The Bridge* and *Last Dryad*, have torsos positioned like *Schuylkill's*.

Unceremoniously, on July 23, 1924, the eve of the hottest day of the year, the fence was removed from the completed fountain. The next evening saw 10,000 sweltering people tango-dancing in the streets around it, to the music of the police band; Calder and Eyre were nowhere in sight. His river figures done, and weary after a lawsuit involving *Last Dryad*, Calder and his wife were far away, cruising the Mediterranean with Eyre aboard the *President Wilson*. The Swann Memorial was the largest and the last public work of the Fountain Society, which for fifty-five years had charge of the city's drinking fountains. About this time, the Society merged with the Women's Society for the Prevention of Cruelty to Animals, which thereafter operated fountains for both groups.

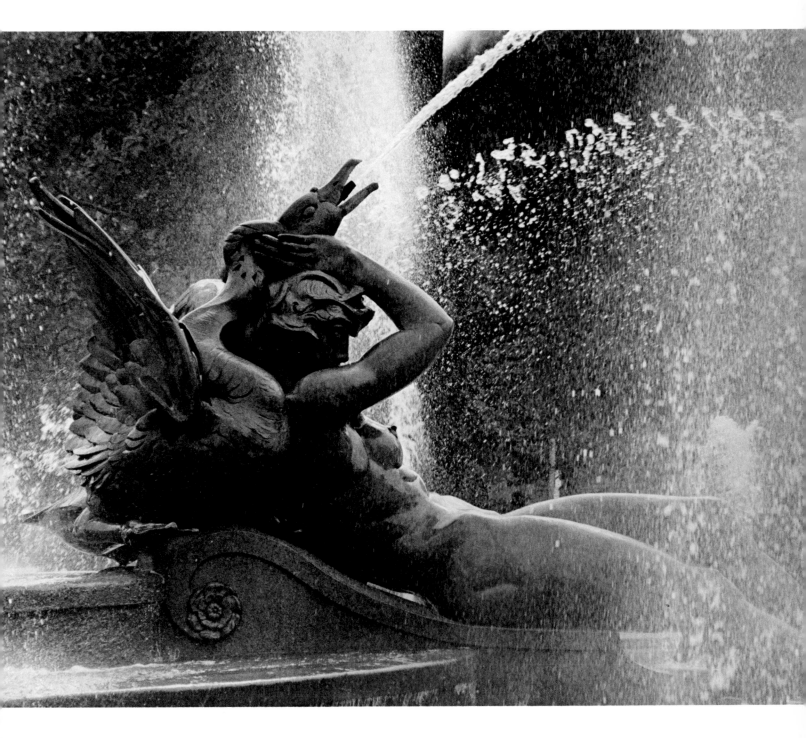

Later, despite a generally favorable reaction to the fountain, certain citizens were not pleased with it. They wondered if the average person would grasp the significance of its statuary and surrounding details, to which Calder replied: "The meaning of works of art is just as mysterious as life itself. It can be explained in many ways by people of different philosophies. . . . There are lots of things in life we do not understand; art is no exception."[27]

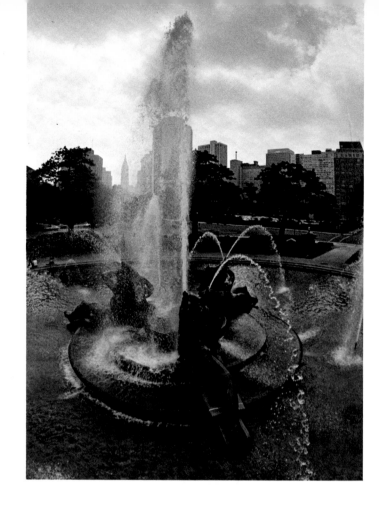

Alexander Stirling Calder (1870–1945)
Swann Memorial Fountain. 1924
Logan Circle
Bronze, figures 132″ high
(granite base 62″ above pool bed)

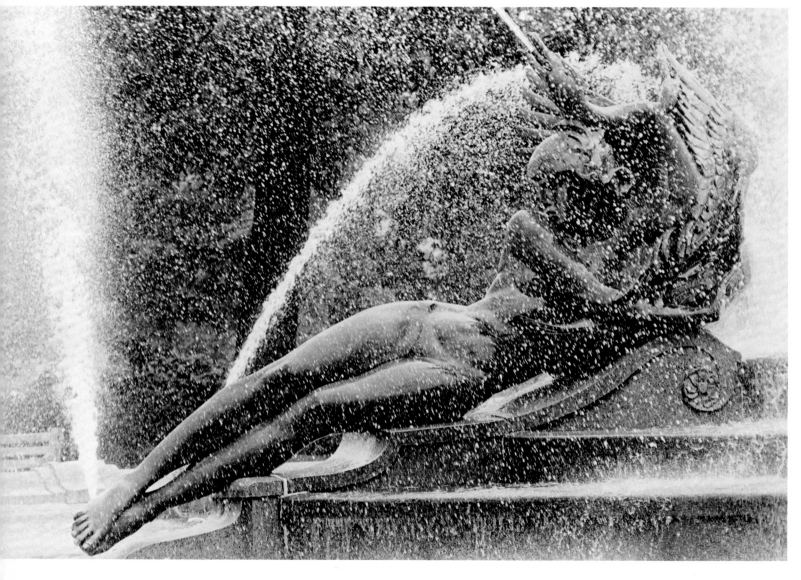

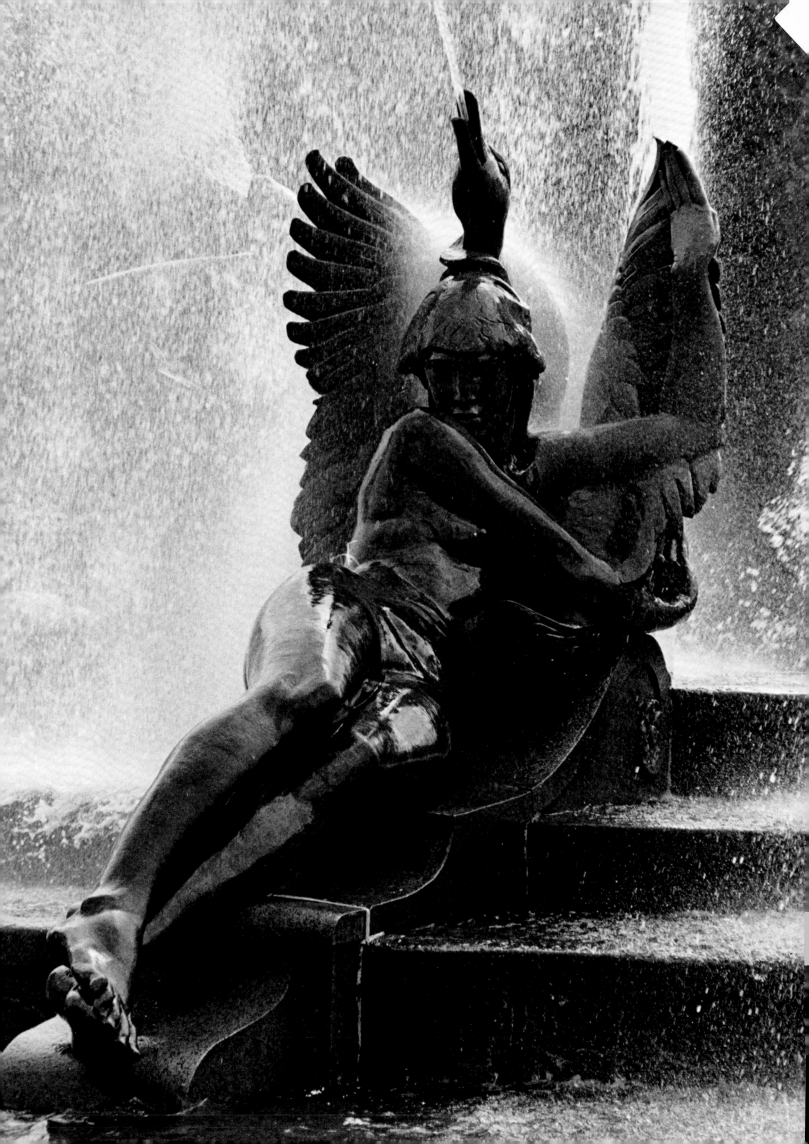

Art Deco Architecture and Sculpture

by George Thomas

photographs by Bernie Cleff

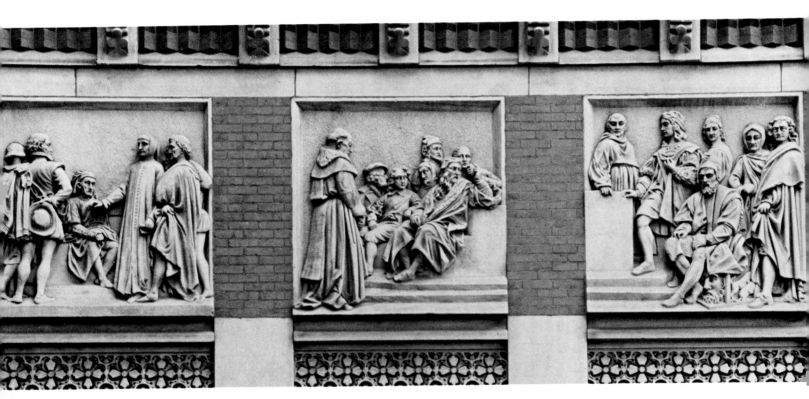

Pennsylvania Academy of the Fine Arts

Figurative sculpture on Philadelphia's buildings forms one of the largest and most important categories of its public statuary. These sculptural works might be approached in a variety of ways. Certainly the art historian would consider the entire group, noting patterns of style, theme, and subject. For instance, the recurring theme of male and female flanking the entrance of a building, as on the Fidelity Mutual Life Building, the Pennsylvania State Building for the Sesquicentennial, and on the two Federal buildings between Ninth and Tenth on Chestnut, might result in an article with a Thurberesque title such as "The Battle between the Sexes." "Philadelphia Architecture and World Imagery" might be the title for an article dealing with the buildings of this city where there are reliefs depicting the four corners of the earth, as on City Hall, the Fidelity Mutual Life, and the Post Office Building at Ninth Street. To the architectural historian, there is another area of interest,

namely the purpose of the architect who used the figurative sculpture and the purpose of the sculpture used on the buildings. It seems likely that the presence of figurative sculpture is an indication of an attitude toward architecture common to many of the architects of this city, past and present, an attitude which held that a building's facade ought to take an active role in the creation of the urban milieu, communicating use and function, and even describing the client to the passerby. It is an urban, and one might add, urbane, concept, implicit in many nineteenth- and twentieth-century buildings in this city, and an idea which is being disseminated across the country, thanks largely to the work and writings of Robert Venturi, one of the first and certainly among the most challenging champions of the type of design which produces what I term "informative" architecture.

Two generations of Philadelphia architects made extensive use of figurative sculpture. The first achieved

maturity in the decade which followed the Civil War and had completed its most important work by 1895. The second generation, active between the two world wars, found more significant applications of figurative ornament, but followed the general custom of the older generation. Our interest will therefore center on the more recent buildings and their designers, but it would not be amiss to discuss briefly the work of the earlier generation which established so many of the prime conventions in the use of sculptural ornament.

Three major architects who integrated figurative sculpture into their designs stand out: Frank Furness (1839–1912), Willis G. Hale (1847–1907), and John

Schuylkill Navy Building, Photo George Thomas

McArthur, Jr. (1823–1890). City Hall, the prime work of the latter, has already been presented in this volume. Furness' Pennsylvania Academy of the Fine Arts, Broad Street Station, and Hale's Schuylkill Navy Building merit attention. Of the three buildings, only the Academy has escaped demolition, but a similar solution was applied to the lost buildings as well. On the Academy, six small relief panels, carved by Alexander Kemp, were placed high up on the facade in a location so distant that it is difficult to imagine them playing a significant architectural role, such as leading the eye toward the center or helping to terminate the facade by forming a cornicelike mass. The reliefs are too small and too distant to achieve either effect, and in any case are superseded in those roles by architectural elements which satisfy those organizing intentions. The panels form little more than a part of the general polychromatic patterning common to the Venetian or Ruskinian Gothic styles. If their role is not architectural, their presence can be explained in another way, for it is their subject matter which was important to Furness. The reliefs are a copy, albeit simplified in number of figures and fragmented into six sections, of Paul Delaroche's frescoed hemicycle entitled the "Palace of the Fine Arts," which was painted between 1837 and 1841 in the main lecture room of theÉcole des Beaux-Arts. The individual figures represent the great architects, sculptors, and painters of the past. Their presence on the facade established a link between the European artistic heritage and this New World school, a link directly connected to the French Academic tradition. The reliefs have a role then, but one which is descriptive, informing the passerby about the purpose of the building rather than fulfilling some architectural task.

Figurative reliefs played similar descriptive roles on Furness' Broad Street Station and on Hale's Schuylkill Navy Building. Again, relatively small figures informed the pedestrian about the nature of the building and its patron. The figures by Karl Bitter on the facade of Broad Street Station described the complexity and size of the Pennsylvania Railroad system. The three panels on the upper register of the Schuylkill Navy structure depicted some of the sports sponsored by the club, with the larger, central panel devoted to the club's featured activity, rowing. It is perhaps worthy of note that in each case the reliefs articulate the relationship between the building and its owner. The resulting identification of the building as a symbol of the patron will result whether the building was designed in Furness' Gothic style or McArthur's Second Empire style, or whether the sculptor is the local man, Alexander Milne Calder, or the New Yorker, Karl Bitter, and, as we shall see, the same direct relationship will mark the buildings of the generation of architects who worked after World War I.

During the next generation, the use of figurative sculptural embellishment on commercial and public architecture became increasingly rare, although sculptural ornament reappeared from time to time on exposition architecture, notably at the Columbian Exposition in Chicago of 1893, and later at the Louisiana Purchase Exposition of 1904 in St. Louis. Obviously too, sculpted figures gave a measure of archaeological accuracy to ecclesiastical and academic buildings designed in the medieval styles. Because sculptural decoration had remained customary on architecture of those categories, it should not be surprising that an exposition building and a building by architects accustomed to working in the medieval styles signaled the rising interest in architectural sculpture on public and commercial buildings in Philadelphia after World War I.

The Fair building, the Pennsylvania State Building for the Sesquicentennial Exposition, was a design by the late Ralph B. Bencker, while the firm of Zantzinger, Borie, and Medary, architects of the Episcopal Divinity School, were the designers of the Fidelity Mutual Life Building. Although both buildings were under construction during 1926, the Pennsylvania State Building was completed during the summer, a year earlier than the insurance

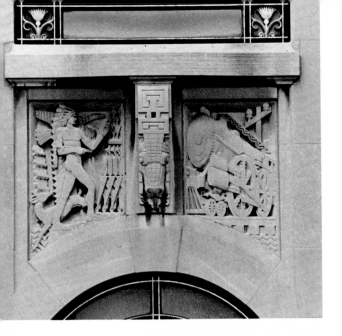

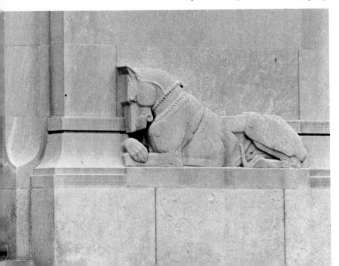

Fidelity Mutual Life Insurance Company

company building. Thus, Bencker's building might be considered to be earlier; certainly it had wider public exposure and was the more immediately important. Its striking modernistic design points to Bencker's interest in the American and European modern movements, but the design also served as part of the meaning of the building. Bencker wrote, "In its design no forms have been borrowed from European prototypes to make it 'Classic,' nor has it followed 'Colonial' precedent, thus relegating itself to a single past expression of our national life. Its trend is modern, and its dominant note the 'vertical' motif which is gradually asserting itself as the typical American contribution to architectural expression. Thus, being expressly American, it serves not only to memorialize an event of 150 years ago, but as well the present greatness of the state in industry, resources, culture, government and art" (figure 1).[1] Despite the grandeur of Bencker's concept, one which might be considered by the "colonialists" of our day, the building is worthy of attention because of the presence of a series of enormous reliefs which decorated the building and explained its purpose, as had been done by the earlier generation, but which also served a new role, that of helping the fairgoer to organize his perceptions of the building. Thus, the largest and most important figures were placed on pylons flanking the central entrance pavilion, engaging the viewer's attention and reinforcing the role of the architectural elements.

The figures within the pylons deserve attention, in part because of their relation to the building, and in part because of the meaning intended by the architect. A male on the left and a female on the right, enclosed within the pylon for most of the height of the figures, seemed to grow from the wall at their bases, joining them inseparably to the building's mass and erasing the usual distinction between architecture and sculpture. The equal size of the male and female figures represented a strikingly modern concept, the equality of the sexes, undoubtedly suggested by the most recently passed amendment to the Constitution which had given women the right to vote. The style of the figures was of interest, too, pointing to Egyptian and Mayan sources, both in the shaping of the figures and in their relation to the wall and to the entrance. Conceived in a rigidly frontal manner, they were carved in broad, simple masses, with each plane strongly differentiated. They were, in a sense, a modernization of an ancient source and marked that creative fusion of past and present so common in the best modern design of the 1920s.

The following year, the Fidelity Mutual Life Insurance Company Building (figure 2) was completed. This structure, which stands on an irregular site at Pennsylvania and Fairmount avenues, was designed in a style which its architects called "Modern Classic." There were ample expanses of wall surface provided for the work of the noted architectural sculptor Lee Lawrie, who had achieved fame for his work in the Gothic style at New York's Cathedral of St. John the Divine, Saint Thomas' Church, and in the modern style on B. G. Goodhue's Nebraska State Capitol.[2] Here, as on Bencker's building,

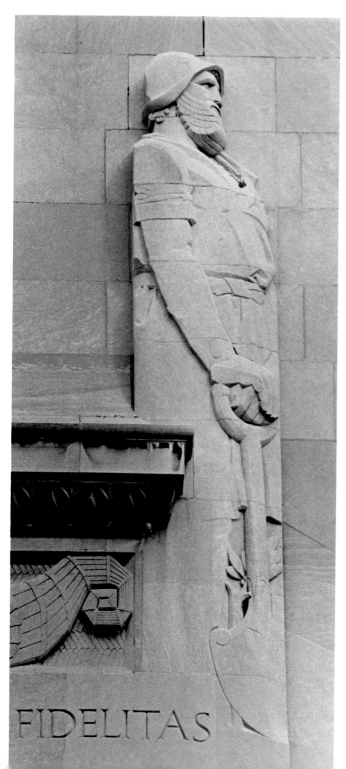

the walls appeared to be massive and load-bearing, providing a ground for sculpture, which unlike the sculpture of Furness' and Hale's generation is both descriptive and architectural, informing and organizing.[3]

The sculptural program (the degree of complexity makes that term advisable) of the Fidelity Mutual Building can be divided into two parts. The large figures carved from the limestone of the building's facade represent the company, while the smaller bronze figures on either side of the raised entrance pavilions represent the insured (one actually lifts the building across a street; figures, male on the left and female on the right, confront each other, while below, great danes, symbols of fidelity and hence of the company, gaze at the viewer at eye level). The figures overhead, identified by captions inscribed in the wall, represent the prime virtues of the company. Friendship and Prudence face each other over Olive Street, while Fidelity and Frugality are the virtues of the main entrance. More of the company's merits are allegorically presented by a row of animals at the tops of the entrance pavilions, which are interspersed with the leafage of the acroteria. Squirrels, opossums, owls, and pelicans represent respectively, frugality, protection, wisdom, and, in a real medievalism, charity. (Medieval scholars believed that pelicans fed their young on their own flesh.)

On the long flanks, four designs, which alternate in the spandrels between the windows of the first and second floors, depict four of the continents of the world, and, in a sense, the four corners of the earth, for North, East, South, and West are represented by images of Europe, Asia, Africa, and America. The architects thereby managed to present the idea of the company's worldwide operations, but also linked the building to an earlier tradition as the place where cosmic forces met. In Philadelphia, the most important examples of that tradition are to be found on City Hall, where the same four continents are represented over the four entrance pavilions, and on the Bertrand Gardel Monument at Mount Vernon Cemetery by Napoleon Le Brun, where representations of these four continents joined in mourning the death of Mrs. Gardel. Although the same four continents appear on each building, indicating some common design source, the symbolic figures differ from one building to the next. Here, a horse, an elephant, a lion, and a bison represent the four continents; on City Hall, the figures are the same except that a camel replaces Africa's lion.

Ultimately, however, it is the quality of Lawrie's sculpture and not the program which gives the Fidelity Mutual Life Insurance Building its extraordinary beauty, surpassing its larger neighbor up on the hill by the same architects. The delicacy of the modeling, the crispness of the edges, and the exaggeration of the joints of each muscular figure recall Assyrian reliefs, which Lawrie had revived in his Hammurabi relief on the Nebraska State Capitol. Unlike the Assyrian sources, however, strong contour lines were established by the depth of the stone blocks, which contrast with the subtlety of the reliefs,

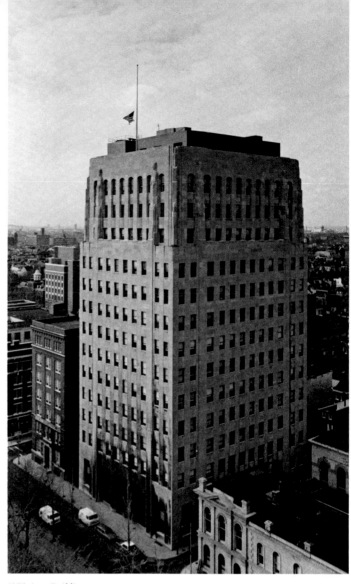

N.W. Ayer Building

creating a tension between detail and form, with the detail establishing an intimate relationship between the figures and the viewer, while the forms created by shadow are of a scale appropriate to the entire building.

Despite the force of Lawrie's work and the elegance of the design of the Fidelity Mutual Life Building, it is the N. W. Ayer Building (figure 3) on Washington Square which becomes the real climax to the decade of the 1920s. Designed by Ralph Bencker in 1929 for Philadelphia's best-known advertising agency, it is the great example in Philadelphia of the integration of figurative sculpture with the tall office building. Although connections might be made with Goodhue's well-known Indian-headed skyscraper for the Chicago Tribune Building competition, and with the same architect's Nebraska State Capitol, the idea of the subtly tapering shaft, surmounted by great figures, remains unique. The figures, which begin at the setback line of the building's top, and thus grow from the masses of masonry below, give to the entire building a sense of volume and plasticity, as if it were sculpted by some giant hand.

The eight figures which capped the building and the reliefs in the spandrels of the upper levels were carved in situ by a team of sculptors, J. Wallace Kelly and Raphael Sabatini, who would work with Bencker for the next generation, creating the "jazz-modern" or "Automat"

style.[4] As might be expected from the prominence of the great figures, they form part of another complex image system, which described the goals and purposes of the advertising industry to the viewer. That program was summed up by Bencker in an article in the *Architectural Forum* in which he wrote, "The motifs used in the decoration of the interior and exterior of the structure were taken from fundamentals of the advertising business; they are the human figure, symbolizing the creative mind, and the figure of Truth; the open book as the vehicle of advertising; and the winged bird as the messenger, symbolizing the widespread power of advertising." Thus, the great figures at the top represented the truth of advertising spread to the four winds, while down below, on the bronze doors of the entrance, were all of the figures of the program.[5] The figures even spread into the building. Clouds of birds cover the ceilings, while a Brancusilike bronze by Kelly formed an accent to the elevator court. If the content seems naive in a generation which has seen payola become a common word, and product recalls a matter of standard business policy, nonetheless, the effort of the company and its architect to communicate with the public is to be commended.

As surely as the general optimism of the 1920s had affected the architectural styles of that decade, encouraging the exuberant, rich figurative style used by

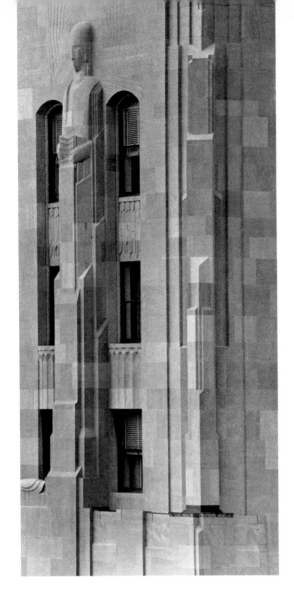

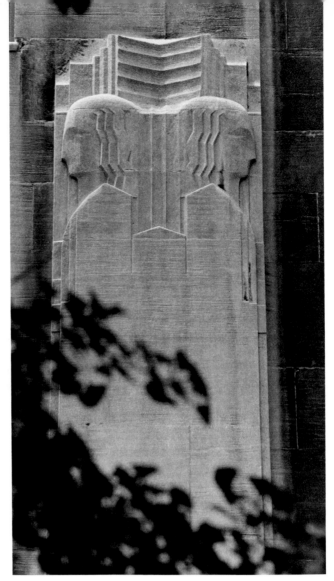

architects such as Ralph Bencker and sculptors such as Lee Lawrie, the Depression produced a climate which made architectural sculpture seem too costly a frill. There were, however, two classes of buildings in which the practice of enriching the facade with figurative and descriptive sculpture continued—the escapist architecture of the movie theater and the buildings of the federal government, which preached confidence and optimism to the public by the use of those very frills associated in the public mind with the "good old days." The fusion of the usual governmental classicizing styles with motifs from the commercial architecture of the previous decade formed the basis for the federal style of the 1930s. Three of the finest examples of the style were erected in Philadelphia, the Thirtieth Street Post Office by Rankin and Kellogg in association with Tilden, Register, and Pepper, and two buildings on the site of the old Post Office on Chestnut between Ninth and Tenth Streets, Paul Cret's Federal Reserve Bank, and Harry Sternfeld's Federal Building (United States Post Office and Courts). Apart from the great eagles over the door and bands of Mayan ornament, the Post Office is relatively unadorned. Its bulk relates to its river site and to the austere Thirtieth Street Station across the street. On the other hand, the more closed and urban Chestnut Street site demanded a more intimate solution, one which both Cret and

Sternfeld resolved by the use of sculpted panels on the facades of their buildings. The two Chestnut Street buildings are further visually related to each other by a common cornice height, by such a motif as the grouping of windows into vertical bands, and by the predominant horizontality of both designs.

Despite those general similarities, the two buildings are extraordinarily different, for each represents a major pole within the federal style. Cret's pure white marble building looks to a specific, classical prototype, the choragic monument to Thrasylus in Athens, as published in J. M. von Mauch's *Die architektonischen Ordnungen der Griechen und Römer* (Berlin, 1875).[6] It reflects Cret's point of view, which held that certain forms and proportions have an inherent meaning and beauty, one which can be transferred from one building to another. In Cret's work, the same design was used for the Integrity Trust Company of 717 Chestnut Street in Philadelphia and on the Federal Reserve Building in Washington, D.C., as well as on the Château-Thierry Battle Monument in France. Sternfeld's building seems to relate to Cret's building, but not because of a belief in a canon of form on Sternfeld's part, for he was one of the most original designers of his generation, but because of the strength of his feeling for the urban matrix, and his recognition that clearly perceivable visual similarities are fundamental to the

creation of an ordinary urban place. Indeed, it will be apparent that Sternfeld's intentions are not at all classicizing—that effect is only the result of his accommodation to Cret's earlier building. The strongly stressed duality of the function of the building as both courthouse and post office is anticlassical in conception, as is the absence of strongly stressed closures at the ends or at the top of the facade. The mixture of materials, granite at the base and limestone above, makes it even clearer that Sternfeld's building draws more from the commercial than the classical antecedents of the federal style.

A similar and fitting duality is evident in the type of figurative sculpture on the two buildings. Those on Cret's Federal Reserve Bank were from the hand of the French sculptor, Alfred Bottiau, who had worked with Cret on the Integrity Trust Company and on the Château-Thierry Monument. The figures are clean-limbed, slender, even delicate, and are placed in a setting which parallels the major lines of the building, integrating the figures into their architectural frame. The figures on Sternfeld's Federal Reserve Building were the work of a team of men, some chosen by the architect, others by the government, who did little more than execute Sternfeld's already developed program. Donald De Lue worked on the Courthouse facades, on Chestnut and Market streets, and created the Triton Fountain in the small court between

the Federal Reserve and the Federal Building, and Edmond Amateis was responsible for the execution of the panels on the post office, or Ninth Street facade, while the state shields, representing the circuit of the Federal District Court, were the work of Louis Milione. Instead of the Beaux-Arts delicacy of Bottiau's figures, Sternfeld's men worked in a muscular and plastic manner, creating a style reminiscent of the American regionalist painters, Thomas Hart Benton and John Steuart Curry. It is a style peculiarly adapted to the powerful building whose surfaces and functions they articulate.

Sternfeld used the subjects of the reliefs to define the duality of the internal plan and function of the Federal Building. Differences in style of the reliefs indicate the differing types of relations between these governmental agencies and the people. Amateis' narrative and informal figures of postmen in regional settings, ranging from the eastern cities to the far West, and from the arctic North to the tropical South describes Sternfeld's view of the postal system as the most direct and intimate connection between the people and their government (figures 2 & 3). Their garrulous informality forms a powerful contrast with the austere confrontation which Sternfeld envisioned between a blindfoldless Justice and a figure of Law of Mosaic sternness (figure 4). The ritual nature of the judicial process is indicated by the stars and bars, and by the presence of eagles of Michelangelesque force

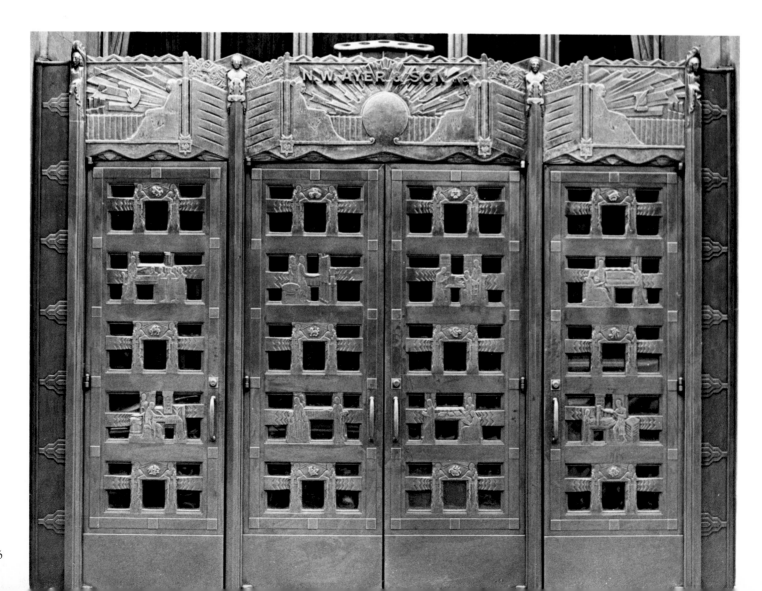

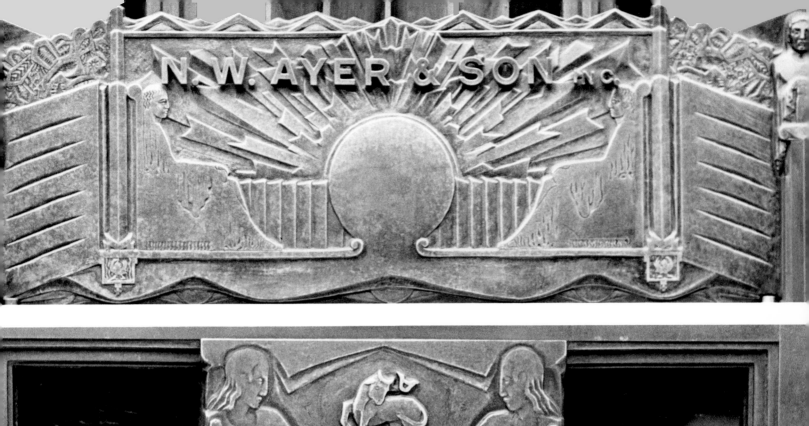

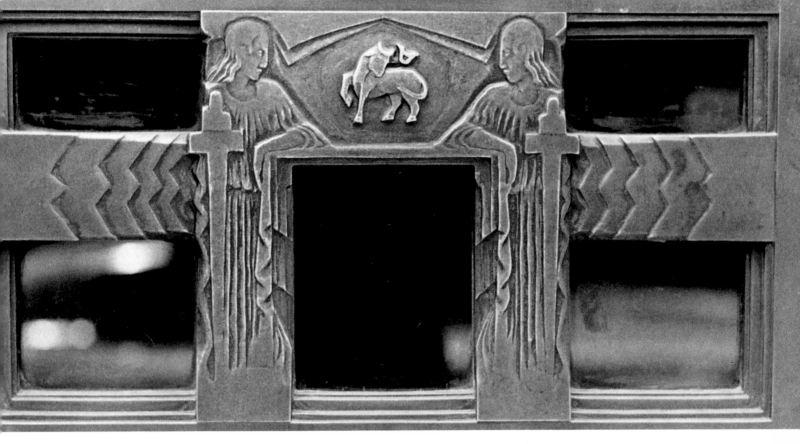

Federal Reserve Building

unequaled in American sculpture.[7]

Bottiau's figures on the Federal Reserve Bank have a more limited role, emphasizing the entrances and pointing allegorically to the activities of the Federal Reserve System. The male on the right holds a sheaf of wheat in his right hand and cradles in his left arm the tools of industry. Beyond, a ship sails in the distance; clearly the relief represents the commerce of the nation. On the other side, a seated woman parallels the young man in position and gesture, holding a figure of Athena Parthenos in her extended hand. She apparently represents the Federal Reserve System, appealing to Athena for the wisdom to guide the nation's commerce well, obviously a national concern in the midst of the Depression.

Although all of these architects and sculptors

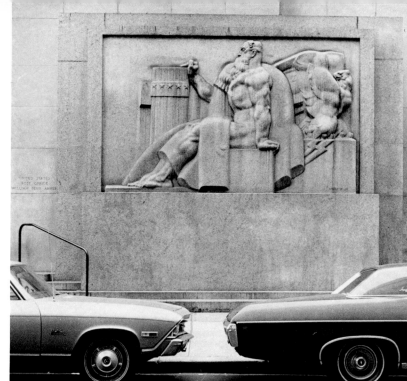

Federal Building (Post Office)

worked in different, personalized styles, and for different and demanding clients, they held in common the belief that a building's facade forms the prime means of communicating with the public, and that communication ought to rise above the banal to inform the passerby about the patron and the activities which take place within the building. The massive appearing facades of their buildings belied the skeletal system within, but the facade's role has traditionally given information about more important concepts than the nature of the technical solution to the building's internal structural system. In short, the facades of these buildings were given a social role, that of making meaningful the urban landscape, and that aim was frequently satisfied by the skillful integration of figurative sculpture into the building's facade.

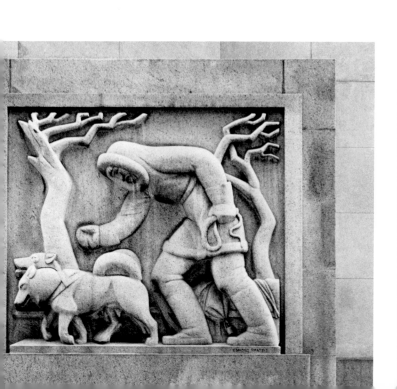

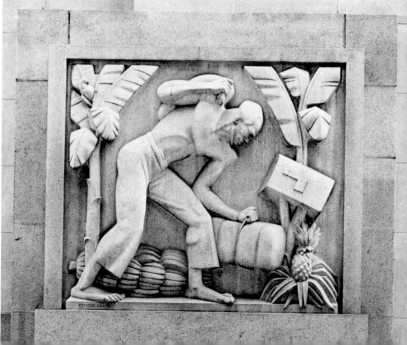

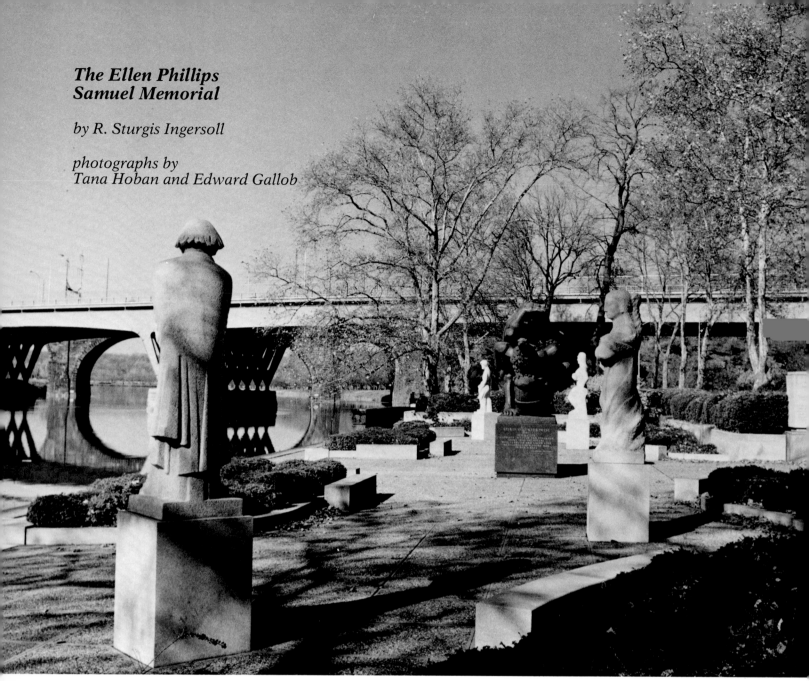

View of North Terrace

The Ellen Phillips Samuel Memorial

by R. Sturgis Ingersoll

photographs by Tana Hoban and Edward Gallob

Ellen Phillips Samuel, a Philadelphian, had been a generous supporter of cultural matters throughout her life, and for many years an active member of the Fairmount Park Art Association. She died on October 1, 1913, leaving her estate, subject to a life interest in her husband, J. Bunford Samuel, and after substantial legacies to friends and Philadelphia institutions, to the Art Association, to apply the income in creating, on a 2,000-foot strip bordering the Schuylkill River, statuary "emblematical of the history of America—ranging in time from the earliest settlers of America to the present era."

Following the death of his wife, Mr. Samuel expressed great interest in her project and during his life commissioned and had instated at the south end of the strip the standing figure of Thorfinn Karlsefni by the Icelandic sculptor Einar Jonsson. On his death in 1929 the generous fund, totaling approximately $700,000, came into the possession of the Association to carry out the directions of Mrs. Samuel's will. Under the administration of the Association, this bequest increased substantially.

There were several challenges to be met. In the year of the execution of her will, 1907, Mrs. Samuel selected a strip of greensward bounded on the west by the Schuylkill River and on the east by the East River Drive, which was then a gravel road traveled almost exclusively by horse-drawn pleasure carriages—victorias, runabouts, phaetons, and occasionally four-in-hand coaches and tandem dogcarts. An automobile was a rare sight and as such was subject to a twelve-mile-an-hour speed limit. Between the greensward and the drive was an asphalt pavement used by strolling pedestrians on a clear afternoon. By the time the Association received the fund, the horse had disappeared, the strollers had all but disappeared, and the drive itself had become a blacktop highway crowded through the day and night by speeding automobiles. The location, however, could not be changed.

The major challenge was to determine the best approach in carrying out the donor's directive to create an "emblematical" history of America. For several years thoughts were exchanged back and forth. The alternatives

seemed to be to erect a row of portrait statuary of the important political and spiritual shapers of our destinies, or sculptural symbols of such abstractions as Faith, Democracy, Wisdom, Patriotism and Justice. Both of these concepts were rejected by the rather youthful committee of the Association's trustees, appointed by its president. Since the writer is the only surviving member of the committee as it functioned through the years, he will refer to the committee in the first person.

We concluded that the subject matter of the statuary should be an expression of the ideas, the motivations, the spiritual forces, and the yearnings that have created America. The Association's architect, the distinguished Paul Cret, envisaged the setting for the statuary as consisting of three terraces with groupings of statues at both ends of each terrace. In passing, we desire to record the invaluable aid tendered to us by Mr. Cret and his staff, headed by John Harbeson, not only with respect to architectural factors, but also in the commissioning of the sculptors and in the innumerable details inherent in a project of this nature.

After the settings had been designed, we broke down the chronological sequence of the subjects into six categories: (1) the early settlement of the eastern seaboard; (2) the creation of a nation by the political compacts of 1776 and 1787; (3) the trek westward; (4) the consolidation of democracy and liberty in the mid-nineteenth century by the freeing of the slaves and the welcoming to our shores of countless Europeans, featuring, in essence, opportunity for all; (5) the physical development of man-made America; (6) and finally, the spiritual factors that shaped our inner life. From the beginning we planned that inscriptions would be incised in stone behind or flanking the sculptures, quoting American literature, either imaginative or political, as a method of passing down noteworthy expressions of our culture in permanent form. The members of the committee separately spent many hours researching the wide field from which quotations might be drawn. We would then meet, compare notes, and reach conclusions.

In January, 1933, at the annual meeting of the members of the Association, the committee presented its program, which was unanimously approved and for the ensuing decades quite closely adhered to. A principle which we religiously followed was that of giving the sculptor the theme and then letting him interpret it without interference by the committee. This indeed presented challenges to the sculptors. We did, however, reserve the right to reject a sculptor's development.

The central terrace was the first one to be constructed. We had decided on a major group expressing the Spanning of the Continent, with flanking figures of a Ploughman, "who broke the land for harvest," and a Miner, "who searched the earth for treasure"—land and gold being the motivations of the movement. The major complementary group was to express the aspiration for freedom, with flanking statues of an unshackled

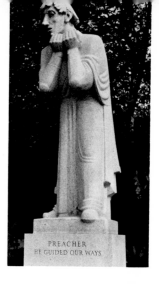

PREACHER
HE GUIDED OUR WAYS

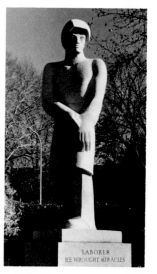

LABORER
HE WROUGHT MIRACLES

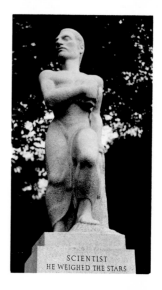

SCIENTIST
HE WEIGHED THE STARS

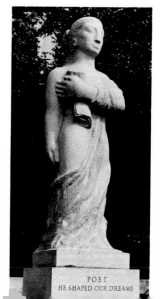

POET
HE SHAPED OUR DREAMS

251

Slave and an Immigrant, seeking release from lands across the sea.

It was now our obligation to select the sculptors. To guide us, we organized an International Exhibition of Sculpture at the Philadelphia Museum of Art in 1933. Through invitations to sculptors in Europe and America, North, Central, and South, we first received innumerable photographs. From these and our personal knowledge of the work of many of the sculptors, we invited a large number to send to the exhibition, at our expense, one or more pieces of their choice, not necessarily those represented by the photographs. As a result, 364 works by 105 sculptors were assembled in bronze, stone, wood, and plaster, covering a wide range of tastes and styles.

With this field before us, we commissioned Robert Laurent to create the major group emblematical of our western migration, J. Wallace Kelly, *The Ploughman*, and John Flannagan, *The Miner*. For the other end of the terrace we commissioned Gaston Lachaise to create the major group expressing the aspiration for freedom, with Hélène Sardeau to create the flanking *Slave* and Heinz Warneke the *Immigrant*. A heavy blow fell when word came of the sudden death of Gaston Lachaise in 1935. He had completed a one-quarter scale model of his impressive, imaginative concept, which gave every promise of being the germ of a masterpiece. We had it cast in bronze, and it is now in the Philadelphia Museum of Art. Maurice Sterne was commissioned to take Lachaise's place.

Laurent's *Spanning the Continent* is a highly successful monument, embodying the essential theme; *The Ploughman* by Kelly is a stone carving in the best of all traditions; *The Miner* by John Flannagan, certainly the greatest American stone carver, was not up to his full standard, due doubtless to his deteriorating health. The three other artists, Sterne, Sardeau, and Warneke, expressed the theme of freedom, with the freed Slave and the Immigrant searching for and finding a new way of life, no longer earthbound.

We believe that the quotations incised on the stone backgrounds of the two major groups were particularly apt; two by contemporary poets and one each by Abraham Lincoln and William Cullen Bryant, of the Civil War generation:

Spanning the Continent
The valleys and gorges are white with the covered wagons,
Moving out toward the west and the new, free land.
　　　　　　　　　　　　　　Stephen Vincent Benét
America is west, and the wind blowing,

Spirit of Enterprise

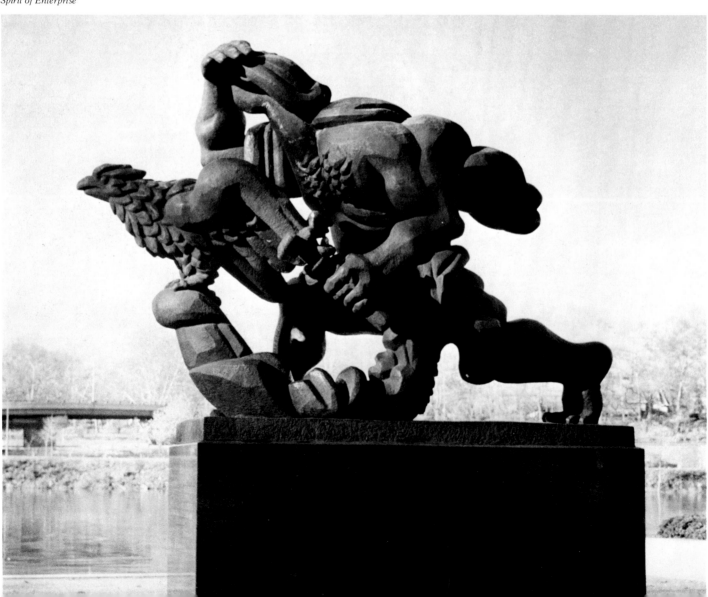

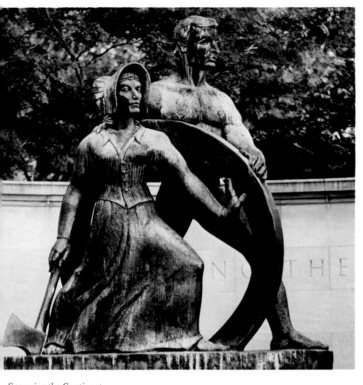

Spanning the Continent

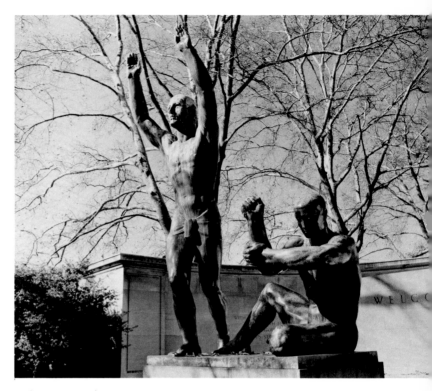

Welcoming to Freedom

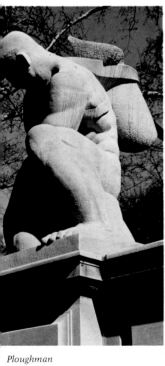

Ploughman

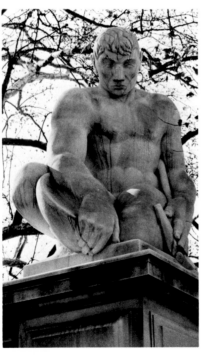

Miner

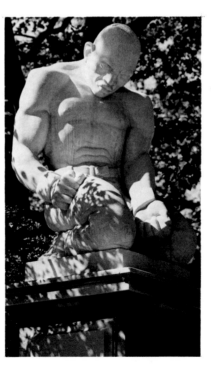

Slave

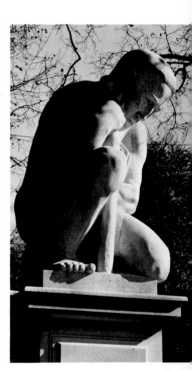

Immigrant

America is a great word, and the snow,
A way, a white bird, the rain falling,
A shining thing in the mind, and the gulls' call.

Archibald MacLeish

Welcoming to Freedom
With malice toward none, with charity for all, with
firmness in the right as God gives us to see the right, let
us strive to finish the work we are in.

Abraham Lincoln

Here the free spirit of mankind, at length,
Throws its last fetters off; and who shall place
A limit to the giant's unchained strength,
Or curb his swiftness in the forward race?

William Cullen Bryant

The International Exhibition of 1933 had been a public success and of great value to us in selecting the sculptors for the central terrace. With the architectural components of the south terrace nearing completion, we organized and displayed, under the same procedure as in 1933, the Second International Sculpture Exhibition, on view through the summer of 1940. There were 431 pieces exhibited. European entries were limited because of the war.

The themes determined for this terrace were the Settling of the Seaboard and the Birth of the Nation. We selected American artists identified more with the establishment and with national reputations than those who had created the pieces for the central terrace. The experienced monument-maker Wheeler Williams, who later became president of the National Sculpture Society, carved the somewhat conventional statement of the Settling of the Seaboard; flanking standing figures of a Puritan and a Quaker were by Harry Rosin, an instructor at the Pennsylvania Academy of the Fine Arts. With perception and imagination, Henry Kreis carved the double figure group signifying the joinder of youth and age in arriving at the compacts founding our government; flanking figures of a Soldier of the Revolution and a Statesman of that era were by Erwin Frey.

The sculpture in this terrace is markedly static and serious, perhaps too serious, lacking any romantic touch. Opinions differ but most would conclude that the sculpture in this terrace is inferior to that in the central one. It may easily be that the impact of the war, not a war of song and flag-waving, inspired a certain solemnity. The inscriptions were also serious, lacking the poetry of those in the central terrace:

Settling of the Seaboard
If we consider the almost miraculous beginning and
continuance of this plantation, we must needs confess

Puritan

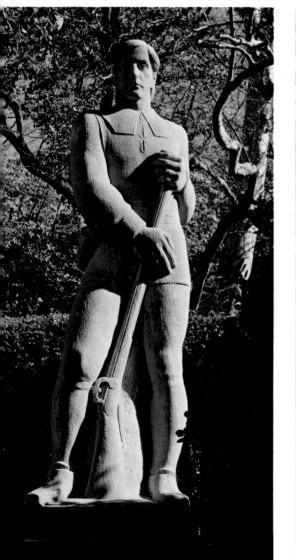

Quaker

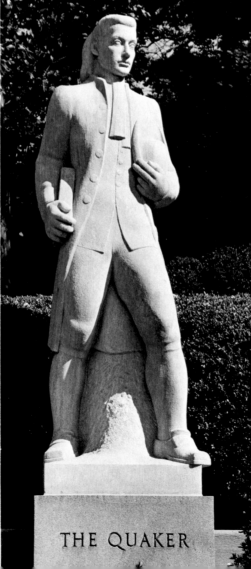

Revolutionary Soldier

THE QUAKER

that God hath opened this passage unto us and led us by the hand into this work.

Alexander Whitaker
I have great love and regard towards you, and I desire to win and give you love and friendship by a kind, just, peaceable life, and the people I send are of the same mind, and shall in all things behave themselves accordingly.

William Penn's address to the Indians
The Birth of a Nation
We hold these truths to be self-evident, that all men are created equal, that they are endowed by their Creator with certain unalienable rights, that among these are life, liberty, and the pursuit of happiness.... And for the support of this Declaration, with a firm reliance on the protection of Divine Providence, we mutually pledge to each other our lives, our fortunes, and our sacred honor.

Declaration of Independence
Except for certain finishing touches, all work on the memorial was suspended during the war and its immediate aftermath. By 1949, the income from the fund having been largely unspent during this period, we embarked with faith and enthusiasm in creating the north terrace, the faith and enthusiasm being justified by the results obtained. In the summer of that year we held our Third International Sculpture Exhibition. There were 252 works exhibited, many from foreign countries. It was a noteworthy success, attesting to an awakening interest in sculpture—an attendance of over 250,000, widespread publicity in national magazines, a sculptor's day, consisting of invitations to all exhibitors to celebrate the art of carving and modeling and culminating in a double-spread photograph in *Life* magazine of seventy visiting sculptors seated on the main staircase of the Philadelphia Museum. Of the mass photograph, the salty Jo Davidson said, "Never had so many sculptors been scrubbed and assembled in one place before." It may be truly said that this awakened interest stemmed largely from the prior international exhibitions of the Association; the publicity given the Samuel Memorial was in marked contrast to the fact that, through the decades, sculpture, as has been said, had been the stepchild of the arts.

Our purpose in creating the north terrace was to express the physical and spiritual forces that made America, rather than historic incidents. We envisaged standing figures of the Poet, who shaped our dreams, the Preacher, who from Puritan days had guided our paths, the Scientist, who harnessed nature, the Laborer, who built our cities, railroads, and factories, and finally two

Statesman

255

major groups: one expressing our energy, termed by us "Constructive Enterprise," but later changed to "The Spirit of Enterprise," the other expressing that particular development of the twentieth century, "Social Consciousness."

From the 1949 exhibition we selected four artists to carve the individual standing figures: Waldemar Raemisch for *The Preacher;* José de Creeft for *The Poet;* Koren der Harootian for *The Scientist;* and Ahron Ben-Shmuel for *The Laborer.* These pieces were to be of granite in contrast to the limestone of the other terraces. Two artists were commissioned for the bronze groups—Jacques Lipchitz for *Constructive Enterprise* and Gerhard Marcks for *Social Consciousness.* The places of birth of these artists suggested an artistic League of Nations: Raemisch and Marcks, Germany; der Harootian, Armenia; de Creeft, Spain; Ben-Shmuel, North Africa; and Lipchitz, Lithuania. This variety was not intentional on our part, but in fact the diversity of cultural backgrounds is interestingly revealed in the sculpture produced.

We were disappointed with Marcks's study and he withdrew from the undertaking, but we substituted with great success the controversial Jacob Epstein, the Jew of New York's Lower East Side, who spent most of his life in London, where he gained fame and notoriety. As Lipchitz and Epstein progressed, it became apparent that their concepts in design, size, and content would not be appropriate for inclusion in the same terrace. Both artists were on the way to creating great monuments. We therefore arrived at a fortunate solution; the Lipchitz would be placed in the center of the terrace, flanked by the granite figures, the Epstein on the west terrace of the Philadelphia Museum.

The somewhat simultaneous creation of four monumental granite figures entailed a formidable undertaking. All but the work by Ben-Shmuel were cut by hand without benefit of mechanical chisels. We kept in close touch with the artists, visiting their studios to view work in progress, and welcoming them on their visits to Philadelphia. Epstein came from London twice and won our hearts and minds. Though in his seventies, he was an exceedingly agile workman. Henri Marceau, the co-chairman of the committee, visited London and saw Epstein's great figures through the casting process. Lipchitz spent months supervising the casting of his work at the Modern Art Foundry in Long Island City.

Finally, in 1960, with the placement of Lipchitz' gigantic bronze on its granite pedestal, the thirty-year endeavor to create an emblematical history of our country was concluded. Lipchitz was particularly thrilled by the words inscribed on the pedestal of his *Spirit of Enterprise:*

> *Our nation, glorious in youth and strength, looks into the future with fearless and eager eyes, as vigorous as a young man to run a race.*
>
> Theodore Roosevelt

Now, forty years after accepting the challenge presented by our benefactor's will, have we done well or ill? First, we believe that we proceeded wisely in preparing and following the initial program; second, in holding the three international sculpture exhibitions; third, in granting to the sculptors freedom in interpreting the ideas set forth in the program. In most of our selections we broke away from the unimaginative, complacent tradition of American commemorative sculpture. We did not shy from representational art nor from artists identified with modern movements; we hoped to obtain pieces that would cause spectators to think and feel and, in a large majority of the pieces, we believe that we attained those ends.

The Samuel Memorial, including the Epstein on the terrace of the Art Museum, is the work of sixteen sculptors. Commissioning that number of sculptors within a span of twenty years was, one might say, a risky undertaking considering the period involved and the fact that since Saint-Gaudens and Remington creative sculpture in America had been in the doldrums. We believe we did well, perhaps we might have done better. It is our conviction that the end result expresses with serious inspiration what Ellen Phillips Samuel intended and that, with passing decades, the work will in no small degree be a pertinent manifestation of the culture of the mid-twentieth century. Certain of the pieces are true masterpieces, and there are few mediocrities.

In closing, it must be recorded that the late Henri Marceau was the sparkplug of the endeavor. Almost single-handedly he organized the three international shows, was the admired nurse of the architects and artists, and had that amazing capacity of being able to accomplish in one day what takes most of us three. We owe him a great deal.

Jacques Lipchitz (1891–1973)
Spirit of Enterprise. 1960
Samuel Memorial,
East River Drive south
of Girard Avenue Bridge
Bronze, height 125"
(granite base 56")

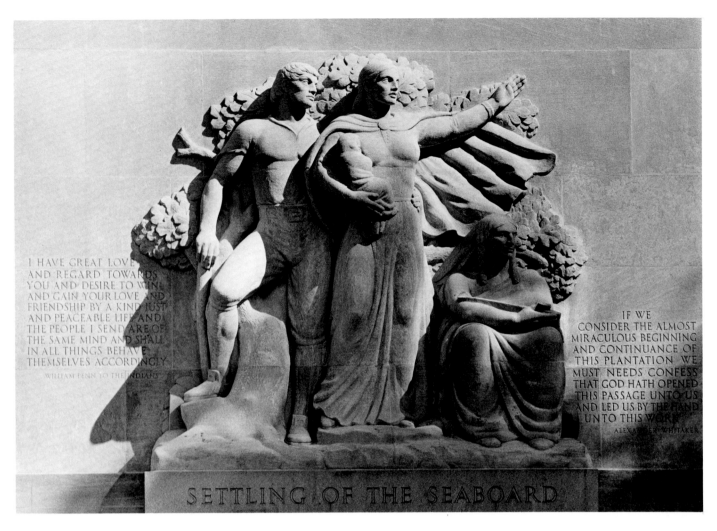

I HAVE GREAT LOVE
AND REGARD TOWARDS
YOU AND DESIRE TO WIN
AND GAIN YOUR LOVE AND
FRIENDSHIP BY A KIND JUST
AND PEACEABLE LIFE AND
THE PEOPLE I SEND ARE OF
THE SAME MIND AND SHALL
IN ALL THINGS BEHAVE
THEMSELVES ACCORDINGLY
WILLIAM PENN TO THE INDIANS

IF WE
CONSIDER THE ALMOST
MIRACULOUS BEGINNING
AND CONTINUANCE OF
THIS PLANTATION WE
MUST NEEDS CONFESS
THAT GOD HATH OPENED
THIS PASSAGE UNTO US
AND LED US BY THE HAND
UNTO THIS WORK
ALEXANDER WHITAKER

SETTLING OF THE SEABOARD

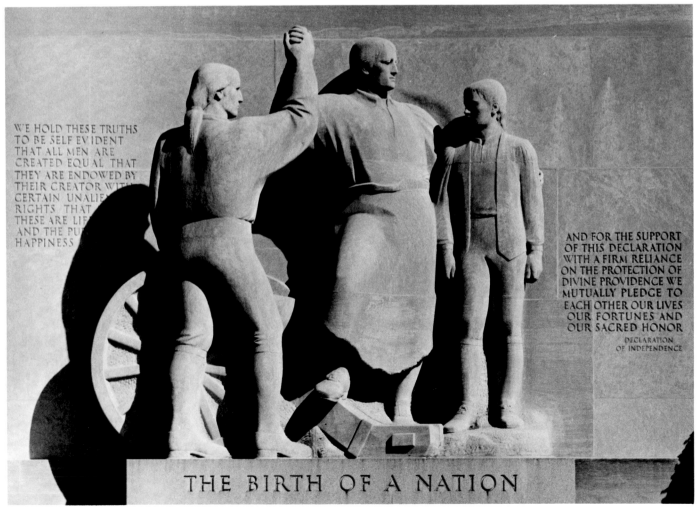

WE HOLD THESE TRUTHS
TO BE SELF EVIDENT
THAT ALL MEN ARE
CREATED EQUAL THAT
THEY ARE ENDOWED BY
THEIR CREATOR WITH
CERTAIN UNALIE
RIGHTS THAT
THESE ARE LIF
AND THE PU
HAPPINESS

AND FOR THE SUPPORT
OF THIS DECLARATION
WITH A FIRM RELIANCE
ON THE PROTECTION OF
DIVINE PROVIDENCE WE
MUTUALLY PLEDGE TO
EACH OTHER OUR LIVES
OUR FORTUNES AND
OUR SACRED HONOR
DECLARATION
OF INDEPENDENCE

THE BIRTH OF A NATION

257

Prometheus Strangling the Vulture and The Spirit of Enterprise

by John Tancock

photographs by
Tana Hoban

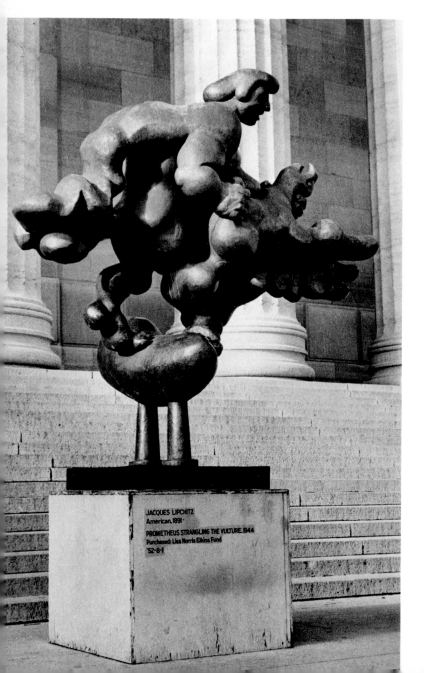

Two works by Jacques Lipchitz both situated within the confines of Fairmount Park—*Prometheus Strangling the Vulture* on the steps of the Philadelphia Museum of Art and *The Spirit of Enterprise* on the north terrace of the Ellen Phillips Samuel Memorial on the banks of the Schuylkill—span a period of well over twenty-five years in the artist's creative thinking and reveal the constancy of his monumental aspirations. The two sculptures were, in fact, inaugurated within seven years of each other, in 1953 and 1960 respectively, but the first ideas for a Prometheus date back to at least 1931. By that time Lipchitz' reputation as one of the leading European sculptors was already well established. Few would have disputed his claim to be the leading sculptor associated with the cubist movement, although by the end of the 1920s his art had encompassed such a wide range of formal possibilities that the cubist period could only be regarded as one of deliberate self-restraint, preparing the ground for the more expansive gestures of his recent work.

It is doubtful if any other major sculptural oeuvre of the twentieth century shows such stylistic and thematic diversity as that of Lipchitz, ranging from the austerity and near abstraction of a cubist work like the limestone *Man with a Guitar* of 1916 in the Museum of Modern Art, New York, to the tattered formal complexity of the Philadelphia Museum of Art's *Prayer* of 1943 (figure 1), and from the serene detachment of the cubist world of harlequins, musicians and still lifes to the deeply felt social and religious implications of his later works. Referring to "two streams" in his art, "one, very planned, worked over and worked out; the other, lyrical and spontaneous,"[1] Lipchitz has given the explanation for this apparently deep-seated inconsistency. What might at first glance appear to be a mere succession of styles or

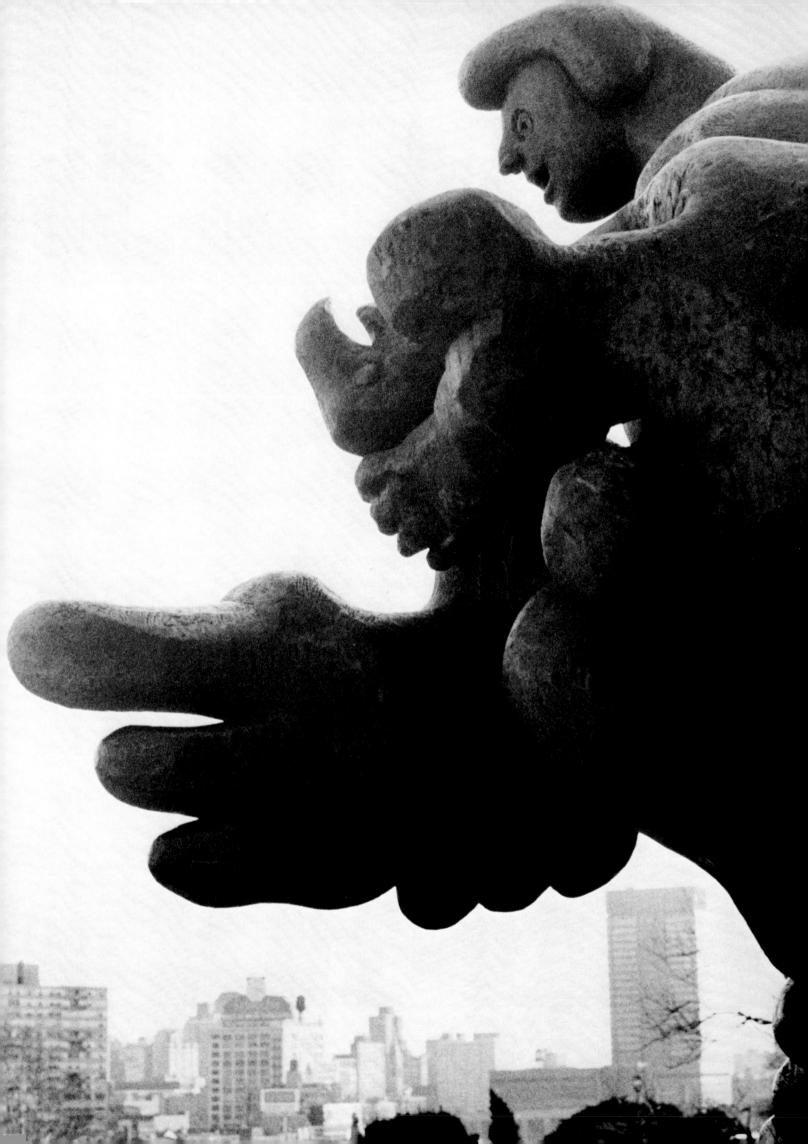

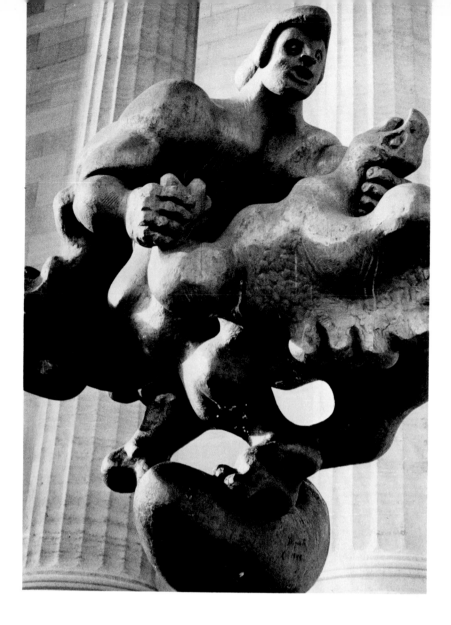

"periods," dependent less on personal drives than on a responsiveness to the cultural climate of the time, is seen to be the perfectly consistent expression of a man of protean sensibility.

The 1920s saw a marked expansion in Lipchitz' cubist style. The architectural ordering of massive forms in the classic, predominantly carved cubist works, for some of which Lipchitz admitted to using "blueprints,"[2] was superseded by the playful handling of ribbons of metal in the series of "transparents," many of which date from 1926. Although the subject matter remained classically cubist, the possibility of a freer and more spontaneous approach to sculpture could be glimpsed. Beginning with *The Couple* of 1928–29 in the Rijksmuseum Kröller-Müller, Otterlo, an element of surrealist ambiguity begins to appear in the images. The fused forms of the copulating figures in *The Couple* can be read as a prehistoric animal, its mouth (the space between the two heads) open in a piercing cry. In *Mother and Child* of 1930 in the Cleveland Museum of Art, the form of the mother can be seen simultaneously as a bird, while the figures in *Song of the Vowels* (Collection Nelson A. Rockefeller, New York), which dates from 1931–32, suggest the form of a mighty bird with spread wings.

Simultaneously with this surprising and whole-hearted, if unconscious, plunging into the mysteries of metamorphosis (Lipchitz had little if nothing to do with the orthodox surrealists), there occurred a drastic rethinking as to the kind of subject matter appropriate to sculpture. An émigré from Russia and of Jewish birth, Lipchitz could not help but be alarmed by the threatening events occurring in Europe. Following the return from Peru in 1931 of the poet and mystic, Juan Larrea, described by one commentator as "the next great single influence after Juan Gris,"[3] Lipchitz turned increasingly to the world of mythology to express his disquiet and anger at the unchecked rise of Nazism. Larrea's account of the terrible battle enacted on feast days in a region of the Andes in Peru between a bull and a condor sewn to its skin seemed to Lipchitz to express perfectly the plight of the world in 1932, unable to restrain or even recognize the poisonous forces threatening its very existence. Themes of struggle, strongly political in intent, dominate the 1930s—*Jacob Wrestling with the Angel* (1932) and *David and Goliath* (1933), in which the figure of the giant actually wears a swastika, and the various versions of *The Rape of Europa* (figure 2), executed in 1938 and 1941, to name but a few.

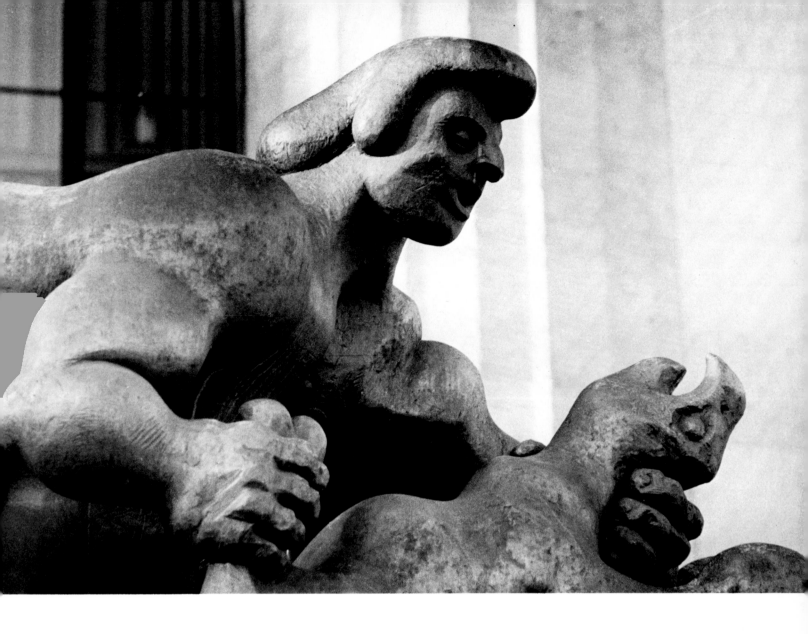

Lipchitz first thought of a victorious Prometheus—"a Prometheus not enchained, rather the guardian of the flame....It is not as chained to a rock, with a vulture picking at his entrails, that he can dream of coming to the aid of stricken mankind."[4] Although a sketch of 1931 seems to represent Prometheus waiting helplessly for the vulture to commence his punishment,[5] a sketch of 1933 showed, in the words of Lipchitz, "Prometheus triumphant. He had already broken his chains, and a small vulture, barely alive, was no longer able to bar his forward path." But Lipchitz soon saw that such optimism was misplaced. In 1936 the director of the International Exhibition of 1937 asked the sculptor to participate in the decoration of the Palais de la Découverte et des Inventions (The Pavilion of Discovery and Inventions). By now Lipchitz was so deeply alarmed that his sculpture began to assume a vatic dimension, not reflecting terrible events, as in the case of Picasso's *Guernica*, but prophesying and warning of dire consequences. "I wished to say to men: 'If you desire to continue freely in your creative work, it will be necessary for you to enter the struggle and conquer the forces of darkness that are about to invade the world.' "[7]

Two studies of 1936[8] show a more traditional and baroque treatment of the theme. Lipchitz' sculpture had to compete with the *folie de grandeur* of the Grand Palais, among the most prominent sculptural adornments of which are the huge neobaroque chariots by Georges Recipon, which he in fact admired, and so it is not surprising that the figure of the hero looks back through the *Prometheus Bound* of Rubens in the Philadelphia Museum of Art to the flailing limbs of the Laocoön. The final solution, however, had its origin in the sketch of 1933 rather than in those of 1936. In the first of these a young, robust Prometheus wearing a Phrygian cap, the symbol of democracy, choked the vulture with both hands, but Lipchitz felt that this gesture created an awkward, closed volume. In a development of this idea, the standing figure of Prometheus choked the vulture with one hand only, defending himself with the other against the claws of the bird (figure 3). "The struggle is terrible, but it needs only a glance of the eye to see on which side Victory will lie. The vulture is conquered. It needs only time and stone to vanquish this preying bird."[9]

From this, a plaster enlargement sixty-nine inches high was made, and then the final version for the Grand Palais, about forty-six feet high. The fate suffered by this group lived up to Lipchitz' worst fears. Taken down from

its elevated position eighty feet above the ground in the Grand Palais after the closing of the exhibition, the sculpture was placed on a low pedestal outside one of the entrances of the Palais, near the Champs Élysées. Following a right-wing campaign against the sculpture, conducted principally in the columns of *Le Matin* in April, 1938, the plaster was smashed to pieces and removed to the national warehouse. Lipchitz' symbol of cautious optimism had proved to be premature.

Living in constant fear of his life, even carrying poison in his pocket, Lipchitz fled to America in June, 1941. Two years after, it seemed as if the *Prometheus* might be reborn so as to announce its message to the world. The Brazilian government required a sculpture to provide a focal point for the large curving exterior wall of the auditorium of the new Ministry of Education and Health Building in Rio de Janeiro. Lipchitz provided yet another variation on the theme of Prometheus that had come to have such a tragic and personal significance for him. In the maquette for this work Prometheus still strangles the bird with one hand and wards off the claws with the other, but the nature of the struggle has been changed completely by the removal of the combat from the ground to a weightless realm seemingly high above it. With legs crossed and balancing improbably on a bean-shaped base, Prometheus dominates the bird with ease. In contrast to the massive and rather overgeneralized forms of the 1937 version,[10] those of 1943 are amorphous and cloudlike. Deeply penetrated by space (as is all of Lipchitz' sculpture after the period of the ''transparents''), the image comes and goes before one's eyes like a vision seen in the clouds. Yet the whole is impeccably organized. Naturally, yet artfully, the forms of wings and cloak flutter into a diamond-shaped mass that reads with all the visual clarity of the diamond-shaped relief in Belgian granite of 1924, *Musical Instruments*.[11] Lipchitz does not exaggerate when he states that he has remained a cubist to the present day in spite of his ''baroque'' formal language.

The maquette was then enlarged to approximately seven feet in height, the understanding with the Brazilian government being that it would be enlarged to three times that size before being placed on the auditorium wall. The government, however, broke the agreement. In 1944, with unseemly haste, the plaster was cast in bronze in its original dimensions and attached to the wall, a small speck on a blank surface instead of being the dominating feature as Lipchitz envisaged it. The first *Prometheus* was rejected by a hostile public; the second was disowned by the artist himself. The third, now in Philadelphia, narrowly escaped destruction.

In 1952 the plaster of the 1943 version was included in the 147th Annual Exhibition of Painting and Sculpture at the Pennsylvania Academy of the Fine Arts, being awarded the George D. Widener Gold Medal. It was in Philadelphia on January 5 when a fire destroyed the entire contents of Lipchitz' studio on 23rd Street, New York, including the numerous models for the *Virgin of Assy* and

the project for what is now called *The Spirit of Enterprise*, a commission received from the Fairmount Park Art Association in 1950. With money from the Lisa Norris Elkins Fund the Philadelphia Museum of Art purchased the plaster of Prometheus from the exhibition, the casting in bronze being undertaken by the Modern Art Foundry in 1952–53. The first cast now dominates the steps of the museum; the second and last forms part of the collection of the Walker Art Center, Minneapolis.

At this point in his career Lipchitz could not have been more pleased to receive a commission of the importance of that received from the Fairmount Park Art Association as, ever since the failure of the *Prometheus* for Rio de Janeiro, he had hoped for the opportunity to work on a monumental scale again. The Art Association requested a group for the north terrace of the Samuel Memorial, the title chosen being *Constructive Enterprise* (for a full account of the development of the Samuel Memorial see the essay by R. Sturgis Ingersoll contained in this volume). In the words of the report of September 8, 1949: ''Its treatment might be from many angles. It might express the vigor, the power of harnessed nature, or the strength of men harnessing nature and making it conform to their uses and desires. The physical power of men, their imaginative dreams, the surge of their material expansion, the skill of craftsmanship, the power of labor, are all suggestive.'' The contract was signed in March, 1950, Lipchitz agreeing to produce a bronze sculpture of approximately ten feet in height, on a pedestal to be erected by the Association of approximately four feet in height. The sculptor agreed to submit a preliminary model in wax, on the scale of three inches to the foot, within a period of eight months, the full-size model to be completed within eighteen months.

Like the *Prometheus, The Spirit of Enterprise*, as it is now called, was preceded by a large number of preliminary studies. From the very beginning the form of an eagle figured prominently, although at a certain point the project had to be modified as Lipchitz' concept of a pioneer striding forward impetuously, his feet actually resting on the bird, proved to be unacceptable to the committee.[12] In the revised version the aggressive dynamism of the first project was somewhat modified, the eagle being replaced by the dove of peace and a caduceus being placed in the hands of the pioneer. The quarter-size project was formally accepted in July, 1951, but, unfortunately, as already mentioned, this was destroyed by fire in January, 1952. Lipchitz had to start all over again. However, since the Association had by now designated another site for Epstein's *Social Consciousness*, he was free to return to his original concept of placing a great deal of emphasis on the eagle. The new, somewhat modified projects of 1953, commenced after Lipchitz moved into his new studio at Hastings-on-Hudson, New York, represent a young man striding forward, peering ahead, with one hand extended. In the smallest and probably the earliest of the four, measuring 9⅛ inches the bird perches on a rock and has

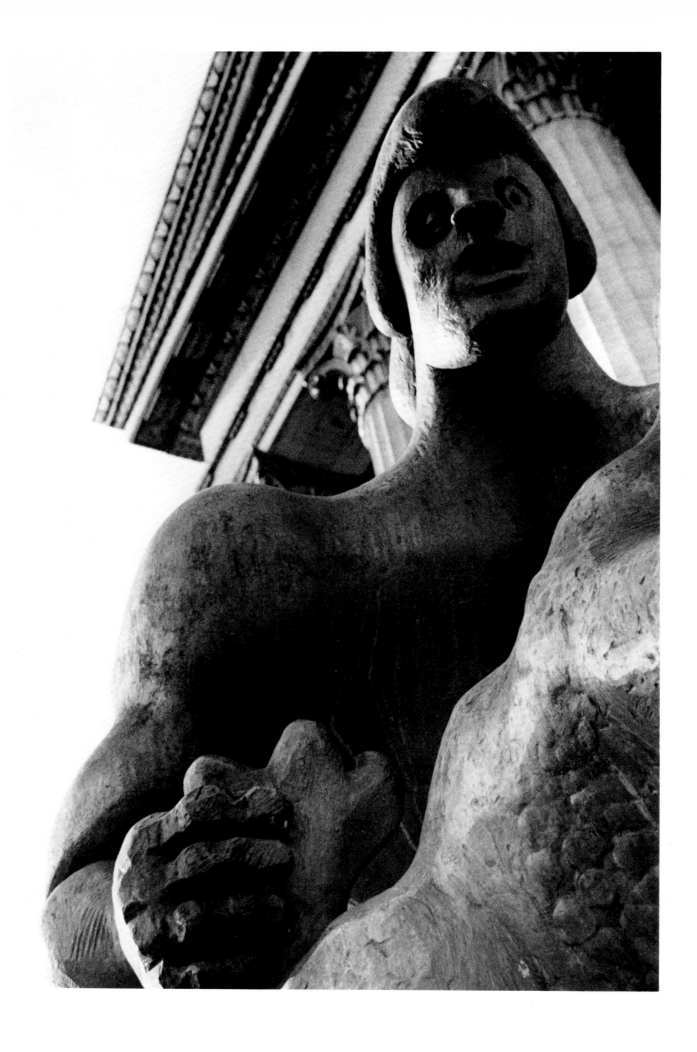

no contact with the male figure. In two others 11¼ and 16½ inches high respectively,[13] the man still peers ahead but he now touches the bird with one hand. A more unified effect is achieved by the use of swirling, seemingly plaited forms that represent the rocks on which the bird perches, the flying draperies, and the human figure itself.

The 31¼ inch study in the Tate Gallery, London, begins to approach the monument as finally executed. The eagle, which now stands on a pronouncedly phallic support, strains forward with wings outstretched, while the dynamic male figure which holds a caduceus in his left hand scans the horizon with his right.

In undertaking this subject Lipchitz returned to the kind of optimistic theme that the dire events of the 1930s and the war years had forced to remain dormant. For a brief period during the 1930s Lipchitz, like so many intellectuals, felt drawn toward the ideals, if not the practice, of communism. Dating from 1934 are a number of studies for monumental works on optimistic themes with socialistic overtones. Three studies for *Toward a New World*,[14] which date from 1934, represent pioneering spirits, one striding forward purposefully and carrying an unfurled flag, the other digging feverishly in the ground, the dynamism of the leftward movement recalling the great relief by François Rude on the Arc de Triomphe, *Le Départ des Volontaires*. The *Study for a Bridge Monument* of 1936 is organized along similar lines.[15] The nature of the theme proposed by the Art Association thus brought about the re-emergence of a kind of rhythmic organization that had long intrigued Lipchitz but that circumstances had forced him to deal with on only a small scale. This came, then, not as an imposition, as might well have been the case, but as an opportunity to express his admiration for the spirit of the founders of his newly adopted country.

The affirmative side of Lipchitz' personality had been only implicit in the themes of struggle that preoccupied him in the 1930s and the war years. Beginning with the *Virgin of Assy*, however, he felt confident enough on occasion to look beyond the symptoms of disorder to the sources of inspiration, spiritual and moral, that had prevented mankind from succumbing meekly to the onslaughts of Nazism. The hallucinatory equivalence

between man and bird that was such a striking feature of a number of works in the 1920s and 1930s had, in *Prometheus Strangling the Vulture*, become a struggle between the two. In *The Spirit of Enterprise*, which is surely a development of the Promethean theme and has on occasion been identified as such,[16] the battle has been won. Man and bird are united in their endeavor.

Lipchitz worked long and assiduously on this project. Delays occurred in 1955 as the casting of the *Virgin of Assy* required Lipchitz' constant supervision, but in January, 1956, the Association approved the model with which they were familiar from photographs and authorized the sculptor to proceed with the creation of the full-size model. In May, Lipchitz reported that he had brought his model of *Constructive Enterprise* "to such a point where only a kind of unification of all the elements is needed to finish it,"[17] although work was still going on in October. Instead of having his model enlarged mechanically, Lipchitz worked on the enlargement himself, making constant modifications, with the result that in October, 1957, at least a month's work remained to be done on the plaster.[18] The casting in twenty separate pieces, under Lipchitz' supervision, took well over a year and was not actually completed until July, 1960. At this point the title was officially changed to *The Spirit of Enterprise*. The unveiling finally took place in October, 1960.

Facing downstream, this looming man of dark bronze presents its most complicated aspect to the road. Seen from behind as one approaches the city along the East River Drive, the forms are highly ambiguous but rapidly assume legibility as the foreshortened view is replaced by a parallel one. Compared with the nebulous and highly suggestive dissolution of forms in the *Prometheus*, *The Spirit of Enterprise* is distinguished by its specificity and evenly distributed emphasis, rendered more apparent by its monumental scale. It is rooted firmly to the ground, although ready to spring forward, whereas the struggle between Prometheus and the vulture takes place in the upper air. In its vigorous, even dogmatic statement of forms, Lipchitz found the perfect equivalent for the quality he set out to celebrate, the Spirit of Enterprise.

Prometheus Strangling the Vulture. 1952
Philadelphia Museum of Art, East Court
Bronze, height 96″

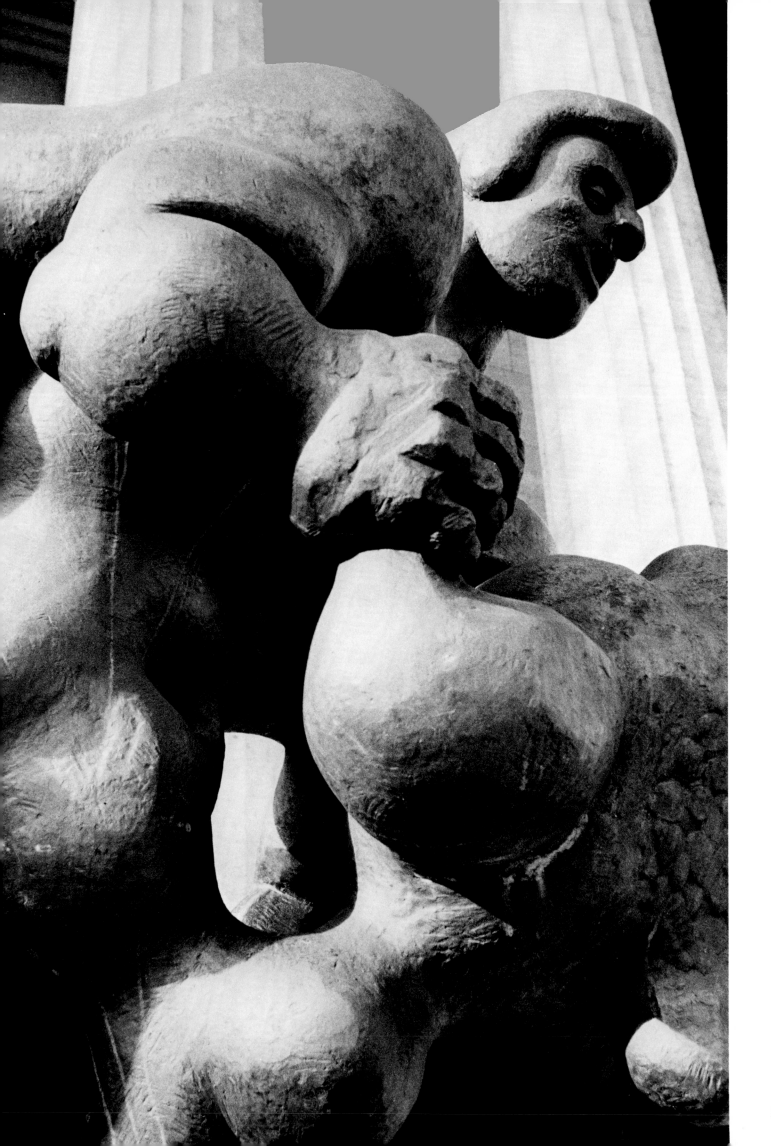

Social Consciousness

by John Tancock

*photographs by
Edward Gallob*

Now that Jacob Epstein is no longer a controversial figure, the degree to which his merits and defects as a sculptor were evenly matched is readily apparent and no more so than in *Social Consciousness*, the monumental group originally commissioned by the Fairmount Park Art Association to accompany Jacques Lipchitz' *Spirit of Enterprise* on the north terrace of the Ellen Phillips Samuel Memorial. The commissioning of this work was an important event in Epstein's career for, although he chose to think of himself as a monumental sculptor, he had received no public commissions for over two decades, the last having been *Night* and *Day* (1929) on the London Transport Headquarters Building in Westminster. In addition, it represented a return to the country of his birth, which he had left for France in 1902. In 1905 he moved to London and became an integral, although problematic, part of the English art world, his ties with America remaining purely personal.

Epstein was not, however, the first sculptor that the Association approached to represent the part of "America's dream...based upon communal welfare expressed in our hospitals, our missionary work, our university education, our Red Cross, and our very real sense of practical Christianity.... The major statue should be an idealization from the multitude of possibilities available. It might suggest brotherhood, the lack of class consciousness, the friendliness, humor, and kindliness

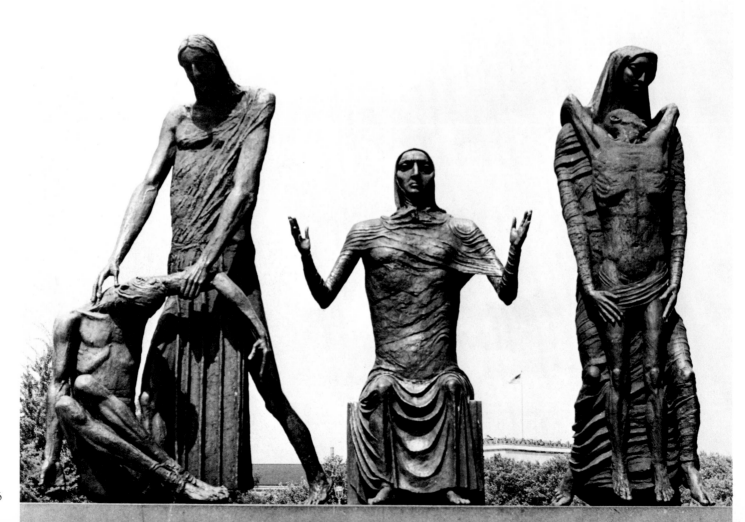

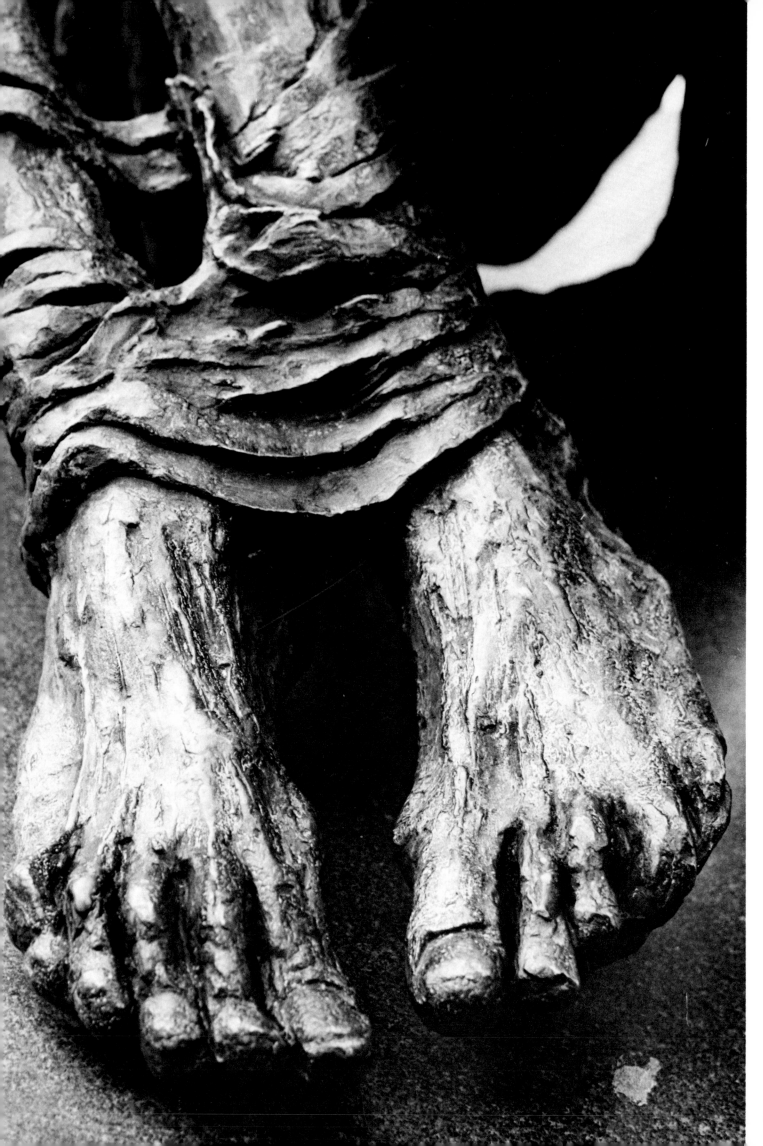

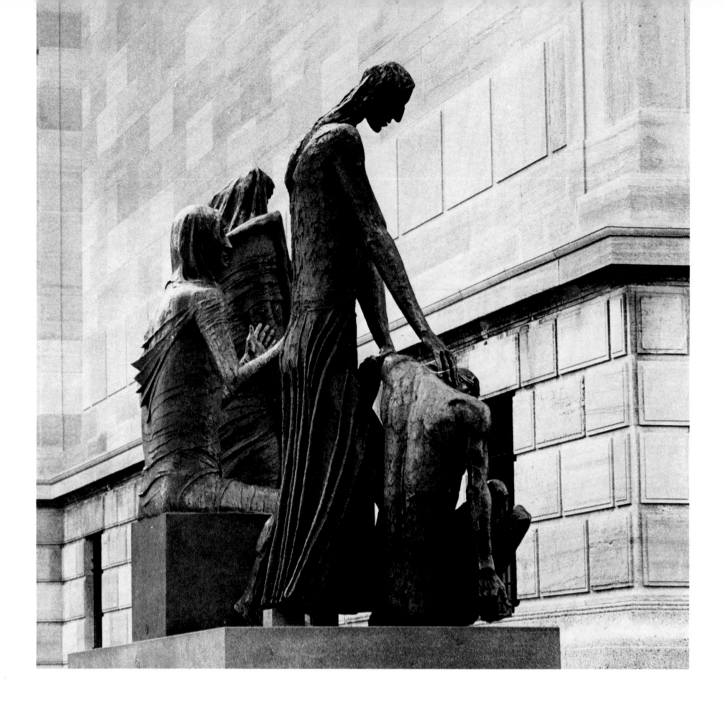

that are basically American.''[1] For an ideal theme of this kind it seemed that the German sculptor Gerhard Marcks would be eminently suited, and he was asked to submit a project in 1950. Marcks accepted the commission, not without trepidation,[2] but showed in both of his projects that his rather tame idealism, expressed for the most part in decorative nudes and animals, was not at all adapted to the representation of this kind of theme. Quite apart from the unconsciously humorous impact of this encounter between a matronly figure, clad in headscarf and short skirt, and a younger, apparently pregnant woman, the two verticals of which were too close in rhythm to the supporting figures of the ensemble,[3] the committee felt that Marcks had not done justice to all the ramifications of the scenario they had provided.[4] Consequently, he was informed that his final study was not acceptable and the committee had to look elsewhere. Curiously enough, they turned to a sculptor, Jacob Epstein, whose artistic personality, in its total lack of restraint and its flamboyance, was the complete antithesis of Marcks's.

Throughout his career Epstein had stressed the humanistic values of the art of sculpture, an emphasis that led on the one hand to the production of a series of portrait busts of members of his family and of celebrities of the time and on the other to monumental works in bronze and marble that represented traditional Christian subjects as well as themes of a more general nature. From the very beginning, when he provided a series of illustrations for Hutchins Hapgood's *The Spirit of the Ghetto,* Epstein had shown a fascination with human personality and with different human types. More emphatic in their characterization than Rodin's busts, Epstein's nevertheless reveal him at his best, responding to the still unformed features of his young daughters with as much enthusiasm as to the craggy features of *Admiral Lord Fisher* (1916) or *Joseph Conrad* (1924).

But Epstein was a man of catholic taste, appreciating not only the great moments of European sculpture, but also the tribal art of Africa and the South Seas. He was among the first to discover the aesthetic qualities of

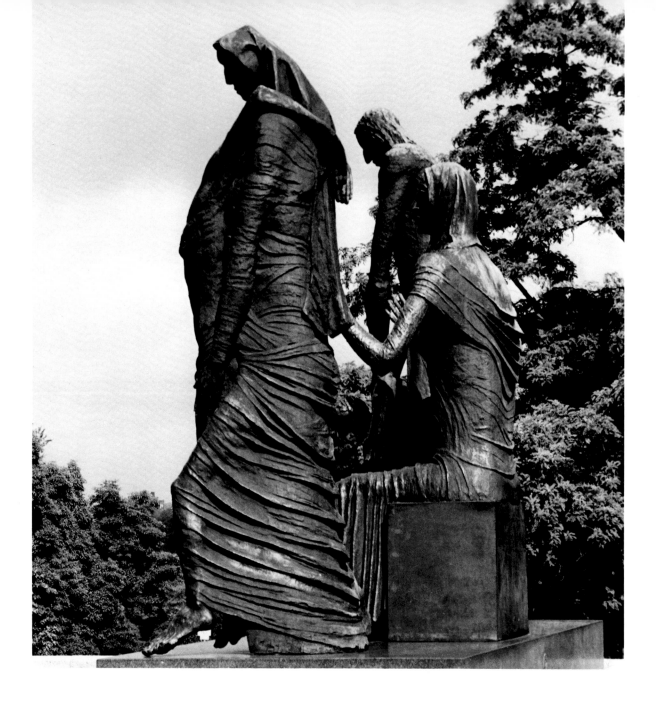

"primitive" art and began early to form a collection that has been equaled by few. The African influence was readily—too readily—apparent in a number of carvings of 1913 *(Cursed be the day whereon I was born, Mother and Child,* the carvings in Flenite, and the two versions of *Venus)*, although in the later carvings the specific references to African art were eliminated, that massive simplicity of style that relates to earlier, pre-Renaissance modes of stone carving characterizing works like *Genesis* (1930), *Adam* (1938), and *Ecce Homo* (1934). No longer capable of shocking, these works now seem merely overemphatic and not a little vulgar.

Unfortunately, the wide disparity of style between the modeled portrait busts and the carved sculptures was not limited to works in different media. Frequently, within a single work, the separate parts were related not by sculptural necessity but by the artist's will. Epstein had very little feeling for the organic flow of the body, a serious defect considering that for the greater part of his career he was a vociferous exponent of naturalism. In his

full-length works the bust is generally better than the body, and the head is generally better than the bust. His repertoire of gesture was severly limited, tending to the posed and mannered—e.g., *Meum with a Fan* (1918), *Betty Peters* (1939), *Fifth Portrait of Kathleen* (1935)—with the result that most of his full-length figures have a curiously uncoordinated air about them, such as *Youth Advancing* (1951) and *The Liverpool Giant* (1956).

Epstein did, however, have another monumental style that minimized his defects and accounted for the production of some of his best works. *The Tomb of Oscar Wilde* (1912), which was executed at a time when Epstein was seeing a great deal of the Parisian avant-garde, especially Modigliani, and which represents a sinister-looking angel gliding forward on massive wings, shows that he had a considerable gift for decorative stylization. In later works—*Lazarus* (1947), the Cavendish Square *Madonna and Child* (1951), and the *Christ* for Llandaff Cathedral (1957)—Epstein reduced the suggestion of body to a minimum, hiding it behind funerary cerements in the

Lazarus and stylized draperies in the two later works. Suspended against background walls, the *Madonna and Child* and the *Christ* are reduced to iconic images, powerful and highly effective in their religious context.

In approaching Epstein, the Fairmount Park Art Association was taking a certain risk, since his public works, from the time of the unveiling of the Strand statues on the British Medical Association Building in 1908, had always given rise to heated controversy, especially those carved in the "primitive" style. Disregarding this possibility, the committee sent Epstein the scenario of the memorial in October, 1950. Although work he was doing for the Festival of Britain prevented him from replying until the following February, he soon warmed to the idea, feeling that "the scope of the ideas involved" demanded a group rather than a single figure "to express all that is implied in the recommendations."[5] He made three small studies about this time—a *Warrior with Sword*, a *Mourner*, and a *Seated Mother*—only the maternal figure being retained in the final version. The completed contract having been returned on June 21, 1951, Epstein commenced work on the central figure, using the small maquette of a seated figure with outstretched arms as his model.

Throughout his career Epstein had been obsessed with themes of fertility and maternity, his works on these subjects ranging all the way from the grossness of *Maternity* and *Genesis* to the idealized and highly successful naturalism of the 1927 *Madonna and Child*. By the time he received the commission for *Social Consciousness*, work was already far advanced on the Cavendish Square *Madonna and Child*, and it was in this hieratic style that he conceived the seated figure. This is no longer the maternal image of *Genesis*, expressing "the profoundly elemental in motherhood, the deep down instinctive female,"[6] but one approaching more closely Walt Whitman's "grand, sane, towering, seated Mother,/ Chair'd in the adamant of Time," one of the phrases that the committee originally planned to incise on the stone, although in the event it was not. Nonetheless, Epstein seems to have allowed his image to be shaped by this phrase, which must have been communicated to him during his preparations. He later referred to it as *The Eternal Mother* or *Destiny*. "To my mind," he wrote, "this figure will have an aspect of Eternity, and I hope you will think so."[7]

As is the case with nearly all the monumental figures, *The Eternal Mother* consists of a portrait mounted on a body that was clearly of secondary interest to the sculptor. Epstein revealed his priorities very distinctly in a description he gave of his work on the *Risen Christ* of 1917. The suffering head of his friend Bernard Van Dieren reminded him of Christ. "With haste I began to add the torso and the arms and hand with the accusing finger. This I then cast and had, as a certainty, the beginning of my statue. So far the work was a bust. I then set up this bust with an armature for the body. I established the length of the whole figure down to the feet. The statue rose swathed in clothes."[8] Likewise, the head of the

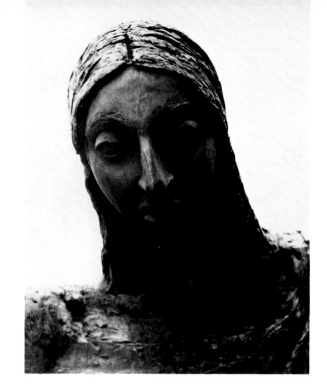

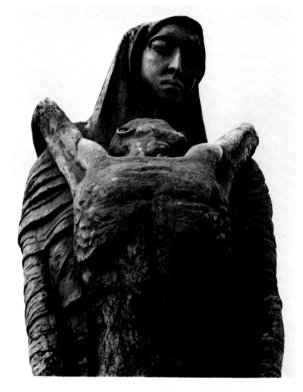

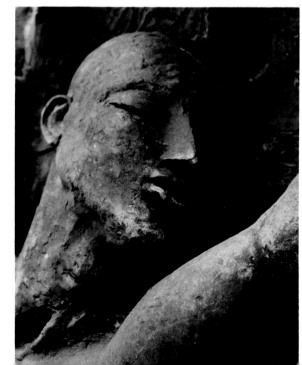

Mother was based on that of one of his favorite models, Sunita, who posed for the *Madonna and Child* in 1927, and whose features were used in *Lucifer* of 1943–45. Unfortunately, to the contemporary viewer the stylization of the whole figure is not sufficiently rigorous to prevent the upsurge of certain frankly irrelevant questions, such as what would she look like if she were to stand up? The disproportion between the immense shapeless torso and the angular, sticklike limbs remains merely disconcerting.

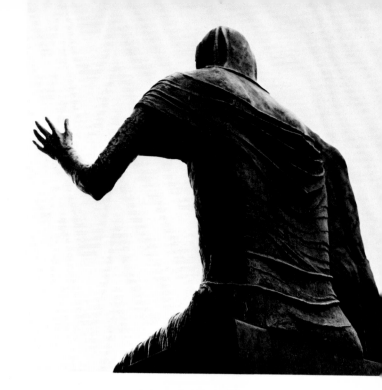

The two flanking groups are much more successful. Epstein did not start work on these until May, 1952, when the seated figure was being cast in plaster, his solitary working habits and the crowded state of his studio preventing him from working on more than one figure at a time. "The group to the left of the...seated figure is a great 'Consoler,' a gentle and saving hand extended to help the afflicted and downhearted of the world," he wrote in September, 1952.[9] Prior to this group, Epstein had shown little or no interest in the spatial complexities that rose from the relationship between two or more figures. In the rare works that do not represent an isolated figure—*Night* and *Day* (1929) and *Jacob and the Angel* (1940)—the physical proximity of the human forms is so close that the unitary impact of the sculptural mass is not broken, the desire to retain this deriving ultimately from Epstein's understanding of primitive sculpture. The striking ease with which he handled the relationship between the two figures in the *Great Consoler* group makes one wish that he had attempted such groups more frequently.

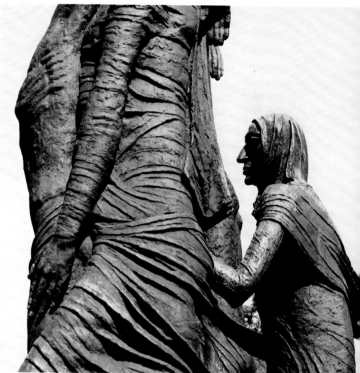

While the second group was being cast in plaster, Epstein started work on the third, which he originally thought of as one of "gladness and optimism, giving a new facet to the drama of the whole work."[10] Eight months later he described the group, which consists of a draped standing female figure supporting at the hips a loincloth-clad youth who bends backwards to clasp her shoulders, as "a mother receiving her man child, a figure supported ...who turns finally with utmost surrender to those powers that guide and support us."[11] Elsewhere he referred to it more specifically as death. "I have attempted to depict the idea of Death receiving mankind...mankind being received by a draped and cowled figure."[12] For the head of Death, Epstein followed the features of Marcella Barzetti, which he had used for the Madonna in the Cavendish Square group, although the curious relationship between the two figures looks back to a much earlier group, *Day* (1929), in which the naked boy stands with his back to his father while straining to embrace him.

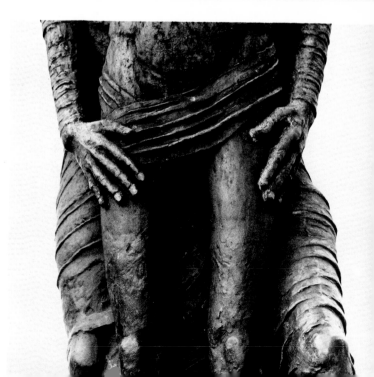

The casting of the group took place during 1954 and was finished by November. It soon became apparent to the committee, however, that the location originally determined upon between the Schuylkill and the East River Drive was far from ideal. It was felt that a full understanding of its message required "contemplative repose,"[13] and that this was not a state of mind that could be achieved while driving past at forty miles an hour. Epstein felt that a background of rocks of the kind he had seen in Fairmount Park would be appropriate as "it would

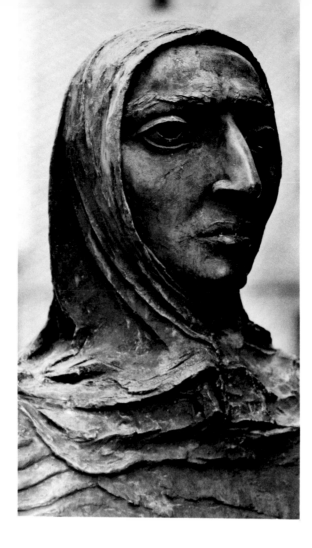

add to the feeling of permanence that the group should have."[14] Consequently, it was decided to place the group in a temporary location prior to its final placement, on the northern end of the terrace at the west entrance of the Philadelphia Art Museum, facing south. This site showed off the monument to such advantage that it was decided to leave it there. It was unveiled in 1957 and has remained on the same site ever since.

Epstein believed *Social Consciousness* to be his major work, at least during the time he was working on it, and the reasons for this are not hard to deduce. For a brief period in his career, he associated with exponents of the most radical art of his time. From 1912 to 1915 he shared the same concerns as Modigliani, Brancusi, Lipchitz, and Gaudier-Brzeska, advocating direct carving as the only really effective way to cleanse sculpture of its impressionist heritage. In spite of the declared similarity of aim, however, Epstein never went so far as to investigate formal problems for their own sake. Subject matter was important to him even during this brief interlude. By the end of World War I it had become of prime importance, and by 1950 he was totally out of sympathy with all forms of abstraction. "It isn't sculpture at all," he said, "because sculpture iş an art of form, of human form. What the 'pure form' is that they keep talking about I don't know. They are merely devising machinery and constructions in which they seek for novel effects."[15] He saw himself now as a survivor from a sturdier generation, maintaining single-handed the

prophetic and didactic role of the sculptor in an insane society. His utterances on this subject now have rather a quaint ring to them. "If it were possible," he wrote in December, 1954, "I would like my sculpture to point the way out of the present morass. That I am compelled to do so single-handed is a great pity but I am convinced I can do it."[16]

The Philadelphia commission must clearly have filled Epstein with delight. Here was a subject into which he could sink his teeth, a dignified statement of a number of interlocking themes vital to the smooth functioning and moral well-being of society. It was the kind of undertaking for which he had always hoped, but to which it now seems that he was far from being suited. Epstein was at his best when he was least ambitious, as in his portraits, or when he worked in a style that minimized his defects as a figural sculptor (the "hieratic" style). Twentieth-century sculptors have, on occasion, produced great portraits, but Epstein is one of the very few declared portraitists to have produced numerous likenesses that are also considerable works of art. Some of the pieces on religious themes—the *Madonna and Child* (1927), the *Lazarus* (1947), the Cavendish Square *Madonna and Child*—may also be counted among the most successful works of Christian art produced in this century. The necessity of interpreting themes that had been defined through centuries of tradition imposed restrictions on the sculptor that proved to be entirely advantageous.

The theme of *Social Consciousness*, on the other

hand, gave him too much scope. He interpreted the abstract subject matter in terms of the emotive iconography derived from his earlier work and the result was a very curious coupling. Had the equation been entirely successful from a sculptural point of view, the frankly irrelevant question of the theme would not have been at issue, but the juxtaposition of the three groups demands an explanation that is not provided in the sculpture itself. As it is, they are linked only by the literary ideas of the scenario as interpreted by Epstein, and none too convincingly at that. Epstein was a solitary worker, used to carving his marbles single-handed and to working with a minimum of assistance in the studio. He worked on each of the groups—*Compassion*, *The Eternal Mother*, and *Succor* (or *Death*)—individually, and this is only too apparent in the way they relate, or fail to relate, to each other on the pedestal. as is the case with most of Epstein's work, *Social Consciousness* is the sum of a number of parts, some of which are very fine, but which do not add up to a convincing whole. Given the nature of the commission, however, it is open to question if the results would have been different in the hands of any other sculptor.

Jacob Epstein (1880–1959)
Social Consciousness. 1955
Philadelphia Museum of Art,
West Entrance
Bronze, 146″
(granite base 27½″)

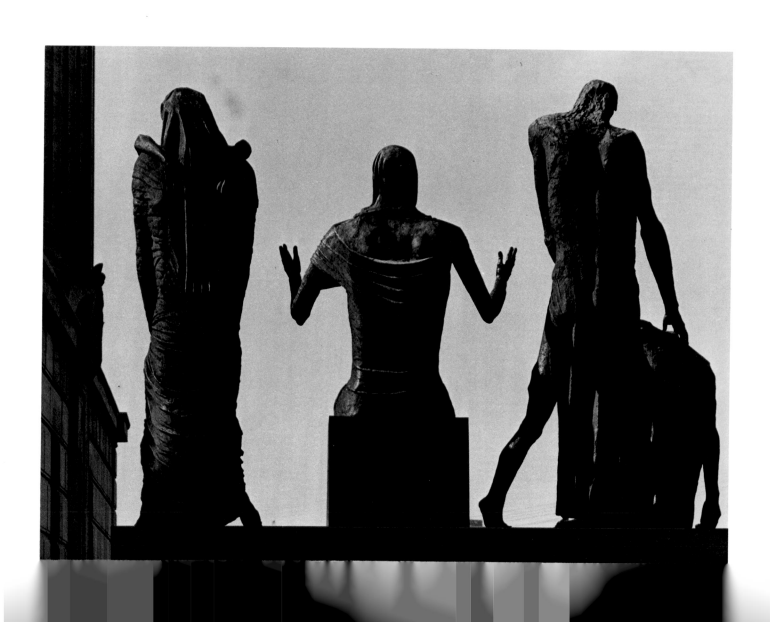

Albert Laessle (1877–1954)
Billy. 1914
Rittenhouse Square
Bronze, height 26″ (granite base 22″)

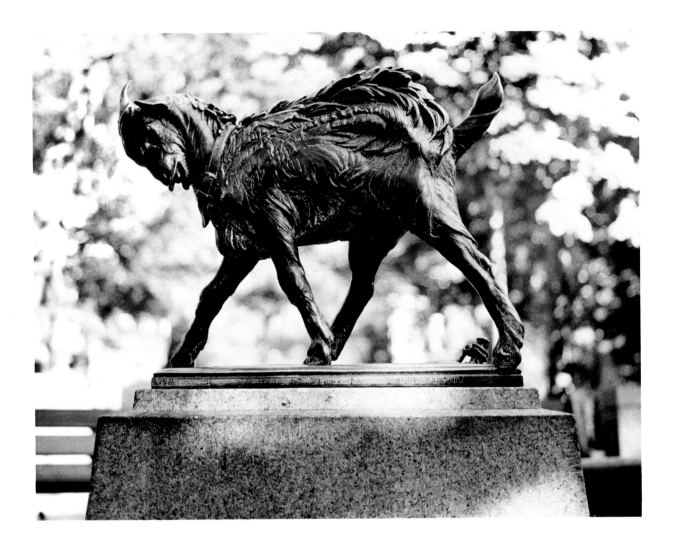

While a student under Charles Grafly at the Pennsylvania Academy of the Fine Arts, Laessle established his reputation for small animal sculpture. In an interview he later recalled: "One day one of the boys in the class brought in a ten pound snapping turtle for Mr. Grafly's dinner....I borrowed it, and became so much interested that I decided to use it in a composition....I conceived the idea of a struggle between a turtle and a giant crab over the body of a dead crow." When this work was exhibited at the Art Club, he was accused of casting from life. Undaunted, he made a wax of the turtle and silenced his critics. This piece, *Turtle and Lizards*, was subsequently cast in bronze and exhibited at the Loui-

siana Exposition in 1904.

His billy goat was inspired by a family pet, the incorrigible scavenger of the family grounds, and was given to the city by Eli Kirk Price II through the Fairmount Part Art Association. An article in *The Studio* (1924) described *Billy* as "safely tethered, and in the sobriety of bronze, in one of Philadelphia's most beautiful breathing spaces—Rittenhouse Square. The children who frequent this square can never forego a ride on his back, and the little hands clasping his horns have entirely rubbed the patina from the bronze, so that the points appear to be tipped with gold."

R. Tait McKenzie (1867–1938)
The Rev. George Whitefield. 1918
University of Pennsylvania,
Men's Dormitory Quadrangle
Bronze, height 96″ (limestone base)

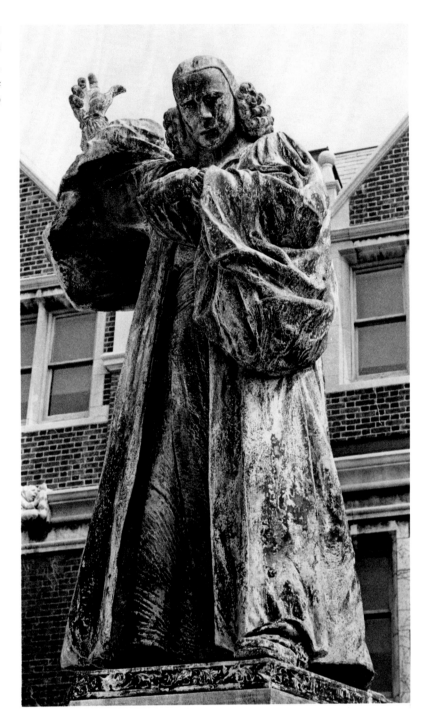

Whitefield (1714–1770), the celebrated revivalist, was a zealous advocate of education in the American colonies. The Charity School of 1740, to which the University of Pennsylvania traces its beginnings, was a fruit of his ministry, and the chapel built for him that year has been considered the scene of the University's foundation. His statue, commissioned in 1914 by Methodist alumni of the University, was dedicated on June 15, 1919.

McKenzie, its sculptor, was born in Ontario, received the degree of doctor of medicine from McGill University, and in 1904 became professor of physical education at the University of Pennsylvania. While holding that post, he pursued a distinguished career as a sculptor.

A curious episode concerning his *Whitefield* links it to a similar occurrence in the life of the great preacher who was once denied the use of a church on the excuse that the crowds he would attract might damage its interior. Similarly, when McKenzie's *Whitefield* was considered for exhibition at the Pennsylvania Academy, it was rejected because of its "unusual proportions and weight and the possible danger to the building if it were moved in." There were those who thought the rejection was based on the fear that it would dominate the exhibition because of its dramatic force.

Einar Jonsson (1874–1954)
Thorfinn Karlsefni. 1915–1918
East River Drive,
Boat House Row
Bronze, height 88″
(granite base 67″)

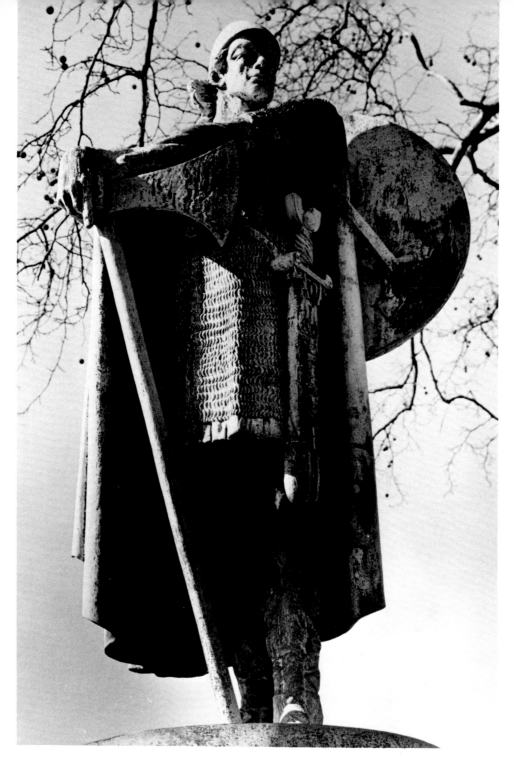

Ellen Phillips Samuel's munificent bequest to the Fairmount Park Art Association for sculptures "emblematic of the history of America" is described elsewhere in this volume. To supplement her liberality, her widower, J. Bunford Samuel, presented this statue of an Icelandic hero as the first work in a vast historic program. Little is known of Karlsefni except what is recorded in the Saga of Eric the Red, in which he appears as an intrepid explorer and a leader of men.

Mr. Samuel engaged in extensive research on Karlsefni and engaged Einar Jonsson to create an ideal image of him, since no portrait was extant. Born in Reykjavik, Jonsson studied at the Royal

Academy in Copenhagen for two years and then in Rome, where he acquired a thorough knowledge of classical sculpture. He was living in Iceland, working on commissions for European patrons, when World War I broke out.

On behalf of the Fairmount Park Art Association, Charles Cohen on November 20, 1920, when the statue was unveiled, praised "the generosity of the donor in thus himself beginning the work of erecting the memorial not only by his addition to the funds available [but also] the service he has rendered by his initiative with his advice and counsel in determining the character of the memorial and of the actual completion of this noble statue."

Albert Laessle (1877–1954)
Penguins. 1917
Philadelphia
Zoological Gardens,
entrance to Bird House
Bronze, height 25″
(marble base 37″)

Wayne Craven has described the charm of this sculptor's work: "Laessle could find a kind of drama and humor amid life in the barnyard, and his small bronzes became quite popular for their charming expression of animal personalities; this came from an intimate knowledge of their ways." He studied at the Pennsylvania Acadaemy of the Fine Arts (where he later taught, 1921–1939) and in Paris. Returning from Europe, he maintained a studio near the Zoo, where he could observe animals. His work brought him much well-merited recognition: a bronze medal in Buenos Aires in 1910; the Pennsylvania Academy's fellowship prize in 1915; the first sculpture prize at the Americanization Through Art exhibition in Philadelphia in 1916; and the George D. Widener memorial gold medal at the Pennsylvania Academy in 1918.

It was in 1918 that the original bronze *Penguins* went on exhibition at the Academy. Four replicas were also made, and one of these was purchased in 1918 by the Fairmount Park Art Association for $1,000.

R. Tait McKenzie (1867–1938)
Young Franklin. 1914
University of Pennsylvania,
33rd Street between Spruce and Walnut
Bronze, height 96″
(limestone and granite base 71″)

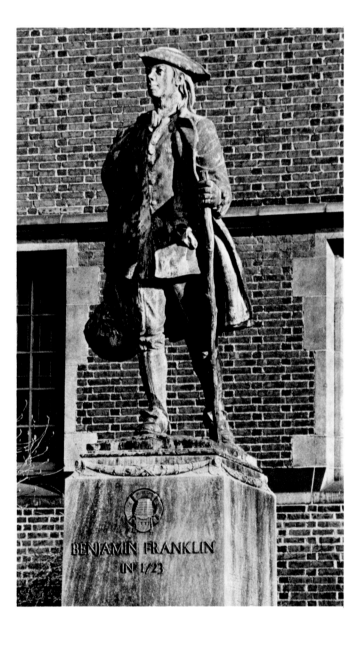

Franklin's portrait as a young man was thought to be appropriate as an example to the students who attend the University he founded. The concept of his statue is described by Christopher Hussey, McKenzie's biographer: "On leaving his brother's employ in 1723, Franklin came to New York by water, and thence to Amboy, sleeping all night in the boat. In his autobiography he describes his walk from there to Burlington and his arrival in Philadelphia on a Sunday morning." Franklin's words summarizing this are inscribed on the statue's pedestal: "I have been the more particular in this description of my journey, that you may compare such unlikely beginnings with the figure I have since made there."

The other inscription on the base, which was designed by Paul Cret, reads: "This memorial dedicated at the 10th reunion of the Class of 1904 is a tribute to the inspiration and example of the founder of the university to many generations of the sons of Pennsylvania." Commissioned in 1910, the *Young Franklin* is McKenzie's first attempt at commemorative sculpture. Its head is based on the bone structure of Houdon's bust of Franklin, but is rendered youthful. The figure was modeled in clay from a nude, directly from life, so that the rhythm of walking would be convincing.

Albert Jaegers (1868–1925)
Pastorius Monument. 1917
Vernon Park, Germantown
Marble, height 324″
(marble and granite base)

The village of Germantown was founded in 1683 by Francis Daniel Pastorius, who settled there with thirteen families from Crefeld, where they had been persecuted for belonging to the Mennonite sect. This "Founder's Monument" was a joint commission sponsored by the German-American Alliance, which donated $25,000, and the United States Congress, which matched that amount. The competition for the monument was won by J. Otto Schweizer, with Jaegers second, but after the Commission on Fine Arts ordered both sculptors to remodel Jaegers won first place. German-born, he had come to America in 1882. Among his best-known commissions were the statues for the Fine Arts Building in St. Louis, the Customs House in New York, and his *General von Steuben* in Washington.

World War I delayed the unveiling of the Pastorius Monument, which was to have been in May, 1917. The government dissolved the German-American Alliance and the monument was held in storage in the War Department. There was much feeling against it for it was regarded as German propaganda, and the opinion was expressed that it would be better to display captured German cannon instead. Finally, on November 10, 1920, Mayor J. Hampton Moore accepted the monument for the city. Criticism continued, however, and in 1933 the Germantown Historical Society tried to get it taken away because it was "crude, gross and meaningless either as art or history." During World War II it was once again removed from view, but it continues today a familiar Germantown landmark.

Beatrice Fenton (1887–)
Seaweed Girl Fountain. 1920
Lemon Hill Drive, East Fairmount Park
Bronze, height 61″ (natural rock base 35″)

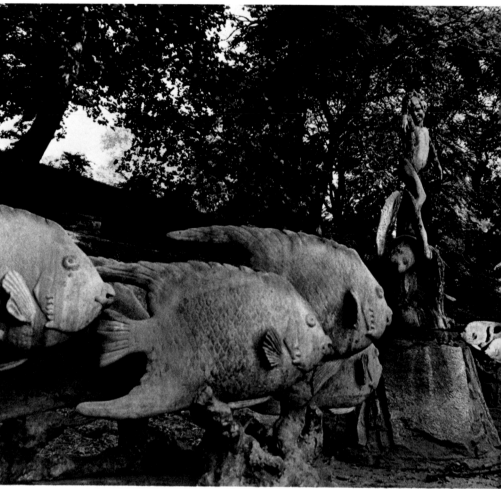

Beatrice Fenton, a Philadelphian, is the daughter of Dr. Thomas Hanover Fenton, who was a close friend of Thomas Eakins. She studied at the School of Industrial Art (now the Philadelphia College of Art) and later at the Pennsylvania Academy of the Fine Arts, where she took the Stewardson and Cresson prizes in 1909–1910.

In 1921 Edwin F. Keene, a director of the Stetson Hat Company, wrote the Art Jury of the Fairmount Park Art Association: "Some time ago, I gave Miss Beatrice Fenton a commission to model a fountain figure suitable for the centre of the pond at the foot of Lemon Hill, at Poplar Street. She has completed the plaster cast which she has at her studio, 1523 Chestnut Street. I am desirous of presenting this figure completely mounted in the pool to your Association." Duly accepted, the piece is signed "Beatrice Fenton Sc 1920, Bureau Brothers, founders."

This lively little girl poised on the back of a sea porpoise was awarded the Pennsylvania Academy's Widener Gold Medal in 1922 and won a bronze medal in 1926 at the Sesqui-Centennial. In 1961 the Fairmount Park Art Association commissioned the sculptress to add to the pond, in which the Seaweed Girl was placed, two groups of angel fish swimming through bronze coral reefs. Placed there in 1963, they spray their jets of water from their mouths and complete the ensemble.

Hermon Atkins MacNeil (1866–1947)
Civil War Soldiers and Sailors Memorial. 1921
Benjamin Franklin Parkway at 20th Street
Marble: height of both pylons about 480″ (granite bases)

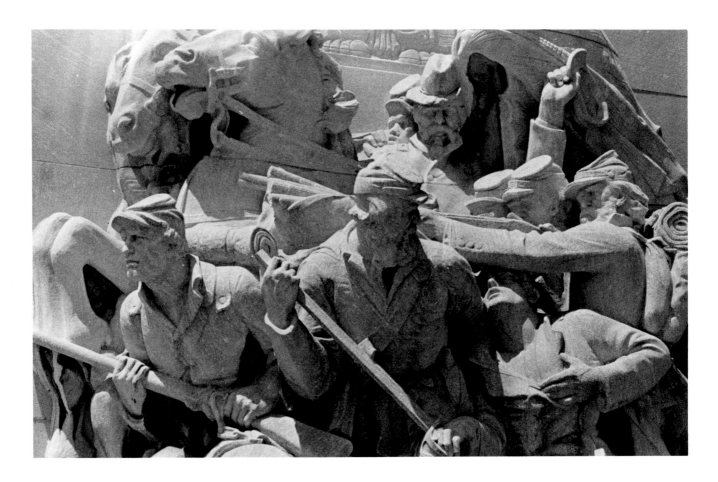

Actuated by a burst of patriotism during World War I, the City of Philadelphia in 1918 appropriated funds for a Civil War memorial estimated to cost $88,000. Hermon Atkins MacNeil was chosen as sculptor, Lord and Hewitt of New York as architects, and Piccirilli Brothers were the stone carvers.

MacNeil had trained at the State Normal Arts School in Massachusetts, had taught modeling at Cornell University, and had then sought further training in Paris. On his return to America in 1891 he was engaged by Phillips Martiny to work on the sculpture for the Chicago Columbian Exposition. At Chicago, and later at Rome, he became fascinated with the subject of American Indians, but on his subsequent return to America commissions for monuments and war memorials replaced his absorption with the natives.

His two pylons were placed at the entrance of what was to have been called the "Parkway Gardens" for which they were conceived as an impressive gateway. The figures on the pylon to the left dedicated to Sailors are 132″ in height, while those to the right, dedicated to Soldiers, are 156″ high. In 1954–1955, the pylons were moved to accommodate the expressway, but they continue dramatic hallmarks of the Benjamin Franklin Parkway.

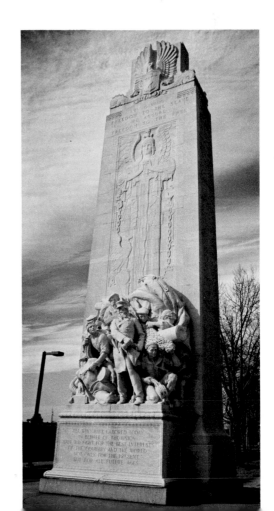

Paul W. Bartlett
(1865–1925)
Robert Morris. 1923
Second Bank of
the United States,
Library Street
Bronze, height 114″
(limestone base)

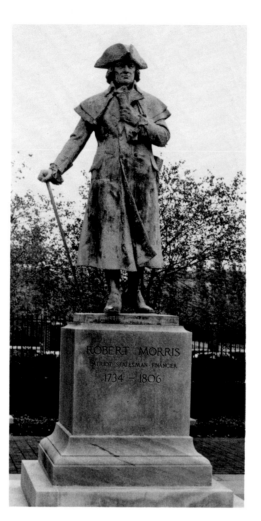

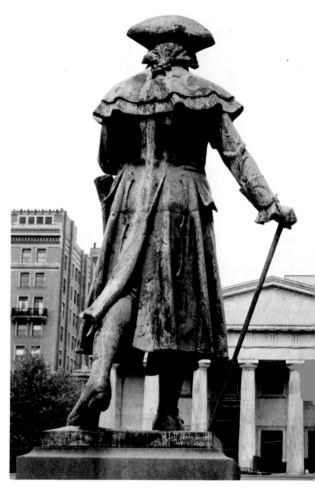

As early as 1897 a memorial committee was formed to honor Robert Morris, an effort sponsored by a group of Welshmen in South Wales and the Bankers' Association of Pennsylvania. By about 1911 it had raised some $10,000, a figure augmented by an appropriation of $21,000 by the legislature. The chairman of the Memorial Committee was Roland Taylor who was also a trustee of the Fairmount Park Art Association. These groups approved the awarding of the contract to Richard E. Brooks of Washington in 1915. On his death two years later, the commission went to Bartlett who devoted a year of intensive study to Robert Morris. He rejected Brooks' sketch and executed the present figure which shows "Morris struggling through the snow to raise funds for Washington's troops at Valley Forge.

The manuscript protruding from his pocket represents the subscription list which he obtained. It amounted to $1,400,000, a sum which enabled the Americans to gain the victory at Yorktown." The statue was completed shortly before Bartlett's death and was cast by Limerick Brothers in Baltimore in 1925. Its base was cut by Piccirilli Brothers of New York. Unveiled on June 18, 1926, on the Chestnut Street steps of the Second Bank of the United States, it was moved in 1961 to a site south of the bank.

Born in New Haven, Bartlett spent most of his life in Paris, where he attained renown. His statue of Lafayette (1908) in Paris, a gift of American school children, was his first public monument. He is perhaps best known for his pediment on the House Wing of the Capitol in Washington.

Alexander Stirling Calder (1870–1945)
Gate Posts and Fountain. 1920s
University Museum, 33rd and Spruce Streets
Insignia, marble, height about 54″, width 213″, wall-mounted;
fountain, marble, height 115″ (marble basin); _Africa_, granite,
height 76″; _America_, granite, height 67″; _Asia_, granite, height 67″;
Europe, granite, height 67″; all four statues are mounted
on brick and granite bases about 228″ high.

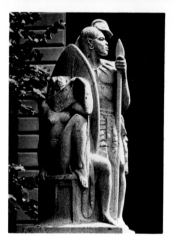

The University Museum had its beginnings in 1893, when it was known as the Free Museum of Science and Art. Its first main wing, completed in October, 1915, was designed by Wilson Eyre, Frank Miles Day and Cope and Stewardson. The east wing was added in the 1920s by the same group of architects and included the handsome gates and fountain.

The architects, sculptors, and craftsmen who created this wing were closely associated professionally as members of Philadelphia's T-Square Club. Alexander Stirling Calder was asked to do the sculptural embellishment, Nicolo D'Ascenzio the stained glass and mosaics, and Samuel Yellin the wrought iron work. Calder's Gates display four sculptures emblematic of the continents—Asia, Europe, Africa and America—and thus suggest the scope of the Museum's collections. The fountain relief shows two birds drinking beneath a mask. In

1931, Calder instructed Wilson Eyre and Gilbert McIlvaine concerning the placement of the figures as follows: "In regard to the facing of the groups on the gate posts at the Museum, I thought very strongly at the time and still think that for that particular building, considering its use as housing collection…is well expressed by the wall shutting off the street, that these groups should face, as they do, the forecourt and the building.…The street is so comparatively narrow and blocked by the stadium, so there is practically no approach, which would be the only excuse for facing them out (north) like soldiers on parade. Another reason for facing them south was that they receive _sunlight in front_ and their background is better. The composition is unique." Calder and the architects had planned the entrance with skill and taste, and that scheme remains unaltered today.

Alexander Stirling Calder
(1870–1945)
Shakespeare Memorial. 1926
Logan Square,
Parkway near 18th Street
Bronze, height 72"
(black marble base 170")

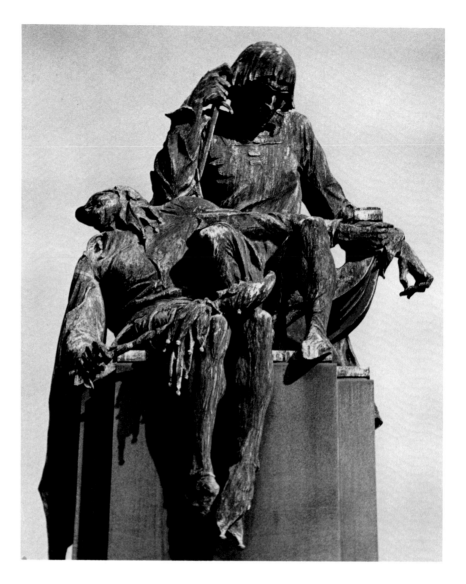

This dramatic memorial is situated near Calder's Swann Memorial Fountain of 1924. Much smaller in scale, it is less formal than the three large figures in the Logan Square basin. The subject, more complex than the usual bust or standing figure of Shakespeare, depicts Hamlet leaning his head against a knife with the jester Touchstone at his feet, his head thrown back in laughter. The two figures represent Tragedy and Comedy. Inscribed on the base are the lines from *As You Like It:* "All the world's a stage, and all the men and women merely players." On the reverse side are listed ten actors, including three Drews who performed Shakespeare in Philadelphia, as well as the names of three distinguished Philadelphia scholars—Joseph Dennie, Horace Howard Furness, and Horace Howard Furness, Jr.

The concept for a memorial to the great playwright dates from 1892 when John Sartain wrote to the Fairmount Park Art Association in the name of the Saint George's Society (he was a member of both organizations), proposing that private and public subscriptions be solicited to be called the Shakespeare Memorial Fund. By 1917 enough money had accrued so that J. Massey Rhind offered his services

as a sculptor. However there was no competition and the commission went to Alexander Stirling Calder with Wilson Eyre and Gilbert McIlvaine as architects. The contracts were signed on August 1, 1919. Overseeing the project were the Shakespeare Memorial and the Fairmount Park Art associations. The site was carefully worked out by Eyre and McIlvaine, Paul Cret, and Jacques Gréber, who were then drawing the plans for the Parkway and the buildings along the boulevard, and was approved by the Philadelphia Art Jury in 1926. Appropriately, the Shakespeare Memorial was placed on a main axis in front of the Free Library which had been designed by Horace Trumbauer (1868–1938).

Calder's figures (90% copper, 7% tin, 3% zinc) were cast by the Roman Bronze Works, New York, between July and November of 1926 at a cost of $4,875. Their one-quarter size model in bronze is at Brookgreen Gardens, South Carolina. Dedicated on Shakespeare's birthday in April, 1929, Calder's work was uprooted from its carefully planned site in 1953 to make way for the Vine Street extension of the expressway. Moved thirty feet due south, it remains one of his masterpieces.

Gaston Lachaise (1886–1935)
Floating Figure. 1927
3rd and Locust Streets
Bronze, height 51¾", length 96" (marble base 96")

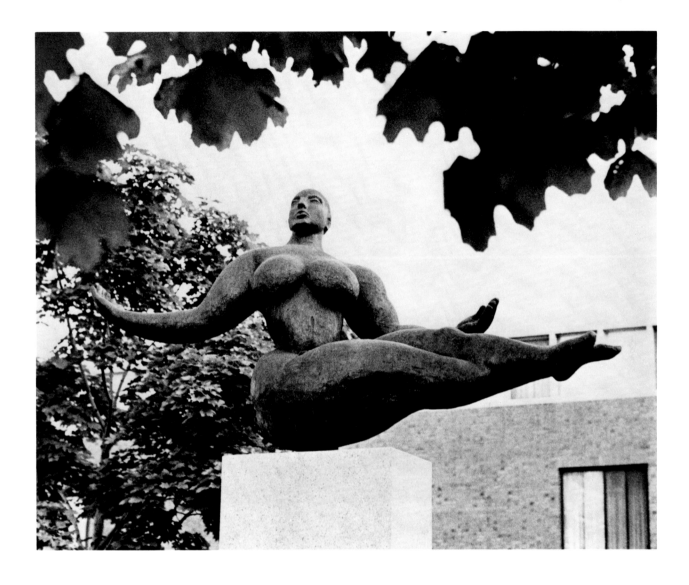

Born to a family of cabinetmakers, Lachaise's style stemmed from his French Beaux Arts training on the one hand and the tradition of Rodin's heroic sculpture on the other. He did not reach maturity as an artist until after his arrival in America in 1906.

According to Hilton Kramer: "What brought Lachaise to America was an encounter, while still in Paris, that changed the course of his life. 'At twenty, in Paris,' Lachaise later wrote, 'I met a young American person who immediately became the primary inspiration which awakened my vision and the leading influence that has directed my forces.' This 'young American person' was Isabel Nagle, the Boston lady whom Lachaise followed to America and later made his wife. It was she who became his model, his muse, and his abiding inspiration.... Both the eroticism and the monumentality of his art, and especially their combination in certain works that have still not lost their power to shock, owe a great deal to the peculiar rapture this 'young American person' sustained in Lachaise's life to the very end."

The *Floating Woman* of 1927, now in the Museum of Modern Art, New York, contains the typical exaggerations of his female sculptures that recall somewhat the carvings on ancient Indian temples. Through negotiations conducted by R. Sturgis Ingersoll with the foundation that controlled the rights to the sculpture, a second casting was acquired in 1963 for the Society Hill Town House development designed by the architect Ieoh Ming Pei, and sponsored by the Alcoa Corporation and the Redevelopment Authority. This heroic sculpture is an excellent example of Lachaise's remarkably original style—an exaltation of the flesh.

Carl Paul Jennewein (1890–)
Pediment. 1932
Philadelphia Museum of Art, north pediment
Polychrome terra cotta, height 144″, length 840″

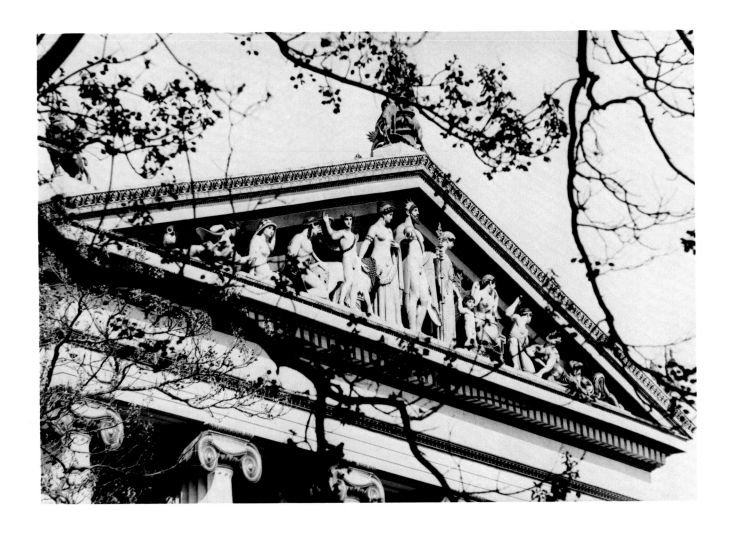

Jennewein was born in Stuttgart, Germany, and emigrated to the United States in 1907. He studied at the Art Students League, 1908-1911, and won the Prix de Rome in 1916. The impact of classical sculpture on his style was profound and, as a result, Jennewein developed a decorative and highly stylized oeuvre similar to that of Paul Manship. In 1932 he won the Widener Gold Medal at the Pennsylvania Academy of the Fine Arts for his war memorial for Tours, France. His architectural sculpture earned him several medals from the Architectural League for such commissions as the door of the British Empire Building in Rockefeller Center, New York, figures for the Department of Justice Building in Washington, and the program for the Philadelphia Museum of Art. In 1927 he was given the architectural medal of honor at the Architecture and Allied Arts Exposition in New York.

The project for the pediment in Philadelphia was completed in 1932. Its iconography, briefly, is "Sacred and Profane Love." The central figure is Zeus. On the right are Demeter, Ariadne, Theseus and the Python. On the left, Aphrodite, Eros, Adonis, Zeus, and Aurora with the Owl. In all, there are thirteen free-standing figures of terra cotta, covered with brilliant ceramic glazes. The other architectural details in polychrome are the column capitals, the cornice, the portico ceiling, the vault ceilings on the ground level, and the four-acre tile roof. The revival of ornamental and architectural sculpture was a particular specialty of the architects of this structure—Horace Trumbauer, C. C. Zantzinger, and C. Louis Borie, Jr. Their "Art Deco" style was in great demand; the "modern" can be seen in the Parkway's Fidelity Mutual Building and the "classic" in this illustration. The five-year project for the pediment required the construction of special kilns—Zeus weighs over a ton.

The south pediment, designed by John Gregory (1879–1958) and symbolizing the "Pursuit of Wisdom," was never developed beyond the scale model, which is still in storage.

J. Otto Schweizer (1863–1955)
All Wars Memorial to Colored Soldiers and Sailors. 1934
Lansdowne Drive, West Fairmount Park (near Memorial Hall)
Bronze, overall height 258″ (granite base)

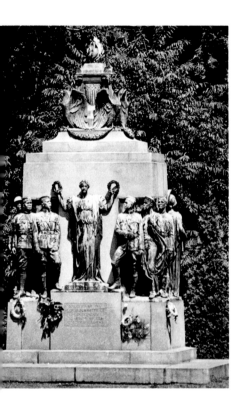
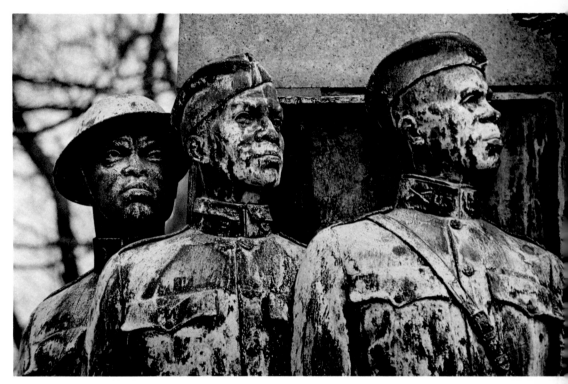

In 1927 an Act of the Pennsylvania legislature resolved: "It is fitting and proper that the patriotic services of the colored soldiers of the Commonwealth who served in the various wars in which the United States has engaged should be memorialized and that a lasting record of their unselfish devotion to duty should be made as an inspiration for similar service by future generations." For this purpose, the state appropriated $50,000 and J. Otto Schweizer received the commission for a memorial which has been described as follows: "On each side of the memorial are represented officers, soldiers and sailors of the United States forces; between them is the allegorical figure of Justice extending the symbols of Honour and Reward. At the rear are symbolic figures of the principles for which the wars were fought and for which service and sacrifice were rendered. Crowning the group is the flaming Torch of Life, surrounded by four eagles."

For some years before the unveiling on July 7, 1934, there was a battle over where the memorial was to be located. The Parkway, Fitler Square at 23rd and Pine Streets, and Cheltenham Township (where during the Civil War Negro soldiers had trained at Camp William Penn) were considered. Finally, City Council and the Commissioners of Fairmount Park compromised on the present site, about 100 yards from Alexander Milne Calder's *General Meade.*

John Gregory (1879–1958)
General Anthony Wayne. 1937
Philadelphia Museum of Art, East Terrace
Gilded bronze, height about 144″
(cold spring rainbow granite base 162″)

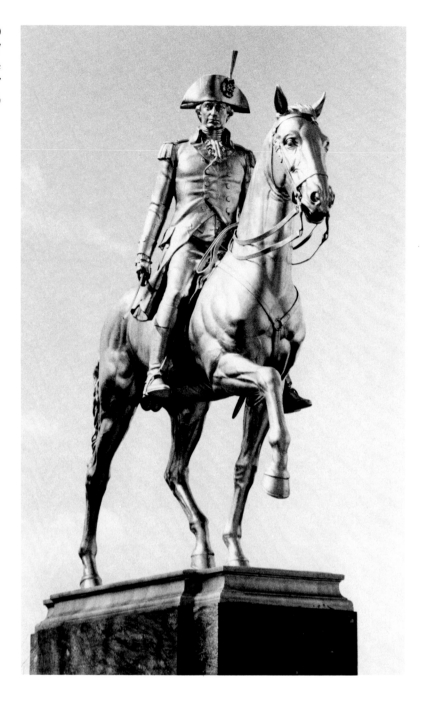

The seventy-fifth anniversary publication of the Pennsylvania Society Sons of the Revolution (1962–1963) describes the sculpture of Anthony Wayne as one of the most ambitious of its efforts, "for it occupied the Society more or less continuously for forty-five years and culminated in a monument visible from both the Benjamin Franklin Parkway and the Schuylkill Expressway. In 1893 a special committee of thirteen—one for each original state—was appointed to procure designs and devise means to raise moneys for a monument to be erected in Philadelphia in honor of Pennsylvania's foremost Revolutionary officer, Major General Anthony Wayne. With much planning and effort a fund was assembled over many years—slowly after the initial burst of enthusiasm subsided. With additional contributions of only $280.91 in 1904 and $229.81 in

1906, for example, nonetheless, by 1934 the sum of $30,000 was on hand.... By 1937 the Committee was able to report that a full size equestrian statue in clay had been executed as a prototype. Contracts were let for a polished granite pedestal, for the bronze casting, and for its gold-leafing by a special process deemed practically permanent."

Over that long period a number of architects were involved in the design—Horace Wells Sellers, John T. Windrim, and, finally, the distinguished Paul Cret. The final figure, with its handsome granite base, a collaboration between Gregory and Cret, was cast by the Roman Bronze Company, and the special gold leaf applied by Gustave Ketterer (regilded in 1968). At long last, on September 17, 1937, the 150th anniversary of the signing of the Constitution, the dedication ceremony took place.

James Earle Fraser
(1876–1953)
Benjamin Franklin. 1938
Franklin Institute
Marble, height 150″
(marble base 100½″)
Gift of William L. McLean
to the Franklin Institute.

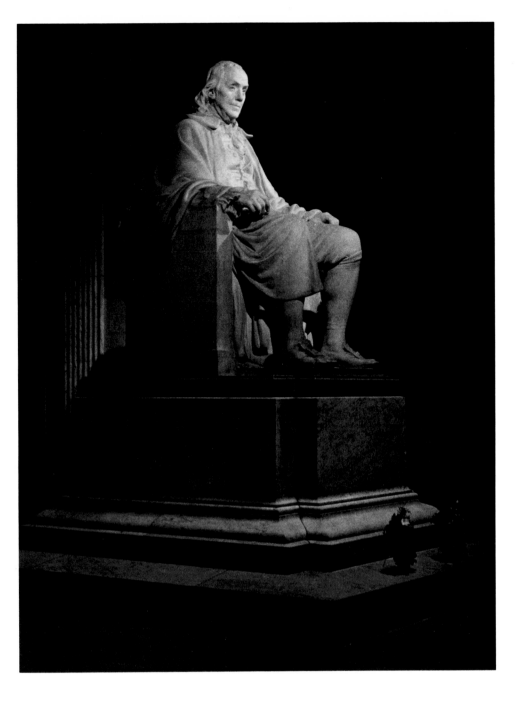

One of America's best-known sculptors, Fraser was born in Winona, Minnesota, in 1876, and early in life became a protégé of Augustus Saint-Gaudens. His statue of a weary Indian slumped over a horse, "The End of a Trail," became internationally famous. He was the designer of the "buffalo nickel." One of his outstanding works is his statue of Alexander Hamilton in the Treasury Department, but critics generally agree that the *Franklin* statue is his masterpiece. The dedication of the Franklin Institute's new building was postponed for four years until Fraser could complete this heroic figure.

Made entirely of pure white Seravezza marble from Italy, the statue rises nearly twenty-one feet above the floor and weighs thirty tons. The pedestal on which it rests, Rose Aurora marble from Portugal, weighs ninety-two tons.

In discussing his approach to the work, Fraser said: "I came to the conclusion that his great impulse was an all-pervading curiosity, and I have conceived Franklin a massive figure, tranquil in body, with latent power in his hands, but with an inquisitive expression in the movement of his head and the alertness of his eyes, ready to turn the full force of his keen mind on any problem that concerned line."

Jo Davidson (1883–1952)
Walt Whitman. *c.* 1939
Broad Street and Packer Avenue
Bronze, height 102″
(granite base 48″)

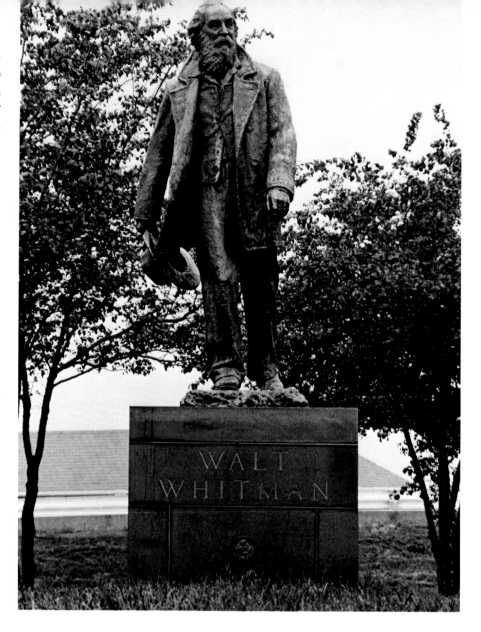

Of the hundreds of portrait studies that Davidson made, his *Walt Whitman* was one of his favorites. Davidson looked somewhat like Whitman, and spiritually they were alike. Averill Harriman, appreciating the sculptor's interest in the poet, tried to interest the New York Park Commission in obtaining the work for the city. Unsuccessful with the city authorities, Harriman next suggested Bear Mountain Park on the Hudson River, where Whitman had sojourned.

"Friends helped me collect books and papers about Walt Whitman," Davidson recorded in his autobiography, "His *Leaves of Grass* was my constant companion. I carried it in my pocket wherever I went. I wanted Walt afoot and lighthearted. I modeled a life-sized nude first, and had an articulated life-sized armature made especially for it. The armature was so constructed that I could move the arms and legs, the hands, the feet, the head, in fact any part of the clay figure. Nothing in my statue of Walt Whitman could be static and finally, I got the rhythm I was after. I had to make a sure Whitman, a singing Whitman—a Whitman who said to you: 'Camerado, I give you my hand...will you come travel with me?'

There is no greater happiness than working on something one wants very much to do. As Whitman said, 'Henceforth I ask not good fortune—I myself am good fortune.' Before going to its final abode, my Walt Whitman was set up in the New York World's Fair of 1939. It was placed on a small pedestal. He seemed to like it there, striding joyously along among the moving throngs. After the World's Fair shut down, my statue of Walt was set up at its destined site in Bear Mountain Park. At the unveiling ceremonies, Robert Moses, Park Commissioner of New York, told how the statue had escaped him. He was not quite sure whether this was a statue of Walt Whitman by Jo Davidson or a statue of Jo Davidson by Walt Whitman."

The plaster cast was shown at the 1949 Sculpture International in Philadelphia, which led to the bronze cast commissioned by the Fairmount Park Art Association in 1957 to be placed at the approach to the Walt Whitman Bridge as a gift to the City of Philadelphia and the Delaware River Port Authority. The dedication took place in the spring of 1959.

Gerhard Marcks (1889–)
Maja. 1942
East Court, Philadelphia Museum of Art
Bronze, height 88¼″ (marble base 28″)

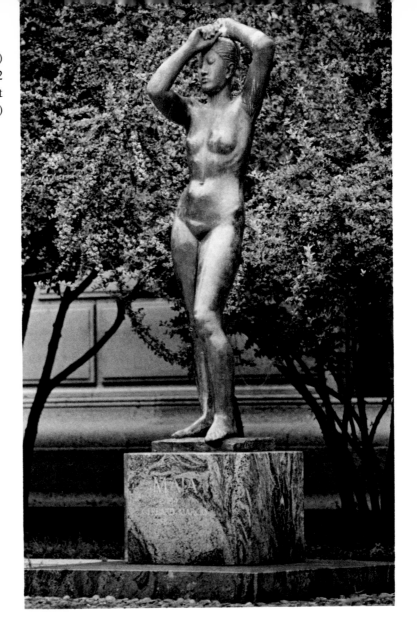

Marcks was born in Berlin on February 2, 1889. He studied with Kolbe and Gaul in Berlin and participated in Walter Gropius' great Bauhaus Experiment in 1919. Although most of his work was well known in Europe, he was not famous in the United States until the 1930s. In the 1949 outdoor exhibition, "Sculpture International," his *Maja* was one of the most popular figures. This important show was described in the Fairmount Park Art Association press release as follows: "The two hundred and fifty works constituting the 3rd SCULPTURE INTERNATIONAL organized by the Fairmount Park Art Association, will be placed on public display at the Philadelphia Museum of Art on May 15th and will continue on exhibition through September 11th. The Sculpture International, considered by sculptors to be the most important exhibition open to them, was announced over a year ago in the hope of stimulating the production of new works for the exhibition. Previous exhibitions, organized by the Association were held at the Museum in 1933 and in 1940 as preliminary stages in the awarding of commissions to the ten sculptors who have collabo-

rated in the creation of the Ellen Phillips Samuel Memorial located on the East River Drive in Fairmount Park, Philadelphia. The Exhibition is divided into an outdoor section, displayed in the Museum Courtyard and the indoor section which is installed in the Great Hall of the Museum. Exhibited for the first time in this country in the foreign section are the following items; *Maja* by Gerhard Marcks; *Cavaliere*...by Marino Marini; *Homme Assis* by Fritz Wotruba...and *Helikon* by Barbara Hepworth...."

Gerhard Marcks's *Maja* was the Fairmount Park Art Association's first purchase from the $20,000 fund available. It cost $6,500. After being damaged in a windstorm in 1951, the statue was repaired by the Modern Art Foundry on Long Island. In 1952 the lovely nude was loaned to the Art Institute of Chicago and traveled from there to the Museum of Modern Art in New York before returning to Philadelphia. It is signed: "Maja/1942/Gerhard Marcks/1889." There is a second cast in the City Art Museum of St. Louis.

Wharton Esherick (1887–1970)
Reverence. 1942
Philadelphia Museum of Art
Black Walnut, height 108″

Wharton Esherick studied at the Philadelphia Museum School of Art and the Pennsylvania Academy of the Fine Arts. Enjoying a distinguished reputation, he received a gold medal from the Architectural League in 1954, and was one of the eleven winners in the International Sculpture Competition for "The Unknown Political Prisoner." Posthumously awarded the American Institute of Architects Medal for Craftsmanship, Esherick, a designer of furniture, interiors, and structures, was more than a sculptor. He left to the Nation his studio-home near Paoli, which he laboriously constructed stone by stone as a small museum. He carved the rafters, the floor boards, the kitchen utensils and the magnificent free-form staircase which was shown as an object-sculpture at the 1939 New York World's Fair.

In 1949 he exhibited his strangely moving figure of *Reverence* at the Third Sculpture International Exhibition. Of this piece, Walter E. Baum wrote in a review in the Philadelphia *Evening Bulletin:* "Local interest, of course, will be centered in the purchase of Wharton Esherick's strange figure called Reverence. Here the simplest elements of the human form are used to invest a longish piece of black walnut with something of human dignity. Esherick, known for his carved furniture as well as figure pieces, is a sculptor of great originality and here again the selection will be put down as an excellent choice." The choice was made by the Fairmount Park Art Association at a cost of $1,500.

Sidney Waugh (1904–1963)
General Casimir Pulaski. 1947
Reilly Memorial,
Philadelphia Museum of Art,
west side
Bronze, height 112″
(granite base 90″)

Through the will of General William M. Reilly (1890), a trust fund was established to erect monuments to the Revolutionary heroes Pulaski, Lafayette, Montgomery and Baron von Steuben when sufficient funds had accumulated. "Lafayette, Montgomery, Pulaski and Steuben," recorded General Reilly, "were foreigners and volunteers. Natives, respectively, of France, Ireland, Poland and Germany, young, ardent and animated by an intense love of liberty [they] threw themselves into the cause of emancipating the colonies from the yoke of British tyranny."

By 1938, General Reilly's fund amounted to $112,000 and the Pennsylvania Company and three trustees of the estate (one of them R. Sturgis Ingersoll) petitioned the Orphans' Court to carry out the provisions of the will. Four internationally known sculptors were selected and C. Louis Borie designed

the bases. The four figures were placed on the lower terrace to the west of the Art Museum. Later, two more were added to the group: *John Paul Jones* by Walker Hancock, instated in 1957; and *General Nathaniel Greene* by Lewis Iselin, Jr. in 1961.

The sculptor of Pulaski, Sidney Waugh, received his early schooling in Amherst, Massachusetts, and entered the Massachusetts Institute of Technology at the age of sixteen. Three years of training in Rome was supplemented by instruction under Bourdelle and Bouchard in Paris. In 1929 he won the Prix de Rome. Returning to the United States in 1932, he received a number of commissions for the new federal buildings in Washington. From 1933 on Waugh was associated with the Steuben Division of the Corning Glass Works, designing many of the engravings for their commemorative vases and bowls.

Paul Manship (1885–1966)
Aero Memorial. 1948
Logan Circle at 20th Street
Bronze, height 96″ (limestone base 116″)

The Aero Club of Pennsylvania in 1917 made a gift to the Fairmount Park Art Association, which, acting as trustee, undertook the responsibility of a memorial to the aviators who had died in World War I. Subscriptions from the public were to be matched by the Association. In October, 1939, when the fund amounted to $30,606, negotiations were begun with Paul Manship.

Manship's mature style was a cross-pollination of his early "Greco-Roman Antique" work and the avant garde style of the 1920s and 1930s, now called "Art Deco." He held almost every honor a sculptor can be given. Among his works are the *Prometheus* in New York's Rockefeller Plaza and the *Diana,* the *Actaeon,* and *Moods of Time* designed for the 1939 New York's World's Fair.

The original scheme for the Aero Memorial was

monumental and was abandoned because of its expense. Discussions, compromises, and rejected models slowed the project until in 1944 a celestial sphere was agreed on, the subject being an astronomical instrument with the names of the stars, planets, and constellations in Latin. The work was to be appropriately sited in front of the Franklin Institute.

Manship had made a number of spheres: one in the League of Nations at Geneva, dedicated to Woodrow Wilson; several smaller versions made in 1920; and four larger ones in 1924 (today at Brookgreen Gardens, South Carolina, Phillips Academy, Andover, Cranbrook School, Michigan, and the Fogg Art Museum, Boston). Philadelphia's Parkway globe, six feet in diameter, was set on a base designed by Joseph P. Sims in 1949, and was dedicated on June 1, 1950.

Walker Hancock (1901–　　)
Pennsylvania Railroad War Memorial. 1950
30th Street Station,
Penn Central Transportation Company
Bronze, height 468″ (black granite base)

Born in St. Louis, Walker Hancock won a scholarship to the Saint Louis School of Fine Arts in 1917. After further studies, he became a student of Charles Grafly at the Pennsylvania Academy of the Fine Arts. Prizes and a national reputation followed: the Cresson Traveling Scholarship in 1922 and 1923; and the Prix de Rome in 1925. He has since been sculptor in residence at the American Academy in Rome, 1956–1957 and 1962–1963, and has served from 1930 to 1966 as Head of the Sculpture Department at the Pennsylvania Academy of the Fine Arts. Numerous examples of his work are to be seen—garden sculpture, portraits, architectural sculpture and several memorials. Among the best known of the latter are the three angels of victory on the tower of the Lorraine American Cemetery at Saint-Avold, France, and Philadelphia's large bronze in the concourse at 30th Street.

The unveiling of the railroad memorial on August 10, 1952, was attended by railroad officials, General Omar N. Bradley of the Joint Chiefs of Staff, and the sculptor himself. A young railroad employee who had won the Congressional Medal of Honor, Robert E. Laws, pulled the unveiling tapes, revealing a heroic bronze of the Archangel Michael, Angel of the Resurrection, with a figure of an uplifted soldier in his arms. The angel stands on a black granite base on which are inscribed the 1,307 names of the railroad employees who died in World War II. Below the names cut in the stone are a helmet and ammunition belt, symbolizing the equipment left on the battlefield.

This great symbolic bronze carries the following appropriate phrase on the base: "That All Travelers Here May Remember Those Of The Pennsylvania Railroad Who Did Not Return From The Second World War."

William Zorach (1887–1966)
Puma. 1954
Azalea Garden,
northwest of the
Philadelphia Museum of Art
Labrador marble,
height 40½" (granite base 25")

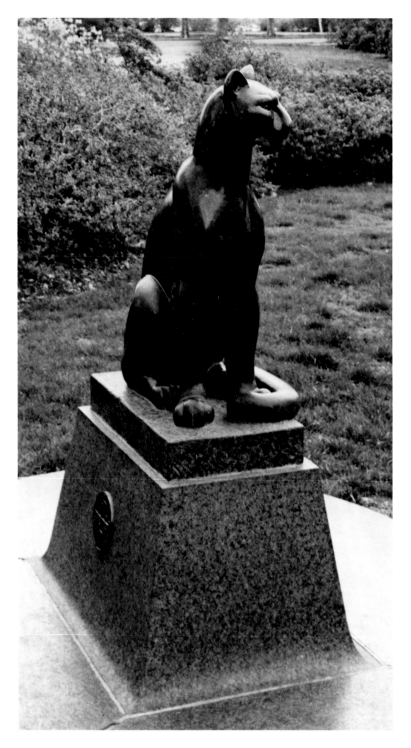

Zorach emigrated as a very young child from Lithuania to the Mid-West. Educated in Ohio's public schools, he was trained as a lithographer and painter. In Paris in 1910 he became part of the Fauve-Cubist circle, and both he and his wife, Margeurite, participated in the 1913 Armory Show. At about this time, Zorach began to carve, first wood and later in stone. He was one of the first carvers of his generation to make the break completely with the "academic style."

The history of Philadelphia's *Puma* begins with the Pennsylvania Horticultural Society's gift in 1953 of the Azalea Garden to the City. The plantings came from private subscriptions and donations. In 1961 a request for cooperation from the Fairmount Park Art Association for sculpture resulted in the purchase of this lithe cat to embellish the garden. The work was purchased for $15,000, a modest price at today's standards, from the 157th Annual Exhibition at the Pennsylvania Academy of the Fine Arts (1962), where it had been awarded a Widener Gold Medal. The base was designed by George B. Roberts, and the 900 pound *Puma* was unveiled in 1963.

Carl Milles (1875–1955)
Playing Angels.
East River Drive
at Fountain Green Drive
Bronze, height 84″
(concrete bases 240″–276″)

Milles was born in Lagga, Sweden, and was trained as a carver-modeler to a cabinetmaker. This skill maintained him throughout years of deprivation as a young sculptor in Paris (1897–1904). In 1907 he returned to Stockholm and began to build his house and studio on the rocky cliffs of the island of Lindingo across the bay. This is the site of today's great outdoor museum called Millesgarden, where the original five angels are located.

Milles' reputation rose to international fame with his exhibition at the Tate Gallery in London in 1926, his first exhibition outside Sweden. Although his sculptural style had changed in 1917, he was one of the outstanding practitioners of sculpture as architectural embellishment. Meyric Rogers, in his book on Milles, wrote: "One important clue to the basic quality of Milles's work can be found in his strong love of life and his equally profound humanity.... His joyous assertion of the value and freedom of life contains something almost stern.... With him

there is apparently no thing or idea that cannot find its sculptural equivalent or visual symbol, not by an intellectualized allegory but simply and directly by an almost childlike process of image-making. This innocence of vision gives a freshness of concept and of execution beyond the reach of the lesser artist...." The last years of his life were spent teaching in America at the Cranbrook Academy of Art in Bloomfield Hills, Michigan.

Second casts of the five originals in Stockholm made by Milles were intended for a nursery or nursing school in Philadelphia, but negotiations fell through. Of the five, two went elsewhere, one to Kansas City and the other to Falls Church, Virginia. The remaining three were acquired in 1968 by the Fairmount Park Art Association. The architects, Bower and Fradley, who designed the bases for them, were awarded a silver medal by the American Institute of Architects, Philadelphia Chapter. The angels were dedicated on April 26, 1972.

Waldemar Raemisch (1888–1955)
The Great Mother and **The Great Doctor.** 1955
Youth Study Center, 20th and the Parkway
Bronze: *Great Mother*, height 119";
Great Doctor, height 136" (concrete bases 36")

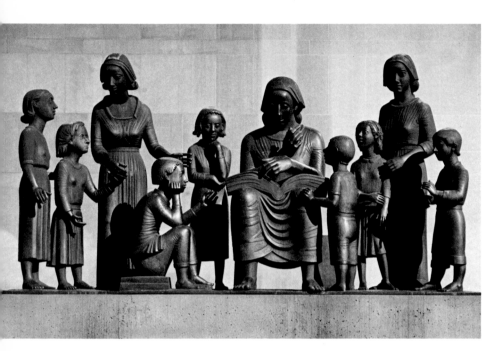

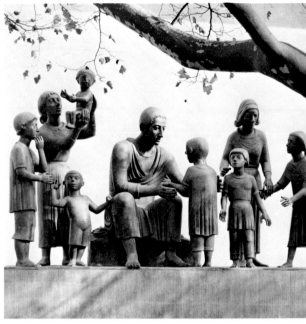

Three sculptors were considered for the commission to embellish the Youth Study Center, designed by Carroll, Grisdale and Van Alen: Ivan Mestrovic, the refugee Yugoslavian at Syracuse, New York; Carl Milles at Cranbrook in Michigan; and the German refugee Waldemar Raemisch at the Rhode Island School of Design. Raemisch had fled the Nazi terror in 1939, after having been removed from an important post at the Berlin State School of the Museum of Arts and Crafts. Raemisch's style is rather formal and medieval, best described as symbolic—for instance, his use of generalized child figures rather than individual portrait studies brought this work under particularly sharp criticism in the early 1950s. The Art Commission, however, resolved the choice in 1954 when his small bronze model was accepted. He was granted a studio at the American Academy in Rome, nearby the foundry which was to do the casting. Working with

him was one of his students, a Prix de Rome winner, Gilbert Franklin. At this time, Raemisch was also cutting the stone *Preacher* for the Samuel Memorial on the East River Drive.

Both sculptures turned out to be his last works—he died in Rome in 1955—and the final touches were done by Gilbert Franklin. They were unveiled quietly in November, 1956, and later received a special citation at the 1958 National Gold Medal Exhibition of the Architectural League of New York (gold medals are granted only to living sculptors). The citation read: "For the exceptional quality of his two sculptured groups of figures designed for the Youth Study Center of Philadelphia, Pennsylvania...we, the undersigned, declare this work to be a high achievement of creative expression sensitively interpreted and successfully related to the architecture with great strength of form and warmth of feeling."

Joseph J. Greenberg, Jr. (1915–)
Bear and Cub. 1957
Philadelphia Zoological Society,
near the bear pits
Black granite, height 43″ (base 11″)

This sculpture was commissioned for the Zoo by the Fairmount Park Art Association. It is signed "J. Greenberg 1957."

The sculptor was born in Philadelphia on November 30, 1915. From 1935 to 1939 he studied at the Tyler School of Fine Arts of Temple University, and in 1940 exhibited at the Second Sculpture International, Philadelphia Museum of Art, and in 1949 at the Third Sculpture International. During a residence in Italy, 1949–1953, he had his first one-man show in Rome. He has since exhibited his sculptures extensively and has served as President of the Philadelphia Chapter, Artists Equity Association.

Among his major Philadelphia commissions are additional sculptures for the Zoo, for branch libraries of the Free Library, for the Bell Telephone of Pennsylvania Building, for the City Health Center, for the House of Detention, for the Home of the Aged, for the Community Center at 22nd and Columbia Avenue, for the Philadelphia Civic Center, and for the Presbyterian Hospital.

Among awards he has received was the Gold Medal of Da Vinci Alliance, Philadelphia, in 1947, a $1,000 prize at the Metroplitan Museum of Art's National Sculpture Exhibition in 1951, the 1962 Craftsmanship Award of the Pennsylvania Society of Architects, a citation from the Philadelphia Chapter, American Institute of Architects, Temple University's Fountain Competition, and, in 1972, First Prize in Sculpture at the Allen's Lane Award Exhibition. His works are represented in the permanent collections of seven institutions.

**Appendix
Section V**

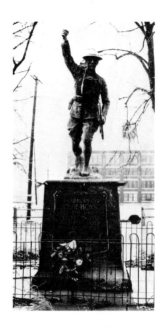

Unknown Artist
World War I Memorial
5th and Spring Garden Streets
Bronze, height 89" (granite
base 60")
Provenance unknown. Cast by
Flour City Casting Company.

Unknown Artist
History of Printing. 1927
East Pediment, Free Library of
Philadelphia, 19th and Vine
Streets
Indiana limestone, height 120",
width 516"

Evelyn Beatrice Longman
Batchelder (1874–1954)
Thomas Sovereign Gates. 1941
University of Pennsylvania,
Gates Pavillion, 33rd and
Spruce Streets
Bronze, height 23" (granite
base 49")
Purchased by the University.
Originally placed in Houston
Hall. Reinstated at present
location January 18, 1954.

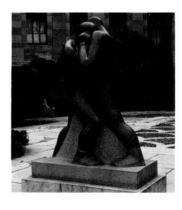

Ahron Ben-Shmuel (1903–)
The Boxers
Philadelphia Museum of Art,
East Court
Granite, height 61½" (concrete
base 37½")
Instated April 30, 1958. On
indefinite loan from the artist to
the Commissioners of Fairmount
Park. Exhibited at the 1940
Sculpture International,
Philadelphia Museum of Art.

Ahron Ben-Shmuel (1903–)
Coiled Snake
Philadelphia Zoological Gardens,
entrance to Reptile House
Granite, height 17" (granite
base 12")
Purchased through WPA Aid to
Artists. Instated October
10, 1940.

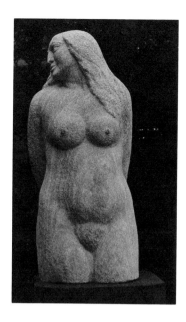

Simone Brangier Boas
(1895–)
Woman
Philadelphia Museum of Art,
East Court
Marble, height 46″ (granite base)
Gift of the artist to the
Commissioners of Fairmount
Park. Instated March 19, 1962.
Exhibited at the 1940 Sculpture
International at the Philadelphia
Museum of Art.

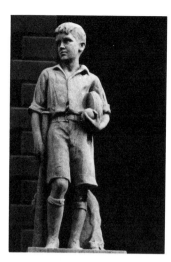

Beatrice Fenton (1887–)
Children's Hospital Gateposts
Children's Hospital, 17th and
Bainbridge Streets
Limestone, height 63″ (granite
and brick bases, about 170″)
Commissioned by the Hospital
in 1931.

Cornelia Chapin (1893–1972)
Giant Frog
Rittenhouse Square
Granite, height 38″ (granite base
17″)
Given to the City in 1941 by the
Rittenhouse Square
Improvement Association.

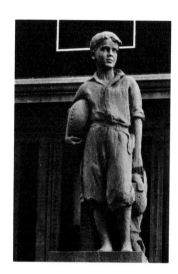

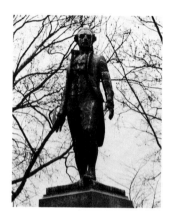

Guiseppe Donato (1881–1965)
Thomas Fitzsimmons
Logan Circle, east side
Bronze, height 100″ (granite
base 79″)
Gift of the Society of the
Friendly Sons of St. Patrick to
the City. Instated September
16, 1946.

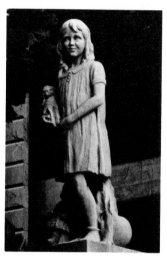

Giuseppi Donato (1881–1965)
West Pediment. 1940
Municipal Court Building, 19th
and Vine Streets
Indiana limestone, height 120″,
width 516″

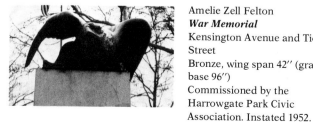

Amelie Zell Felton
War Memorial
Kensington Avenue and Tioga
Street
Bronze, wing span 42″ (granite
base 96″)
Commissioned by the
Harrowgate Park Civic
Association. Instated 1952.

Beatrice Fenton (1887–)
***Evelyn Taylor Price Memorial
Sundial.*** 1947
Rittenhouse Square
Bronze, height 59″ (granite
base 36″)
Commissioned by the
Rittenhouse Square
Improvement Association.
Instated in 1947.

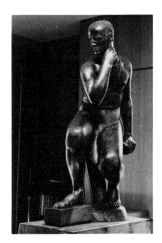

James House, Jr. (1902–)
Aristotle. 1946–49
University of Pennsylvania,
Penniman Library, Thomas
Woody Seminar Room
Black walnut, height 44″ (wild
cherry base)
Gift of Dr. Thomas Woody to the
University. Instated November
30, 1967.

Harriet Whitney Frishmuth
(1880–)
Berwind Tomb—Aspiration
Laurel Hill Cemetery
Vermont granite figure and base,
178″ by 144″ by 82″
Commissioned by Mrs. Harry A.
Berwind in 1933 from the
Presbrey-Leland Studios, New
York. Entire monument carved
from a single block. Instated in
the fall of 1933.

James House, Jr. (1902–)
John Dewey. 1952–53
University of Pennsylvania,
Penniman Library, Thomas
Woody Seminar Room
White oak, height 25″ (white
oak base)
Gift of Dr. Thomas Woody to the
University. Instated November
30, 1967.

Walker Hancock (1901–)
***Judge Charles Lincoln
Brown.*** 1940
United States Courthouse, 18th
and Vine Streets
Marble, height 88″ (limestone
and marble base 68″)
Gift of the friends of Judge
Brown to the City. Figure carved
by J. K. Watt. Instated in 1947.

Frank Lynn Jenkins (1880–1927)
Charles Custis Harrison
University of Pennsylvania,
Quadrangle
Bronze, height 60″ (limestone
base 45″)
Gift of John Cromwell Bell.
Instated in 1925.

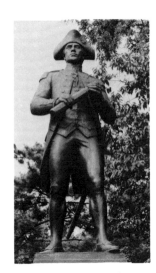

Walker Hancock (1901–)
John Paul Jones
Reilly Memorial, Philadelphia
Museum of Art, west side
Bronze, height 113″ (granite
base 92″)
Bequest of General William M.
Reilly. Instated in 1957.

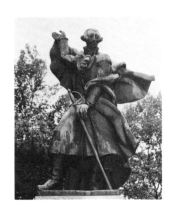

Raoul Josset
Marquis de Lafayette
Reilly Memorial, Philadelphia
Museum of Art, west side
Bronze, height 125″ (granite
base 90″)
Bequest of General William M.
Reilly. Instated in 1947.

Sylvia Shaw Judson (1897–)
Mary Dyer
Philadelphia Museum of
Art, storage
Bronze, height 96″
Original at Massachusetts State
House, Boston. Second cast
purchased by the Fairmount
Park Art Association in 1960.

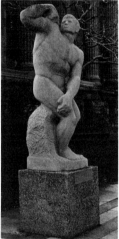

J. Wallace Kelly (1894–)
Laborer
Philadelphia Museum of Art,
East Court
Limestone, height 108″
(concrete base)
Commissioned under the WPA
Public Works of Art Project
(1933–39). On indefinite loan to
the Commissioners of Fairmount
Park. Exhibited at the 1940
Sculpture International at the
Philadelphia Museum of Art.

J. Wallace Kelly (1894–)
General Richard Montgomery
Reilly Memorial, Philadelphia
Museum of Art, west side
Bronze, height 114″ (granite
base 96″)
Bequest of General William M.
Reilly. Instated in 1947.

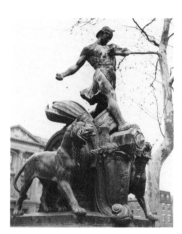

Albert Laessle (1877–1954); initial
concept by Charles Grafly
(1862–1929)
*General Galusha Pennypacker
Memorial*
Logan Circle
Bronze, height 128″ (limestone
base 106″)
Commissioned by the State Art
Commission and the General
Pennypacker Memorial
Committee. Instated June
1, 1934.

Archer Lawrie
Felis Leo
Philadelphia Zoological Gardens,
Carnivora House
Limestone bas-relief, 66″ by 57″
Commissioned by the
Philadelphia Zoological Gardens.
Instated in April, 1951.

Archer Lawrie
Felis Tigris
Philadelphia Zoological Gardens,
Carnivora House
Limestone bas-relief, 66″ by 57″
Commissioned by the
Philadelphia Zoological Gardens.
Instated in April, 1951.

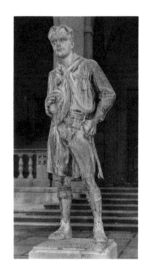

R. Tait McKenzie (1867–1938)
Boy Scout. 1937
Boy Scout Headquarters, 22nd
and Winter Streets
Bronze, height 72″ (limestone
base 22″)
Commissioned by the
Philadelphia Council, Boy
Scouts of America. Instated June
12, 1937. This is an enlarged
version of an 18″ statuette by the
artist in 1915.

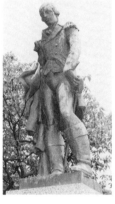

R. Tait McKenzie (1867–1938)
Edgar Fahs Smith. 1923
University of Pennsylvania,
Smith Walk
Bronze, height 72″ (limestone
base 47″)
Gift of John Cromwell Bell.
Instated June 12, 1926.

R. Tait McKenzie (1867–1938)
World Wars Monument
Girard College
Bronze, height 96″ (granite
base 72″)
Commissioned by the Board of
Directors of City Trusts. Instated
May 20, 1932.

Albino Manca (1898–)
Tiger at Bay
East River Drive, near
Philadelphia Museum of Art
Bronze, 28½″ by 82″ (natural
fieldstone base)
Purchased by the Fairmount
Park Art Association from an
exhibit at the Pennsylvania
Academy of the Fine Arts.
Instated in 1966.

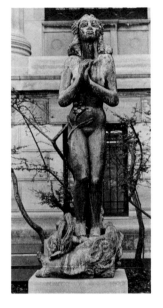

Maria Martins
Yara
Philadelphia Museum of Art,
East Court
Bronze, height 83″ (limestone
base 31″)
Anonymous gift to the
Philadelphia Museum of Art in
1942. Instated July 6, 1942.
Exhibited in plaster at the 1940
Sculpture International at the
Philadelphia Museum of Art.

Henry Mitchell (1915–)
Giraffe. 1955
Bustleton and Magee Streets
playground
Bronze, height 79″
Purchased by the City through
funds provided by the
Redevelopment Authority 1%
Fine Arts Program and the
Department of Recreation.
Instated in 1955.

Henry Mitchell (1915–)
Hippo Mother and Baby
Philadelphia Zoological Gardens,
Children's Zoo
Bronze, height 28½″
Commissioned by the
Philadelphia Zoological Gardens.
Instated in May, 1957.

Henry Mitchell (1915–)
Courtship
Philadelphia Museum of Art,
East Court, Henry M. Phillips
Memorial Fountain
Eight bronze bas-reliefs, height
30″, diameter 120″
Commissioned by the
Commissioners of Fairmount
Park and the Philadelphia
Museum of Art. Instated in 1958.

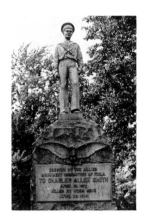

Francis P. Moitz
Charles Allen Smith
McPherson Square, Kensington
and Indiana Avenues
Granite, height 60″ (granite
base 96″)
Memorial to the second
American killed at Vera Cruz in
1914. Gift of local citizens to the
City. Instated October 21, 1917.

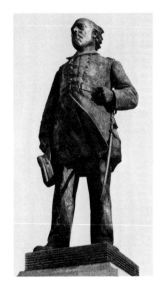

Samuel Murray (1870–1941)
Admiral George W. Melville
Philadelphia Navy Yard
Bronze, height 96″ (granite base)
Commissioned by the City
through a bequest of Admiral
Melville. Instated in 1923 in what
is now Franklin D. Roosevelt
Park. Moved to present location
in 1967.

Yoshimatsu Onaga (–1955)
N.R.A.
Philadelphia Museum of Art,
East Court
Limestone, height 85″ (concrete
base 30″)
Commissioned under the WPA
Public Works of Art Project
(1933–39). On indefinite loan to
the Commissioners of Fairmount
Park.

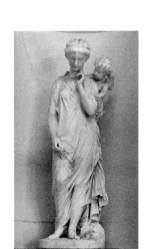

R. H. Park
Love Triumphant
Memorial Hall, center hall
Marble, height 65″
Gift of Mrs. M. Frank Kirkbride
in memory of her father, James
Dougherty, to Fairmount Park
Art Association. Instated 1919.

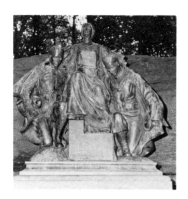

Harry Lewis Raul (1883–)
***The American War Mother
and Her Sons***
Wister's Wood, Belfield Avenue,
Germantown
Bronze, height 96″ (granite
base 60″)
Gift of the Philadelphia Chapter
of American War Mothers to the
City. Instated in 1928.

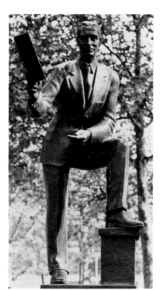

Harry Rosin (1897–1973)
Mr. Baseball (Connie Mack)
Veterans' Stadium, Broad and
Patterson Streets
Bronze, height 90″ (granite
base 66″)
Commissioned by the Connie
Mack Memorial Committee and
placed at the Connie Mack
Stadium, 20th Street and Lehigh
Avenue in April, 1957. Moved to
present location August 20, 1972.

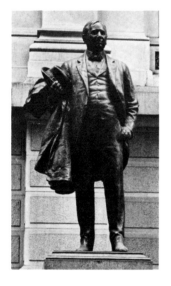

John Massey Rhind (1860–1936)
John Wanamaker
City Hall, East Plaza
Bronze, height 102″ (granite
base 84″)
Gift to the City through the John
Wanamaker Memorial
Committee. Commissioned in
May, 1923. Instated November
29, 1923.

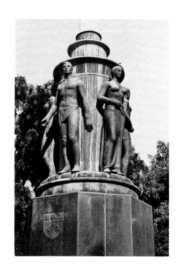

Charles Rudy (1940–)
***All Wars Memorial to Penn
Alumni*** (flagpole base). 1951
University of Pennsylvania,
Franklin Field
Bronze, height 84″ (granite
base 104″)
Gift of Walter H. Annenberg.
Instated December 15, 1952.

Victor Riu (1887–)
Fantasia. 1958
Public Federal Savings and Loan
Company, 8th and
Chestnut Streets
Black granite, height 41″
(concrete base)
Purchased by the Public Federal
Savings and Loan Company
from the artist. Instated in 1966.

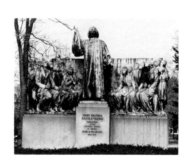

J. Otto Schweizer (1863–1955)
***Henry Melchior Muhlenberg
Memorial***
Lutheran Theological Seminary,
7301 Germantown Avenue
Bronze: center figure, height 96″
(granite base 85″); flanking
reliefs, height 72″ (granite
bases 72″)
Originally commissioned by the
City to be placed on the
Parkway, it was later purchased
for the Lutheran Seminary with
funds donated by Sunday School
children. Instated October
27, 1917.

Frances Serber (1905–) and
Nicholas Marsicano (1914–)
History of Shelter. 1940
2601 Parkway Apartments
Ceramic tile, 12 panels, 144′ in
length by 4½′ wide
Marsicano designed the mural
and Serber fired and glazed
the tiles.

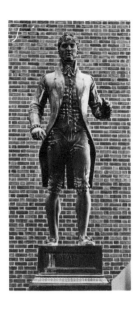

Lawrence Tenney Stevens
(1896–); initial design by
Frank Lynn Jenkins (1880–1927)
John Harrison
University of Pennsylvania,
storage
Bronze figure, height 120″
(base 102″)
Originally placed at the corner of
the science building, 33rd and
Spruce Streets, in 1935.

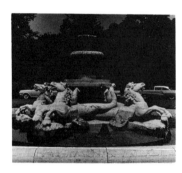

Christopher Untenberger
Fountain of the Sea Horses
East Fairmount Park, west of the
Philadelphia Museum of Art
Travertine, height of figures 57″,
total height 128″
Gift of the Italian Government in
commemoration of the Sesqui-
centennial. Instated June 6, 1928.
Replica of a fountain in the
Borghese Gardens, Rome,
c. 1740.

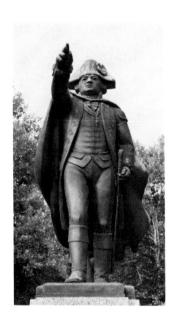

Warren Wheelock (1880–1960)
General Frederich Von Steuben
Reilly Memorial, Philadelphia
Museum of Art, west side
Bronze, height 114″ (granite
base 91″)
Bequest of General William M.
Reilly to the City. Instated
in 1947.

Three-Way Piece Number 1: Points

by Anne d'Harnoncourt

*photographs by
George Krause*

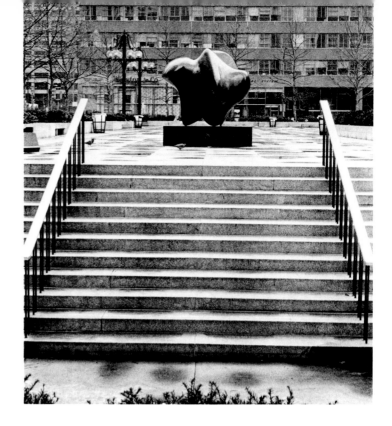

In the complex history of sculpture in the twentieth century, Henry Moore occupies a unique place. In an age of experimentation with new materials, he remains devoted to stone, wood, and bronze. Aware of the radical, formal innovations of the constructivists and the open, metal sculptures of post-cubist sculptors, he has never been tempted by pure abstraction. The lonely, attenuated figures of Giacometti and the plump, suggestive, biomorphic forms of Jean Arp are deeply rooted in a surrealist dreamworld which Moore entered only briefly in the 1930s. Moore shares with Brancusi a passionate devotion and attention to nature, and with Lipchitz an overriding concern for mankind, but both the gleaming

perfection of the *Bird in Space* and the expressionist violence of much of Lipchitz' work since the thirties are foreign to the rugged tranquillity of Moore's reclining figures. His long and full career has been characterized by an internal integrity and force which has produced an art of continuous innovation without radical extremes. Moore is the great humanist sculptor of our time.

Born in a Yorkshire mining town in 1898, Moore did not begin to sculpt in earnest until he came to London, after serving in World War I. He therefore learned from, but did not share in, the early inventions of cubism. From his first years in art school, Moore turned to the great sculpture of the past as much as to the art of his

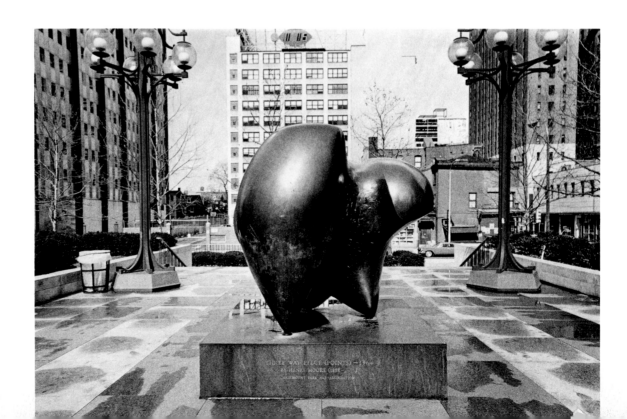

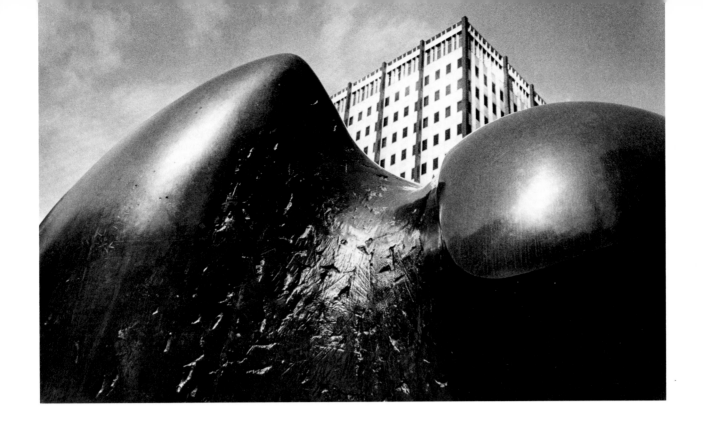

contemporaries for his deepest inspiration. He has always been one of the most devoted haunters of the British Museum, and important aspects of his early work derive from the stone gods of ancient Mexico as well as from the pierced forms of Archipenko. Throughout his life, Moore's interest in the art of both past cultures and contemporary movements has been supplementary to his profound study of the human form and of the natural world around him. His sculpture has drawn steady strength from the rocks and moors of the Yorkshire countryside of his childhood.

Moore's most celebrated achievement has been the long and richly varied series of reclining figures which fuse his observation of the human body with a generalized suggestion of the hills and crevices of a landscape. But the reclining figures and Moore's other favorite human themes, like that of mother and child, have, at intervals, shared his attention with less familiar images, which seem to be drawn from the more rudimentary world of plants and animals. During the 1930s, when Moore's involvement with the international surrealist and abstract movements was at its height, he produced a number of sculptures which made use of biomorphic rather than specifically human form; blocky stone monoliths vaguely suggesting heads or crouching animals (figure 1), the remarkable "stringed figures," and

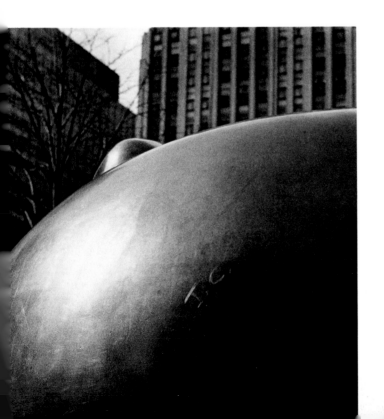

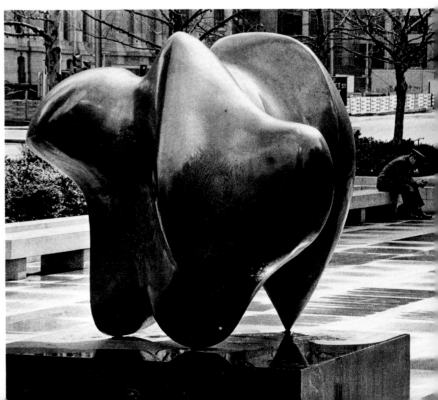

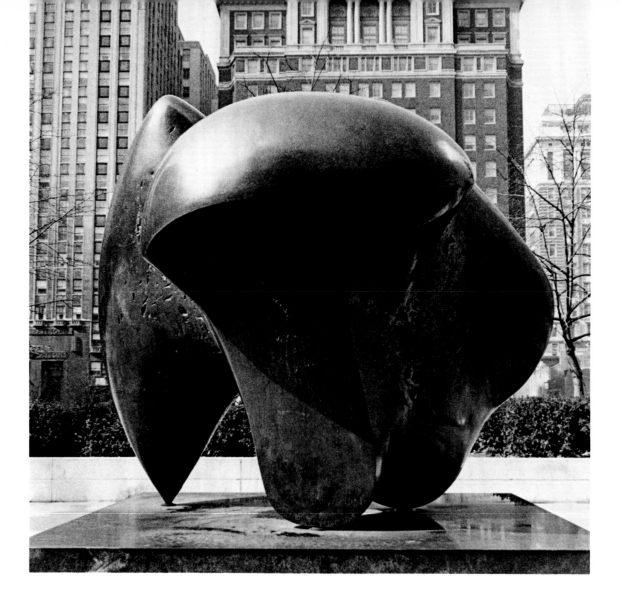

a series of grouped, pebblelike objects which appeared to be placed in some intimate but obscure relationship to one another. It is these early works which seem most relevant to Moore's recent monumental, nearly abstract bronzes.

Scale has always been important to Moore, and even his earliest carvings, which the exigencies of limited materials and awkward studio space forced to be small, give a sense of potential monumentality. "I personally would like to think," he remarked in 1964, "that the smallest sculpture that one makes has a bigness in it which would, if it had been necessary, have allowed the work to be enlarged without losing anything. In fact I would like to think that it would have gained, and in that sense I have an admiration, an ambition, a goal for something which looks big even in a photograph."[1] During the thirties and forties Moore's work was generally about half-human scale, increasing to life size after World War II in major works, but it was the commission from UNESCO in 1956 for a great sculpture for their Paris headquarters which Moore says "stretched my idea of size."[2] Moore chose his beloved reclining figure as a theme, and carved her in travertine sixteen-feet long. During the 1960s Moore created a series of monumental bronzes, partly in response to the steadily increasing number of commissions he has received for public spaces, and partly

satisfying his own desire to work in a big scale. With the notable exception of *Nuclear Energy* of 1964–65 at the University of Chicago, which commemorates the first successful nuclear reaction, the theme of Moore's recent commissioned works has been of his own choosing and he has consistently avoided a specific subject. Several have been variations on the reclining figure, including the mighty 1963–65 piece for Lincoln Center in New York, but Moore has also found a new and powerful vein of imagery which has produced a burst of creative energy astonishing in an artist in his mid-sixties.

Three-Way Piece Number 1: Points of 1964 is one of this group of recent bronzes, which include its alter ego *Three-Way Piece Number 2: The Archer* (1964–65), as well as *Knife Edge Two Piece* (1962-66), the Chicago *Nuclear Energy, Locking Piece* (1963–64), and *Large Arch* (1962–63). These sculptures have less explicit relation to the human figure as a whole than most of Moore's work, although the Chicago bronze resembles his earlier series of "Helmet Heads," and the *Large Arch* is conceived as a torso. Rather, they seem to derive from a more intimate penetration of nature, to the very bones and rocks which lie beneath her surface. It is probable that the germ of the sculptural idea for *Three-Way Piece Number 1* lay in a small pebble, balanced on three projecting surfaces, which was picked up by the sculptor years ago and

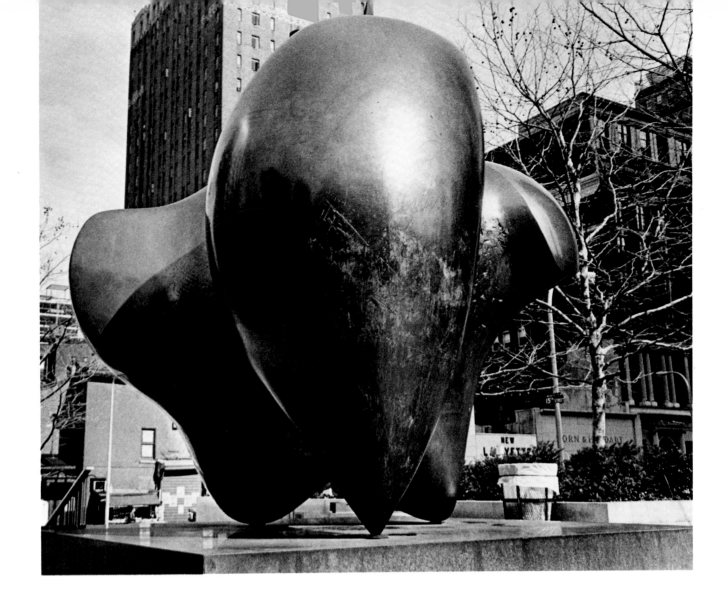

preserved with other odd-shaped bits of bone, shell, and flint in his studio.[3] Another recent large work, the elephantine *Locking Piece* (figure 2), was inspired by a fragment of bone with a socket and joint which Moore found in his garden. That a large, virtually abstract sculpture in bronze should have its origins in a small fragment of the natural world is profoundly characteristic of Moore. In a famous statement for the English group Unit One in 1934 he wrote, "the observation of nature is part of an artist's life, it enlarges his form-knowledge, keeps him fresh and from working only by formula, and feeds inspiration." Moore then went on to specify what was to be learned from each natural form in a passage that reads like a description of his own sculpture:

> *Pebbles and rocks show Nature's way of working stone. Smooth, sea-worn pebbles show the wearing away, rubbed treatment of stone and principles of asymmetry.*
>
> *Rocks show the hacked, hewn treatment of stone, and have a jagged nervous block rhythm.*
>
> *Bones have marvellous structural strength and hard tenseness of form, subtle transition of one shape into the next and great variety in section.*[4]

In the conception and realization of his art, Moore virtually assumes the role of nature itself, bringing his ideas into solid existence by "wearing away" and

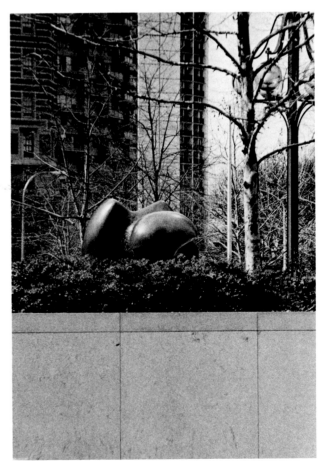

"hacking" at his material like wind eroding a hillside or a river carving itself a channel through rock.

Moore's working methods have varied somewhat over his career, but he remains constant in this unremitting and intense observation of human and natural form. Starting with his student days in the 1920s, many sculptures were born or grew out of his sketchbooks, where studies of treetrunks, bones, animals, and human models drawn from life mingled with ideas for his own carvings. At the same time, Moore often made a number of small "sketch models," diminutive clay or plaster studies which he molded with his hands, exploring his ideas for a sculpture directly in three dimensions. Since the 1950s, as the spatial complexity of his work has increased, he has relied less upon drawings than upon the sketch models, and it seems likely that there were no preliminary drawings for *Three-Way Piece Number 1*, as there are none for many of the recent large bronzes.

From the sketch models, of which he may make a great many for any one idea, Moore now often moves to a larger "working model." In the case of *Three-Way Piece*, the working model measures twenty-five inches high and was cast in bronze in an edition of seven. This large, rather finished study allows Moore to refine and strengthen his original idea, always with an eye to its capacity for potential enlargement. The working model for *Three-Way Piece: Points* is very close to the final version, with the exception of its smooth, unmarked bronze skin in contrast to the rough and thoroughly worked surface of the monumental piece.

In the final stage of developing a large sculpturelike *Three-Way Piece*, Moore and his assistants construct a spiky wooden armature and build up the full-scale model by degrees with cloth and wet plaster (figure 3). Once it has dried and hardened, Moore takes up his carving tools and works over the smooth white plaster until it becomes scored and pitted in places like the hide of an old animal. As a young sculptor, Moore believed firmly in the doctrine of truth to material and the importance of a sculptor's direct contact with his medium. He rebelled against the

custom, prevalent in the nineteenth century, of having the artist's preliminary model cast in bronze, or even copied in marble, by other craftsmen. Most of Moore's early work was carved directly in stone or wood, and his first experiments with bronze were carried out by the sculptor in person in a small foundry at the bottom of his garden. It is only after World War II that he has turned with increasing frequency to the remarkable qualities of strength and durability offered by bronze, which enables him to create forms that simply could not support themselves in stone. Certainly, *Three-Way Piece Number 1* would be unthinkable in marble, with its vast bulk resting delicately on three small points. But Moore has brought his old preferences to his use of bronze: "I am by nature a stone-carving sculptor, not a modelling sculptor. I like chopping and cutting things, rather than building up. I like the resistance of hard material.... Even now, in producing my bronzes, the process that I use in making the plaster original is a mixture of modelling and carving."[5]

The full-scale plaster model for *Three-Way Piece*, which is still owned by the sculptor, was made in an outdoor studio at Moore's home in Much Hadham, Hertfordshire. It was cast in Germany by the Noack Foundry in Berlin, where most of his monumental bronzes have been realized. Three casts were made and the first now stands in John F. Kennedy Plaza in the center of downtown Philadelphia. It was purchased by the Fairmount Park Art Association in 1967, and placed on its present site in September of that year. Of the remaining two casts, one has been placed on the campus of Columbia University in New York, and the other belongs to a private collector in Lake Forest, Illinois.

Moore pays great attention to the details of the finish of his bronzes. The ultimate destination of the sculpture is taken into consideration as he determines the tone and color of the patina: bright if the piece will be seen against a background of trees, darker if it will stand alone against the sky. The Philadelphia cast of *Three-Way Piece* has a dull golden sheen which marks its presence amidst the steel, glass, and concrete of the city.

Three-Way Piece Number 1: Points (seventy-six inches high) looms above the surrounding shrubbery on its urban site like some slow, mammoth beast, poised but not static on its three supporting limbs. The pebble which suggested its essential form has been subsumed into a being of great presence, which obscures its specific

source. Yet one has the persistent temptation to discover some recognizable creature in the rich variety of views it offers to the strolling passerby. A powerful curved form ending in the sharpest of the three points suggests the great beak of a bird, wings folded and hunched down on the ground. Move a few steps further and that image fades, as a humpbacked animal from the African plains pivots warily on the same pedestal. A sculpture by Moore is almost always related to something in his past work, which forms a vast organic continuum, but *Three-Way Piece: Points* has no obvious prototype, although it bears an odd affinity in form as well as title to a much earlier, eccentric piece, the thornlike *Three Points* of 1939–40 (figure 4).

But any resemblance it bears to work of the 1930s by virtue of its compact, tense form and compelling presence is much diminished by a structural intricacy which the simpler, monolithic shapes of his earlier work did not possess. Moore's recent work eludes verbal description and a sequence of perceptive photographs, such as these provided by George Krause, are essential to an understanding of the Philadelphia bronze. Moore has recently made a statement about his original intention for the piece, which illuminates its particularly rich formal complexity:

> *"Three-Way Sculpture: Points" was an attempt to show one work from below as well as from on top and from the side. My idea was to make a new kind of sculpture, less dependent on gravity, which could be seen in at least three positions and be effective in all of them; a sculpture which you could understand more completely because you knew it better.*[6]

Although the size and weight of monumental bronze prohibits views from above and below, the sense of its being a sculpture fully realized on all surfaces remains vivid and makes *Three-Way Piece* unusual, even in Moore's variegated oeuvre.

Like Brancusi's egg-shaped carvings in marble, which Moore much admired, *Three-Way Piece* invites tactile exploration. One can imagine Moore turning the sketch model again and again in his hands until it achieved equal sculptural interest in all directions.

Its companion piece, *Three-Way Piece Number 2: The Archer* is equally intricate in conception, but in it Moore provides a remarkably different solution to the same physical and structural problem of a massive form whose

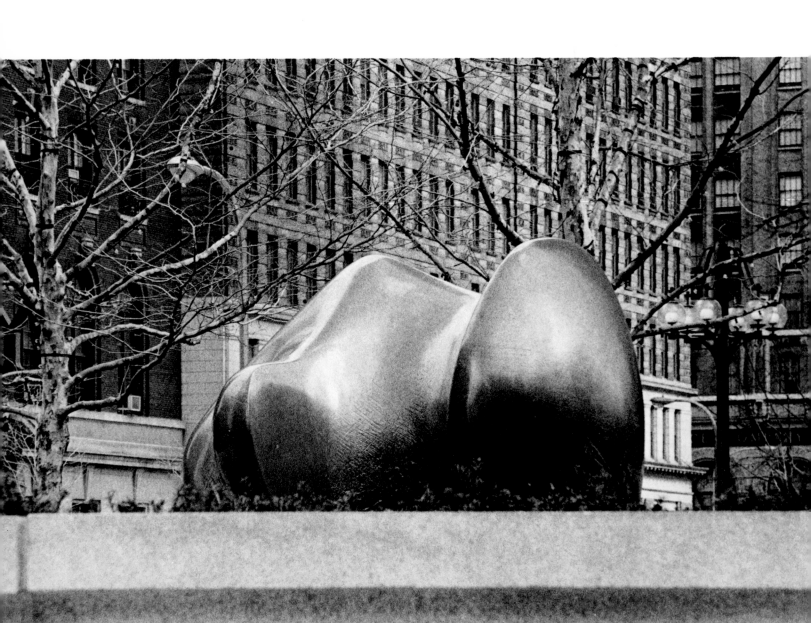

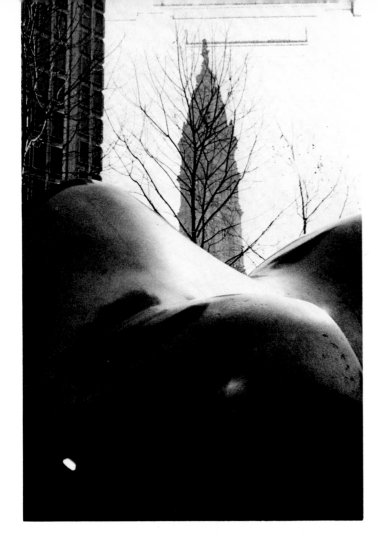

represent. *When a work has this powerful vitality we do not connect the word Beauty with it.*

Beauty, in the later Greek or Renaissance sense, is not the aim of my sculpture.

Because a work does not aim at reproducing natural appearances it is not, therefore, an escape from life—but may be a penetration into reality, not a sedative or drug, not just the exercise of good taste, the provision of pleasant shapes and colours in a pleasing combination, not a decoration to life, but an expression of the significance of life, a stimulation to greater effort in living.[9]

Henry Moore (1898–　　)
Three Way Piece Number 1: Points. 1964
John F. Kennedy Plaza,
15th and Arch Streets
Bronze, 54″ (granite base)

energies thrust in three directions (figure 5). One cast of *The Archer* stands in Nathan Phillips Square in Toronto. It is a taut, clean-cut sculpture in which the precise curved form of the "bow" strains outward from the erect form that controls it, into a perfect, static balance. *The Archer* is at once more abstracted and more suggestive of a human configuration (archer, outstretched arm, and bow) than *Three-Way Piece: Points,* which has the internal structural integrity and lack of differentiation of a rock, a bone, or some primitive form of animal life.

Three-Way Piece: Points is the work of a sculptor whose hand and eye have grown enormously sophisticated over the years without becoming facile. Such sculpture maintains a certain reserve, corresponding to Moore's wish that "sculpture should always at first sight have some obscurities, and further meanings."[7] The viewer's knowledge that this is an artist's invention struggles with his awareness that it possesses a natural force and rightness in itself. Verging on the abstract, *Three-Way Piece* resists being seen as inanimate material shaped from without and gives the impression, so essential to Moore's genius, of "having grown organically, created by pressure from within."[8] Moore expressed his desire to achieve sculpture of this quality in the 1934 essay for Unit One quoted above, and his words retain their aptness thirty years later for the bronze that dominates the northern end of John F. Kennedy Plaza:

　　…a work can have in it a pent-up energy, an intense life of its own, independent of the object it may

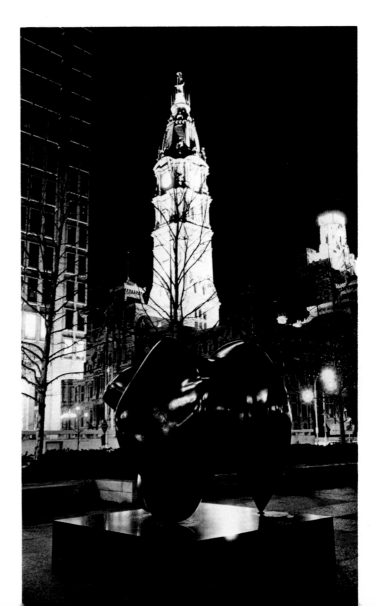

Heinz Warneke (1895–)
Cow Elephant and Calf. 1962
Philadelphia Zoological Gardens,
inside main gate
Granite, height 136″
including base (single block)

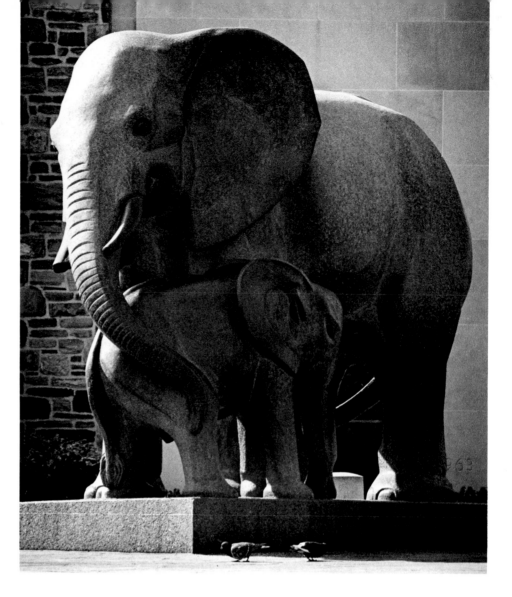

Born in Bremen, Germany, Warneke came to the United States in 1923 and became a citizen in 1930. A Life Fellow of the National Institute of Arts and Letters and a Fellow of the National Sculpture Society, professor at George Washington University, and head of the Sculpture Department at the Corcoran School of Art, he has exhibited widely and won many honors. Warneke did a large part of the architectural sculpture for the Episcopalian National Cathedral in Washington, D. C., but is best known to Pennsylvanians as the creator of the *Nittany Lion* on the Penn State University campus.

In 1959 the Fairmount Park Art Association invited a group of sculptors to submit designs for a sculpture to be placed in the north section of the Zoo. Warneke won the competition with a one-quarter scale plaster model of an African elephant and her baby. The problems involved in enlarging the figure were formidable; the scaling up the model in clay and then to plaster was accomplished in the New York Studio of Rochette and Parzini. The figure was then transported to Al Steinskulptur Atlier in Oslo, Norway, to be cut into a huge piece of flawless gray Bergan granite, purchased from a new quarry

at a small town called Larvik, where it was rough cut at the site. The contractor handling this operation, as well as its shipping to Oslo, and finally to Philadelphia, was Rolf Fredner of New York. The actual carving was done by Norwegian stone cutters in Oslo under Warneke's supervision. The thirty-seven-ton *Cow Elephant and Calf* that emerged from the granite is the largest monolithic, freestanding sculpture in the United States.

This gigantic group was transported across the Atlantic by freighter in the autumn of 1962. Braces of stone were left so that the elephants would not chip or crack in transport. These were removed by the sculptor on the site at the Zoo, where its formal dedication took place on May 25, 1963. In a letter to John F. Lewis, Jr., Warneke related an amusing anecdote of one of his friends traveling by train from New Haven to Washington: "On the way down Mr. Moore... looked out of the train window toward the Zoo in the late afternoon darkness of the rainy Friday and said to his wife, 'Just look at that mother elephant left wandering about loose at this hour with her calf. What in the world do the Zoo people mean?' "

Jose de Rivera (1904–)
Construction #66. 1959
University of Pennsylvania,
Annenberg School of Communications,
3620 Walnut Street
Chrome nickel steel-welded sheet,
43″ by 52″ by 44″ (travertine base 49″)

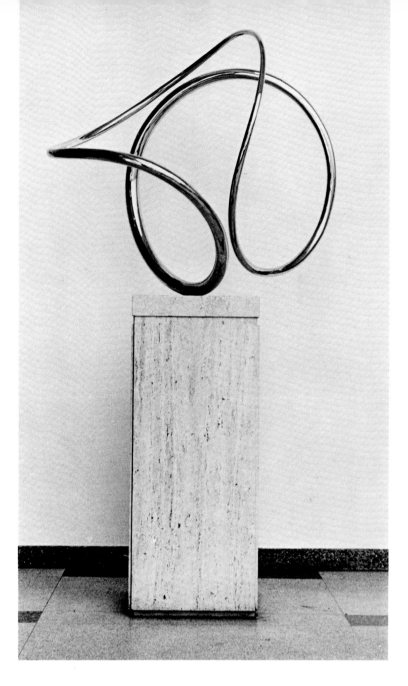

Born in West Baton Rouge, Louisiana, Rivera worked as a machinist, tool and die maker, and blacksmith from 1922 to 1930. He had very little formal art education except for a class in drawing at the Studio School, Chicago, with the painter John W. Norton. His first exhibition was in Chicago in 1930 at the American Painting and Sculpture Annual. His early work shows a strong Brancusi influence. In 1938 he was commissioned under the Federal Arts Project of the WPA to execute a sculpture for the Newark Airport (now in the Newark Museum). De Rivera's career had just begun when World War II intervened. Following the war, in which he served in both the Army and Navy, his elegant polished forms appeared regularly in the national and international exhibitions, and he taught as well at Brooklyn College, New York, and was visiting critic at Yale in 1935–1955.

Jose de Rivera has said of his work: "Art for me

is a creative process of individual plastic production without immediate goal or finality. The prime function is the total experience of the production....I am conscious always of the necessity for a prime, visual, plastic experience. The content, beauty and source of excitement is inherent in the interdependence and relationships of the space, material, and light, and is the structure."

Construction #66 was purchased by the M. L. Annenberg Foundation for the new communications center at the University of Pennsylvania under the Redevelopment Authority 1% for Fine Arts Program. Instated in 1963 with Alfred E. Poor as architect, it is a unique work of art, forged, welded, and polished by the artist. It had been previously exhibited in 1960 at the United States Steel Corporation, and at the Whitney Museum in New York in de Rivera's retrospective show of his work in 1961.

Seymour Lipton
(1903–)
Leviathan. 1963
Penn Center Plaza,
17th Street between
Market and John F.
Kennedy Boulevard
Nickel silver on
monel metal,
height 40½″
(granite base 94½″)

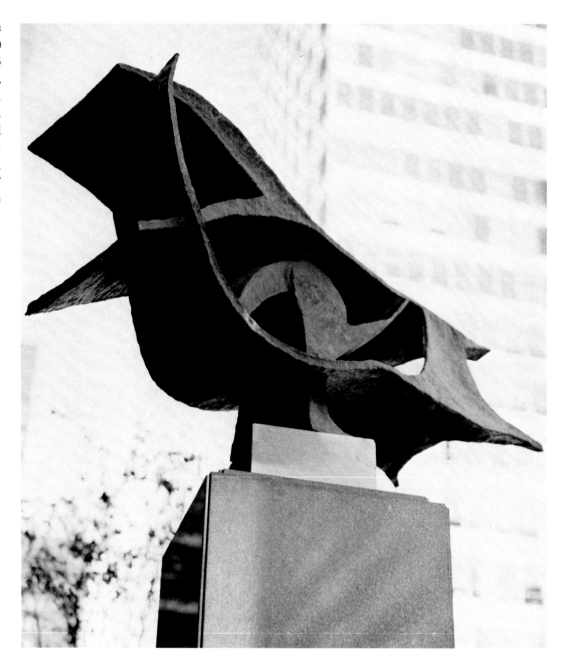

Largely self-taught in sculpture, Lipton's formal education was acquired at Brooklyn Polytechnic Institute and Columbia University, where he took his degree in 1927. After a series of successful exhibitions at galleries and museums, his reputation was firmly established. He has been awarded a number of prizes, including the top acquisition prize at the Sao Paulo Biennale in 1957, and his works have been shown abroad at the Venice Biennale (1958), the Brussels World Fair (1958), and also at the Seattle World Fair in 1963. Lipton has also held grants from both the Guggenheim and Ford Foundations and has served on the faculties of Cooper Union, New York City; New School for Social Research, New York City; and Yale University.

Writing extensively and lucidly about his work, Lipton has recorded: "The high road, if there is one for sculpture, is along the historic path of the meaning of man's life. The big symbolism is of the soul of man today, as it has always been. To be achieved, this must be rendered in the plastic language of today....The Greek tragic playwrights, Shakespeare, Dylan Thomas, Bach, funerary bronzes of ancient China, Oceanic sculpture, Franz Kline, the metaphysical reality of Klee, H[ieronymus]. Bosch, the wild ocean beach, gnarled roots, spring in the woods are some of the things I've felt strongly about."

Leviathan was purchased in 1969 from the Marlborough Gallery, New York, with funds from the National Endowment for the Arts. It had been shown previously as part of the 1967 Outdoor Arts Festival in Penn Center and was exhibited as well in a one-man show at the Phillips Collection, Washington, in 1963; Marlborough Galleries, New York, in 1965; Philadelphia Museum of Art in 1968; and in another one-man show at the Milwaukee Art Center, 1969. It now enhances the revitalized business district in Penn Center.

Alexander Calder (1898–)
Three Disks One Lacking. 1964
Penn Center Plaza,
17th Street and
John F. Kennedy Boulevard
Painted metal sheeting,
height 102″, width 84″

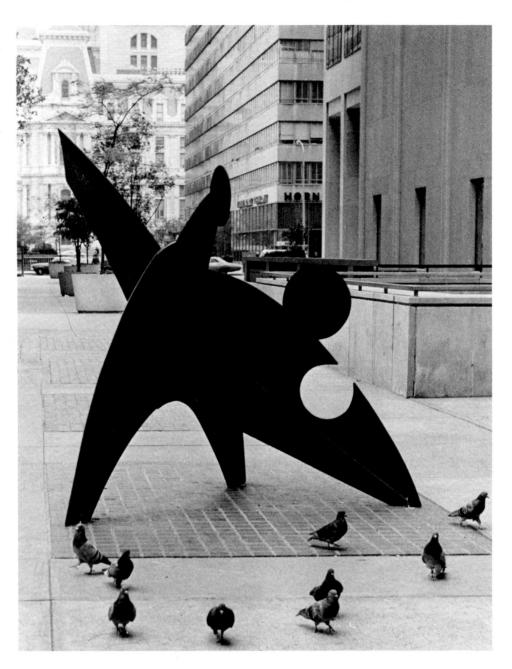

Philadelphia-born Alexander Calder is the third generation of a family of sculptors; Alexander Milne Calder, author of the *General Meade* in the West Park and City Hall's sculpture, was his grandfather. Alexander Stirling Calder, author of the Logan Square Fountain, was his father. His mother was also artistic and studied painting at the Pennsylvania Academy of the Fine Arts. Despite this background, his formal education was in engineering, not the Arts. In 1919 he took a degree in Mechanical Engineering at Stevens Institute in Hoboken, New Jersey. For several years Calder worked at a variety of jobs until in 1923 he entered the Art Students League in New York. Next, he went to Paris, paying for his passage by painting the decks of the ship. From 1926 to 1929 his experiments with wire and wood-animated toys brought him to the attention of the avant garde of Paris' art world—Picasso, Miró, and Fernand Léger.

Moving from wire sculpture, he began making stationary sculptures of bright discs of colored metal, influenced by the pure color of the rectangles he saw in the Dutch painter Mondrian's canvases. Hans Arp called them "stabiles." Soon after, Calder put the objects in motion with a motor or pulley or let the wind animate them. These works Marcel Duchamp named "mobiles." Calder has stayed with these basic forms ever since, refining and amplifying them. He has been honored many times with both major exhibitions and awards, and he is the only American artist represented in the Puskin Museum in Moscow. One of the most enduring qualities about his work is humor—a love of play to stimulate the imagination. Calder remains an uncomplicated person in this most complex time. He says, "I just plod along."

The Penn Center stabile was purchased with money given by the National Endowment for the Arts and by the City of Philadelphia. It was placed in the Plaza near the IBM Building in 1969.

Seymour Lipton (1903–)
The Voyager. 1964
University of Pennsylvania,
Annenberg Center
for Communication
Arts and Sciences,
3680 Walnut Street
Nickel silver
on monel metal,
height 31″
(limestone base 82″)

Rarely does an artist speak or write about his work as well as Lipton. His notebooks convey clearly his aesthetic theories: "While it is true that our sensibilities today are somewhat reflexed to appreciate technological forms, there are deeper forces at work. Sculpture predicated on formal sensibilities alone no matter what its expressiveness, caters to areas of experience outside the central sensibilities of our times since the thirties....For myself, ideas, feelings, unconscious drives and other factors are drawn into the organized forms, hopefully to be held in dynamic suspension there. Thus the original generating forces are not frittered away as overt subject-matter, but are rendered in dramatic tension with the abstract forms forever as mysterious as life. This direction of sculpture for me I believe answers all levels of human need and when successfully done can achieve major art."

The Voyager was given in 1971 to the Annenberg Center of the University of Pennsylvania in honor of Harold L. Zellerbach, Class of 1917, by his family under the Redevelopment Authority's 1% for Fine Arts Program. It had been exhibited previously at a one-man exhibition at Marlborough Gallery in 1965 and at the Milwaukee Art Center in 1969.

Henry Mitchell (1915–)
Impalla Fountain. 1964
Philadelphia Zoological Gardens
Bronze, height 240″ (black granite base)

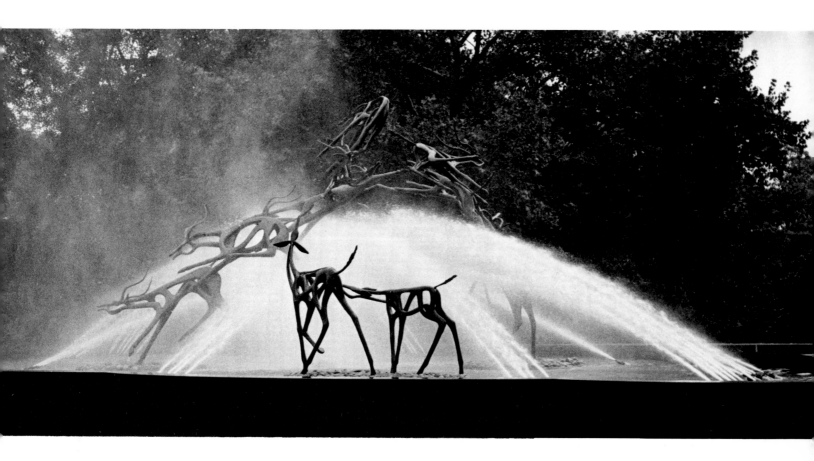

Although not a native Philadelphian, Henry Mitchell studied locally at the Tyler School of Art (Temple University) and the Accademia de Brera as a Fulbright scholar. He is represented in public and private collections in the United States and Europe.

One of the most memorable sights in Africa are the impalla antelopes. When threatened by danger they "explode" in flight, sometimes leaping fifteen feet in the air to escape. Mitchell's fountain captures this sudden flight as a herd scatters with twelve of these life-size animals arching over ten jets of water in an oval-shaped pool. The skeletal forms are characteristic of the impalla's lightness and agility, and they are executed in three graceful arcs while a mother and her calf graze nearby, unaware of the alarm which has caused the rest of the herd to bolt. The animals in flight are intricately joined together by mortise and tenon joints and brass pins—for example, the hoof of one animal is inserted into a hole in the back of another.

The fountain is dedicated to the memory of Herbert C. Morris, a former officer and director of the Zoological Society of Philadelphia. Most of the cost of the $140,000 project was donated by Mrs. Morris, with donations from supporters of the Zoo and the Fairmount Park Art Association. The black granite base pool and general setting was designed by the architectural firm of Hatfield, Martin and White, and the bronze animals were cast by Battaglia and Company in Milan. As 250 watched, a switch was thrown on April 25, 1964, and the jets of water burst up and inward to the center of the basin, directly beneath the leaping impalla.

Leonard Baskin (1922–)
Old Man, Young Man, The Future. 1966
Society Hill Towers,
3rd and Locust Streets
Bronze: *Old Man*, height 76¾",
self-standing; *Young Man*, height 75",
self-standing; *The Future*, height 51"
(brick base 63")

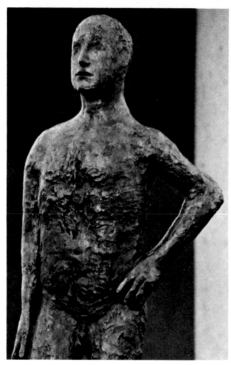

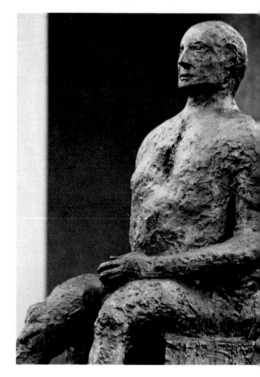

Baskin was born in New Brunswick, New Jersey, and moved to Brooklyn in 1929, where he went to a local Yeshiva school. In 1940 he attended the School of Architecture and Allied Arts of New York University, and in 1942 went on to the School of Fine Arts at Yale. After serving in the United States Navy, he returned to take a Bachelor's degree at the New School for Social Research, New York City. He holds the following awards for graphics and sculpture: Tiffany Foundation Award (Sculpture), 1947; a Guggenheim Fellowship in Creative Printmaking, 1953; a National Institute of Arts and Letters grant for graphic arts, 1961; and a subsequent medal (1969) from that institute, as well as an American Institute of Graphic Arts medal in 1961.

Leonard Baskin has written: "We expire in an age of labels and I've primed one for myself: I term myself a 'moral realist.' Man and his condition have been the totality of my artistic concern. May I quote myself? 'Our human frame, our gutted mansion, our enveloping sack of beef and ash, is yet a glory. Glorious in defining our universal sodality and glorious in defining our utter uniqueness. The human figure is the image of all men and of one man. It contains all and it can express all. Man has always created the human figure in his own image, and in our time that image is despoiled and debauched. ...The forging of works of art is one of man's remaining semblances to divinity. Man has been incapable of love, wanting in charity and despairing of hope. He has not molded a life of abundance and peace and he has charred the earth and befouled the heavens more wantonly than ever before. He has made of Arden a landscape of death. In this garden I dwell, and in limning the horror, the degradation and the filth, I hold the cracked mirror up to man. All previous art makes this course inevitable.' "

The three pieces at Society Hill Towers are a seated old man, a standing young man, and a winged birdlike future. They were part of the commission for the Towers designed by the architect Ieoh Ming Pei under the Redevelopment Authority's 1% for Fine Arts Program.

Harry Bertoia (1915–)
Fountain Sculpture. 1967
Civic Center Plaza
Copper tubes,
bronze welded,
height about 144″,
width 168″, depth 216″

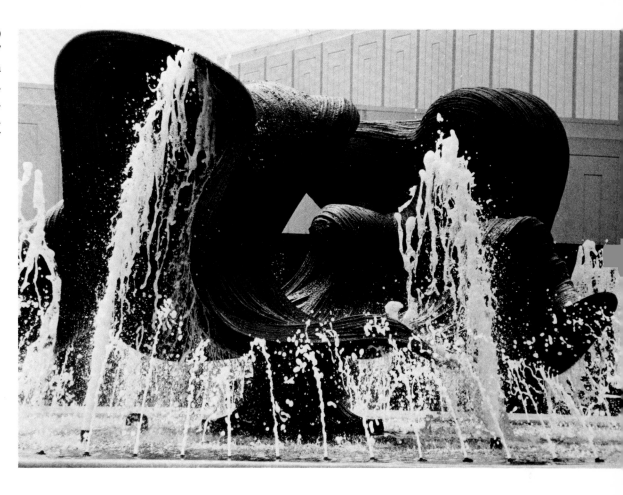

The City of Philadelphia commissioned the sculptor and the architectural firm of Davis, Pool and Sloan, in consultation with the New York architect Edward Durrell Stone, to design this fountain. Bertoia describes his fountain thus: "The concept embodies a spacial involvement with flowing forms complimentary to the movement of the water. Outer forms and inner hollows interrelate continuously. An element of surprise is achieved by the dramatic transformation of the positive forms changing suddenly to cave-like interiors. This work was coordinated with the architectural setting and was specifically done for the City. Contrast is attained by the dark surface of the sculpture and light tone of the walls forming the plaza."

Bertoia's Italian heritage has had a profound effect on his life and work. He immigrated to the United States at the age of fifteen and won a scholarship in 1930 to Cranbrook Academy, Bloomfield Hills, Michigan. Cranbrook, in those years, was a unique educational experiment in the German Bauhaus tradition—small classes, a handcraft atmosphere, and complete freedom for the students. Walter Gropius lectured, Carl Milles was sculptor-in-residence, and Eero Saarinen and Charles Eames were present. Bertoia stayed to teach metalworking

for four years. In 1943 he went to California to work with Charles Eames, designing chairs. After he became a United States citizen in 1946, he returned to Bally, Pennsylvania, to work for Knoll, Associates, who at that time were employing designers, architects and sculptors such as Mies van der Rohe, Le Corbusier and Isamu Noguchi.

Harry Bertoia's prints and sculptures were awarded the American Institute of Architects' craftsmanship medal in 1956, and his work can be found in the collections of Robert Sarnoff, Joseph Hirshorn, and Max Bill. His work was among the fine arts chosen to represent this country at the Brussels World's Fair in 1957. Mrs. Eleanor West, in a script written for a Bertoia film (1965), described his work eloquently as follows: " 'Creative endeavor without possession, action without self-assertion, development without domination, these are intrinsic virtues.' (Confucius) So believes the sculptor, Harry Bertoia. His works are never signed and seldom named. His sculpture seems to belong more to the people who see it than to the man who created it....The sculpture of Harry Bertoia is elemental; sometimes stark, sometimes gay. It is a rediscovery, a remembering, an experience."

Henry Mitchell (1915–)
The Sower. 1968
Provident National Bank,
Broad and Chestnut Streets
Bronze, height 95″
(marble base 5″)

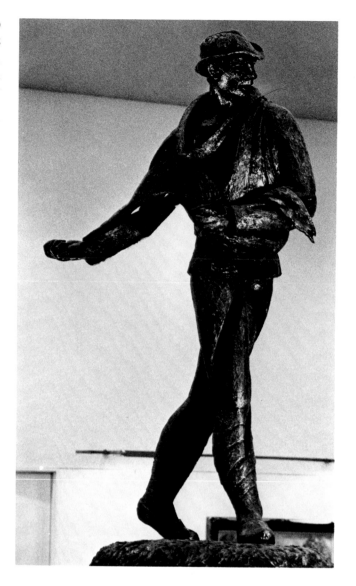

The Provident Bank has used *The Sower* by Jean Francois Millet, a painting acquired from the Vanderbilt Collection, as a hallmark for many years. Millet produced several versions of this work done before 1850, and one of these hangs today in the Bank's 17th and Chestnut Streets branch office. It represents a stocky peasant sowing grain, and is a fitting symbol of thrift and hard work.

In 1966 the board of directors of the Bank commissioned Henry Mitchell to sculpt several versions of the "Hommage a Millet" in wax. A small, eighteen-inch bronze of the final version is in the executive offices of the Bank, being the selection of the committee in February, 1967. That fall, the sculptor enlarged the model five times using plaster over a welded steel armature. Mitchell's studio was nearby the founder, Fonderia Battaglia, Milan, Italy, and casting was begun by the "lost wax" method in February, 1968. The arms and legs were cast as separate units and welded to the torso and head, weighing 1,227 pounds when complete. A base of sienna yellow marble was placed inside the oval tellers area and final installation took place in the summer of 1968.

Gerd Utescher (1912–)
Merchants Bartering. 1968
Fifth Street Wholesale
Distributors Association Inc.,
5th and Spring Garden Streets
Fibreglass with plastic resin,
bronze patina, 58″
(concrete base 48″)

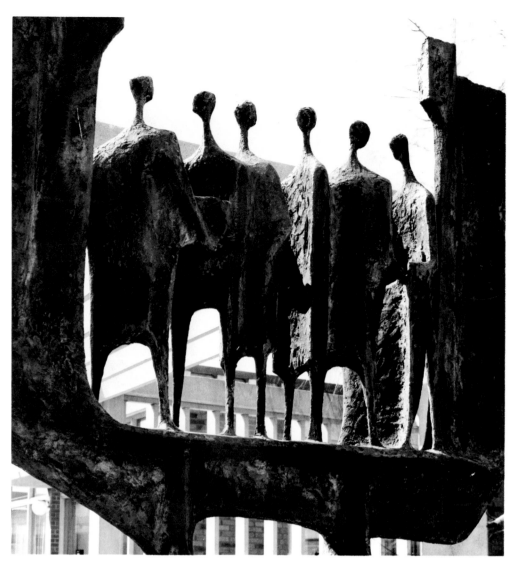

Educated in Germany at the Academy of Arts, Gerd Utescher has taught at the Philadelphia Museum of Art, the Pennsylvania Academy of the Fine Arts, and the Philadelphia College of Art. He has exhibited at the Philadelphia Museum of Art, the Pennsylvania Academy of the Fine Arts, and held a one-man show at the Philadelphia Art Alliance in 1958. His work is represented in the following collections: University of Pennsylvania Hospital, Lafayette College, Fleisher Art Memorial, and in private collections in Germany, Italy, and the United States.

Merchants Bartering was shown at the 20th Anniversary of the Philadelphia Chapter of Artists Equity Exhibition at the Philadelphia Civic Center in 1968. It was purchased for the Wholesalers Distributors Association under the 1% program for fine arts. The complex was designed by the architect Milton Schwartz and Associates.

Harold Kimmelman (1923–)
Decline and Rise. 1969
West Mill Greenway, 51st and Reno Streets
Stainless steel, height 53″

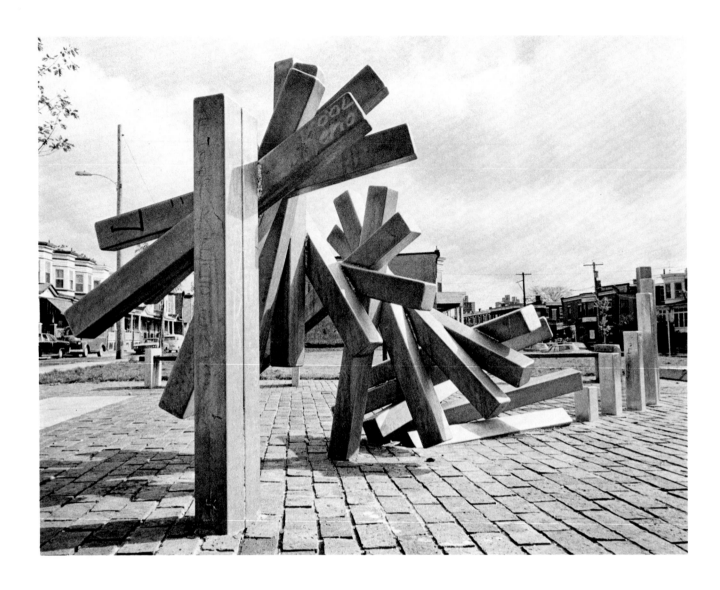

Kimmelman's work reflects a family tradition of metal working, for his father was a master Philadelphia craftsman in creating ornamental iron work. Beginning his formal training with the painters Henry Hensche and Hans Hoffman at the Cape School of Art in Provincetown, Harold Kimmelman continued his study of sculpture at the Pennsylvania Academy of the Fine Arts.

This one-ton, columnar play sculpture for children was commissioned by the architect Edward Maurer of George Neff Associates in April, 1968.

Work on it began in June, 1969, and it was instated in October, 1969. Kimmelman has given his own description of the piece: "Decline and Rise graphically represents the physical collapse in 1948 of a section of housing into a rain sewer, and the later reconstruction of the sewer along with a park and recreation area. I made the falling pieces of sandblasted dull stainless steel; the rising pieces are mirror-polished stainless steel. The corners and edges are rounded to make the sculpture safe for children to play upon."

Constantino Nivola (1911–)
Dedicated to the American Secretary. 1970
Continental Building, 4th and Market Streets
Concrete and sand, height 126″;
fourteen panels, each 36″ wide; total width 504″

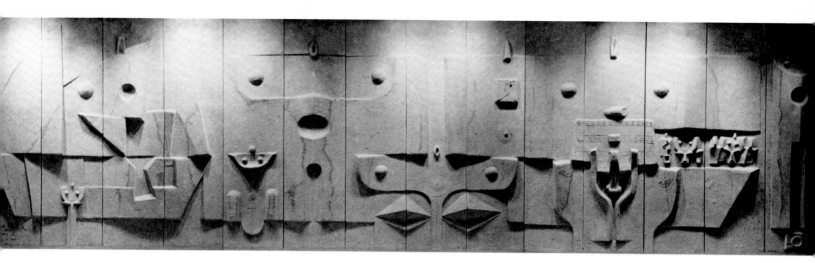

Professor Nivola was graduated from the Istituto d'Arte, Monza-Milano, as Maestro d'Arte. He practiced graphic design, painting, and sculpture in Milan and Paris, before coming to the United States in 1939. From 1955 to 1958 he taught at Harvard University, where he was director of the Design Workshop. In the past years he has executed sculpture projects for a war memorial in Washington, D. C., the Olivetti showroom in New York, the Law School and Quincy House of Harvard, the McCormick Exposition Center in Chicago, and four public schools in Brooklyn and Manhattan. He prepared a large group of sculptures for the Stiles and Morse Colleges at Yale University, two public schools in Brooklyn, and a hospital in New York. Also, he has been design critic at the School of Architecture at Columbia University, and a visiting critic in sculpture at the American Academy in Rome in 1972. Le Corbusier, the renowned architect and planner, commented on Nivola's material and style: "Tino Nivola is too modest, he is full of talent. To amuse his children and himself at the seashore, he has invented a game which is one of the finest that one can play: sculpture. Here, the tide is coming in; he must work quickly. He has to know something about it, he has to act with clarity and decision.... Nivola has made magnificent sculptures on sand. Where the devil did he go to look for the undeniable style which animates his work? He is a son of Sardinia, an island left until now happily sheltered from covetous machinations. There must be on this island traces of the oldest civilizations, and Nivola has unquestionably made a discovery at the right moment."

The "sandcast" sculptural mural in the lobby of the Continental Building and the small relief outside were commissioned under the Redevelopment Authority's 1% Fine Arts Program by the architects of the building, Berger, Caltabiano and Ascione. The unique process of pouring sand and concrete into molds is a painstaking process. The panels were reinforced with steel for mounting on the wall. There is a similar panel called the *Family of Man* at the Van Pelt Library, University of Pennsylvania, the architects of which were Harbeson Hough Livingston & Larson.

Harold Kimmelman (1923–)
Underwater Sunscreen. 1971
Lawncrest Recreation Center,
6000 Rising Sun Avenue
Stainless steel, 240″ by 216″

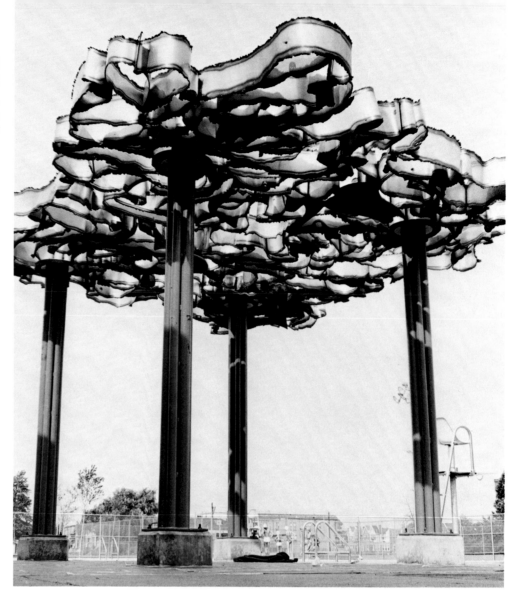

Art critic Dorothy Grafly has written about Kimmelman's work: "Modern in approach and feeling, without being abstract, Kimmelman deals with the active life of our time. At the turn of the century, sculptors (especially those under European influence) went to mythology or allegory for inspiration. Today they find it in the life they, themselves, live, as does Kimmelman...." Harold Kimmelman himself wrote: "In working with heat and pressure, the metal at times seems to resist the form I am shaping. Obviously the metal isn't speaking to me but it is giving me an opportunity to consider a subtle change in form, perhaps a more pleasing form. The problem is how far to extend the change. Too far and I may lose control. So each encounter with the metal becomes a kind of challenge to keep control and to maintain the integrity of the initial concept."

The sunscreen was designed to provide shade for the swimming pool and the shadows it casts are a carefully planned element of the sculpture. Although the support poles are not part of the original concept, the sculptor writes: "I designed it as a sunscreen made from ribbons of stainless steel. These ribbons are formed into currents and swirls. Hanging under them are 3 fish swimming....This work.. . is made from 12 gauge type 304 Stainless Steel, flame cut on the edges."

The sculpture was commissioned in 1969 by Edward Onufer of the Kuljian Corporation, approved by the Art Commission in August, 1969, and instated in August, 1971, under the Redevelopment Authority's 1% for Fine Arts Program.

William P. Daley (1925–)
Helical Form. 1972
Germantown Friends School,
Germantown Avenue
and Coulter Street
Tomasil bronze, diameter 60″
(limestone base 30″)

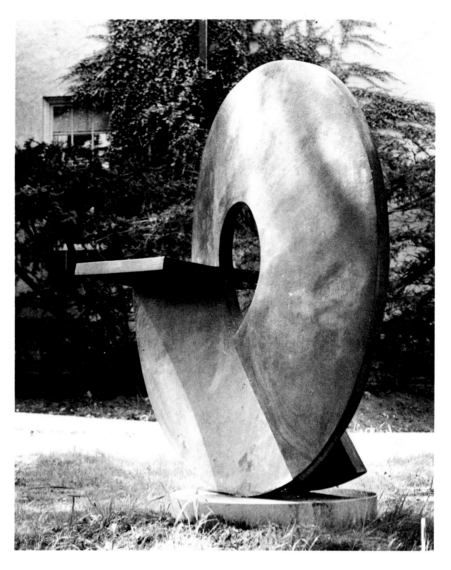

The sculptor was born in Hastings on Hudson, New York, and went to public schools there. His advanced education includes degrees from the Massachusetts College of Art in 1950 and Columbia University Teachers in 1951. Daley has been a teacher at the University of Northern Iowa, the State Universities at New Paltz and Fredonia, New York, the University of New Mexico, and for fourteen years has held the post of Professor in Design and Ceramics at the Philadelphia College of Art. In a whimsical letter reviewing his career he wrote: "As a boy in grade school, I enjoyed the permissions of being 'dumb.' Evidencing little aptitude for the academic, I was chosen to draw the harvest doggerel on the black board in colored chalk....I began art school wanting to be a painter, but I was persuaded by a good teacher of the difficult satisfactions of making clay stand up by itself. During the years I have taken pleasure in making other materials behave....During the twenty-two years since art school I have worked as a house painter, carpenter, and industrial designer, but during this time my best energies have been given to teaching....The things I have made while teaching I have made for myself, and those whom I love and respect."

The large *Helical Form* is five feet in diameter and weighs 1,400 pounds. The bronze was cast by the Modern Art Foundry in Queens, New York. Daley worked full scale in wax for casting and did all of the grinding and finishing of the rough casting. The work was accomplished under the Redevelopment Authority's 1% for Fine Arts Program and was dedicated April 8, 1972, in conjunction with the opening of the T. Kite Sharpless Building for Science and Mathematics. The sculptor describes his work as follows: "The sculpture is a symbol of continuousness. The form is related to a mobius strip and a double helix. Its perpendicular terminus on one end is level with the world. Its plate-like roundness gives it qualities of one location in a continuous set of locations. ...I believe a good school is a place where beginnings and endings are illusions. Schools and meetinghouses are places where one seeks what is beyond—there always is something. The history of Germantown Friends School is testimony of such a quest."

George Sugarman (1912–)
Untitled Wall Sculpture. 1972
Albert M. Greenfield School, 22nd and Chestnut Streets
Painted aluminum, height 204″, length 276″, depth 216″ (wall-mounted)

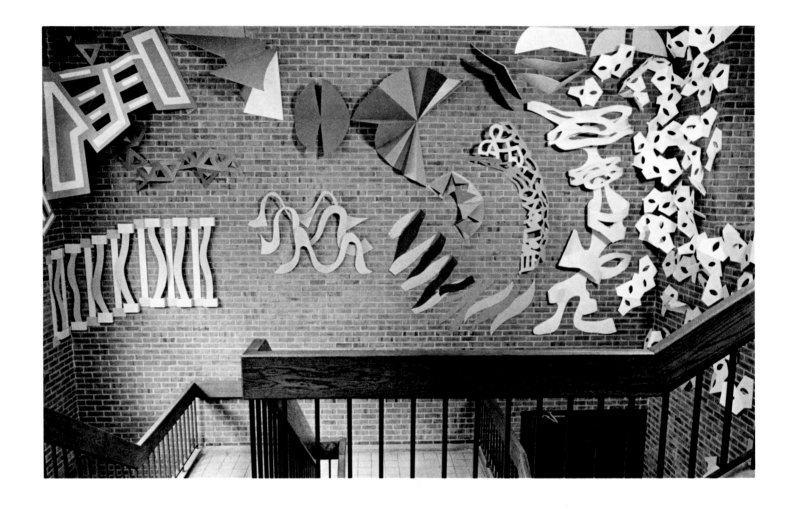

A lithographer as well as a sculptor, George Sugarman emerged from obscurity to sudden fame with an unexpected second prize for sculpture in the 1961 Carnegie International Exhibition in Pittsburgh, three Longview Foundation grants in 1961, 1962, and 1963, and a Ford Foundation grant in 1965 for the Tamarind Lithography Workshop in Los Angeles. Dr. Sidney Simon of the University of Minnesota had discussed Sugarman's place in the contemporary scene: "his work itself resists categorizing. Although he has been widely exhibited and written about, his work has not been included for precisely this reason in any of the numerous pace-setting 'thematic' exhibitions that have been held since 1961. No flexibility of terms can make him out to be neo-Dada, pop, op, hard-edge or minimal. His work is instead uniquely personal, a judgment that carries an unusual burden of meaning; for, given the continuing interest that

his work commands, it is a situation that has no parallel at the present time." Sugarman himself has said, "Must we remain the obedient children of our ancient fathers? Isn't it time we went for a stroll on our own in 1959?" and, in discussing his sculpture: "It was what I wanted to do....There it was, clear, direct, specific. The color made it more so, and made it much more difficult for people to accept."

Sugarman has exhibited in America, South America, and Europe. He has taught at Hunter College, New York, and at Yale. This wall sculpture was designed specifically for this location as part of the architecture of the lobby, and was commissioned by the Albert M. Greenfield Foundation. It was executed in aluminum, was painted from Sugarman's design, and was installed by Lippincott, Inc. of New Haven, Connecticut.

Louise Nevelson
(1899–)
Atmosphere &
Environment, XII.
1970
Philadelphia Museum
of Art,
West Entrance
Corten steel,
height 219″,
length 120″,
width 60″
(plywood base)

A few years after her birth in Kiev, Russia, Louise Nevelson's family emigrated to Rockland, Maine, where her father established a lumber business. At an early age Miss Nevelson became aware of her talent: "My whole life has been geared to being a visual artist. I never wanted to live another kind of life. When I was a little girl, I used to play with crayons and clay."

She attended the Art Students League, studied abroad, and worked briefly as Diego Rivera's assistant. Later she began to combine diverse materials into assemblages at her New York studio, before concentrating on scraps of wood which she hammered into compositions suggestive of landscapes. In the mid-1950s she started to enclose these into shadow boxes and to assemble the boxes into walls.

Her sculpture is dominated by her eye for the placement of details: "It's either instantaneously right or it's not." On the subject of a series of collages, she explained: "I put down a large sheet of black paper, then start adding pieces, building up the composition in layers. They're flat, but it's the same effect as the sculpture." In many of her works in the 1950s jagged pieces of wood are layered on in a manner that suggests rough-hewn brushstrokes. Some of her more recent works replace the welter of shapes with a few simple forms, or with rows of parallel slats. Perhaps this reflects the steel and glass severity of Manhattan skyscrapers, or perhaps it satisfies a need in the artist for increased order—an esthetic house-cleaning. However that may be, it grows out of and completes her earlier work, rather than contradicting it. (Bill Marvel, "Louise Nevelson: Lady of Action, Shaper of Wood," *The National Observer*, December 22, 1973.)

Appendix
Section VI

Boris Blai (1893–)
Johnny Ring
Temple University, Mitten Hall
Bronze, height 60″
(granite base 60″)
Gift of the Class of 1958 to
Temple University. Instated
April 30, 1965.

Jon Bogle (1940–)
Nidus
Temple University, Paley Library
Courtyard
Steel, 48″ by 48″
(granite base 48″)
Purchased by Temple University
through the Boris Blai Fund.
Instated in 1966.

Joseph C. Bailey
Dolphin Play Fountain
Schwartz Playground, 10th and
Jefferson Streets
Epoxy and fiberglass, length 59″;
concrete basin, diameter 228″
Funds provided through
Redevelopment Authority 1%
Fine Arts Program.
Instated in 1972.

Bernard Brenner (1927–)
Pattern of Flight
Philadelphia International
Airport, Waiting Room
Welded steel, length 184″
Funds provided through the
city's fine arts requirement

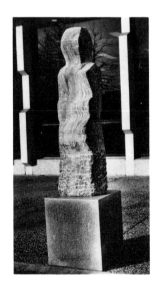

Katherine Joy Bintliff
(1944–)
Figure in Blue Marble
Temple University, Paley Library
Courtyard
Blue marble, height 45″
(concrete base 12″)
Purchased by Temple University
through the Boris Blai Fund.
Instated in the summer of 1966.

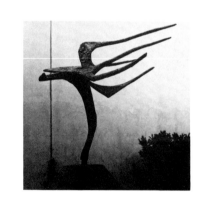

Bernard Brenner (1927–)
Phoenix Rising from the Ashes
Southwark Branch, Free Library,
7th and Carpenter Streets
Copper and bronze, height 59″
(concrete base 37″)
Funds provided through the
city's fine arts requirement.
Instated in 1963.

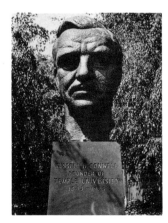

Boris Blai (1893–)
Russell H. Conwell. 1951
Temple University,
Founder's Garden
Bronze, height 42″ (black granite
base 60″)
Gift of the artist to Temple
University. Instated in
the spring of 1968.

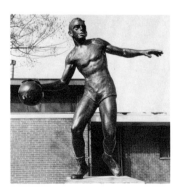

Joe Brown (1909–)
Athlete
Vogt Playground, Unruh Avenue
and Cottage Street
Bronze, height 48″ (brick
base 54″)
Funds provided through the
city's fine arts requirement.
Instated in 1967

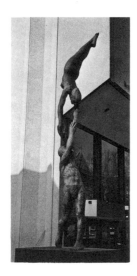

Joe Brown (1909–)
Two Athletes
Temple University, Health and
Physical Education Building
Bronze, height 234″ (wood
base 60″)
Gift of the alumni of the
Department of Health, Physical
Education, and Recreation to
Temple University.

Jean Francksen (1914–)
A Fish Story
Finnegan Playground, 69th
Street and Grove Avenue
Cast-concrete, height 80″
Funds provided through
Redevelopment Authority 1%
Fine Arts Program.
Instated in 1967.

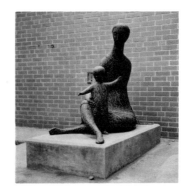

Joseph J. Greenberg, Jr.
(1915–)
Child Care
Health Center #4, 44th Street
and Haverford Avenue
Reinforced plastic, height 45½″
(concrete base 10½″)
Funds provided through the
city's fine arts program.
Instated in 1966.

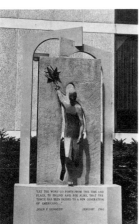

Robert Devoe (1928–)
John F. Kennedy Memorial
Temple University, Kennedy
Court
Artificial stone, 96″ by 24″
(granite base 30″)
Funds provided by Temple
University, Student Council and
Class of 1965. Instated July, 1967.

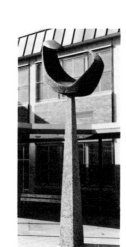

Joseph J. Greenberg, Jr.
(1915–)
Chimpanzee
Philadelphia Zoological Gardens,
Rare Mammal House
Limestone relief, 31″ by 21″
Instated in May, 1965.

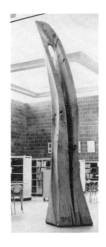

Wharton Esherick (1887–1970)
Rhythm #1
South Philadelphia Branch, Free
Library of Philadelphia, Broad
and Morris Streets
Linden wood, height about 156″
Funds provided through the
city's fine arts requirement.
Instated in 1965.

Joseph J. Greenberg, Jr.
(1915–)
Freedom Symbol
Martin Luther King Recreation
Center, 22nd Street and
Columbia Avenue
Bronze, about 60″ by 48″ by 36″
(concrete base 96″)
Funds provided through the
city's fine arts requirement.

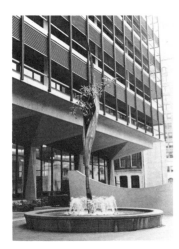

Clark Fitz-gerald
Milkweed Pod
Rohm and Haas Building, 6th
and Market Streets
Bronze, height about 252″;
fountain basin, diameter 180″
Funds provided through
Redevelopment Authority 1%
Fine Arts Program. Instated
in 1966.

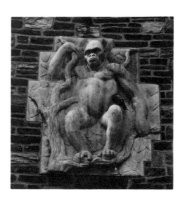

Joseph J. Greenberg, Jr.
(1915–)
Gorilla
Philadelphia Zoological Gardens,
Rare Mammal House
Limestone relief, 81″ by 70″
Instated in May, 1965.

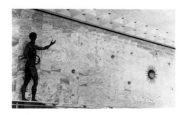

Joseph J. Greenberg, Jr.
(1915–)
Heroic Figure of Man. 1963
Bell Telephone Company, 16th
Street and the Parkway
Bronze, height 150″ (black
marble base 42″)
Commissioned by the Bell
Telephone Company. Instated
June 23, 1964.

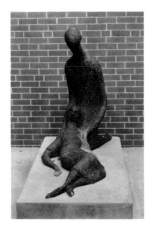

Joseph J. Greenberg, Jr.
(1915–)
Medical Care
Health Center #4, 44th Street
and Haverford Avenue
Reinforced plastic, height 45″
(concrete base 10½″)
Funds provided through the
city's fine arts requirement.
Instated in 1966.

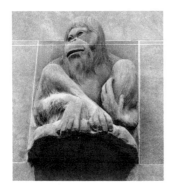

Joseph J. Greenberg, Jr.
(1915–)
Orangutan
Philadelphia Zoological Gardens,
Rare Mammal House
Limestone relief, 31″ by 21″
Instated in May, 1965.

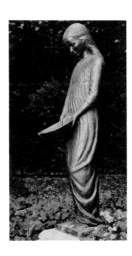

Edward Fenno Hoffman III
(1916–)
Girl with Basin
College of Physicians garden,
22nd and Chestnut Streets
Bronze, height 46½″ (concrete
base 9″)
Purchased by the Philadelphia
Unit of the Herb Society of
America. Instated in June, 1958.

Klaus Ihlenfeld
Bronze Sphere
Fairmount Manor Apartments,
Fairmount Avenue between 6th
and 7th Streets
Bronze, diameter 78″ (concrete
base 6″)
Funds provided through
Redevelopment Authority 1%
Fine Arts Program.
Instated in 1970.

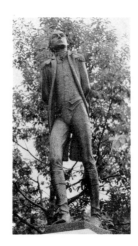

Lewis Iselin, Jr. (1913–)
General Nathaniel Greene
Reilly Memorial, Philadelphia
Museum of Art, west side
Bronze, height 111″ (granite
base 85″)
Bequest of General William M.
Reilly. Instated in 1961.

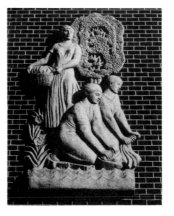

Dexter Jones (1926–)
Women Washing
Philadelphia General Hospital,
Laundry and Linen Exchange,
58th and Lindberg Streets
Cast aluminum, height 123½″
(base 94″)
Funds provided through the
city's fine arts requirement.
Instated in 1968.

Dexter Jones (1926–)
City Seal
Municipal Services Building,
Reyburn Plaza
Gold-leafed bronze bas-relief,
height 132″
Funds provided through the
city's fine arts requirement.
Instated in 1966.

Dexter Jones (1926–)
Haddy
Philadelphia Zoological Gardens,
south entrance to Reptile House
Bronze, height 51″ (natural rock
base 37″)
Commissioned by the Zoo.
Instated in 1971. Represents the
first dinosaur found in North
America by Joseph Leidy at
Haddonfield, N. J., in 1858.

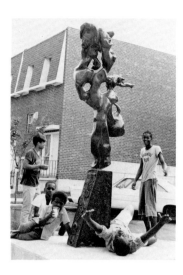

Tonnie Jones (1944–)
The Funder
West Mill Creek Town Houses,
Haverford Avenue between 46th
and 48th Streets
Bronze, height 120″ (concrete
base)
Funds provided through
Redevelopment Authority 1%
Fine Arts Program.
Instated in 1971.

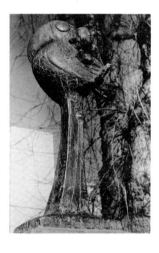

Karl Karhumaa (1924–)
Beginning of an Adventure
Recreation Center,
Conshohocken Avenue and
Windemere Street
Bronze, height about 45″
(concrete base)
Funds provided through the
city's fine arts requirement.
Instated July 1, 1966.

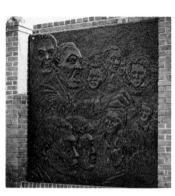

Paul Keene (1920–) and Neil
Lieberman (1935–)
***Martin Luther King Freedom
Memorial***
59th Street Baptist Church, 59th
and Pine streets
Five fiberglass bas-reliefs:
central panel 84″ square; others
30″ by 36″
Funds provided by the
Fairmount Park Art Association.
Instated October 10, 1971. The
reliefs depict important people
and events in the Civil Rights
movement.

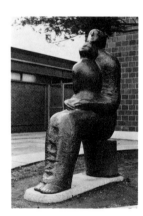

Evelyn Keyser (1922–)
Mother and Child
Health Center, Broad and Morris
Streets
Bronze, height 72″ (concrete
base)
Funds provided through the
city's fine arts requirement.
Instated in 1964.

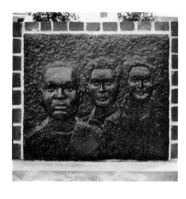

Evelyn Keyser (1922–)
People Pyramid
Playground, 18th and Wallace
Streets
Welded aluminum, height 108″
(brick base 78″)
Funds provided through the
city's fine arts requirement.
Instated in November, 1970.

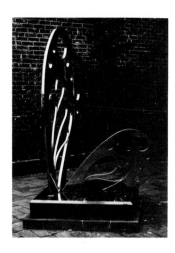

Harold Kimmelman (1923–)
Butterfly
Second and Delancey Streets
Stainless steel, height 72″
(polished black granite base)
Funds provided through
Redevelopment Authority 1%
Fine Arts Program.
Commissioned by Penn Tower
Development Corporation.
Instated in December, 1971.

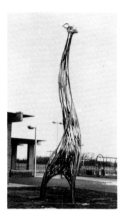

Harold Kimmelman (1923–)
Giraffe
Dunks Ferry Recreation Center,
Dunks Ferry and Mechanicsville
Road
Welded stainless steel,
height 240″
Funds provided through the
city's fine arts requirement.
Instated in 1969.

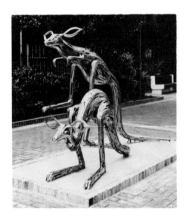

Harold Kimmelman (1923–)
Kangaroos
Lawrence Court Walkway, 4th
and 5th Streets between Spruce
and Pine Streets
Welded stainless steel, height 60″
(concrete and brick base)
Funds provided through
Redevelopment Authority 1%
Fine Arts Program.
Commissioned by Penn Tower
Development Corporation.
Instated in March, 1972.

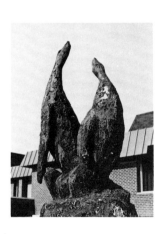

Bernard Lee
Seals
Marshall L. Shepard Village,
42nd Street and Haverford
Avenue
Perlite with epoxy finish figures
on base of the same material,
48″ by 42″ by 36″
Funds provided through
Redevelopment Authority 1%
Fine Arts Program.
Instated in 1969.

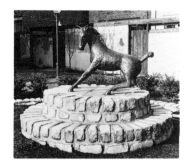

Margaret Wasserman Levy
(1899–)
Mustang at Play
Head House Square
Corporation, 2nd and Pine
Streets
Bronze, height 37½″ (fieldstone
base 26″)
Funds provided through
Redevelopment Authority 1%
Fine Arts Program.
Instated in 1969.

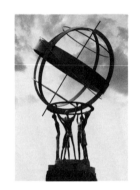

Margaret Wasserman Levy
(1899–)
Whale
Martin Luther King Recreational
Center, 22nd Street and
Columbia Avenue
Fiberglass, height 50″ (concrete
base 24″)
Funds provided through the
city's fine arts requirement.
Instated in 1968.

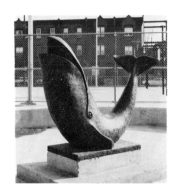

Margaret Wasserman Levy
(1899–)
The Whole World in Our Hands.
1964
Drexel University Campus, 33rd
and Chestnut Street
Bronze, height 50″ (rough
granite base 48½″)
Funds provided through
Redevelopment Authority 1%
Fine Arts Program.
Instated in 1969.

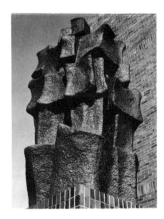

Neil Lieberman (1935–)
Bronze Figure
Philadelphia General Hospital,
Medical Examiner's Building
Bronze, height 132″ (brick base)
Funds provided through the
city's fine arts requirement.
Instated *c.* 1970.

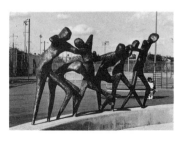

Neil Lieberman
Spray Pool Sculpture
Moylan Recreation Center, 25th
and Diamond Streets
Epoxy, 60″ by 124″ (concrete
base, height 21″)
Funds provided through the
city's fine arts requirement.
Instated 1972.

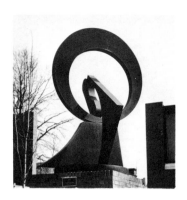

Richard Lieberman (1916–)
Unity
Bingham Court, 4th and
Locust Streets
Corten steel, height 168″
(brick base 48″)
Funds provided through
Redevelopment Authority 1%
Fine Arts Program. Instated
December, 1970.

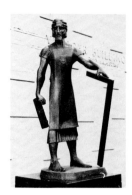

Maurice Lowe (1929–)
St. Joseph the Worker
St. Joseph's College, 54th Street
and City Line Avenue
Bronze, height 34½″ (granite
base 28″)
Commissioned by St. Joseph's
College. Gift of the Evening
College class of 1966.
Instated May 2, 1968.

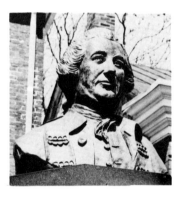

Carl Lindborg (1903–)
John Hanson
Gloria Dei (Old Swedes) Church,
Delaware Avenue and Christian
Street
Bronze, height 24″ (granite base
79″); seven bronze bas-reliefs on
base, diameters 9¼″
The bust is the gift of the
Swedish Colonial Society. The
base is the gift of the Vasa Order
of Sweden in America. Instated
October 7, 1967.

Henry Mitchell (1915–)
Giraffes
Philadelphia Zoological Gardens,
Carnivora House
Bronze, height 46″
Gift of the Fairmount Park Art
Association. Instated
May 12, 1960.

Jacob Lipkin (1909–)
Ape
Philadelphia Zoological Gardens,
Carnivora House
Granite, height 21″
Gift of the Fairmount Park Art
Association to the Zoo.
Instated in 1969.

Constantino Nivola (1911–)
The Family of Man. 1961
University of Pennsylvania,
entrance to Van Pelt Library
Two concrete bas-reliefs,
126″ by 219″
Commissioned by the University
of Pennsylvania. Instated
in 1962.

George Papashvily (1898–)
Butterfly
Woodmere Art Gallery, 9201
Germantown Avenue
Granite, 6½″ by 39″ (fieldstone
base 19″)
Purchased by the Woodmere Art
Gallery from an exhibition of the
artist's work in January, 1964.
Instated in June, 1964.

Jacob Lipkin (1909–)
The Prophet
John F. Kennedy Plaza
Marble, height 96″
Gift to the City by a group of
businessmen in 1968.

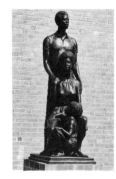

Charles C. Parks (1922–)
The Family
Fifth and Poplar Streets
Bronze, height 70″ (brick
base 26″)
Funds provided through
Redevelopment Authority 1%
Fine Arts Program.
Instated in 1972.

Richard Loeb
Reclining Figure
Temple University, Paley Library
Courtyard
White marble, height 12″
Purchased by Temple University
through the Boris Blai Fund.
Instated in 1966.

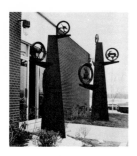

Charles C. Parks (1922–)
Transportation
Avis Rent-a-Car, 6615 Norwitch
Drive
Corten steel columns, heights
162″ and 109″
Funds provided through
Redevelopment Authority 1%
Fine Arts Program.
Instated 1969.

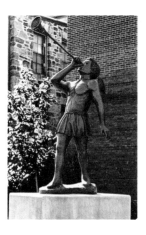

Ron T. Pierce (1943–)
Awakening. 1971
Union Baptist Church, 1910
Fitzwater Street
Bronze, height 74″ (concrete
base 44″)
Funds provided by Fairmount
Park Art Association.
Instated in 1971.

Sarala Ruth Pinto (1925–)
Phoenix above Maltese Cross
Fire station, 12th and Reed
Streets
Bronze, height 66″
(wall-mounted)
Final model approved January,
1962, for Redevelopment
Authority 1% program.
Prefabricated by Colonial Iron
Craftsmen, Lancaster Avenue.
Instated *c.* 1962.

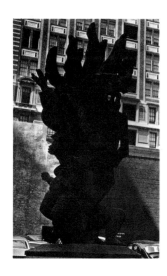

Nathan Rapaport
***Monument to Six Million
Jewish Martyrs***
16th Street and the Parkway
Bronze, height 216″ (black
granite base)
Given to the City by the New
Americans Association, a group
of 400 families, many of whom
fled Poland after World War II.
Instated April 26, 1964.

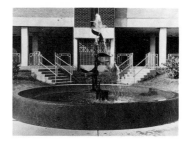

Christopher Ray (1937–)
Fountain
Ascension Manor, 8th and
Poplar Streets
Wrought copper, height 84″;
diameter of basin 180″
Funds provided through
Redevelopment Authority 1%
Fine Arts Program.
Instated in 1970.

Stephen Robin (1944–)
Shell Composition
Temple University, Paley Library
Courtyard
Limestone, height 30″ (granite
base 12″)
Purchased by Temple University
through the Boris Blai Fund.
Instated in 1966.

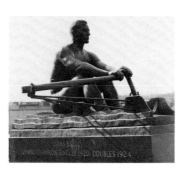

Harry Rosin (1897–1973)
John B. Kelly
East River Drive, near rowing
grandstands
Bronze, height 57″ (granite
base 34″)
Commissioned and funded by
private citizens. Instated
June 26, 1965.

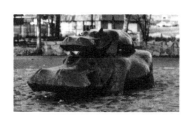

Berthold Schiwetz (1909–)
Hippo Family
Durham Park, Lancaster and
Wyalusing Avenues
Bronze, 36″ by 24″ by 60″
Funds provided through the
city's fine arts requirement.
Instated in 1962.

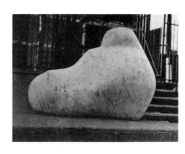

Jane E. Stein (1944–)
Bird Form
Temple University, Paley Library
Courtyard
Blue marble, 18″ by 12″
(concrete base 36″)
Purchased by Temple University
through the Boris Blai Fund.
Instated in 1966.

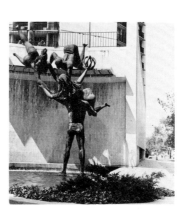

Oskar Stonorov (1905–1969) and
Jorio Vivarelli
The Tuscan Girl Fountain
Plaza Apartments, 18th Street
and the Parkway
Bronze, height 312″
Funds provided through the
city's fine arts requirement.
Instated June 9, 1965.

Francis Stork
Repose
Temple University, Paley Library
Courtyard
Granite, 24" by 36" (granite
base 36")
Purchased by Temple University
through the Boris Blai Fund.
Instated in 1966.

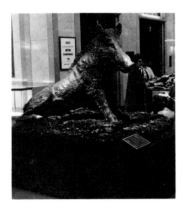

Pietro Tacca (1577–1640)
Il Porcellino. c. 1613
Strawbridge and Clothier's
Store, 8th and Market Streets
Bronze, height 31" (black marble
base 24")
This is the fifth known cast of
the Wild Boar in the Straw
Market in Florence. The cast was
commissioned by Ferdinando
Martinelli of Florence. It was
rented by Strawbridge and
Clothier for an Italian Festival
and subsequently purchased in
October, 1966.

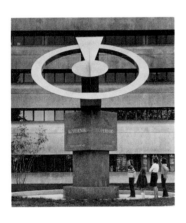

Dudley Talcott
Kopernik (Nicolaus Copernicus,
1473–1543)
Eighteenth, Race, and Parkway
Stainless steel, height 144",
diameter 192" (base, red granite,
height 140", diameter 96")
Gift of Polish-Americans of
Philadelphia. Dedicated August
18, 1973, to commemorate the
500th anniversary of the birth of
the Polish astronomer.

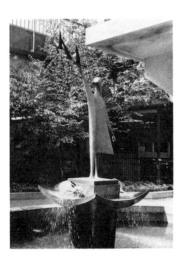

Gerd Utescher (1912–)
*Emancipation Proclamation
Fountain*
Penn Center, Subway Court,
15th and Market Streets
Bronze, height 96"
(concrete base)
Commissioned by the City in
commemoration of the 100th
anniversary of the Emancipation
Proclamation. Initial funds
provided by the contributions of
Philadelphia school children.
Instated February 12, 1965.

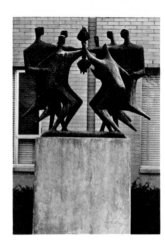

Gerd Utescher (1912–)
Guardians of Fire
Fire station, 711 South
Broad Street
Bronze, 30" by 24" by 18"
(concrete base about 60")
Funds provided through the
city's fine arts requirement.
Instated in 1964.

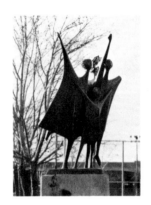

Gerd Utescher (1912–)
Playing Children
Playground, 57th Street and
Haverford Avenue
Bronze, 48" by 36" by 18"
(concrete base)
Funds provided through the
city's fine arts requirement.
Instated June 28, 1967.

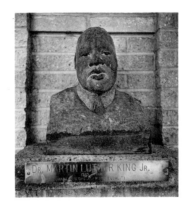

James W. Washington, Jr.
(1909–)
Martin Luther King. 1969 (one of
six including: Crispus Attucks,
Benjamin Banneker, George
Washington Carver, Frederick
Douglass, and Nat Turner)
Progress Plaza Shopping Center,
Broad and Oxford Streets
Granite, height 18" (from
ground 39")
Funds provided through
Redevelopment Authority 1%
Fine Arts Program.
Instated *c.* 1971.

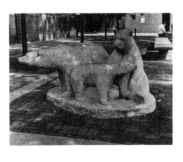

Sherl Joseph Winter (1934–)
Family of Bears. 1966
Delancey Park, Delancey Street
between 3rd and 4th Streets
Precast concrete, height 42½"
Funds provided through
Redevelopment Authority 1%
Fine Arts Program.
Instated in 1966.

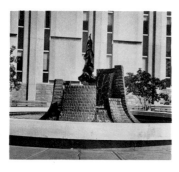

Sherl Joseph Winter (1934–)
Flame
Drexel University Campus, 33rd
and Chestnut Streets
Bronze, height 91"; Belgian
block and concrete basin, height
44½"
Funds provided through
Redevelopment Authority 1%
Fine Arts Program.
Instated June, 1968.

Sherl Joseph Winter (1934–)
Whales. 1971
John Hancock Public School,
East Crown Street and Morrell
Avenue
Cast concrete, 50" by 132" by 96"
Funds provided through the
city's fine arts requirement.
Instated in 1972.

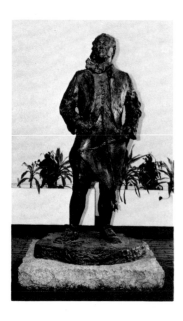

Agnes Yarnell
Benjamin Franklin with Kite.
1965
Franklin Institute Research
Laboratories, 20th and Race
Streets
Bronze, height 73" (rough
marble base 8")
Funds provided through
Redevelopment Authority 1%
Fine Arts Program.
Instated in 1966.

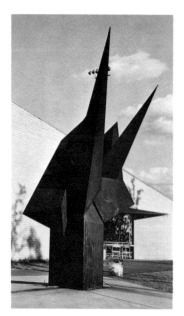

Marco Zubar (1925–)
Bird in Flight
Awbury Tract Tennis and
Recreation Center, Ardley and
Haines Streets
Corten steel, height 147"
Funds provided through the
city's fine arts requirement.
Instated in 1971.

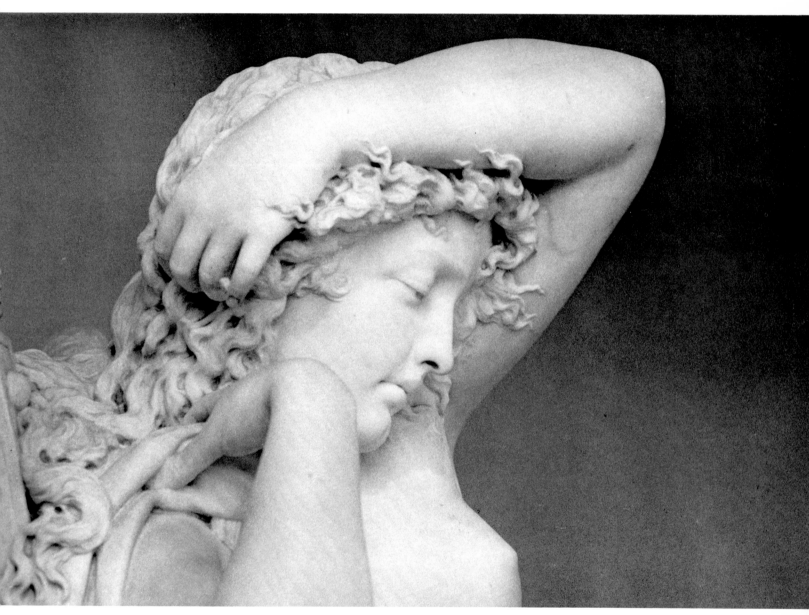

Detail of *Première Pose*, photographed by Bernie Cleff.

Biographies

Authors

Glenn F. Benge, Associate Professor of Art History at Temple University's Tyler School of Art, has lectured and written on the sculpture of Antoine-Louis Barye, who was the subject of his doctoral dissertation at the University of Iowa.

Wayne Craven is the author of *Sculpture in America, from the Colonial Period to the Present.* Since 1960 he has been the Henry Francis du Pont Winterthur Professor of Art History at the University of Delaware.

Anne d'Harnoncourt earned her M.A. at the Courtauld Institute of Art, London University. She is the Curator of Twentieth-Century Painting at the Philadelphia Museum of Art.

Victoria Donohoe studied at the Graduate School of Fine Arts, University of Pennsylvania, where she was awarded the degree of M.F.A. Since 1962 she has been the art critic for the *Philadelphia Inquirer.*

John Dryfhout is Curator of the Saint-Gaudens National Historic Site in Cornish, New Hampshire. He has prepared a definitive *catalog raisonné* of Saint-Gaudens' works.

George Gurney is a Ph.D. candidate at the University of Delaware. He has taught art history at Sweet Briar College and at the University of Hartford and is a Kress Fellow at the National Gallery.

Robert Sturgis Ingersoll (1891–1973) was a distinguished Philadelphia lawyer and patron of the arts. President of the Philadelphia Museum of Art from 1947 to 1964, he served as Chairman of the Samuel Committee creating the Samuel Memorial in Fairmount Park.

Michael Richman wrote his masters thesis on the sculptor Edward Kemeys and his Ph.D. dissertation for the University of Delaware on Daniel Chester French. He is Assistant to the Director, National Portrait Gallery, Smithsonian Institution.

Charles Coleman Sellers, Librarian Emeritus of Dickinson College, was awarded the Bancroft Prize in 1970 for his biography of Charles Willson Peale. He is also the author of a history of Dickinson College.

David Sellin has taught art history at Colgate, Tulane, and Wesleyan and served as Assistant Curator of Painting at the Philadelphia Museum of Art. He is currently planning the reconstruction of the Centennial art exhibit for the Smithsonian Institution.

Lewis Sharp, whose doctoral dissertation for the University of Delaware was on the sculptor John Quincy Adams Ward, joined the staff of the Metropolitan Museum of Art as an Assistant Curator in the American Painting and Sculpture Department in 1972.

John Tancock attended Downing College, Cambridge, and the Courtauld Institute of Art, University of London. A staff member of the Impressionist and Modern Picture Department at Sotheby Parke Bernet, he has prepared a catalogue of the Rodin Museum.

George Thomas held a Kress Fellowship, 1971–1972, at the University of Pennsylvania, where he is a Ph.D. candidate. He is co-author of a catalogue on the architecture of Frank Furness.

Photographers

Bernie Cleff, a native Philadelphian, graduated in 1950 from the Philadelphia College of Art, where he taught photography 1961–1971. He has won many awards and his photographs have appeared in many magazines.

Edward Gallob, a self-taught photographer, has had his work exhibited in a number of museums and his photographs have appeared in many publications. He is the author of *City Leaves, City Trees* and *City Rocks, City Blocks and the Moon.*

Tana Hoban is married to Edward Gallob and is partner-owner of the Hoban-Gallob studio in Philadelphia. The winner of more than a dozen gold medals, her special gift is photographing children.

George Krause attended the Philadelphia College of Art. He has had several one-man shows and his photographs are in the permanent collections of a number of museums. He is a Guggenheim Fellow.

Seymour Mednick studied at the Philadelphia College of Art where he has also been an instructor in the Department of Photography. His photographs have appeared in many journals and he has been the recipient of many awards.

Dennis W. Weeks attended the Tyler School of Art and L'Univesité de Montpellier, France. He has served as instructor of photography at the Cheltenham Art Center.

Murray Weiss, was Associate Professor of Photography, Philadelphia College of Art, where he taught for many years. He organized the Fine Art Photography Department at the Layton School of Art, Milwaukee where he now teaches. His work has appeared in numerous exhibitions.

Archivist

Carolyn Pitts was a Fulbright Lecturer in Fine Arts in Istanbul, Turkey. She served as Archivist for the Fairmount Park Art Association and was awarded a grant from the National Endowment for the Humanities for a historic study of Cape May, New Jersey.

Authors' Illustrations and Footnotes

William Rush at Fairmount / page 8

Fig. 1. John Krimmel. *Fourth of July in Centre Square* (Latrobe's Pump House and Rush's *Nymph*). 1810–12. Painting. Pennsylvania Academy of the Fine Arts.

Fig. 2. William E. Tucker. *Fairmount Water-Works.* Engraving. Philadelphia Museum of Art.

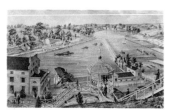

Fig. 3. J. T. Bowen. *Schuylkill River from Fairmount* (showing *Mercury* on pergola). 1838. Lithograph. Historical Society of Pennsylvania.

1. Talbot F. Hamlin, *Benjamin Henry Latrobe* (New York, 1955), 159, 166.

2. *Poulson's American Daily Advertiser*, August 28, 1809.

3. Common Council Minutes, September 14, 1809, 313, Philadelphia City Archives.

4. Watering Committee Bills, bill of Adam Traquair, September 24, 1810, *ibid.*

5. Hamlin, 166-167.

6. Henri Marceau, *William Rush, 1756–1833. The First Native American Sculptor* (Philadelphia, 1937), 7.

7. Watering Committee Papers, 1809, Philadelphia City Archives.

8. Abraham Ritter, *Philadelphia and Her Merchants…*(Philadelphia, 1860), 105.

9. Marceau, 9–21.

10. *Ibid.*, 28.

11. *Ibid.*, 16.

12. *Ibid.*

13. J. Thomas Scharf and Thompson Westcott, *History of Philadelphia* (Philadelphia, 1884), I, 605; Thomas Gilpin, "Fairmount Dam and Water Works, Philadelphia," *Pennsylvania Magazine of History and Biography*, XXXVII (1913), 471–479.

14. Marceau, 56.

15. *Poulson's American Daily Advertiser*, April 9, 1825.

16. Scharf and Westcott, III, 1853.

17. John P. Sheldon, letter of December 4, 1825, *Pennsylvania Magazine of History and Biography*, XVIII (1894), 124.

18. Scharf and Westcott, II, 1066.

19. Watering Committee Papers; Common Council Minutes, May 5, 1825, with concurrence of Select Council, 283, Philadelphia City Archives.

20. Marceau, 20–21.

21. Domenico de Rossi, *Raccolta di Statue Antiche e Moderne…*(Rome, 1704), Pl. XXVI, copy at Library Company of Philadelphia.

22. *A Guide to the Lions of Philadelphia* (Philadelphia, 1837), 59–60.

23. Watering Committee Bills, Philadelphia City Archives.

24. Marceau, 11.

25. Hamlin, 319 n.

26. *Philadelphia Gazette*, January 18, 1833, quoted by Marceau, 7.

Barye's *Lion Crushing a Serpent* / page 30

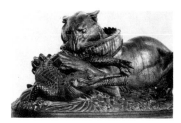

Fig. 1. Barye, *Tiger Devouring a Gavial Crocodile*, bronze, L. *ca.* 41", 1831, Paris, Louvre. Photo Glenn F. Benge.

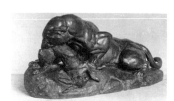

Fig. 2. Barye, *Jaguar Devouring a Hare*, bronze, L. 41", Salon of 1850, Baltimore, Walters Art Gallery.

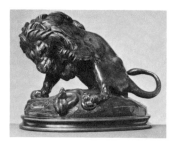

Fig. 3. Barye, *Lion Crushing a Serpent Under its Hindpaw*, bronze, H. 5⅛", Baltimore, Walters Art Gallery.

1. The chief sources for Barye are: Arsène Alexandre, *Antoine-Louis Barye* (Paris, 1889); Charles De Kay, *Barye, Life and Works* (New York, 1889); Roger Ballu, *L'Oeuvre de Barye* (Paris, 1890); Stanislas Lami, "Barye," *Dictionnaire des sculpteurs de l'école française* (Paris, 1898–1921), I, 69–85; Charles Saunier, *Barye* (Paris, 1925); Charles Otto Zieseniss, *Les Aquarelles de Barye* (Paris, 1955); Glenn F. Benge, *The Sculpture of Antoine-Louis Barye in American Collections, with a Catalogue Raisonné* (Ann Arbor, Mich.: University Microfilms, 1969); *idem, Barye Bronzes in the George A. Lucas Collection, Baltimore Museum of Art Annual*, 4 (Baltimore, 1971), an illustrated, critical catalogue of 126 bronzes; *idem*, "Barye's Uses of Some Géricault Drawings," *Walters Art Gallery Journal*, 31, 32, as for 1968–1969 (1971), 13–27; *idem*, "The Bronzes of Barye," essay for an exhibition catalog, The Sladmore Gallery, London, England, 1972; *idem*, "Barye's Pediment for the Palace of the Louvre, Napoleon Crowned by History and the Arts," *Walters Art Gallery Journal*, in press. See also note 6 below. Aspects of this essay were discussed in the author's paper, "Levels of Meaning in Barye's *Lion Crushing a Serpent*," read at the national CAA convention, in the session on nineteenth-century sculpture chaired by Professor Ruth Butler, in New York, January, 1973. I wish to express my appreciation to Temple University for a grant-in-aid which enabled me to study the archival and primary visual material related to Barye, in Paris in 1971. I am most grateful to M. F. Dousset, Inspecteur Général des Archives, Adjoint au Directeur Général, Archives Nationales de France, and to his staff, for affording me access to the Barye documentation. For their most generous assistance I wish to thank M. Pierre Pradel, Conservateur en Chef du département des Sculptures, M. Jene René Gaborit, Conservateur au département des Sculptures, and M. Maurice Serullaz, Conservateur en Chef du Cabinet des Dessins, all of the Musée du Louvre; M. G. LeRider, Conservateur en Chef du Cabinet des Médailles, Bibliothèque Nationale, and Mesdames de Roquefeuil and Aghion, also of the Cabinet des Médailles; and Mlle M. C. Regnault, Conservateur des Dessins, Musée du Petit Palais.

2. Lami, "Barye," 70, 74. The plaster original was given to the Musée de Lisieux after its purchase by the state. The lost-wax bronze, cast by the founder Honoré Gonon, was commissioned for the *Liste civile* at a price of 7,500 francs.

3. Paul A. Gagnon, *France Since 1789* (New York, 1964), 115.

4. Lami, "Barye," 75–76. The original documents are preserved in Archives Nationales F¹³ 1244. A reduction of the relief is illustrated in Benge, *Sculpture of Barye*, fig. 170, and in other places.

5. The original bronze is signed with the handwritten form, *Barye*, unlike the simple block-letter capitals of his later signatures. Along the rim of the base it is inscribed: BRONZE DE PARIS FONDU PAR HONORE GONON ET SES DEUX FILS AN 1832. Lami, "Barye," 70, 74: *Musée du Louvre. Barye: Sculptures, peintures et aquarelles* (Paris, 1956), 21. Reductions of the original are discussed in Benge, *Sculpture of Barye*, cat. nos. 160, 161.

6. George Heard Hamilton, "The Origin of Barye's Tiger Hunt," *Art Bulletin*, XVIII (1936), 250–257.

7. Lami, "Barye," 72, 73; Archives Nationales F¹³ 22731.

8. Albert E. Elsen, *Rodin* (New York, 1963), 205, 207.

9. See Benge, *Sculpture of Barye*, 177 and figs.

10. For recent discussions of the criticism of Barye see Gérard Hubert, "Barye et la critique de son temps," *Revue des Arts*, VI (1956), 223–30, and Benge, *Sculpture of Barye*, 24–42, notes and bibliography.

11. He said, "The further I went along, the more this feeling increased: it seemed to me that my being was rising above the commonplaces, the small ideas, the small anxieties of the moment." Walter Pach, trans., *The Journal of Eugène Delacroix*, (New York, 1961), 129–131.

12. D. G. Charlton, *Positivist Thought in France During the Second Empire, 1852–1870* (Oxford, 1959).

13. Discussed in Benge, *Sculpture of Barye*, 87–89, notes and figs.

14. Victor Hugo elaborated his concept of the grotesque in his preface to the drama *Cromwell* (1827), a major document for romantic poetics. Benge, *Sculpture of Barye*, 89–93, notes and figs.

15. Significantly, Mme de Staël advocated the artistic expression of a wide array of subtly discriminated states of feeling and not the most violent of extremes. The subtle shades and nuances of feeling were to be presented for a truly romantic delectation. Benge, *Sculpture of Barye*, 81–87, notes and figs.

16. Two original drawings by Barye, probably made in the Museum of Comparative Anatomy, delineate the structure of the claw-manipulating mechanism of a feline paw and the lateral and dorsal views of the feline claw. Benge, *Sculpture of Barye*, figs. 305, 344.

17. Archives Nationales F¹⁷ 22731; Lami, "Barye," 70.

18. Discussed in Benge, "An Overview of the Art of Barye," *Barye Bronzes in the George A. Lucas Collection* (Baltimore Museum of Art, Baltimore, in press).

19. An example of this relationship of the Lion of Leo and the Serpent of Hydra appears in Albrecht Dürer's woodcuts of star charts, *ca.* 1515, for Johann Stabius, illus. in, *The Complete Woodcuts of Albrecht Dürer*, ed. by Willi Kurth (New York, 1963), figs. 295, 296. See also the two examples of Leo directly above Hydra, as in Barye's bronze, in David Bergamini, *The Universe. Young Readers Edition* (Time-Life Books, New York, 1968), 6, 12.

20. Lami, "Barye," 71, 72, 77; *Musée du Louvre. Barye*, 21, 22.

21. For the relation of Barye and goldsmithery see Benge, *Sculpture of Barye*, 175–183, notes and figs., and *idem*, "Barye's Uses of Some Géricault Drawings," *Journal of the Walters Art Gallery* 31–32, as for 1968–69 (1971), 13–27.

22. Benge, *Sculpture of Barye*, cat. nos. 133–136. Lengths of the several variations are 29½", 14⅛", 8⅛", and 6⅞".

23. *Catalogue des Bronzes de Barye*, Rue de Boulogne, No. 6 (Chaussée-d'Antin), Paris, Années 1847–1848; reproduced in Ballu, *Barye*, 163, as Nota. 2.

24. For a discussion of Barye's drawings related to the *Lion Crushing a Serpent*, and the *Tiger Devouring a Gavial*, see Benge, *Barye Bronzes in the George A. Lucas Collection*; see also the series of dissection drawings examined in Benge, *Sculpture of Barye*, 219–222, notes and figs.

25. I wish to thank Miss Carolyn Pitts

and Miss Ann Marie Cioschi for their invaluable assistance with the original documents.

26. A transcription of the principal letter follows. The official, printed heading reads: "Ministère de l'Instruction Publique et des Beaux-Arts/Exposition Universelle de 1889/Commissariat Special des Beaux-Arts." It is sent from and dated: "Palais des Champs-Elysées, le 15 février 1889." It is addressed to: "Mʳ le Directeur des Batiments Civils/République Française." The text reads: "La Commission de l'Exposition Rétrospective a décidé de faire exécuter le moulage de quelques ouvrages de sculpture décorant les monuments Publics de Paris. En première ligne figurent les deux oeuvres suivantes:
Barye: Lion et Serpent (Jardin des Tuileries).
d°: Lion de la Colonne de Juillet.
Je vous serai très reconnaissant de procurer a M. Poussadoux, Chef de l'Atelier de Moulages du trocadéro, les autorisations qui lui permettront de procéder sans retard à l'éxécution de ces travaux.
Agréez, Monsieur le Directeur, l'assurance de ma haute considération." The letter is stamped: "Le Deputé Commissaire Spécial des Beaux-Arts." It is signed: "Proust" (AN F²¹ 2906).

27. Benge, *Sculpture of Barye*, 59–67 and notes; and *idem*, "George A. Lucas, An American Amateur," in *Barye Bronzes in the George A. Lucas Collection*, fully cited in note 1 above.

28. The monument is placed in the Ile Saint-Louis, toward the eastern tip of the island, directly beside the Pont Sully-Boulevard Henri IV. Just a half-mile to the northeast, along the Boulevard Henri IV, one finds Barye's powerful *Striding Lion* relief, installed on the base of the July Column in the Place de la Bastille. The architect's project drawing is illustrated in Benge, *Sculpture of Barye*, fig. 545.

29. *Ibid.*, fig. 213.

The Statue in the Garden / page 36

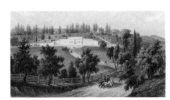

Fig. 1. Laurel Hill Cemetery 1848. Lithograph by August Koellner, Print Department, Philadelphia Museum of Art.

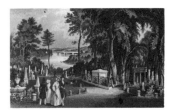

Fig. 2. Laurel Hill. Engraving by A. W. Graham (after W. Croome), Print Department, Philadelphia Museum of Art.

Fig. 3. Left, Samuel Townsend Monument, South Laurel Hill, 1852. Engraving from Smith's *Illustrated Guide to Laurel Hill* (Philadelphia, 1852).
Fig. 4. Right, Major Levi Twiggs. Engraving from Smith's *Illustrated Guide to Laurel Hill.*

1. The quote is reprinted on page 160 of the *Guide to Laurel Hill Cemetery, near Philadelphia*, which was published by C. Sherman in 1844, with drawings by John Notman. It was taken from a speech by Mr. Chadwick in his report to Parliament, originally published in the *London Quarterly Review* for March, 1844.

2. *Guide to Laurel Hill*, 13.

3. *Ibid.*, 156.

4. *Ibid.*, 16. Similar sentiments were expressed by Edward Everett in his oration at the dedication of the Gettysburg Cemetery.

5. A complete description of the meeting and its sculpted representations is in all of the guides to Laurel Hill, one of the more interesting of which is to be found in R. A. Smith, *Smith's Illustrated Guide to and through Laurel Hill Cemetery* (Philadelphia, 1852), 40–45. Thom's connection with public sculpture in this city continued, for in the 1870s another group entitled *Tam O'Shanter* was acquired, and the architect Charles Burns was commissioned to design a "rustic shelter" for the piece. *American Architect and Building News*, IV, no. 157 (December 28, 1878), 216. Carolyn Pitts informs me that the *O'Shanter* group no longer exists.

6. The specific attribution of the Ball monument to T. U. Walter was made by Robert Ennis, who is currently at work on a thesis on Walter.

7. *Architectural Review and American Builder's Journal*, I (1868), 313.

8. Bailly's bibliography is extremely limited; one of the few biographical notes is that written by Edward Strahan in *The Masterpieces of the Centennial International Exhibition* (Philadelphia, 1876), I, *Fine Art*, 55–58.

9. A bronze statue of Washington, presently in front of Independence Hall, replaces Bailly's original marble piece, now to be seen on a balcony above the central courtyard of City Hall.

Randolph Rogers, *Abraham Lincoln* / page 46

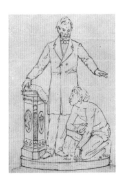

Fig. 1. Thomas Ball, drawing for the Lincoln Memorial, 1865–66. Photograph in the Stillé Papers, Historical Society of Pennsylvania.

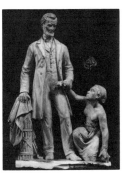

Fig. 2. Randolph Rogers, model for the Lincoln Memorial, 1867. Courtesy of the Michigan Historical Collections of the University of Michigan, Ann Arbor.

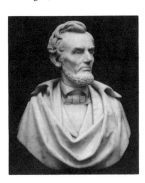

Fig. 3. Randolph Rogers, *Abraham Lincoln*, marble bust, 1866. Courtesy of the Pennsylvania Academy of the Fine Arts.

1. The Lincoln Monument Association had an office located at 522 Walnut Street in 1866, and the next year had moved to 506 Walnut Street. The Association received a charter from the Pennsylvania legislature on April 15, 1867.

2. Other members of the Committee on Design were: Morton McMichael, mayor of Philadelphia, 1866–69; James Pollock, former governor of Pennsylvania; Nathaniel B. Brown, Philadelphia Postmaster in 1865, then treasurer of the U.S. Mint, in 1867 president of Fidelity Trust, later chairman of the Bureau of Awards of the Centennial of 1876; Daniel Dougherty; Isaac Hazelhurst; William Kern; H. C. Howell; B. C. Godfrey; Henry C. Lea; James L. Claghorn; J. B. Lippincott; Francis Wells; and Lewis Redner.

3. Quoted from Stillé's obituary in the *Philadelphia Times*, August 8, 1899. During his tenure with the committee, Stillé became a professor

of history and English literature at the University of Pennsylvania, and in 1868 was appointed its provost, a position he held with great distinction for twelve years; he was also president of the Historical Society of Pennsylvania from 1892 to his death in 1899.

4. See David Wllace, *John Rogers, The People's Sculptor* (Middletown, Conn., 1967).

5. John Rogers to Stillé, December 18, 1866, C. J. Stillé Papers, Historical Society of Pennsylvania (hereinafter cited as Stillé Papers).

6. Rinehart to Stillé, January 16, 1867, *ibid.*

7. Powers to Stillé, January 9, 1867, *ibid.*

8. Two photographs and a drawing of Ball's model are in the Stillé Papers.

9. Ball to Stillé, January 18, 1867, *ibid.*

10. Randolph Rogers to Stillé, January 22, 1867, *ibid.* The committee may have known of Rogers' work through his Soldiers' Monument of 1865–69 for the National Park of Gettysburg. See Millard Rogers, *Randolph Rogers, American Sculptor in Rome* (Amherst, 1971), 100, fig. 45.

11. Stillé Papers.

12. Michigan Historical Collections, Ann Arbor, Mich. Information courtesy of Nesta R. Spink, curator, the University of Michigan Museum of Art, and Robert M. Warner, director, Michigan Historical Collections.

13. Stillé Papers.

14. *Ibid.*

15. *Ibid.*

16. *Ibid.*

17. *Ibid.*

18. *Ibid.*

19. A few years later Ball's design was commissioned to be enlarged and cast in bronze for Washington, D.C. It was completed in 1874 and two years later a variant of it was unveiled in Boston. For the Washington statue see W. Craven, *Sculpture in America* (New York, 1968), fig. 7.5.

20. Clipping in Stillé Papers.

21. Stillé Papers.

22. For an illustration of this monument see Craven, *Sculpture in America*, fig. 9.4.

23. Stillé Papers.

24. For a discussion of Volk's life mask and an illustration of his bust of Lincoln see Craven, *Sculpture in America*, 240–242 and fig. 7.15.

25. See Minute Book of the Fairmount Park Art Association, II, 2, where it is noted on December 7, 1886, that $84.00 were appropriated for the purchase of the mask and hands. The following year the Association gave these pieces to the Pennsylvania Museum, then located in Memorial Hall; from this institution they passed, in 1905, to the Philadelphia Museum of Art. (See letter dated December 20, 1905, in Museum archives.)

26. The inscription reads: "This cast was made for Fairmount Park Association. A subscriber to the fund for the purchase and presentation to the United States Government of the original mask made in Chicago, April 1860 by Leonard W. Volk from the living face of Abraham Lincoln. This cast was taken from the first replica of the original in New York City, February 1886."

27. See Craven, *Sculpture in America*, p. 202 and fig. 6.10.

28. For Marshall's portrait see the *Catalogue of American Portraits in*

The New-York Historical Society (New York, 1941), no. 466, p. 184; for Carpenter's portrait see Herbert Mitgang, "The Art of Lincoln," *American Art Journal*, II, no. 1 (Spring 1970), 12, fig. 14.

29. Stillé Papers.

30. Rogers seems to have made the four eagles himself, but the other bronze accessories on the pedestal—the garlands, the crossed swords, the American flags, and the United States coat of arms—apparently were produced by the Robert Wood Foundry of Philadelphia. *Third Annual Report of the Commissioners of Fairmount Park* (Philadelphia, 1871), 63.

31. Stillé Papers.

32. *Lippincott's Magazine*, III (February, 1869), 199.

33. Agreement from Struthers and Son, January 9, 1869, Stillé Papers. The inscriptions in the granite were carved by Struthers and Son and read, on the four panels: (south face) "To Abraham Lincoln from a grateful people"; (east face) "Let us here highly resolve that the government of the people and for the people shall not pass from the earth"; (north face) "I do order and declare that all persons held as slaves within the States in rebellion are and henceforth shall be free"; (west face) "With malice towards none, with charity towards all, with firmness in the right, as God gives us to see the right, let us finish the work we are in."

34. Rogers to Stillé, January 24, 1869, Stillé Papers.

35. Childs to Stillé, January 22, 1869, *ibid.*

36. Rogers to Stillé, November 8, 1869, *ibid.*

37. Stillé Papers.

38. *Ibid.*

39. For an illustration of the *Seward*, see J. Sanford Saltus and Walter E. Tisné, *Statues of New York* (New York, 1923), opp. p. 42.

40. For an illustration, see *ibid.*, opp. p. 30.

Edward Kemeys, *Hudson Bay Wolves* / page **54**

Fig. 1. *Wounded Wolf*, 1870, bronze, Kemeys Foundation, Inc., Westchester, Virginia. Photograph courtesy of the National Collection of Fine Arts, Smithsonian Institution.

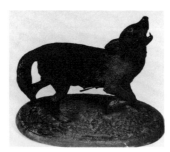

Fig. 2. *After the Feast*, 1878, bronze, Kemeys Foundation. Photograph courtesy of the National Collection of Fine Arts.

Fig. 3. *Fighting Panther and Deer*, 1872, bronze, Kemeys Foundation. Photograph courtesy of the National Collection of Fine Arts.

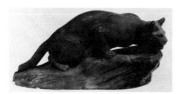

Fig. 4. *The Deer Stalker*, 1880–85, plaster, Kemeys Foundation. Photograph courtesy of the National Collection of Fine Arts.

1. *Preamble and Constitution of the Fairmount Park Art Association* (Philadelphia, 1871), 3.

2. A bronze statue, *Night*, by Edward Stauch was donated to the Association by Edwin N. Benson and accepted by the commissioners on April 13, 1872. Technically, this predates *Hudson Bay Wolves*, but because the Association actually commissioned the artist, was involved in the project, and paid for the work, I wish to emphasize Edward Kemeys pre-eminent role.

3. "The days when I left the East to sojourn for an all too short time in Old Illinois were always red letter days. The contrast between life in New York City and the yearly visits to the Mississippi valley was as sharp as could well be imagined. Yet there was always a certain balance in the two extremes which seem, when I think of it now, perhaps necessary to awake to keener life the Art impulse I felt stirring within but knew not what its meaning to me was to be...." Edward Kemeys, "A Sculptor in the Sunset-land" (unpublished manuscript, n. d.), 13, Kemeys Foundation, Inc., Winchester, Va.

4. Lorado Taft, *The History of American Sculpture* (New York, 1903), 470.

5. Frances E. Kent, "Edward Kemeys, Artists in Amboy" (paper read before the Women's Club, Perth Amboy, N. J., 1925), 15.

6. Record Group 15, Civil War Pension File for Edward Kemeys, KC 873–988, National Archives and Records Service, Washington, D. C.

7. Kemeys, "A Sculptor," 20. While Kemeys regarded these anatomical studies of the prairie animals as nothing more than taxidermic exercises, the lessons were beneficial.

8. Hamlin Garland, "Edward Kemeys, A Sculptor of Frontier Life and Wild animals," *McClure's Magazine*, V (July, 1895), 123.

9. Kemeys, "A Sculptor," 28.

10. Garland, "Edward Kemeys," 124.

11. Wayne Craven, *Sculpture in*

America (New York, 1968), 537; *Dictionary of American Biography*, X, 317–318; Emerson Hough, "Edward Kemeys—America's First Sculptor of Wild Animals," *Field and Stream*, IX (June, 1904), 143; *The National Cyclopedia of American Biography*, VIII, 279.

12. *Wolf at Bay* (1907.12.4) and *Wounded Wolf* (1907.12.3) were originally loaned to the Smithsonian Institution in 1907. Today the former is in the possession of Sherwood Kemeys, Silver Springs, Md.; the latter is in the collection of the Kemeys Foundation, which purchased the bulk of Edward Kemeys' sculptures from his grandson in November, 1970. While the inscriptions are accurate, it is impossible to determine the founder or when they were actually cast.

13. Minute Book of the Fairmount Park Art Association, I, 42. To my knowledge no formal letter was issued by the Association soliciting sculptures.

14. *Ibid.*, 48–49.

15. *Ibid.* J. Frailey Smith, chairman of the Committee on Ways and Means of the Association, and Charles H. Smith also had the opportunity to examine Kemeys' group and "expressed themselves as well satisfied with it."

16. Minute Book of the Several Committees, excepting the Committee on the Meade Memorial, of the Fairmount Park Art Association, I, 6.

17. Memorandum of Agreement with Edward Kemeys, June 25, 1872, Fairmount Park Art Association, Archives.

18. Archives.

19. "I was in Phil. a short time since.... I went to the Foundry and found that by reason of the weather our work was not proceeding very well. Mr. Bureau said the men suffered very severely from the heat. Of course I could not do anything to hasten matters as my duty is simply to oversee the work." Kemeys to Cox, Archives.

20. Cox to Theodore Cuyler, Archives.

21. Minute Book of the Fairmount Park Commission, III, 144–145, City Hall Archives, Philadelphia.

22. Minute Book of the Fairmount Park Art Association, I, 55–56.

23. *Ibid.*, 61.

24. *Ibid.*, III, 156.

25. Archives.

26. Report of the Committee on Works of Art, December 23, 1872, Archives.

27. Kemeys to Cox, December 27, 1872, Archives. The Robert Wood Foundry received $1,500 for casting.

28. J. Frailey Smith to Cox, Archives. No sooner was the work placed near the Ferndale Pool in the West Park than it became necessary to change the site. On September 4, 1874, Bellangee Cox wrote to the commissioners: "The location of the Bronze group of Wolves...is generally complained of as being too remote from the portions of the Park most frequented by the people." By May 29, 1876, because of the Philadelphia Centennial Exposition, the statue was moved "immediately north of Lansdowne entrance to the West Park." *Fairmount Park Art Association, Fifth Annual Report* (Philadelphia, 1877), 11. In September, 1956, the group was relocated to the Philadelphia Zoological Garden because of the construction of the Schuylkill

Expressway.

29. Fairmount Park Art Association, "Addresses at Annual Meeting," *Twenty-fifth Annual Report* (Philadelphia, 1897), 26.

30. At the Fine Arts Palace of the World's Columbian Exposition, Kemeys exhibited *After the Feast* for the first time. While there is no foundry mark, a letter in the possession of the National Collection of Fine Arts, Smithsonian Institution, written by Kemeys to S. P. Langley, April 26, 1893, indicates that many plaster models loaned by the artist in 1883 to the Smithsonian were being shipped to the American Bronze Company, Grand Crossing, Illinois. This firm probably also cast the ten bronzes which Kemeys included in the Chicago Fair. (At the time of his 1883 temporary gift, Kemeys retained a duplicate plaster of *After the Feast* in his possession. The Smithsonian plaster was not returned in 1893.) In 1907, the bronze version of *After the Feast* was loaned to the Smithsonian. In 1970, both the plaster (1907.12.76) and the bronze (1907.12.6) were sold by the sculptor's grandson to the Kemeys Foundation. In May, 1894, in conjunction with the unveiling of the two *Lions* at the entrance of the Art Institute of Chicago, Kemeys exhibited *Before the Feast*. It was purchased by the museum. In 1956, it was transferred to the Field Museum of Natural History, Chicago.

31. Kemeys to Cox, May 12, 1973, and May 19, 1873, Archives. Kemeys proposed to execute a life-size work for $3,000. In the letter of May 19, written by Kemeys in response to a letter sent by Cox on May 2 (unlocated), Kemeys quoted a price of $4,000 for a statue of heroic proportion.

32. In his address at the twenty-fifth annual meeting, Kemeys mentioned:
I wish I might take you to the places where I verified the difficult poses of these beasts, for I saw this group as plainly in my mind as you can see it; made from close anatomical studies, first drawn, then modeled, added to from time to time as the years went by, a labor of love—my best work—judged by all the Canons of Art. The small model was sold in England, and I wish that I might place the colossal of this in Fairmount Park.
One bronze of this group was purchased by Walter Winans (1852–1920), an English animal sculptor in December, 1877 (unlocated). A second cast (1907.12.2), loaned by the sculptor's widow, Laura Kemeys, to the Smithsonian in 1907, is now in the possession of the Kemeys Foundation.

33. Hockley to George Corliss, secretary of the Pennsylvania Academy of the Fine Arts, December 4, 1885, files of the Academy.

34. For a more complete biography, see Michael Richman, *Edward Kemeys (1843–1907); America's First Animal Sculptor* (Middleburg, Va., 1972), 3–46.

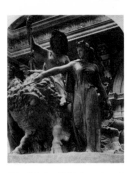

Fig. 1. John Bell. *America:* Cast from the original group on the Albert Memorial by H. Doulton & Co. in terra cotta. Here seen in the great central hall of Memorial Hall.

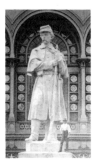

Fig. 2. Carl Conrads. *The American Soldier.* Exhibit of the New England Granite Co. before the north central entrance of the Main Building.

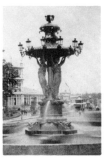

Fig. 3. Frederic Auguste Bartholdi. *Fountain of Light and Water.* Cast iron, gas illuminated. Belmont Avenue looking north to the Sons of Temperance Ice Water Fountain.

Fig. 4. Frederic Auguste Bartoldi. *Hand of the Statue of Liberty.* Copper: armature of Eiffel. Lit by electricity.

Fig. 5. Memorial Hall, Gallery B: Vinnie Ream, *Miriam;* Randolph Rogers, *Nydia, Blind Girl of Pompeii.*

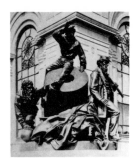

Fig. 6. Larkin G. Mead. *The Navy.* Bronze. Exhibit of the Ames Mfg. Co., Chicopee, Mass. West corner of Memorial Hall.

Fig. 7. United States Galley C, from Frank Leslie's Illustrated Historical Register.

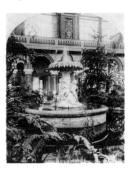

Fig. 8. Margaret Foley, *Fountain,* in Memorial Hall.

Fig. 9. *The Dreaming Iolanthe,* King Rene's Daughter. A study in butter by Caroline S. Brooks.

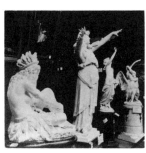

Fig. 10. Annex Gallery 3: Italian Department: E. Caroni, *L'Africana;* R. Peduzzi, *Berenice;* D. Barcaglia, *Butterfly;* R. Perduzzi, *Boy and Swan.*

Fig. 11. "Curios from the Gold Coast": Gold Coast Colony Exhibit, Main Building.

1. The younger Eckstein became Hiram Powers' instructor in Cincinnati.

2. Edward Strahan [pseud. of Earl Shinn] *The Masterpieces of the Centennial International Exhibition* (Philadelphia, 1876), vol. I, *Fine Art,* 38. Earl Shinn wrote about Philadelphia and the Centennial under his own name as well as various pseudonyms, but is best known as Edward Strahan. In the text his proper name is used throughout.

3. *Ibid.*

4. *Ibid.,* 38–39.

5. Phillip T. Sandhurst, *et. al., The Great Centennial Exhibition* (Philadelphia, 1876), 21.

6. *Philadelphia Daily Times,* November 8, 1878.

7. See John Maass, "A Tale of Two Horses," *Sunday Bulletin Magazine,* March 8, 1970.

8. Strahan, 63.

9. George D. Curtis, *Souvenir of the Centennial Exhibition: or, Connecticut's Representation at Philadelphia, 1876* (Hartford, 1877), 150.

10. J. S. Ingram, *The Centennial Exposition* (Philadelphia, 1876), 370–371; see also H. W. French, *Art and Artists in Connecticut* (Boston, 1879), 162–163.

11. Samuel Burr, *Memorial of the Centennial International Exhibition* (Hartford, 1877), 740. For detailed information on the sculpture, see Curtis, 150. The figure, at parade rest, stands 21½ feet. It was destined for a pedestal at Antietam 23½ feet high. "For the superiority of their exhibit, showing variety of design, excellence of material and workmanship," the company won commendation.

12. James J. Green, "The Organization of the Catholic Total Abstinence Union of America, 1866–1884," Records of the *American Catholic Historical Society of Philadelphia,* LXI (June, 1950), 87; see 86f. for the fountain.

13. On Kirn see "The One-Armed Sculptor of Fairmount Park," *North American,* June 25, 1911. He lost his right arm erecting *Orestes and Pylades,* a work by his master, Carl Steinhäuser, in Fairmount Park.

14. Edward C. Bruce, *The Century—Its Fruits and Festival* (Philadelphia, 1877), 90.

15. Kirn remade the *Father Mathew.* The basin of the fountain is forty feet in diameter and stands at the center of a granite plinth in the shape of a Maltese cross. Around the basin wall are medallions, portraits of Catholics who participated in the Revolution: Marquis de Lafayette, Count de Grasse, Kosciuzko, George Meade, Casimir Pulaski, Stephen Moylan, and Orono, chief of the Penobscot Indians. An eighth place remains blank (for General Wilkinson?). Total cost of the fountain was $52,000. See Ingram, 680–683; Burr, 738–741.

16. John W. Forney, *A Centennial Commissioner in Europe, 1874–1876* (Philadelphia, 1876), 137.

17. *Ibid.,* 138–139.

18. *Ibid.,* 223.

19. See for details on the fountain and on the hand of *Liberty,* Bartholdi to Thomas Cochran, Paris, March 15, 1876. Record series 231.12, Committee on Grounds, Plans, and Buildings, Correspondence and Papers, 1873–1876, City Hall Archives, Philadelphia.

20. Forney, 223.

21. Bartholdi to Cochran, March 15, 1876, includes a diagram marking point F at the northeast corner of Machinery Hall.

22. Strahan, 306.

23. *Ibid.*

24. Forney, 212.

25. Strahan, 126.

26. W. H. H. to the *New York Herald,* dateline Paris, April 20, 1874.

27. Strahan, 125–126.

28. *Ibid.,* 126, 215–216.

29. Forney, 116.

30. *Ibid.,* 117.

31. David M. Armstrong, *Day Before Yesterday* (New York, 1920), 194; see also Albert TenEyck Gardner, *American Sculpture: A Catalogue of the Collection of the Metropolitan Museum of Art* (New York, 1965), 26–27.

32. William J. Clark, Jr., *Great American Sculptures* (Philadelphia, 1877), 75. Like Shinn, Clark was a Philadelphian, a Pennsylvania Academy alumnus, and an active member of the Philadelphia Sketch Club. On *Nydia,* see Millard F. Rogers, Jr., "Nydia, popular Victorian image," *Antiques,* 97 (March, 1970), 374–377.

33. Ingram, 711, translated from the Roman newspaper *Il Diritto.*

34. Burr, 570.

35. *Art Journal,* 2 (1876), 127f.

36. See Strahan, 201f. for discussion on casting in Munich, Florence, and Paris.

37. Forney, 113.

38. Connelly wrote his will in Florence on April 4, 1912: "I, the undersigned Pierce Francis Connelly of Philadelphia, Pa., native born American citizen, son of Pierce & Cornelia Connelly of Philadelphia, Pa., sculptor by profession…residing in Florence…"

39. Henry T. Tuckerman, *Book of the Artists; American Artist Life* (New York, 1867), II, 599.

40. Lorado Taft, *The History of American Sculpture* (New York, 1903), 261.

41. James J. Jarves, *Art Thoughts* (New York, 1869), 319.

42. John Sartain, "Report of the Chief of the Bureau of Art," *United States Centennial Commission. International Exhibition, 1876* (Washington, 1880), I, *Report of the Director-General,* 141–160.

43. June 1, 1876.

44. John F. Weir, "General Report of the Judges of Group XXVII. Plastic and Graphic Art," *United States Centennial Commission. International Exhibition 1876* (Washington, 1880), VII, *Reports and Awards,* 638.

45. Clark, 93.

46. *Ibid.;* see also Strahan, 216.

47. Taft, 257.

48. Clark, 100.

49. Taft, 258.

50. *Ibid.*, 256.

51. Sandhurst, 497.

52. Joseph M. Wilson, *The Masterpieces of the Centennial International Exhibition* (Philadelphia, 1876), III, *Historical Introduction, cxxxvii.*

53. *Centennial Eagle*, July 25, 1876. 62–63.

54. Clark, 141–142.

55. For instance, G. B. Lombardi's *Susannah*, reproduced in *Art Journal*, 1 (1875), facing p. 214; on deposit at the Pennsylvania Academy were three Lombardi works.

56. Strahan, 55.

57. Burr, 573, 589.

58. *Ibid.*, 591.

59. December 20, 1876; Dorothy Weir Young, *The Life and Letters of J. Alden Weir* (New Haven, 1960), 116.

60. Marietta Hollery, *Josiah Allen's Wife as a P. A. and P. I.; Samantha at the Centennial* (Hartford, 1877), 524.

61. Ingram, 705–706, illus. p. 704. See also Frances Lichten, *Decorative Arts of Victoria's Era* (New York, 1950), 242.

62. Archives of the Fairmount Park Art Association.

63. *Art Journal*, I (1875), 380.

64. *Ibid.*, II (1876), 32.

65. Taft, 280.

66. Strahan, 152.

67. James D. McCabe, *The Illustrated History of the Centennial Exhibition* (Philadelphia, 1876), 900.

68. Weir, 627.

69. Strahan, 59.

70. McCabe, 900.

71. Sold at auction by C. G. Sloan & Company, July 11, 1961.

72. The *Africana* was in the Mayflower Hotel in Washington, D. C., until about fifteen years ago, when it was sold to a man who installed it in a third-floor room. It fell through three floors to the basement unharmed, and was then sold to the present owner, Kaplan Cohen, of Alexandria, Va.

73. Presented to the Pennsylvania Academy by Gustavus S. Benson, September 11, 1876. Soon after the Centennial, a replica was in the W. F. Sales Collection in Providence, R. I. For descriptions of American collections of the period, see Edward Strahan, *The Art Treasures of America* (Philadelphia, 1879).

74. Strahan, 217.

75. See *The White, Marmorean Flock*, catalogue no. 15; *Young Trumpeter* in the Bixby Memorial Free Library, Vergennes, Vermont.

76. Barzaghi's *Finding of Moses* was given to "a friend of the Academy" in 1950. It may not be the one in the Crisconi Oldsmobile showroom on South Broad Street, if Mr. Crisconi's recollection that his grandfather bought it at Freeman's Auction Galleries in the 1930s is accurate. Story's *Jerusalem* was given away to another "friend of the Academy" and sits today in Philadelphia Memorial Park, Frazer, Pa., with the inscriptions erased. Howard Roberts' widow donated the *Première Pose* to the Philadelphia Museum of Art in 1926. *Honor and Death*, priced at $10,000 at the Centennial, which even then was about the cost of production, was on deposit at the Academy. Repeated attempts by the artist and his family to sell it to the Academy failed (1883, 1890, 1901, 1921, 1922 and 1938). The artist's daughter then presented it to Rosemont College. There is no record of the fate of John Gibson's *Venus*, a variant of the one which so stirred critics in 1862 because of its lifelike polychromy. A Centennial fountain installed in the main square of Mt. Holly, N.J., in 1877 (apparently the one cast by Bartholdi's iron founder, Durenne, and exhibited in Agricultural Hall) was demolished in 1922.

77. Wilson, cliv.

The Sculpture of City Hall / page 94

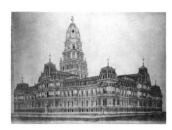

Fig. 1. 1872 photozincograph by F. A. Wenderoth of an early design for City Hall by John McArthur showing the appearance of sculpture on the tower. Photograph courtesy of the Historical Society of Pennsylvania.

1. The material for this article has been culled from numerous sources. The bibliography here mentions only the most important works used. Most newspaper citations come from the scrapbooks of Samuel Perkins, and all quotations appear exactly as found in the original source. For architecture: Roger Butterfield, "The Cats on City Hall," *The Pennsylvania Magazine of History and Biography*, LXXVII (1953), 439–451; John Webster Keefe, "The Setting of the Designs for the Philadelphia City Hall and Its Building History through the Laying of the Cornerstone, July 4, 1874 "(M.A. thesis, Yale University, 1965); John Maass, "Philadelphia City Hall: Monster or Masterpiece?", *Journal of The American Institute of Architects*, XLIII (February, 1965), 23–30; Lawrence Wodehouse, "John McArthur, Jr. (1823–1890)," *Journal of the Society of Architectural Historians*, XXVIII (December, 1969), 271–283. For sculpture: Frederick Faust, *The City Hall, Philadelphia, Its Architecture, Sculpture and History* (Philadelphia, 1897); *A Guide to the Sculpture of City Hall, Philadelphia*, Publication of the Division of Public Information, Office of the City Representative (Philadelphia, 1968); "New City Hall, Philadelphia; Sculpture and Ornamentation" (Philadelphia, 1883), vols. 1–5 (collection of photographs of the plaster casts made for City Hall), Historical Society of Pennsylvania, Philadelphia; "Sculpture and Ornamental Details in Bronze and Iron of the New City Hall" (Philadelphia, 1883), vols. 1–5 (a duplicate set of photographs of the plaster casts), Philadelphia Historical Commission. Archival material related to the Commissioners for the Erection of the Public Buildings: a) at Philadelphia City Hall Archives—Minutes of the Commissioners for Erection of the Public Buildings, 1870–1901, vols. 1–4, no. 160.1; Executive Committee Minutes, 1873–1893, vols. 1–2, no. 160.4; Cash Book, 1872–1901, vols. 1–4, no. 160. 14; Tower Cost Book, 1889–1896, vols. 1–2, no. 160.15; Drawings, Plans, c. 1870–1901, no. 160.20; Pamphlets, 1860–1893, vols. 1–6, no. 160. 23; Photographs of the New Public Buildings, c. 1901, no. 160.29; b) at the Historical Society of Pennsylvania—Letters of Samuel C. Perkins, President of the Commission for Erection of Public Buildings, 1875–1901, vols. 2–4; Samuel C. Perkins, Philadelphia Public Buildings Scrapbooks, nos. 1–30. Special thanks go to John Daly and Ward Childs of City Hall Archives, John Maass, Dr. Wayne Craven, Margaret Calder Hayes, Victoria Donohoe, Carolyn Pitts, Mary B. Wilson and Richard C. Gurney. Note: the references to the sculpture on the exterior of City Hall are made according to the visual division of the stories and not according to the interior floors.

2. On January 6, 1873, McArthur asked to have certain details of the construction left to the discretion of President Perkins and the architect between meetings. The commissioners approved the request.

3. Butterfield, "The Cats on City Hall," 439.

4. Maass, "Philadelphia City Hall," 27.

5. This was later changed to the arms of Philadelphia.

6. The identification of *Mechanics* and *Plenty* at this point in the development of the plans gives a hint that the future iconography of the building was beginning to germinate. In fact, on the southwest corner pavilion today *Mechanics* is the theme of the sculpture on the west face, and *Plenty* or *Agriculture* is illustrated on the south face. It is unfortunate that the other six figures on the photozincograph cannot be identified because they might also coincide with the themes represented on the other six faces of the corner pavilions: *Arts* and *Sciences* (southeast), *Navigation* and *Military* or *Liberty* (northeast), and *Commerce* and *Industry* (northwest).

7. Struthers and Sons may have cut labor costs by the new and more rapid methods of stone carving: a) through "sand blasts," as reported in the *Evening Bulletin*, November 30, 1874; and b) later through the use of saws, which were fed by iron shot, as related in the *Evening Telegraph*, October 3, 1878.

8. In both Europe and the United States an architect usually submitted his plans for a public building to a committee, which in turn might commission several sculptors for individual works that would be placed on the building. The sculptors often felt the need to compete with one another, and the architecture merely became a pedestal for their creations, which might be quite different in style from one another and not closely coherent with the prescribed subject.

9. The best source of information about the early career of Alexander Milne Calder comes from his autobiography published by the Fairmount Park Art Association in its *Twenty-fifth Annual Report* (Philadelphia, 1897), 19–20.

10. Interestingly enough, the subject of the four continents was a major theme of the memorial, yet it is impossible to suggest that Calder had any responsibility for the subject appearing on City Hall.

11. According to his own words, between 1868 and 1871 Calder modeled "for a number of leading architects of Philadelphia and New York" before making Philadelphia his permanent residence.

12. A simple answer might be that other sculptors did not realize the scope of the sculptural ambitions because the early plans did not reveal a large program except the tower, and by the time the designs were confirmed McArthur felt fully confident of Calder's abilities. One other sculptor is mentioned in the minutes as receiving payments for "plaster models" (May and August, 1874); this was Alexander Kemp, about whom little is known except that he was hired to carve the sculptured panels on the front of the Pennsylvania Academy of the Fine Arts in 1876.

13. Joan Younger Dickinson, "Aspects of Italian Immigration to Philadelphia," *The Pennsylvania Magazine of History and Biography*, XC (1966), 453.

Throughout the construction of City Hall, the plaster models were exhibited in the "model room" near the south entrance. However, as early as 1877 some were loaned to the permanent part of the International Exhibition in Memorial Hall, which later became the Pennsylvania Museum. Other models were temporarily given to the Spring Garden Institute for students to work from in classes. By 1894 public interest in the casts had waned, and the commissioners directed that after local institutions had chosen what they wanted, the models that remained in City Hall were to be destroyed to make room for offices. The *Evening Telegraph* on July 26, 1894, remarked that it would take a half dozen sturdy men two days with heavy hammers to reduce the unclaimed plasters to atoms. None appears to have survived.

14. Faust, *The City Hall* [2].

Alexander Milne Calder, *William Penn* / page 104

Fig. 1. An engraving of Joseph A. Bailly's sketch for the statue of *William Penn*, as it appeared in *Leslie's Illustrated Newspaper*, October 3, 1875. Photograph courtesy of the Historical Society of Pennsylvania.

Fig. 2. Original aluminum bronze cast of the one-tenth scale model for *William Penn*, finished by Calder in 1886. This cast was given to the Historical Society of Pennsylvania by the widow of Henry C. Forrest, who directed the casting and erection of the *Penn*. Photograph courtesy of the Historical Society of Pennsylvania.

Fig. 3. *William Penn* (plaster) in Calder's studio. Photograph courtesy of the Pennsylvania Academy of the Fine Arts.

Fig. 4. The head of *Penn* in studio, 1894. Photograph courtesy Archives, City of Philadelphia.

1. For a complete bibliography of the sources for this article, see the first note in my essay on "The Sculpture of Philadelphia City Hall" in this volume. I wish to thank Michael Richman for his suggestions.

2. Deleted.

3. Minutes of the Commissioners for the Erection of the Public Buildings, 1887–1897, III (December 28, 1892).

4. The sketch model was cast in aluminum bronze at two different times. The *Philadelphia Inquirer* on March 6, 1889, reported that "William Penn, in aluminum bronze, stood on the table of the Public Building Commission....The statuette about two feet in height, is the work of the same New York company that put in the railings and did other bronze work about City Hall." The caster was probably the Henry Bonnard Company. The *Ledger and Transcript* on April 16, 1891, carried the following note: "President

Schumann, of the Tacony Iron and Metal Works, is having some very artistic small-size statues cast in aluminum bronze that are facsimiles of the big statue of William Penn. They are about two feet in height, and are intended to be placed as ornaments or mementoes in the municipal offices or court rooms of the city." Copies of these statuettes are owned by the Historical Society of Pennsylvania, the Engineer's Club of Philadelphia, and the Detroit Institute of Arts.

5. The modern antennae that now protrude from the top of *Penn's* hat hardly serve the function of a meniscus, and Calder would undoubtedly shudder at the sight.

John J. Boyle, *Stone Age in America* / page 110

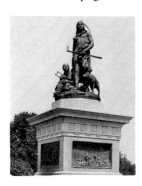

Fig. 1. *An Indian Family (The Alarm)*, 1881–4, bronze, Chicago. Photograph courtesy of the Chicago Historical Society.

Fig. 2. *The Corn Dance*, 1882–3, clay model, destroyed. Photograph courtesy of the Chicago Historical Society.

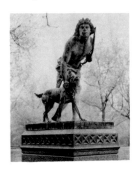

Fig. 3. *Indian Hunter*, John Quincy Adams Ward, 1857–68, bronze, New York City. Photograph courtesy of the Art Commission of the City of New York.

1. Draft of autobiography of John J. Boyle, undated, p. 2, Archives of the Fairmount Park Art Association (hereinafter cited as Archives). This draft has been edited, but these notations have been omitted.

2. "John J. Boyle Dies; A Pioneer Sculptor," *Public Ledger*, February 11, 1917, p. 3.

3. *Ibid.* David Sellin, Research Fellow, National Collection of Fine Arts, Smithsonian Institution, told the author about Eakins' early involvement with the Philadelphia Sketch Club. Mr. Sellin also said that Boyle signed a petition on January 22, 1876, in which members of this club asked the officials of the Pennsylvania Academy of the Fine Arts for permission to work in their new building.

4. *Ibid.*

5. Lorado Taft, *The History of American Sculpture* (New York, 1903), 505, notes that Bailly was a rather modest sculptor "who settled in Philadelphia in 1850, and built up a considerable business in portraits and clever specimens of commercial art." Bailly's biographer, Edwin G. Nash, mentioned "he...was an instructor at the Pennsylvania Academy from 1876 to 1877." *Dictionary of American Biography*, I, 502–503.

6. *Paris Salon. Catalogue illustré du Salon* (Paris, 1880), 73, entry No. 6136. Boyle also claimed he exhibited in the 1879 Salon, but his name was not listed.

7. Lorado Taft, "The Monuments of Chicago," *Art and Archaeology*, XII (September-October 1921), 123.

8. Draft of autobiography, 2.

9. *National Cyclopedia of American Biography* (New York, 1906), XIII, 73.

10. "Chicago Statues and Monuments," *Chicago Daily News*, September 13, 1937, p. 1.

11. Draft of autobiography, 2.

12. Minute Book of the Several Comittees, excepting the Committee on the Meade Memorial, of the Fairmount Park Art Association, I, 36.

13. Minute Book of the Fairmount Park Art Association, I, 247. Interestingly, the canceled check in the amount of $1,000 is in the possession of the Association. The check is dated December 21, 1883, but was not cashed until May 10, 1885, by the Commercial National Bank of Philadelphia. The check was endorsed and addressed 3831 Lancaster Avenue. Since Boyle also wrote a letter to Hockley from Paris on May 12, it must be assumed that Boyle used his Philadelphia home address on a check which he mailed from Paris.

14. Taft, *History of American Sculpture*, 408.

15. Archives.

16. Dana to Hockley, *ibid.*

17. Boyle to Hockley, *ibid.*

18. Hockley to George Corliss, secretary of the Pennsylvania Academy of the Fine Arts, December 4, 1885, files of the Academy. In this letter, written principally about a monument proposed by Edward Kemeys, Hockley mentioned that the Association was still committed to Boyle in the amount of $8,500. With the original contract calling for $10,000, and $1,000 paid at the time of the signing, $500 must then have been sent to Boyle in Paris.

19. *Explication des Ouvrages de Peintures, Sculpture...du Salon*, 2nd ed. (Paris, 1886), 298. Boyle entered the plaster model in the Salon, No. 3567.

20. *Ibid.* The Americans were Herbert Adams (1858–1945), Paul W. Bartlett (1865–1925), and George Bissell (1839–1920).

21. Salon de 1887. *Catalogue illustre Peinture et Sculpture* (Paris, 1887), 47. The bronze was entry No. 3692. Boyle also exhibited a marble portrait

medallion of Mlle. B (No. 3693) which has not been located.

22. "Monthly Record of American Art," *Magazine of Art*, XI (January 1888), v.

23. *Fairmount Park Art Association, Sixteenth Annual Report* (Philadelphia, 1888), 13.

24. *Ibid.*, 12.

25. *Fairmount Park Art Association ...Issued on the Occasion of its Fiftieth Anniversary, 1921* (Philadelphia, 1922), 48.

26. Draft of autobiography, 3, Archives.

27. Taft, *History of American Sculpture*, 404, 407.

28. Charles H. Caffin, *American Masters of Sculpture* (Garden City, N.Y., 1911), 227.

29. Henry T. Tuckerman, *Book of the Artists; American Artist Life* (New York, 1867), II, 581; Lewis I. Sharp, "John Quincy Adams Ward: Historical and Contemporary Influences," *American Art Journal*, IV (November 1972), 72–73.

30. For the biographies of these four sculptors, see Wayne Craven, *Sculpture in America* (New York, 1968), 514–553.

31. *F.P.A.A....Fiftieth Anniversary*, 144.

Alexander Milne Calder, *General Meade* / page 118

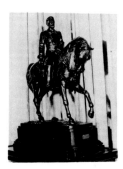

Fig. 1. *General Ulysses S. Grant*, bronze equestrian statuette by Joseph A. Bailly. Robert Wood & Co., Bronze Founders, Philadelphia. Presented to the Union League of Philadelphia by Edwin N. Benson in 1871. 37½″ in length, height 34″ (43⅜″ with base).

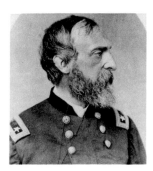

Fig. 2. Major General George Gordon Meade. Photograph by F. Gutekunst, Philadelphia, about 1863. Courtesy, Historical Society of Pennsylvania.

Fig. 3. Alexander Milne Calder in his studio with full-size working model of his *Meade* equestrian statue, 1886. Chester Coleman Gutner.

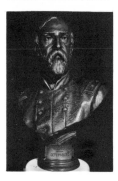

Fig. 4. *General George Gordon Meade*, bronze portrait bust of heroic size by Alexander Milne Calder. Commissioned, 1892. Cast by Bureau Brothers, Philadelphia. Union League of Philadelphia.

1. The following is a brief summary of the sources of information for this article: Fairmount Park Art Association's minutes of the Board, Annual Reports, committee minutes, archival material, special publications including Pamphlet No. 20 of the 1887 unveiling ceremonies; birth and death records, ship passenger lists, city directories, census records, deeds, judgments;—from City of Philadelphia Archives; Commonwealth of Pennsylvania, General Services Administration; records from Scotland; Historical Society of Pennsylvania, General G. G. Meade Papers, photographs; Pennsylvania Academy of the Fine Arts, Minutes of the Board (1875 for Bailly in South America, 1876 for Calder signing petition), Minutes of the Committee on Instruction, archival material, registrar's records, annual exhibit catalogues, school circulars; Union League records; Loyal Legion War Library and Museum records and books; U. S. Treasury Department; Mrs. Edgar Scott, zone vice-president of the U. S. Equestrian Team, verified that the pose of the horse Baldy in Calder's statue depicts forward motion being checked by the general; Mr. George G. Meade and Mr. George G. Meade Easby, the latter after consulting other members of the Meade family, says Miss Henrietta Meade's bronze equestrian model is still missing since the robbery of her house shortly before her death; Mr. Chester Coleman Gutner, Wynnewood, photo of working model of *Meade* in Calder's studio; books, magazines, newspapers, files in seven departments of Free Library of Philadelphia. I gratefully acknowledge assistance also from Dr. Evan H. Turner, Miss Carolyn Pitts, Mr. George Gurney, Mrs. Buffie Havard, and many others.

2. Mentioned in Calder's interview, *North American*, June 20, 1920.

3. Mockingly called "the saluter," that equestrian was torn down twice by angry mobs. Bailly outlived the first (1878) but not the second (1889) attack on it and a nearby standing statue of Blanco, nicknamed "the lazy," also by Bailly. The information about Bailly's Blanco monuments comes from the National Academy of History in Caracas, the translation having been made by the Venezuelan consulate general in Philadelphia, and from the John Boulton Foundation, Caracas.

4. Painted in Madrid after Regnault had begun copying Velazquez' *Surrender of Breda* there in 1868, this portrait of the general rallying Spanish patriots against the Moors did not please Prim because of its bare head ("very absurd without cap") and what struck him as an unwashed face. The artist would make no alterations, however, preferring to keep it as it was. By 1872 the portrait hung in the Luxembourg Museum in Paris, moving to the Louvre in January, 1881. It received much favorable comment in books and periodicals here and abroad during the 1870s and 1880s, at the height of Regnault's fame, and reproductions were available. Meade was born in Cadiz, Spain, a year after Prim and outlived the Spanish hero by two years.

5. George Gurney called my attention to this reference.

6. Calder had been concerned earlier with the representation of a rearing horse in City Hall's arms of Pennsylvania.

7. This same Gutekunst photograph was the basis for the Union League's gold medal presented to General Meade on July 4, 1866, for Thomas Hicks's Loyal Legion oil portrait of 1876, and for emblems of the Philadelphia Meade Memorial project. A steel engraving showing a portrait of General Meade in profile appeared on the $1,000 United States Treasury note, series 1890 and 1891.

8. Incidentally, on the same West Park drive, the Catholic Total Abstinence Union Fountain contains a portrait medallion of Revolutionary War patriot George Meade, the general's grandfather.

9. The Fairmount Park Art Association did not officially extend the scope of its sculpture activities city-wide until April 17, 1888.

Emmanuel Frémiet, *Joan of Arc* / page **124**

Fig. 1. Giuseppe de Nittis, La Place des Pyramides, 1875. Oil, 92 by 74 cm. (Salon, 1876) Paris, Musée du Luxembourg.

1. Autobiographical note on Frémiet, *Fairmount Park Art Association; An Account of Its Origins and Activities …Issued on the Occasion of Its Fiftieth Anniversary* (Philadelphia, 1922), 221. Principal sources for biographical information are: Jacques de Biez, *Emmanuel Frémiet* (Paris, 1910); Etienne Bricon, "Frémiet," *Gazette des Beaux Arts*, Series 3, XIX (1898), 494–507; XX (1898), 17–31; R.A.M. Stevenson, "Emmanuel Frémiet," *The Art Journal*, XLIII (1891), 129–135; Jane Van Nemmen, entry on Frémiet in *Nineteenth Century French Sculpture: Monuments for the Middle Class* (Louisville, Ky., 1971), introduction by Ruth Mirolli for an exhibition at the J. B. Speed Art Museum.

2. *Louis D'Orléans* is in the restored Chateau de Pierrefonds, and the others are as follows: *Condé* (Chantilly, 1881); *Stephan* (Jassy, Roumania, 1882); *Porte-Fallot* (Hotel de Ville, Paris, 1882–83); *Charles V* (Bibliothèque Nationale, Paris, 1883); *Velasquez* (unlocated, 1890). *Napoleon I*, originally at Grenoble, was re-erected at Lafferty in 1929. See *Monuments for the Middle Class*, 176.

3. Archives of the Fairmount Park Art Association (FPAA)

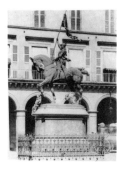

Fig. 2. Emmanuel Frémiet, *Joan of Arc*, 1872–3, bronze, Place des Pyramides. Destroyed, 1899. Service De Documentation Photographique De La Réunion Des Musées Nationaux.

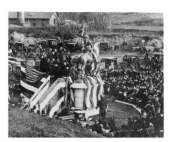

Fig. 3. Unveiling *Joan of Arc*, November 15, 1890. Collection of Theodore Newbold, Philadelphia.

Fig. 4. Philadelphia *Joan of Arc* in transit after gilding, Fairmount Park Art Association Archives.

4. de Biez, 142. Signed on base under right hind leg: "E. Frémiet. Thiébaut Frères Fondeurs. Paris."

5. de Biez, 147.

6. Bricon, XX, 26.

7. de Biez, 151 ff.

8. FPAA Minutes, II (1886–1897), 34–35.

9. *Ibid.*

10. Hockley to Howell, August 3, 1889, FPAA Archives. Documents hereinafter cited in the text with dates and principals, but not otherwise identified, are from these archives. Money was apparently short, and the *Bear Tamer* went to the Corcoran Gallery.

11. *Ibid.*

12. Received September 16, 1889. My translation and italics. FPAA Archives.

13. FPAA Archives.

14. Hockley to Howell, March 22, 1890.

15. FPAA Minutes, October 28, 1890.

16. Hockley to Howell, June 25, 1890.

17. O. G. Hempstead & Sons to FPAA, June 20, 1890.

18. Atkinson & Myhlerty to FPAA, July 25, 1890.

19. See Atkinson & Myhlerty bill of October 8, 1890, for itemized account; also their letter to L. Miller, October 3, 1890; and Bureau Brothers to Russell Thayer, December 25, 1890, for details on installation. Two small screws helped align the statue, but it was otherwise not fastened, being immobilized by its own weight.

20. Thayer to Howell, October 6, 1890.

21. Unveiling of the *Equestrian Statue of Jeanne D-Arc*; Frémiet Sculptor. Fairmount Park, Philadelphia, Saturday, November 15, 1890. (FPAA pamphlet = 21), bound with the *Nineteenth Annual Report of the Board of Trustees*. In addition to the officials mentioned here, a special committee represented the French colony at the ceremonies: Messrs. Theo. Lorenz, Emile L. Feffer, Constant Doriot, Jules Dehon and Emile Lefevre.

22. Vossion's awkward English translation of a letter to him of March 10, 1891, from Frémiet (FPAA Archives) is here paraphrased for the correct sense of the message.

23. W. C. Brownell, *French Art* (New York, 1892); here quoted from the 1901 edition, 166-168.

24. FPAA Minutes, II, 81–82 (March 1, 1893). See also Stevenson, "Frémiet," 132. E. Bénézit, *Dictionnaire*, lists a drawing by Frémiet of an equestrian *Joan of Arc* as having sold for 155 francs on November 23, 1894.

25. de Biez, 151 ff.

26. de Biez, 154.

27. Signed on base near left hind foot, "E. Frémiet"; on right side of base, "Leblanc-Barbedienne." Note fleurs-de-lis and other variations in trappings. It was commissioned on the recommendation of L. Bernard Hall, then Director, who dealt directly with the artist, according to David Lawrence, Curator of the Art Museum, National Gallery of Victoria, to David Sellin, July 16, 1959.

28. *Fairmount Park Art Association, Eighty-eighth Annual Report* (Philadelphia, 1960), 8.

Rudolph Siemering, *The Washington Monument* / page 132

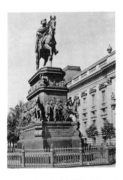

Fig. 1. *Frederick The Great* by Christian Rauch (1758–1844). Berlin. Original in the State Library, Berlin.

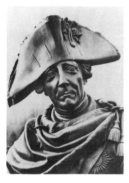

Fig. 2. *Frederick The Great*, head, by Christian Rauch. Berlin. Original in the State Library, Berlin.

1. See *Ceremonies Attending the Unveiling of the Washington Monument Erected in Fairmount Park and Presented to the City of Philadelphia by the State Society of the Cincinnati of Pennsylvania Saturday, May 15th, 1897* (Philadelphia, 1897), 12.

2. *Ibid.*, 17.

3. Document in the archives of the Society of the Cincinnati of Pennsylvania, Philadelphia.

4. For a full account see "In the Court of Common Pleas, No. One for the County of Philadelphia. In re The Washington Monument Fund, (held by the Pennsylvania Company for Insurances on Lives and Granting Annuities as trustees)." A copy of this document is preserved in the archives of the Society of the Cincinnati of Pennsylvania.

5. Unfortunately, information regarding the subject of the competition for the monument and the names of the artists involved has not been forthcoming. According to Berthold Daun, *Siemering* (Bielefeld and Leipzig, 1906), 78, Siemering entered a competition "mit zwei amerikanischen, einem englischen und einem italienischen Bildhauer...."

6. See Minutes of the Society of the Cincinnati of Pennsylvania for January 23, 1878. "The Chair stated that Mr. W. W. Story, an eminent sculptor of Rome, when recently in this country, had met informally with a number of the members of this Society and had communicated his views upon the subject of an appropriate design for the *Washington Monument* to be erected in the future under the supervision of the Cincinnati." There was some disagreement within the Society as to

whether the monument should be national in scope or more narrowly Pennsylvanian, although finally a compromise was reached, the Standing Committee resolving that the purposes of the monument would be best attained by representing the most distinguished officers in Revolutionary service as accessory figures to that of Washington, "in all cases giving due consideration to the claims and services of Pennsylvanian officers" (Minutes of April 23, 1879).

7. Some of Siemering's best-known monuments include those to Frederick the Great in Marienburg (1877), to Luther in Eisleben (1883), and to Professor V. Graefe in Berlin (1883). These are reproduced in Daun, *Siemering*, 26, 34, and 40.

8. Siemering to the Society of the Cincinnati of Pennsylvania, July 29, 1879, archives of that Society. Unless otherwise stated, all the other documents quoted are in the same location. Certain changes in detail occurred during the execution of the monument. Thus the animals in the monument as finally erected do not correspond with those in the written description.

9. *Ibid.*

10. By October 19, 1881, when the contract was signed, the fund of the Society of the Cincinnati amounted to $151,178, while that held in trust by the Pennsylvania Company amounted to $60,798.

11. Siemering to the Trustees of the Washington Monument Fund.

12. Trustees of the Washington Monument Fund to Siemering.

13. Trustees of the Washington Monument Fund to Siemering, November 2, 1880.

14. Trustees of the Washington Monument Fund to Siemering, January 26, 1881.

15. Contract between the State Society of the Cincinnati of Pennsylvania and Siemering, October 19, 1881. It was also agreed that if, owing to unforeseen circumstances, the money for the monument failed, the first portion of the monument to be dispensed with should be the animals at the four corners, next the river figures, and then such parts as, in the opinion of the sculptor, would least detract from the grandeur of the whole.

16. Siemering to the Trustees.

17. Sartain to the Trustees, April 26, 1886.

18. Charles H. Meyer to Richard Dale, June 11, 1882.

19. Gustav Schwab to Richard Dale, November 11, 1887. Schwab had supplied Siemering with a certain amount of documentary material and had been to see the colossal figure of Germania from the Leipzig War Memorial on the grounds of the Berlin Centennial Exhibition in 1886.

20. Sylvester to the Trustees of the Washington Monument Fund, March 11, 1889.

Auguste Rodin, *The Gates of Hell* / page 158

Fig. 1. Second architectural sketch for *The Gates of Hell*. 1880. Musée Rodin, Paris.

Fig. 2. Third architectural model for *The Gates of Hell*. 1880. Terra cotta, 39½ × 24¾ × 6¾". Rodin Museum, Philadelphia. Jules Mastbaum Collection.

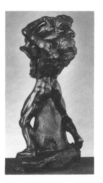

Fig. 3. *I Am Beautiful*. 1882. Bronze, 27¾ × 12 × 12½". Rodin Museum, Philadelphia. Jules Mastbaum Collection.

1. Letter, February 5, 1880, Archives Nationales, Paris.

2. See list of acquisitions made by the State in the Archives Nationales.

3. See Jane Van Nimmen, "Dubois," in *Nineteenth Century French Sculpture: Monuments for the Middle Class*. Catalogue of an exhibition at the J. B. Speed Art Museum, Louisville, Kentucky, November 2–December 5, 1971, cat. no. 62, reproduced p. 164. Introduction by Ruth Mirolli.

4. These are reproduced in Albert E. Elsen, *Rodin's Gates of Hell* (Minneapolis, 1960), plates 33, 36, 38, and p. 65.

5. *Ibid.*, plate 40.

6. Letter quoted in Robert Descharnes and Jean-François Chabrun, *Auguste Rodin* (Paris, 1967), 82.

7. *Ibid.*

8. Gustave Geffroy, *Le Statuaire Rodin* (Paris, 1889), 11.

9. Truman H. Bartlett, "Auguste Rodin, Sculptor," reprinted in Albert E. Elsen, *Auguste Rodin, Readings on His Life and Work* (Englewood Cliffs, N. J., 1965), 69.

10. Octave Mirbeau, "Auguste Rodin," *La France*, February 18, 1885, reprinted in *Des artistes; Première Série 1885–1896* (Paris, 1922), 13 (author's translation).

11. Geffroy, *Le Statuaire Rodin*, 11 (author's translation).

12. Reproduced in *L'Art Français*, no. 41 (February 4, 1888).

13. Ovid, *Metamorphoses* (trans. Frank Justus Miller), 12.11.217–225.

14. Auguste Rodin, *Les Cathédrales de France* (Paris, 1914).

15. Léonce Bénédite, "Dante et Rodin," in *Dante Mélanges de critique et d'érudition françaises publiés à l'occasion du VIᵉ Centenaire de la mort du Poète*, MCMXXI (Paris, 1921), 214.

16. René Cheruy, "Rodin's 'Gate of Hell' comes to America."

17. Léonce Bénédite, "Le Musée Rodin," *Les Arts*, no. 168 (1918), 24.

18. *Ibid.*

The Smith Memorial / page 168

1. Minute Book of the Smith Memorial, Fairmount Park Art Association, I, 57–59.

2. *Ibid.*, II, 313–314.

3. *Ibid.*, III, 385.

4. *Ibid.*, 526.

5. *Ibid.*, 533–534.

6. *Ibid.*, V, 667–668.

7. *Ibid.*, VI, 724.

Augustus Saint-Gaudens, *Garfield Monument* / page 180

Fig. 1. Adams Memorial, Rock Creek Church Cemetery, Washington, D. C. Copy in Cornish, N. H. Photograph by Gordon Sweet.

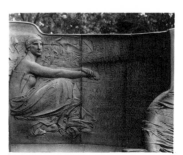

Fig. 2. *Courage*, Farragut Monument. Photograph by Peter A. Juley & Son.

1. I would especially like to thank Miss Carolyn Pitts for her assistance to me in providing an armload of copies of the manuscripts from the Fairmount Park Art Association concerning this commission, and for her diligence in other requests.

2. Committee membership consisted of Joel J. Baily, chairman, Charles Howell, secretary, Charles J. Cohen, Thomas Hockley, and Lincoln Godfrey.

3. *Monumental News*, I, no. 2 (February, 1889), 20.

4. Shaw Memorial (Boston), *Henry Bellows* (New York City), *Diana* (Madison Square Garden, New York City), *Puritan* (Springfield, Mass.), standing *Lincoln* and Bates Fountain (Chicago), to mention the monumental pieces alone.

5. Archives of the Fairmount Park Art Association (Archives).

6. Saint-Gaudens' Papers, Dartmouth College Archives, Hanover, N. H. The contract is dated January, 1894.

7. Dartmouth College Archives. Louis Saint-Gaudens assisted his brother Augustus in a number of commissions from about 1873 until the latter's death in 1907. Louis and his wife, Annetta Johnson Saint-Gaudens, were both sculptors and lived in Cornish, N. H., from 1900 until his death in 1913 and hers in 1943.

8. McKim, Mead, and White Collection, New York-Historical Society. There are five drawings there from the Garfield commission.

9. Rosamond Gilder, ed., *Letters of Richard Watson Gilder* (New York, 1916), 150. Gilder was editor of *Century Magazine* and a close friend of Saint-Gaudens. He wrote to Homer Saint-Gaudens stating that the Century Company had the original death mask of Garfield. Saint-Gaudens was very particular about his realism. His *Lincoln* of 1887 resulted from the discovery of the life mask and cast hand in a fellow artist's studio.

10. Thought to be a quotation from James Thomson (1700–1748). Saint-Gaudens to Charles Howell, May 27, 1895, Archives.

11. *New York Daily Tribune*, May 31, 1896, p. 2.

12. Lorado Taft, *Modern Tendencies in Sculpture* (Chicago, 1928), 34.

13. Homer Saint-Gaudens, ed., *The Reminiscences of Augustus Saint-Gaudens* (New York, 1913), II, 16.

Daniel Chester French, *Ulysses S. Grant* / page **188**

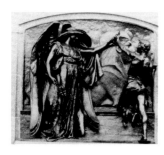

Fig. 1. The Milmore Memorial, 1890–1893, bronze, Forest Hills Cemetery, Jamaica Plain, Massachusetts. Photograph, Michael Richman.

Fig. 2. View of the Court of Honor, World's Columbian Exposition, Chicago, 1893 (displayed are French's and Potter's *Wheat*, French's *Republic*, and their *Quadriga*). Courtesy, Library of Congress.

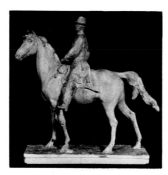

Fig. 3. Maquette for the Hooker Equestrian, 1899, plaster, Chesterwood, Stockbridge, Massachusetts (a property of the National Trust for Historic Preservation). Photograph, Michael Richman.

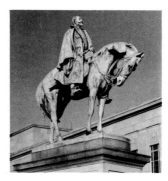

Fig. 4. General Charles Devens, bronze, 1902–1906, Worcester, Massachusetts. Photograph, Michael Richman.

1. Minute Book I, 279, Fairmount Park Art Association, Archives.

2. The Chicago statue was executed by Louis T. Rebisso (1837–1899) and was described by Lorado Taft: "Our equestrian statue of General Grant... is perched upon a nondescript pile of masonry which rests in turn upon a bridge. The sculpture harmonizes with the architecture in its complete absence of artistic distinction." Lorado Taft, "The Monuments of Chicago," *Art and Archaeology*, XII (September–October, 1921), 123. The statue for St. Louis was by Robert Bringhurst (1855–1925). "A bronze statue eight feet high...is to be erected at St. Louis." It shows the distinguished general dressed in a slouch hat, military frock coat and overcoat and high boots. In one hand he holds a field-glass, and the other rests on the knob of his sword." "Monthly Record of American Art," *The Magazine of Art*, XI (December, 1887), iii. The equestrian statue for New York was completed in 1896 and was the work of William Ordway Partridge (1861–1930).

3. *Report of Joint Meeting of Grant Memorial and Works of Art Committees, Fairmount Park Art Association.* It was at this time that the Association decided to erect an equestrian monument.

4. This long-awaited action was stimulated by a personal note sent to Howell by fellow committee member Leslie W. Miller, who began: "I enclose the address [sic] of the sculptors who are as it seems to me most likely to be of use in the Grant matter." This letter of March 6, 1892, listed the names of Olin Warner (1844–1896), F. Edwin Elwell (1858–1922), J. Scott Hartley (1845–1912), Daniel C. French (1850–1931), Paul W. Bartlett (1865–1925), and Cyrus E. Dallin (1861–1944). Before acting on Miller's recommendations, the committee received a second list submitted by Augustus Saint-Gaudens. It included the names of French, Bartlett, Warner, and Frederick MacMonnies (1863–1927). This unsigned piece of paper is endorsed "3/26/92 - 4 PM Mr. St. Gaudens will finish the Shaw Monument in 6 to 8 months and will then take up the Garfield for FPAA and finish it before anything else." Archives. It must be conjectured that Saint-Gaudens met with a member of the Association to discuss his statue of President James A. Garfield. In August, 1891, he had been asked to accept the Grant commission but had declined to become involved in a second time-consuming project for Philadelphia. He consented, however, to name sculptors he thought qualified.

In the years from 1886 until 1892 other sculptors, including John J. Boyle (1851–1917), Charles Henry Niehaus (1855–1935), Franklin Simons (1839–1913), and Henry Jackson Ellicott (1847–1901), expressed an interest in the *Grant*. Foreign sculptors were for a time considered, but dismissed as members of the Association felt their nationality would make the work "unamerican." Minute Book, II, 50, Archives.

5. French to Howell, March 29, 1892, Archives.

6. French to Howell, *ibid.*

7. French to W. M. R. French, December 14, 1892, Box 83, Papers of the Daniel Chester French Family, Library of Congress.

8. *Fairmount Park Art Association, Twenty-first Annual Report* (Philadelphia, 1893), 10.

9. French to Howell, Archives.

10. French to Howell, *ibid.*

11. *Fairmount Park Art Association, Twenty-second Annual Report* (Philadelphia, 1894), 27.

12. French to Howell, Archives.

13. French to W. M. R. French, Box 83, French Papers.

14. French to Howell, Archives.

15. Minutes of the Smith Memorial, VI, 751, *ibid.*

16. French to Howell, *ibid.*

17. H. D. Sate, Private Secretary to the Governor of Pennsylvania, to Howell, June 14, 1893, *ibid.* On May 16, 1972, Henry E. Brown of the Pennsylvania Historical and Museum Commission reported that no law was enacted.

18. Archives.

19. Frank Miles Day to Howell, July 24, 1897, Archives. This letter mentioned that the excavation for the pedestal was underway. French to Howell, October 24, 1897, *ibid.* French wrote that he had learned from Day that construction has been postponed.

20. Cohen to Howell, *ibid.*

21. N7–138, the Century Collection, Archives of American Art, Smithsonian Institution.

22. *North American*, April 28, 1899.

23. *Ibid.*

24. French to Cohen, *Archives.*

25. "I find in Boston a very interesting set of young artists, students at the Art Museums, enthusiastic and in earnest, who to be sure, look on me as one of the old ones, but are glad to include me in their gatherings. Potter, my assistant, is one of this set and I know through him all that is going on." French to W. M. R. French, December 2, 1883, Box 82, French Papers. For a discussion of the execution of the *Harvard*, as well as other works executed by French in the 1880s, see the author's "The Early Public Sculpture of Daniel Chester French," *The American Art Journal*, IV (November, 1972), 96–115.

26. French to W. M. R. French, March 23, 1886, Box 82, French Papers.

27. French to Howell, October 1, 1898, Archives.

28. Adeline Adams, *The Spirit of American Sculpture* (New York, 1923), 60.

Frederick Remington, *Cowboy* / page **196**

Unless otherwise indicated, all documents cited are in the archives of the Fairmount Park Art Association, and were called to my attention by Carolyn Pitts.

1. January, n.d., 1899, Frederic Remington Memorial Collection, Ogdensburg, N. Y. This and further documentation in Ogdensburg was located through the microfilms in the Archives of American Art, National Collection of Fine Arts, Smithsonian Institution, Washington, D.C. (hereinafter cited as A.A.A./Ogdensburg).

2. March 24, 1906, A.A.A./Ogdensburg.

3. N.d., A.A.A./Ogdensburg.

4. *Collier's*, March 18, 1905.

5. Remington to his wife, April 14, 1905, A.A.A./Ogdensburg.

6. March 17, 1905.

7. April 11 and 14, 1905; and Miller to Cohen, May 14, 1908.

8. April 12, 1905.

9. Minutes of May 5, 1905, meeting; also James M. Beck to Miller, May 12, and Miller's draft to Remington, n.d.

10. May 12, 1905.

11. May 17, 1905.

12. Remington to Miller, December 4, 1905.

13. January, n.d., 1906, A.A.A./Ogdensburg; see also January 18, 1906.

14. A. G. Hetherington to Remington, July 21, 1908.

15. Filed May 14, 1906.

16. January 5, 1907.

17. January 25, 1907.

18. February 15, 1907.

19. March 13, 1907.

20. May 2, 1907.

21. December 12, 1907.

22. December 16, 1907.

23. December, n.d., 1907.

24. December 24, 1907.

25. Formally approved March 14, 1908.

26. May 22, 1907.

27. *Fairmount Park Art Association, Thirty-seventh Annual Report* (Philadelphia, 1909), 18.

28. Remington to Miller, received February 13, 1908.

29. April 10, 1908.

30. Returning home, he acquired a farm near Guthriesville, Pa., where he wintered Cody's buffaloes and horses, and at one time ran a livery stable at Coatesville.

31. Alfred Stauffer in the *Herald*, Honey Brook, Pa., February 27, 1958.

32. *F.P.A.A., Thirty-seventh Annual Report*, 41.

33. N.d., 1908, A.A.A./Ogdensburg.

34. Minutes of April 10, 1908, meeting.

35. Hetherington to Remington, July 2, 1908, A.A.A./Ogdensburg.

36. *North American*, June 21, 1908.

37. July 2, 1908, A.A.A./Ogdensburg.

38. June 22, 1908, *ibid.*

39. June 29, 1908, *ibid.*

40. Harold McCracken, *A Catalogue of the Frederic Remington Memorial Collection* (New York, 1954), 30.

Alexander Stirling Calder, *Swann Fountain* / page **230**

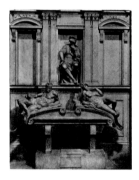

Fig. 1. Tomb Of Lorenzo De'Medici, 1524–1534, by Michaelangelo (1475–1564). Medici Chapel, Florence....showing *Twilight* (left), *Dawn* (right), *Lorenzo* (above).

Fig. 2. Latona Fountain, *c.* 1670, Balthazar Marsy *(c.* 1628–1674), sculptor. Versailles.

1. Dated May 17, 1878; registered Philadelphia, March 31, 1891; admitted to probate April 3.

2. Calder to Fountain Society president Charles J. Cohen, May 30, 1921, Fountain Society Papers. The Fountain Society Papers were given in 1972 to the Fairmount Park Art Association through the kindness of Miss Martha B. Newkirk.

3. Minutes of the board of the Fountain Society, August 4, 1916, saluting the work of Joshua L. Baily, its president from 1883–1915.

4. *Annual Report, Episcopal Hospital*, 1877, 15. See also Pennsylvania SPCA Papers 1867–68, Historical Society of Pennsylvania, Philadelphia, for personality traits.

5. A death bed codicil to Mrs. Swann's will, widely redistributing nearly all her assets anew, provoked twenty-two years of court battles.

6. Principals in the March 28, 1917, move to hire Eyre were Society president Charles J. Cohen and the board's Swann committee member, attorney John Hampton Barnes (whose projected 1902 town house and 1912 suburban home Eyre designed). The board members included Franklin Bodine (Eyre client S. T. Bodine's cousin) and George Bodine. Eyre was architect for earlier board member A. J. Drexel (clients verified by Dr. Edward Teitelman). Other Swann committee members then were J. S. Jenks and H. Tatnall.

7. In a letter to Charles J. Cohen of December 23, 1918 (Fountain Society Papers), Eyre, acknowledging that the Logan site was then being saved for a more costly project, movingly disclaimed that beauty is linked to money or importance and expressed satisfaction with the budget.

8. Wilson Eyre and McIlvaine descriptive statement, January 25, 1921, Fountain Society Papers. Charles Cohen felt the same about the relationship between water and sculpture, elaborating his views in a letter to J. H. Barnes dated November 15, 1916.

9. Resolution adopted July 1, 1921, by Fairmount Park Commission. Fountain Society Papers.

10. In the contract, Calder agreed to deliver finished models to the foundry within eighteen months. Fountain Society Papers.

11. L. R. E. Paulin, "Alex. Stirling Calder; A Young Philadelphia Sculptor," *House and Garden*, III (June, 1903), 317–325. The magazine was cofounded by Eyre, its early editor. Artist John Lambert introduced Calder and Eyre.

12. Eyre and McIlvaine statement, Fountain Society Papers.

13. This, with the high center flow, is the fountain's chief beauty, Eyre maintained. *Ibid.*

14. *Evening Bulletin*, November 17, 1924.

15. Calder to the *Philadelphia Inquirer* to settle a dispute about the fountain's symbolism, quoted in the October 20, 1955, edition; and in an earlier unidentified clipping, Philadelphia Art Commission file. Eyre's descriptive statement and the *Evening Bulletin*, November 17, 1924, also name rivers.

16. John Greenleaf Whittier's reference to the Delaware and Schuylkill in his *The Pennsylvania Pilgrim, and Other Poems* (Boston, 1872), 21.

17. "Fifty feet in height, supplemented by lesser vertical and curved jets grouped around it, but placed axial with the different streets which intersect at this point" (Eyre and McIlvaine statement). This fountain constantly recycles its 30,000 gallons of water which are totally drained and replaced each Friday.

18. Whittier, *Pennsylvania Pilgrim*, 22.

19. *Evening Bulletin*, November 17, 1924.

20. The Wissahickon, "made attractive by its...wildness, and rugged, rocky, woody character," is located in a "romantic dell, through which [it] finds its meandering way." John F. Watson, *Annals of Philadelphia and Pennsylvania* (Philadelphia, 1877), II, 42.

21. Whittier, *Pennsylvania Pilgrim*, 33.

22. The swans and fish were originally gilded, as at Versailles.

23. "Tasting the fat shads of the Delaware," Whittier, *Pennsylvania Pilgrim*, 29.

24. Born at Shamokin, Pennsylvania, Chief Logan *(c.* 1725–1780), whose eloquent speech was preserved by Jefferson, received his name because of his father Shikellamy's great regard for James Logan.

25. Whittier, *Pennsylvania Pilgrim*, 21.

26. Emblematic of Dr. and Mrs. Swann and their interest in animals, these are mute swans, not the trumpeter swans here when Penn came. Water lily or lotus, symbols of purity, are a reminder that the Schuylkill supplies the city's water, while a swimming catfish adds a realistic note.

27. *Evening Bulletin*, November 17, 1924. For other specific criticisms see the unidentified clipping in the Pennsylvania Academy of the Fine Arts library file.

Art Deco Architecture and Sculpture / page **240**

Fig. 1. Sesquicentennial Gates. Ralph B. Bencker. Photograph courtesy Archives, University of Pennsylvania.

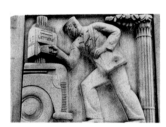

Fig. 2. *East.* Edmond Amateis. Photograph George Thomas.

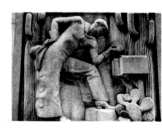

Fig. 3. *West.* Edmond Amateis. Photograph George Thomas.

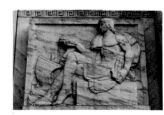

Fig. 4. Figure. Alfred Bottiau Federal Reserve Bank.

1. Willis G. Hale, Schuylkill Navy Building, 1426–1428 Arch Street. 1889. Demolished January, 1972.

2. Zantzinger, Borie, and Medary, architects; Lee Lawrie, sculptor, Fidelity Mutual Life Insurance Building. 1926–1927. 26th and the Parkway.

3. Ralph B. Bencker, architect, N. W. Ayer Building. 1929. East Washington Square.

4. Paul Cret, architect, Federal Reserve Building. 1932. Chestnut Street between 9th and 10th streets.

5. Harry Sternfeld, architect, U.S. Post Office. 1934–1940. 9th and Chestnut streets.

6. The Federal Reserve Bank in Philadelphia has been rarely published. John Harbeson, of the firm of Harbeson, Hough, Livingston, and Larson, successors to the firm of Cret and Kelsy, gave much of his time and information. Some written materials can be found in the Federal Reserve publication, the *3-C Book*, and in Kenneth Reid's "Paul P. Cret, Master of Design," *Pencil Points*, XIX (October, 1938), 632–633.

7. Much of my information came from a delightful conversation with Mr. Sternfeld in May, 1972. The building has been published in "Philadelphia Court House and Post Office, The Ballinger Company and Harry Sternfeld, Architects," *Pencil Points*, XXII (September 1941), 557–570.

Jacques Lipchitz, *Prometheus Strangling the Vulture* and *The Spirit of Enterprise* / page **258**

Fig. 1. *Prayer.* 1943. Bronze, height 42½". Philadelphia Museum of Art. Gift of R. Sturgis and Marion B. F. Ingersoll.

Fig. 2. *The Rape of Europa.* 1941. Bronze, height 34". Formerly collection R. Sturgis Ingersoll, Penllyn, Pennsylvania.

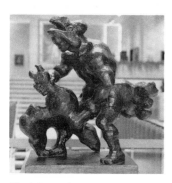

Fig. 3. *Prometheus Strangling the Vulture*. 1936. Bronze, height 36". Art Museum, Princeton University.

1. Katherine Kuh, *The Artist's Voice; Talks with Seventeen Artists* (New York and Evanston, 1960), 155.

2. *Ibid.*, 156.

3. Irene Patai, *Encounters, The Life of Jacques Lipchitz* (New York, 1961), 256.

4. Jacques Lipchitz, "The Story of my Prometheus," *Art in Australia* (June–August 1942), 29.

5. Reproduced in H. H. Arnason, *Jacques Lipchitz: Sketches in Bronze* (New York, Washington, London, 1969), plate 68.

6. Lipchitz, "Story," 29.

7. *Ibid.*

8. Arnason, *Lipchitz*, Plates 121, 122.

9. Lipchitz, "Story," 34.

10. Reproduced in Maurice Raynal, *Jacques Lipchitz* (Paris, 1947), no pagination.

11. *Ibid.*

12. Patai, *Encounters*, 372, and personal communication from the artist.

13. Arnason, *Lipchitz*, plates 149, 151.

14. *Ibid.*, plates 108–110.

15. *Ibid.*, plate 119.

16. *Jacques Lipchitz Skulpturen und Zeichnungen 1911–1969*, catalogue of an exhibition at the Neue Nationalgalerie, Berlin, September 18–November 9, 1970, no. 54.

17. Lipchitz to R. Sturgis Ingersoll, May 3, 1956, Archives of the Fairmount Park Art Association.

18. See report from R. Sturgis Ingersoll of October 14, 1957, Archives.

Jacob Epstein, *Social Consciousness* / page **266**

1. R. Sturgis Ingersoll, "Report of The Committee, As Adopted By The Trustees, On The Subject Matter Of The Sculpture and Inscriptions For The Ellen Phillips Samuel Memorial," *Fairmount Park Art Association, Sixty-Second Annual Report* (Philadelphia, 1934), 33.

2. Marcks to R. Sturgis Ingersoll, March 10, 1950, Archives of the Fairmount Park Art Association (hereinafter cited as Archives).

3. Henri Marceau to Curt Valentin, December 1, 1950, Archives.

4. "His group does not suggest the key position which the Family occupies as a major force in building the nation. SOCIAL CONSCIOUSNESS has more to do with man's respect for his fellow men and his earnest endeavor, through communal enterprise, to better the lot of the community and (in turn) the nation in which he lives." *Ibid.*

5. Epstein to Ingersoll, February 27, 1951, Archives.

6. Epstein, *Epstein, An Autobiography* (London, 1955), 139.

7. Epstein to Ingersoll, February 28, 1952, Archives.

8. Epstein, *An Autobiography*, 101.

9. Epstein to Ingersoll, September 12, 1952, Archives.

10. *Ibid.*

11. Epstein to Ingersoll, April 16, 1953, *ibid.*

12. Undated press clipping, *ibid.*

13. Ingersoll to Epstein, December 2, 1954, *ibid.*

14. Epstein to Ingersoll, January 12, 1955, *ibid.*

15. Emily Genauer, "Abstraction, Realism, Both Awful—Epstein," *Herald Tribune Book Review*, July 24, 1955.

16. Epstein to Ingersoll, December 16, 1954, Archives.

Henry Moore, *Three-Way Piece Number 1: Points* / page **308**

Fig. 1. *Figure*, 1937 Bird's eye marble, 20" high City Art Museum, St. Louis*

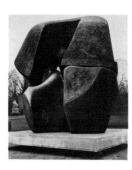

Fig. 2. *Locking Piece*, 1963–64 Bronze, 115½" high

Fig. 3. Armature for *Three-Way Piece Number 1: Points*, with cloth stripping

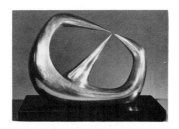

Fig. 4. *Three Points*, 1939–40 Polished bronze, 6 × 7⅝ × 3⅞" (photograph courtesy Marlborough Fine Art, Ltd., London)

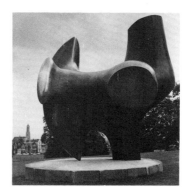

Fig. 5. *Three-Way Piece Number 2: The Archer*, 1964 Bronze, 128" high Edition of 3 (photograph courtesy Marlborough Fine Art, Ltd., London)

*Unless otherwise noted, all photographs are courtesy of the artist.

1. Philip James, ed., *Henry Moore on Sculpture* (New York, 1971), 127–129 (from a 1960 interview with Donald Hall).

2. Donald Hall, "An Interview with Henry Moore," *Horizon* (New York), III, no. 2 (November 1960), 113.

3. David Sylvester, *Henry Moore* (London, 1968), 55; catalogue of an exhibition at the Tate Gallery, London, July 17–September 22, 1968.

4. Herbert Read, ed., *Unit One; The Modern Movement in English Architecture, Painting, and Sculpture* (London, 1934), 29–30.

5. John Hedgecoe, *Henry Spencer Moore* (London, 1968), 447.

6. *Ibid.*, 501.

7. James, *Henry Moore*, 62 (reply made in 1969 to a student doing a thesis).

8. Edouard Roditi, *Dialogues on Art* (London, 1960), 188.

9. Read, *Unit One*, 30.

Detail of *Washington Monument*, photographed by George Krause.

354

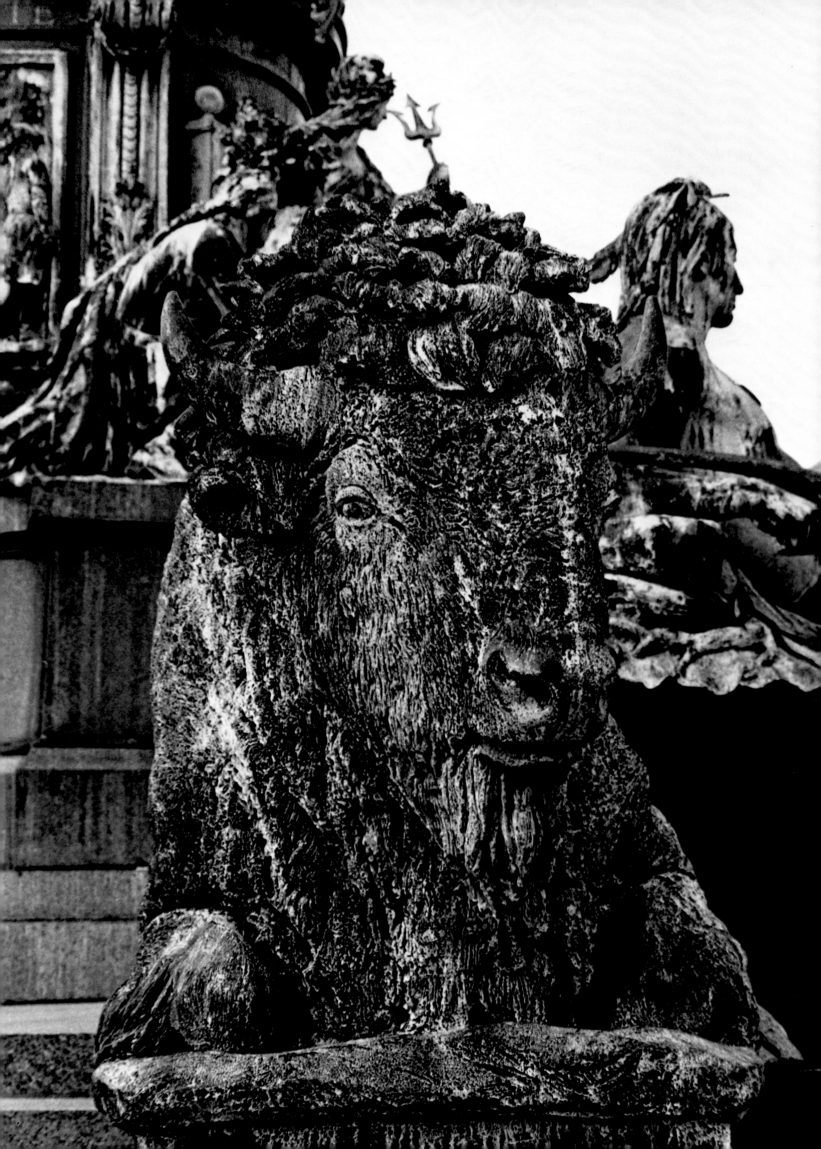

Index

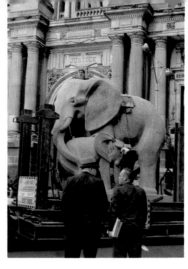

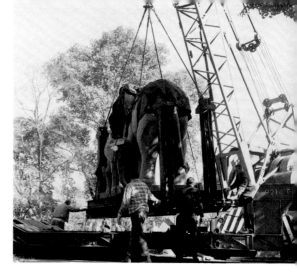

Views of *Washington Monument*, photographed by George Krause.

Designed by Sam Maitin
in association with Deborah Seideman

Printed by Rapoport Printing Corporation

Typesetting by Walter T. Armstrong, Inc.
supervised by Martin Silfen

Typeface is Aster

Paper is Meade Black and White Dull, 80 lb.

Binding by Alan Horowitz & Son

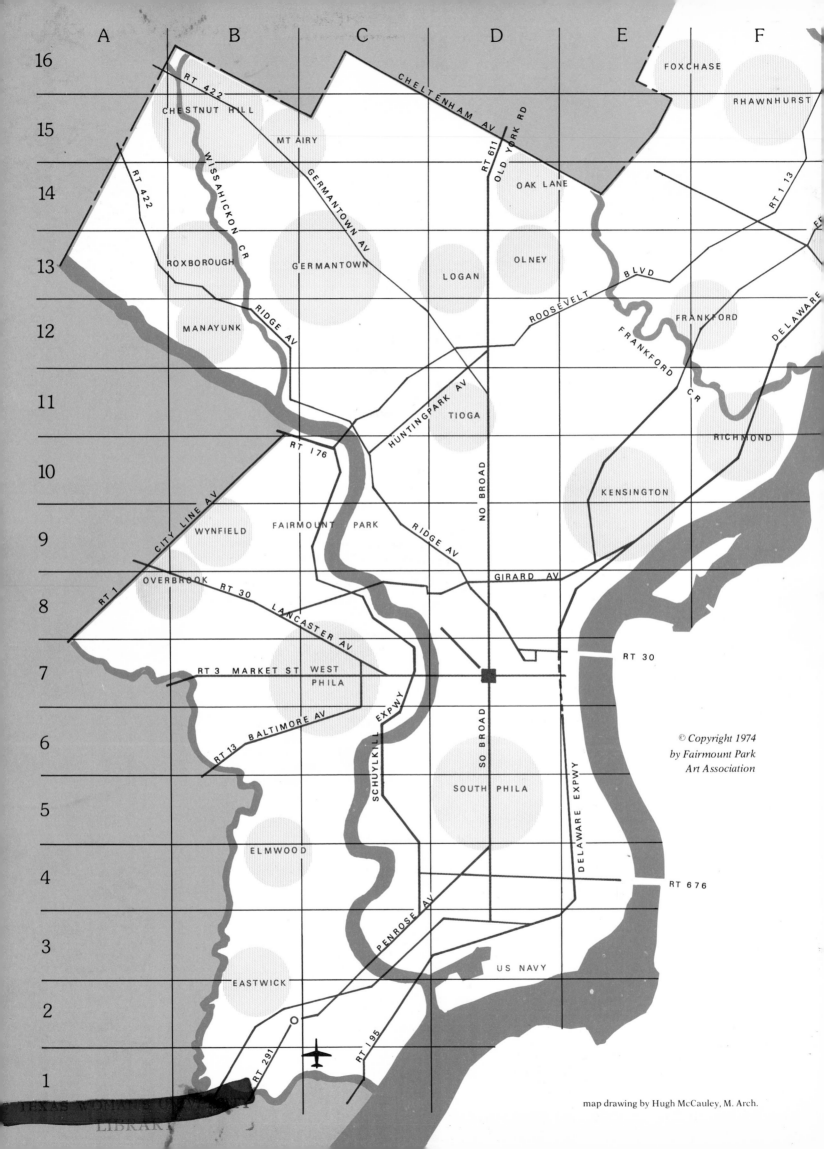

© Copyright 1974
by Fairmount Park
Art Association

map drawing by Hugh McCauley, M. Arch.